10/91      43.50

# ARTEMISIA GENTILESCHI

# Artemisia Gentileschi

## THE IMAGE OF THE FEMALE HERO IN ITALIAN BAROQUE ART

### BY MARY D. GARRARD

PRINCETON UNIVERSITY PRESS

PRINCETON, NEW JERSEY

Copyright © 1989 by Princeton University Press
Published by Princeton University Press, 41 William Street,
Princeton, New Jersey 08540
In the United Kingdom: Princeton University Press,
Oxford

Library of Congress Cataloging-in-Publication Data

Garrard, Mary D.
Artemisia Gentileschi : the image of the female
hero in Italian Baroque art.

Bibliography: p.
Includes index.
1. Gentileschi Lomi, Artemisia, 1593–ca. 1652—
Criticism and interpretation.  2. Heroines in art.
3. Painting, Italian.  4. Painting, Baroque—Italy.
5. Feminism and art—Italy.  I. Title.
ND623.G364G37  1988      759.5      88-9881
ISBN 0-691-04050-8 (alk. paper)

Published with the assistance of the J. Paul Getty Trust

Second printing, 1989

9  8  7  6  5  4  3

This book has been composed in Linotron Galliard

Clothbound editions of Princeton University Press books
are printed on acid-free paper, and binding materials are
chosen for strength and durability.
Paperbacks, although satisfactory for personal collections,
are not usually suitable for library rebinding

Printed in the United States of America by
Princeton University Press
Princeton, New Jersey

THIS BOOK IS DEDICATED TO ITS SUBJECT,

Artemisia Gentileschi, artist *prima inter pares*,

WITH ADMIRATION, GRATITUDE,

AND AFFECTION

# CONTENTS

## APPENDICES

*(English translations of documents from the original Italian texts
by Efrem G. Calingaert, edited by Mary D. Garrard)*

# LIST OF ILLUSTRATIONS

CHAPTER 1

CHAPTER 2

## CHAPTER 3

CHAPTER 6

## APPENDIX A

APPENDIX B

# PREFACE

MY INTEREST in Artemisia Gentileschi was sparked in 1976, when, on reading Eleanor Tufts's book on women artists, *Our Hidden Heritage*, it occurred to me that Artemisia's *Self-Portrait as the Allegory of Painting* harbored unrecognized iconographic complexities. At that time, still early in the evolution of feminist-inspired art historical scholarship, the very notion that a painting by a woman might be examined for significant content was both radical and thrilling. The immediate outcome of that investigation was a paper delivered at the College Art Association meeting in Los Angeles in 1977—appropriately, in a session chaired by Eleanor Tufts; the paper then became an article (1980), whose substance now forms the nucleus of Chapter 6 in this book.

It was my great fortune to have developed and expressed my interest in Gentileschi just at the time and in the place that the groundbreaking exhibition curated by Ann Sutherland Harris and Linda Nochlin, *Women Artists: 1550–1950*, opened in Los Angeles. Included in the exhibit were six paintings by Artemisia, one of which especially caught my attention—the *Susanna and the Elders* from Pommersfelden. As I set to work exploring the Susanna theme in art, it became increasingly clear that Artemisia's version of this subject differed in a single fundamental respect from others by men: it told a timeworn story, freshly and originally, from a woman's point of view. The results of that study were ultimately published as an article (in Broude and Garrard, 1982), and they materialize here in Chapter 3.

As I worked on the Susanna topic, I began to glimpse the shape of a larger work. The book, which then came to seem inevitable, was begun in 1978–79, with the assistance of a grant from the American Association of University Women and a grant-in-aid from the American Council of Learned Societies. This valuable support permitted the European travel essential to the study, and I would like to acknowledge the equally valuable assistance I received at numerous institutions, at both the beginning and later stages of work. In the rich iconographic archives of The Warburg Institute, London, I found material that gave direction to my thought, and I am especially grateful to Jennifer Montagu for her help. In Florence, I enjoyed the kind cooperation of the staffs of the Kunsthistorisches Institut, the Archivio di Stato, and the Biblioteca Nazionale, and among the many individuals who took time to assist me, I would like to thank Marco Chiarini, Caterina Caneva, and Silvia Meloni Trkulja. I am equally grateful to staff members of the Bibliotheca Hertziana and the Archivio di Stato in Rome, and I owe special thanks to the Director of the Spada Gallery, Roberto Cannatà. My appreciation goes as well to Nicola Spinosa and Maria

Nappi, of the Soprintendenza alle Gallerie, Naples, and especially to its former direc-
tor, the late Raffaello Causa. For special help, I am also indebted to Piero Pagano
(Rubinacci Galleria d'Arte, Genoa), to the late Alessandro Morandotti of Rome, to
Amedeo Morandotti of Milan, and to Patrick Matthiesen in London.

My deep appreciation goes to museum and library personnel in American insti-
tutions, most particularly the Library of Congress, which has long been a second
home. At the National Gallery of Art in Washington, D.C., I have benefitted from
the professional wisdom and extraordinary personal generosity of Sarah Fisher (Con-
servation) and Caroline Backlund (Library), and I thank as well Lamia Doumato and
the library staff, and Dean Beasom (Photography). I was also kindly assisted by Keith
Christiansen at the Metropolitan Museum of Art, New York; and at the Fogg Art
Museum, Harvard University, by E. Peters Bowren (Director), Kate Olivier and Teri
Hensick (Conservation), Phoebe Peebles (Archivist), Ada Bortoluzzi, and Martha
Heinz (Photography). I owe special thanks to Patrice Marandel (Curator) and Bar-
bara Heller (Paintings Conservator), at the Detroit Institute; and I remain grateful
to Susanne P. Sack, Chief Conservator of the Brooklyn Museum, for her critical
insights.

I am fortunate to have been given continual support for this project by my own
institution, The American University, support that has taken many forms: money
from the Mellon Foundation Fund for defraying expenses; a course release and a leave
that gave me valuable time to write; the moral support of my colleagues on the Wom-
en's Studies Committee; and the tolerance and understanding of the faculty and staff
of the Department of Art. For knowledgeable help at a crucial late stage, I thank
especially my University colleagues, Ben Kahn and Roger Simonds, and my friends
Claire R. Sherman and H. Diane Russell. I have also valued intellectual stimulation
from the latter two friends, from Sheila ffolliott, and other members of the Collo-
quium on Women in the Renaissance sponsored by the Folger Institute, Washington,
D.C., an interdisciplinary seminar now in its fourth year.

My intellectual debts begin with Alfred Moir, my first art history professor many
years ago at Newcomb College, whose written work and personal advice assisted me
greatly when I entered Caravaggio territory. I would like also to acknowledge a very
special debt to R. Ward Bissell. Ours has been, to me, a model of scholarly colleague-
ship, and I appreciate especially his generosity and open-mindedness, as we have
worked through our shared concerns and our differences of perspective. Warmest
thanks go to Ann Sutherland Harris, whose assistance and encouragement have been
a continuous support. My deepest gratitude is to Pamela Askew, whose advice, in-
spiration, and guidance inform every page of this book, and who represents for me
the highest possible standard of art-historical scholarship.

Among those colleagues and friends whose direct practical assistance helped
bring this book into being, I must name first of all my former student and friend,

Efrem G. Calingaert. Not only did she spend countless hours at the laborious work of translation to produce the splendid results of Appendices A and B, she also worked as liaison for me with many Italian museums, photographers, and collectors. Her initiatives often led to the solution of problems I had given up on, and I deeply value her contributions to the book. I am also indebted to Anna Modigliani of the Archivio di Stato, Rome, who assisted us in making the translations and in corollary investigations far beyond normal professional expectations. Over the course of my work, I was lucky to have as excellent research assistants several then and former students: Barbara Evans, Claudia Vess, and particularly Sussan Babaie, who helped me over a long period. Thanks of a different order are due another former student, Rodney Franko, whose close scrutiny of the Naples *Judith* when it was in Washington led to my reconsideration and x-ray analysis of the painting. For help with photographs and a variety of special favors, I thank the following individuals: Elena Ciletti, Everett Fahy, Alison Hilton, Mary Kelly, Henry Kraus, Ann Tzeutschler Lurie, Elisabeth B. MacDougall, Sheila S. Rinehart, Dr. Karl von Schönborn, Richard Spear, and Clovis Whitfield.

I owe a particular debt of gratitude to some of Artemisia Gentileschi's successors—certain contemporary women artists whom I am fortunate to count as friends, especially Miriam Schapiro, May Stevens, and June Wayne. In different ways, their belief in Artemisia and in me, their encouragement and impatience to have this book, have driven me to finish it, and I hope that it may serve as historical testament to the singular importance of their own art.

I am deeply indebted to Carol Betsch for believing in this book and persuading others of its worth. I am fortunate in having had a very productive and enjoyable working relationship with my editors at Princeton University Press, Eric van Tassel and Sherry Wert, and with my designer, Jan Lilly. We are grateful to the J. Paul Getty Trust for a generous publication subsidy, which made possible the book's extensive illustrations.

Special thanks belong to Sr. Andrea Perla, a gentleman who rescued from an errant Italian train some luggage containing all my Gentileschi notes, not for making this book possible in the usual sense, but for surely preventing its being impossible.

Finally, I thank my colleague and partner, Norma Broude, who has encouraged and sustained me throughout this project. Her creative stimulus, editorial advice, and sound judgment have contributed to the book in countless ways.

# ARTEMISIA GENTILESCHI

# INTRODUCTION

THERE were many Caravaggisti, but only one Caravaggista. Artemisia Gentileschi, the only known female follower of Caravaggio, adapted the bold and dramatic style of Caravaggesque realism to expressive purposes that differed categorically from those of her male contemporaries. Beyond her immediate seventeenth-century context, Gentileschi has, among all pre-modern women artists, given us the most consistently original interpretations of the many traditional themes that she treated. It is my purpose in this book to give her expressive originality at least some of the full art historical consideration that it deserves but has yet to receive.

Artemisia has suffered a scholarly neglect that is almost unthinkable for an artist of her caliber.[1] The neglect began in her own time, when she was, like most women artists, notable more as an exotic figure in the art world than as an artist whose *oeuvre* might deserve definition and inventory. Baglione (1642) gave her a sentence at the end of his biography of Artemisia's father, Orazio Gentileschi. Sandrart (who knew her personally and painted a picture for her) was more objective, including a portrait and a brief but equitable paragraph in his *Academie* of 1675. Baldinucci (1681) wrote a much fuller discussion of Artemisia (four pages—more than he gave Orazio) that provided valuable descriptions of several pictures, but was focused only upon her Florentine period. Artemisia Gentileschi was not mentioned by other seventeenth-century biographers—Mancini, Scannelli, Bellori, or Passeri. De Dominici, the eighteenth-century chronicler of Neapolitan artists, wrote a short laudatory paragraph on Gentileschi in his life of Massimo Stanzione, yet she received no mention from Pascoli.[2]

None of the brief passages devoted to Artemisia provided anything like a full biography. By the dawn of art historical scholarship, it was too late. Da Morrona (1812) would have liked to write a more complete account of her life, but was limited to what he could learn from Baldinucci, and from a surviving member of the Medici family in Florence. Lanzi (1828) similarly relied upon Averardo de' Medici (who owned a now-lost *Susanna* by Artemisia), yet he could name only two of her paintings, and he asserted boldly, as did Walpole (1762) and other writers, that she was best known for her portraits—a dimension of Artemisia's *oeuvre* that is presently represented by barely two examples. Lanzi further confused Artemisia's stylistic position, describing her as a follower of Reni and Domenichino who "was not unskilled in other approved styles."[3] More direct evidence of Gentileschi's life became available shortly afterward, when Ticozzi and Bottari included six letters written by the painter to Cassiano dal Pozzo in their monumental collection of artists' letters, a documentary

milestone followed by the publication of letters from Artemisia to her Sicilian patron, Don Antonio Ruffo, in 1916.[4]

Serious scholarship on Artemisia Gentileschi began with Roberto Longhi's ground-breaking article of 1916, "Gentileschi padre e figlia," the first effort to define her *oeuvre* in the context of Caravaggism, and to distinguish her pictures from those of Orazio. Her meager treatment by early biographers, however, as well as the lack of documentation in published archival material, made the task extremely difficult. Many works by the painter that are mentioned in literary sources and correspondence are lost or unidentified; conversely, even today, no existing painting can be fully documented from commission through execution. The scholarly problem has been compounded by Artemisia's close early relationship with her father, whose art was in part the basis for her own, and whose art hers first resembled. Even so, the careless indifference that has seen these two very different artists repeatedly lumped together would not be brooked in scholarship on other teacher-pupil relationships, such as that of Perugino and Raphael. As late as the 1960s, the primary sources for Artemisia Gentileschi were Longhi's preliminary article and Hermann Voss's entry in Thieme-Becker.

Artemisia's *oeuvre* has been expanded and corrected by several modern scholars, most especially R. Ward Bissell, who wrote the first major and still authoritative article (1968); Alfred Moir (1967) and Richard Spear (1971), who gave her prominent and even-handed discussion in books on the Caravaggisti; Evelyn Borea, who constructed an important Gentileschi section in a key Caravaggeschi exhibition of 1970; and, more recently, Ann Sutherland Harris, Mina Gregori, Erich Schleier, Nicola Spinosa, and others, who have contributed in scattered publications to Gentileschi connoisseurship.[5] To date, however, no monograph has yet appeared on Artemisia Gentileschi, an extraordinary fact when one thinks of the Italian publication industry devoted to countless minor Italian artists, as well as of the penchant of German and American Ph.D. candidates to mine every remotely prospective scholarly vein. The conclusion is, I think, inescapable: Artemisia Gentileschi has been neglected because she was female.

Like other women artists of the Renaissance-Baroque period, Artemisia was a celebrity whose achievements were lauded extravagantly, but who was not taken seriously as an artist, as an equal among equals, either by her contemporaries or by subsequent art historians. Extraordinary in every sense, Gentileschi was characteristically—the scholars cited above are rare exceptions—treated as *hors de combat*. The Renaissance masculine perception of women as lacking both intelligence and the capacity for genius (the single ingredient essential to artistic greatness) led writers of the period to appraise women artists as phenomenal women rather than as artists, and to extend, chivalrically, special recognition for achievement beyond normal expectations for their sex.[6] And despite the feminist movements of the nineteenth and twentieth centuries, the perspective that sets women artists apart from the mainstream has

persisted in modern art history. In 1929, Aldo De Rinaldis wrote a book on Neapolitan painters that did not include Artemisia Gentileschi. Benedict Nicolson, in a review of Caravaggesque scholarship written in 1974 (*Burlington Magazine* 116 [October]: 603–616), could describe recent research on the movement with an itemized inventory of new attributions among the Caravaggisti, including the most obscure of painters, but without a word on Artemisia Gentileschi (an omission corrected, however, in *The International Caravaggesque Movement*, Nicolson's 1979 catalogue of works by the Caravaggisti). *Rome 1630*, by Yves Bonnefoy (Paris: Flammarion, 1970), a book that focusses microscopically on a short period, with names of forgotten and forgettable artists paraded through—including, despite the book's title, a discussion of Orazio Gentileschi in France–includes not a single mention of Orazio's equally celebrated daughter.

If Artemisia has been ignored by writers touched by a masculinist bias, she has been warmly embraced by those fortified with a feminist sensibility. She has consistently been a centerpiece in the books on women artists that began to appear in the early 1970s, notably those of Ann Harris and Linda Nochlin, Eleanor Tufts, Elsa Fine, and Germaine Greer. Greer, who heralded Gentileschi as "The Magnificent Exception," reflected the common feminist wisdom that she was, of all the women artists working before the late nineteenth century, the most outstanding, the giant. This may well be true, yet the reasons for that status have not been fully articulated. The present book is thus an effort to fill a gap that has existed in both conventional and feminist scholarship, for in neither realm has the expressive character of Artemisia Gentileschi's art been given adequate definition. Many feminist writers, though offering the corrective of aesthetic enthusiasm and literary attention, have limited their accounts to biographical celebration, with only perfunctory or non-comparative analysis of the forms and styles of her imagery. On the other hand, scholars oriented to connoisseurship have concentrated on distinguishing the hands of Artemisia and Orazio (or those of Artemisia and Cavallino or Stanzione).[7] Yet while the formal differences between Artemisia and her father are subtle, the expressive differences are vast. Hers is an art of energy and drama, not mood and poetic silences. And though Artemisia's female characters may superficially resemble those of Orazio, they respond and act in an entirely different way.

In this book, I have explored a line of investigation initiated in two earlier articles, whose premise was that women's art is inescapably, if unconsciously, different from men's, because the sexes have been socialized to different experiences of the world.[8] My conclusions in those two instances—here replicated in many others—were that Artemisia's art was indeed radically different in expression and in the interpretation of traditional themes from that of her male contemporaries. Because I have been more concerned with defining the expressive character than in pursuing the connoisseurship of Artemisia's painting, I have not attempted to write a *catalogue raisonné*. But it is worth noting that in identifying Artemisia's pronounced female per-

spective, we are given another dimension of the artist's "hand," and thus another tool for connoisseurship judgments. This is of particular potential usefulness for Artemisia, whose small *oeuvre* (fewer than thirty undisputed pictures) affords a shaky base and an insecure chronology for firm attribution and dating. Undoubtedly, there remain works to be discovered, pictures now hidden under other names in museums and private collections. However, since an appreciative understanding of an artist's *oeuvre* is often the precondition to and not the result of rediscovering and cataloguing it, I hope that a side benefit of my iconographic approach may be to establish a temperamental as well as stylistic touchstone for future Gentileschi attributions.

Despite her consistent adoption of a female perspective, Artemisia was distinctly different from most of the women artists of her era (to the extent that we presently know their work) in her determination to compete with the top-flight male artists of her time. Most women artists before the nineteenth century aspired to professional success, but not to an expressive or stylistic singularity that might jeopardize their precarious achievement. For Sofonisba Anguissola, Lavinia Fontana, or Elisabetta Sirani, it appears to have been enough to be accepted professionally; to attempt an innovative artistic contribution was unnecessary, perhaps hazardous. Arguably, women artists have suffered greater professional disadvantage from their lack of opportunity to grow and develop through competition with artist-peers than from their exclusion from guilds, academies, and study of nude models. Though disadvantaged at the entrance level, women artists enjoyed special status thereafter, yet as a separate artistic species. Praised lavishly and excessively for their achievements, with no direct competitors, they had little incentive to develop or change their art—a situation both ironic and unfortunate, since as outsider, a female artist was uniquely equipped to speak with an original voice, were she to speak from her own nature rather than on behalf of adopted masculine values.

By contrast with such women artists who tended toward both stylistic and expressive conservatism, Gentileschi aggressively modelled her style upon the most contemporary trends around her, modifying it freely to accommodate personal or local tastes, moving from Roman Caravaggism to exaggerated *fiorentinità*, to Caravaggism again, and to Neapolitan classicism, with a dazzling virtuosity equalled by few male contemporaries. At every stage, she drew compositional inspiration from works by the most prominent artists—Orazio Gentileschi, Caravaggio, Rubens, Cigoli, Vouet, Van Dyck. And, as I shall demonstrate, she influenced many of her male contemporaries, not only Cavallino and Vouet, but even Rembrandt and Velázquez. At the same time, in her flamboyantly divergent interpretations of popular biblical or classical themes, Gentileschi issued a deliberate invitation to be compared (and thus contrasted) with the men from whose work she openly distinguished her own.

Yet in her choice of artistic models for the creation of her new expressive interpretations, Artemisia presented a covert demand that her art be associated with the work of certain male artists with whom she felt deeper psychic and aesthetic affinity,

namely Michelangelo and Caravaggio. Artemisia's creative inspiration from Cara-vaggio is well known, but I will propose that her understanding and application of his profoundly original artistic thinking was deeper than that of many of his other followers. As will also be seen, she repeatedly modelled her work on that of Michelangelo, with whom she may have felt a personal connection through Michel-angelo Buonarroti the Younger, great-nephew of *il divino* and affectionate patron of Artemisia herself.

Gentileschi's interaction with the masculine artistic tradition was complex. She could draw creative inspiration both from imaginative identification with female char-acters and from the male heroic models of antique and Renaissance art, yet her use of those models was unpredictable. Artemisia's inspired transformation of formal pro-totypes produced a special mixture of masculine and feminine elements, and the cre-ation of what might be called an androgynous ideal. As good an example as any is Artemisia's Pitti *Judith* (Color Plate 5), a painting whose two central characters are unmistakably female, yet display "masculine" vigor and heroic resolve, even as they evoke specific male formal paradigms (discussed in Chapter 5). Such female characters cannot satisfactorily be called heroines, for they behave as female heroes, as women who are endowed with the traits of that fuller humanity that has traditionally been allowed only male characters. Yet with their cross-gendered traits, they are perhaps more three-dimensional than stereotyped images of either sex. Bringing her own gender experience to her female characters, Artemisia could make them roundly plausible, not as "women" but as whole persons. Simultaneously, as one of those gifted women possessed (in the words of Maude Bodkin) of an "imaginative life largely shaped by the thought and adventure of men,"[9] Artemisia could enlarge the field of her female characters' actions beyond the conventions that circumscribed women both in society and art.

In this respect, Gentileschi's art invites comparison with that of Michelangelo and Caravaggio, Donatello and Leonardo. Her gender-inverted version of androgyny helps to remind us that the androgynous vision is not necessarily a consequence of homoerotic preference, but rather of the ability to identify with or imagine the ex-perience and viewpoint of the opposite sex. Such a vision greatly broadens the range of artistic expression. Some artists, like Rembrandt, achieve it by understating differ-ences between the sexes, subordinating them to a universal humanity. A rare few male artists, such as Leonardo, while sharing many viewpoints of conventional misogyny, manage nevertheless to enrich a fundamentally masculine visual tradition through the use of the female as the primary expressive and symbolic model.[10] Others, like Dona-tello, Michelangelo, and Caravaggio, play upon our gender expectations, creating cross-gender images that combine elements of each sex in new ways, opening new dimensions of human experience to our imaginative life. There was a context for un-derstanding the androgyny of Michelangelo and Caravaggio as "indecent," and they got into trouble over it."[11] Artemisia's virago *Judith*s might have offended the author-

ities, too, had there been a rationally definable context in which to place them. But as there was only the unofficial religion of patriarchal misogyny, her aggressive females were met with an unspoken fear and suspicion. Both in her own time and later, their powerful feminist message was largely ignored.

Much of what Artemisia achieved was, as Leo Steinberg aptly observed of Michelangelo's last paintings, "a gift to the twentieth century" (because no other century would have them).[12] It was not that the style of Gentileschi's work was new and unfamiliar, as in Michelangelo's case, but that the expressive content of her imagery could not be acknowledged, nor perhaps consciously recognized, in an era that would not concede the value of authentic female experience. It has remained for the twentieth century to provide her true audience: women and men conditioned by a consciously realized feminism to respond to and share in an art in which female protagonists behave as plausible human beings.

IN THIS study, I devote a great deal of attention to the behavior of the characters in paintings. The formal concerns that were a preoccupation of early modern scholarship, and the socio-theological focus of more recent art history, have desensitized us significantly to other goings-on in paintings, to the interaction of figures as on a stage (like Hogarth's "dumbshow"), and—in seventeenth-century paintings in particular— to the states of being created by artists in their pictorial theaters that imply not only the events that precede and follow, but also the entire historical and psychological ambient of the figures' immediate situation. Among their other innovations, Caravaggio and Annibale Carracci were pioneers in a new focus upon individual characters, as distinguished from the narrative or decorative elaboration of multiple parts that typified late sixteenth-century *maniera* art. A comparison of a representative picture by Caravaggio, his *Judith*, for instance, with images of a similar theme by a late sixteenth century painter (see figs. 255 and 253), readily demonstrates that if the artist restricts his *mise-en-scene* to only a few figures, placed on a shallow stage and rendered naturalistically with optical precision, each of those individuals looms very large, as a specific person rather than a type, and each personal reaction to the central event assumes expanded importance.

We see in Gentileschi's *Judith* (Color Plate 5) a similar artistic choice, with similar results: these characters suddenly matter as individuals. And if the artist further freezes the figures in action, like a single frame in a cinematic sequence, a profound stillness is born of arrested living motion, which can induce the viewer to meditate intensely on that event's spiritual or psychological meaning. In such a state, believing absolutely in the characters' dramatic reality—as one does while watching a good play—the viewer is equally convinced of the significance of the events that precede and follow the moment we are privileged to glimpse. But in the painting, unlike the play, we will never see the entire sequence, will never know the end. It is this frustrating paradox, that we are shown only a slice of a living reality whose saturated

realization has provoked our intense curiosity to know more, that drives us to scru-
tinize every detail of the picture for more evidence of its meaning (in dramatic terms,
its plot, but also, as in drama, its philosophical implications). In the absence of the
drama's finale, we are also compelled to think historically, to recognize in the move-
ments and poses of the figures those echoes of past art—in the Caravaggio, it may be
Roman sculpture, in the Gentileschi, Michelangelo's *David*—that are the artists' way
of loading the image with associations relevant to the main idea.

I have approached Gentileschi's work with a sense that her paintings demand and
were intended to be read in this way. By Artemisia's time, the third century of a con-
tinuous tradition of pictorial narrative in Italy, painting an image of a traditional
theme had become an inventive challenge, one that tested the artist's familiarity with
the theme and its possible conceptual variations, even as it encouraged a desire to
renew the concept through unusual accents or emphases, selections of different mo-
ments in the narrative, or unexpected connections with other works of art. Such ex-
pressive concerns, I would venture, were as much on the artists' minds as the accurate
depiction of objects observed, or the composition of figures in space, which may
frequently have been regarded as means to the larger end of a new *invenzione*.

Recent scholars such as Boschloo and Spear have recognized that the "coming
down to earth" of artists in the early seventeenth century was not entirely due to the
influence of Caravaggio's earthy naturalism, but was a more spontaneous and wide-
spread phenomenon that began in the late sixteenth century.[13] Its broad base notwith-
standing, however, the particularizing tendency that came to be identified with the
Caravaggesque Baroque has, from Caravaggio's own day to the present, frequently
been disparagingly and mistakenly identified as simplistic visual realism.[14] A deeper
understanding of Caravaggio's art, to which we have been led by certain modern
scholars (especially Friedländer, Lavin, and Röttgen), prepares one to understand
that such "realism" is more accurately understood as *realization*—giving concrete
form to important spiritual or philosophical concepts—which may include, but is not
restricted to, an interest in capturing the surface appearance of everyday objects.
While the philosophical dimension of naturalist art—even Caravaggio's—has not
even now been accorded its full due, it may nevertheless be supported by the example
of Artemisia Gentileschi, whose art was an independent manifestation of the par-
ticularizing approach, and who was successfully stimulated by Caravaggio's example
to undertake some of the sophisticated expressive uses to which such a naturalist style
might be put.

THE first chapter of this book is a historical and biographical account of Gentileschi's
career, in which the painter and all of her published works are discussed in the context
of the art of her time. While a definitive catalogue of the artist's work remains to be
written, I have taken a position on standing or new attributions, and have also pro-
posed a few more new ones—judgments that are intended as contributions to an en-

larged discourse on the shape of Artemisia's *oeuvre*. The second chapter places her in another context, one newly created by historians (though not yet widely adopted by art historians), that of historical feminism—the evolving dialogue on the subject of women known in the Renaissance as the *querelle des femmes*, which was broadly reflected in prints and visual images. The core of the study is the last section, consisting of four chapters, in which five themes treated in paintings by Gentileschi are examined in relation to their respective iconographic traditions.

Each of the themes treated—Susanna, Lucretia, Cleopatra, Judith, and the Allegory of Painting—concerns a female character, yet each also involves mythic archetypes of male and female. Many, if not most, of the myths, legends, and themes depicted in Western art contain both male and female characters, yet they have taken shapes that are largely male creations (or reworkings of older, pre-patriarchal material). The constant recurrence of images of certain themes in art is itself eloquent testimony to the strange vitalizing power of archetypal images, and to their function as visual metaphors for compelling ideas or intensely felt beliefs. Common sense tells us that the myths, legends, and visual archetypes have held important meanings, though perhaps different meanings for the two sexes. One woman's alternative perception of a traditional story, with an unexpected shift of emphasis, is revealed in a letter written by Artemisia Gentileschi herself, in which she describes a famous episode in the legend of Perseus as the story of "Andromeda, when she was freed by a certain knight on the flying horse Pegasus" (Appendix A, no. 28).

The hypothesis of this book, of which Gentileschi's paintings are the proof, is that when re-examined and reinterpreted by a female artistic intelligence, the old themes can be made to yield their dormant night-sides, to offer fresh meanings, and so to renew their ancient power over us.

PART I

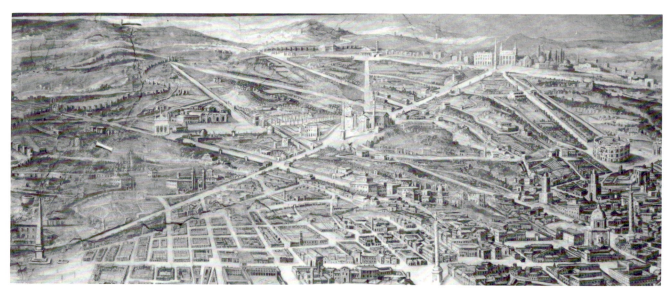

1. Map of Sistine Rome, fresco, Biblioteca Vaticana.

# Artemisia Gentileschi in Her Time: Life and Art

## ROME, 1593–C. 1613

Artemisia Gentileschi was born in Rome on July 8, 1593, at a propitious historical moment, and under artistically favored circumstances.[1] The eldest child and sole daughter of the painter Orazio Gentileschi and his wife Prudentia Montone, Artemisia was the only one of four children to develop a significant aptitude for the art of painting.[2] Orazio trained his daughter as an artist, with evident pride in her accomplishments. By 1612, when she was not yet nineteen years old, her father could boast of her extraordinary talents, claiming that in the profession of painting, which she had practiced for three years, she had no peer.[3] This claim was scarcely an exaggeration, for Artemisia's earliest paintings display a highly precocious artistic ability, which consisted in equal parts of an early mastery of technical skills, an extensive informal artistic education in Rome, and sheer creative genius.

In the years around 1605 to 1610, the probable period of Artemisia's apprenticeship, Rome was a newly transformed and artistically vital city. Around the Gentileschi family's neighborhood, the artists' quarter that lay between the Piazza di Spagna and S. M. del Popolo (Fig. 1),[4] large new architectural spaces had recently been created—thanks to the bold urban vision of Sixtus V—whose broad straight avenues converged upon the obelisk at the center of the star-shaped Piazza del Popolo. Novel to Artemisia's elders, but a familiar part of her own youth, were the new churches that sprang up over Rome in the last quarter of the sixteenth century in the wake of the Counter-Reformation. This architectural expansion was followed by an explosion of painted decorations, in palaces as well as churches, on canvas and in fresco. The works in progress during Artemisia Gentileschi's adolescence included some of the most important pictorial ensembles seen in Rome for half a century: the Carracci frescoes in the Farnese Gallery (c. 1597–1604); Caravaggio's paintings for chapels in S. Luigi dei Francesi (1599–1604) and S. Maria del Popolo (1600–1601); and the St. Andrew frescoes in S. Gregorio Magno by Guido Reni and Domenichino (1609).

From infancy, Artemisia's personal world was filled with her father's artist friends, mostly of an older generation than that represented by the Bolognese classi-

cists who largely dominated the Roman scene in the first decade of the seventeenth century. Her own godfather was a painter named Pietro Rinaldi. A better-known artist, Giuseppe Cesari (later Cavaliere) d'Arpino, a late Mannerist painter for whom the young Caravaggio worked, attended the baptism of her brother Giovanni Battista, born a year after Artemisia, and the Flemish painter Wenzel Coebergher was godfather to Giulio, born in 1599.[5] The strong contingent of Northern artists in Rome in the years around 1600 was centered in the quarter where the Gentileschi family lived, and Orazio's personal connections with these artists are manifest—particularly with the German painter Adam Elsheimer, who came to Rome in 1600, and whose influence has been detected in the intimate scale and poetic lyricism of some of Orazio's early Roman paintings.[6] Artemisia's own early life, however, was more significantly shaped by the art and personality of Caravaggio. By 1602, when she was only nine years old, Caravaggio's revolutionary early paintings in S. Luigi dei Francesi and S. M. del Popolo were already on public view in Rome. Artemisia is likely to have personally known Caravaggio, a colleague of her father who sometimes borrowed studio props from him. When she was ten, Orazio and Caravaggio were publicly associated as part of the "Via della Croce clique" accused by the painter Giovanni Baglione of libel against him.[7] Although Caravaggio himself left Rome permanently in 1606, his pictures were steadily entering Roman churches and private collections during Artemisia's childhood years, and his startling artistic innovations were undoubtedly as much a topic of conversation in the Gentileschi household as in the broader Roman artistic world.

Artemisia's absorption of Caravaggio's style was mediated by Orazio's response to the radical young Lombard artist. Caravaggio's assertion in the Baglione trial testimony that Orazio was not a close friend, nor even a *valentuomo*, has not discouraged scholars from recognizing that, on balance, a closer artistic relationship existed between these two men than between Caravaggio and such artists as Cavaliere d'Arpino and Federico Zuccaro, whose critical attitudes he professed to share. Yet Orazio's response to Caravaggism was, as Bissell aptly described, "considered, not superficial."[8] When Caravaggio's art burst into his life, Orazio was already almost forty years old, his personal style well grounded in late *maniera* ideal-based imagery, from which he was only gradually drawn by Caravaggio's example to the direct depiction of forms from life. Orazio initially responded, in such of his paintings as the Corsini Gallery *St. Francis Supported by an Angel* (Fig. 2) of c. 1600-1603 to works of Caravaggio that were already old-fashioned in style—lyrical and gentle paintings of the 1590s, such as the *Ecstasy of St. Francis* (Fig. 3) and *The Rest on Flight*. But these afforded a firm basis of delicate poetic naturalism that would set Orazio's course for the balance of his career. His affinity for the early Caravaggio was conditioned by his Tuscan heritage, which had equipped him with a disciplined understanding of the volumetric linear precision of the Florentine form-drawing tradition, and also with the already

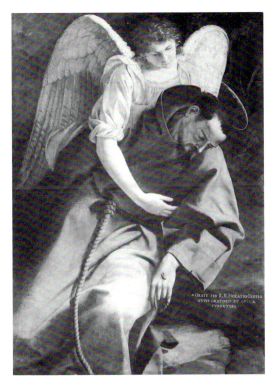

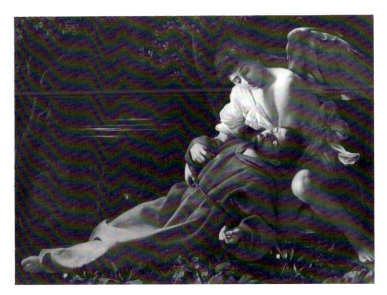

2. Orazio Gentileschi, *St. Francis Supported by an Angel*, c. 1600–1603. Rome, Galleria Nazionale d'Arte Antica, Palazzo Corsini

3. Caravaggio, *Ecstasy of St. Francis*, c. 1595. Hartford, Wadsworth Atheneum

successful hybrids of the ideal and real that were produced in Florence in the late sixteenth century by Santi di Tito and Lodovico Cigoli.[9]

Orazio's two critical artistic experiences—an early steeping in Florentine tradition and a mid-life confrontation with Caravaggio's bold chiaroscural naturalism—were for Artemisia roughly reversed. Her own earliest knowledge of art would have included Caravaggio's dramatic, "virile" paintings in Rome: Saints Matthew, Peter, and Paul in S. Luigi dei Francesi and S. M. del Popolo, the Chiesa Nuova *Entombment*, and the *Death of the Virgin* (briefly in S. M. della Scala). She did not directly encounter the Tuscan tradition until her move to Florence in 1613–14, when she was about twenty-one. The delicate and calculated balance between Tuscan *maniera* idealism and strong Roman realism that Orazio had spent half his life achieving was thus for Artemisia an initial point of departure.

Artemisia's first dated picture, the *Susanna and the Elders* at Pommersfelden (Fig. 4 and Color Plate 2), signed and dated 1610, affords the principle touchstone for the artist's earliest works.[10] Although it was painted in the year of Caravaggio's death, the picture displays no obvious connection with Caravaggism, and only a single detail shows us that she has begun to look at the art of the radical master: the foreshortened hand of the elder on the left, spread as an ovoid shape, which directly echoes a hand

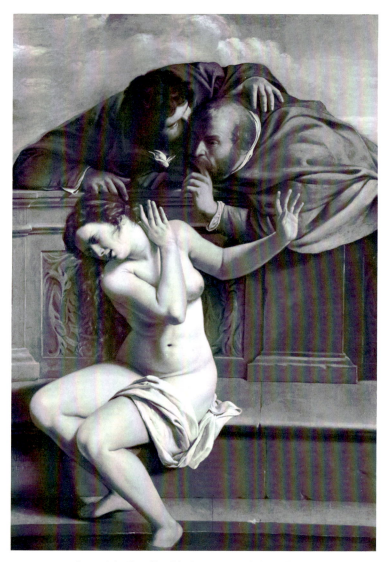

4. Artemisia Gentileschi, *Susanna and the Elders*, 1610.
Pommersfelden, Schloss Weissenstein

in Caravaggio's Casa Coppi *Judith Beheading Holofernes* of 1598–99 (Fig. 255). In its stiffly diagonalized composition and animated facial expressions and gestures, the *Susanna* displays instead an incredibly mature assimilation of Orazio's recent style, as seen in such paintings as the *Penitent Magdalen* at Fabriano (c. 1605), *St. Michael Overcoming the Devil* (c. 1605–1608), and the Dublin and Spada *David*s of 1605–1610 (Figs. 169 and 266).

Artemisia's early dependence upon her father's model is less surprising than her unusually early signs of independence from her only teacher. Since females were not eligible for normal paths to artistic careers, such as training with more than one established master, travel, or memberships in guilds, Artemisia's apprenticeship to her

father would have been her only access to the profession. The progress of that apprenticeship, given its familial informality, is difficult to trace. Orazio claimed in 1612, in his petition to the Grand Duchess of Tuscany, that his daughter had been brought up in the profession of painting, and in three years had gained a mastery and knowledge unequalled even by mature artists. We cannot be certain whether this meant that she only began to paint in 1609, or began to paint independently at that time; it was more likely the latter, to judge from the quality of the *Susanna*, and also from Orazio's case for Artemisia's precocity, in which he cited particular (unnamed) pictures that she had painted, that demonstrated her unparalleled knowledge.[11] As a girl in a non-aristocratic household, Artemisia is unlikely to have had extensive formal education; at the age of nineteen, she stated that she could not write and could read only a little.[12] Her earliest paintings reflect, therefore, an intensive schooling in the language of art. The *Susanna* boldly, even proudly, sets forth Orazio's principal legacy to his talented pupil: a disciplined mastery of anatomical drawing, and a sophisticated control of light, shade, and color. The painting displays especially the subtly nuanced use of color that would separate both Orazio and Artemisia from the local-color orientation of many contemporary Caravaggisti: carefully modulated hues, close in value, with shadows responsive to adjacent tones, set off by large areas of brown and gray, and with a contrasting scale of flesh tones from pearl white to ruddy pink, the latter colors concentrated naturalistically on hands, feet, and faces. Yet the specific color scheme of the *Susanna*—a complex cluster of red-violet, yellow-green, red, and grayed blue—differs from Orazio's preferred major triad of those years, and the character of Artemisia's color mix suggests that she was already looking at other art around her.

Both for the color of the *Susanna* and for aspects of its design, the young painter appears to have turned to an especially well-known model. Artemisia's cool violet, mustard-green and gray-blue closely echo the hues of Michelangelo's Sistine Ceiling frescoes, more than they do most seventeenth-century examples, and her modulated color in the drapery—from rose to grape, from green to gold—reflects an appreciation of Michelangelo's richly nuanced color that was unusual in its day.[13] The twisted body of the nude figure seated tensely on a hard stone seat closely recalls the *ignudi* (Fig. 5), while Susanna's arm gestures connect her (in reverse) with the figure of Adam in the *Expulsion* scene (Fig. 168). The common antique source for both Artemisia and Michelangelo, an Orestes sarcophagus, is discussed in Chapter 3, but it is here more pertinent to observe that in her earliest signed and dated painting, Artemisia sought inspiration for a heroic female character in the heroic males created by a revered High Renaissance master. That Artemisia Gentileschi should have identified personally with Michelangelo Buonarroti is especially comprehensible in view of her close attachment to Michelangelo Buonarroti the Younger, great-nephew of the artist, who was a family friend and major supporter of Artemisia in Florence (see below, p. 34). She may have felt herself part of an artistic lineage that reached through Michelangelo

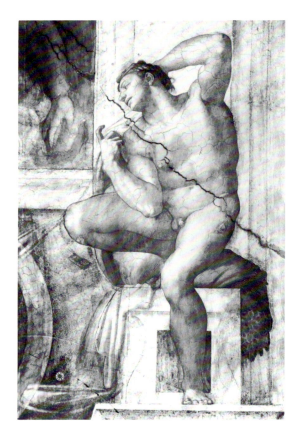

5. Michelangelo, nude male figure, 1509–1511.
Rome, Vatican, Sistine Ceiling

Merisi da Caravaggio, a man of her parents' generation and her own acquaintance, back to Caravaggio's own artistic model, Michelangelo Buonarroti, a legendary figure to whom she could also claim a personal link. As we shall see, Gentileschi's aspiration to Michelangelo's measure can be observed at several critical stages of her life.

Artemisia's profit from exposure to other artistic monuments of Rome is suggested in a rare vignette afforded by the documents. On two excursions in the early summer of 1611, she set out by carriage—clearly on Orazio's instruction—to visit the three principal churches in Rome in which significant papal projects were in progress: Santa Maria Maggiore, St. Peter's, and the Quirinal Palace.[14] In S. M. Maggiore, where Pope Paul V's ambitious decoration of the Cappella Paolina had been underway since 1605, Artemisia would have seen in progress the ceiling paintings of Cigoli and Guido Reni (1610–12), currently being executed under the direction of her father's colleague, Cavaliere d'Arpino. At St. Peter's, Carlo Maderno's extension of the nave and creation of the facade, begun in 1607, were nearing completion, and Michelangelo's great dome (set in place only 20 years earlier) was receiving its mosaic inner decoration, again at the hands of Cesari d'Arpino. At the Quirinal Palace, where her father was at work when Artemisia and her friends arrived, and at the adjacent garden

casino of Scipione Borghese where Orazio was also employed, the young artist was
exposed to more innovative pictorial projects, and as well to one of the most advanced
groups of painters then working in Rome.

In the Quirinal, the decoration of the Sala Regia was being carried out by Ago-
stino Tassi, a landscape and marine painter recently arrived from Florence, in collab-
oration with Giovanni Lanfranco and Carlo Saraceni. At the time of Artemisia's visit,
Orazio Gentileschi was working in collaboration with Tassi (whose friends and rela-
tives made up the visiting party with Artemisia) on some now-destroyed frescoes in
the Quirinale, in the Sala del Concistoro; that same September, they would begin
work together in the newly built "Casino of the Muses" of Scipione Borghese.[15] There,
among the Muses and the musicians who served as poetic pictorial counterpoints to
the feasts and entertainments of Scipione Borghese, appears the portrait-like image
that has been identified as the young artist herself (Figs. 6, 7). If the identification is
correct, then the inclusion of Artemisia's image here may have been meant to com-
memorate an artistic debut as well, since it could easily have been she who executed

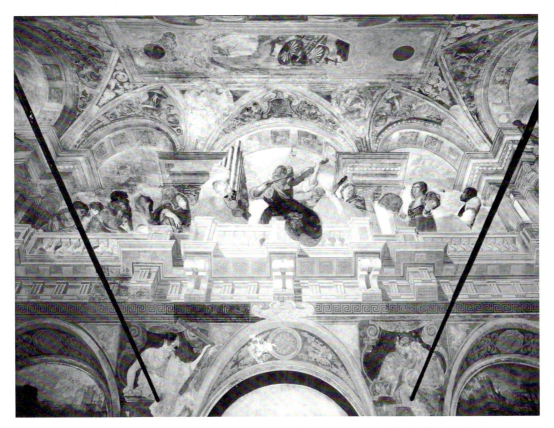

6. Orazio Gentileschi and Agostino Tassi, *Musical Concert Sponsored by Apollo and the Muses*,
1611–12. Vault fresco, Rome, Palazzo Pallavicini-Rospigliosi, Casino of the Muses

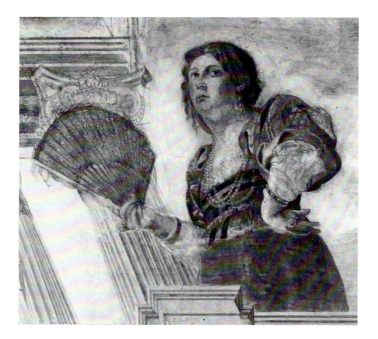

7. Orazio Gentileschi and
Agostino Tassi, *Musical Concert
Sponsored by Apollo and the
Muses*, 1611–12, detail of
Artemisia Gentileschi(?). Vault
fresco, Rome, Palazzo
Pallavicini-Rospigliosi,
Casino of the Muses

some of the figures in this fresco cycle that are now given to "Orazio's assistants."[16]
The illusionistic *quadratura* framework in the Casino of the Muses was painted for
Orazio's figures by Tassi, who, because of his skill in architectural perspective, had
reportedly been asked by Orazio to instruct Artemisia in perspective. One such lesson
a few months earlier may have afforded the occasion for Tassi's initial intimate en-
counter with Artemisia, an encounter that led to the famous rape trial of 1612.

Agostino Tassi's rape of Artemisia Gentileschi, one of the *causes célèbres* of art
history, is extensively documented in the testimony of the trial that resulted from the
suit brought by Orazio Gentileschi against his friend and colleague. The Italian text
of the trial testimony, published in part many years ago, and in nearly complete form
recently,[17] is included in this volume for the first time in English translation (see Ap-
pendix B). To read the trial testimony is to descend to a genuinely depressing level of
sexual and moral sordidness. Even upright citizens do not look good in police court,
and the cast of characters involved in this incident included some very seamy types
indeed. Yet it is a precious document, affording a very large slice of raw seventeenth-
century reality, and a few facts that can be sifted from the heap of self-serving half-
truths and lies.

In March of 1612, Orazio Gentileschi filed suit against Agostino Tassi for injury
and damage, initiating the seven-month trial that became a public scandal. Artemisia
testified under oath that in May 1611, she had been sexually violated by Agostino Tassi.
She described the frequent appearance of Agostino in the Gentileschi household and
his friendship with Orazio's tenant, a certain Tuzia, who, according to Artemisia,

acted as procuress for Tassi. Agostino's initial efforts to court Artemisia were unwel-
come, despite strategic assistance from his allies Cosimo Quorli and Tuzia. Although
part of the seduction strategy—and of Tassi's defense as well—had been to accuse
Artemisia of prior promiscuity, she maintained throughout the trial that she had been
a virgin, forcibly deflowered by Tassi. Artemisia was subjected to the torture of *sibille*,
metal rings tightened by strings around her fingers, to prove that she was telling the
truth. Her loss of virginity was confirmed when the judge ordered a physical exami-
nation by two obstetricians, one of whom added gratuitously that the defloration was
not recent. Weighing against this evidence, which could be interpreted to imply sex-
ual promiscuity potentially damning to the Gentileschi side of the case, was Arte-
misia's impassioned and detailed description of the rape and of her active resistance,
to the point of wounding her assailant with a knife, and the confirmation of her ac-
count by Tassi's own friend Stiattesi.

The role of Tuzia in the affair is of particular interest because she enjoyed a close
personal relationship with the Gentileschi household before the Tassi incident. Ac-
cording to her testimony, the families became acquainted in the spring of 1611, when
they lived across the street from each other on Via Margutta. They all took a house
together on Via della Croce (because, Tuzia said, of the friendship between Artemisia,
herself, and her daughter), where they lived from April 10 to July 16 of 1611. The two
families moved together a third time in July 1611, to the house facing S. Spirito in
Sassia, where they lived at the time of the trial, and where, according to Tuzia, Orazio
had obligingly cut a door and staircase between their living areas. Tuzia's loyalty to
the Gentileschi family was ultimately compromised, however, by her friendship with
Tassi. Her description of the girl's flagrant, openly sexual behavior with Tassi
stretches credibility as much as does her image of a pure and clean Agostino Tassi,
lovingly devoted to Artemisia and her father (of which even the judge was openly
skeptical). Yet Tuzia's account is worth reading for her detailed descriptions of the
outings to S. Paolo fuori le Mura and to Monte Cavallo, which evoke two days in the
life of the artist with the narrative precision and the fresh authenticity of a page from
a diary.

Despite her street-wise sophistication, Artemisia must have felt Tuzia's betrayal
quite deeply. Given her situation as the only girl in a family of four sons, motherless
since age twelve, Artemisia's close friendship with Tuzia and her daughter is entirely
believable, and the loss of that friendship—which set a pattern for a life lived in a
world of men, with no close female friendships ever mentioned—may have triggered
a compensatory fantasy in her art. Several of Artemisia's most important paintings,
in particular the *Judith*s that date from shortly after the trauma of the rape, have as
their expressive core a solidarity and unity between women.

After the rape, Agostino had assured Artemisia that they would be married. It
would have been the only honorable way to salvage the situation, since, as the trial
testimony amply demonstrates, an unmarried woman who had had sexual intercourse

was considered to be damaged property, cheaply available to all, but worthless as a wife to any man other than he who had deflowered her. Artemisia may have believed his promises of marriage at first, since (the accounts agree on this point) Tassi actively prevented her marriage to others. But Agostino's intention to avoid marriage must have become increasingly apparent to Artemisia in the months following the rape, when, as she described, he never went out with her in public, yet continued to approach her sexually in her home, always through the door of Tuzia's apartment. Her own attitude toward the continuing sexual relationship appears to have been totally pragmatic, in the context of the *mores* of her day. She testified that she discouraged him from giving her presents, since "what I was doing with him, I did only so that, as he had dishonored me, he would marry me" (Appendix B, ms. 22).

Tassi, whose intent was to muddy the sexual waters as much as possible, denied having had intercourse with Artemisia, and produced in his testimony a comic opera of accusations of others. He suggested that his friend Giovanni Battista Stiattesi had had sexual relations with Artemisia, an allegation he extended, through his witnesses, to a host of men—Geronimo Modenese, Pasquino Fiorentino (who had conveniently died since), Francesco Scarpellino, a red-bearded cleric named Artigenio, and even Artemisia's father. Agostino depicted Artemisia as an incessantly flirtatious and insatiable whore—and not only Artemisia herself, but her mother (whom he could not have known) and aunts as well. Much of the testimony offered against Artemisia by Tassi's witnesses was sensibly refuted by Orazio Gentileschi, who charged one of the witnesses, Nicolo Bedino, with false testimony, setting off a sub-trial and torture by *sibille* of that unfortunate fellow who had worked for both Orazio and Tassi.

Artemisia's innocence of these accusations was defended by Tassi's erstwhile friend Giovanni Battista Stiattesi, whose own intimate relationship with Agostino had extended to the exchange of love poems. In a letter to Tassi that was admitted as evidence, Stiattesi described Artemisia as a poor girl badly treated and disgraced by Agostino and Quorli, and he defended her under oath as well. No other witnesses spoke directly in her defense, but a great deal of indirect evidence may have offset Tassi's absurdly exaggerated charges, such as the report to Tassi by his own spies that Artemisia was virtuous. In the end, the unreliability of Tassi's witnesses and his own reputation as a multiple sexual offender may have weighed more heavily with the court than any presumption of Artemisia's virtue. Agostino, who had earlier been imprisoned for incest with his sister-in-law Costanza, was charged at the rape trial with having had his wife murdered, and it also came out that he had had children by Costanza, whom he had brought to Rome from Livorno.[18] Despite all this, however, and despite the basic credibility of Orazio and Artemisia's charges, it appears that Agostino was released from prison after eight months, and that the case was eventually dismissed.

Aside from its harsh illumination of personal relationships, the trial testimony also yields some art historical information. Although Tassi claimed that he had come

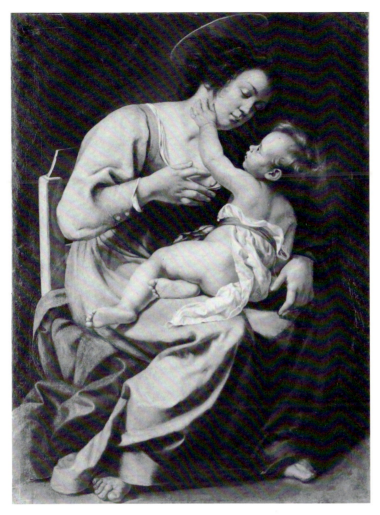

8. Artemisia Gentileschi, *Madonna and Child*, c. 1609.
Rome, Spada Gallery

to teach Artemisia perspective—the only witness to do so (except for the heavily-coached Bedino)—Artemisia recounted that when Tassi approached her on the day of the rape, she was painting an "image (*ritratto*) of one of Tuzia's boys, for my own pleasure" (Appendix B, ms 17). Tuzia affirmed this account in her own testimony, adding that she assisted Artemisia by holding the child on her lap. It is improbable that this was a portrait of the child, and indeed the description evokes more precisely the image of a Madonna group. This circumstantial evidence that the young Artemisia painted Madonnas (which would have been considered an appropriate subject for a female artist) can be further connected with two Madonna and Child compositions that may reasonably be attributed to her hand.

The first is a *Madonna and Child* in the Spada Gallery, Rome (Fig. 8 and Color Plate 1), a work whose modern attribution to Artemisia was rejected by several

scholars, and which hangs now under the name of G. F. Guerrieri.[19] Although the Spada *Madonna* may appear at first glance to have little in common with Artemisia's *Susanna*, whose central figure is more refined, the pictures share certain features, of which the most obvious is the seated, slightly crouched posture of the female figure. The hair styles of Susanna and the Madonna are almost identical, down to the wispy strands that fall on the cheek (an effect that was later to become a kind of trademark of the painter). More telling than this is Artemisia's distinctively personal treatment of the back of an extended hand, with dimples painted to suggest the concavities between knuckles. The "dimpled knuckles" can be seen in both the Spada *Madonna* and the *Susanna*, and they appear again in Artemisia's paintings of the Florentine period—the *Penitent Magdalen* and the *Allegory of Inclination* (Fig. 25 and Color Plate 7; Fig. 28).

The massive and tactile figure of the Madonna may be explained as an intensified response by the young artist to Michelangelo and other Renaissance prototypes. The extraordinary monumentality of the lower half of this figure, with its powerful knees and dangling hand, brings to mind the heroic seated figures of the Roman High Renaissance: Michelangelo's Moses, in S. Pietro in Vincoli; his Prophets and Sibyls of the Sistine Ceiling (Fig. 9); and, in the church of S. Agostino, Raphael's *Isaiah*, and the sculptural Madonna and Child groups of both Andrea and Jacopo Sansovino (Fig.

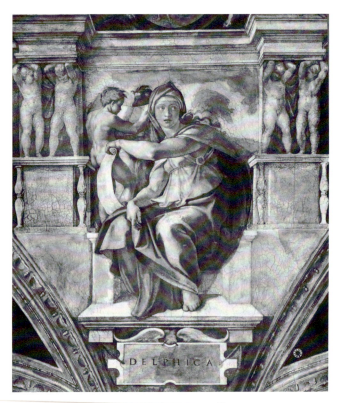

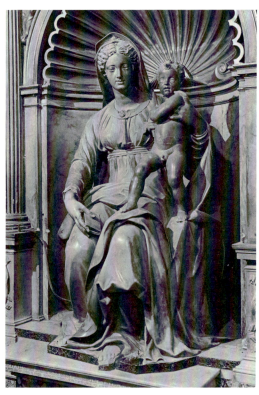

9. Michelangelo, *Delphic Sibyl*, 1509–1511. Rome, Vatican, Sistine Ceiling

10. Jacopo Sansovino, *Madonna and Child*, 1518–21. Rome, S. Agostino

10).[20] Artemisia's debt to these models, and to Michelangelo's Sistina especially, is no less evident in the dynamic energy of the *Madonna*'s drapery folds. On the other hand, the gentle, homely Madonna and her private interaction with her child do not sustain the heroic mood, and are closer to several *Madonnas* that have been placed in Orazio's *oeuvre* of the 1605–1610 period, particularly the Bucharest *Madonna* (Fig. 11), and the fine example formerly in the Matthiesen Gallery, London (Fig. 12).[21]

I would suggest that the ex-Matthiesen *Madonna*, which carries only a modern attribution to Orazio, may instead have been painted by Artemisia herself. Although the technical and formal perfection of this painting are outstanding, its finesse is surely not beyond the reach of the painter of the Pommersfelden *Susanna*. All of the features that point to Orazio's authorship—its Orazian facial type and broad simple drapery folds—could point as well to Artemisia, and the electric vigor of the radial and zigzag folds are closely comparable to those of the Spada *Madonna* (Fig. 8).[22] Uniquely indicative of Artemisia, once again, are the Madonna's dimpled knuckles, a feature that is not found in Orazio's work at all. Also, the ex-Matthiesen *Madonna* exhibits an earthy physicality and a tender intimacy between mother and child that are not seen in the Madonnas attributed to Orazio, aristocrats by comparison, who gaze on their children with remote detachment. Psychological intimacy is conspicuously absent from Orazio's entire *oeuvre*, while Artemisia's work—quite aside from

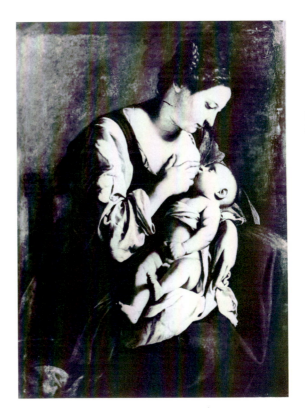

11. Orazio Gentileschi, *Madonna and Child*, 1609–1610(?). Bucharest, Muzeul de Arte al Republicii Socialiste Romania

12. Artemisia Gentileschi (here attributed), *Madonna and Child*,
c. 1608–1609. Formerly London, Matthiesen Fine Art Ltd

the few paintings that display a violent form of psychic interaction—can consistently
be distinguished from her father's by the intensity of her characters' engagement. That
the gentle and ideal maternal love exhibited in the ex-Matthiesen *Madonna* should
never have recurred in Artemisia's *oeuvre* is not surprising, considering the traumatic
personal events of 1611–12.

Another picture in the Spada Gallery that has held a shaky modern attribution to
Artemisia is the *Woman Playing a Lute* (Fig. 13 and Color Plate 3), a work hanging in
the same room with the Spada *Madonna*, whose dimensions it approximates.[23] The
picture is unquestionably by Artemisia's hand, despite its rather wooden appearance
in monochrome photographs, for it exhibits a number of the stylistic traits that we

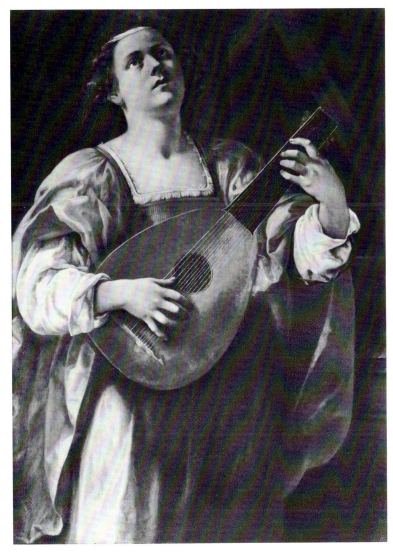

13. Artemisia Gentileschi, *Woman Playing a Lute*, c. 1610–12.
Rome, Spada Gallery

have identified among the early works. The restlessly energetic drapery is thoroughly comparable to that of the Spada *Madonna*, and the deeply curved, slightly pouting mouth connects the figure with both the Spada and ex-Matthiesen *Madonna*s. Yet in its coloration, the *Lutist* represents a new direction. The picture is an arrangement in gold and brown: the whole dress is made up of subtle modulations of gold, played against the yellow-brown of the lute and the red-gold of the hair (also the hair color of *Susanna* and the Spada *Madonna*).

A context for the Spada *Lute Player* may be found in 1611, when the theme of female musicians was extensively developed by Orazio in the frescoes of the Casino of the Muses (Fig. 6). Although Artemisia's figure resembles no one of these precisely,

she may have been stimulated by them to paint a model playing a musical instrument. Closely related to the Spada *Lutist* are two works ascribed to Orazio: the *Young Woman with a Violin* in Detroit (Fig. 14), who, though seated and at rest, looks upward, like the *Lutist*, in an ethereal and dreamy manner, and the *Woman Playing a Lute* in the National Gallery, Washington (Fig. 15).[24] These pictures have all been occasionally designated St. Cecilias, but since Cecilia's attribute is normally the organ and not the violin or lute, the figure may more generally represent the Allegory of Music.[25] Artemisia's rather timid, even conservative, interpretation of the subject in the Spada painting does not justify an extensive treatment of the iconographic theme in this book. However, the relationship of the Spada and Detroit musicians to other Allegories of Music and St. Cecilias, as well as to Allegories of the Senses (such as Ribera's [lost] *Sense of Hearing*, painted in Rome in 1615–16), and to single musicians by Terbrugghen, Honthorst, Vouet, Domenichino, and others, unquestionably deserves further investigation.

A *Judith* named in the 1612 rape trial proceedings may have been painted by Artemisia. Although efforts to identify the painting have presumed that this was a work by Orazio,[26] there is a discrepancy in the trial testimony as to whether the *Judith* in

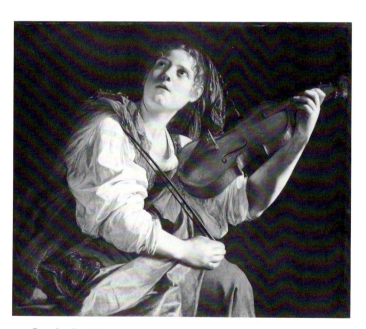

14. Orazio Gentileschi, *Young Woman with a Violin*, c. 1611–12. Detroit Institute of Arts

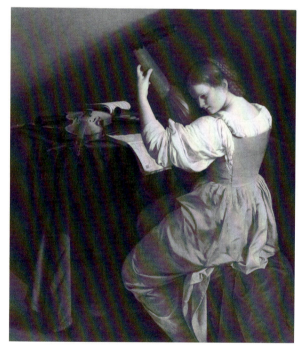

15. Orazio Gentileschi, *Woman Playing a Lute*, mid-1610s. Washington, D.C., National Gallery of Art

question was painted by Orazio or Artemisia. In his opening petition, Orazio spoke of some paintings by himself, especially a *Judith* of large size (*"alcuni quadri di pittura di suo padre et ispecie una Iuditta di capace grandezza"*), which Agostino Tassi, Artemisia's accused rapist, and his accomplice Cosimo Quorli had taken from Donna Tuzia.[27] Yet two other references to the *Judith* in the testimony indicate that the painting belonged to Artemisia. Stiattesi testified that Artemisia had had a painting of Judith, described as *non fornito* ("not supplied," or "uncommissioned"), which she had given to Tassi.[28] Cosimo Quorli, Stiattesi added, then attempted to get from Agostino the *Judith* given him by Artemisia, by means of a letter forged with Artemisia's name, an action for which he (Stiattesi) had reprimanded Cosimo, saying that "he should not take a painting of that sort away from a young girl." This account of the *Judith* stolen from Artemisia is repeated in the summary report of the trial testimony as established fact, with additional information on the painting's whereabouts. While Orazio may have exercised some proprietary rights over the stolen *Judith*, it was not returned to him after the trial.[29] This and the fact that the work had been in Artemisia's possession strongly suggest that it may have been she and not Orazio who painted it.

A possible explanation for the ambiguity of authorship in the trial records is that the *Judith* given by Artemisia to Tassi was a copy by her of a work of her father—a copy that may even have been destined for sale *as* an Orazio, hence the father's claim at the trial. A promising candidate is the replica in the Vatican (Fig. 16)[30] of Orazio's *Judith and Her Maidservant* now in Hartford (Fig. 17). In style, this painting is generally close to Orazio, and its proximity to the Hartford canvas is borne out, as Bissell has shown, by the more distantly related variant in the Jandolo Collection, which is surely by an artist farther removed from the Gentileschi orbit.[31] Yet this painting does not appear to be by Orazio, whose personal variations on his own themes are typically more freely and divergently handled, as in his Spada and Berlin *David*s, his Rome and Madrid paintings of St. Francis, or his Berlin and Ottawa versions of *Lot and His Daughters*.[32] Moreover, there are subtle stylistic differences between the Vatican and Hartford pictures that suggest the hand of a copyist. In the American painting, the forms are treated consistently as tactile volumes, while surfaces in the Roman picture are flatter, and there is a greater reliance upon strong light and shade contrasts to suggest rather than describe volume. Such precise definition of solid volumes is characteristic of Orazio, a reflection of his Tuscan training, but Artemisia, trained in the less *disegno*-oriented Roman environment of her own generation, had already begun to move away from his linear mode toward a more painterly approach by 1610, when she painted the *Susanna*.

The intervention of another artistic personality in the Vatican painting is also suggested in the considerable deviation of the facial types from the Hartford version, a change that is not usually seen in Orazio's replicas of his own work. The character of Judith is almost completely reinvented, as if studied from a different figure entirely.

Her broader, heart-shaped face, softened expression, rearranged hair, and the added pearl earring, transform her into a plumper, more matronly version of her intense and girlish prototype. Bissell suggests that the model for the figure of Judith in the Hartford picture was Artemisia herself, noting a physical resemblance between this figure and the female figure in Orazio's fresco in the Casino of the Muses (Fig. 7).[33] Such a hypothesis is not easily confirmed—the physical identity of these faces seems possible but not inevitable—yet it may gain some credence from the attribution of the Vatican painting to Artemisia. For the decisive alteration of the head of Judith in the Vatican variant strongly suggests that its author was Artemisia herself, whose motivation to change this figure derived from her personal connection with it, and from her reaction to her own appearance in Orazio's painting, whatever that reaction might have been. No other artist would have had as much reason to reconceive this figure in an otherwise close copy.

For these reasons, then, it seems likely that Artemisia's earliest experience with a Judith picture was as copyist of (and perhaps as model for) her father's Hartford *Judith*, and that her copy of this work, the Vatican painting, was the *Judith* in dispute

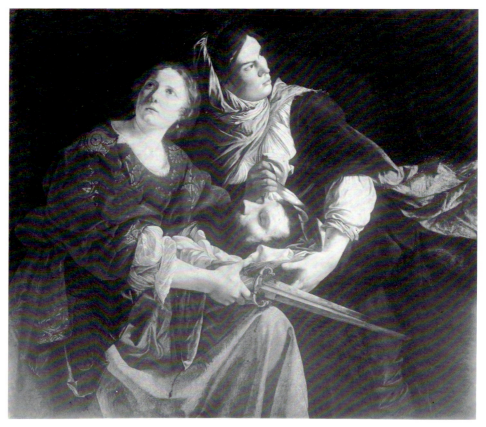

16. Artemisia Gentileschi (here attributed), *Judith and Her Maidservant with the Head of Holofernes* (after Orazio Gentileschi), c. 1610–12. Vatican, Pinacoteca

in early 1611, according to the trial testimony. A dating of around 1610–12 for both the Hartford and Vatican *Judith*s would be consistent with the fact that the Hartford painting's composition was taken from a classical prototype of particular interest to both Orazio and Artemisia at that time. The unusual compositional arrangement—the two figures' heads drawn close together into a rounded pyramidal unit, but looking in different directions, and with a sweeping curve below—closely resembles a passage in the Orestes sarcophagus that served Artemisia for the figure of Susanna in her painting of 1610, and that also served Orazio in his Dublin *David Killing Goliath* of 1605–1610 (see Chapter 3, Figs. 151, 167, and 169).

It would be dangerous to hazard more than a tentative chronological sequence for Artemisia's five earliest paintings, since in the virtually factless vacuum in which we operate, any suggested order of execution may depend upon apparent, but not necessarily real, "developments." One perceives an evolution in the handling of drapery, only to find that it conflicts with a development in compositional skill, or in psychological expression, color, or drawing. This is true for the early or otherwise murky periods of any artist's career, with the added imponderable that the teacher of

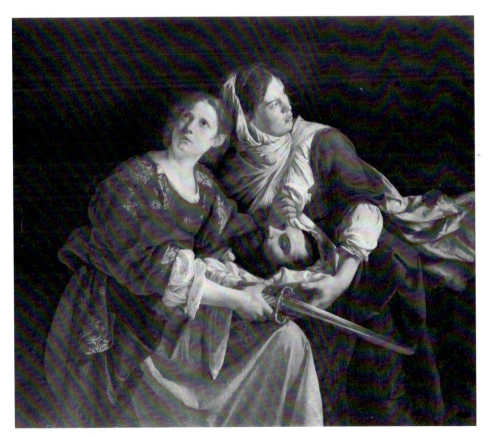

17. Orazio Gentileschi, *Judith and Her Maidservant with the Head of Holofernes*,
c. 1610–12. Hartford, Wadsworth Atheneum

a young artist, in this case Orazio, may have set his hand upon the canvas to help the pupil here or there, contaminating the art historian's evidence for a one-hand-only attribution. But while recognizing the possibility of Orazio's assistance in the earliest works, we nevertheless must not presume it, and we should be safest in taking at face value the indicated meaning of the proud inscription on the *Susanna* (Chapter 3, Fig. 152), that it is a work entirely by the young painter's hand.

The ex-Matthiesen painting, simplest and closest to Orazio's example in both design and color, is perhaps the earliest of the group, and may be dated c. 1608–1609 (but surely no earlier). The Spada *Madonna*, of perhaps 1609, would appear to be slightly later than the London picture on account of its more complex and compact design and its active drapery rhythms, qualities the painting shares with the pictures that follow. These two *Madonna*s most likely precede the *Susanna* dated 1610, given its greater sophistication in composition, action, synthesis of sources, and handling of color and light. (That such pictures, both technically polished and expressively whole, should have been painted by a girl of sixteen or seventeen may seem amazing, but we should remember that around the age of sixteen, Michelangelo executed the *Battle of the Centaurs* and *Madonna of the Stairs* reliefs, that Raphael at sixteen had already painted the *Vision of the Knight* and *The Three Graces*, and that by seventeen Bernini had produced the *Amalthea and Infant Jupiter*, which was taken for an antique original.) Artemisia's Spada *Lute Player*, though in style reminiscent of the Spada *Madonna*, may nevertheless belong to the period 1611–12, by virtue of its musical context shared with Orazio's Casino of the Muses frescoes and the Detroit *Violinist*. The latter painting, dated 1611–12 by Bissell, is in turn contextually related to the Vatican *Judith* and its Hartford model, for Judith's pose is identical to that of the young violinist. The relationship between these images remains to be explained,[34] yet in light of the common dependence of Artemisia's *Susanna* (1610) and Orazio's Hartford *Judith* upon a single classical prototype, it is reasonable to date the Vatican *Judith* around 1610–12 as well.

After the rape trial, Artemisia emerged as a self-directed and independent artist, whose style, now clearly separable from that of her father, began to exhibit a distinctly creative adaptation of Caravaggio's imagery to her own expressive purposes. In a picture here redated, the Naples version of *Judith Slaying Holofernes*, we can see the transitional stage, when her figures, still Orazian, began first to function in a Caravaggesque theater of harsher and more dramatic light and action. X-radiographs of the underpainting of the Naples *Judith* (Figs. 18 and 274), a painting previously thought to be a variant or replica of Artemisia's picture in the Uffizi, have revealed numerous pentimenti, indicating that this is likely to be her earliest version of the Judith theme, predating the Uffizi picture that until now has been considered the original version of the decapitation theme (see Chapter 5, pp. 307 ff.).[35] The Naples *Judith* is likely to have been painted in 1612–13, soon after the rape experience (which helps to account for its expressive violence), but while Artemisia was still in Rome. Such a re-creation would explain the picture's compositional dependence upon prototypes seen in

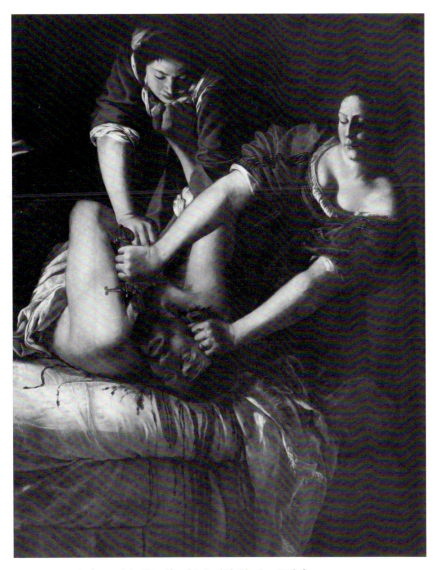

18. Artemisia Gentileschi, *Judith Slaying Holofernes*, 1612–13.
Naples, Museo di Capodimonte

Rome: Caravaggio's *Judith* of c. 1598–99, and Rubens's "Great Judith," whose design is preserved in Cornelius Galle's engraving (Chapter 5, Fig. 273).

The work that set an expressive keynote for both Artemisia and Rubens was Caravaggio's Casa Coppi *Judith* (Chapter 5, Fig. 255). Her appropriation of the motif of gory decapitation for the first of several depictions of the Judith theme introduced into her *oeuvre* the note of bloody violence for which she would become infamous.[36] Rubens's painting appears to have served Artemisia primarily as a Caravaggesque model for a more operationally explicit and dramatically convincing depiction of the decapitation of Holofernes than Caravaggio himself afforded. But while Rubens saw in Caravaggio's work an example of dramatic action to which violence merely lent

narrative credibility, the bloody violence of the Naples *Judith* places Artemisia in the vanguard of artists who pushed Caravaggesque naturalism to horrific extremes—in her case, for electrically intense expression. With the exception of the Uffizi *Judith*, which is essentially a replica of the Naples picture, she was never so violent again in her art. And although Caravaggesque realism and dramatic chiaroscuro would continue to sustain Artemisia's art through the 1630s, she responded briefly to other influences during the seven-year period that she lived in Florence, specifically to the Tuscan artistic tradition, and to the stylistic tastes fostered in the Florentine Academy and by the aristocratic life of the Medici court.

### FLORENCE, 1614–1620

On November 29, 1612, one month after the rape trial ended, Artemisia Gentileschi was married to a Florentine artist named Pietro Antonio di Vincenzo Stiattesi (who was probably a relative of the trial witness G. B. Stiattesi). The two were living in Florence at least by November 1614, when they are documented in the records of the Accademia del Disegno. Artemisia and her husband both used the facilities of the Accademia from 1614 on, and she became an official member of the Academy in 1616.[37] By March 1615, she was described by Andrea Cioli, Secretary of State to Grand Duke Cosimo II, as a well-known artist in Florence.[38] Artemisia's unusually smooth acceptance by the Florentine artistic establishment is quite remarkable, considering that women artists in the Renaissance and Baroque periods met their stiffest professional resistance in the academies of art. She could not, for instance, have become an active member of the Roman Accademia di S. Luca, whose rules of 1607 specifically prohibited women from attending meetings, though they could be elected Academicians.[39] Nor would she have been able to participate, either in the Accademia di S. Luca or in the various informal private "academies," in any instructional program such as drawing from the nude model or studying mathematics and perspective. (Thus it is credible that Tassi could have been employed to teach her perspective.) One would expect her to have encountered even greater resistance from the exclusively masculine Florentine Accademia del Disegno, which had had no women members since its founding in 1563. Unlike Bologna, Rome, or even Cremona, cities that boasted one or more famous women artists in the sixteenth century, Florence in 1614 had yet to see any active female artists whatsoever.[40]

Artemisia's instant Florentine success is probably to be explained by her arrival as a protégée of a prominent Florentine, Michelangelo Buonarroti the Younger, who was a strong advocate of Artemisia in Florence, and who may have been a close family friend.[41] Buonarroti (Fig. 19), the great-nephew of the illustrious Michelangelo, had in 1609 purchased a house near the sculptor's original home in Via Ghibellina, turning the former into a monument to the famous Florentine artist. Work on Casa Buonarroti began in 1612, and the painted decorations were initiated in 1615. Artemisia was one of the first artists to be given a commission for a painting in Casa Buonarroti,

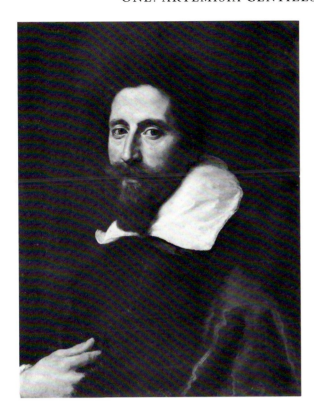

19. Cristofano Allori, *Michelangelo Buonarroti the Younger*, c. 1610. Florence, Casa Buonarroti

she was paid proportionately more for her work than many of the other artists in the project, and she may well have come to Florence under the wing of this man who so obviously favored her.[42]

Artemisia's relatively swift emergence in Florence as a member of the Academy also points to her early support by the Medici family. Cosimo II, who became Grand Duke in 1609, followed his father Ferdinando I in protecting and supporting the fledgling Accademia del Disegno, which had been founded by Vasari and others under Cosimo II's grandfather, Cosimo I, in 1563. The Florentine Academy was from its inception conceived as a vehicle for consolidating the social position of artists, for elevating them from the medieval guild system with which, from the early sixteenth century, they resisted association.[43] The autocratic Medici court played a substantial part in developing and sustaining this aristocracy of artists. Throughout the last quarter of the sixteenth century and well into the seventeenth century, artistic training and achievement, participation in the affairs of the Academy, and Medici patronage continued to be closely intertwined. Only on a high social level, with the support of a princely patron like the Grand Duke, could a female artist like Artemisia, "unique in this profession," as Orazio had described her, have taken a seat in the Accademia del Disegno.

In July 1612, in the midst of the Tassi-Gentileschi litigation, Orazio had written a letter to Cristina of Lorraine, the dowager Grand Duchess of Tuscany and mother of Cosimo II, appealing to her to prevent the rumored imminent release of Agostino Tassi from the Corte Savella (where he was held during the trial) by some of his Florentine friends, and offering her a painting by Artemisia along with the prospect of seeing more of her works.[44] If Cristina responded to this appeal, it may well have been in sympathy for Artemisia's plight, which Orazio did his best to elicit through a detailed description of Tassi's crimes and Artemisia's pathetic situation. The artist's service to the Medici court is documented at least as early as 1618, when her now-lost *Bath of Diana* is mentioned in the Guardaroba Medicea (discussed below), and again in the letter that she wrote to the Grand Duke on February 10, 1620 (Appendix A, no. 1), informing him as her employer of a forthcoming trip to Rome. By that date, she must have worked for the Grand Duke for some time already, since several of her Florentine paintings were unquestionably Medici commissions.

Ironically, Artemisia's work found more favor in Florence than did that of the father who had interceded for her. Cosimo II had thought of inviting Orazio to Florence in 1615, but was discouraged by negative reports from his Roman ambassador, which stated that Orazio's work was weak in drawing and composition, beyond which he had "such strange manners and way of life and such temper that one can neither get on nor deal with him."[45] Artemisia herself would have had good reason to concur with such a judgment, if Passeri was correct in saying that her father and Tassi soon overcame their past hostilities and began to work together again.[46] Given that Orazio, even with good intentions, had exposed Artemisia to public scrutiny, the *sibille*, and the dubious vindication of the court, one imagines that relations between Orazio and Artemisia may have been strained in the years immediately following the trial, and even that her choice of the family name "Lomi" instead of "Gentileschi" for her signature on paintings in Florence may have been a calculated gesture of separation; but there remains no real evidence of their personal relationship in those years.[47] In any event, Orazio spent a good many of the years between 1613 and 1620 in the provincial artistic backwater of Fabriano, while his daughter rapidly emerged in a major artistic capital. Under these circumstances, we may regard it a formality, and not a needed endorsement, that Orazio should have been present as witness for Artemisia's matriculation in the Accademia on July 19, 1616.[48] Indeed, in 1618, before the Council of the Accademia del Disegno, Artemisia successfully rejected a certain claim brought against her by her brother Francesco to the Council of the Arte degli Speziali, on the basis of her exclusive affiliation with the Accademia del Disegno, to whose privileges, she argued, she was entitled and to whose rules she was subject.[49]

Though not the most active of Medici patrons of the arts, Grand Duke Cosimo II and his wife Maria Maddalena of Austria (Fig. 20) nonetheless sustained the uniquely Florentine court art that had flourished under Cosimo's father Ferdinando I. The rituals of court ceremonies—marriages, funerals, and festivals—were aesthetic

events in themselves, theatrical performances engineered by talented architects and designers such as Bernardo Buontalenti and Giulio Parigi. While Artemisia Gentileschi lived in Florence, she would have seen such spectacular festival performances as *The War of Love* and *The War of Beauty*, equestrian ballets held in Piazza Santa Croce in 1616, and would likely have been present at the theatrical entertainments and their *intermezzi* that were held on the occasion of state marriages, such as that of Cosimo II's sister Caterina to Ferdinando Gonzaga, Duke of Mantua, in 1617.[50] These events were commemorated in the etchings of Jacques Callot (Fig. 21), the Lorrainese artist whose sojourn in Florence (c. 1612–21) corresponded almost precisely to Artemisia's. The numerous artists supported in Florence by the Medici court occasionally participated as singers and dancers in the frequent musical and theatrical performances held at court, and it is possible that a "Sig.ra Artimisia" who sang with three other women, dressed as gypsies, on an evening in 1615 was the painter herself.[51]

Arguably Cosimo's most important cultural contribution was his granting of asylum to Galileo Galilei when the great astronomer-mathematician came under attack from the Inquisition in 1616. Galileo (Fig. 22), who in 1610 had discovered the moons of the planet Jupiter (subsequently named "Medicean Planets," in honor of his patron), was now able to confirm Copernicus's revolutionary proposition that the

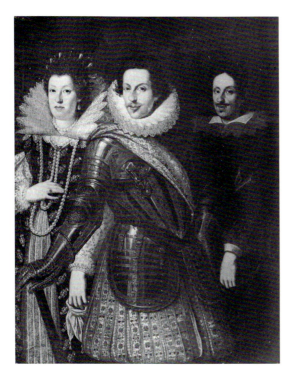

20. Justus Sustermans, *Cosimo II and Maria Maddalena of Austria with Their Son*, mid-seventeenth century. Florence, Uffizi

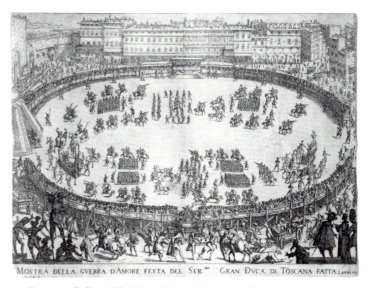

MOSTRA DELLA GVERRA D'AMORE FESTA DEL SER.ᴹᴼ GRAN DVCA DI TOSCANA FATTA Lanno 1616

21. Jacques Callot, *The War of Love: Parade in the Amphitheatre*, etching, 1616. Washington, D.C., National Gallery of Art

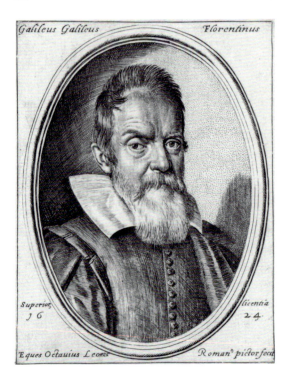

22. Ottavio Leoni, *Galileo Galilei*,
engraving. Washington, D.C., National
Gallery of Art

earth revolved around the sun. On Cosimo's invitation, Galileo came to Florence in
September 1610, where he joined the ducal court as court mathematician, enjoying
political protection until Cosimo's death in 1621.[52] The mathematician had many Flor-
entine friends and supporters, including a number of artists. His own considerable
interest in art led him to develop an ability as a draftsman sufficient to gain him en-
trance to the Accademia del Disegno in 1613, to collect paintings, and to express aes-
thetic opinions.[53] Artemisia Gentileschi was among Galileo's artist friends. She wrote
him a letter in 1635, when he was under house arrest in Arcetri, playfully beginning
with a mock philosophical proposition (Appendix A, no. 9), asking his help in getting
paid for two pictures that she had sent to Ferdinando II, Cosimo's successor, and
reminding him that he had performed a similar service for her fifteen years earlier.
Although no other correspondence between them is preserved, the tone of Artemisia's
letter implies that they had maintained friendly contact over the years.

It has been said that Artemisia Gentileschi brought Caravaggism into Florence,[54]
a contention that might be supported by the presence there of her powerful *Judith
Slaying Holofernes*, now in the Uffizi (Fig. 36 and Color Plate 8). But the impact of
this dramatic painting seems to have been minimal in Florence, where Caravaggism
was never especially vigorous. Furthermore, the Uffizi *Judith* is an exception to the
style of Artemisia's other Florentine paintings, for reasons explained below, and it is
more accurate to say that she began to adapt to the Florentine mode almost as soon

as she arrived, before the Caravaggism first seen in the Pitti *Judith* could be sustained or developed.

The Pitti *Judith* (Fig. 23 and Color Plate 5), whose attribution to Artemisia goes back to a 1637 inventory, was probably painted in Florence shortly after the artist's arrival there in 1613 or 1614.[55] The Pitti *Judith* is intensely Caravaggesque in its austere simplicity of design, cool color, and assertive chiaroscuro, and in the haggard virility of its heroine. Moreover, memory of a work by Caravaggio may have led to the innovative arrangement of the two female figures. Interlocked, facing in opposite directions, their gazes turned toward a single focus, they re-create in reverse the figure group on the right of the *Calling of St. Matthew* (Chapter 5, Fig. 280). The composition of the Pitti *Judith* is, I believe, wholly the artist's own, and predates rather than

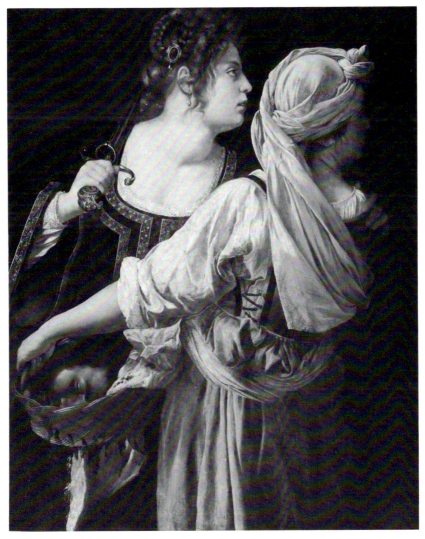

23. Artemisia Gentileschi, *Judith and Her Maidservant*, c. 1613–14.
Florence, Palazzo Pitti

24. Orazio Gentileschi,
*Judith and Her Maidservant.*
Oslo, Nasjonalgalleriet

follows a related composition in Oslo (Fig. 24) that bears an attribution to Orazio Gentileschi. By contrast with the Pitti picture, the Oslo *Judith* displays compositional and expressive peculiarities, as well as an uncohesive relationship of figures, that suggest a variation on a theme rather than an original design.[56] If Orazio painted the Oslo *Judith*—and he remains the leading candidate—he manifestly adapted a composition of his daughter's, which he may have had occasion to see, if he was indeed in Florence in 1616, as is believed.[57] Artemisia's Pitti *Judith* thus represents not only the end of the artist's apprenticeship with her father, but perhaps also the first instance of her influence upon him. The painting also signals Artemisia's embarkation upon the intermittently vigorous Caravaggism that would mark the next two decades of her career.

Beyond the Caravaggism of its lighting and dramatic intensity, the Pitti *Judith* displays Artemisia's response to Florentine taste. For the first time in her art, the heroine is dressed in elegant, richly ornamented garments, a shift toward a refinement both aesthetic and social that bespeaks the artist's new position in an aristocratic court. Elaborate jewelry and fine clothing are seen again in the Uffizi *Judith* (which differs from the Naples *Judith* in these respects), and the same taste for decorative richness is seen in the lavishly ornamental chair back and the florid style of Artemisia's signature in the *Penitent Magdalen* (Fig. 25 and Color Plate 7). Artemisia's temporary attraction to the taste of the Medici court led her to artistic models dating back more than half a century. The expressive hyper-refinement of the *Magdalen*, with the tightly oiled locks of her hair, and the elongation and exaggerated jointing of her fingers, especially recalls the *maniera* court portraits of Bronzino (Fig. 26). Gentileschi may even have learned from such sophisticated prototypes how to make effective icono-

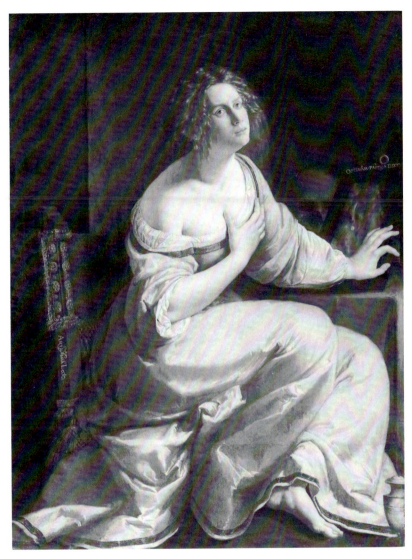

25. Artemisia Gentileschi, *The Penitent Magdalen*, c. 1617–20.
Florence, Palazzo Pitti

graphic use of jewelry, for, as is discussed below in Chapter 5, the images on the jew-
elry worn by her Judiths invoke heroic paragons in a manner reminiscent of certain
*maniera* portraits, such as Bronzino's portrait of Bia de' Medici, the natural daughter
of Cosimo I, in which the medallion worn by the girl alludes to her father (Fig. 27).[58]

The only fixed date for a work executed by Artemisia in Florence is provided by
the Casa Buonarroti commission of August 1615 for the *Allegory of Inclination* (Fig.
28), which was completed in August 1617.[59] The rather conventional allegorical figure
supplied by Artemisia for her first documented commission in Florence stands stylis-
tically between the Pitti *Judith* and the *Penitent Magdalen*, exhibiting both the norm-
ative proportions and anatomical naturalism of the former, and the new spirit of grace
and refinement of the latter. Artemisia's figure, which according to Baldinucci was

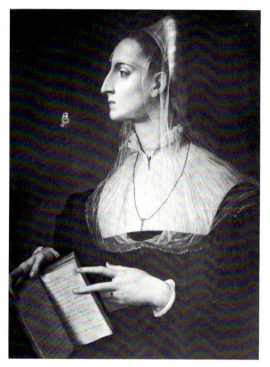 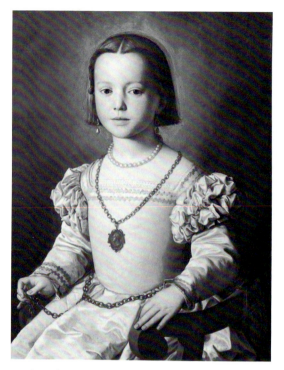

26. Agnolo Bronzino, *Laura Battiferri*, c. 1560.
Florence, Palazzo Vecchio

27. Agnolo Bronzino, *Bia di Cosimo de' Medici*,
c. 1542. Florence, Uffizi

originally nude and was covered with drapery by another artist for reasons of deco-
rum,[60] is a glamorized and serene version of her *Susanna*; indeed, since hers would
have been the only fully nude female figure on the ceiling, it is quite possible that
Artemisia's reputation as a specialist in the depiction of the female nude had preceded
her. In a period when life drawing from female models was still uncommon in the
academies, Artemisia's informal access to female models gave her a rare advantage
over her masculine peers;[61] further, the gender symmetry of artist and subject may
have had an appeal of its own. The expressive differences between *Susanna* and the
*Allegory of Inclination* result, however, not only from the aesthetic tastes of the new
Florentine ambient, but also from the different iconographic context, since the
allegorical figure was part of a cycle of ceiling paintings set in a white wooden
framework with gilded decoration, the individual scenes and figures of which were
unified by a common level of idealization no less than by the continuous deep blue
background sky.

Gentileschi's figure symbolizing "Inclination" was one of a group of paintings
requested by Michelangelo Buonarroti the Younger for the *galleria* in Casa Buonar-
roti, to fill an artistic program that he had devised to glorify his illustrious great-uncle
(Fig. 29).[62] On the walls were paintings depicting important episodes in the artist's

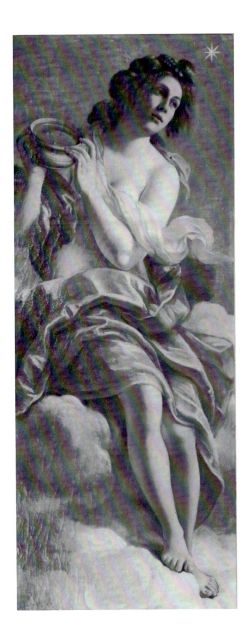

28. Artemisia Gentileschi, *Allegory of Inclination*, 1615–16. Florence, Casa Buonarroti

life; on the ceiling, the events following Michelangelo's death—his funeral ceremonies in S. Lorenzo, the construction of his tomb in S. Croce—culminating in scenes of apotheosis: *Michelangelo Crowned by the Arts of Painting, Sculpture, Architecture and Poetry*, and *Fame Elevating Michelangelo to Immortality*. At the corners of the rectangular ceiling were eight single figures that symbolized Michelangelo's personal virtues: inspiration (*ingegno*), inclination, study, tolerance, love of country, piety (*pietà*), moderation, and honor. The wall pictures were executed by the most prominent artists in Florence: Anastasio Fontebuoni, Giovanni Biliverti, Jacopo da Empoli, Matteo Rosselli, Fabrizio Boschi, and others, as were the five major ceiling panels (by Ago-

29. "Galleria" of Michelangelo Buonarroti the Younger. Florence, Casa Buonarroti

stino Ciampelli, Tiberio Titi, Nicodemo Ferrucci, Francesco Curradi, and Sigis-mondo Coccapani). The lateral ceiling panels of the Virtues and two scenes of cupids with crowns were assigned, with two exceptions, to pupils of the preceding artists, young men still in their masters' workshops. The exceptions were Artemisia Genti-leschi and Giovanni di San Giovanni, independent artists.

That Artemisia was paid for her figure over three times what Giovanni di San Giovanni received, and almost as much as the amount given the older artists for much larger pictures, clearly reveals the privileged position given the artist by her patron. That status could have been bestowed for any number of reasons: personal favoritism, sympathy for her recent misfortunes, or even an exaggerated admiration for female achievement in painting. But although Artemisia's special treatment may have been occasioned by her unique position as a woman in a world of male artists, the situation does not justify a tendency on the part of art historians to credit her with having influenced the style of her colleagues' work at Casa Buonarroti.[63] Works that have been said to be influenced by Artemisia's *Inclination*, such as Coccapani's *Michelangelo Crowned by the Arts . . .* (Fig. 30) and Vignali's *Love of Country* (Fig. 31), were executed during the same period as hers (from mid-1615 to late 1616), and it would be difficult to establish absolute precedence. Since the artists whose styles most resemble Arte-

misia's *Inclination*—Vignali, Coccopani, Allori—were trained by late Mannerist Florentine artists and in the Accademia del Disegno, it is more reasonable to regard the style reflected on the ceiling of Casa Buonarroti simply as a shared Florentine style, fostered in the studios and the Academy, to which Artemisia now adapted herself, and which contributed to the harmony of this decorative ensemble.[64] The style of the ceiling, reflected especially in the ovoid, aristocratic faces, was a pervasive one in Florentine court art around 1615–16, and could be seen as well in related easel paintings, such as Cristofano Allori's Pitti version of *Judith with the Head of Holofernes* (Fig. 262). Artemisia perhaps played a role in sustaining that style, but she surely neither created it nor was uniquely identified with it.

The *Penitent Magdalen* (Fig. 25 and Color Plate 7), now in the Pitti Palace, has reasonably been regarded as a grandducal commission, because of its Medici collection provenance and the connection between its theme and the name of the Grand Duchess, Maria Maddalena.[65] A similar play on names was manifested in the Grand

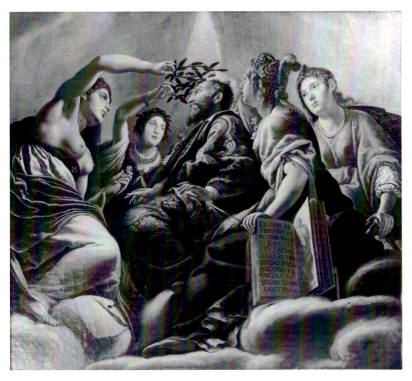

30. Sigismondo Coccopani, *Michelangelo Crowned by the Arts of Painting, Sculpture, Architecture and Poetry*, 1615–17. Florence, Casa Buonarroti

31. Jacopo Vignali, *Love of Country*, 1615–17. Florence, Casa Buonarroti

Duke's commission of a five-act comedy, *Santa Maria Maddalena*, in early 1621, also presumably a compliment to his wife.[66] The expressive character of Artemisia's *Magdalen*, fervently and piously penitent, clearly appealed to—and may well have been induced by—the austerely religious Grand Duchess, who brought to the ducal court an enthusiasm for somber masses and endless vespers. After Cosimo's death in February 1621, Maria Maddalena evidently sustained the court's celebration of her scriptural counterpart: in July 1622, a dialogue was performed at court between Mary Magdalen and Martha, as exponents of the *vita contemplativa* and the *vita attiva*.[67] These events suggest that Artemisia's *Magdalen* may have been painted late in her Florentine period, between 1517 and 1520.

The *Magdalen* is for many modern observers a rather disappointing example among the surviving pictures of Artemisia's early period, and it has been perceived as a painting that uniquely lacks feminist expression. Yet the Magdalen herself is a complex and ambivalent figure. A prostitute and sexual libertine who repented of a life of vanity and sin to become a humble follower of Christ, and whose path of passive meditation was praised by Christ over Martha's domestic labors,[68] Mary Magdalen represents a rather confusing female model. From one viewpoint, between the penance imposed upon Mary's previous sinful sexuality and Christ's disparagement of Martha's domesticity, there seems little to inspire a woman. Even so, the pair had been since the Middle Ages symbols of the active and contemplative life, and the Renaissance turned the polarity between these sisters into a philosophical dialogue, which reached consummate expressive subtlety in works by Caravaggio (Fig. 32), Saraceni, and (perhaps) Orazio Gentileschi.[69] Other artists—Caravaggio again, and also Terbrugghen and Bigot (Fig. 33)—focussed on the single figure of Mary to bring out the moment of inner spiritual conversion, sometimes juxtaposing the mirror and skull (as

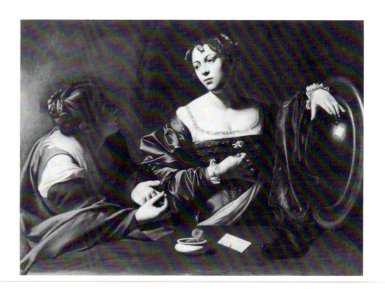

32. Caravaggio, *The Conversion of the Magdalen*, c. 1598. Detroit Institute of Arts

33. Trophime Bigot, *Vanitas*,
c. 1630–33. Rome, National
Gallery, Palazzo Corsini

does Artemisia) to invoke the themes of vanity, self-knowledge, and death. Such deeply serious images, and the popularity of the Magdalen theme in Baroque painting, suggest the special poignancy of Mary Magdalen as a model for women. Her conversion and adoption by Christ, with whom she had a special intimate relationship, could give hope to female "sinners" of the Catholic world, while her sanctioned, transforming meditation could be seen to carry women to an intellectual and spiritual plane normally occupied only by men.

Quite a few of the seventeenth-century Magdalen pictures are expressively more convincing than Artemisia's *Magdalen*, whose overdramatization lacks credibility, and who seems restlessly trapped in a luxury she lacks the will to renounce. Gentileschi was clearly not temperamentally attracted to a heroine of the contemplative life, at least not at this time, and her failure to develop a fully decisive Magdalen indirectly demonstrates the artist's need to identify personally with her characters in order to bring them to life. Artemisia nevertheless managed to introduce into the painting, more subversively, a luxurious richness of color not seen previously in her work, which may well have appealed to the grandducal court on a sensual rather than moral level. The Magdalen's dress, which covers a good third of the painting's surface, is a rich, deep gold, with luminous brown-gold shadows. Her hair, golden blond as in the *Inclination*, sustains the light coloration of the picture. The dark green of the tablecloth is echoed in the decorative band at the neck and hem of the dress; the chair back, a deep burgundy, with gold ornament, completes the regal color triad for which Artemisia was later known. In its lush gold and dark green coloring, the *Magdalen* closely resembles Cristofano Allori's *Judith* (Fig. 262), a picture that particularly invites comparison as it now hangs in an adjacent room in Palazzo Pitti. One suspects that it was Artemisia and not Allori who initiated the use of a seductive gold; she had explored that color range in the Spada *Lutist* and would return to it later, whereas

golds were more unusual for Allori. But since the dating of Allori's *Judith* is no longer altogether clear, a firm conclusion on this point cannot be reached.[70]

The comparison is suggestive on another level, however, for the elegant poise and austere beauty of Allori's impassive Judith points up the physiognomic awkwardness and strange intensity of Artemisia's Magdalen. As if determined to make her character humanly credible, she gives her a slight double chin, flesh-rimmed eyes, and an unusually ugly foot.[71] Yet in these emphatically physical details—and especially in the wildly luxuriant hair that, though tightly curled at the face, flows abundantly and freely at the sides and down the back—lurks a barely repressed sensuality that subverts the traditional understanding of the Magdalen as a convert to spirituality even as it subtly sustains her pre-conversion identity as an erotic woman. Artemisia's Mary Magdalen is shown on the brink of choosing that better path to which the inscription on the mirror alludes, but while this is the picture's overt meaning, its subtext hints of a lingering psychic resistance to submission, even submission to Christ. Perhaps not entirely consciously, Artemisia takes liberties with the received plot, focussing not upon the "right"—that is, the morally obedient—decision of the heroine, but instead upon the moment before, when the critical issue for her is posed, and when, between vice and virtue, she seems to contemplate the futility for her of both. In the *Lucretia*, painted only a few years later, Gentileschi would apply this stratagem more deliberately, to create a powerful character who is genuinely larger than the man-made dilemma she was meant to symbolize.

The peculiar combination of saint and, not sinner, but physically human female is seen in a small Florentine painting that is certainly by Artemisia. This is a half-length figure of *St. Catherine* in the Uffizi (Fig. 34), earlier ascribed to a follower of Artemisia, but attributed to the artist herself in 1966.[72] The strange image—a highly literal, distinctly unglamorous studio model dressed in costume—provides an important connective between Gentileschi's Roman and Florentine paintings. In her ghostly transfixion on the beyond, the figure resembles the Spada *Lutist*, a work that also invites comparison for the articulated joints of the saint's right hand (the other hand is dimpled). The open angle of the back of her neck and the dark-shaded eyelids recall the Pitti *Judith*, while the unkempt bushy hair—here almost comically juxtaposed with a fussily bejeweled crown—echoes that of the *Magdalen*. As in the *Lutist*, the life of the painting is displaced from the static, zombie-like figure to a spirited interplay of colors: here between the red dress and the grape and dull gold mantle, with a delicate translucent gold lace across the breast. For stylistic reasons, this modest picture is likely to come from the early years of Artemisia's Florentine period, where it thus joins the Spada *Lutist* and the first two *Judith*s to show an extraordinary fluctuation in Artemisia's art between 1612 and 1614, as if in alternating currents of active and passive reaction to the trauma of the rape, the trial, and their aftermath.

Another picture in Florence that should rightly be assigned to Artemisia's early years in the city is the *Minerva* (Fig. 35 and Color Plate 6). Though traditionally dated

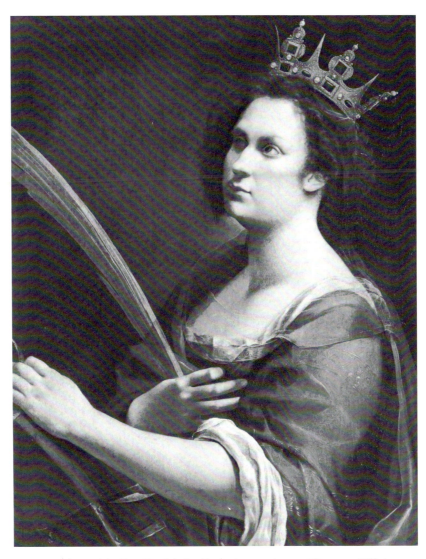

34. Artemisia Gentileschi, *St. Catherine*, c. 1614–15. Florence, Uffizi

much later, this rather awkward image finds its natural context with the Uffizi *St. Catherine* and the Pitti *Judith*.[73] Its superficial classicism is misleading, for in the original, one is struck by an underlying vitality, both in the color harmonies and in the peculiar rendering of the goddess of wisdom. The rose-lavender and salmon drapery, the deep green of laurel in Minerva's hair and hand, are set against an olive-gold and silver-gray shield, creating an effect of subdued richness. The painting is an odd combination of the naturalistic and the ideal: the face, at first glance blandly classical, is in fact that of a plain girl who wears lip rouge on unclassically protruding lips. The styling of the hair also indicates the combined approach; lacquered into flat waves *all'antica* on the lighted side, it is carelessly coiffed on the shaded side. The artist's steadily observing hand is also seen in the handling of details: a shadow cast on the

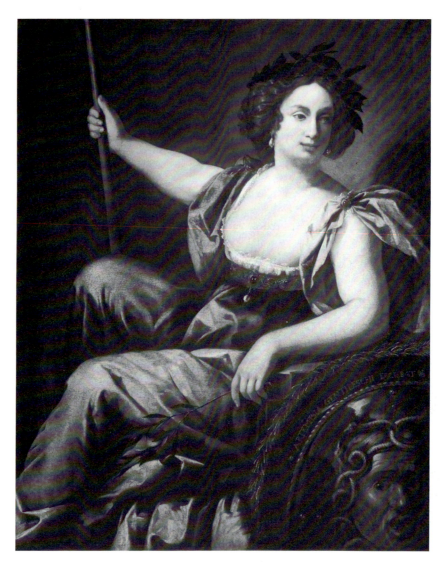

35. Artemisia Gentileschi, *Minerva (Anne of Austria?)*, c. 1615. Florence,
Soprintendenza alle Gallerie

cheek by one earring, the bluish shadow that envelops the other pearl. A note of crude
liveliness is struck in the Gorgon's head on the shield, whose close dependence upon
Caravaggio's Medusa in the Uffizi, indicated in such an anomaly as the exposed lower
teeth, makes it clear that Gentileschi knew her iconography.[74] This curious painting,
atypically classicizing for Artemisia at this time, and a somewhat awkward hybrid of
the real and ideal that finds no correspondence in her later work, has not been com-
fortably situated in the artist's *oeuvre*. I believe that it may be explained as a rather
special Florentine commission, an allegorical portrait of Anne of Austria as Minerva.
As is discussed more fully below, in Chapter 2, the young bride of Louis XIII of
France was, in the years surrounding her wedding in 1615, under particular scrutiny

by an illustrious member of the house of Medici, namely, her new mother-in-law, Marie de' Medici. Inasmuch as similar Minervan iconography was later to figure in imagery supporting both Marie de' Medici and Anne of Austria, Artemisia's *Minerva* could be explained as a Medici-commissioned, early exercise in this royal iconographic current—despite the probability that the painting never went to France.

Several other paintings by Artemisia in Florence survive only in written record. Two pictures by her are cited in Medicean inventories of 1618–23, a *Hercules* and a *Bath of Diana*. The *Diana*, described in an entry of 1618 (1619?), was an unusual and ambitious venture for her at this time, containing a number of nude female figures, a landscape, and a grotto ("*più Ninfe e Donne Igniude al Natur<sup>e</sup> con una Grotta*").[75] The description evokes Domenichino's famous picture, *Diana with Nymphs at Play* (Chapter 5, Fig. 289), painted in Rome in 1616–17, and conceivably there was some relation between the two works. (Domenichino himself would have passed through Florence on his journey to Bologna in 1617.) Two more works no longer known to us were mentioned by Baldinucci, a *Rape of Persephone* that was in Palazzo Pitti along with the *Judith* now in the Uffizi, and an *Aurora* in the house of Florentine nobleman Giovanni Luigi Arrighetti.[76] The *Aurora* was described by Baldinucci in vivid detail, as a figure "shown in the act of rising from the horizon where dawn is breaking, who clears away the dark mists of night." The figure may have been loosely based on Guido Reni's *Aurora* in Palazzo Rospigliosi, Rome (1613–14), which Artemisia certainly knew, but echoes of her own idiosyncratic female imagery erupt through Baldinucci's verbal sketch of a nude figure beautiful in proportion and in color, whose hair is dishevelled, whose arms extend upward toward the sky, and who stands struck by the emerging morning light (*restando solamente percossa dalla nascente mattutina luce*). The extraordinary beauty of Artemisia's *Aurora*, noted by Baldinucci as a work that demonstrated *ingegno* in the hand of a woman, was celebrated in 1625 in an inscription accompanying the Dumosthier drawing of Artemisia's own hand (see below, p. 63).

Finally, we come to the Uffizi *Judith* (Figs. 36, 37; and Color Plate 8), which should be placed at the end of Artemisia's Florentine period.[77] This picture now appears to be a second version of the composition first developed in the Naples *Judith* (Fig. 18 and Color Plate 4), and it is likely to be the work in progress mentioned by Artemisia in her letter to the Grand Duke of 1620 (Appendix A, no. 1). Informing her patron that she was going to Rome for a few months, the artist promised to carry out a commission, for which she had already received an advance, "within two months at the most." It was probably for this commission that Artemisia had requested, one month earlier, one and a half ounces of ultramarine blue in order to complete a painting begun for the Grand Duke. For this expensive pigment, she put up as collateral some of her own household goods on February 15, five days after her letter to Cosimo II, and pledged to complete the work within six months.[78] As it happens, the Uffizi *Judith* is the only one of Artemisia's preserved Florentine pictures (aside from the Naples *Judith*) to contain a large area of blue, a fact that tends to support the identi-

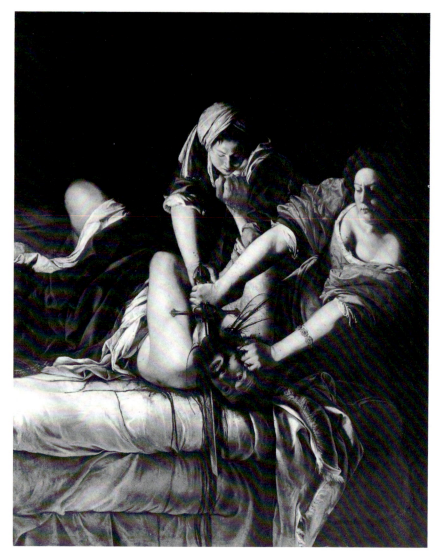

36. Artemisia Gentileschi, *Judith Slaying Holofernes*, c. 1620.
Florence, Uffizi

fication of the painting with the Grand Duke's last commission. The relatively short
time frame set by the painter would also be compatible with the execution of a replica.

The style of the Uffizi *Judith* further points to a dating late in the decade of the
teens. In replicating the Naples painting, Artemisia shed some of her recently ac-
quired *fiorentinità*, and resumed the chiaroscural force that was seen briefly in her
early Roman period, and which was to develop more powerfully in the decade of the
1620s when she was again in Rome. Yet although the Uffizi *Judith* is compositionally
and expressively Caravaggesque, its coloristic complexity, with a scheme of deep
burgundy, dark blue, and gold, is far more sophisticated than the simple red and blue

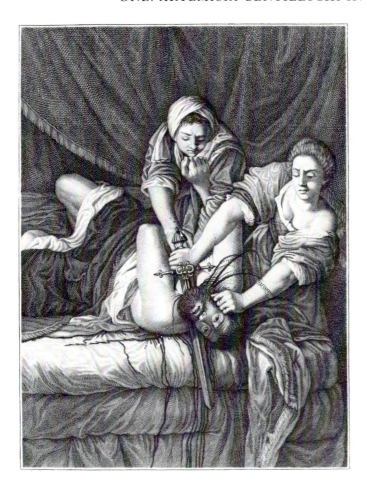

37. Artemisia Gentileschi,
*Judith Slaying Holofernes*,
engraving after, from Marco
Lastri, *Etruria Pittrice*
(Florence, 1791)

structure of the Naples *Judith*, and anticipates the dark richness of the *Judith* and *Esther* of the 1620s. It is entirely consonant with the stylistic character of the Uffizi *Judith* that it should have been painted for a Florentine patron in Rome, where its model, the Naples *Judith*, may have remained throughout Artemisia's Florentine years.[79]

The Grand Duke died on February 28, 1621. There is no evidence that Artemisia returned to Florence before the death of her patron, and she would have had little professional reason to do so afterwards. Her letter to Cosimo II clearly demonstrates her restlessness in Florence, in her stated desire to go to Rome to visit friends in order to recover from recent illnesses and family worries (which included, it should be noted, the birth of a daughter). Gentileschi is documented in Rome, where she would remain through most of the 1620s, by her 1622 inscription on a portrait now in Bologna (Fig. 43). The commission for the Bolognese portrait may have been obtained by Artemisia on a journey with her father to Venice and Genoa during the year 1621.

## GENOA, VENICE, AND ROME, 1620–C. 1630

In February 1621, the Genoese nobleman Giovan Antonio Saoli, in Rome for the papal election, invited Orazio Gentileschi to come to Genoa to work for him.[80] Orazio, whose quest for commissions was to lead him farther and farther north, accepted the invitation, and worked in Genoa between 1621 and 1624, when he departed for France. The likelihood that Artemisia accompanied him to Genoa is supported by the long-time presence in Genoese collections of two works that are surely by her hand, the *Lucretia* (Fig. 38 and Color Plate 9) and the *Cleopatra* (Fig. 39 and Color Plate 10). Although both pictures were early inseparable from the *oeuvre* of Orazio, and though

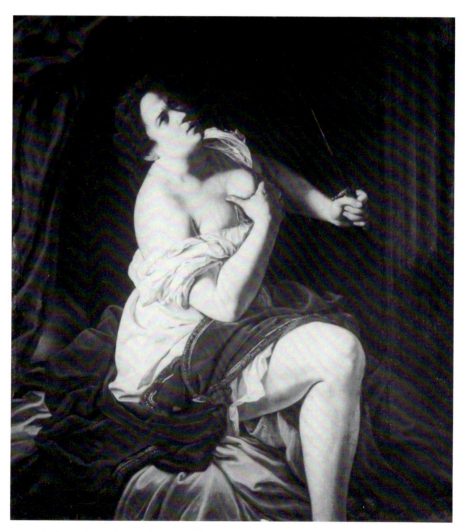

38. Artemisia Gentileschi, *Lucretia*, c. 1621. Genoa, Palazzo Cattaneo-Adorno

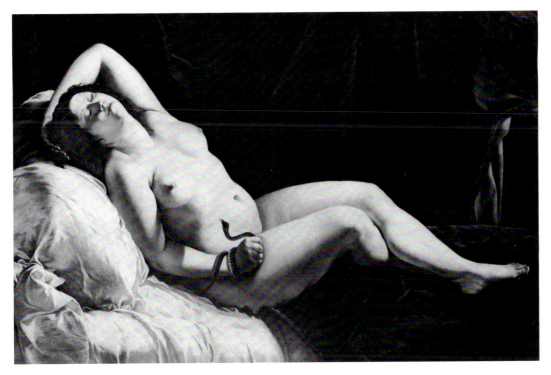

39. Artemisia Gentileschi, *Cleopatra*, 1621–22. Milan, Amedeo Morandotti

some scholars continue to favor Orazio as the author of the *Cleopatra*, I believe that Morassi and Bissell were correct in giving the two paintings to Artemisia, for the attributions can be sustained on both stylistic and expressive grounds. The *Lucretia* closely resembles Artemisia's Florentine *Magdalen* in pose and facial type, and the *Cleopatra* can be similarly connected in facial type and in its somewhat awkward realism with the Uffizi *Judith*. In color and lighting, no less than in the treatment of drapery, the Genoese paintings are consistent with Artemisia's work of the late teens and early twenties. More telling even than these factors, however, is the distinctive expressive character of the two pictures, which will be discussed more fully in Chapter 4.[81]

The evidence from the paintings that Artemisia may have gone to Genoa gains credence from the certainty that she was in Venice in the 1620s. In a letter of 1649, Artemisia named Venice in a list of cities where she had received commissions (Appendix A, no. 16). Her stay in Venice is documented by some verses written in her praise and published there in 1627, in which she is described as a "Roman painter in Venice."[82] Despite the publication date of the poems, Artemisia's visit is likely to have occurred in 1621, since in 1622 and from 1624–26 she is continuously documented in Rome (see below, p. 63). Moreover, as Bissell has suggested, the Venetian journey may have originated in an effort to gain the patronage of Cosimo II's son, Don Giovanni de' Medici, who was working for the Republic of Venice (and to whom Orazio

appealed for a commission in 1617). After this prospective patron's death on July 19, 1621, there were fewer reasons for the Gentileschi to be drawn to the Adriatic city.

The Venetian verses dedicated to Artemisia address among her works one or more *Lucretia*s and a *Susanna*, which suggests that Artemisia may have taken with her to Venice the *Lucretia* today preserved in Genoa. The *Lucretia* may have been painted soon after Artemisia left Florence, in view of the similarity of the figure in style and pose to the Florentine *Magdalen*. The *Cleopatra*, on the other hand, though close to the *Lucretia* in style, reflects both Venetian and ancient Roman prototypes (see Chapter 4, Figs. 219 through 224), as does Orazio's closely comparable *Danae* (Fig. 208), whose original version was painted in about 1621 for Orazio's Genoese patron, Giovan Antonio Sauli. (Artemisia's echo in the *Cleopatra* of the Vatican *Ariadne* and Giorgionesque Venuses corresponds to Orazio's combination in the *Danae* of Titian's *Danae*s and *Venus*es and, in the gesture of the outstretched arm, to a standard type from Roman sculpture.) The best explanation of these connections is that Artemisia joined Orazio in Genoa, where both found some commissions; then followed a journey to Venice (with sample works in hand, including the *Susanna* of 1610 and the *Lucretia*). By 1622, we know that Artemisia was back in Rome, perhaps briefly accompanied by Orazio before his return to Genoa. There, under the stimulus of her recent experiences, she executed the *Cleopatra*, most likely at the request of the Genoese patron who eventually owned both pictures (Pietro Gentile), and whose desire for the latter painting could have been prompted by sight of the *Lucretia*, which was presumably brought back to Genoa by Orazio.

The Gentileschi paintings in Genoa took their places in the palazzi of an art-collecting aristocracy, among works by Van Dyck, Guercino, Guido Reni, Rubens, Sebastiano del Piombo, Correggio, and Titian. The holdings of the Genoese palaces were described in the eighteenth century by Carlo Giuseppe Ratti, who cited some thirteen pictures by Orazio Gentileschi (without acknowledging Artemisia's existence).[83] Pietro Maria di Cesare Gentile, who owned Artemisia's *Cleopatra* and *Lucretia*, as well as Orazio's *Abraham and Isaac* and a *Judith and Maidservant*,[84] lived in Piazza di Banchi in the palace of his family, whose ranks included five doges, numerous senators, and other state officials. Gentile played an important role as Genoese patriot in the city's struggles against the House of Savoy in 1624–25. Also active in the Genoa-Piedmont battles was Orazio's original patron in the city, Giovanni Antonio Sauli (or Saoli).[85] Although Sauli was not named by Ratti among Orazio's patrons in Genoa, Domenico Saoli, presumably of the same family, owned Orazio's *Magdalen*, the *Danae*, and a *Lot and His Daughters*. Carlo Cambiaso, who lived in the Palazzo Brignole (Bianco), owned the Detroit *Woman and Violin*, along with Orazio's *St. Sebastian, David and Goliath*, and the Hartford *Judith*.[86]

In the cosmopolitan environment of Genoa, a rich banking and shipping republic, the Gentileschi would have been in contact not only with aristocratic patrons, but also with other artists and art dealers, many from northern Europe. Orazio's acquaint-

ance with Anthony Van Dyck is documented in the portrait drawing made of him by Van Dyck for his collection of engraved portraits, *The Iconography*, carried out in the 1630s. Although interaction between these men dates primarily from their English period, the late 1620s and the 1630s, Van Dyck's sketch of Orazio's Hartford *Judith* indicates his awareness of Orazio as early as his years in Genoa.[87] Artemisia, too, must have known Van Dyck personally. The two artists would surely have met in Genoa, where the Flemish painter arrived in November 1621, and again in Rome, where he spent seven months in 1622 and eight months in 1623.[88] Van Dyck seems to have been familiar with Artemisia's work, to judge from his own *Susanna and the Elders* (Fig. 40), painted a few years after his stay in Genoa. In this painting, unusually dramatic for Van Dyck, the heroine's gestures faintly echo motifs in Artemisia's Pommersfelden *Susanna* and *Lucretia*, and her paintings quite credibly formed part of the vast reservoir of dynamic narrative poses that Van Dyck collected in Italy.

Another artist in whom Artemisia had reason to be interested was the aged Genoese painter Sofonisba Anguissola. Anguissola, originally from Cremona, had married Orazio Lomellino, a ship's captain from a Genoese family, and had moved with him to Genoa by about 1584. Shortly preceding Gentileschi as an internationally celebrated woman artist, Anguissola reputedly held cultural court in her Genoese home,

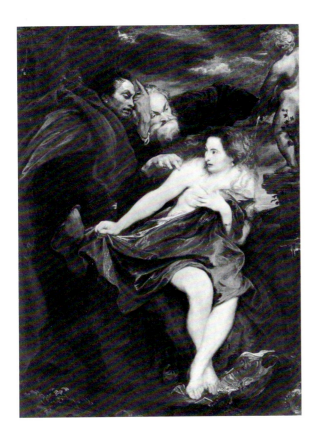

40. Anthony Van Dyck, *Susanna and the Elders*, c. 1625. Munich, Alte Pinakothek

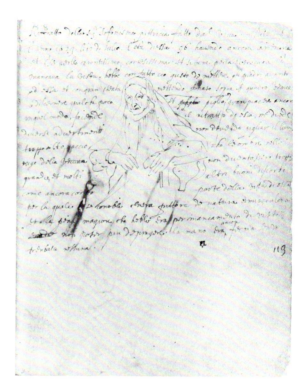

41. Anthony Van Dyck, *Sofonisba Anguissola*,
1624, from the Italian Sketchbook.
London, Trustees of the British Museum

which she maintained along with properties and contacts in Sicily. She settled in Pa-
lermo shortly before her death in 1625 at the age of 97. It was in Palermo that Van
Dyck drew her portrait in 1624 (Fig. 41), and noted that despite her age and blindness,
she was mentally alert and had given him much good advice about painting.[89] Van
Dyck and Artemisia Gentileschi may both have known Sofonisba in Genoa as well, if
Soprani is correct in saying that she spent her last years in that city.[90] But certainly
Artemisia would have known her by reputation if not in person. No obvious connec-
tions exist between the art of Anguissola and Gentileschi, and there is no evidence
that Artemisia had a special interest in other woman artists, yet it remains fascinating
to imagine what a conversation might have been like between Europe's two most
illustrious female painters of the time.

It is apt to have been from Genoa, the chief port of entry to Italy from the North
by sea, that Artemisia's works, or copies of them, found their way to Holland, and—
as is proposed in Chapter 4—into the hands of the young Rembrandt. Several of
Rembrandt's naturalistic female nude images of the 1630s bear suggestive resemblance
to the *Lucretia, Susanna,* and *Cleopatra,* while the *grand guignol* sensationalism of
Rembrandt's *Blinding of Samson* (1636; Fig. 42), and even the specific poses of Samson
and the soldier above him, may have been influenced by Artemisia's *Judith Decapi-
tating Holofernes.* The compositional resemblance of Rembrandt's *Samson* to Arte-
misia's *Judith* becomes quite striking when we recall that the composition of the Na-

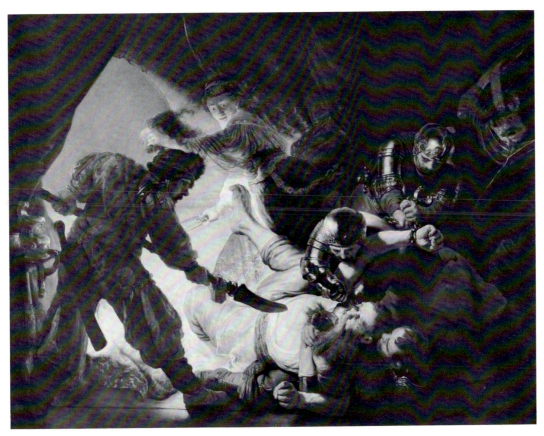

42. Rembrandt van Rijn, *The Blinding of Samson*, 1636. Frankfurt, Staedelsches Kunstinstitut

ples picture originally extended to include the entire body of Holofernes, as in the Uffizi version. Also, the x-radiograph of the Naples version of this theme (Fig. 274) shows that, like Rembrandt, Artemisia originally depicted a wedge-shaped opening in the tent on the left.[91]

In 1622, Artemisia was again in Rome, a fact she inscribed on a painting now in Bologna, the so-called *Portrait of a Condottiere* (Fig. 43).[92] Although the subject of this full-length portrait of a man in armor has not been identified, the Maltese cross on the chest indicates that he was a member of SS. Maurizio e Lazzaro, a military order of North Italian origin.[93] The family of the *condottiere* (perhaps more accurately described as a *gonfaloniere*) was evidently meant to be designated in the coat of arms depicted on the tablecloth at the left, but the cleaning of this painting in 1964 showed this detail to be more puzzling than informative. The overlaid design, nine squares in checkerboard of dark and light contained in an ovoid frame (Fig. 44), proved to have covered an earlier pattern of three chevrons, points downward, two silvers flanking a black one (Fig. 45). The earlier coat of arms had been thought to be a variant of the family arms of the Pepoli, who donated the painting to the Pinacoteca in Bologna in the 1920s (the Pepoli arms, however, consisted of five, not three, rows of squares), but after the cleaning, no known heraldic connections could be established for the

43. Artemisia Gentileschi, *Portrait of a Gonfaloniere
(Pietro Gentile?)*, dated 1622. Bologna, Pinacoteca

chevron design.[94] The superimposed checkerboard design, on the other hand, may easily be connected with a Gentileschi patron of that period, for its form is identical to the arms of the Gentile family of Genoa (Fig. 46). Pietro Maria di Cesare Gentile, who owned Artemisia's *Cleopatra* and *Lucretia* and who was an active military figure in the 1620s, would seem a good candidate.[95] The unusual and unidentifiable character of the earlier armorial device suggests the possibility that this might have been a meaningless emblem, a kind of blank, as it were, painted by Artemisia in Rome for a patron whose family arms were filled in later—for reasons that can only be guessed at.

The *Gonfaloniere* portrait is an orthodox example of the standing military or political hero type developed by Titian (Fig. 47) and employed by almost every seven-

44                                   45                                   46

44. Artemisia Gentileschi, *Portrait of a Gonfaloniere (Pietro Gentile?)*, detail of coat of arms, before cleaning. Bologna, Pinacoteca

45. Artemisia Gentileschi, *Portrait of a*

*Gonfaloniere (Pietro Gentile?)*, detail of coat of arms, after cleaning. Bologna, Pinacoteca

46. Arms of the Gentile family of Genoa, from Spreti 1928–35

teenth-century court artist from Van Dyck to Velázquez. More specifically, the armored gentleman shares the Knights Templar iconography with Caravaggio's portrait of a Grand Master of the Knights of St. John, *Alof de Wignacourt* (Fig. 48), of 1607–1608, a portrait that may have inspired the forceful chiaroscuro and vividly specific physiognomy of Artemisia's image.[96] Though unusually short in stature, Artemisia's *gonfaloniere* is given presence by the painter, through the handsome, dignified color harmonies established in the dark green sash and the red and gold patterns on the tablecloth and the flag at upper right, as well as through the optical precision with which the face and its expression are defined. Naturalistic touches characteristic of the artist are the beautifully painted bluish-white lace at the neck and cuff, and the shadow cast on the brow by an overhanging lock of hair.

Although the *Gonfaloniere* is the only portrait certainly by Artemisia that survives, a number of writers have made the curious statement that she was known for her portraiture. Both the anonymous Venetian poet of 1627 and the authors of the scurrilous epitaphs published after her death in 1653 affirm that she was celebrated as a portrait painter. Sandrart, Baldinucci, De Dominici, Da Morrona, and Ratti attest that she painted many celebrities, knights, and princesses in Rome and Naples; and

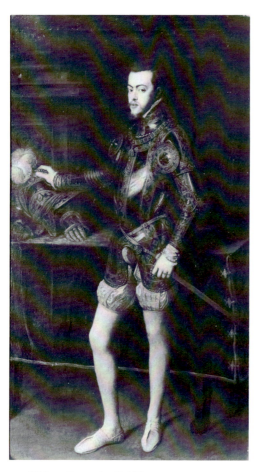

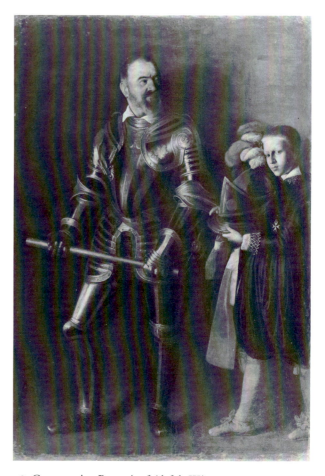

47. Titian, *Portrait of Philip II*.
Madrid, Prado

48. Caravaggio, *Portrait of Alof de Wignacourt with a Page*, 1607–1608. Paris, Louvre

according to Horace Walpole, she excelled her father in portraiture while in England, and "drew some of the royal family and many of the nobility."[97] Yet no such prominent images have emerged in any of these cities. There can be no doubt that Artemisia carried out a certain amount of portraiture; in the trial testimony she acknowledged having painted a portrait for a friend of Tuzia (Appendix B, ms. 128), she speaks in a letter of a portrait of a duchess (Appendix A, no. 4), and her portrait of an engineer, A. de Ville, was reportedly engraved by Jérôme David.[98] One suspects, however, that her reputation as a portrait artist may have been enhanced by a stereotyped coupling of women artists and portraiture, resulting in part from the fact that female artists were often more restricted to this genre than male artists, as Da Morrona noted, and also from popular conventional conceits that played upon the double beauty of female artist and subject, as seen in the Venetian verses of 1627 (see also Chapter 2, pp. 173 ff.).

GENTILESCHI probably resided in Rome from 1622 to the end of the decade. Between 1624 and 1626, her name was included in the census of S. Maria del Popolo, which showed her as living on Via del Corso.[99] The census of 1624 informs us that she was head of a household consisting of herself, two servants, and a daughter. There is no mention of her Florentine husband, Stiattesi, from whom Artemisia was obviously separated, and of whom she eventually lost track altogether (in 1637 she asked Cassiano dal Pozzo if her husband were still living [Appendix A, no. 13]). In 1625 Artemisia was specified as godmother to a child who was named for her, and in 1626 she was godmother to another child named for her daughter Prudentia.[100] Prudentia (or Palmira, as she is called in two census listings) was the daughter born in Florence about 1618, whose marriage prospects in the mid-1630s would prompt Artemisia to seek funds to raise a dowry (Appendix A, nos. 12 and 14). There appears to have been a second daughter, born some years after Prudentia-Palmira, whose marriage to a Knight of the Order of St. James on March 13, 1649, is mentioned by her mother in a letter written on the day of the wedding (no. 17). If, as seems probable, there were two daughters, it is noteworthy that both were painters, trained no doubt by their mother, although nothing is known of their work.[101]

Artemisia's artistic prominence in Rome in 1625 is confirmed by an unusual commemoration: a drawing made of her hand holding a paintbrush, rendered with exquisite precision by a French artist, Pierre Dumonstier le Neveu (Fig. 49).[102] The

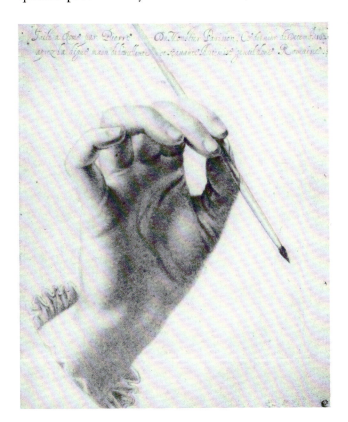

49. Pierre Dumonstier le Neveu, drawing of the hand of Artemisia Gentileschi with paintbrush, 1625. London, Trustees of the British Museum

artist dedicated the sheet at the top with equal care: "*Faict à Rome par Pierre Dumon-stier Parisien, Ce dernier de Decemb. 1625 // aprèz la digne main de l'excellente et sçavante Artemise gentil done Romaine.*" On the reverse is a conceit that elaborates on the theme of the *artiste savante*, proclaiming that while Aurora's hands are praised for their rare beauty, Artemisia's own hands are worth a thousand times as much, for their ability to create marvels that ravish the eyes of the most judicious connoisseurs.[103] Dumon-stier's distinction of value between the natural light brought to the world daily by the hands of Dawn and the marvels of intellectual light brought by the hands of the learned painter is a tribute to the artist's *savoir faire* that would echo, through the painter's own metaphoric language, in Artemisia's *Self-Portrait* of 1630 (Fig. 79). A more orthodox commemorative image, a portrait medal of the artist (Fig. 50), was created around this time or slightly later; its inscription reads simply and grandly, "ARTEMISIA GENTILESCA PICTRIX CELEBRIS."[104] Gentileschi was further pronounced a marvel in the portrait engraving by Jérôme David (Fig. 51), probably executed during the same period (allegedly, but not necessarily, after a self-portrait), the border inscription of which designates her "ARTEMISIA GENTILESCHI ROMANA FAMOSISSIMA PITTRICE."[105]

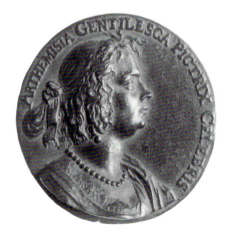

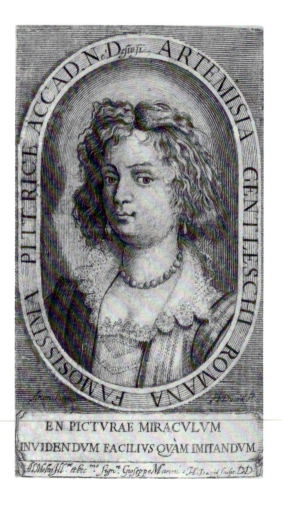

50. Anonymous artist, *Portrait Medal of Artemisia Gentileschi*, c. 1625–30. Berlin, Staatliche Museen

51. Jérôme David, *Portrait Engraving of Artemisia Gentileschi*, c. 1625–30. London, Trustees of the British Museum

Artemisia's second Roman period coincided with the beginning of the pontifi-
cate of Urban VIII (1623–44), and with important shifts in artistic taste and style. The
transformation of the face of Rome begun in the late sixteenth century was sustained
with a new burst in the energetic artistic projects sponsored by Urban VIII (Maffeo
Barberini) and carried out by his chief architect and sculptor, Gian Lorenzo Bernini.
Bernini, who served Scipione Borghese in the early 1620s—producing the *Rape of Per-
sephone* (1621–22), *David* (1623), and *Apollo and Daphne* (1622–25), now in the Borghese
Gallery—began to work for the new pope in 1624, commencing with the Baldacchino
and the pope's own tomb, the first of Bernini's extensive contributions to the interior
decoration of St. Peter's. The brief pontificate of the Bolognese Gregory XV (1621–
23), however, had strengthened the position of the Bolognese artistic contingent in
Rome, an arrival reflected in such major frescoes as Guercino's *Aurora* in Casa Lu-
dovisi (1621) and Domenichino's St. Andrew paintings in the choir of S. Andrea della
Valle (1622–27). The Bolognese papacy brought to the fore as well Monsignor Aguc-
chi, the secretary of state who had championed the classicizing tendencies of his com-
patriots and had developed an idealist artistic theory that stood as a polar opposite to
Caravaggesque naturalism.[106] Agucchi's theories, later given more systematic form by
Bellori, sternly deprecated the "mere" imitation of nature in favor of an idealizing
style that enhanced nature with beauty and art. This theoretical position gained cre-
dence in Rome in the 1620s and 1630s, when Caravaggism was on the wane, even as
it was spreading elsewhere in Europe.

Around 1620, Caravaggio's art was openly defended in Rome by a lone critical
voice. Vincenzo Giustiniani (Fig. 52), the wealthy Genoese banker whose palace was
adjacent to S. Luigi dei Francesi, had not only avidly collected Caravaggio's paintings
(he owned some fifteen works, including the *Victorious Cupid* and the first *St. Mat-
thew*), but had also articulated a sophisticated theoretical defense of naturalism in a
letter written sometime before 1620 to a Flemish agent of the King of Spain.[107] In this
important document, Giustiniani set forth a list of twelve categories of painting, in
which the highest category was a rare and difficult synthesis of the second and third
highest. The third highest category was painting *di maniera*, from the artist's imagi-
nation without a model; the second highest (superior both to the preceding category
and to the idealizing approach recommended by Agucchi) was painting directly from
natural objects, though with attention to design, color, and proportion. The highest
method, painting both from imagination and from life, was, Giustiniani maintained,
practiced only by the greatest artists—Caravaggio, the Carracci, Guido Reni. In his
understanding that Caravaggio brought both poetic imagination and good design to
his imitation of nature, and in his embrace of both the naturalism and the classicism
of Annibale Carracci, Giustiniani displayed a critical acumen far ahead of his contem-
poraries. His taste for and understanding of the subtle complexity of Caravaggio's art
suggests that he would also have appreciated the formal and expressive sophistication

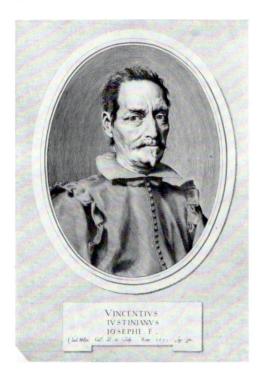

VINCENTIVS
IVSTINIANVS
IOSEPHI F.

52. Claude Mellan, *Portrait Engraving of Vincenzo Giustiniani*, 1620s(?). London, Trustees of the British Museum

of Artemisia's art, and indeed, he owned at least one of her paintings, a *David with the Head of Goliath*, a work unfortunately no longer known to us.[108]

Giustiniani's vast art collections also reflected the breadth of his taste. His palace contained a wealth of antique sculptures, whose documentation preoccupied Giustiniani in his later years; among them was the Orestes sarcophagus that probably served Orazio and Artemisia Gentileschi as a font of formal motifs around 1610 (see Chapter 3). Giustiniani's painting collection included "old masters" such as Holbein, Titian, and Veronese, but it primarily stressed the work of contemporary artists—Caravaggio, the Carracci, Guercino, Reni, Lanfranco. Giustiniani also collected works by an especially large number of Northern artists, many of whom were residents in his palace. It was Northern painters in particular who sustained anti-classicizing and naturalistic interests in Rome in the 1610s and 1620s: the Dutch Caravaggisti Gerrit van Honthorst, Hendrick Terbrugghen, Dirck van Baburen; the French Caravaggisti Simon Vouet, Valentin de Boulogne, Trophime Bigot, Nicolas Tournier, Nicolas Régnier; the landscape painters Claude Lorrain, Paul Bril, Bartholomeus Breenbergh, and Cornelis Poelenburgh; and Pieter Van Laer and the Bamboccianti, a group that reoriented the genre implications in Caravaggesque art in a small-scale and picturesque direction. Nearly all these artists lived in the artist's quarter of Rome, on Via della Croce, Via Paolina, or Via Margutta, and they actively contributed to its

bohemian flavor; in 1623, the confraternity of the Dutch and Flemish artists was formalized in the founding of the Schildersbent.[109] Artemisia, who had returned to her old neighborhood in Rome, manifestly had close contact with the Dutch and French Caravaggesque artists during the 1620s. In her fourth surviving *Judith* (her third new formulation of the theme), the majestic picture in Detroit, Gentileschi displayed a consummate integration of several Northern sources within a forceful Caravaggesque structure.

Artemisia's Detroit *Judith and Her Maidservant* (Fig. 53 and Color Plate 12), which has been generally dated about 1625, is by universal acclaim one of the great masterpieces of the Caravaggesque Baroque.[110] This forceful picture displays the artist's mature talent for dramatic narrative, dynamic chiaroscuro, and the creation of monumental female heroes. Of foremost interest is the new figure type depicted—an older, heavier, more mature character than any seen in Artemisia's *oeuvre* so far, a figure whose strength of will is conveyed as much in her alert, determined face as in her massive body proportions. This character did not come from Caravaggio, who, with only a few exceptions, perpetuated the traditional dichotomizing of female characters into youthful beauties or wrinkled old women, as did most of his male disciples. A female figure remarkably similar to Artemisia's Judith in the Detroit painting, who may have fired the latter's conception, is the dark, ponderous woman in Domenico Fetti's *Melancolia* of c. 1616 (Fig. 54). Gentileschi could have seen Fetti's non-idealized, heroically meditative woman, painted in the second decade of the century for the Mantuan court, when she travelled between Genoa and Venice in 1621.[111] Yet Artemisia's Judith is primarily a creation of her own, one who evolved from a line of active and increasingly powerful female characters, from the *Susanna* to the Pitti and Uffizi *Judith*s. This new figure type, a dark, heavy, unidealized middle-aged woman, was influential in Roman art of the 1620s: she was surely the inspiration for Anteveduto Grammatica's queenly *Judith* (dated 1620–25), and not vice versa (Fig. 271). More easily imitated than understood, the figure recurred in comically caricatured form in Rutilio Manetti's buxom, shrewish *Delilah* of c. 1625–27 (Fig. 55).[112]

The Detroit *Judith* also represents an extraordinary transformation of a variety of artistic sources into a new whole. Certain details of the picture's setting appear to have been suggested by Adam Elsheimer's Apsley House *Judith* (discussed below in Chapter 5): the curtain filling an upper corner, the objects on a table delicately outlined in candlelight. In the twenty years since Elsheimer painted the Apsley House *Judith*, however, candlelight night scenes had become very popular in Rome, and the dramatic tenebrist lighting of Artemisia's picture was probably generally influenced by works like the *Judith* of c. 1615–20 by her father's old friend Carlo Saraceni (Fig. 56), or the nocturnes that Gerrit van Honthorst painted in Rome in the teens (Fig. 57), which earned him the Italian nickname "Gherardo delle Notte." Honthorst, who was in Rome from 1610–12 to 1620 and in Florence in 1620,[113] would undoubtedly have

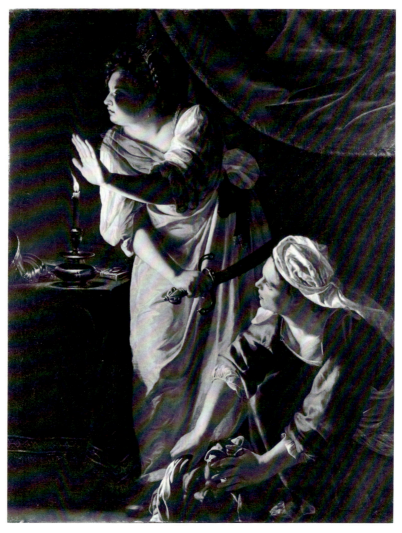

53. Artemisia Gentileschi, *Judith and Her Maidservant with the Head of Holofernes*, c. 1625. Detroit Institute of Arts

had contact with Artemisia, and his lighting may have influenced hers, just as he had himself been influenced by Orazio in his distinctive color arrangements and music-making scenes of the early 1620s.[114]

The striking pose of Artemisia's monumental figure of Judith may have been partly inspired by the figure of the temptress in French painter Simon Vouet's *Temptation of St. Francis* (Fig. 58), painted between 1622 and 1624 for the Alaleoni Chapel of S. Lorenzo in Lucina.[115] The reciprocal artistic interaction of Vouet and Gentileschi is first signaled in the relation between these two paintings, and it remains very difficult to determine the direction of influence. The relative dating of the Vouet *Temptation* and Gentileschi *Judith* supports the inference that his picture was the source

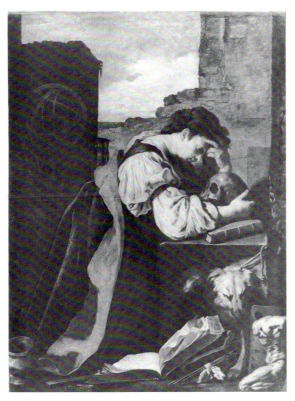

54. Domenico Fetti, *Melancholia*, c. 1616. Paris, Louvre

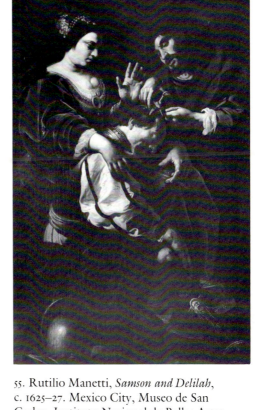

55. Rutilio Manetti, *Samson and Delilah*, c. 1625–27. Mexico City, Museo de San Carlos, Instituto Nacional de Bellas Artes

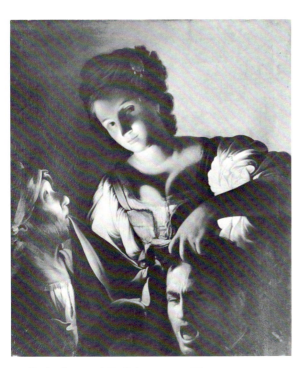

56. Carlo Saraceni, *Judith*, 1615–20. Vienna, Kunsthistorisches Museum

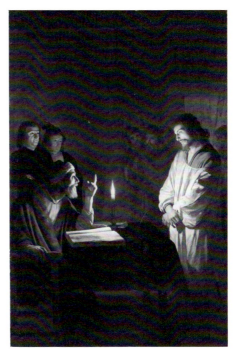

57. Gerrit van Honthorst, *Christ before the High Priest*. London, National Gallery

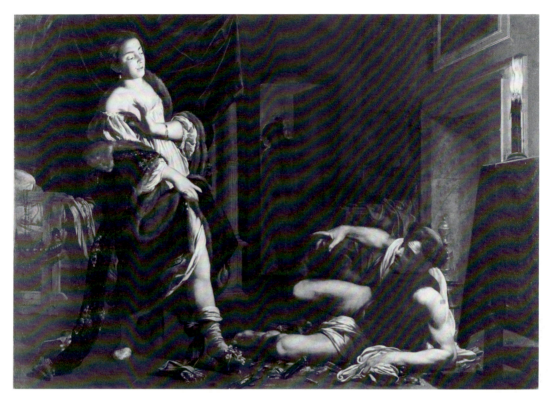

58. Simon Vouet, *Temptation of St. Francis*, 1622–24. Rome, S. Lorenzo in Lucina, Alaleoni Chapel

for her figure, yet there is no compelling reason for dating the *Judith* after Vouet's *Temptation*. Moreover, one finds in his temptress elements related to another of Artemisia's pictures, the *Esther*, which probably dates from the early 1620s (see Fig. 63), especially the striking motif of the straight bared leg combined with a crumpled boot-top. Did Vouet fuse motifs from two Artemisian figures into one, or did Gentileschi distribute elements from one figure into two? We are not aided by their biographies, which suggest parallel development. Vouet could have known both Orazio and Artemisia when he came to Rome in 1613, and he was in Genoa in 1621, the year that both father and daughter were there. Until 1627, when he returned to Paris, Vouet lived in Artemisia's neighborhood in Rome, and moved in the same circle of artists patronized by Cardinal Barberini and Cassiano dal Pozzo. Moreover, as Vouet was himself married to an artist, Virginia da Vezzo (whose work unfortunately remains virtually unknown), one imagines that Artemisia may have found in that couple sympathetic friends.[116]

Other resemblances between works by Vouet and Artemisia suggest an interaction that went both ways. Several of Vouet's female figure types of the 1620s—for example, the *Judith* in the Louvre (Fig. 59), ascribed to Vouet by Dargent and Thuil-

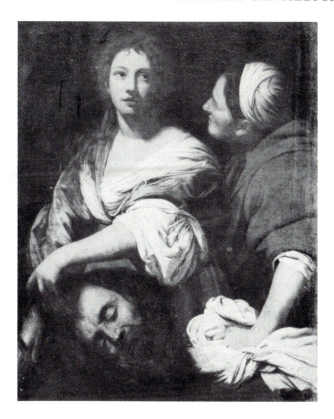

59. Simon Vouet (ascribed to), *Judith*, 1621. Paris, Louvre

lier, who tentatively situate it in Genoa c. 1621—reflect the likely influence of Arte-misia's Uffizi *Judith*, which Vouet could have seen in Rome in 1620 or in Florence en route to Genoa.[117] On the other hand, Vouet's *Circumcision*, painted in Rome in the 1620s and sent to Naples, appears to have influenced later Gentileschian types in such pictures as the *Birth of St. John the Baptist* (Figs. 88, 91; see below, pp. 97, 99). The two painters may, over the years, have provided each other with creative stimulation. If the Alaleoni Chapel temptress predated Artemisia's *Judith*, it proved a lucky resource, for Gentileschi strengthened the interplay of chiaroscuro and counterposed arms to create a more aesthetically powerful and more forcefully dramatic design.

But despite an evident affinity between the artists that probably led to mutual formal inspiration in the 1620s, Vouet remained, like nearly all of Artemisia's male contemporaries, fundamentally unaffected by her heroic female iconography. His Ju-diths, fortune-tellers, and female lovers are thoroughly conventional types who play the stock roles of women, either as temptresses or saints. (The series of *femmes fortes* executed by Vouet when he returned to Paris for the wife of the Duc de la Meilleraye, discussed in Chapter 2, was probably requested by the patron.) A similar response to Artemisia's work is seen in Claude Mellan, a French artist close to Vouet. Mellan's

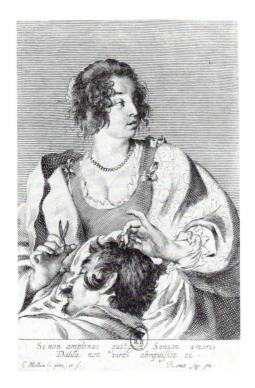

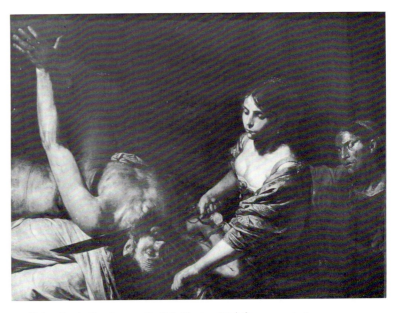

60. Claude Mellan, *Samson and Delilah*,
engraving after a painting of c. 1627.
Paris, Bibliothèque Nationale

61. Valentin de Boulogne, *Judith Slaying Holofernes*, c. 1626.
La Valletta (Malta)

engraving after one of his own paintings of c. 1627, *Samson and Delilah* (Fig. 60), is
connected with a series of half-length female figures engraved by Mellan after paint-
ings by Vouet, Virginia da Vezzo, and others.[118] This image of a heroine with a sharply
chiaroscural head turned alertly to one side must have been inspired by Artemisia's
Detroit *Judith*. Yet like Vouet's seductress in the *St. Anthony*, or Valentin's coldly
virginal executioner in his Malta *Judith* (Fig. 61), Mellan's *Delilah* sustains the tradi-
tional dichotomizing of women into "good" and "evil" characters,[119] a moral type-
casting seen ubiquitously among the Roman Caravaggisti—as for instance, in Dirck
van Baburen's *Procuress* (Fig. 62), painted in Rome about 1622.

In the context of such pictures, Artemisia's unstereotyped female characters and
her radical expressive reversals of male and female roles stand out—to our eyes at
least—as revolutionary, and it is tragic that today no more than four or five works can
be identified from her second Roman period, which was perhaps her greatest period
of creative achievement. We are fortunate that another major painting from this pe-
riod has survived, the *Esther before Ahasuerus* in the Metropolitan Museum (Fig. 63),
a work that has been dated in the 1640s, but surely belongs to the early 1620s.[120] The

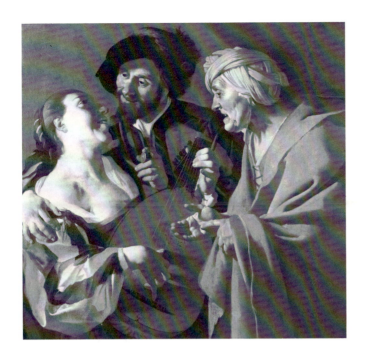

62. Dirck van Baburen, *Procuress*, c. 1622. Boston, Museum of Fine Arts

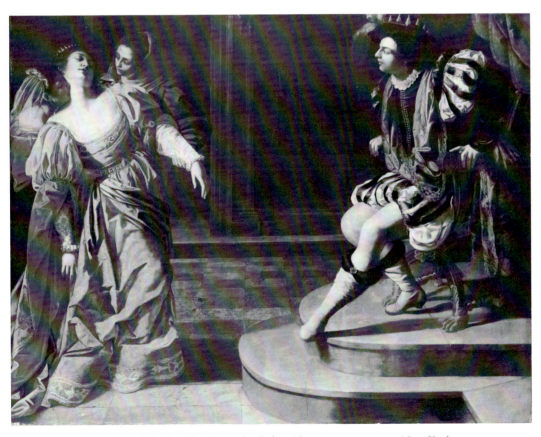

63. Artemisia Gentileschi, *Esther before Ahasuerus*, c. 1622–23. New York, The Metropolitan Museum of Art

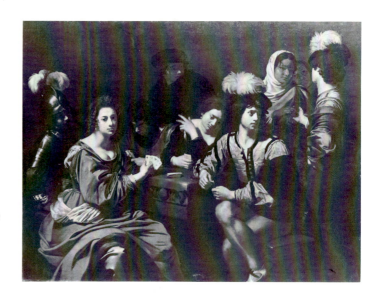

64. Nicolas Régnier, *Card Game and Fortune Teller*, 1620s. Budapest, Szépmüvészeti Múzeum

depiction of the king in colorful Caravaggesque dress would have been totally out of place in Naples at mid-century, but fits comfortably in the context of paintings of the 1620s like Régnier's *Card Game and Fortune Teller* (Fig. 64). Moreover, the *Esther*'s style—its tenebrist lighting, bold physical movements, and realistically described faces and garments—places it closer in Artemisia's *oeuvre* to the Detroit *Judith* and the *Gonfaloniere* in Bologna than to the more idealized and refined Prado *Birth of St. John the Baptist*.

Another telling consideration for the dating of the *Esther* is the inclusion of Venetian references in its composition. Veronese's version of this theme (Fig. 65) is recalled in the grouping of the queen and her two attendants, her decoratively patterned dress,

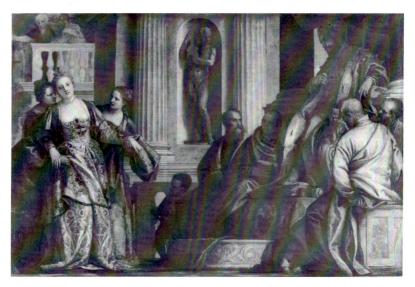

65. Paolo Veronese(?), *Esther before Ahasuerus*. Paris, Louvre

and the curved steps leading to Ahasuerus's throne. The characteristically Venetian motif of the page boy (in this Veronese, a dwarf) and a dog were originally included by Artemisia in the space between Esther and Ahasuerus. This group, completely legible in x-ray (Fig. 66), but also now visible to the naked eye (Fig. 67), was painted over by the artist herself.[121] Artemisia, who returned to Rome in 1622 after her north

66. Artemisia Gentileschi, *Esther before Ahasuerus*, x-radiograph of lower right section. New York, The Metropolitan Museum of Art

67. Artemisia Gentileschi, *Esther before Ahasuerus*, detail of lower mid-section, pentimento. New York, The Metropolitan Museum of Art

Italian sojourn, understandably would have carried such Venetian imagery into her work in the early 1620s. Finally, the majestic demeanor and extraordinary pictorial status given to Esther in this painting connect it with Artemisia's strongest period of heroic female imagery—that is, the 1620s, not the 1640s.

Like many artists who treated the popular Esther theme in the late sixteenth and early seventeenth centuries, Artemisia chose to depict the moment in the biblical story when Queen Esther, crowned to replace the unsubmissive Queen Vashti, who "refused to come at the king's commandment," has come to her husband, King Ahasuerus, to appeal to him not to permit Haman, his prime minister, to exterminate the Persian Jews.[122] In order to make her unbidden—and hence illegal—appeal to the king, the queen has had to fast for three days, and to don her royal robes, so that she might find "favor in his sight." Esther's passionate swoon before her husband is not mentioned in the scriptural account, yet it was a frequent image in paintings of the theme, perhaps chiefly because it conveyed to viewers Esther's hidden emotional involvement as a Jew herself—a fact not yet known to Ahasuerus. A secondary association accruing to a swooning Esther would have been with the Virgin Mary, with whom Esther was typologically linked, and who was often depicted in Christian art fainting at the foot of the cross, supported by two other women. The association of Esther and Mary was especially popular in the Counter-Reformation period, when Marian iconography and imagery was encouraged, and although the fainting Virgin was less heroic than the upright "*stabat Mater*" type, a visual reminder of Mary in Esther nevertheless would have reinforced the memory of Esther's courage and her divinely mandated mission.[123]

A third expressive consequence of depicting Esther as fainting was the hierarchic contrast thereby emphasized between the elevated, enthroned king, who metaphorically represented the seat of reason and justice, and the eccentrically positioned, impassioned supplicant, whose status as the king's dependent is conveyed in her lower position. It was a distinction preserved, in fact, in images of a non-swooning but modestly deferential Esther (Fig. 68). Such a juxtaposition of the king and queen, carefully balanced to convey her womanly ability to influence his judgment through persuasion rather than overt defiance, understandably had a ready appeal in a culture that sustained the same traditional concept of appropriate male-female relationships. In Poussin's strongly classicized version of this theme, dating from the 1650s (Fig. 69),[124] the interchange between the patriarchally authoritative Ahasuerus, disposed as a right-angular form, and the valiant yet emotionally weak heroine, who sinks in a crumpling curve, assumes archetypal force. (We are to see the sexes similarly contrasted in the *Brutus* and *Horatii* of Poussin's Neoclassical follower, David.) The conventions are at least superficially preserved in Artemisia's *Esther*, though a comparison between her version of the theme and that of Poussin effectively illustrates the stylistic polarity between the classical and Caravaggesque Baroque seen in Rome at around 1620.

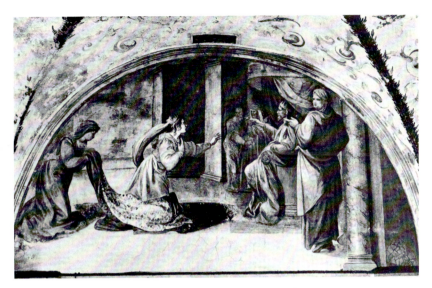

68. Orazio Gentileschi, *Esther before Ahasuerus*, fresco, c. 1598–99.
Farfa, Abbazia

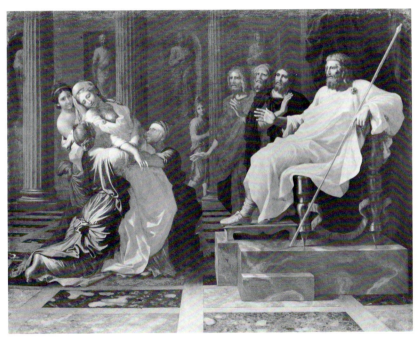

69. Nicolas Poussin, *Esther before Ahasuerus*, 1650s.
Leningrad, Hermitage

Perhaps more interesting, however, are the differences in expression. Artemisia's Queen Esther, a fully regal figure from her monumental, physically mature form to her crown, sinks only slightly and slowly in a dignified contrapposto, her massive figure fully visible due to the skillful subordination of the attendants. Esther's resonance as a heroic character is deepened by her foreshortened head, strong neck, and prominent Adam's apple, an image that evokes Michelangelo's prototypical foreshortened heads, especially and aptly the head of the punished Haman from the Sistine Ceiling (Figs. 70, 71).[125] The allusion demonstrates once more Artemisia's resourceful and inventive borrowing from Michelangelo, and her ability to draw cross-gender inspiration. In the Metropolitan painting, it is Esther, more than the surprisingly youthful Ahasuerus, who maintains a center of gravity within her body, which, like a magnet, seems to have drawn the king's body from the throne in a rising movement. By contrast to Poussin's bearded and togaed *paterfamilias*, shown in serene judicial repose, Gentileschi's Ahasuerus is depicted as an elegant, modish dandy of a type that, in Caravaggio's vocabulary, often indicates a worldly superficiality. The visual subtext of this painting hints at a reversal of roles, that she is the reigning monarch and he the young upstart. From a textual viewpoint, however, Artemisia's depiction of King

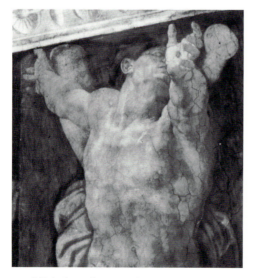

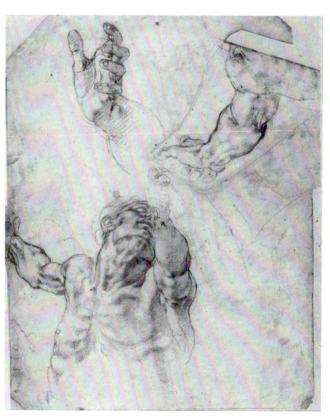

70. Michelangelo, *Punishment of Haman*, 1509–1511, detail of Haman. Rome, Vatican, Sistine Ceiling

71. Michelangelo, preparatory drawing for *Punishment of Haman*, 1509–1511. Haarlem, Teylers Museum

Ahasuerus in a state of tense surprise—almost alarm—is fully justified, for she seems to have intended to express the king's reaction not to Esther's fainting, but rather to her illegal invasion of his hall. This intention would have been more clearly conveyed had she not painted out the dog at the king's feet, who was depicted as on his guard, the stiff-legged and snarling defender of his master, restrained by the page boy (Fig. 67).

Why Artemisia should have eliminated this unusual feature can only be guessed; certainly she thereby strengthened the picture's design, creating a significant void between the protagonists. However, the excision of the page and dog coincided with other interesting compositional changes. As can be clearly seen in the x-ray, the two-tiered step leading to the king's throne was first placed about four inches lower than its present level, an earlier conception reflected as well in the indications of a different, and lower, chair arm beneath Ahasuerus's left hand. The artist had apparently positioned the king several inches lower, and if Esther's position was not correspondingly different, this would have placed the queen on the same or even higher level than the king, making her—even more decisively than we now see—the chief protagonist of the painting.[126] Artemisia's reworking of the picture is no less fascinating than her original interpretation, and—mindful of the frequently conservative role played by public patrons, as in the case of Caravaggio's two *St. Matthews*—we may speculate that the changes may have been requested by those who commissioned the work. One important change of aesthetic consequence was made after the raising of Ahasuerus's figure and probably after the removal of the dog and boy. The king's left forefinger did not originally point, but curved limply with the other fingers around the chair arm. The extension of the finger—quite likely an expressive replacement for the wary dog—was a brilliant compositional stroke that serves to charge both the figure and the room with psychic tension.

Both the Detroit *Judith* and the *Esther* are intensely theatrical pictures, in which the dramatic actions of monumental figures are amplified by strong lighting and by rich, sonorous color harmonies. In each work, the heroine wears a dress of deep "Artemisia gold" that plays regally against a vibrant burgundy curtain. The color scheme of the *Esther* is the more complex—and the more self-consciously Venetian—with the blue-white-gold and sumptuous textural patterns of the heroine's dress framed by the salmon and mustard green of her attendants' clothing. Ahasuerus wears striped sleeves and breeches of white and a green that changes to blue, a virtuoso example of *drappo cangiante* (see below, Chapter 6); these are set off by a plum-colored scarf and a Veronese yellow-green vest. Passages of great subtlety, such as the delicate golden ends of Ahasuerus's scarf, are juxtaposed with bold shapes of crumpled drapery. The *Judith*, a more classically restricted and less lyrical painting, projects an augmented major triad color structure of gold, green, red, violet, blue; but its shadows are filled with reflected color, and even its strongly subordinated passages contain finely painted details that delight and surprise the eye.

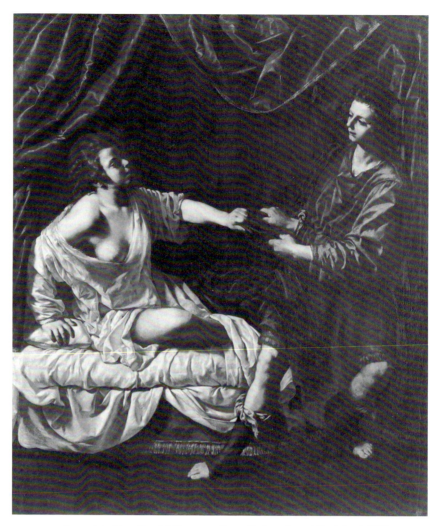

72. Artemisia Gentileschi (here attributed), *Joseph and Potiphar's Wife*,
c. 1622–23. Cambridge, Mass., Fogg Art Museum

Another painting that is surely by Artemisia, and was probably painted early in
her second Roman period, is the *Joseph and Potiphar's Wife* in the Fogg Museum (Fig.
72 and Color Plate 11). This picture, attributed in 1968 to Gentileschi by Everett
Fahy—an attribution that gained the support of several scholars—was nonetheless
reattributed by the same writer in 1976 to the Neapolitan artist Paolo Finoglia.[127] Yet
there are several compelling points in support of Artemisia's authorship of this pic-
ture. One is its general compositional origin among similar *Joseph*s from the Floren-
tine-Roman circle of the Casa Buonarroti group. Cigoli's *Chastity of Joseph* in the
Borghese Gallery, signed and dated 1610 (Fig. 73), was the model for several variants
by his pupil Biliverti (Fig. 74),[128] and the Fogg *Joseph* shares with these works the tent
setting with lifted curtains, Joseph's stance, the rumpled bedclothes and tousled

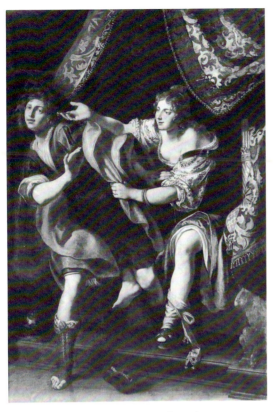

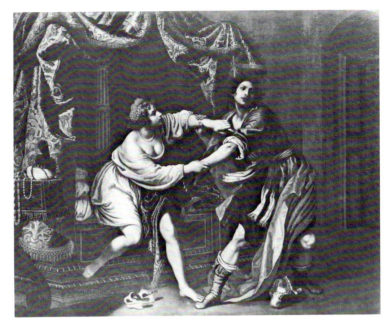

73. Lodovico Cigoli, *Chastity of Joseph*, 1610.
Rome, Borghese Gallery

74. Giovanni Biliverti, *Chastity of Joseph*, early seventeenth century.
Rome, Galleria Nazionale d'Arte Antica, Palazzo Barberini

appearance of Potiphar's wife, and the conception of the protagonists' interaction as a kind of tug-of-war. The theme of Joseph's temptation by Potiphar's wife, along with other adventures of the biblical hero in Egypt, was not commonly depicted by Neapolitan artists, but was especially popular in central Italian art, and indeed the Cigoli, Biliverti, and Gentileschi versions differ little from notable Cinquecento examples, such as Bronzino's tapestry in the Palazzo Vecchio, Florence, and Propertia de' Rossi's marble relief at S. Petronio, Bologna (Fig. 75).[129]

Artemisia's hand may be detected in the Fogg *Joseph* in such stylistic hallmarks as the tucked and wrinkled sheets, the crumpled draperies, and the facial type and hair style of the female figure. Beyond these, we can recognize her mind at work in the reformulation of the relationship between Joseph and his would-be seducer. In an approach reminiscent of her treatment of Esther and Ahasuerus, Artemisia has rendered Joseph not as a virile hero, as had Cigoli and Biliverti, but as a gangling adolescent. Potiphar's wife is no longer a caricatured blowsy wench, but rather—surely a conscious inversion—more plausibly human than Joseph, a natural, flesh-and-blood character, whose sexuality is the more convincing for its understatement, in the

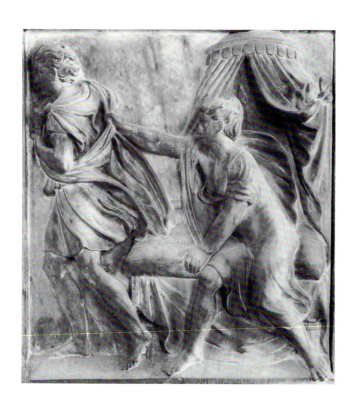

75. Propertia de' Rossi, *Joseph and Potiphar's Wife*, marble relief, c. 1570. Bologna, S. Petronio

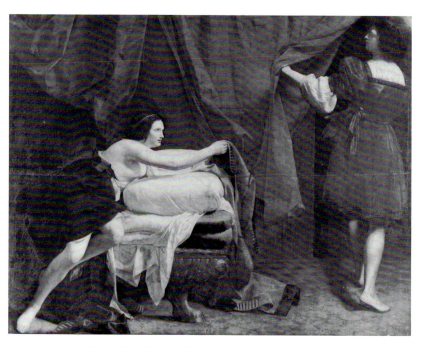

76. Orazio Gentileschi, *Joseph and Potiphar's Wife*, c. 1632.
Hampton Court

exposure of a single breast, a shoulder, and a knee. As conceived by Artemisia, Potiphar's wife differs radically from Cigoli's and Biliverti's versions, and also from Orazio Gentileschi's version of c. 1632 (Fig. 76),[130] in her axial stability, her solid and secure grounding on the bed, and her firm, effective grasp of Joseph's garment. Unquestionably, she will win this tug-of-war (unlike Orazio's forlorn rejected lover), and will gain for her own purposes the false evidence of her sexual conquest of the innocent Joseph. Artemisia, who must have noticed that the story is an inversion of that of Susanna, in this instance appears to side with the sexual adventurer rather than the sexual object, perhaps because Potiphar's wife seemed a more interesting character than the priggish, self-righteous Joseph, who could announce, "There is none greater in this house than I," and whose sexual resistance was based solely upon his respect for Potiphar's possessive rights as husband.[131] Artemisia's *Joseph* cannot be dated later than the 1620s, in view of its connections with the Florentine-Roman prototypes and its stylistic position in her *oeuvre*. The painting probably closely followed the Uffizi *Judith*, but is likely to have been painted in Rome, shortly preceding the *Esther* and Detroit *Judith*; thus a date of around *1622–23* is suggested.

WITH the papal accession of Pope Urban VIII, important new private patrons emerged in Rome, including two nephews of the pope and another member of the Barberini entourage, Cassiano dal Pozzo, each of whom commissioned work from Artemisia Gentileschi. Cardinal Francesco Barberini (1597–1679), twenty-six years old when his uncle became pope, launched his own art collections with a set of tapestries designed by Rubens, given to him by the king of France, Louis XIII, during the Cardinal's first diplomatic mission to France in 1625. Francesco (Fig. 77), an avid francophile thereafter, patronized Vouet and Valentin, and also Nicolas Poussin, who had come to Rome in 1624. In 1625, he purchased for the Barberini family its palace on the Quirinal, which would see in the next decade illustrious ceiling decorations painted by Andrea Sacchi (1629–31) and Pietro da Cortona (1633–39). These paid lavish tribute to Urban VIII and also secured the stylistic favor of the classicizing tastes of the Barberini family. Cortona was supported by Francesco, and Sacchi by Francesco's brother Antonio (1608–1671), who was also made a cardinal (at age 19), and who sustained the family propaganda mill in other ways.[132] The vast art collections of the Barberini Palace grew steadily in the 1630s, and the inventories provide a staggering view of that encyclopedic family enterprise.

Only one picture by Artemisia is recorded in the Barberini inventories, a "*donna con un'amore*," which was perhaps a Venus and Cupid.[133] However, she sent paintings to Francesco and Antonio from Naples in the 1630s, as we learn from letters she wrote to Cassiano dal Pozzo and Francesco d'Este (Appendix A, nos. 5, 6, 13), including two works ready to be sent in 1637: a *Christ and the Samaritan Woman*, and a *St. John Baptist in the Desert*. Her association with the Barberini circle is recorded further in the story told by Baldinucci of her encounter with the painter Giovanni Francesco

77. Andrea Sacchi, *Cardinal Francesco Barberini*. Cologne, Wallraf-Richartz Museum

Romanelli, a minor follower of Cortona under the wing of Francesco Barberini, who allegedly painted a portrait of Artemisia in the act of painting a still-life of fruit. Baldinucci's assertion that Artemisia was known for her naturalistic fruit still-lifes is only slightly less puzzling than his statement that she painted many portraits, since no still-lifes from her hand have been identified, and again the statement may result from the traditional stereotyping of women artists' activities.[134]

A more satisfactory joining of literary mention with a preserved work of art is found in Artemisia's artistic relationship with Cassiano dal Pozzo, and its reflection in her *Self-Portrait as the Allegory of Painting*. Cassiano (1588–1657), a highly cultivated scholar, collector, and patron (Fig. 78), played a far more significant intellectual role in Rome than did the Barberini.[135] He had come to Rome from Tuscany in about 1611, and as a close friend of Cardinal Francesco, with whom he travelled to France in 1625 and 1626, found employment in the Barberini household. Cassiano's encyclopedic interest in all aspects of knowledge led him to collect scientific instruments, sponsor books on medicine and botany, and create a museum of rarities—birds, plants, precious stones, and anatomical drawings. His fascination with archaeology resulted in a vast collection of drawings and prints documenting Roman antiquities, organized by subject. Though not a wealthy man, Cassiano nevertheless managed to settle his entire income on support of the arts and sciences, particularly upon the Accademia

EQVES CASSIANVS APVTEO
VETVSTATIS LVX.NOSTRI SECVLI DECVS.
POSTERITATIS EXEMPLAR.

78. Pietro Anichini, *Cassiano dal Pozzo*, engraving. London, Trustees of the British Museum

dei Lincei, the scientific body to which he was elected in 1621, and he built a strong collection of contemporary paintings, whose focus upon his most famous protégé, Nicolas Poussin, best reflected his classical tastes. Cassiano's voluminous correspondence with artists, including Artemisia Gentileschi, remains an important source of information for seventeenth-century art.[136]

Cassiano had been Artemisia's principal patron and supporter in Rome, as her first preserved letter to him makes clear. On August 24, 1630, she wrote from Naples, acknowledging measurements he had sent her for a picture she had promised him, and asking him for six pairs of gloves as "gifts for some of the ladies" (Appendix A, no. 2). The picture Cassiano wanted is mentioned twice more in 1630: a week later (no. 3), she referred again to the commission, this time calling it a portrait; and in December (no. 4), she informed her patron of the completion of the work, now described as a self-portrait. She may never have delivered the picture, however, for in a letter of 1637 (no. 13), she stated her intention to send him a self-portrait "which you once requested, to be included among [your] renowned painters," in a shipment of paintings destined for Francesco and Antonio Barberini, but apparently not received. In her last known letter to Cassiano a month later (no. 14), the portrait is not mentioned.[137]

The self-portrait that Artemisia completed for Cassiano in 1630, delivered or not,

79. Artemisia Gentileschi, *Self-Portrait as the Allegory of Painting*, 1630.
London, Kensington Palace, Collection of Her Majesty the Queen

must be identical with the *Self-Portrait as the Allegory of Painting* (Fig. 79 and Color Plates 14, 15), which now hangs in Kensington Palace. This painting, acquired by Charles I between 1639 and 1649, is the only extant self-portrait certainly by Artemisia's hand, although several have been ascribed to her.[138] One such misattributed work, a *Portrait of a Woman Artist* in the Palazzo Corsini, Rome (Fig. 80), though stylistically diverse from Gentileschi's example, is nevertheless thematically related to the *Self-Portrait*, and may also have been destined for Cassiano's portrait collection. In the Corsini picture, a woman whose brush, palette, and laurel-crowned head identify her as the Allegory of Painting paints the image of a man on her canvas.[139] Inas-

80. Anonymous artist, *Portrait of a Woman Artist*. Rome, Galleria Nazionale d'Arte Antica, Palazzo Corsini

much as the woman's face bears some resemblance to the image of Artemisia recorded in Jérôme David's engraving (Fig. 51), it is quite possible that Artemisia was here presented as the contemporary embodiment of Pittura by another artist. In view of the comparable dimensions of the two pictures, and the Roman provenance of the Corsini painting, the latter work could have been destined for Cassiano dal Pozzo's famous artist series, either as substitute for the desired image of Artemisia, or as a hybrid of himself and Gentileschi (perhaps consciously alluding to her *Self-Portrait as "Pittura"*), in a formulaic combination of male artist and female allegory that was not unusual (cf. Fig. 314, Chapter 6).[140] Cassiano may have been interested in acquiring a portrait of Artemisia because she was a woman artist. His collections were built around curiosities of natural phenomena; the portrait collection was described as containing "persons singular for their longevity or physical peculiarity, for precocious intelligence, or some other reason."[141] Cassiano sought images of such other women as Anna Colonna, whose portrait he solicited from the female painter Giovanna Garzoni (in 1630–31), and two French women, Madame d'Aubignan and Madame d'Ampus, from Fra Giovanni Saliano; and his collection allegedly contained a portrait of Christina of Sweden.[142]

Artemisia's *Self-Portrait as the Allegory of Painting* advances an educated play on female imagery prescribed in Cesare Ripa's *Iconologia*, which has suggested to some

writers that the picture's iconography may have been defined by Cassiano dal Pozzo. It is more probable, however, as is discussed below in Chapter 6, that it was Artemisia herself who took witty and thoughtful advantage of her special identity as a woman artist to create an image that combined allegorical and portrait traditions in a unique manner. Her personal steeping in the intellectually sophisticated Roman art world of the 1620s is summed up in this image, with its allusions to the important theoretical and stylistic debates of the era. No less important is the *Pittura*'s projection of an opposite ideal of the creative artist from that expressed in the Casa Buonarroti pictures among which Artemisia had worked. The painting is infused with the expression of inner, not outer, worth, in terms that Michelangelo himself would have valued.

The *Self-Portrait* also stands as a watershed that divides into two halves the artist's early career in Rome and Florence and her later Neapolitan activity. After 1630, with the exception of a few years' stay in London, Artemisia Gentileschi would live the rest of her life in Naples.

## NAPLES, 1630–C. 1638

Between August 1630 and November 1637, Artemisia is documented consistently in Naples, where she produced a substantial number of paintings. The exact date of her move from Rome remains unknown; although some recent scholars have placed this as early as 1626, it was probably closer to 1630.[143] For one thing, the tenor of the artist's letters to Cassiano dal Pozzo in 1630 suggests that she had only recently come to Naples.[144] Also implied in Artemisia's letters to Cassiano from Naples is a personal independence unusual for women of her day. Despite De Dominici's statement that Gentileschi was accompanied to Naples by her husband (*suo Consorte*),[145] she had probably been long separated from Stiattesi (about whom she would belatedly inquire in 1637 [Appendix A, no. 13]); in any event, she was listed in a Roman census of 1625 as head of her household. Nowhere in Artemisia's letters is a male consort mentioned, and she relied upon her brother Francesco to carry out her business affairs in other Italian cities and in England.[146]

All the more remarkable, therefore, is Artemisia's tenacious survival in Naples, a city that she disliked "because of the fighting, and because of the hard life and the high cost of living" (Appendix A, no. 11). She made a life there, no doubt, because of the wide availability of artistic commissions. Naples in the early seventeenth century was the largest city in southern Europe—three times the size of Rome—and the second largest city in Europe after Paris. No less than the Jesuits and Theatines who filled Neapolitan churches old and new with Counter-Reformation imagery, the Spanish viceroys who ruled the city were active patrons of the arts—men such as the Count of Monterrey, who, having served as viceroy in Naples in the 1630s (and as ambassador to the Vatican before that), returned to Spain in 1638 accompanied by some forty shiploads of paintings and ancient sculpture. Naples attracted as well many

merchants from port cities all over the Mediterranean and Northern Europe, many of whom, such as the Fleming Gaspar Roomer, were active international art patrons. Like Rome in the early sixteenth century, or New York in the twentieth, Naples was the major art capital, a magnet for artists seeking opportunity and success.

Caravaggio's short stay in Naples in 1606–1607 had created in the city a favorable climate for the reception of artists from central Italy. It helped a great deal that his realist style was compatible with the Spanish taste that shaped the Neapolitan court, a taste sustained by the Spaniard Jusepe de Ribera (1591–1652), who moved from Rome to Naples in 1616, and by Giovanni Battista Caracciolo (c. 1575–1635), a native Neapolitan who absorbed Caravaggism in both Naples and Rome. On the other hand, even before Artemisia's arrival, a current of Bolognese classicism was developing in Naples, initiated by local artists' contact with Rome, and by Guido Reni's visit in 1620–21. Long sojourns in Naples by Domenichino (1631–34) and Lanfranco (1634–46) helped to solidify Bolognese-Roman tendencies, and the ascendancy of classicizing taste is indicated in the fact that these artists received the most prominent commissions. Thanks as well to the influential presence in Naples of two major altar paintings by Vouet, executed in Rome in the 1620s,[147] Caravaggesque naturalism was gradually replaced in Naples in the 1630s and 1640s—as it had been a decade earlier in Rome—by a more ideal and graceful style of painting, represented principally by Massimo Stanzione, Bernardo Cavallino, and eventually by Artemisia Gentileschi herself.

Despite her expanded opportunities in Naples, Gentileschi continued to maintain and cultivate central Italian connections, and for years she nurtured a hope of returning to Florence or Rome, both of which clearly suited her temperament better than Naples. She sustained her Roman ties through Cassiano dal Pozzo, with whom she corresponded until 1637, and who served as her intermediary for commissions from the Cardinals Barberini. In 1635, Artemisia sent two large paintings (presently unidentified) to the Grand Duke of Tuscany—now Ferdinando II, son of her former patron Cosimo II (Appendix A, no. 9)—and in letters to the Grand Duke's Secretary of State, Andrea Cioli, she expressed a desire to return to Medici service in Florence (nos. 10–12). In May of 1636, she planned a journey to Pisa to sell property to raise funds for her daughter's marriage, and hoped to link the trip with a four-month stay in Florence under the Grand Duke's patronage. This did not work out as planned, for in 1637 we find her still in Naples, anxious to return to Rome, her other "native city," as soon as the daughter's marriage was settled (no. 13).

Other patrons outside Naples in the 1630s included "the Lord Duke of Ghisa," to whom she sent a painting in 1635 (no. 9). This was undoubtedly Charles of Lorraine (1571–1640), Duke of Guise and Joyeuse, who retired to Italy in 1622 after an active political and military career in France.[148] Artemisia also sustained a correspondence with Francesco I d'Este, Duke of Modena, to whom she sent paintings from Naples and London between 1635 and 1640, through her brother Francesco (nos. 6a, 6b, 7,

15a and 15b). The Duke of Modena, a major patron of the period, whose princely visage was recorded by Bernini and Velázquez (Fig. 81), presided over an artistically vital court, which Artemisia sought actively, though apparently unsuccessfully, to join.[149] Her claim in letters of 1635 (nos. 6a, 9) that she had served the major potentates of Europe, including the kings of France, Spain, and England, can largely be substantiated. Charles I owned several of her paintings, including works that may have entered his collection in the early 1630s, as is discussed below. At least one painting of the early 1630s was painted for King Philip IV of Spain: the *Birth of St. John the Baptist*, now in the Prado. No works by Artemisia for the King of France (Louis XIII) have been identified, but her claim in this regard is not implausible, considering Orazio's service in the late 1620s to Marie de' Medici, mother of Louis XIII, and in the light of the new possibility that Artemisia's own *Minerva* may have been painted for the French royal house (see above and Chapter 2).[150]

During her first years in Naples, Artemisia worked for a variety of patrons. She alluded to an eminent one in a letter of 1630 (Appendix A, no. 2), when she promised Cassiano to paint him a self-portrait after completing some works for "the Empress." This must have been Maria of Austria, sister of the King of Spain, who stayed in Naples as top-ranking royalty for four months, between August and December of

81. Velázquez, *Francesco I d'Este,
Duke of Modena*, 1639.
Modena, R. Galleria Estense

1630, while on her journey to Trieste to marry Ferdinand of Austria.[151] Also in Naples in late 1630 was the Spanish painter Diego Velàzquez, who painted a portrait of Maria of Austria.[152] It is quite probable that the two painters would have met at the viceregal court, and, as is discussed in Chapter 6, we may speculate that Velázquez saw and later drew inspiration from Artemisia's *Self-Portrait as the Allegory of Painting*. The direct naturalism of her work, especially the *Self-Portrait*, would have appealed to Spanish taste. Gentileschi may even have come to Naples by invitation from the ruling Spanish royalty, inasmuch as several of her paintings were purchased in Rome in about 1626 by the Duke of Alcalá (Fernando Afám de Ribera, viceroy in Naples in 1629–31; see Chapter 6).[153] Thanks to the recent discovery of an inventory of the Duke of Alcalá's palace in Seville, Pacheco's mention of one or more pictures by Artemisia bought by the Duke in Rome around 1626 can now be amplified to as many as five paintings.[154] The inventory lists as by the hand of "*Artemissa gentilesca*": a "Magdalen seated in a chair sleeping on her arm," a "half-figure of David holding a harp," a "St. John the Baptist," and two portraits of Artemisia that may have been self-portraits. The first-named of these works has been identified by Jonathan Brown and Richard L. Kagan with a *Magdalen* now in the Cathedral of Seville, a proposal that warrants serious consideration.[155]

In 1630 Artemisia signed and dated a large altar painting of the *Annunciation* (Fig. 82). This picture, her first known church commission and her largest work to date, was probably painted for S. Giorgio de' Genovesi, the Genoese church in Naples, a commission that may have been obtained through the artist's earlier contacts in Genoa.[156] Its slight compositional resemblance, in reverse, to Orazio Gentileschi's *Annunciation* painted for S. Siro in Genoa in c. 1622 (Fig. 83) has been noted, and could be explained as the patron's desire to have a picture like one back home. Yet the comparison reveals the expressive insufficiency of Artemisia's composition, for though it is more fully Baroque than Orazio's painting in its elimination of architectural setting, its heightened chiaroscuro and selective focus, Artemisia's *Annunciation* nevertheless lacks a dramatic intensity that even Orazio could invest.

A reason is not hard to find. The sparkling interplay of characters seen in many of Artemisia's compositions of the 1620s—*Judith, Esther, Joseph*—results from the juxtaposition of two physically active figures. The theme of the *Annunciation*, however, calls for one supremely still figure, the Virgin, whose qualities of purity, humility, and open-hearted receptivity were especially stressed in Counter-Reformation doctrine. Artemisia created a female character who conforms to the Marian ideal in her gentle inclination, the modest lowering of her eyelids, and her graceful gestures. Yet the artist did not invest the angel Gabriel with that motor energy which establishes an active-passive counterpoint in compositionally successful Annunciations. He has none of the animation of Orazio's awkwardly anxious Gabriel, and his upward-pointing arm is neither anatomically credible nor effectively placed. With its absence of psychological tension between the Virgin and Gabriel, this painting contrasts signif-

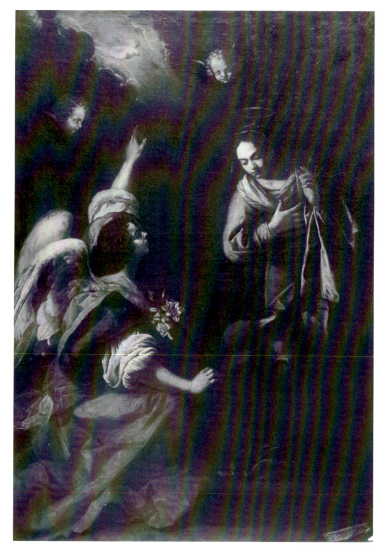

82. Artemisia Gentileschi, *The Annunciation*, signed and dated 1630.
Naples, Museo di Capodimonte

icantly with such charged works as the *Esther before Ahasuerus*. We may guess that
Artemisia, concluding that it would be inappropriate to make the Virgin more asser-
tive, may have been disinclined to allow Gabriel—messenger of God though he is—
to dominate Mary psychologically. In the *Self-Portrait* painted in the same year as the
*Annunciation*, Artemisia was able convincingly to fuse motion and stillness, inner
state and outer action, in the single figure openly herself, a remarkable fact that points
up her inability to give full life to a character with whom she did not closely identify.

Artemisia's next signed and dated painting, the so-called "*Fame*" of 1632 (Fig. 84
and Color Plate 16),[157] is stylistically continuous with the *Annunciation* in its dark

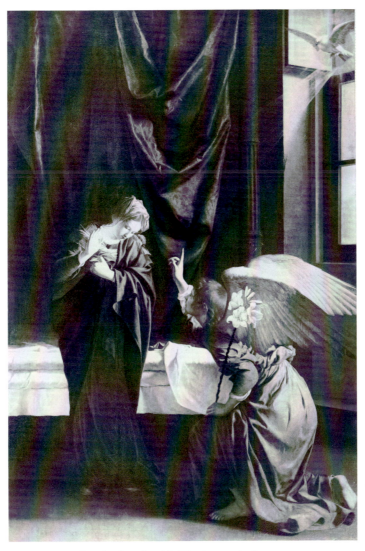

83. Orazio Gentileschi, *The Annunciation*, c. 1622.
Turin, R. Pinacoteca

coloration and the character of its drapery patterns, but the *"Fame"* displays a more vigorous, looser brushstroke than any painting seen to date, as well as a more overtly classicized physiognomy for its heroine. Although the figure has been identified as an allegory of Fame based on Ripa's *Iconologia*,[158] her attributes differ somewhat from those prescribed for Fame by Ripa—she holds no olive branch and she has no wings or medallion with a heart. The figure is more likely to represent Clio, the muse of History, who, according to Ripa, is crowned with laurel and holds the trumpet in one hand and a volume of Thucydides in the other. A *Clio* in Leningrad attributed to Ribera (Fig. 85) is shown with just these features. Artemisia's book is unlabelled, but it is

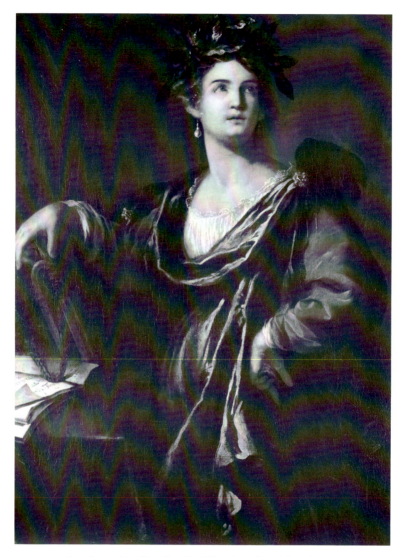

84. Artemisia Gentileschi, *Clio*, signed and dated 1632.
Private collection

open, and the information inscribed on its pages must have been meant to clarify the meaning of the image. According to the inscription (Fig. 86), the painting was dedicated by the artist to a "Signore Rosiers" or "Trosiers," names that have not been found in Neapolitan sources. The name might be connected, however, with the Rosières family, an old branch of French nobility, many of whose seventeenth-century members served the Dukes of Lorraine. One of these, Antoine de Rosières II, Seigneur d'Euvesin, and first Maître d'Hotel of the Duke of Lorraine, died in Paris in 1631.[159] Rosières's protector is likely to have been Charles of Lorraine, Duke of Guise, to whom Artemisia sent a painting in 1635. Quite possibly, the *Clio* was not ordered by

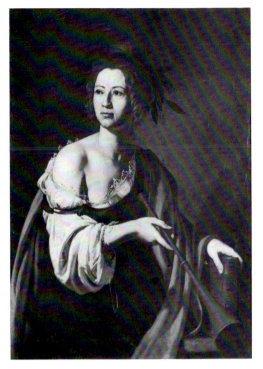

85. Jusepe de Ribera (attributed to), *Clio*, seventeenth century. Leningrad, Hermitage

86. Artemisia Gentileschi, *Clio*, 1632, detail of inscription. Private collection

Rosières, but dedicated to him, and we may speculate that a man recently deceased, Rosières, was here commemorated, perhaps by his protector the Duke of Lorraine, or perhaps by the artist herself, who might have been his friend. The inscription may then be understood as follows: "*1632 / Artemisia faciebat / all Illus^te M(emoria) / Sngre. Rosier(e)s.*" (The more cryptic writing on the right page of the book, which has eluded every modern writer's understanding, may possibly have been meant simply as a general evocation of Thucydides as a writer in Greek, since several of the characters resemble Greek letters.)

As I have suggested, the painting expresses the historical importance of a man no longer living, not through a posthumous portrait but through an allegorical tribute to him from Clio, the muse of History. This concept permitted the creation of a splendid female image as stand-in for the deceased hero. More, however, than an avoidance of portraiture for the sake of female iconography, the *Clio* is in a larger sense a commentary on a three-faceted relationship: between the absent Sr. Rosières who is commemorated; the fictive muse of History, imaged and presiding, for whom Rosières is a mere example; and the absent but ubiquitous artist, whose presence is asserted both in the inscription and in the physical work of art, and whose vision embraces the whole. Such a meditation on the role of the artist in the assurance of

human fame not only echoes Renaissance precedent, it also prefigures Vermeer's developed expression of the idea in his *Allegory on the Art of Painting* of 1666–67 (Fig. 87), in which the painter works before a model who is adorned with the attributes of Clio.[160] Quite likely, Artemisia also explored the iconography of the Wildenstein *Clio* in two pictures owned by Charles I, the *Poesia with Trumpet* and an *Allegory of Painting* (a different work from the Kensington *Self-Portrait*; see below, notes 191, 192). To be sure, both Gentileschi and Vermeer took their iconographic details straight from Ripa's *Iconologia*, yet in view of the general rarity of individual images of Clio (as opposed to the more commonly depicted Fame), it is not inconceivable that Artemisia's work in this vein—especially visible in English collections—became known in Holland through the frequent traffic of artists between England and the Lowlands.[161]

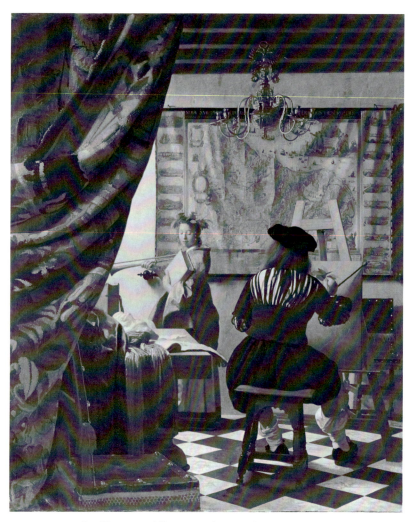

87. Jan Vermeer, *Allegory on the Art of Painting*, 1666–67.
Vienna, Kunsthistorisches Museum

None of the rest of Artemisia's Neapolitan paintings are dated, and their chronology can only be approximated. Four more pictures may securely be assigned to the 1630s, before the painter's departure for London in about 1638. These include three works done for the choir of the Cathedral in Pozzuoli, and one picture now in Madrid, the *Birth of St. John the Baptist* (Fig. 88 and Color Plate 19). The latter painting was probably the earliest. Signed, like the *Annunciation*, with the artist's name on a *cartellino* on the ground, the *Birth of the Baptist* went to the Buen Retiro Palace in Madrid as part of Massimo Stanzione's series of the life of St. John the Baptist painted for Philip IV (Fig. 89).[162] Since Stanzione and Gentileschi arrived in Naples in 1630, and a copy of one of Stanzione's pictures in the group is dated 1637, the series has been dated in the early to mid-1630s. New circumstantial evidence permits us to refine that dating to 1631–33.[163] Gentileschi's St. John the Baptist painting joined those of Stanzione in the Buen Retiro amidst a staggering wealth of paintings by the leading artists of seventeenth-century Europe: six Roman histories by Lanfranco, Domenichino, and others; magnificent landscapes by Claude Lorrain and Poussin; works by Rubens and Van Dyck; and the largest concentration of paintings by Velázquez to be found anywhere in the world.[164]

Much has been made of the artistic relationship between Stanzione and Gentileschi, and the presumption of her influence on him has derived from De Dominici's description of Massimo's informal apprenticeship to Artemisia in the years immediately following her arrival in Naples. Allegedly, he went every day to watch her paint, and, "modest, humble and judicious," imitated her coloring (though not her design, said by De Dominici to be unsuccessful in large-scale pictures). Later writers have designated Artemisia the innovator who led Stanzione both to rich light effects and to greater classicizing.[165] Yet neither the artists' biographies nor their paintings bear out this *topos*. Stanzione, roughly eight years Artemisia's senior, was an established artist by 1617, when he was working in Rome at S. M. della Scala with Saraceni and Honthorst, and when he must have made his studies of Caravaggio, the Carracci, and Vouet. Stanzione's earliest known works, such as the *St. Agatha in Prison* (Fig. 90) and the *Young St. John the Baptist*, date from just after 1630, when he had returned to Naples after a five-year stay in Rome, and already they display a smoothly composite lyric classicism, blended of Reni, Domenichino, and many other sources. But in 1630, Artemisia, as her *Annunciation* and *Self-Portrait* clearly show, had not yet abandoned tenebrist naturalism, nor would she yet in the *Adoration* and other Pozzuoli paintings of the later 1630s. And it is difficult indeed to sort out her alleged influence upon Stanzione's color from that of the numerous other colorists with whom he had had contact.

We may more productively focus upon the cycle on which the two painters collaborated, the pictures for Philip IV's Buen Retiro Palace (Figs. 88, 89), to observe that in this project, Gentileschi and Stanzione appear to have met each other halfway in the interest of creating a harmonious ensemble. In the *Birth of St. John the Baptist*,

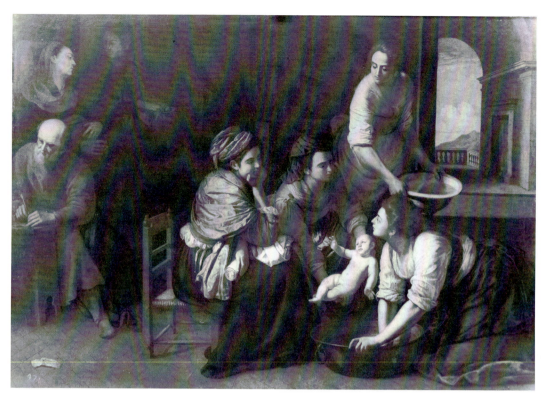

88. Artemisia Gentileschi, *Birth of St. John the Baptist*, 1631–33. Madrid, Prado

89. Massimo Stanzione, *Decollation of St. John the Baptist*, 1631–33.
Madrid, Prado

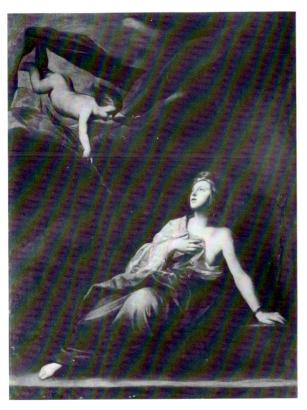

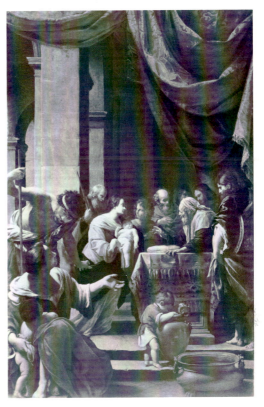

90. Massimo Stanzione, *St. Agatha in Prison*, early 1630s. Naples, Museo di Capodimonte

91. Simon Vouet, *The Circumcision*, signed and dated 1622. Naples, Museo di Capodimonte

Artemisia tempered her realist *tenebroso* with more even lighting and a more classical composition, creating an unusually idealized image for her *oeuvre* at this time. Correspondingly, in his *Decollation of St. John the Baptist*, Stanzione heightened light-shade contrasts and sharpened detail, to give a greater than usual sense of earthy reality. Such an explanation, which presumes that artists sometimes adjusted style to situation, helps to meet the difficult necessity of dating Artemisia's *Birth of St. John the Baptist* in the decade of the 1630s. Faced with a commission that encouraged her in a classicizing direction, Artemisia could have drawn inspiration from the measured design of a painting by her former associate, Vouet, whose *Circumcision* (Fig. 91) was painted in Rome in the 1620s and sent to Naples, where it had an impact upon many Neapolitan artists.

The Gentileschi paintings for the choir of the Duomo at Pozzuoli formed part of a set of commissions assigned to several artists sometime after 1631, when extensive renovation of the medieval cathedral was begun under the new bishop, Martino de León y Cárdenas. Artemisia's three pictures—*SS. Proculus and Nicea, The Martyrdom*

*of St. Januarius* and *The Adoration of Magi* (Figs. 92, 93, 94, and Color Plates 20, 21)—joined eight other works by Stanzione, Lanfranco, Agostino Beltrano, Cesare Francanzano, and others in a cycle for the choir carried out between 1636 and 1640.[166] Artemisia's paintings are likely to have been among the earliest supplied, since the dedicatory plaque to SS. Proculus and St. Januarius, dated 1633, is placed below her *SS. Proculus and Nicea*. St. Proculus, a deacon martyred at Pozzuoli under Diocletian, was a local patron saint along with his mother Nicea; St. Januarius, bishop of Benevento and early Christian martyr, became Naples's most beloved patron saint, popularly believed to protect the city against volcanic eruptions, because he had emerged from a furnace unharmed.[167]

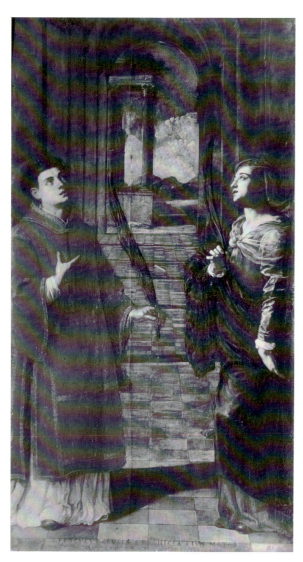

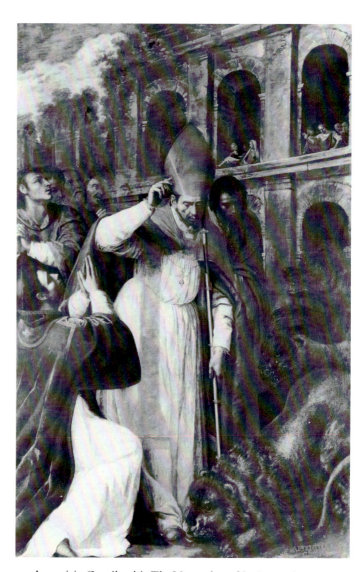

92. Artemisia Gentileschi, *SS. Proculus and Nicea*, 1636–37. Naples, Laboratorio di Conservazione di Capodimonte

93. Artemisia Gentileschi, *The Martyrdom of St. Januarius in the Amphitheater at Pozzuoli*, 1636–37. Naples, Laboratorio di Conservazione di Capodimonte

Artemisia's *St. Januarius* (Fig. 93)[168] illustrates an earlier episode in the saint's life, when he was miraculously unhurt by wild beasts in the amphitheater at Pozzuoli. In developing her image of the popular Neapolitan saint, Artemisia must have looked at such relevant paintings as Caracciolo's *St. Januarius with Bishop-Saints* at S. Martino (Fig. 95), painted in the late 1620s or early 1630s, which, with its related sketch for the saint in the fiery furnace, shows Caracciolo's temporary abandonment of Caravaggism for a more mellifluous and exuberantly Baroque image. The Pozzuoli *Januarius* is radically different: a highly particularized image whose lions are as individual as the human figures, whose setting is a near-literal rendering of the Roman amphitheater that stands at the heart of the Neapolitan suburb of Pozzuoli. The difference between Caracciolo's and Gentileschi's Januarius paintings has been taken to indicate Artemisia's awkward and incomplete effort to adjust to the new Bolognese innovations, though one might more objectively conclude that she was, of the two, the more consistent and steadfast exponent of Caravaggesque naturalism.

Artemisia's Pozzuoli pictures reflect the beginnings of collaborative activity. The hand of Viviano Codazzi (1604–1670) has been detected in the architectural background of the *St. Januarius*, a reasonable inference in view of Gentileschi's reported later collaboration with the Bergamasque architectural landscape painter. Codazzi—as fate would have it, a follower of Agostino Tassi in this genre—arrived in Naples in about 1634 and supplied architectural backgrounds for pictures by Lanfranco, Stanzione, Domenico Gargiulo (called Micco Spadaro), and Artemisia Gentileschi.[169] The ungainly design of the *St. Januarius*, by comparison with such other paintings in the cycle as Lanfranco's *St. Peter*, may have resulted partly from a multiplicity of hands. Since the full architecture of the Pozzuoli amphitheater would have had to be imaginatively reconstructed by the artist—the ruins of the real building rise only to the first level—Artemisia might reasonably have called on a specialist for assistance. But the surface handling is so consistently fluid from figures to animals to building, it must have been she herself who gave the composition its final painterly unity.[170] The *SS. Proculus and Nicea* (Fig. 92), on the other hand, though probably composed by Gentileschi, is likely to have been finished by another artist. While its spatial setting has precedent in the *Esther before Ahasuerus*—and the short, large-headed figures resemble the *Gonfaloniere* portrait—the faces and upper drapery of Nicea are inconsistent in style with the figure of St. Januarius.

The third picture, the *Adoration of the Magi* (Fig. 94), is a more internally consistent painting than either of the other Pozzuoli pictures, and appears to be entirely by Gentileschi's hand. The slightly disjointed angularity of the standing magus is characteristic of her treatment of male figures, and in this case contributes to the expressive effectiveness of the painting by establishing a mood of intimacy and reverence. The solemn, dreamlike mood of Artemisia's *Adoration*, sustained in tenebrist naturalism, invites comparison with Velázquez's version of the same theme (Fig. 96) painted in 1619, and though it is improbable that Gentileschi had seen this particular

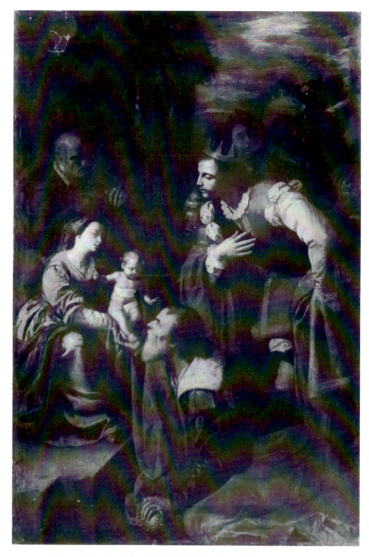

94. Artemisia Gentileschi, *The Adoration of the Magi*, 1636–37.
Naples, Laboratorio di Conservazione di Capodimonte

work by the Spanish artist, the comparison bears out the general expressive conso-nance of her art with his.[171] The artists offer analogous groupings of large-scale, earthy individuals, whose slow, reverential motions suggest a contemporary re-enactment of the sacred event. Only the Madonna and Child groups are significantly different, for Artemisia's relaxed bourgeois mother is distinguished from Velázquez's iconic young peasant both in physical type and in her more natural human interaction.

The Virgin of the Pozzuoli *Adoration*—mature and dignified, with aquiline fea-tures—has roots in Artemisia's earlier female figures. She is in a sense Susanna or Lucretia grown up, now decorous and restrained. This new female character bears a certain resemblance to the Virgin in Vouet's *Circumcision* (Fig. 91), and some generic

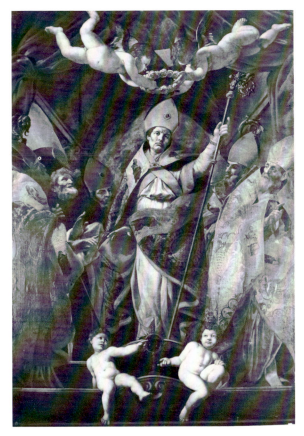

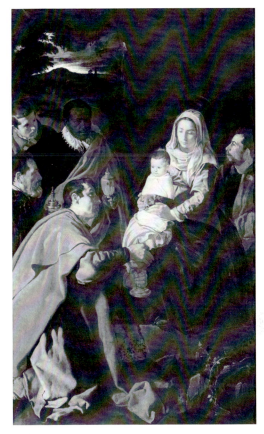

95. Giovanni Battista Caracciolo, *St. Januarius with Bishop-Saints*, late 1620s–early 1630s. Naples, S. Martino

96. Velázquez, *The Adoration of the Magi*, 1619. Madrid, Prado

relation to Stanzione's female figures.[172] But the change in Artemisia's figure type may signify more than simply a response to changing fashions. The decorous and dignified Virgin, who functions maternally but with a certain businesslike dispatch (like the nurses of the infant Baptist), is a far cry from the violently antisocial heroines of Artemisia's earlier years. Decorum is of course a concomitant of the classicizing vision, and to some extent Artemisia Gentileschi must have participated in the general shift of European art at mid-century, away from the early century's interest in intense emotional states—as seen in Caravaggio's *Boy Bitten by a Lizard* or Rembrandt's early self-portraits—and toward a Cartesian systematization of the passions, epitomized in the philosophical calm of Poussin's pictorial world. On another interpretative plane, however, Artemisia's new protagonist is a thoroughly socialized female who carries out public responsibilities with modest efficiency, without heroic aspirations beyond the role assigned. A relationship is therefore suggested with the artist's own adaptation to collaboration, as in the Buen Retiro and Pozzuoli cycles, and with her personal

adjustment to public prominence and material success in Naples. As her characters became more conventional, they became more influential. The female face seen in the Pozzuoli *Adoration*, which recurs in Artemisia's Columbus *Bathsheba* of the 1640s, would find its way into the typological vocabulary of Bernardo Cavallino, Francesco Guarino, and others.

Another figure of this physical type appears in a *Lucretia* in the Capodimonte Museum, Naples (Fig. 97 and Color Plate 22), a painting presently ascribed to Stanzione, but which in fact must be by Artemisia, as Longhi long ago recognized.[173] Certain elements of the setting, such as the checkerboard floor, the sharp and precise light, and the strangely animate objects on the table, find closer correspondences in

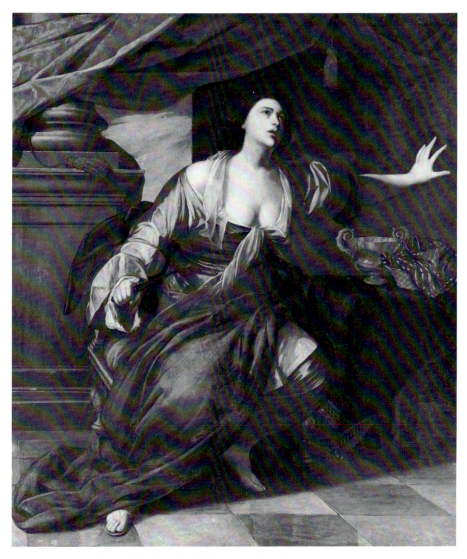

97. Artemisia Gentileschi (here attributed), *Lucretia*, 1642–43.
Naples, Museo di Capodimonte

Gentileschi than in Stanzione. In color the painting is thoroughly characteristic of Artemisia. The salmon, blue, and brown of the heroine's clothing are echoed in the pale blue and brown of floor tiles, while the undergarment exposed at her left knee is shot through with lilacs and greens. The red curtain at upper left and the complementary dark green of the tablecloth are further connected through gold accents in the curtain's tassel and the golden kylix and edging of basket cloth. As in the first *Susanna* and in the *Esther*, the painter demonstrates interest in crumbling stone, for the marble plinth has been aged by the painter with a couple of nicks at its base. A more telling sign of the artist's hand is the expressive interpretation of the theme, which is thoroughly consistent with Artemisia's earlier *Lucretia* in Genoa. Here too the heroine is shown with knife poised, questioning rather than succumbing to the fate of suicide that propriety demands. (The artist's attitude toward that self-sacrificial suicide may be conveyed in the female figure, splayed like Marsyas, who forms the left handle of the kylix.) Yet the expression is subdued, and the difference between this nobly attired aristocrat, who gestures grandly in a palatial setting, and her counterpart of nearly twenty years earlier, the plain, muscular, and half-naked *bourgeoise*, whose acute private anguish is heightened by her constricted bed-space, is effectively the difference between the adult Artemisia—accomplished, successful, and secure—and the young woman whose enormous ambition to express raw feelings outreached her desire to conform.

The aristocratic grandeur of the second *Lucretia* is also a clue to the picture's dating, for it demonstrates for the first time Artemisia's response to Van Dyck's influence in her use of a Van Dyckian formula of column base and curtain, combined with the sitter's expansive gesture and her classically idealized face. The *Lucretia* was thus surely painted after the artist's sojourn in England, where she would have had prolonged exposure to examples of the Flemish painter's dominance of English court portraiture, both in his own work and in that of English followers.[174] This clue is important, for it permits us to define more precisely Artemisia's style changes in the last two decades of her life, and to pinpoint the early 1640s, at the end of her English period, as the turning point when Caravaggesque naturalism was finally replaced by classicizing generalization, the result of influence from the prevailing mode in both London and Naples—or perhaps more accurately, of the artist's concession to a major shift of taste on the part of her patrons.

Another welcome addition to Gentileschi's *oeuvre* is the *Cleopatra* from a private collection in London (Fig. 98 and Color Plates 17 and 18) that was recently exhibited in Naples, bearing a new attribution to the artist.[175] Formerly ascribed to Stanzione, this *Cleopatra* is unquestionably a work by Artemisia, whose presence is visible in every respect, from the characterization of the glamorous Egyptian queen as a homely young girl, as in the *Cleopatra* painted in Genoa in c. 1621 (Color Plate 10), to features that are virtual signatures, such as the servant woman with sleeves rolled, who resembles figures in the Prado *Baptist* and the Columbus *Bathsheba* (Figs. 88, 115).

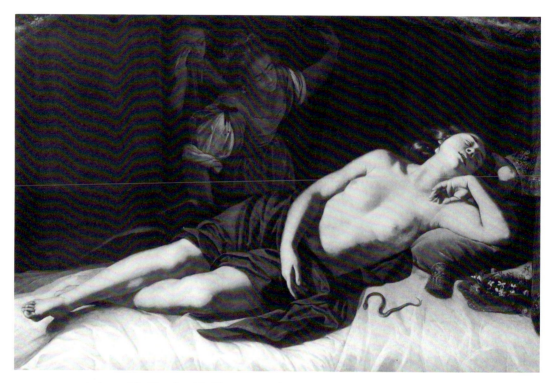

98. Artemisia Gentileschi, *Cleopatra*, early 1630s(?). London, private collection

Artemisia's *Esther* is recalled in the relationship between a powerful dominant figure (whose head is similarly foreshortened) and her two female attendants, who are smaller in scale and coloristically subordinated.

Yet as this range of comparisons suggests, the London *Cleopatra* is difficult to place chronologically. Gregori has pointed out its compositional relation to reclining female nudes painted by Orazio in the 1620s, especially the *Penitent Magdalen* painted in Genoa for Giovanni Antonio Sauli in 1621 and its several variants (Fig. 99), and also to an engraving of the *Penitent Magdalen* by Claude Mellan (Fig. 100).[176] Mellan's print, generally recognized as an adaptation of Orazio's design executed in Rome about 1629–30, is closer in certain details to the London *Cleopatra* than is Orazio's prototype, a point that has led Gregori to suggest that Artemisia may have employed the print as the basis for her painting.[177] We need not fix this relationship too literally, for Cleopatra's pose is a standard type for reclining female nudes; moreover, Artemisia's figure is a closely observed, independently realized image, whose hypnotic power transcends its putative sources. Possibly this work preceded that of Mellan, perhaps painted in the late 1620s for another patron in Genoa, where the Cleopatra theme seems to have enjoyed special popularity (see below, Chapter 4, note 93). However, the specifically Neapolitan character of the two women in the background

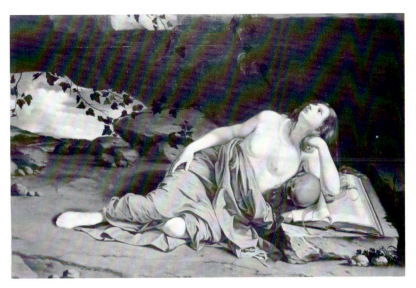

99. Orazio Gentileschi, *Penitent Magdalen*, c. 1625. New York,
Richard L. Feigen & Co., Inc.

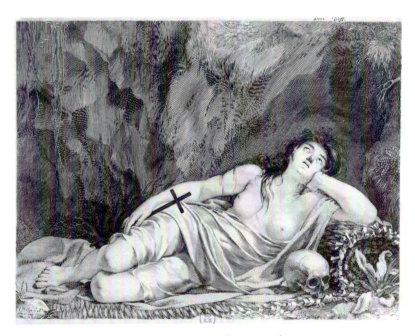

100. Claude Mellan, *Penitent Magdalen*, engraving, c. 1629–30.
Paris, Bibliothèque Nationale

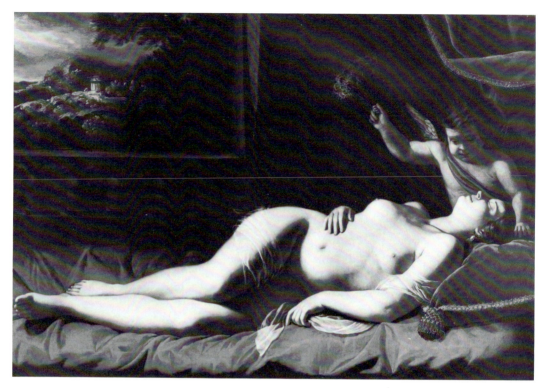

101. Artemisia Gentileschi, *Sleeping Venus*, early 1630s. Princeton, N.J.,
Mr. and Mrs. J. Seward Johnson Collection

indicates a more likely dating in the early 1630s, sometime between the *Self-Portrait* and the Prado *Baptism*. As in the case of the two *Lucretia*s, the London *Cleopatra* diverges in style from the Genoese *Cleopatra* (though not as radically), yet it still shares significant iconographic features with the earlier version of the theme (see Chapter 4).

Quite recently, a painting of the *Sleeping Venus* in a private American collection has convincingly been ascribed by Józef Grabski to Artemisia (Fig. 101).[178] Although this reclining female nude is more idealized than is usual for Artemisia, both in body and in physiognomy, many individual features connect it strongly with her *oeuvre*. The fringed, stiff curtain at upper right finds counterparts in the *Esther* and Detroit *Judith*, while the braided tassel of her pillow is virtually identical with that seen in the London *Cleopatra* (and in the newly ascribed *Galatea*, discussed below). Grabski noted parallels for the figure of Venus in Orazio's reclining nudes (particularly the Sauli *Danae*) and in Artemisia's London *Cleopatra*. However, a more relevant stimulus for both the *Cleopatra* and the *Sleeping Venus*—despite its different subject—is Caravaggio's *Sleeping Cupid* of 1608 (Fig. 102), which Artemisia would certainly have known in Florence.[179] In her memory of this powerfully tenebrist, palpably real

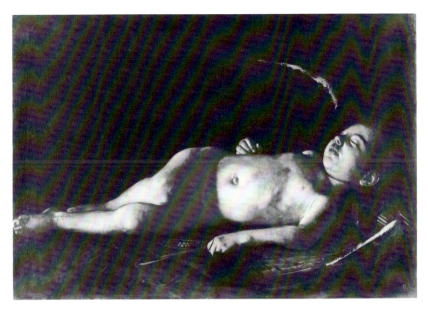

102. Caravaggio, *Sleeping Cupid*, 1608. Florence, Palazzo Pitti

Amor—which Hibbard rightly said looked like a dead baby—Artemisia found a model, both for her image of his mother, Venus (the pose and lighting), and for her dead Cleopatra (the foreshortened face and toothy open mouth). It is possible that the *Sleeping Venus* in Princeton is identical with a "*donna con amore*" recorded in the Barberini inventories sometime between 1624 and 1636, and thus it may well be the work sent as a gift from the artist to Cardinal Antonio Barberini early in 1635.[180] With its firm modelling and strong chiaroscuro, the Princeton *Venus* can comfortably be dated in the first half of the 1630s, and although its deep landscape background (complete with a round Temple of Venus) points ahead to works of the 1640s, such landscapes were already becoming a standard feature of Artemisian compositions, as we learn from a letter to Cassiano dal Pozzo of 1637 (Appendix A, no. 14).

Several lost works painted by Artemisia in Naples in the 1630s can be identified by name. A life-size *David Holding the Head of Goliath* was shown in 1631 to Joachim von Sandrart, along with other paintings characterized by the German artist and writer as "equally rational in conception." Sandrart added that he painted a replica of his own *Death of Cato* (now in Padua) for Artemisia, whom he praised highly as an artist, commenting that she enjoyed masculine glory; and he included her portrait in his imaginary *Teutsche Academie* of famous artists.[181] The *St. Catherine* mentioned in a letter of 1635 to Andrea Cioli (Appendix A, no. 10), characterized by the artist as "finished some time ago," must nevertheless date from the early 1630s and not from Artemisia's Florentine period when she first knew Cioli, since the rest of the passage implies that this commission was a recent one. Two paintings engraved by Pieter de

Jode II, a *Child Sleeping Near a Skull (Allegory on Death)* (a work perhaps also based
on Caravaggio's *Sleeping Cupid*), and a *Holy Family with Zachariah and St. Elizabeth*,
are associated by their subjects more with Artemisia's Neapolitan years of the 1630s
than with the late years.[182]

By 1635, Gentileschi began to cast around for patronage prospects outside Naples.
She hinted of forthcoming visits to Francesco d'Este at Modena and to Andrea Cioli
in Florence, and she sent and offered pictures to Grand Duke Ferdinando II, ostensi-
bly to pave the way for her return (Appendix A, nos. 7 through 12). The plan evi-
dently fell through, for two years later, she was still in Naples. In the fall of 1637,
needing money to finance her daughter's marriage, Artemisia offered some large
paintings to Cardinals Francesco and Antonio Barberini. She wrote to Cassiano dal
Pozzo (nos. 13 and 14) mentioning an unspecified number of paintings for the cardi-
nals, and two for Cassiano himself to be included in the shipment, the long-promised
self-portrait (discussed above), and another picture, unnamed. In the same shipment
was a painting for "Monsignor Filomarino," a major art patron, both in the Barberini
circle in Rome and in Naples, where he became Archbishop in 1642.[183] In the second
letter (no. 14), she named the subjects of two of these works: a *Christ and the Samari-
tan Woman*, with the twelve apostles, in an extensive landscape (12 x 9 *palmi*); and a
*St. John the Baptist in the Desert* nearly as large. Neither painting is known today, and
inasmuch as the *Self-Portrait* does not seem to have reached Cassiano, it is possible
the pictures were never sent to Rome.[184] Artemisia's description suggests that land-
scape had become an increasingly significant element in her Neapolitan paintings, an
interest only hinted at in the *Adoration, St. Januarius*, and the *Birth of the Virgin*, and
hardly more developed in the known paintings of the 1640s. It seems, then, that land-
scape may be counted as another entire area of Artemisia's *oeuvre*, along with portraits
and still-life, that is inadequately represented among the paintings known today.

## ENGLAND, 1638–C. 1641

By 1638, Artemisia was in residence at the court of King Charles I and Queen Hen-
rietta Maria of England (Fig. 103). She served the English king for two or three years,
for the first time in seventeen years working alongside her father, who had been in
that country since 1626.[185] It has reasonably been proposed that Artemisia went to
England on account of her father's failing health (he died there on February 7, 1639),[186]
but if so, she also responded to a standing invitation to the English court. There is
no reason to doubt her claim in a letter of January 25, 1635 (Appendix A, no. 6a),
written to Duke Francesco I d'Este in Modena, that Charles I had sent her brother
Francesco to "take me into his service." Artemisia's second mention of English
patronage in her letter to Galileo (October 9, 1635; no. 9) combines with evidence that
a *Tarquin and Lucretia* by Artemisia was in the king's collection as early as 1633–34 to
support the probability that her reputation and some of her paintings preceded her

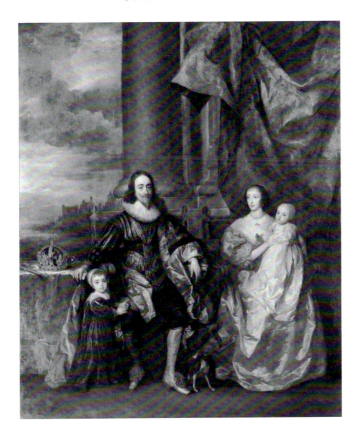

103. Anthony Van Dyck, *Charles I
and Henrietta Maria,
Prince Charles and Princess Mary.*
Royal collections

journey to the British Isles.[187] This is not surprising, since Orazio would have paved
the way for her; and indeed, Francesco could have brought examples of her work
there as early as 1628.[188]

The voracious art-collecting appetites of Charles I and his efforts to attract Italian
artists to his court are well known.[189] The king's astonishing wholesale purchase of
the Gonzaga collection in Mantua in 1627, accomplished by his undercover agent
Daniel Nys, secured Charles's reputation as owner of the most impressive private art
collection in Europe, and his residences at Whitehall, Hampton Court, and Green-
wich were filled with masterpieces by Raphael, Titian, Correggio, Mantegna, and
Caravaggio, and with treasures of ancient and Renaissance sculpture.[190] Charles's
collecting in Italy was not limited to the Gonzaga purchase. Van der Doort's inven-
tory of 1639, which reflects the extensive purchases made by the king in the 1630s,
includes three paintings by Artemisia: a *Susanna and the Elders*, a *Tarquin and Lucre-
tia*, and a half-length figure of Fame.[191] Inventories made shortly after the king's exe-
cution in 1649 were more extensive than Van der Doort's because the latter only
named works in Whitehall, while the subsequent list included all palaces and houses
(and hence may well name works that were purchased earlier). The second inventory
lists, in addition to the above-named paintings, the following works by Artemisia

Gentileschi at Hampton Court: a *Self-Portrait*; a *"Pintura"*; a *"Saint Laying his Hand on fruit"*; and a *"Bathsheba Bathing with other naked figures."*[192] All of these paintings except the *Bathsheba* were sold in 1651, but according to an inventory of 1687–88, the *Self-Portrait* was reclaimed by the crown.[193] Today only the *Self-Portrait* (Fig. 79 and Color Plate 14), which now hangs at Kensington Palace, can be identified in the royal collections.

In the early years of his reign, Charles invited a number of Italian artists to England, including Guercino, Albani, Caroselli, and the sculptor Pietro Tacca, but the only Italians to accept the invitation were Orazio and Artemisia Gentileschi and the sculptor Francesco Fanelli. Most of the artistic luminaries at the English court during Orazio's tenure were from the Netherlands. Gerrit van Honthorst came to London for eight months in 1628 with his assistant Joachim von Sandrart to execute a major commission, the painting of *Apollo and Diana* in the Banqueting House at Whitehall.[194] Rubens was in England intermittently in 1629–30 as diplomatic emissary of the Spanish king; while there, he carried out the painted decorations in the Banqueting Hall at Whitehall that celebrated the peace with France and Spain accomplished finally in 1630, largely through Rubens's own diplomacy.[195] Both were long gone by the time Artemisia arrived, but she would have had ample occasion to renew her acquaintance with Van Dyck, who came to London in 1632 and, after a decade of phenomenal success as a portrait painter, was buried in St. Paul's in 1641.

One of Artemisia's major activities in London, and perhaps her chief reason for being there, was to help Orazio carry out the commission extended to him in 1635 to decorate the ceiling of the Queen's House at Greenwich. She assisted him this time not as his pupil-apprentice, but as the mature and vigorous supporter of her tired, seventy-five-year-old father, who now wished nothing more than to return to his native Italy, having experienced in London both personal harassment by a jealous colleague and artistic eclipse by the brighter lights of Van Dyck and Rubens.[196] The execution of nine canvases for the forty-foot-square ceiling of the Great Hall of the Queen's House at Greenwich was an incredibly ambitious undertaking for a man of his age and health, and Artemisia's share in the project surely included more than the two or three figures that scholars have assigned to her. Whatever she may have contributed to the scheme, however, was ultimately subsumed under Orazio's name, a generous gesture for (or perhaps a callous slight of) a woman with an international reputation of her own.[197]

The Queen's House at Greenwich (Fig. 104), built by Inigo Jones a generation earlier for Queen Anne, was half-finished at the queen's death in 1618. Work resumed for Henrietta Maria of France, to whom King Charles I granted the Palace and Park of Greenwich and the unfinished house in 1627, soon after their marriage. Jones completed the major part of the Greenwich house by 1635, having in the meantime carried out the Banqueting House, Whitehall, and the Queen's Chapel, St. James. The central hall of the Queen's House (Fig. 105), a pure Palladian cube, received its black-and-

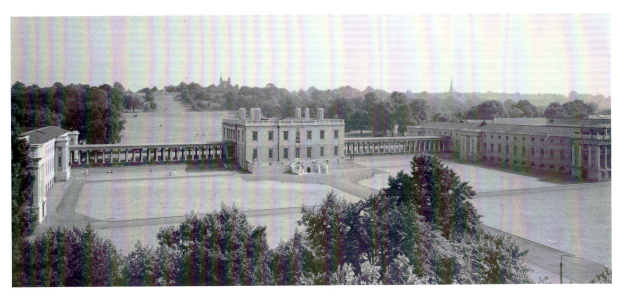

104. Inigo Jones, Queen's House, 1616–35, exterior. Greenwich

white marble tile floor in 1636–37; its geometric pattern is echoed in the structure of the ceiling above. Inigo Jones himself probably supplied this design—a squared central roundel flanked by four rectangles with four corner roundels—a design that resembles Veronese's ceiling at the Villa Barbaro at Maser, of which the architect had made drawings.[198] Although Orazio probably did not begin the ceiling paintings before 1636, when the wooden armature establishing their fields was carved, he must have been well into the project when Artemisia arrived in 1638. Whether or not all the paintings had been completed when Orazio died in February 1639, they must have been set in place by the end of that year, when the interior of the house was virtually finished (and when negotiations for pictures by Rubens and Jordaens for the Queen's Drawing Room had begun).[199] At the outbreak of the Civil War in 1641, the Queen's House was closed, Henrietta Maria left for Holland, and the ceiling paintings gathered dust until their removal and reinstallation at Marlborough House sometime after 1711.[200]

The iconographic program of the Greenwich ceiling, *An Allegory of Peace and the Arts under the English Crown* (Fig. 106), is an adaptation of the allegorical types of Cesare Ripa to the immediate political needs of the British crown.[201] In the central roundel, Peace, wearing an olive wreath and bearing an olive branch, is sustained by Victory, achieved and flanked by Strength and Concord, personifications whose attributes allude to other virtues as well, such as Strength's association with Wisdom, through an allusion to Minerva. As Ripa observed, Peace makes possible the flourishing of the Arts, and hence the seven Liberal Arts are depicted in the central scene, the Trivium on the left of Peace, the Quadrivium on the right. The central theme of the Greenwich ceiling connects it with a succession of paintings commissioned by Charles I that celebrated his virtuous and glorious rule. The Muses and the Liberal Arts appeared frequently in Caroline commissions, such as Honthorst's *Apollo and Diana* of

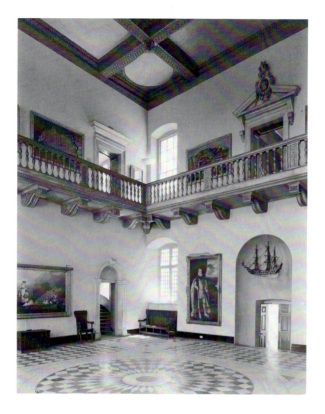

105. Inigo Jones, Queen's House,
1616–35, central hall.
Greenwich

1628, in which the Liberal Arts are presented to the King and Queen by the Duke of
Buckingham dressed as Mercury, in an idyllic reign that sees, in the foreground, Envy
and Hate destroyed by Virtue and Love.[202] The theme of the Arts flourishing under
the benevolent and peaceful reign of Charles I was sustained as well in Rubens's ceil-
ing for the Banqueting Hall, and in Orazio Gentileschi's *Apollo and the Nine Muses* for
York House (1628).[203] That peaceful reign, unstable to begin with, was shortly
doomed to a violent end, but as Bissell aptly notes, "the psychological need for rein-
forcement was enormous." The theme of a Renaissance of the arts in the Utopian
political world of the Caroline court was also popular in the court masques of Ben
Jonson and Inigo Jones, which carried out the king's propaganda more overtly. The
English royal masques, with their mannerist designs, perspective scenery, sea battles,
and heavy allegory, would have seemed familiar to Artemisia in particular, since they
were based directly on the tableaux and intermezzi of Callot, Buontalenti, and Giulio
Parigi—those very extravaganzas that she had seen twenty years earlier in Florence.[204]

The Gentileschi paintings for the ceiling of the Queen's House offered another
brand of aesthetic conservatism in their descent from the Venetian and North Italian
painted ceiling tradition. As in many an Italian Renaissance ceiling fresco, the figures
seated around the rim of the central roundel and in the outer roundels and rectangles
are solid and stable forms, evenly lighted in consistent response to the natural light

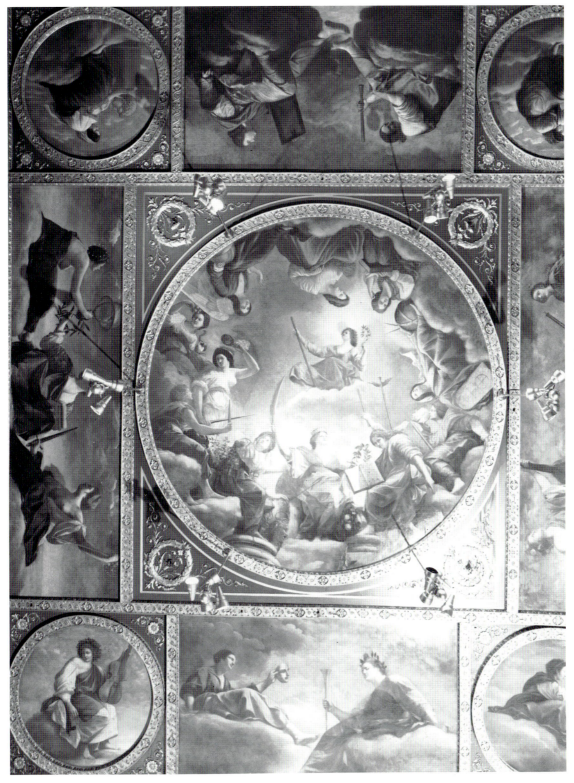

106. Orazio and Artemisia Gentileschi, *An Allegory of Peace and the Arts under the English Crown*, 1638–39. Ceiling, central hall, Queen's House, Greenwich (now Marlborough House, London)

of the room.[205] Orazio has been criticized for not going beyond Veronese in this and other of his English paintings, and his solution to the problem at hand is indeed retarded by comparison with the dynamic and sometimes exuberant ceilings of contemporary Rome. Yet his adaptation of a Venetian Renaissance decorative scheme to conservative English tastes was itself an effective mediation between the two countries' traditions, paving the way for Robert Streeter and James Thornhill's Italianate allegories at Greenwich, London, and Oxford. The role of the Gentileschi in deprovincializing England is thus comparable to that of Van Dyck and Rubens, and earlier, Holbein.

The ceiling at Greenwich also gives visual form to an idea of significant contemporary relevance, and of utmost importance to artists: the relationship of the visual arts to the Liberal Arts. By introducing the arts of Painting, Sculpture, and Architecture, along with Music, into the corner roundels, adjacent to (though not merged with) the seven traditional Arts, Gentileschi joined his program to an ongoing continental debate about the intellectual status of the visual arts. The issue had been resolved in Italy a century earlier, but it was still controversial in Spain and England, where the medieval guild system lingered longer, much to the regret of many artists who saw themselves as gentlemen and resented obligations owed to the craft guilds.[206] Neither the king, whose chief interest lay in peace propaganda, nor the intellectual liberal arts tradition represented by Francis Bacon, Inigo Jones, and Lord Arundel, which was more scientific than aesthetic in orientation, is likely to have prompted the innovative (for England) inclusion of the visual arts among the Liberal Arts.[207] The iconography of the corner roundels may thus have been suggested by the artists themselves: Orazio, who had his own grievances of professional status in England, or Artemisia, whose *Self-Portrait as the Allegory of Painting* was in England at the time. Given the decisive views on this subject that she undoubtedly held (see Chapter 6), it is difficult to imagine Artemisia being present while the program for the Greenwich ceiling developed without contributing to its bold assertion of the place of the visual arts among the Liberal Arts and Muses.

Artemisia's own hand has been discerned in the cycle by scholars, by Hess in the figure of Arithmetic in the central roundel, and by Bissell among the Muses in Urania, Euterpe, and (perhaps) Clio (Figs. 112, 108, 107).[208] Father and daughter had by this stage moved farther apart, and though both were subject to the classicizing drift of the period, by the late 1630s their independent works looked considerably different from each other. Artemisia's more ideal paintings of the 1630s—the *Clio* and the Madrid *Baptist*—alternated with pictures still shaped by Caravaggesque naturalism and by an abiding respect for physical matter, as the Pozzuoli *Adoration* attests. Not until the 1640s did generalization fully set in. Orazio's English works, on the other hand, are marked by a stiff staginess and expressive blandness, as in the *Finding of Moses* of 1633, and a self-conscious grand manner that was manifested also in a broadening and generalizing of drapery folds, as seen in the Hampton Court *Joseph* (c. 1632)

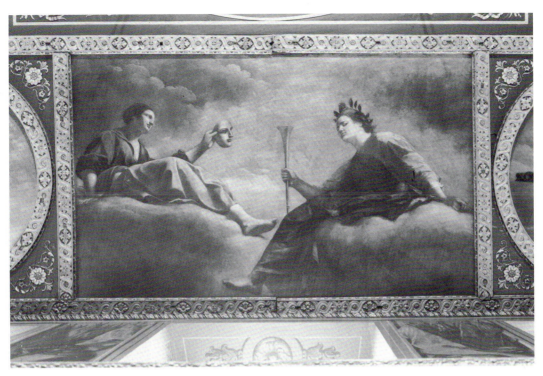

107. Orazio and Artemisia Gentileschi, *The Muses Clio and Thalia*, 1638–39. Side panel, ceiling, from Queen's House, Greenwich (now Marlborough House, London)

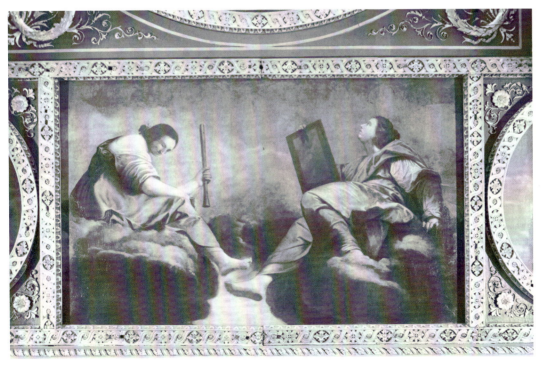

108. Orazio and Artemisia Gentileschi, *The Muses Euterpe and Polyhymnia*, 1638–39. Side panel, ceiling, from Queen's House, Greenwich (now Marlborough House, London)

and *Sibyl*—a trend begun as early as the Vienna *Magdalen* of 1625–28. These qualities, considerably exaggerated, are exhibited in most of the figures of the central roundel at Greenwich.[209] Quite different from these are three of the Muses: Clio, Polyhymnia, and Terpsichore (Figs. 107, 109, 111). Self-possessed and aware of their surroundings on an entirely more sophisticated level than their context warrants, these women sit and move heavily, slowly, thoughtfully. Their bodies, like the clouds on which they sit, are more solid, strongly modelled in light and shade, and defined by complex, diaphanous draperies. Such purposeful, ponderated movements and intricate lighting of cloth is found in Artemisia's Pozzuoli *Adoration*, just as the component of psychic presence is a constant in all of her earlier works—far more than in Orazio's *oeuvre*— and we may safely ascribe these three figures *in toto* to Artemisia herself.

Of the remaining Muses, several display broad, graceful poses that are intimately Orazian (Urania [Fig. 112] resembles his Potiphar's Wife; Erato [Fig. 110] recalls the

109. Artemisia Gentileschi, *The Muse Polyhymnia*, 1638–39. Detail of side panel, ceiling, from Queen's House, Greenwich (now Marlborough House, London)

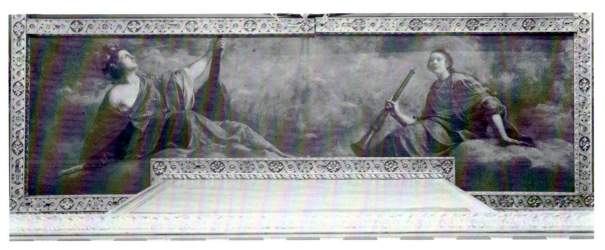

110. Orazio and Artemisia Gentileschi, *The Muses Erato and Terpsichore*, 1638–39. Side panel, ceiling, from Queen's House, Greenwich (now Marlborough House, London)

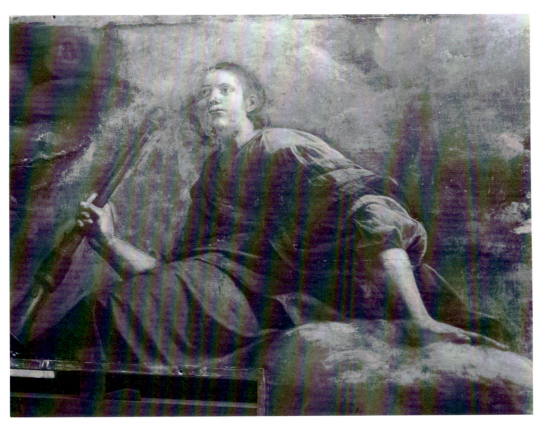

111. Artemisia Gentileschi, *The Muse Terpsichore*, 1638–39. Detail of side panel, ceiling, from Queen's House, Greenwich (now Marlborough House, London)

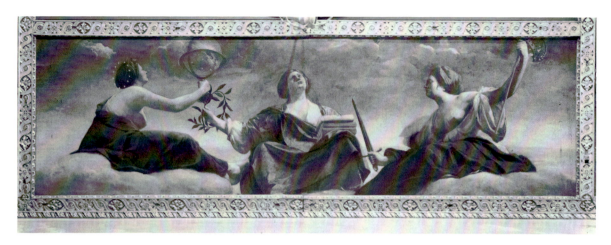

112. Orazio and Artemisia Gentileschi, *The Muses Urania, Calliope and Melpomene*, 1638–39.
Side panel, ceiling, from Queen's House, Greenwich (now Marlborough House, London)

Hampton Court *Sibyl*), but the sharp precision of their drapery and lighting, as well as the anatomical accuracy of their breasts, suggests the hand of Artemisia. It is likely, therefore, that these figures were painted or completed by Artemisia following her father's death, perhaps after his designs. Among the Muses, only Calliope, Thalia, and (perhaps) Euterpe appear to have been executed by Orazio (Figs. 112, 107, 108). The corner roundels present yet another stylistic effect: the figures' busy activity connects them with the naturalistic credibility of the Muses, but they are descriptively more generalized and, sitting lightly on the clouds, they function fully in the allegorical mode, like the figures of the central roundel. The Pittura and Scultura (Figs. 113, 114) suggest Artemisia slightly more than the other two, which are by another hand altogether. We should not exclude the possibility that Francesco Gentileschi, who was in London at this time, or Artemisia's unmarried daughter, trained as an artist, might have taken part in finishing the project.[210] But the four corner figures especially are heavily overpainted, and their expression is probably strongly affected by an eighteenth-century overlay.

By the end of 1639, the Greenwich panels presumably completed, Artemisia began to explore new prospects of patronage in Italy. In December 1639, she wrote a letter to Duke Francesco d'Este, her patron in Modena whom she had planned to visit on her way to England (Appendix A, no. 15a), sending him a painting with her brother, and hinting broadly that she would rather work for him than for the King and Queen of England. There is no evidence that this offer brought results, but Artemisia undoubtedly left England soon after in any event, for her hosts' lavish support was coming to an end as the political crisis deepened. By 1642, fighting had broken out between the royalist Cavaliers and the Puritan Roundheads, precipitating the civil wars that dominated the rest of the decade, ending in the establishment of the Com-

113. Gentileschi family(?), *Pittura*, 1638–39.
Corner roundel, ceiling, from Queen's House, Greenwich
(now Marlborough House, London)

114. Gentileschi family(?), *Scultura*, 1638–39.
Corner roundel, ceiling, from Queen's House, Greenwich
(now Marlborough House, London)

monwealth and in the beheading of Charles I in 1649. According to Baldinucci's contemporary report, Artemisia was said to be working in Naples in 1642,[211] and it is probable that in 1640–41 the artist returned to the city that had earlier displeased her, but where she would spend the final decade of her life.

## NAPLES, 1642–1652

The first known painting of the final Neapolitan period is the *Bathsheba* now in Columbus, Ohio (Fig. 115 and Color Plate 23), a painting described by De Dominici as having hung with a pendant Susanna in the home of Dottore Luigi Romeo, Baron of S. Luigi.[212] The painting's traditional date in the early 1640s is probably accurate, since its idealized figure types and aristocratic architectural setting are consistent with the Capodimonte *Lucretia*. At the same time, the *Bathsheba*'s measured composition and motifs such as the kneeling woman with basin connect it with the *Birth of the Baptist* of the early 1630s, an indication that both idiosyncratic motifs and classicizing nods recurred in varying combinations in Artemisia's *oeuvre* of the final two decades. The *Bathsheba* is continuous with works of the 1630s in another respect, for, according to De Dominici, the background architecture of the picture was painted by Viviano Codazzi (who had painted the architecture of Artemisia's *St. Januarius*), while the background landscape was painted by Domenico Gargiolo.[213] In the *Bathsheba*, both

115. Artemisia Gentileschi, *David and Bathsheba*, early 1640s.
Columbus, Ohio, Museum of Art

landscape and architecture are strongly subordinated to the quiet drama occurring on the front plane, yet in the very inclusion of such elements, especially landscape, Artemisia acceded to a growing contemporary taste. In a letter to Cassiano dal Pozzo of 1637 (Appendix A, no. 14), she stressed the inclusion of a deep landscape setting in a painting she was sending him, and while the landscape was perhaps not by her hand, later correspondence suggests that she eventually painted her own landscape backgrounds (no. 22).

Two new Gentileschi attributions datable in the 1640s point the way to a complete redefinition of the last decade of the artist's career. The first of these is a large

and important painting, *Lot and His Daughters* (Fig. 116 and Color Plate 24), that has long borne an attribution to Bernardo Cavallino. When the picture was included in a major Cavallino exhibition of 1984, a catalogue entry included the suggestion that Gentileschi and not Cavallino may have been its author.[214] This plausible proposal can be supported by the painting's stylistic and expressive affinity with Artemisia's *oeuvre*, and also by the likelihood that it is identical with the lost Gentileschi *Lot and His Daughters* described by De Dominici in the collection of the Dr. Romeo who owned the Columbus *Bathsheba*.[215]

In style, the Toledo *Lot* is connected with Artemisia by its delicate, diaphanous folds of cloth, by its subtle color harmonies (the play of salmon pink and pale brown seen in the lower bodies of the two left figures recalls the Naples *Lucretia*), and by an angular diagonality of limbs that creates both formal and psychic tension. These features find few correspondences in the *oeuvre* of Cavallino, which is distinguished on the whole by more graceful and stylized poses; broader, fuller, and more opaque draperies; and a thicker and more painterly brushstroke.[216] The female figures are close reprises of Artemisia's women: the daughter on the left, with rolled sleeve and hair pulled into a bun, resembles the kneeling servant in the Columbus *Bathsheba*, while the daughter on the right echoes the pose of *Bathsheba* herself in the same picture, even as her sharp profile and auburn hair recall the kneeling woman in the *Baptism of St. John*. In the figure of Lot, we see an exposed knee—a familiar Artemisian motif for male characters such as Joseph and Ahasuerus—and also a kind of stiffness, a lack of full expressive definition, that frequently is seen in her male figures. In this painting, as in other Gentileschi compositions involving female and male characters, Lot is central without being dominant; he is here strongly subordinated to his daughters, in light and color, as well as in size. By contrast with the expressive tone of other *Lot*s by Cavallino (e.g., Fig. 117), the women in this painting are not seductresses, and the mood is not ribald.[217] The monumental figures of the women, who flank Lot like giant parentheses, guide their father solemnly toward the necessary acts of incest in order that their people may continue (Lot's wife having perished as a pillar of salt). The heroic expressive tone thus established differs not only from Cavallino's *Lot*s, but from typical depictions of the theme, which often emphasize the bizarre erotic aspects of the story. As we have seen and will see again, Artemisia Gentileschi's accentuation of the female rather than male characters was highly unusual in her culture, and may be taken as a fairly reliable indicator of her artistic presence.

A number of writers have noted Artemisia's influence upon Cavallino (1616–c. 1656), a painter who most likely emerged from Stanzione's workshop but quickly absorbed stylistic lessons from a wide variety of artists. De Dominici tells us that Bernardo studied Artemisia closely and tried to imitate the delicacy of her color.[218] Strangely enough, the justification of influence has sufficed to explain the Gentileschian qualities visible in works ascribed to Cavallino. A painting situated in Cavallino's *oeuvre*, now recognized as a *Triumph of Galatea* (formerly known as *Amphitrite*;

116. Artemisia Gentileschi (here attributed), *Lot and His Daughters*, 1640s(?).
The Toledo, Ohio, Museum of Art

Fig. 118), is dominated by a central nude figure who strongly recalls Artemisia's works of the 1630s and 1640s—the Columbus *Bathsheba*, the Naples *Lucretia*, and the Virgin of the *Adoration*—even as the image of Galatea seated on a shell drawn by dolphins and surrounded by tritons has suggested to more than one writer Artemisia's lost *Galatea* of 1648–49 painted for Don Antonio Ruffo.[219] As Ann T. Lurie has pointed out, the spiky crab shell (*grancio*) substituted here for the more usual scallop shell corresponds to the *grancio* named in the inventory description of Artemisia's *Galatea*.[220] The relationship has generally been taken to exemplify Gentileschi's influence upon her Neapolitan contemporary.

117. Bernardo Cavallino, *Lot and His Daughters*, c. 1650. Collection of the Fellowship of Friends at the Goethe Academy Museum, Renaissance, Calif.

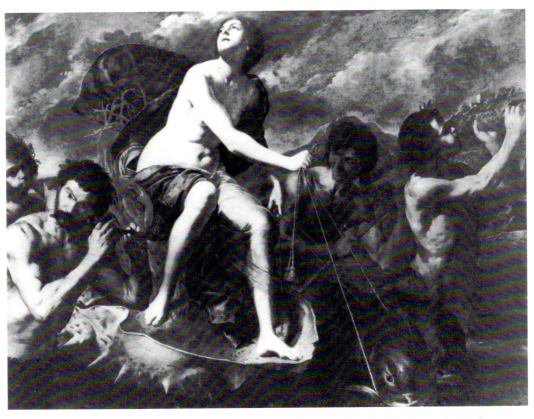

118. Artemisia Gentileschi and Bernardo Cavallino (here attributed), *The Triumph of Galatea*, c. 1645–50. New York, private collection

Quite recently, however, Józef Grabski has proposed that the *Triumph of Galatea* might be identical with the lost painting produced by Artemisia for her Sicilian patron Ruffo, but as a work painted in collaboration with Cavallino in Naples. He suggests that if the painting, whose dimensions are smaller than Ruffo's *Galatea*, had been cut down at a later time, a fifth triton might have been eliminated on the left side, which would make the work correspond exactly to the description in the Ruffo inventories.[221] Grabski argues convincingly that the painting's present design is curiously cramped and unbalanced, and that its extension, particularly on the left and at the top, bringing it to the designated proportions, would establish a more harmonious composition, and one more clearly related to a work earlier named by Lurie as its prototype—Raphael's *Galatea* in the Farnesina in Rome (Fig. 119).[222]

Grabski's suggestion that Artemisia painted the central female figure (and probably, I would add, the dolphins, crab shell, and its cargo of coral), while Cavallino executed the five male tritons, is supported not only by De Dominici's pertinent remarks on Cavallino's poverty in this period, which reduced him to the need to do work for one artist or another,[223] but also by Artemisia's need to deliver a number of large paintings in short time (see especially Appendix A, nos. 19, 20). More signifi-

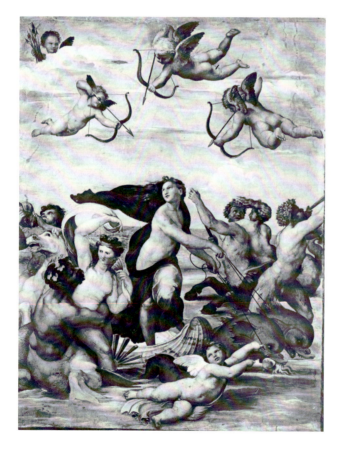

119. Raphael, *The Triumph of Galatea*, c. 1512. Rome, Villa Farnesina.

cantly, the proposal is supported by visual evidence. The solid, compact figure of Galatea, with a rounded upturned and foreshortened head, marked by a prominent, high-bridged nose and graced by a single pearl earring, is surely the sister of Lot's daughter on the right of the Toledo painting, even as the distinctively formed gold tassel near Galatea's right calf is the same as that seen in the London *Cleopatra* and the Princeton *Sleeping Venus* (Figs. 98 and 101).[224] Such recurrences, literally of studio apparatus, yet also signifying an artist's conceptual preferences, help mutually to support all the new attributions to Artemisia—the *Cleopatra, Venus, Lot*, and *Galatea*— and it remains significant that no such figure or form types are found in the presently known works of Bernardo Cavallino. Nor does the slow and dignified turn of Galatea in space resemble individual female figures in Cavallino's *oeuvre*, the latter's movements being generally more sprightly and stylized, almost puppet-like. This distinction, in fact, is visible in the *Triumph of Galatea* as a whole, for the jaunty, playful tritons, painterly but unplastic, are of a separate pictorial world and language from the weighty figure in sharp, bright chiaroscuro who sits among and yet apart from them.

But if the *Triumph of Galatea* was a product of collaboration between Gentileschi and Cavallino, was the painting, then, identical with the picture ordered from Artemisia by Don Antonio Ruffo in 1649? The evidence is less clear on this important point. Although the peculiar composition of the *Galatea* has led some observers to believe that it must have been cut down in size and proportions, others have argued, based on examination of the picture's edges, that it cannot have been cut down and that we see the original composition.[225] If the latter position is correct, then the painting is probably not the same work received by Ruffo by January 30, 1649 (Appendix A, no. 16). However, Artemisia was asked to paint at least one more Galatea for another (unnamed) patron following Ruffo's receipt of her picture (no. 25), and though she hastened to assure Ruffo, who acted as intermediary, that the next version would be different in invention, she may well have painted a smaller replica or variant—this time assisted by Cavallino—perhaps with fewer tritons, but with the distinctive *grancio* repeated. Indeed, the tone of her letter (no. 25) suggests that Artemisia was accustomed to supplying variations on her themes to different patrons. Thus we may safely conclude, on a visual basis, that the central figure in the surviving *Triumph of Galatea* is by Artemisia's hand, and that if this picture is not Ruffo's *Galatea*, it is at least a product of the late 1640s, toward the end of the artist's life, a period to which the Toledo *Lot and His Daughters* should also be assigned.

The last period of Artemisia Gentileschi's artistic career was dominated, and is almost exclusively documented, by her relationship with her new patron, Don Antonio Ruffo of Sicily. Ruffo, a major figure in seventeenth-century patronage, acquired for his collection in Messina important paintings by Italian artists such as Ribera, Guercino, Mattia Preti, and, with special prescience, by Rembrandt, at a time when the Dutch painter's reputation was in a decline in his own country. Ruffo began

to collect works by contemporary artists sometime before 1649, at which time he owned 166 paintings, and it is noteworthy that Artemisia was among the first artists he collected, along with Ribera, Van Dyck, Reni, and Poussin. Her correspondence with the Sicilian nobleman began in early 1649, by which time she had already sent him the *Galatea*. Between January 1649 and August 1650, she sent him at least two more paintings, and her final preserved letter to Ruffo of 1650 acknowledges a request for yet more pictures.[226] In 1652—the probable year of Artemisia's death—Ruffo initiated his commissions from Rembrandt, beginning with the now-famous *Aristotle Contemplating the Bust of Homer* (delivered in 1653), followed by orders for companion pictures from Guercino and Mattia Preti (1660), and for two more ideal portraits from Rembrandt.[227]

Artemisia's pictures for Ruffo also included a *Bath of Diana, with Five Nymphs, Actaeon and Two Dogs*, now lost, which was delivered in the spring of 1650. The *Diana* may have been planned as a pendant to the *Galatea*, given their identical dimensions and the corresponding numbers of figures between them.[228] Two large half-finished paintings described by Artemisia in her final letter to Ruffo of January 1, 1651, an *Andromeda Liberated by Perseus* and a *Joseph and Potiphar's Wife*, were never delivered. Other works promised to her patron, but likewise never received, were a small Madonna and a self-portrait.[229] The correspondence with Ruffo also offers evidence of work for other Neapolitan patrons, such as Alfonso d'Avalos, Marchese of Vasto (or Guasto; Appendix A, no. 23); Don Fabrizio Ruffo, prior of Bagnara (a nephew of Don Antonio—see Appendix A, no. 24), who got three or more paintings (no. 18); the Bishop of St. Agata dei Goti, who got a drawing of Souls in Purgatory (and, insultingly, commissioned another artist to paint the picture from Artemisia's drawing); and the unnamed gentleman who wanted a Galatea and also a Judgment of Paris (no. 25). Artemisia's comment (no. 25) on the drawing of Souls in Purgatory holds additional interest, since no drawings by or ascribed to the painter are presently known. Implicitly, her drawings were chiaroscural and of fundamental importance for the pictorial conception, whose essence, she says, lay in the "inventione," the creation of planes through lights and darks, which was first established in the drawing. It is a telling sign of Gentileschi's artistic stature that her drawings were valued in the seventeenth century as models of compositional invention, and the possibility that some of them still survive in graphic art collections remains to be explored.

Bathsheba was another subject repeated by Artemisia in the 1640s (an earlier version was owned by Charles I; see above, p. 112), and we may speculate that, as with the *Galatea*, the success of Dr. Romeo's *Bathsheba* led to requests for variants by several different patrons. Four existing *Bathshebas* have been assigned to Artemisia's last years, works that are related in design, but which complicate the definition of her late style. One of these, a painting in Leipzig (Fig. 120), is still close to the Columbus version in its style, its decorous expression, and in the elements of setting.[230] Yet the simpler, more active composition and the easy, richly allusive classicism—seen in the

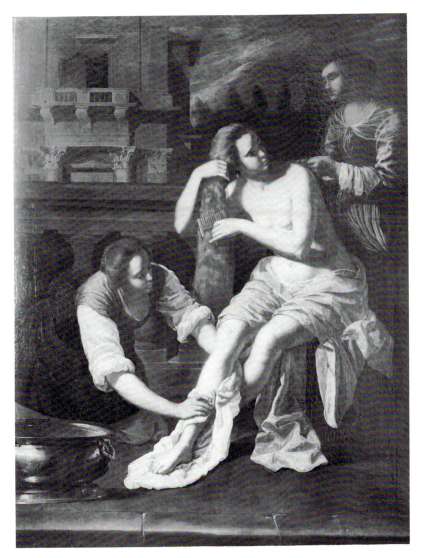

120. Artemisia Gentileschi, *Bathsheba*, early 1640s.
Leipzig, Museum der bildenden Künste

choice of Corinthian rather than Doric capitals, and in the echo of the antique Venus
Anadyomene in Bathsheba's pose—may indicate a dating earlier than Dr. Romeo's
version in Columbus (as Harris suggested), when Artemisia's memories of classical
and classicizing art in the English royal collections were still strong. A second varia-
tion on the theme is found in a painting formerly in Bari (Fig. 121),[231] which presents
an image formally more concentrated than the Columbus version, but expressively
less intense. Here the heroine is introduced as a fully nude, decoratively graceful but
affectedly refined figure, whose overtly sensual body now replaces both biblical nar-
rative and pictorial luxury at center stage.

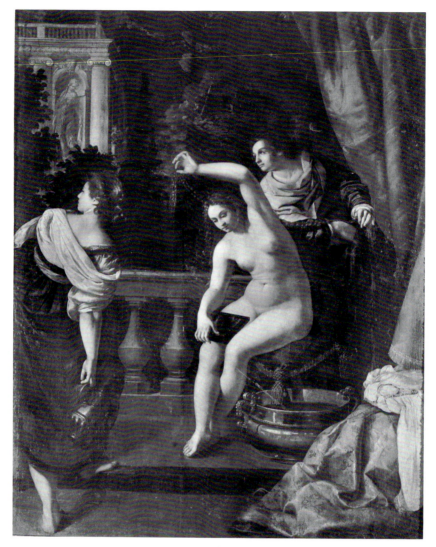

121. Artemisia Gentileschi(?), *Bathsheba*, mid-1640s. Formerly Bari,
Castello di Conversano, Ramunni Collection

The ex-Bari picture is compositionally connected with a *Bathsheba* in Potsdam
(Fig. 122), with which it shares a heightened emphasis upon decorative beauty, as well
as a prominent quotation of an Orazio Gentileschi figure type in the servant on the
left seen from the back.[232] The Potsdam version, in turn, is a close variant of a severely
damaged *Bathsheba* in storage in Florence, which was the model for a tapestry woven
in Florence in 1663 (Figs. 123, 124).[233] No documents support the ascription of these
*Bathsheba*s to Artemisia, yet a formal connecting thread links the pictures with each
other and with the artist. The Florentine *Bathsheba* (Fig. 123), moreover, is circum-

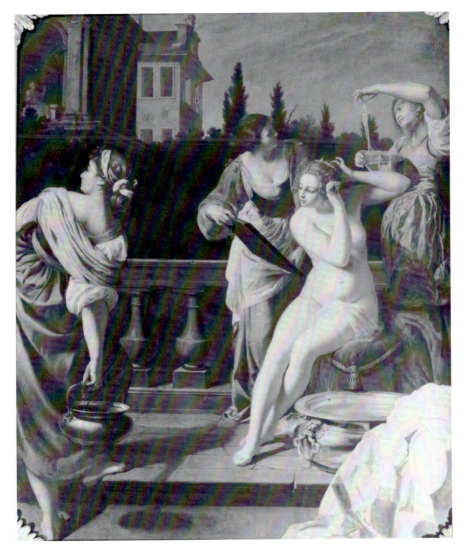

122. Artemisia Gentileschi(?), *Bathsheba*, late 1640s.
Potsdam, Neues Palais

stantially connected with Artemisia's last known painting, a signed and dated *Susanna* of 1652 at Brünn. Because the Brünn picture could be identical with the *Susanna* that belonged to Averardo de' Medici, it is possible that the latter two paintings were included in a shipment to Florence of 1652, and thus that they represent Artemisia's style at the very end of her life.[234]

To complicate matters further, the Potsdam *Bathsheba* was at one time a companion piece to two other pictures in the Palazzo del Giardino of the Farnese in Parma: a *Judith with Her Maidservant* (now Naples, Capodimonte, Fig. 125), and a *Tarquin*

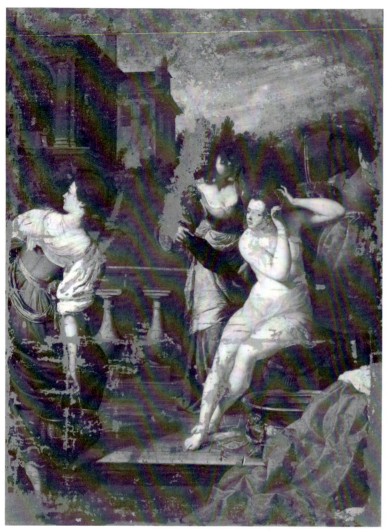

123. Artemisia Gentileschi(?), *Bathsheba*, c. 1652. Florence, Uffizi

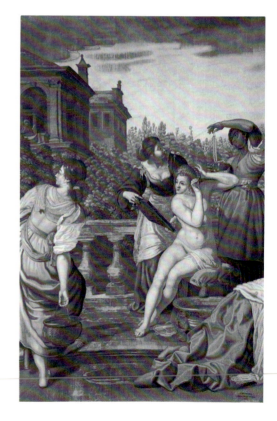

124. P. Fevere, *Bathsheba*, tapestry after Artemisia Gentileschi, 1663. Florence, Uffizi

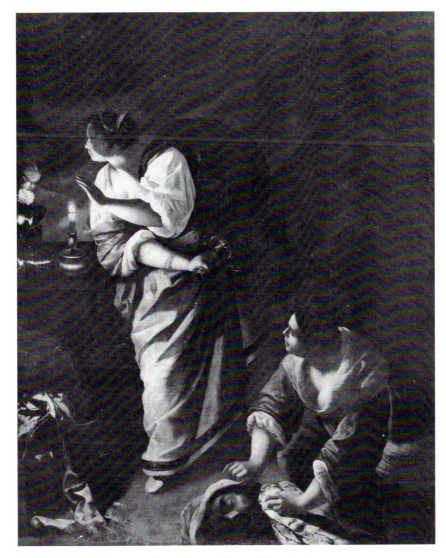

125. Artemisia Gentileschi(?), *Judith and Her Maidservant*, late 1640s.
Naples, Museo di Capodimonte

*and Lucretia*, also in Potsdam (Fig. 126)—all three pictures bearing a seventeenth-century attribution to Artemisia.[235] The first of these is a variant of the Detroit *Judith*, but vastly different in style and expression. The huge canvas is grossly inflated in more than sheer size; the puffy, weightless figures with their grotesque faces and empty gestures are almost parodies of the heroic, purposeful characters of the Detroit version. The display of stylish flesh in the *Tarquin and Lucretia* and *Bathsheba*, and the rhetorical bombast of the *Tarquin*, are merely embarrassing when judged by the standards of the Pommersfelden *Susanna* and the Genoese *Lucretia*. The Potsdam

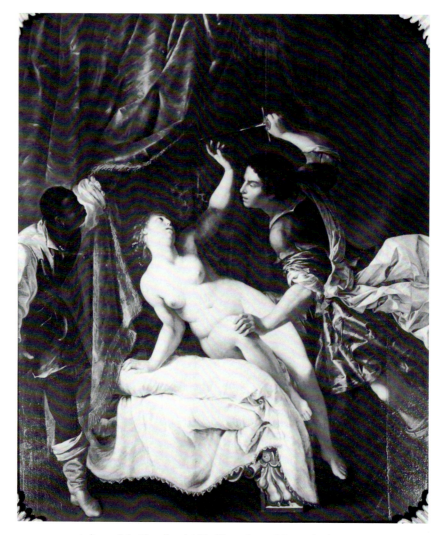

126. Artemisia Gentileschi(?), *Tarquin and Lucretia*, late 1640s.
Potsdam, Neues Palais

*Bathsheba* is somewhat less crude in style, but its expressive emptiness may be measured in its difference from the Columbus version. If indeed this last group of paintings is by Artemisia's own hand—the three *Bathshebas, Tarquin and Lucretia, Judith,* and the Brünn *Susanna*—then we are faced with a late style as strange and incomprehensible as that of Leonardo da Vinci. On the other hand, there is good reason to question the authenticity of the late works, and to suggest that an assistant, perhaps even Artemisia's own daughter, was responsible for these as workshop paintings. Future scholarship may resolve the problem of the late paintings, yet we can presently say at least

that the newly attributed *Galatea* and *Lot and His Daughters* have helped to push the problematic pictures to the very end, and periphery, of Gentileschi's final period.

ARTEMISIA's letters to Ruffo confirm what the proliferation of late paintings suggests, that near the end of her life, she was a highly celebrated artist, whose paintings were regarded by collectors as comparable in interest and value to those of other major artists of the day.[236] The letters also form the single most valuable surviving body of evidence of her artistic personality and practice. In striking contrast with the uncertainty of her early professional situation, when she had to improvise ways to get her patrons to pay her, the mature Gentileschi's established business practice and assured handling of her clients is graphically conveyed in the letters to Ruffo. She insists upon getting the price she has set, and asks for a deposit as well. She has learned not to quote a price before a painting is finished, and, having once been swindled, she does not send drawings in advance. The glimpse of studio practice afforded by the letters is refreshingly pragmatic. Artemisia complains of the high cost of models, and the need to examine numerous candidates, because "out of the fifty women who undress themselves, there is scarcely one good one," and moreover, in a painting with eight figures, one needs more than one model, to "paint various kinds of beauty" (Appendix A, no. 19). Her remark is a distinct echo of an aesthetic credo widely popularized in the Renaissance, that of the Greek painter Zeuxis, whose image of the ideal Helen was drawn from several beautiful models. The theoretical difference between Artemisia's approach and that of post-Renaissance exponents of Zeuxis's method (notably, Raphael and Annibale Carracci) is that her intended result is not a single composite image of *bellezza*, but a collection of distinct individuals who demonstrate several varieties of beauty.[237]

Under Artemisia's arrangement with Ruffo, the price of the painting was determined by the number of figures depicted,[238] a system that indirectly acknowledges what Artemisia implied—that connoisseurs valued in particular the samples of human beauty presented in the figures depicted, and paid accordingly. This method of valuation also explains Artemisia's willingness to capitalize upon her skill in rendering beautiful images of female nudes (based upon a selection of models perhaps uniquely available to her as a woman artist), as well as her choice of such themes as the Bath of Diana, which involved Diana, Actaeon and five nymphs (and two dogs, regarded by Artemisia as better than the figures). The Judgment of Paris (painted for a friend of Ruffo; Appendix A, no. 25) would have called for three prime examples of female beauty, while the Bathsheba theme required a central female nude and several maidservants. Thus one of the pressures affecting Artemisia's shift of style in her late years may have been economic: in order to obtain adequate payment for her work—a constant concern reflected in her letters—the artist was obliged to serve the tastes of male patrons who wanted, evidently from this woman artist in particular, beautiful and luxurious female images that were quite different from the powerful heroines who

distinguish her earlier career—now Bathshebas, not Judiths. Certainly earlier patrons such as Pietro Gentile of Genoa may have made similar demands, yet the *Cleopatra* and *Lucretia*, also nudes, offer not only eccentric samples of female beauty, but an exceptional personal reshaping of a traditional theme.

However, Artemisia's letters also reveal the artist's awareness of her patrons' tastes as distinct from her own. She speaks of producing a painting for Ruffo that will conform both "to my taste and yours" (Appendix A, no. 24); in another letter she speaks of having done three works for Ruffo's nephew, the prior, that were very much to his taste (no. 18). Implied in this is a sense of personal style, an awareness of alternative preferences, and the need to give a patron what he wants. Implicit as well in the Ruffo correspondence is Artemisia's insistence on qualitative standards. She explains (no. 20) that a picture will not be ready as soon as her patron wants it: "I work as continuously, and as fast as I can, but not so [fast] as to jeopardize the perfection of the painting." It would be interesting to know by what standard she judged the perfection of her own work—was it technical, formal, or expressive? Was it indeed possible that Artemisia's personal standards were fully satisfied by the pictures she sold to men like Ruffo and the prior?

Artemisia's own letters display an ambivalent attitude toward herself as a woman artist in a masculine art world. She proceeds from an assumption that women are taken less seriously than men: "If I were a man, I cannot imagine it would have turned out this way" (no. 25). Yet in another letter (no. 17), she uses playful self-deprecation to disarm her patron, even as she asserts pride in her work, to remind him that, as an artist, she is an exception to her sex: "I shall not bore you any longer with this womanly chatter. The works will speak for themselves." *I am a mere woman*, she says, but my *works* partake of sex-blind universality. Moreover, since professional limitations have made it difficult for a woman to compete successfully with men, the handicap of femininity becomes a spur to achievement and an ultimate source of self-esteem. "You will find the spirit (*animo*) of Caesar in this soul (*anima*) of a woman," Artemisia proudly proclaims (no. 24), her play on the words *animo* and *anima* underlining the gender difference that makes her claim distinctive. It must remain an open question whether she had any rapport with other women artists of her time—she could perhaps have known Sofonisba Anguissola in Genoa, Lavinia Fontana and possibly Fede Galizia in her early years in Rome, and certainly Giovanna Garzoni in her second Roman period and in Naples.[239] No evidence is readily available to document the attitudes of these women toward each other. We may venture to guess, however, drawing on twentieth-century insight, that each may have enjoyed the status of "token female," and may not have been anxious to cultivate associations with other women artists that would have only reinforced her image as a member of the exotic female sub-class.

As she grew older, Artemisia's work became more graceful and "feminine," and while this was to some extent part of the general shift in taste and sensibility, it must also have resulted from the artist becoming more and more self-consciously a woman

painter. Her transformation from artist to woman artist would have been aided by both her successes and her failures in the tough competitive world in which she lived—the successes encouraging her to draw upon her strong suit, and her failures prompting a comforting retreat into the convenient (but also real) handicap of gender. It would also, of course, have been in the interest of every male artist and patron in the orbit of that ferocious and threatening prodigy, who launched her career under the mantles of Michelangelo and Caravaggio, to encourage her to be merely a woman artist.

IF DURING her lifetime Artemisia infused her art with the spirit of a masculine Caesar that must have prompted many a male peer to the observation that "she paints like a man," in death she was reclaimed to stereotypical femininity. Shortly after Gentileschi died, two satirical epitaphs were published in Venice, the date of whose publication, 1653, is our sole notice of her death. They are shockingly irreverent, and worse, they define the artist in exclusively sexual terms, as cuckolder of her husband and as temptress, reducing her extraordinary artistic life to a threadbare type of conventional misogyny, worked around standard *vanitas* conceits.

> By painting one likeness after another,
> I earned no end of merit in the world;
> While, to carve two horns upon my husband's head,
> I put down the brush and took a chisel instead.

> Heartseize Gentlewoo-men was I ever to anyone
> Who was able to see me in the unseeing world;
> But now that hid beneath these marble slabs I lie,
> Allure turns to bait and Gentlywormeaten am I.[240]

That two men should be prompted to compose so mean-spirited a comment on a recently deceased artist was perhaps because of rather than in spite of Artemisia's worldly success, a success that was atypical for her sex. Satiric irreverence is often reserved for celebrities whose fame is begrudged by the less successful, a dynamic that may well extend to gender jealousy. Yet it is especially unfortunate that *only* these pathetic lines should survive to commemorate Artemisia Gentileschi, who was the first documented woman in Western history to fulfill our concept of artistic genius. Scurrilous epigrams may have been composed about Raphael or Caravaggio, but their tomb slabs soberly preserve the legend:

> Here lies Raphael, in whose lifetime
> The great Mother of things feared to be outdone,
> And at his death, feared to die.

> Michelangelo Merisi, son of Firmo of Caravaggio—in painting not equal to a painter, but to nature itself—died in Port'Ercole—betaking himself hither

from Naples—returning to Rome—15th calend of August—In the year of
our Lord 1610—He lived thirty-six years, nine months and twenty days—
Marzio Milesi, Juriconsult—dedicated this to a friend of extraordinary
genius.[241]

Our respect for and beliefs about "great" artists are shaped, subtly or otherwise, by
such honorific commemorations, which are repeated and enlarged upon over centu-
ries. Homer and Phidias have grown taller and taller with time; Raphael and Cara-
vaggio approach universal fame already. By contrast, Artemisia Gentileschi's own
grave slab, simply inscribed "HEIC ARTIMISIA," was lost in the restoration of an ig-
noble Neapolitan church.[242] Her reputation lived on in the grotesque distortions of
the Venetian epitaphs, which were translated into Latin, Spanish, and French and
reprinted many times, fueling the legend that has proved more durable than reality—
of Artemisia the love-goddess who happened also to paint.[243]

Of Gentileschi's extraordinary creative life, little was written. Only some thirty-
four paintings and twenty-eight of her letters remain to speak the truth. But while the
letters suggest a pride in honorary masculinity and in personal triumph over gender
handicap, the paintings tell of something else. Within a vigorous style that is not
susceptible to gender stereotyping, Artemisia Gentileschi conveyed an intense generic
identification with women, whose subterranean struggles against men's dominance
are given lucid visual form. In Gentileschi's paintings, women are convincing protag-
onists and courageous heroes, perhaps for the first time in art, and it is this extraor-
dinary accomplishment that is the principal subject of the present study. The proper
historical context for *that* perspective is not the traditional artist's biography, but
rather the evolving history of feminism itself, women's awakening consciousness that
their status was not divinely ordained but man-made, and women's growing realiza-
tion that their presumed inferiority was debatable. It is to that context, the *Querelle
des Femmes* as it was called in the sixteenth and seventeenth centuries, that we must
now turn, in order to situate Artemisia Gentileschi fully in art history. For although
the framework of women's history is only beginning to be reconstructed by scholars,
it is a world to which her art also belongs.

PART II

# CHAPTER TWO

---

# Historical Feminism and Female Iconography

I should think that Nature sometimes errs when she
gives souls to mortals. That is, she gives to a woman
one that she thought she had given to a man.
—Boccaccio, *De Claris Mulieribus*

## HUMANISTS AND FEMINISTS

Artemisia Gentileschi has become something of a cult figure for twentieth-century
feminists, women artists in particular, who have recognized in her work a surprisingly
modern female assertiveness. Her admirers have sometimes been accused of project-
ing their own values and concerns onto an artist of an earlier age. Yet feminism is not
a uniquely modern phenomenon; it has a history. This is not to speak of the sexual
politics of male-female relationships, which have always been with us, but of an out-
spoken feminism—simply defined as a pro-female reaction to sexual inequity—that
can be documented at least since the Renaissance. We must now set forth that history,
to provide a context for Artemisia specifically as a *woman* artist, whose pictorial im-
agery dealt with themes that were the subjects of an especially heated debate during
her lifetime. It is the purpose of this chapter to demonstrate that, though Artemisia's
interpretation of these themes was extraordinary, she was not an isolated phenome-
non. As a woman, she inevitably participated in a world of ideas that bear directly on
her art, a fact that should no more surprise us or diminish her art for us than the
equivalent but blandly normative statement that an artist such as Michelangelo was
both extraordinary yet also of his time, a participant in a culture, some of whose values
and concerns he reflected in his art. Was Gentileschi aware of the arguments about
the woman question that deeply absorbed many of her contemporaries? Was the fem-
inist content of her work recognized by anyone in her day? With our present limited
knowledge, we cannot define fully how she interacted with her culture in these re-
spects, at least not with a precision analogous to Michelangelo's interest in Neopla-
tonic thought. But we know that she did not work in a vacuum, and it is reasonable
to infer that her creation of powerful female characters was supported by the climate
of her time, that the feminist and anti-feminist battles did not pass her by, and that

the important contribution she made to the feminist side of the question may not have gone entirely unrecognized in the seventeenth century.

NEW scholarship has begun to demonstrate dramatically that, contrary to assumptions all of us have held, there was, as the late historian Joan Kelly put it, "a 400-year-old tradition of women thinking about women and sexual politics in European society before the French Revolution."[1] Feminism may be said to date, not from 1900, but from about 1400, when Christine de Pizan first raised a literary voice on behalf of the intellectual and biological equality of women. The intellectual revolution set off by Christine—as great a revolution as those sparked by Copernicus, Darwin, or Marx—was sustained through the next three centuries, though quietly when compared to the more conspicuous and self-celebrated achievements of Renaissance men. Yet women's persistent articulation of the significance of their own different experience of the world resulted eventually in an altered definition of human values, and in a vision of civilization alternative to that conventional history described by Jane Austen as "the quarrels of popes and kings, with wars and pestilence in every page; the men so good for nothing, and hardly any women at all."[2] Now that contemporary historians have begun to reclaim the evidence for early historical feminism, a greatly enlarged picture of Renaissance history has begun to take shape, with contrapuntal and interwoven strands of masculine and feminine experience. Moreover, our nascent critical consciousness has begun to set into more complete perspective not only the economic and social fortunes of women in the world, but also men's and women's attitudes toward masculine and feminine in literature and art, and toward the heroic and so-called heroic male and female characters of the Western mythic imagination.

The literary debate that Christine de Pizan sparked, known as the *querelle des femmes*—the argument about women—became the vehicle for both early feminist theory and misogynist satire. Misogyny, as recent scholars have effectively demonstrated, has not been a monolithic constant in Western civilization, but instead a phenomenon that has fluctuated in response to social change and to specific feminist pressures upon male cultural spokesmen. Traditional misogyny, particularly virulent among the medieval clergy, had weakened in the late Middle Ages as women's social and legal status improved, and in the female-elevating context of courtly love and the cult of the Virgin.[3] But in Italy at least, an open and publicly misogynous outlook was renewed in the Early Renaissance with the revived promotion of family and traditional values, perhaps in reaction to the pro-feminist spirit of the later Middle Ages. In his treatise on the family, *Della Famiglia*, written in the 1430s, Leon Battista Alberti set out a delimited and subordinate role for women within the family that was to become the Renaissance conceptual norm. Observing that women are concerned with "little feminine trifles," but men with "high achievements," Alberti recommends to husbands that they leave all minor matters such as housekeeping to their wives, taking upon themselves "all manly and honorable concerns."[4]

Somewhat curious, in the light of this influential and representative viewpoint, is the fact that the first defenses of women's equality are to be found in the writings of Italian Renaissance humanists, who asserted that at least in theory, women are as capable as men, and who supported this proposition by pointing to famous heroic women in the past, the "women worthies." Close on the heels of the humanist defenses came the more overtly feminist expressions written by women, literary arguments that drew inspiration from the humanist treatises and were partly modelled upon them, but that differed from them in significant respects. Then came the misogynist reactions against the pro-feminist campaigns and against strong historical female figures such as Mary Tudor, Elizabeth I, and Marie de' Medici, which often took the form of literary satires. These positions were not sequential but synchronous: misogyny itself, a pro-female reaction to it, and a misogynist defense against feminism co-existed throughout the sixteenth and seventeenth centuries, and indeed the same basic debate, with arguments little changed, was sustained in the eighteenth, nineteenth, and twentieth centuries.

The *querelle des femmes* assumed a heated initial vigor, however, in the sixteenth and seventeenth centuries. The debate about women was reflected in the visual arts, for many of the images of women in paintings, prints, and sculpture are in fact responses to the continuing "woman question," especially those cycles devoted to "women worthies" (Fig. 127) and to the so-called "*femmes fortes*." These cycles largely

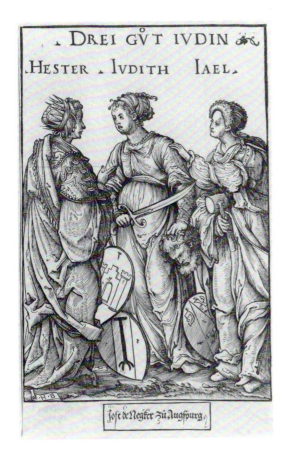

127. Hans Burghmair, *Esther, Judith, and Jael*, from a cycle of Nine Worthies, engraving, c. 1519. B. VII.219.67

extolled ancient female heroines (though not unambivalently, as we shall see), yet the misogynist side of the argument also found an outlet in numerous prints and illustrations that crudely ridiculed the same worthies, as we see in a seventeenth-century French engraving that shows Helen, Cleopatra, and Lucretia as comically frightful hags (Fig. 128).⁵ A closely related stream of imagery issued from the so-called "Power of Women" (*Weibermacht*) *topos*, in which the dangerous power of women over men was demonstrated in images of women beating men with distaffs, stealing their purses, or leading them by the neck. Usually annexed to legendary pairs such as Samson and Delilah, Aristotle and Phyllis (Fig. 129), or David and Bathsheba, the *Weibermacht* theme was especially popular in Northern Europe, where it appeared as early as the fourteenth century, reaching its zenith in the sixteenth century, in choirstall carvings, textiles and graphic arts, and other forms of popular imagery.⁶ Such images were more than passive reflections of the debate, for they participated significantly in the evolving dialogue. As vivid symbols of feminist or misogynist attitudes, they helped to shape opinion about the nature of woman, reinforcing negative biases or giving form—and thus force—to positive but inchoate new concepts. The dynamic interaction between visual images and changing social mores or values is a subject

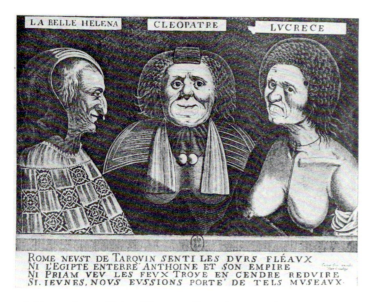

128. Gaspar Isaac, *Helen, Cleopatra, Lucretia*, engraving, seventeenth century, French

129. Hans Baldung Grien, *Aristotle and Phyllis*, woodcut, 1513. London, Trustees of the British Museum

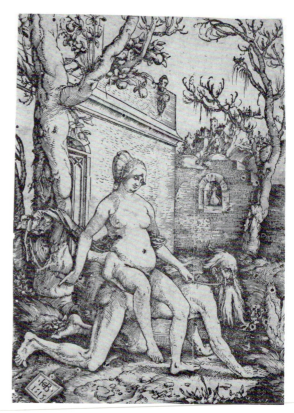

unto itself, however, and I must confine myself here to a brief sketch of the interplay between the intellectual dialogue about the nature of women and the "famous women" artistic cycles of the sixteenth and seventeenth centuries, in order to provide a historical context for Artemisia Gentileschi's unusual female imagery.

THE humanist defenses of women began with Boccaccio's *De claris mulieribus* (1361), the first example of a genre sustained for the next three centuries, in which exemplary women of history and myth were held forth to demonstrate the capabilities of women in the realm of public life and moral virtue. In a succession of brief biographies of famous women both pagan and Christian, Boccaccio argued from example that women had the capacity to read and study, to improve their minds and acquire humanist virtues, to rule and govern, and to lead troops in battle. Boccaccio assessed his women worthies according to specific categories of virtue and achievement: Semiramis, paragon of a wise and skillful ruler, who dressed in men's clothes (pretending to be her own son) and "with manly spirit" conquered Ethiopia and restored Babylon; Lucretia, whose suicide to preserve her reputation made her the arch-*exemplum* of chastity; Artemisia of Caria, who built a marvelous tomb for her husband Mausolus, a symbol of her legendary love for her spouse; Marcia, a Roman woman noted for her painting and sculpture; Sempronia, noted for her intellect and learning, and for the poetry that she wrote.[7] Boccaccio's vision of exceptionally capable females was echoed and expanded upon in the writings of successive humanists, e.g., Lionardo Bruni, who argued for the education of women;[8] Baldesar Castiglione, whose dialogues set at an ideal court of 1508 prominently advanced the intellectual and moral equality of women (though he did not admit them to the military realm);[9] Juan Luis Vives, who advocated education but not public life for women;[10] and Henry Cornelius Agrippa, who extended the argument to assert, not merely the equality, but the superiority of the female sex.[11]

The case advanced by the humanists, that there had been heroic and praiseworthy women in antiquity and in the Middle Ages, took visual as well as literary form. Several editions of Boccaccio's *De Claris Mulieribus* were accompanied by woodcut illustrations, such as we see in a folio produced in Augsburg in 1479 (Fig. 130).[12] The "women worthies" had been conceived as a coherent group even earlier, when there developed a female counterpart to cycles of nine male heroes, the "nine worthie, or *Neuf Preux*," and when both male and female worthies were systematized in fourteenth-century poetry, sculpture, and painting.[13] Typological groupings of women worthies frequently appeared in print series, for example that of Hans Burghmair of c. 1519, in which nine women—three good pagans, three good Jews, and three good Christians—are put forth as female counterparts to a comparable cycle of male heroes.[14] The paragons seen in Burghmair's cycle are characteristic of the genre: the Jews include Esther, Judith, and Jael (Fig. 127); the Christians, Helena, Brigetta, and Elizabeth; the pagans, Lucretia, Veturia, and Virginia. Perhaps stimulated by the

130. *Dido, Queen of Carthage, Supervising the Building of Her City,* woodcut illustration for edition of Giovanni Boccaccio, *Von den ehrlychten Frowen,* Anton Sorg, Augsburg, 1479

popularity of "women worthies" cycles, print cycles also appeared that were devoted exclusively to the life and deeds of one figure, for instance the story of Judith and Holofernes, which was illustrated in a set of etchings by Maarten van Heemskerck (Fig. 131).[15] The extended lives given biblical women like Judith and Esther in six-teenth-century prints parallel the cycles devoted to Old Testament male figures such as Abraham and Isaac. In the broadest sense, such cycles reflect an acceptance of the positive worth of certain legendary women, expressed through the heroic stature assigned to these exceptional historical and biblical figures.

In their acceptance of the principle of equality between the sexes, Renaissance humanists were remarkably progressive in their thinking. In *The Courtier,* Castiglione asserts through the voice of the dominant protagonist, Il Magnifico, what amounts

131. Maarten van Heemskerck, *Judith Cutting off Holofernes' Head,* plate 6 from series of 8, *Story of Judith and Holofernes,* etching, 1564. Hollstein, VIII, 272–279. New York, The Metropolitan Museum of Art

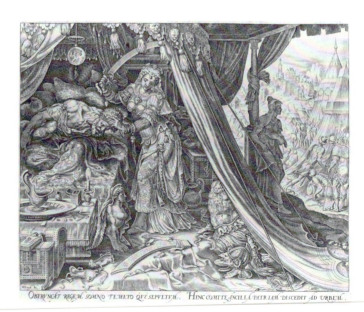

to a classic feminist case: "I say that women can understand all the things men can understand and that the intellect of a woman can penetrate wherever a man's can." To the proposition advanced by Gasparo that woman was an error on Nature's part, who would if she could produce only perfect males, the Magnifico responds that women "do not desire to be men in order to become more perfect, but in order to gain freedom and to escape that rule over them which man has arrogated to himself by his own authority."[16] The humanists advocated female capability in a climate largely dominated by Aristotelian views: that the female was an imperfect version of the male, that the active masculine principle was to be contrasted with the passive feminine (to such an extent that procreation was said to be an exclusively male achievement), and—a position virtually canonical in the Middle Ages and still widely held in the Renaissance—that women were morally inferior to men on account of their animalistic and diabolical lust. As late as 1713, an anatomist could still argue in print that the female was an imperfect male, because her body was colder, and her genitalia incomplete. And the idea persisted in medical literature of the seventeenth century that woman was not only irrational but sexually insatiable, because her womb was an animalistic organ.[17] Such ideas continued to be popularly and even scholastically maintained.[18] Merely to propose, as many of the humanists did, that a woman might rule a nation, or be equal to men in the eyes of God, was to challenge centuries of an entrenched misogyny that passed for philosophical and scientific truth.

Mindful of the heresy of their own views, the advocates of woman's worth adopted a characteristic humanist strategy, and appealed to alternative ancient authorities to support their position. They cited Plato's *Republic* and Plutarch's *Mulierum virtutes*, each of which presents an argument for sexual equality, against their opponents' appeal to the more overt misogyny of Aristotle, as found in the *Politics* and the (misattributed) *Economics*.[19] The debate between the misogynists and anti-misogynists was crystallized in Sir Thomas Elyot's *Defence of Good Women* (1540), in which the Platonic and Aristotelian views of women were contrasted in a dialogue: Candidus, the Platonic defender of women's ability to participate in civic life, debates with Caninius, the "barking Aristotelian detractor" (as Constance Jordan describes him), whom Candidus defeats not only by logical refutation but by adducing a living example of the worthy woman, the captive Queen Zenobia.[20] Thus in philosophical treatises as in visual imagery, the woman worthy was held forth as the proof that females were at least theoretically prepared to carry out masculine duties and noble deeds.

Yet because even the humanists were essentially patriarchal in their views on marriage and in their expectation of female chastity and of a domestic vocation for women, there was in their acclaim of exemplary women only moderate recognition of non-traditional womanly virtues. Lucretia and Susanna were models of the good wife who places her chastity and fidelity to her husband above all else.[21] Zenobia, too, was a dutiful wife who (like Judith) was conveniently cast as a widow, so that her civic

action would raise no conflict of duty as she demonstrated an ability to govern, make laws, and conquer territories. As Jordan points out, Zenobia was popular with humanists like Elyot, who made her the *exemplum* of his case for women, because of the delicate balance in her story between wifely obedience and autonomous action, and it is telling that even her informed independence of mind was ultimately valued as a service to her husband.[22] Other women worthies were perceived with much less subtlety. Despite her heroic public actions, Semiramis was classified at times among the lascivious and morally corrupt because she had allegedly had sexual relations with her own son.[23] Nearly all the female types adduced in the tradition of women worthies effectively conveyed the message that woman's worth depended upon her sexual virtue. At best she might be a spirited but obedient wife; at worst, she was a lewd temptress. In this sense, there was really only one type and one anti-type, since all the female characters, whether virginal martyrs or profligate queens, were inevitably marked by the stamp of sexuality—a sexuality defined by men.

In the *De Claris Mulieribus* of Jacobus Foresti (1493), the stereotyping of women is particularly evident, for here the same few woodcut illustrations are used over and over again to represent what were presumably for the author similar types of women worthies, though in fact there seems little consistent application of image to type. A woman with a spear and a lion-headed shield, for example, stood for such diverse characters as Penelope, Veturia, Manthone, Sofonisba, Porcia, and Helena Tyndari (Figs. 132 and 133).[24] In the *Galleria delle Donne Celebri* of Francesco Pona, published in Verona in 1633, the female characters are classified according to their level of moral virtue: four "*Lascive*," four "*Caste*," four "*Santi*."[25] The poet Giambattista Marino assembled an imaginary *Galleria* of portraits of famous people, in which the men were subdivided into some twenty-six categories: princes, captains, heroes, tyrants, popes, philosophers, doctors, mathematicians, poets, painters, and more. The women were grouped under seven headings: beautiful, chaste, magnanimous, unchaste, wicked, warlike, and virtuous.[26] Such groupings, though more rigid, continue the approach

132. *Veturia*, woodcut illustration for Boccaccio's *De Claris Mulieribus*, Jacobus Foresti, 1493

133. *Penelope*, woodcut illustration for Boccaccio's *De Claris Mulieribus*, Jacobus Foresti, 1493

taken by Boccaccio, who had included among his famous women many infamous characters such as Cleopatra and Dido—infamous not for their historic deeds, but for their reputed moral laxness and lascivious behavior.[27]

The issue of sexuality colored the identities of woman worthies in other ways. Boccaccio frequently described his famous women as "virile," observing in the case of Artemisia of Caria, "What can we think except that it was an error of nature to give female sex to a body which had been endowed by God with a magnificent virile spirit?"[28] Perhaps the prime example of the virile heroine was the character of Judith, whose heroic assassination of a tyrant was, more than the deeds of almost any other woman worthy, most violently masculine. Yet, as we shall see in Chapter 5, Judith was often interpreted by male artists and writers as a sinister and not altogether positive figure on account of her strength and power—and, not least, because of her murder of a man. She became, for many, the strong woman who is *too* manly, the virago.[29] The paradox of such "virile" women worthies is that they were ultimately tainted by that masculinity that defined them as exceptions to their sex, even as it legitimized them. Zenobia, on the other hand, was not perceived as a dangerous virago despite her masculine actions, perhaps because she did not actually kill any men—or, more likely, because she was a foreigner, and hence considered to be racially inferior to the men who were her political enemies. Like Semiramis, Dido, Camilla, and Artemisia, Zenobia was allowed to become a more interesting character by virtue of her stereotypical identity as the barbaric "other," like the "noble savage" in later Western thought.[30] Typically such characters were oriental or Eastern, and often they were juxtaposed with solid citizens of Western legend—Cleopatra with Caesar and Antony, Dido with Aeneas—pairings that carried sexual stereotyping to another metaphoric plane, as we shall examine below in Chapter 4. The point remains, however, that most women worthies were perceived by the humanists as honorary men, or else as females subordinated to a male, or to a cultural construct that provided an androcentric norm.

Some sixteenth-century writers sympathetic to the principle of equality between the sexes, yet sensitive to the problem of their obvious stereotypic differences, explored the possibility of separate forms of virtuous attainment for each sex. In his *Discorso della virtù feminile e donnesca* (1582), Torquato Tasso posed, in an imaginary debate between Plato and Aristotle, the question of whether men and women have the same kind of virtues, an issue that revived a difference of opinion among antique writers. Tasso built upon an Aristotelian distinction between intellectual virtue and affective virtue to argue that while it is desirable for each sex to practice both kinds of virtue, each sex has one dominant virtue—courage for men, chastity for women— whose absence is excusable in the opposite sex.[31] We modern heirs to the legal invalidation of a doctrine of "separate but equal" can recognize the inherently unequal status of the two spheres carved out by Tasso. Underlying the most rational of the humanist arguments was a continuing presumption of separately assigned realms for men and women, and it was not a primary concern of the male humanists to question

the existing social order. Writers like Boccaccio, Castiglione, and Elyot were moti-
vated largely by their recognition of the philosophical fallacies of the misogynist po-
sition, and by a humanist desire to cast the objective light of reason upon yet another
area of intellectual darkness. They focussed upon the exceptional women of myth and
history, the viragoes, to prove the case for the hypothetical capabilities of all women.
Yet their interest in the latter remained at the theoretical level. And even when they
recognized social injustice in the real world—as did Agrippa, when he wrote a de-
tailed description of woman's inferior legal position[32]—they did not press for change.

THE first feminist ideas propounded by women differ from the defenses written by
men in that they were direct reactions to experienced misogyny and to literary attacks
on women. And increasingly, the women were to focus, as men did not, upon the
wrongs of the social order. Christine de Pizan's first feminist works were written in
hot response (albeit a century later) to the misogynous thrust of the popular late me-
dieval *Roman de la Rose*.[33] In her *Livre de la Cité des Dames*, Christine proclaimed fe-
male capabilities in a format adapted from Boccaccio, but the tone, thrust, and pur-
pose of the book are entirely different because she herself was a woman (Fig. 134).
While Boccaccio could praise the intelligence, wit, diligence in study, and scholarly
knowledge of certain women of legend—Sappho, Sempronia, Proba, Pope Joan—
Christine complained in heartfelt outrage about women's historic and contemporary
lack of access to education.[34] Indeed, as feminist scholars have observed, it was the
humanists themselves who imposed practical limits upon the female education they
advocated in the abstract and praised in the worthies.[35] Since a humanist education

134. *Reason, Rectitude, and Justice Appear to Christine de Pizan;*
*Reason Helps Christine Build the City*, fol. 290 in
Christine de Pizan, *Livre de la Cité des Dames*, in her *Collected*
*Works*, Harley manuscript 4431. London, The British Library

was designed to fit a gentleman or a prince to social and public action, there was no real purpose in higher education for women, except for the rare few who actually governed. Not only Vives and Elyot but also Erasmus and Thomas More took up the humanist defense of women and argued for intellectual training for women, but on the specific grounds that this would make them better wives and mothers.[36] By contrast, Christine had earlier suggested that the value of education for women lay in the contributions they might make to general knowledge: "God has given [women] such beautiful minds to apply themselves, if they want to, in any of the fields where glorious and excellent men are active, which are neither more nor less accessible to them as compared to men if they wished to study them, and they can thereby acquire a lasting name, whose possession is fitting for most excellent men."[37]

The female feminists argued not only theoretically against misogyny but also pragmatically for social change, calling for women's participation in governance, in the military, and in the public world. Because they were less interested in theory for its own sake than in the removal of social restrictions that artificially constrained women, their arguments centered around existing injustices and masculine weaknesses, not around female paragons. Considering, for example, the question of whether a woman could govern France, the seventeenth-century French writer Marie de Gournay did not eulogize ancient queens, but pointed instead to the relatively recent and expedient creation of the Salic Law in France to exclude women from a political life they had previously and elsewhere shared.[38] Lucrezia Marinelli, writing in 1601 in Venice, analyzed the causes of misogyny in men (self-love, envy, lack of talent, and disdain born of sexual frustration), and produced a psychosexual analysis of Aristotle. Marinelli's treatise was called *La nobiltà et l'eccellenza delle donne, co' diffetti et mancamenti de gli Huomini* (Fig. 135), a title modelled on the earlier treatise of Cornelius Agrippa. Its subtitle alluding to the defects of men was a barbed reference to a recent misogynist Italian tract outlining the defects of women, Passi's *I donneschi diffetti*.[39] Marinelli, a woman of enormous learning and scholarship, passed over the various renowned female models that a scholar might adduce, to take dead aim at the heart of the matter: the alleged inferiority of women, she said, was due not to biological differences, but to historical conditions. It was men who had created and sustained a myth about women that enhanced their own authority. Not for lack of reason or judgment had women been kept from governing, but because "the men made the laws, and like tyrants, excluded the women from the courts."[40]

In a variation of Tasso's view, Marinelli acknowledged that there were diverse areas of male and female competence, but argued that conservationist female virtues, cultivated in woman's management of the household and nurturing of the family, were of equal or greater value than the active and acquisitory masculine virtues. In a slightly earlier treatise, Moderata Fonte had similarly defended the superior worth of the female contribution to the domestic realm—in effect validating Martha as well as Mary.[41] This defense took the form of a delightful dialogue among a group of female

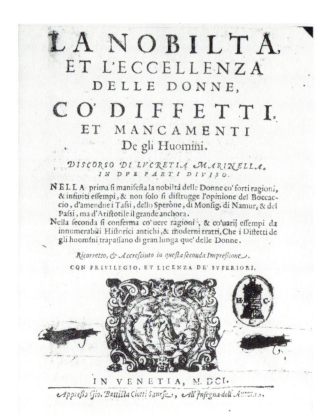

135. Lucrezia Marinelli, *La nobiltà et
l'eccellenza delle donne, co' diffetti
et mancamenti de gli Huomini*,
Venice, 1601, title page

friends of diverse ages and circumstances who gathered at a villa (left to one of the women by an unmarried aunt) with gardens graced by statues of women. The undercurrent of the discussion is the desire for "*libertà donnesca*," a goal summed up in a sonnet recited by one of the participants: "*Libero cor nel mio petto soggiorna, non servo alcun, né d'altri son che mia*" ("as long as a free heart dwells in my breast, I shall not serve anyone, nor shall I belong to anyone but myself").[42]

The women writers also recognized the basic flaw in the tradition of extolling women worthies, namely its implication that all other women were unworthy.[43] The feminists assessed the women worthies rather differently, seeking in their biographies some validation of the lives and experiences of ordinary females. Looking at such extraordinary paragons of chastity as Lucretia and Virginia, Christine de Pizan exquisitely turned the argument from a defense of suicide for the sake of honor into an assertion that women would rather be killed than suffer sexual assault, thus (as she explained in her chapter heading) "refuting those men who claim women want to be raped."[44] Christine preferred to emphasize the independence of the worthies. Her account of Semiramis focuses upon the queen's noble civic deeds, and dismisses her incestuous marriage with her son as simply a strategy for retaining the crown, and a consequence of life at an early time when "people lived according to the law of Na-

ture, where all people were allowed to do whatever came into their hearts without sinning" (thus adding the idea of female sexual choice to the myth of the ancient Golden Age). Taking up the story of Zenobia, Christine stresses her usual virtues of courage, wisdom, and leadership, but she paints a personality of striking independence: Christine's Zenobia resisted marriage because she wanted to keep her virginity, and "slept with her husband only to have children." Fearless, self-controlled, and lacking in vanity, Zenobia was blessed by Fortune, who allowed her "to have a husband who corresponded so well to her own mores."

Arcangela Tarabotti, an impassioned Venetian feminist of the mid-seventeenth century, invoked the women of tradition with pride and scorn—pride in her female heritage and scorn for those who ignorantly claimed that there had been no women learned in science and art. In contrast with eulogists of the women worthies such as Castiglione and Domenichi, who set up dialogues in which the women must ask the men to recite the history of famous women, since they themselves are unlearned,[45] Tarabotti recites the litany herself, adducing the writers, scholars, and philosophers of the past in a long list that goes well beyond Boccaccio's canonical group. Angrily, as if against some imaginary opponent who would dismiss women as inferior, she challenges: "But what shall we say of Aspasia? She was so learned in her philosophical studies that she became the teacher of the great Pericles. . . . What of Assiotea, whom Apuleius and Plutarch celebrate? . . . Where stands Cleubolina, daughter of one of the seven sages of Greece and praised for her writings by the great authors . . . ? Where Barane, wife of Alexander of Macedon, who composed hymns; and where Cornelia, mother of the Gracchi, who composed epistles . . . ?"[46] Like Christine de Pizan, Tarabotti finds heroic female role models in characters tainted for the men by their various sexual lapses: Cleopatra is included among the *donne forti e intrepide*, as one who "feared shame more than she loved life," and whose suicide, achieved by the serpent's bite upon her "*candidissimo petto*," was intended to deprive Augustus of the triumphant opportunity to parade her as a prisoner in Rome.[47]

Too frequently, Marinelli, Tarabotti, and the Italian feminist writers have been dismissed as part of a man-hating contingent,[48] an assessment that ignores the *male* advocates of female superiority, such as F. Agostino Della Chiesa, bishop of Saluzzo and colleague of Marinelli, who anticipated Bachofen in constructing the theory of a pre-patriarchal matriarchy.[49] Something else is signalled, however, by the more numerous women who argued that women were not only equal to but better than men, for they wrote in anger and in newly found female pride and self-confidence. Their intemperate, impassioned treatises are valuable not for their judicial accuracy, but as an important contribution to the elevation of women's self-esteem and toward their eventual escape from the mental conditioning that had kept them enslaved to custom. The early feminist women writers did not so much "hate men" as recognize them for the imperfect humans that they were.

While the male humanists' advocacy of female worth was based upon literary

prototypes or hearsay evidence of what some women had done, the female writers appealed directly to women's own experience. Christine de Pizan is spiritually liberated by her allegorical helpmate, who holds up to her a mirror as the source of true self-knowledge, and rebukes her for believing in masculine authority instead of her own perceptions: "regardless of what you might have read, you will never see such a husband with your own eyes, so badly colored are these lies."[50] Unlike their misogynist opponents, who found Roman authority for the principle of wifely obedience, the women could not appeal to the authority of antiquity, for there were no precedents for their cause in the antiquity that they knew. Thus they were free, as Hilda Smith has put it, "to use their minds creatively, not simply accumulatively, as in traditional scholarship";[51] and thus the women who had so recently been admitted to the humanist citadel of learning were obliged to transcend it, to become quickly more progressive than their model, by the very deficiency the humanist model contained for them. The emphasis given to personal experience was a fragile weapon with extraordinary power, for while all of literature and scripture were hauled out to attack women, the women refuted these from an extramural position, effectively defusing the scriptural authorities, and exposing the embarrassing fact that the great citadel of Western knowledge, for all its complexity and brilliance, was only a masculine construction. Shaped and distorted to men's merely human needs (and excluding women's), the masculine tower of learning was flawed at its base, as Virginia Woolf would much later succinctly confirm. And so when the feminists began to speak, they transformed a debate about the capabilities of women into a sociological critique of the limitations upon objectivity that are imposed by gender.

## THE *FEMME FORTE*

The second decade of the seventeenth century saw a period of intense anti-feminism in tracts published in the major countries of Europe. In England, attacks upon women had had a strong political base, beginning with John Knox's *First Blast of the Trumpet* (1558), which was prompted by the appearance of female rulers—Mary of Guise, Mary Tudor, Catherine de' Medici.[52] (It was Knox's misfortune to have published his claim of female inferiority in the year that Elizabeth I ascended to the throne.) Numerous responses to *First Blast* appeared over the next half-century, some of them defenses of women, but with the frequent familiar argument (now a politically astute one) that although women in general were wicked and weak, some women—such as the worthies of legend—were exceptional. An especially controversial offering in this genre was *The Arraignment of Lewd, Idle, Froward* [sic], *and unconstant women . . . ,* published in 1615 by Joseph Swetnam. This text provoked the outraged response of three female writers, Rachel Speght, Ester Sowernam, and Constantia Munda, who published tracts aimed at Swetnam in 1617: Speght's *A Mouzell for Melastomus,* Sowernam's *Ester hath hang'd Haman: Or An Answere to a lewd Pamphlet, entituled, The*

*Arraignment of Women*; and Munda's *The Worming of a mad Dogge*. The angry tone of the tracts, conveyed by their very titles, serves to indicate the intensity of the debate, but unfortunately none of these defenses significantly advanced the feminist case, as they either accepted the principle of female inferiority or else reacted to gross misogyny with the blind claim of female superiority. Entering the Swetnam fray was a more moderate text, Daniel Tuvil's *Sanctuary for Ladies* (1616), which took the position that there was good and bad in both sexes, and also an anonymous play of 1620, *Swetnam the Woman-Hater*, in which the viewpoints of both Sowernam and Tuvil are reflected.[53]

In Italy, the very idea of a female ruler was beyond consideration, and institutional misogyny flourished in the continuing climate of clerical validation. Misogyny was given new impetus as well by the Counter-Reformation, with its reaffirmation of the teachings of early Church fathers. The Tridentine veneration of Mary and celebration of the virtues of purity and chastity were directly fueled by Early Christian theology, particularly its denunciation of female carnality and elevation of the virginal and chaste woman, opposites that were in fact two faces of the same patristic doctrine.[54] Many anti-feminist writings appeared in Italy in the early seventeenth century. Giuseppe Passi's *I donneschi diffetti* (Milan, 1599), one of the most violently misogynist of the tracts, sets forth the traditional defects of women: luxury, jealousy, adultery, hypocrisy, and so on. Appealing to the positions of Aristotle, the church fathers, and the theologians, and citing contorted versions of legendary women (e.g., Penelope as unfaithful and corrupt), Passi declaimed the female sex as evil and diabolical, lending verbal support to the witch hunts that reached their violent peak in the early seventeenth century.[55] A similar work in verse was G. B. Barbo's *L'oracolo, overo invettiva contra le donne* (Vicenza, 1616).[56] Giulio Cesare Capaccio, in a treatise of 1620 dedicated to his patron, the Duke of Urbino, expressed his opposition to women in government, naming Elizabeth of England as a "horrible example."[57]

In France, foremost of the misogynist tracts was the *Alphabet de l'imperfection et malices des femmes*, by "Jacques Olivier," a pseudonym for the Franciscan Alexis Trousset (Fig. 136). First published in 1617—a year that saw similar printed invectives against women in Germany and elsewhere, as well as a peak in witch-burning—Trousset's *Alphabet* was an enormously influential work that was republished at least eighteen times by 1650.[58] It consisted of an alphabetical list of female vices—*avidissimum animal; bestiale barathrum; concupiscentia carnis*, etc.—that was modelled on a fifteenth-century alphabetical list written by St. Antoninus, Archbishop of Florence.[59] Trousset himself had promised to compose a sequel to his misogynist text in praise of the virtues of women (and may eventually have done so), but he was beaten to it by a number of writers who responded immediately to the *Alphabet* in a series of tracts that extolled female virtues and perfections, in counter-alphabets, counter-arguments, and through the republication of earlier pro-female treatises.

An important stimulus for the French misogynous treatises was the recent fall

# ALPHABET
## DE L'IMPERFECTION
### ET MALICE
#### des femmes.

*Virum de mille vnum reperi : mulierem ex
omnibus non inueni. Ecclef. cap.7.*

De mil hommes i'en ay trouué vn bon,
& de toutes les femmes pas vne,

Dedié à la plus mauuaife du monde.

A PARIS,
Chez IEAN PETIT-PAS, ruë Sainct
Iacques à l'Efcu de Venife prés
les Mathurins.

M. DC. XVII.
Auec Priuilege du Roy.

136. "Jacques Olivier" (pseud. Alexis Trousset),
*Alphabet de l'imperfection et malice des femmes*, 1617,
title page

from power of Marie de' Medici. Marie, who occupied the throne of France from 1610 to 1616 as regent for her son Louis XIII, had imposed an especially strong image of heroic queenship upon her rule. Her early displays of political assertiveness, which included an insistence upon being crowned queen during the reign of her husband Henri IV (though, coincidentally, he was to die the day after her coronation), and her promotion of the career of Richelieu, her personal advisor before he became cardinal in 1622—not to mention her active program of politically effective art patronage—had made Marie de' Medici a powerful yet controversial figure. When in 1617 Louis XIII seized control for himself, his mother was exiled to Blois, where she remained until her escape in 1619. A tentative peace between mother and son was arranged in 1620, and with her readmission to the court came renewed influence over the king. The queen mother's political position shifted considerably in the next decade, however, and the undulating tide of anti-feminist tracts has reasonably been connected with her own fortunes. Elaine Rubin has suggested that the 1617 edition of Trousset's *Alphabet* was directly aimed at Marie de' Medici, and that it is she who appears in the female image on its title page.[60] This is supported by the probability that the queen was offered an indirect piece of advice to remain submissive in a misogynist polemic of 1623, *Les Singeries des femmes de ce temps descouvertes*, through the story of Semiramis,

who massacred her husband and her son, Ninus, in order to rule over men and dared even—so much did she have the courage to imitate the actions of men—to leave the dress of woman and clothe herself again in the royal mantle.[61]

The metaphoric use of a woman worthy to discredit Marie de' Medici turned the tables on the queen's own brilliant management of heroic female iconography, which is seen especially in Rubens's paintings for the *Life of Marie de' Medici* series (1622–25), and also in the literature written for various court ceremonies between 1600 and 1615. From the outset, Marie's queenship had been cast in terms of a personal virile heroism that sustained the exceptional principle of the woman worthy tradition. Contemporary historians described her as having a "male heart," an idea expressed in the arrival ceremony at Marseilles, where she was described as "Hero Heroine," and in her triumphal entry at Avignon, where she was cast as Astraea to Henri IV's Hercules.[62] In this image was revived the powerful archetype that had girded the reign of Elizabeth I: the virgin Astraea, "last of the immortals" sung by Ovid and Virgil, Dante, and the Elizabethan poets, who had "abandoned the blood-soaked earth" with the coming of the warring and evil iron age, but whose return would signal a new golden age of peace and justice.[63] The use of heroic legendary models such as the androgynous Astraea to support the virile identity of Marie de' Medici continued through the regency. The author of the queen's coronation ceremonies compared Marie to Judith, suggesting that she would protect her people as the biblical heroine had delivered the Israelites from tyranny, an analogy that had earlier been applied to Elizabeth.[64] In a pamphlet accompanying the marriage of her son Louis XIII and Anne of Austria, Marie was praised in comparison to the great women of the past: Elizabeth of Portugal, Cornelia, Cleopatra, St. Helen, Zenobia, Joan of Arc, Penthesilea, and Elizabeth of England. In the imagery created for Marie de' Medici, the women worthies were saviours and heroes, not temptresses and sinners, and even that paragon of trickery, Semiramis, was advanced as a model of a mother who, like Marie, gave a new successor to the state.[65]

In her proud association of herself with heroic women of the past—not only legendary women but also recent historical figures—and in the preponderance of female imagery that accompanied her reign, Marie de' Medici accomplished a subtle but significant alteration of the woman worthy tradition. She shifted its emphasis from an acknowledgment of the heroic woman as an exception to her gender to a celebration of the generic capability of the female sex. Modelling herself upon, and encouraging her courtiers to compare her to, earlier French queens such as Blanche of Castille and Catherine de' Medici, Marie appears to have drawn energy, strength, and identity from her ideal pantheon of goddesses and heroines as much as from her own exceptionality. In the prime expression of her heroic queenship, the *Life of Marie de' Medici* cycle of paintings created for the queen's apartments in the Luxembourg

Palace, Rubens gave consummate expressive form to ideas that were surely more his patron's than his own. Thanks to the scholarship of Jacques Thuillier and Deborah Marrow, the imagery of the Luxembourg cycle has begun to be understood as an expression of the queen's own political ambitions.[66] The episodes were apparently chosen to reflect her personal heroism rather than conventional acts of queenship—the escape from Blois, for example, rather than the founding of hospitals.[67] Throughout the cycle, Minerva, the goddess of wisdom and peace, appears as Marie's personal advisor; other goddesses appear—Ceres, Juno, Cybele—either to support the queen or in literal identification with her. In the picture that initiates the cycle (Fig. 137), we see Marie herself as Minerva (merged with Bellona and France), standing helmeted among armor and weapons, with one breast bared (possibly an Amazonian allusion).[68] In the *Felicity of the Regency* (Fig. 138), Marie is shown as the personification of Justice, but also of the Government, which she embodied.[69] Together, Rubens and Marie de' Medici carried the tradition of female allegory to a new creative plane, bringing the allegorical ideas to life through their embodiment in the living queen and in her active female agents. In *The Arrival of Marie de' Medici*, the ship is guided to its mooring, not by the male tritons, but by the female nereids; in the *Coming of Age of Louis XIII*, the ship of state is vigorously propelled by four muscular Virtues who row lustily, totally detached from their emblematic shields, which are attached to the vessel.

Marie de' Medici's commitment to the inspirational example of female role models is further indicated in a project planned while Rubens's cycle was in progress, the decoration of the dome of the entrance portal of the Luxembourg Palace with a series of statues of eight famous women, queens as well as mothers of famous men.[70] The queen's wish to focus the artistic decoration of the Luxembourg Palace upon the women of antiquity, both a tribute and an appeal to her personal heroic genealogy, saw realization in numerous galleries of famous women, especially in projects patronized by Cardinal Richelieu and by Marie's daughter-in-law, Anne of Austria. In 1635, Richelieu requested from Simon Vouet, Philippe de Champaigne, and others for the Palais Cardinal (later Palais Royal) a gallery of famous French heroes that included three women: Marie de' Medici, Anne of Austria, and Joan of Arc; and about the same time, he commissioned a series of illustrious women for the Cabinet de la Reine at his château at Richelieu.[71] With his pupils, Vouet painted a gallery of heroic women for the wife of Maréchale de la Meilleraye at the Hôtel de l'Arsenal (1637), *femmes fortes* of antiquity and modern times, who included Lucretia, Semiramis, Judith, Esther, Joan of Arc, Mary Stuart, and Mme. de la Meilleraye.[72] Vouet was invited in 1645 to provide three paintings of the deeds of famous women for the apartments of Anne of Austria at the Palais Royal, and again in the 1650s for her other apartments in Paris.[73] As Marrow aptly observed, of all these galleries of illustrious women, Marie's commission for the eight statues around the drum of the dome over the Luxembourg Palace entrance was the most ambitious, since it took the imagery of heroic

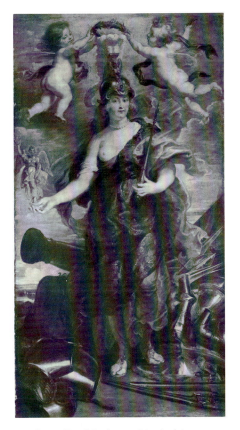

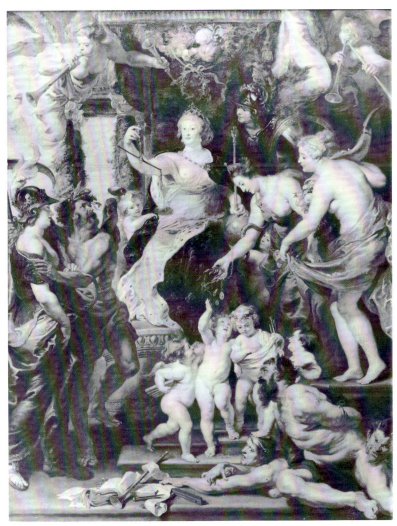

137. Peter Paul Rubens, *Marie de'*
*Medici as Minerva/Bellona*, from the
*Life of Marie de' Medici* cycle,
for the Luxembourg Palace, 1622–25.
Paris, Louvre

138. Rubens, *Felicity of the Regency*, from the *Life of Marie de' Medici*
cycle, for the Luxembourg Palace, 1622–25. Paris, Louvre

women from the private bedrooms of the female ruler to a prominent and monumen-
tal public position.[74] With such a decision, Marie asserted the appropriateness of
images of heroic women for the world of men as well as that of women. It was a
gesture directly analogous to the achievement of Artemisia Gentileschi, who painted
powerful images of comparably heroic women, and largely for male patrons.

Artemisia unquestionably knew of the legendary Marie de' Medici and her lavish
artistic commissions, not least because her own father was in the queen's service from
1624 to 1626, when he produced the *Public Felicity Triumphant over Dangers* as part of
a cycle of female allegorical figures for the antechamber to Marie's apartments in the

Luxembourg Palace.[75] Even before that, Artemisia was resident at the Medici court in Florence from 1614 to 1620, working among artists patronized by the queen, and she undoubtedly would have heard news of the Medici family's most illustrious female member during those years. In the early 1620s, when Marie's cycles of heroic female imagery were begun, Artemisia was in Rome, and it is likely that she continued to hear reports of the assertively feminist queen's activities, whether from artists such as Vouet, or from her patron Cassiano dal Pozzo, who visited Paris in 1625 in the entourage of Cardinal Barberini and wrote a description of the artistic contents of Marie's apartments in the Louvre.[76] Gentileschi's imagination may well have been fired by descriptions of Marie de' Medici's commissions, especially since they held the promise of creating a climate of support for the kinds of images she herself was producing. Certainly the powerful and queenly demeanor of Artemisia's Detroit *Judith* and her Metropolitan *Esther* offer counterparts in kind for the heroic figure of the queen in Rubens's cycle, just as Artemisia's *Self-Portrait as the Allegory of Painting* parallels that cycle's imagery in its fusion of portrait and female allegory.

It is equally probable that Marie de' Medici would have known about Artemisia Gentileschi, the prodigious and extraordinary woman painter, whose earliest work offered images of strong female heroes. She would surely have been informed of Artemisia by Orazio Gentileschi, possibly also by Vouet on his return to France in 1627, and word of the woman artist could have come before 1620 from her own Florentine relatives. There is no evidence that the French queen ever patronized or invited Artemisia to join her court (though what a combination that would have been!). But the absence of documentation may mean little, since there also remains no record of a nearly certain encounter between the two women in England, a decade later. For they surely would have come into contact at the court of Charles I and Henrietta Maria, where the queen mother spent the last years of her life with her daughter, the English queen, between 1638 and 1641, dates that precisely coincide with Artemisia's residence in the Caroline court. Marie had come to England from Holland—where she had visited, among others, the feminist philosopher and painter Anna van Schurman[77]—and one can well imagine that the dowager queen, an artist in her own youth, and the mature woman painter Gentileschi might have found occasions to discuss the art and female imagery they both knew so well. One reads Artemisia's letters with a sense of regret, for nowhere—not even in the single preserved letter that she wrote from England—do they mention by name the most formidable woman of her time. Yet of all the letters that Artemisia may have written, only those to male patrons have survived, and she is hardly likely to have confided feminist experiences or interests to such correspondents.

There is a distinct possibility, however, that at least one of Artemisia's paintings may have originated in the orbit of Marie de' Medici. The most curious of the pictures from Gentileschi's Florentine period, the *Minerva* (Fig. 139), closely resembles a figure type especially prevalent in the court of Marie's regency. Minerva was a central figure

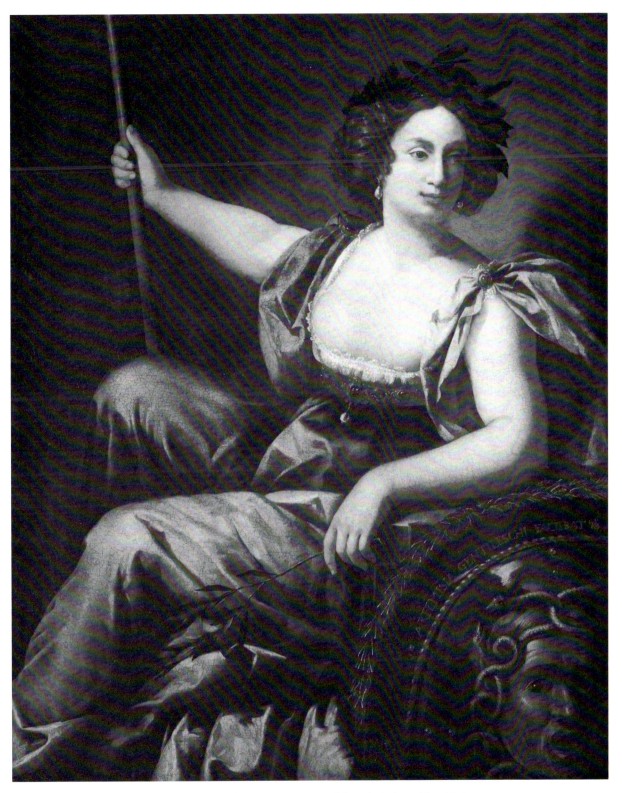

139. Artemisia Gentileschi, *Minerva (Anne of Austria?)* (here identified), c. 1615.
Florence, Soprintendenza

in Marie's personal iconography, appearing not only throughout Rubens's cycle, but earlier, in such images as Ambroise Dubois's *Marie de' Medici as Minerva*, or Guillaume Dupré's medal whose reverse showed Henri IV as Mars and Marie as Minerva. Minerva was the principal character in the Florentine wedding banquet of Marie de' Medici, while a French ballet of 1615 celebrated the triumph of Minerva.[78] The heroic classical goddess, bellicose in aspect but a symbol of peace and the arts, was well adapted to Marie's own program of militant protection of the realm and patronage of culture, and she appeared frequently in allegorical portraits of subsequent French queens and court ladies.[79] By the 1640s, as Mme. de Scudèry related, it had become fashionable for ladies of the grand nobility to be portrayed as *fortitudo* or *Pallas armata*, an identity imposed upon historical queens as well, as we see in an image of *Blanche of Castille as Pallas armata* of 1644 (Fig. 140).[80] At least two portraits of Anne of Austria sustained this imagery: one, at Versailles (Fig. 141), shows the wife of Louis XIII as a young Minerva, seated with a pike in one hand, holding her Medusa-headed shield, her helmet on an adjacent pedestal.[81] The Versailles portrait of Anne, dating from the 1650s and showing the queen as ideally youthful, differs considerably from her distinctive mature image, which is fixed for us in various other portraits (Figs. 142, 143) as a face marked by the less attractive Hapsburg features—heavy-lidded eyes, large hooked nose, and protruding lips.[82]

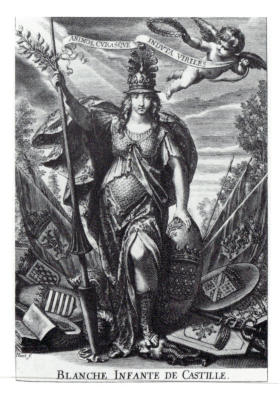

140. *Blanche of Castille as Pallas armata*, engraving, 1644

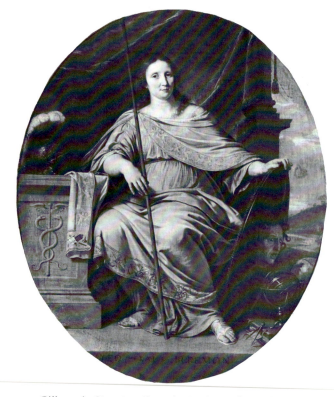

141. Gilbert de Sève (attributed to), *Anne of Austria*, 1650s. Versailles, Museum

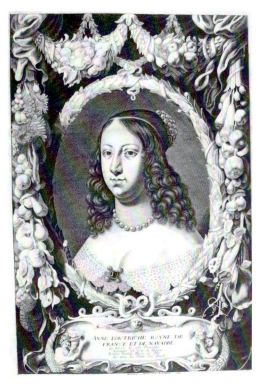

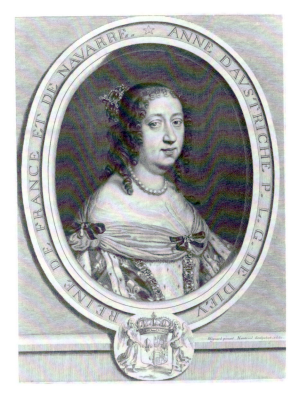

142. Balthasar Moncornet, *Portrait of Anne of Austria*, 1643, engraving. Paris, Bibliothèque Nationale

143. Robert Nanteuil, after P. Mignard, *Anne of Austria, Queen of France and Navarre*, engraving, 1660. Washington, D.C., National Gallery of Art

Looking again at Artemisia's *Minerva*, we can recognize the type of the seated Minerva seen in the Versailles *Anne of Austria*, combined with the bared breasts, laurel wreath, and olive branch that are characteristic imagery in the Marie de' Medici Luxembourg cycle. Her face, though younger and more idealized than that seen in the later portraits, nevertheless displays Anne-like deviations from the classical ideal in the heavy eyelids and drooping, slightly puckered lower lip. Quite possibly, we have here an allegorical portrait of the young Anne, dating from around the time of her marriage to Louis XIII in 1615, painted by Artemisia Gentileschi, an artist working in the queen mother's family circle in Florence. The likelihood that such a commission might have been initiated by Marie herself in France, in her son's name, is supported by Artemisia's later contention that she had worked for the king of France.[83] Such a circumstance would help to explain the atypical woodenness and awkward formality of Artemisia's *Minerva* (which may have been a fusion of a likeness sent to Florence and a live studio model), and it would give the picture a logical context that it presently lacks.[84]

As late as the 1620s, Marie de' Medici continued to look to her native Florence for artists and for artistic ideas, as is demonstrated in the series of ten paintings illus-

trating the history of the Medici family that she commissioned for the Luxembourg Palace from Jacopo Ligozzi, Jacopo Vignali, Giovanni Biliverti, Anastasio Fuontebuoni, and others, many of whom had worked side by side with Artemisia at Casa Buonarroti.[85] The creation of Artemisia's *Minerva* was abundantly supported by Florentine traditions: by the numerous Minerva paintings and prints produced by Botticelli and others in the late Quattrocento, and also by such prototypes of allegorical portraiture as Bronzino's *Andrea Doria as Neptune* of c. 1533 (Fig. 144).[86] But the personal iconographic programs of Marie de' Medici would have given this *Minerva* a contemporary *raison d'etre*, and in the absence of other candidates, the queen would seem its most likely patron. If so, then Artemisia's *Anne of Austria as Minerva* would have been the first of a seventeenth-century succession of Minerva images as allegorical portraits that later proliferated in the French court, and thus is a conceptually important work, even though it may never have been known in France.[87]

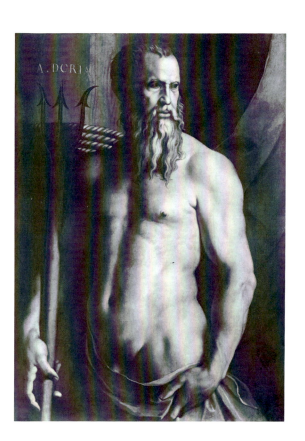

144. Bronzino, *Andrea Doria as Neptune*, c. 1533.
Milan, Pinacoteca Brera

IT WAS during the reign of Anne of Austria that the image of the heroic woman—anticipated in Artemisia's *Minerva* and developed by Marie de' Medici—emerged as a fully codified character in moralistic writings and in pictorial form. Around 1630, the traditional *querelle des femmes* began to be replaced by a new attitude toward women, one that was no longer preoccupied with their theoretical equality, but that took into account the reality of their participation in social and political life. Artists and writers of mid-seventeenth-century France implicitly acceded to the new feminist demands put forth by writers like Marie de Gournay and Madeleine de Scudéry[88] in their homage to a new character—the *femme forte*. The *femme forte* supplanted the woman worthy as a female ideal, and she differed from her Renaissance counterpart, not only in her more positively acclaimed "virility," but also in that she was inspired both by legendary women of the distant past and by modern female rulers such as Elizabeth I, Marie de' Medici, and Anne of Austria. More than any other figure, Anne of Austria personified the *femme forte*, presenting in the numerous illustrated treatises that were dedicated to her during her regency (1643–52) an aesthetically consistent image of a strong, heroic, and independent woman.

Foremost among the writers associated with what Ian Maclean has called "the new feminism" of the period 1630–50 were Jacques Du Bosc and Pierre Le Moyne, who projected the new heroic female image in influential treatises, through their texts and in the accompanying engravings. Du Bosc's *La femme heroique* of 1645 presented eight comparisons of heroes and heroines, each accompanied by a double-page pair of illustrations, engraved by Francois Chauveau.[89] Le Moyne's *Galerie des Femmes Fortes* of 1647 consisted of a suite of twenty biographies of exemplary women in four sets: Jews, Greeks, Romans, Christians. The engravings, executed by Abraham Bosse after designs of Claude Vignon, presented a full-page image of each *exemplaire*, with a frontispiece representing Anne of Austria, engraved by Charles Audran after Pietro da Cortona (Figs. 145, 146, 147).[90] The image of Anne in the frontispiece would have accorded with Marie de' Medici's sense of a female heritage: she stands, a statue on a pedestal, crowned by a laurel-bearing putto, attended by four female figures, and framed by a curving wall whose niches are filled with statues of the heroic women discussed in the treatise. Almost inadvertently, the *Anne* frontispiece is very different in expression from the image that must have been its model—the frontispiece of Jean-Francois Niceron's *Thaumaturgus opticus*, engraved by Audran (after Vouet) in the preceding year (Fig. 148).[91] While in the latter work, the women in niches are clearly personifications—liberal arts or muses—who allegorically enhance the glory of the pedestalized Niceron, the all-female cast seen in the *Anne of Austria* frontispiece invokes a lineage of living women, continuous from the legendary *femmes fortes* down to their modern counterpart.

In its implication of female inclusiveness, the engraving is to be contrasted with the attitude of the author, Le Moyne, who explicitly contrasts the *femme forte* with

145. *Deborah*, from Pierre Le Moyne, *Galerie des Femmes Fortes*, engraving, 1647

146. *Zenobia*, from Pierre Le Moyne, *Galerie des Femmes Fortes*, engraved by Abraham Bosse after Claude Vignon, 1647

ordinary woman. In the view of Le Moyne, Du Bosc, and other writers of the period, the *femme forte* is distinguished from the average female's idleness and lewdness by her "manly" virtues: energy, continence, liberality, magnanimity, stoic apathy, resolution, courage, patriotism.[92] Following in the tradition of humanist feminism, Le Moyne and other moralistic writers described the views of anti-feminist writers as dated curiosities, and they set out to advise women in desirable social behavior that might offset the stereotypes held about them—their alleged infidelity, idleness, and vanity.[93] Yet because the moralists shared attitudes inherited from both antiquity and sixteenth-century writers, that women were morally inferior to men and were more susceptible to temptations of the flesh, they managed by a timeworn rhetorical device to keep the stereotypes as alive as their recommended replacements. Le Moyne, for example, concludes his paean to the heroism of Judith with the following "moral reflection": "Women have not everyday Holofernes's to vanquish; but every day they have occasion to fight against excess vanity, delights, and all pleasing and troublesome passions; the memory of this Heroick Woman may instruct them. . . . Let them learn

from this illustrious and glorious Mistresse to discipline their graces, and to give them devotion and zeal; To imprison dangerous Beauty, and to take from it all the weapons where with it might offend. . . ."⁹⁴ With such a lesson drawn, the mighty Judith was cut down to domestic size, and offered as a model to women to help them resist weaknesses in themselves that one would have thought were properly those of Holofernes.

The term *femme forte*, which began to be used around 1630, was derived from the very source popularized by Trousset's misogynous *Alphabet*: the *mulierem fortem*—that rare, virtuous woman whose price is far above rubies—cited in first verse of the Alphabet of the Good Woman in the Book of Proverbs.⁹⁵ The idea of *fortitudo* implied in the biblical term, though not specifically extolled in the scriptural passage, accrued from the later Christian allegorical personification of Fortitude to the new figure, the *femme forte*, who was also described as *amazone chrestienne* and *femme heroique*.⁹⁶ The *femme forte* archetype was also greatly buttressed and partly defined by the Marian literature that was in such great abundance after the Council of Trent, in the sense that Mary became the theological example *par excellence* of the heroic woman (as well

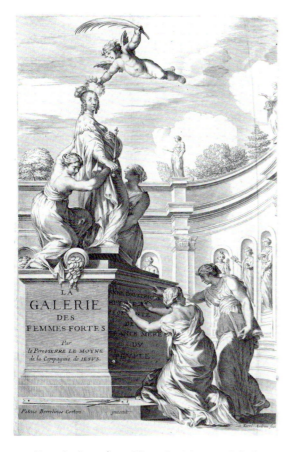

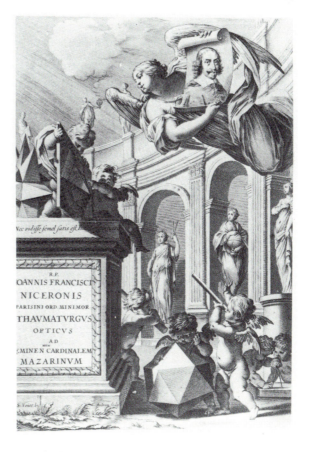

147. Frontispiece, from Pierre Le Moyne, *Galerie des Femmes Fortes*, engraved by Charles Audran after Pietro da Cortona, 1647

148. Charles Audran (after Simon Vouet), frontispiece of Jean-François Niceron's *Thaumaturgus opticus*, 1646

as the incarnation of the biblical *mulier forte*, according to some theologians).[97] Mary exemplifies, as women in general do not, all the desirable virtues—liberality, purity, courage—and, in a sense, she redeems *all* women of the weaknesses peculiar to their gender, just as she redeemed the fall of Eve. The Virgin herself also represents, like the *femme forte*, the "paradox of strength in weakness."[98]

The *femme forte* emerged in the 1640s as a vigorous, active female type, who might be dressed in armor like the *Deborah* from Le Moyne's *Gallerie* (Fig. 145), or equipped with a masculine plumed helmet or spear like Le Moyne's *Zenobia* (Fig. 146), or she might brandish that most virile of attributes, a sword, as does the *Judith* engraved by Abraham Bosse in Lescalopier's *Les Predications* (1645), in which the words "*la femme forte*" are inscribed on the sword (Fig. 149). Images such as these have been interpreted as anti-male and militantly feminist,[99] and depending upon the viewer's sensibility, they may yet have such an effect. However, such equipment of leadership was surely appropriate to female characters who, the humanists had admitted, might rule and lead armies. In this respect the *femme forte* illustrations point up a discrepancy between the imagined and the imaged, between the vaguely conceived capabilities of exceptional women and the threatening visual effect of females armed to carry out deeds of which they were theoretically capable. (That discrepancy, along with the taboos of its attendant sexual symbolism, was pointed up in real life as well, in the experience of Isabella the Catholic, queen of Castile, who wore chain mail in battle and conducted a successful struggle to gain the throne from her half-brother Henry IV and a niece. In the ceremonies held when she became queen, she was prevented from walking behind a man holding a naked sword, because "never was known a queen who usurped this masculine attribute."[100])

In the face of such overt male dread of "castrating women," it may strike us as remarkable that the *femme forte* images should have been at all popular, offering as they often did images of monumental, strong women juxtaposed with tiny and subordinated images of devalued and denigrated men (Fig. 150). Maclean has seen in the popularity of these prints the sustaining idea of "the world turned upside down," and in the paradox of female strength, a marvel appealing to the taste of the Baroque age.[101] It is perhaps the essence of these role-reversed examples that the image of an independent and prestigious woman was thinkable, even enjoyable, to the extent that it did not correspond to normal reality, but remained in the realm of the exceptional marvel. For, like the humanist pro-female treatises (and unlike the feminist treatises by many women writers), the galleries of famous women were not accompanied by a call for real social change. Le Moyne praises exceptional women to the heavens and affirms the principle of equality of the sexes, yet hastily explains that he is not attempting to change women's actual status: ". . . my intention is not to call women to school. I do not wish to make graduates of them: nor change their needles and wool into Astrolabes and spheres. I respect too much the boundaries which separate us: and my question concerns only what they are capable of, and not what they should

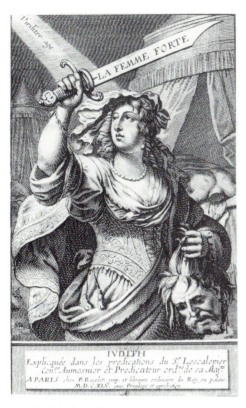

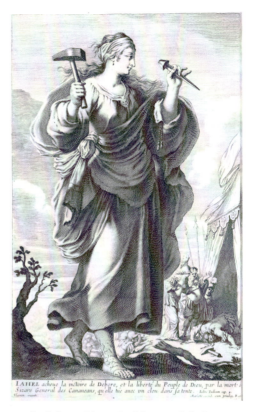

149. *Judith*, from Lescalopier,
*Les Predications*, engraved by
Abraham Bosse, 1645

150. *Jael*, from Pierre Le Moyne, *Galerie
des Femmes Fortes*, engraved by
Abraham Bosse after Claude Vignon, 1647

do."[102] Thus even in the galleries of the *femme forte*, the most vigorous and theoretically positive images of heroic women created by men, lingers the idea that these exceptions are curiosities at best, heroic only insofar as they are virile, and virile only insofar as they are imaginary.[103]

If the power of strong women was mediated in the galleries of famous women by the exceptional context in which they appeared, woman's potential heroism was given another kind of controlling distortion in the drama, poetry, and easel paintings of the age. In these media, classical and biblical figures such as Cleopatra, Dido, Lucretia, and Judith inevitably emerged as heroic by the singular attention they were given, yet the narrative format also afforded a chance for imaginative plot development and for interaction with male characters not usually available in the print gallery context, with the result that the heroines' identities were often largely defined by their association with love and dramatic emotion. Sometimes they were afflicted, innocent figures who evoked pathos, such as Dido, Sophonisba, or Mary, Queen of Scots; or they might be revengeful or diabolic figures, such as Cleopatra, Medea, or Vashti.[104]

Yet the heroic woman was invariably armed with her natural weapon—beauty—and time and again, her male consort had to guard against the fatality of her physical charms. Women were widely ceded the realm of love itself, for it was frequently argued that they were better lovers than men, and in the Neoplatonism of the early seventeenth century, women's association with love was often interpreted as giving them a balance of power with men.[105] At base, however, the concept that underlay much drama and pictorial art of the sixteenth and seventeenth centuries—termed "heroic misogyny" by Maclean—was that women, as agents of the power of love, corrupt and weaken masculine heroic virtue.

The Spanish dramas of the "Siglo de Oro" sharply reflected the clash between the new feminism and traditional misogyny, a conflict resolved by the playwrights through affirmation of the transforming power of love. In numerous plays, such as Lope de Vega's *La vengadora de las mujeres* (1621) or his *Diablos son las mujeres* (1632), a feminist theme is introduced through a heroine, a "man-hating beauty," who argues passionately on behalf of equal rights for women, and sets out to avenge women by renouncing men, love, and marriage.[106] The fresh wind of contemporary feminist controversy blows through these plays, for the pro- and anti-feminist arguments presented by the characters (the women speak of the tradition of the women worthies, the misogyny of men's writings, and the exclusion of women from serious study, while the men complain of woman's inferiority, inconstancy, and evil nature) are clearly drawn from the body of literature devoted to the *querelle des femmes*, from Boccaccio and Agrippa to Trousset and Le Moyne, that had grown in volume and spread throughout Europe. Not only literary arguments, but living feminists, were invoked on the Spanish stage: Calderón's comedy, *Afectos de odio y amor* (printed 1664; composed before 1658), presents a heroine, Cristerna, who has been recognized as a portrait of Christina of Sweden.[107] Queen Christina, whom the Spanish called the "*prodigio del Norte*," was active on behalf of women's rights, and her upbringing as a male, her training in both military and intellectual arts, and her refusal to marry were legendary. Like her model, Calderón's Cristerna works vigorously as queen to improve women's legal and intellectual status. Yet in marked contrast to the historical Christina, the fictional Cristerna is directed by the playwright to do an about-face, fall in love, and marry. Thus the argument that woman is fickle and changeable becomes in this play—and in all the "Siglo de Oro" dramas with a feminist theme—the basis for undermining the feminist argument itself and for reassertion of the "natural" rightness of woman's submission to man and to love, the universal agent of happy union of the sexes.

In both drama and art, we find characters who appear to be "feminist" in that they argue on behalf of women or exercise power over men—whether Cristerna/Christina, or legendary figures such as Cleopatra, Omphale, or Venus—yet whose power is ultimately compromised by the misogynous stereotype of woman's dangerous association with love—dangerous in different ways to both male and female

heroes. Easel paintings, which differ from plays as objects to be enjoyed privately through unique possession, displayed themes concerning female characters more often to suit the erotic tastes of their patrons than to project polemical attitudes about female capability. The popularity of such a theme as Omphale and Hercules—which was more frequently depicted by Renaissance and Baroque artists than any of the deeds of Hercules—indicates, as students of eroticism in art have observed, that images of female dominance over men appealed to male art patrons on a level of pornographic fantasy that had little to do with feminism.[108] Yet, as we shall see in forthcoming chapters, the very women worthies who were the controversial subjects of the *querelle des femmes* and the inspirational icons of the feminist writers—Susanna, Lucretia, Judith, and others—were typically distorted in art into fantasized objects of male sexual gratification, and they sometimes became vehicles of a more overt misogyny. It would be naive to maintain that the energy expended neutralizing and sexualizing the image of women in art in the sixteenth and seventeenth centuries was not at least partly generated by fearful reaction to the changing roles of women in the real world.

## THE IMAGERY OF STRONG WOMEN

Artemisia Gentileschi's paintings must be examined against the background here sketched. In texts and images both pro- and anti-feminist, we have observed the persistence of two attitudes: that only exceptional women were free of the weaknesses of the female sex, and that exceptional women should remain in the realm of emblem, legend, and panegyric as long as their achievements and virtues were perceived to be dangerous in real life. As will be discussed more fully in Part III, Gentileschi's own female characters differ from these stereotypes and from conventional images of women in important respects, which implies the artist's awareness of the issues. Unlike the *femmes fortes* framed by moralizing verses and immobilized by their emblematic format, Artemisia's *Judith*s are armed with swords that cut, weapons they do not hesitate to use. And unlike the beautiful Susannas, Lucretias, and Cleopatras of men's art, who wriggle seductively even *in extremis*, Artemisia's nude heroines convincingly experience pain and emotional anguish. In her *oeuvre*, the stereotypes are inverted: evil women—Cleopatra, Potiphar's Wife—become heroic; saintly characters—the Virgin, Lucretia, Mary Magdalen—exude a meaty vitality. Thanks to the fortunate circumstance of her birthplace and time, the artist was heir to a Caravaggesque vocabulary within which she might develop a set of characters who were persuasively real, not imaginary, women. Through such characters, Gentileschi could suggest indirectly that the women worthies might share in the world of heroic action, not as would-be men, but simply as women who partook equally of the human condition. The result was far-reaching, for she forged a fusion of ordinary woman and heroic archetype that bridged in art a gap that would continue to plague feminist theory.

In light of the *querelle des femmes*, what kind of response did such pictures provoke in Artemisia's contemporaries? There is no evidence that her patrons, all men as far as we know, explicitly recognized the powerful feminist expression of her paintings. It seems likely that her popularity was based on other considerations. The nudity of many of her figures—especially the reclining *Cleopatra*—may have been calculated to satisfy the erotic tastes of her patrons, and Gentileschi herself may have recognized a gender advantage in her ready access to female models.[109] Yet despite her evident willingness to supply paintings that met a demand for suggestive images of the nude female body, Artemisia subverted the very principle of the passively available female body and reversed traditional expectations of the nude. Judged as nudes, her *Susanna*, *Cleopatra*, and *Lucretia*—anatomically awkward, plain in face and limb, and offering a larger slice of ordinary physicality than the genre calls for—must have disappointed patrons accustomed to the plumply seductive figures of a Titian or a Rubens, or to the marmoreal purity of a Guercino, Reni, or Orazio Gentileschi. Artemisia's patrons bought her female nudes and semi-nudes nevertheless, and if the anonymous Venetian poems of 1627 addressed to Artemisia offer a representative viewpoint, her collectors and admirers were probably more erotically stimulated by the idea of the woman painter than by the images she created.

Like Marino's *Gallery*, on which they may have been modelled,[110] the Venetian verses are short commentaries on paintings by well-known artists. Although these poems have been generally regarded as a homage to the painter, the verses subtly and not-so-subtly satirize Artemisia's pictures according to familiar stereotypical formulas. The anonymous author, unquestionably masculine, describes a *Lucretia* by Gentileschi:

> O new marvel!
> Yours, more than others, is indeed an unlucky star,
> Famous and beautiful woman.
> Collatino praised you:
> Tarquinio threatened you:
> Artemisia paints the event and renews it:
> Once Rome saw you cover the dagger with blood:
> Now, more than the dagger, her brush brings you death.

And in another poem:

> Tell me, who offends you more
> Unfortunate chaste woman:
> The husband, the lover, or the painter?[111]

In these verses, the heroine is conspired against by the painter along with the husband and lover, and she is done in by the artist's brush as much as by the bloody knife. Did the author see Artemisia's version of the theme as offensively unorthodox?

Or was there an underlying chivalric assumption that for a woman to paint a woman victim was a betrayal of her sex? If the latter is so, how much this tells us about the male artist's imaginative participation in the rapes and seductions *he* paints!

Artemisia's *Susanna* is presented by the poet as "*modesta*" and "*vergognosa*" (a word that can mean both "bashful" and "shameful"), wanting but not daring to raise her eyes to heaven. The formulation evokes Artemisia's Pommersfelden heroine, with her lowered eyes, even as it stubbornly reasserts the very concept of Susanna as a half-guilty victim that Artemisia, as we shall see, had in that painting studiously avoided:

> Here is the naked and beautiful
> Modest Jew between the two rival lovers,
> White-haired and slandering.
> You can see (art can imitate so well) that she,
> Praying, to heaven wished
> To lift her eyes, and,
> Modest and *vergognosa*, dares not.
> She fears not, indeed not, but dauntless and pious, hopes,
> With good fortune, to see
> Her life in the others' deaths.

The verses present other recognizable stereotypes. Describing a painting of an *Amoretto* by Artemisia (no longer known) in the possession of Iacomo Pighetti, the poet suggests that she understandably should be able to create a more lifelike version than a male artist with "learned virile hand," because as a woman she, like Venus, can also make a living child out of love (*un vivo Amor d'Amor*). No more succinct expression of masculine jealousy of female procreativity—and hence masculine appropriation of artistic creativity—could be found. In the same vein, the artist is invited to paint a portrait of the poet's beloved, and is advised that if "her earthly colors fail to capture the divine light of the subject's eyes," the painter should model the image upon her own face in the mirror. Women, he implies, are interchangeably divine as beauties, though they are not likely to attain divinity in their work as painters.

The final verse sustains the conceit of the female painter as goddess, whose divinity (but not her art) brings Zeuxis or Timanthes to mind before her learned brush. The beauty of the artist, and hence her separate, special path to the ideal and the divine, is a recurrent theme even in the few commentaries about Artemisia herself that remain. We find it in Dumonstier's dedication on his drawing of Artemisia's hand (Fig. 49), which links the painter's achievements in art with an image of a part of her body, her hand, which is itself linked to the beautiful hands of the goddess Aurora.[112] We find it again in Baldinucci's account of the artist G. F. Romanelli, who painted Artemisia's portrait and kept it in his own possession, boasting to his wife about her beauty, until out of jealousy the wife went to see for herself (see above, Chapter 1). And we find it more generally in the enormous popularity of self-portraits of women

artists, for the reason given by Annibale Caro to the father of Sofonisba Anguissola: "There is nothing that I desire more than the image of the artist herself, so that in a single work I can exhibit two marvels, one the work, the other the artist."[113] The frequent praise of women artists for their beauty was not so much a gracious compliment as a triple-barrelled weapon. It indicated, first, that despite their rise above their sex as exceptional *artistes savantes*, they remained on a par with all other women in a fundamental respect, by which they might also be defined. Furthermore, since beauty itself was a suspicious virtue, given its associations with corruptive influences, with vanity, laziness, luxury, and other female weaknesses, mention of the artist's beauty worked to oppose and undermine the acclaim of the learning and wisdom found in her art. And finally, as the Venetian poems show, a beautiful woman's very artistic achievements might be treated as accidental byproducts of a mystic "divinity" she could be said to possess—by virtue, it would seem, of her looks.

By contrast, the artistic creations of men were considered in the Renaissance to be the products of *ingegno*, a term whose meaning ranged from superior rational intelligence to absolute genius resulting from divine inspiration. Women in general were not considered capable of possessing *ingegno* because they allegedly lacked the higher powers of reason, especially those pertaining to inspiration, that were believed in the art academies to distinguish the genuine artist from a mere craftsman.[114] The idea that women were weaker in reason than men and the corollary notion that, being subject to men and thus farther removed from God, women were incapable of divinely inspired invention—concepts that had firm grounding both in scholastic theology and in Renaissance poetic theory[115]—were the bases for the tacit assumption among male artists and theorists of the sixteenth and seventeenth centuries that women might practice painting or sculpture, but could not, on account of their inferior biological nature, produce works of creative genius. Artemisia's own standing among contemporary male artists may be measured in these respects by a few telling comments that survive. Her father Orazio described his young daughter to the Florentine Grand-duchess Cristina as having already arrived, in three years of painting, at a level of knowledge (*sapere*) beyond that of leading masters of the art.[116] Allowing for some hyperbole on Orazio's part, the remark indicates not only pride in his daughter's manual accomplishments but also the extent to which the craft of painting had by the early seventeenth century become associated with intellectual capability. Joachim von Sandrart, the academician and friend of Artemisia, pronounced her work "very rational," a superior compliment for a woman, and one that was bestowed by Baldinucci as well, when he described her *Aurora* as demonstrating the joining of *ingegno* with the hand of a woman.[117] Such praise, however, carries the conspicuous earmark of exceptionality, the implication that Artemisia could be described in terms of knowledge and rationality because, as a woman, she displayed them unusually.

In at least one painting, the *Self-Portrait as the Allegory of Painting* (Color Plate 14), Artemisia demonstrated a full awareness of these issues, through her presentation

of one woman, herself, as a rational and thoughtful artist seen at the moment of creative inspiration. Artemisia's stress on the intellectual in her *Self-Portrait* must similarly be examined against the background of the seventeenth-century belief that women should not be educated in "advanced" knowledge, in the subjects recognized as men's sphere—grammar, logic, history, mathematics. The seventeenth century was a period of great intellectual ferment and educational expansion for men, and consequently the gap between men and women in educational opportunities only widened, despite the advocacy of women's education by feminist writers and salonistes. For this reason, the waste of women's intellectual abilities continued to be a central issue in feminist writings.[118] At mid-century in Holland, Anna Maria van Schurman, linguist and philosopher, advocated extensive female education; late in the seventeenth century, the cause was to be especially championed by English writers—Bathsua Makin, Hannah Woolley, Mary Astell, and Daniel Defoe.[119]

In the approximately three years she spent in the protected circle of the English royal court, Artemisia may well have encountered some of the English feminists, who were, like her patrons, largely royalist and Anglican. She could have had at least passing contact with Bathsua Makin, governess to the children of Charles I and Henrietta Maria, and author of a treatise on women's education published in 1673. Makin, a noted linguist and mathematician, came to Charles's service in about 1641, serving as tutor to the royal children, including Princess Elizabeth, who in her short life (1635–50) had learned many languages and was singled out for special praise in Makin's treatise.[120] The greatest intellectual influence on Makin had been Anna van Schurman, with whom she corresponded, and whom she extols in her treatise as a paragon of the intellectual woman. Inasmuch as Marie de' Medici, also a friend of van Schurman, spent several years at the English court immediately before Makin arrived, there would have been a fairly continuous feminist presence at Charles's court. Her daughter Henrietta Maria was herself a worthy heir to Marie de' Medici, sharing as consort many of the political burdens of Charles I's reign, and forcefully inserting her views on such matters as the Catholic issue (which made her unpopular with Protestant writers). Perhaps fortified by her mother's example, she seems to have cast herself, as did Anne of Austria, in the *femme forte* mold. In a New Year's masque of 1639–40, Henrietta Maria appeared as an amazon—surely in intentional recollection of that earlier *Angla virago*, Elizabeth I—wearing a plumed helmet and with "an antique sword hanging by her side, all as rich as might be."[121] The queen styled herself "Generalissima" when, in Holland, she rode horseback at the head of the army she was bringing Charles (evoking the memory of Rubens's image of her mother in triumph at Juliers), and she is said to have compared her camp life to that of Alexander the Great.[122]

Among such forceful feminist women, Artemisia Gentileschi is likely to have found compatible minds, and if these women never shared conversations on the woman question, it can only be because they were divided by class and status. Gen-

tileschi and Makin probably did not participate in court life as social equals of the
queen and the queen mother, since England lagged behind Italy in accepting artists
as gentlemen (in this case, ladies), as Orazio Gentileschi had discovered to his own
dismay. Yet we may reasonably infer that Henrietta Maria and Marie de' Medici had
more than a passing interest in the phenomenon of the woman artist, and it is not
improbable that Henrietta Maria had encouraged or even initiated Artemisia's
invitation to the English court. The pictures by Artemisia known to have been
acquired by Charles I (nearly all now lost) reveal in their subjects the shared taste of
both artist and patron for woman-focussed themes: Tarquin and Lucretia (acquired
by 1633–34); Susanna and the Elders (by 1639); a Fame (by 1639), a Bathsheba (painted
by c. 1640); a Pittura (painted by 1640), and the *Self-Portrait as Pittura* of 1630
(acquired in the 1630s?).[123] Marie de' Medici herself would likely have come face to
face with the *Self-Portrait*, the only painting from this group that has survived (Color
Plate 14), and one imagines that the queen mother—a lonely, isolated, and unwelcome
guest at the English court—might have warmed to recognize in Artemisia's living
allegory, in which self and archetype are merged, a response and tribute to the spirit
of her own personalized heroic allegorical cycle painted a generation earlier, in a
happier time.

Female imagery flourished as well in Henrietta Maria's personal artistic project,
the Queen's House at Greenwich, which the queen enthusiastically described as the
"House of Delight."[124] The decorative centerpiece of the Queen's House, the ceiling
of the entrance hall painted by Orazio and Artemisia Gentileschi, contained (as we
have seen) a central roundel depicting the Allegory of Peace surrounded by personi-
fications of the Liberal Arts, flanked by images of the Muses. The presentation of such
concepts through female figures represented a completely conventional application of
a familiar allegorical formula, and it would hardly have caused a misogynist stir. Yet
one man's empty allegory may be one woman's source of pride and inspiration, for it
was probably this very ceiling that fired the feminist imagination of Bathsua Makin,
when she wrote:

> It may now be demanded, by those studious of Antiquity, why the Vertues,
> the Disciplines, the Nine Muses, the Devisers, and Patrons of all good Arts,
> the Three Graces, should rather be represented under the Feminine Sex. . . .
> Why should the seven Liberal Arts be expressed in Womens Shapes? Doubt-
> less this is one reason; Women were the Inventors of many of these Arts,
> and the promoters of them, and since have studied them, and attained to an
> excellency in them: And being thus adorned and beautified with these
> Arts, as a testimony of our gratitude for their Invention, and as a token of
> honour for their Proficiency; we make Women the emblems of these things,
> having no fitter Hieroglyphick to express them by. I shall add this one thing,
> worthy observation, to the great honour and commendation of the Femi-
> nine Sex."[125]

For Makin, as for Marie de' Medici, Artemisia Gentileschi, and Christine de Pizan, authoritative images of women confirmed and symbolized their own belief in female capability. Each took stock of an allegorical tradition that had worked to glorify women in principle even as it disadvantaged them in reality, rendering the female sex at once as super-species and sub-species, and as a signifier rather than the significant. And each woman employed that very tradition to advance the feminist cause. Christine de Pizan worked a remarkable transformation when she described her spiritual enlightenment at the hands of the allegorical ladies who came to her rescue at her moment of anguish—Reason, Righteousness, Justice, and the Virgin Mary ("head of womankind"). Inverting the rhetorical convention to draw upon the strength rather than the weakness of the literary idea, Christine imbued her personifications of humankind's highest virtues with the functioning powers of *exponents* of those virtues, thus allotting to women the capacity both to embody an abstract good and to exercise it on behalf of another woman. Marie de' Medici demonstrated in the Luxembourg cycle, through images of herself as Bellona–Minerva and Justice–Good Government, the potential supremacy of the female sex, if the half-loaf of fictive allegory were added to the whole loaf of worldly power. And in her *Self-Portrait as the Allegory of Painting*, Artemisia Gentileschi showed that the living woman artist might also have the best of both the allegorical and the real world—that (as the anonymous Venetian poet had hinted darkly) her functioning creative abilities as a painter might, in some mystic way, be reified by her sex's abstract dominion over the realm of procreation. The threat to masculine social dominance that is inherent in such imagined mergers of the real and ideal is suggested in Nietzsche's remark: "Suppose truth is a woman, what then?"[126]

It is commonly asserted—though Bathsua Makin did not know it—that personifications such as Justice, Abundance, or Charity have been traditionally rendered in art as female because abstractions were feminine in the Latin language.[127] Yet such reasoning ultimately begs the question, since we would have to determine why the ancient languages Latin and Greek *have* gender, and whether a differentiating association between grammatical forms and the separate characteristics of the two human sexes existed at the beginning of language development, in order to understand fully how and why abstract concepts came to be associated with the female sex. And should that association turn out to have been totally coincidental, it would remain significant that it has continued with such force and persistence in Western artistic and literary traditions.

Like the personifications, the women worthies and *femmes fortes* transcended both history and fact, and as archetypes they too held an extraordinary power. Though every image of a mythic or allegorical character may bear value-laden inflections, every imaged recurrence of that archetype also strengthens its universal familiarity and its potency as a template in the memory to reinforce specific beliefs, even contradictory beliefs, that different people or groups might hold. The very images that served Anne of Austria as heroic reinforcement of her own strength may simul-

taneously have confirmed a belief in generic female inferiority that was probably held by most of her masculine courtiers. Certainly the same might be said of artistic images of male heroes, such as Hercules, David, or Apollo—that they too have been multivalent archetypes whose iconographic meanings have varied or changed. There is a significant difference, however, because many of the female archetypes originated in a pre-patriarchal world, and thus the recurrent images of the heroines often served as carriers for more ancient meanings than did those of the heroes. As Bathsua Makin half-guessed, buried in the archetypal vocabulary are glimpses of an older world order, of the female's ancient Neolithic association with art and the crafts (Athena), with agriculture (Demeter), with the creation of civilization (Semiramis), with procreation (Mary). As vehicles that sustained the visual memory—though not the cognitive knowledge—of woman's lost or usurped realm, the archetypal women worthies carried a hidden power, a kind of mana, that was dangerous to the conscious patriarchal mind and thus had to be subconsciously managed, through the compensatory myths of female inferiority.

One form of management lay in the principle of inversion—Athena became servant of the patriarchy, born of Zeus's brain, goddess of war; the ancient benevolent Great Goddess's snake became the symbol of Eve's temptation. Another form of control lay in the linguistically supported mode of conveying abstract ideas through the female image, not only in allegories, but through extended associations given to the characters. Thus Lucretia became a symbol of (men's) political freedom, and Judith a symbol of (male) political victory over tyranny. Whether as warped versions of ancient concepts, or as vehicles for men's ideals, the female archetypes and allegories became denatured, obliged to mean something other than what they originally meant, or what women might wish them to mean. Yet in its obsessive repetition of these characters, one sees the patriculture attempting to deal with forgotten knowledge, struggling—as Jung might have it—both to suppress and to recover its female half. It is a central paradox of our artistic traditions that the ancient natural abilities and powers of women that men sought to control or propitiate through the management of female images were kept alive by the very images contrived to contain them. And living, though misunderstood, the allegories and the worthies could at any time become the vehicle for the restoration of original meaning by a Bathsua Makin or an Artemisia Gentileschi.

PART III of this book concerns five of the themes treated in paintings by Gentileschi, female archetypes who have been especially prevalent in Western art: Susanna, Lucretia, Cleopatra, Judith, and Pittura (the Allegory of Painting). I shall explore the nature and variety of iconographic meanings given each of these characters by male artists, as background and counterpoint to the innovative and original expressive interpretations of Gentileschi. Artemisia's awareness of her own position as a woman artist is demonstrated by her preference for themes celebrating women, a respect in

which she may not have been unique, for what little evidence we have suggests that other women artists of her period may also have gravitated toward the heroines.[128] Yet the depth, strength, and complexity of Artemisia's artistic voice separated her categorically from other women artists of the Renaissance and Baroque era whom we presently know. And she was distinguished, in an era when the modern struggle for women's social equality was taking shape, by her binding of the female heroic archetype to Everywoman, and for her provision of a visual model in which mundane women might recognize themselves, from which they might draw inspiration, and through which all women—beautiful or plain, heroic or ordinary, powerful or powerless—might live vicariously in art.

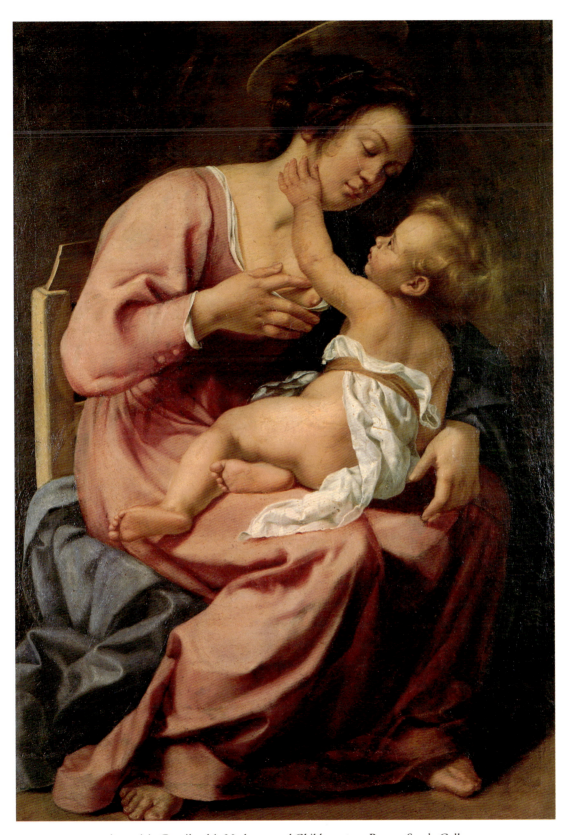

1. Artemisia Gentileschi, *Madonna and Child*, c. 1609. Rome, Spada Gallery

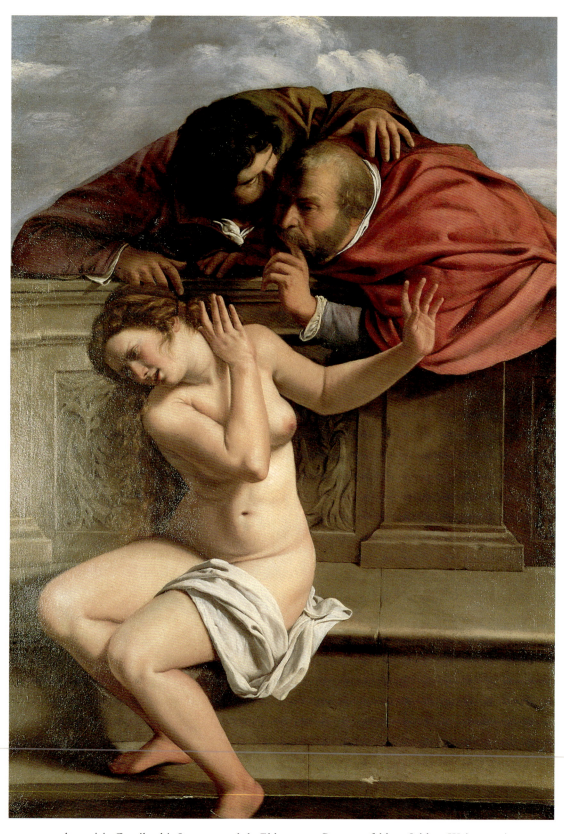

2. Artemisia Gentileschi, *Susanna and the Elders*, 1610. Pommersfelden, Schloss Weissenstein

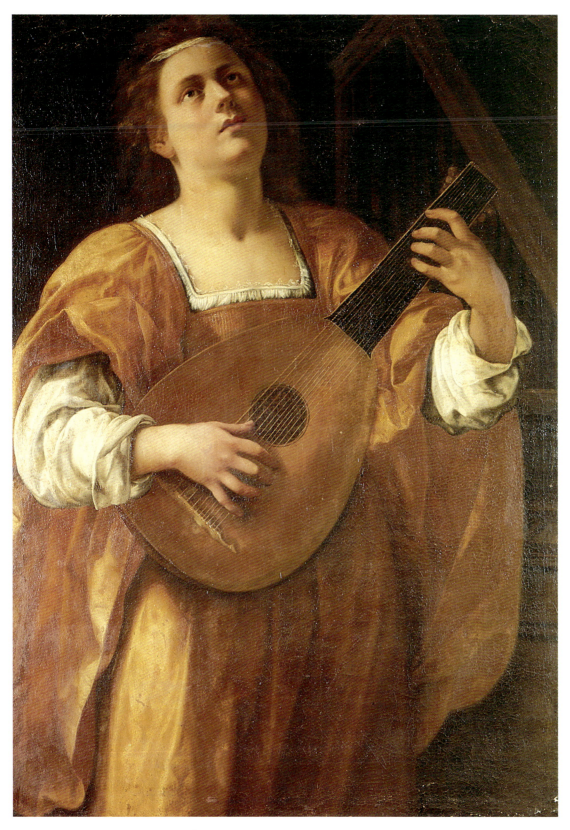

3. Artemisia Gentileschi, *Woman Playing a Lute*, c. 1610–12. Rome, Spada Gallery

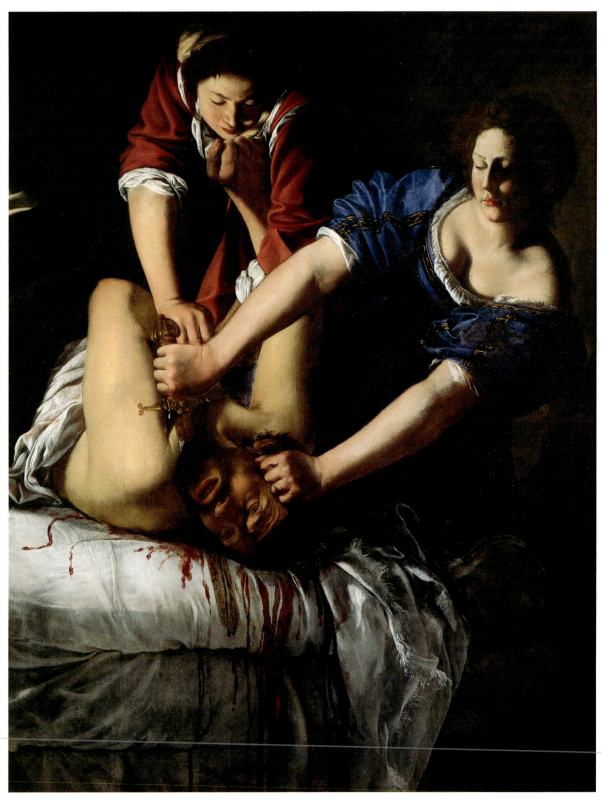

4. Artemisia Gentileschi, *Judith Slaying Holofernes*, 1612–13. Naples, Museo di Capodimonte

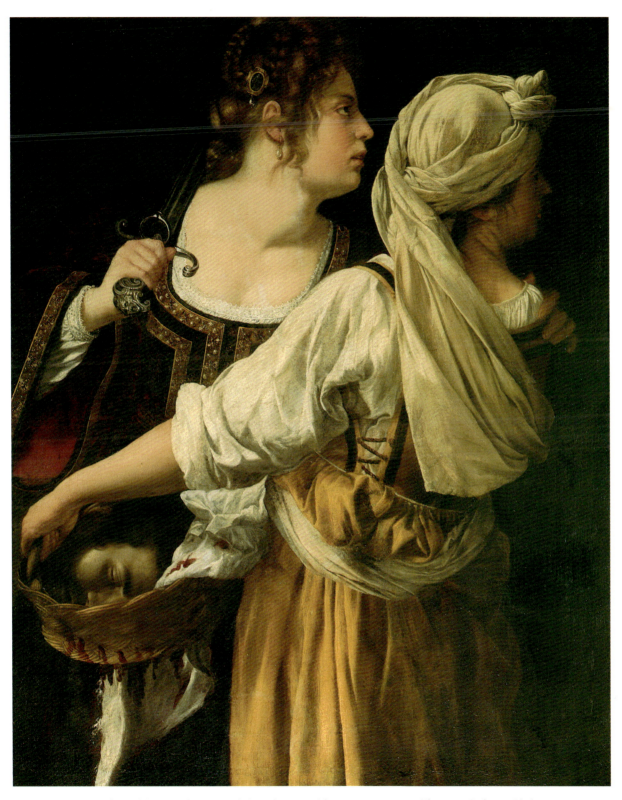

5. Artemisia Gentileschi, *Judith and Her Maidservant*, c. 1613–14. Florence, Palazzo Pitti

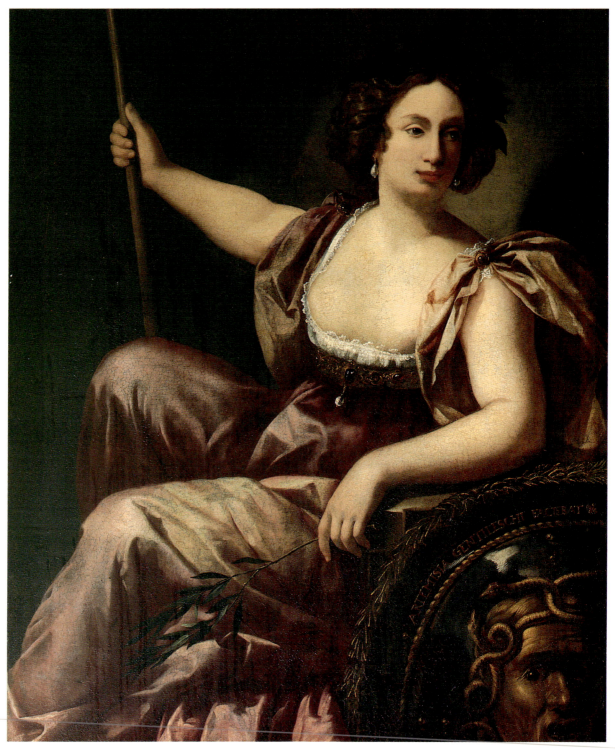

6. Artemisia Gentileschi, *Minerva (Anne of Austria?)*, c. 1615. Florence, Soprintendenza alle Gallerie

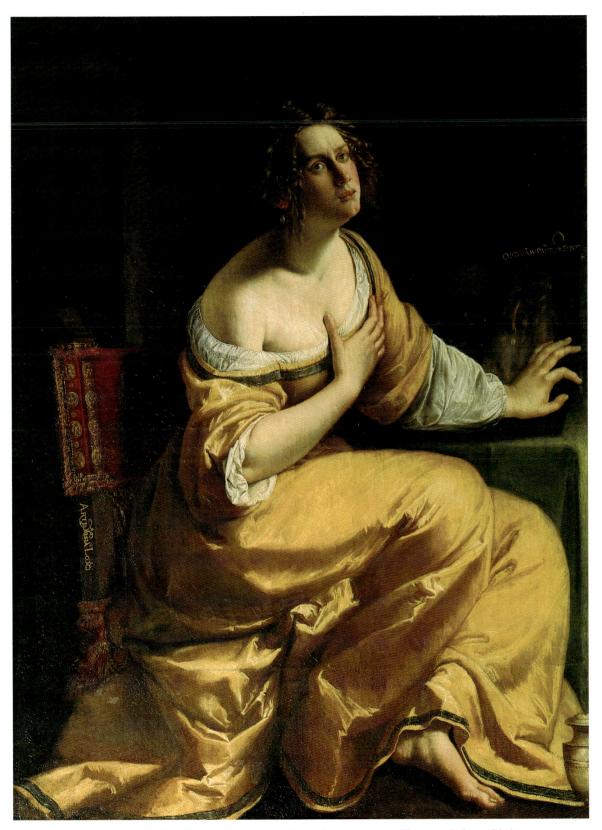

7. Artemisia Gentileschi, *The Penitent Magdalen*, c. 1617–20, Florence, Palazzo Pitti

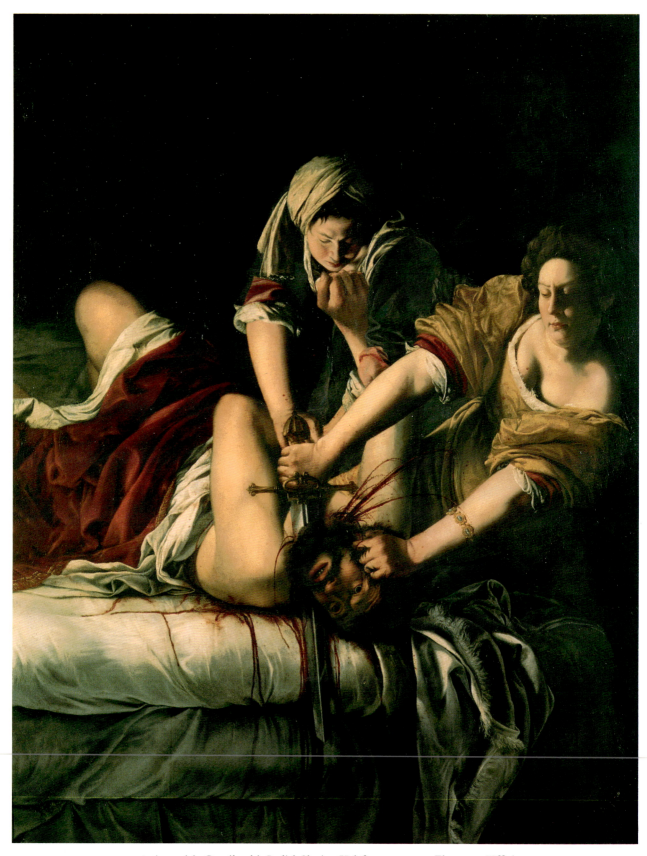

8. Artemisia Gentileschi, *Judith Slaying Holofernes*, c. 1620. Florence, Uffizi

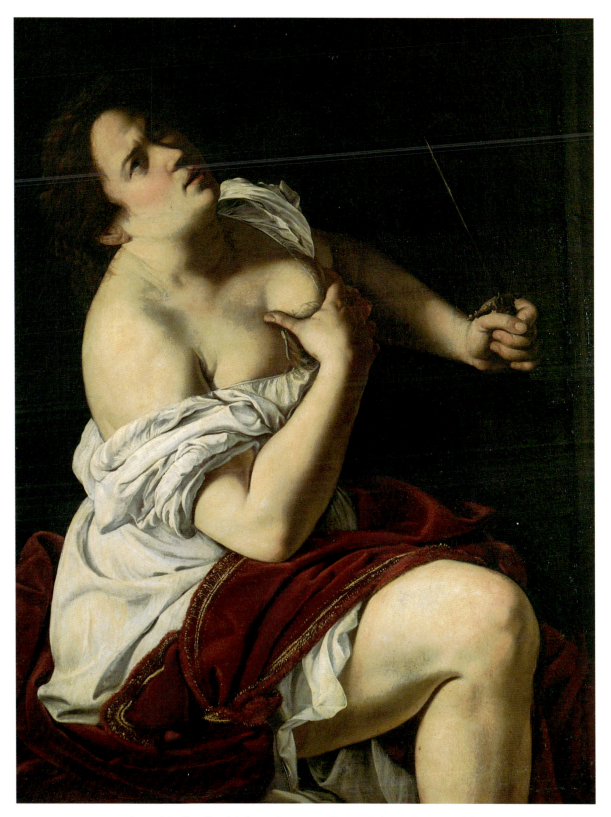

9. Artemisia Gentileschi, *Lucretia*, c. 1621. Genoa, Palazzo Cattaneo-Adorno

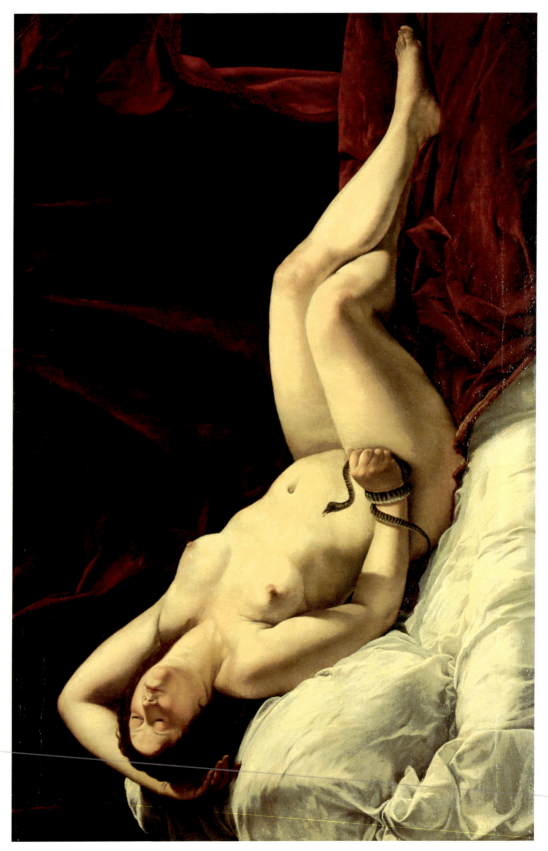

10. Artemisia Gentileschi, *Cleopatra*, 1621–22. Milan, Amedeo Morandotti

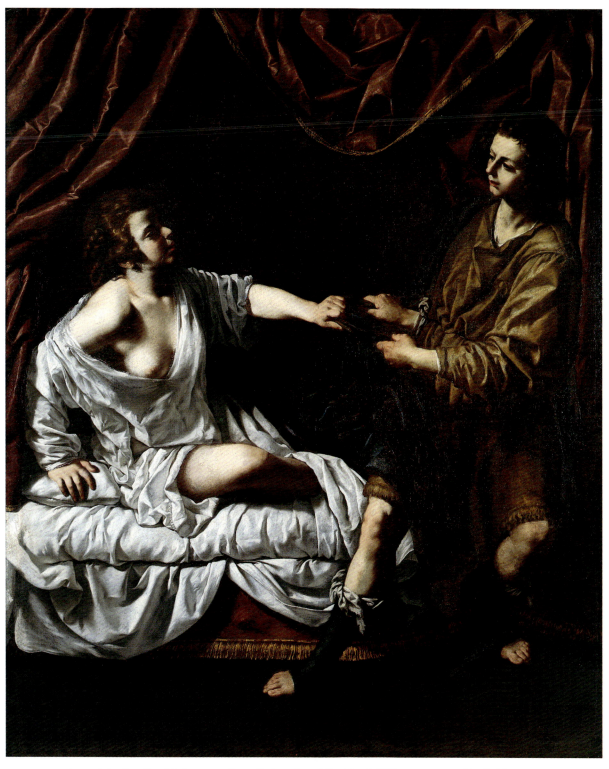

11. Artemisia Gentileschi (here attributed), *Joseph and Potiphar's Wife*, c. 1622–23. Cambridge, Mass.,
Fogg Art Museum

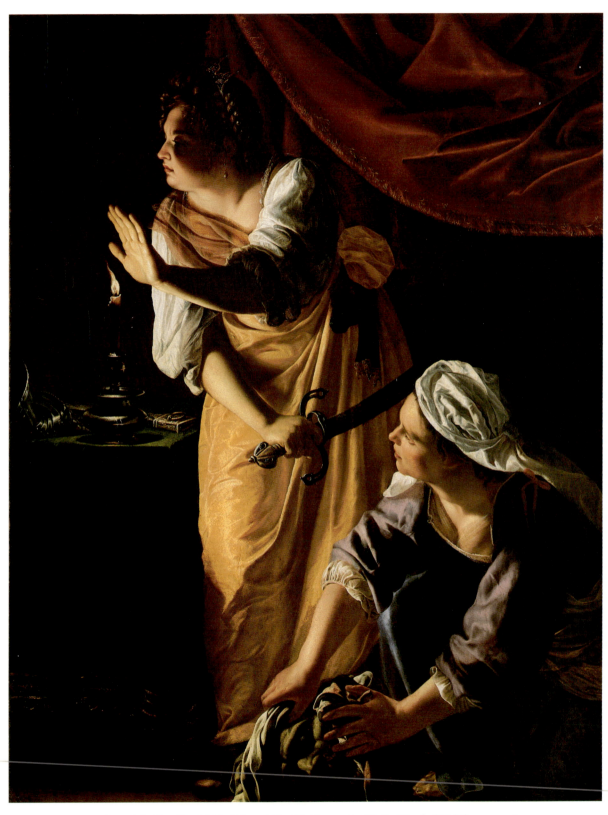

12. Artemisia Gentileschi, *Judith and Her Maidservant with the Head of Holofernes*, c. 1625. Detroit, Institute of Arts

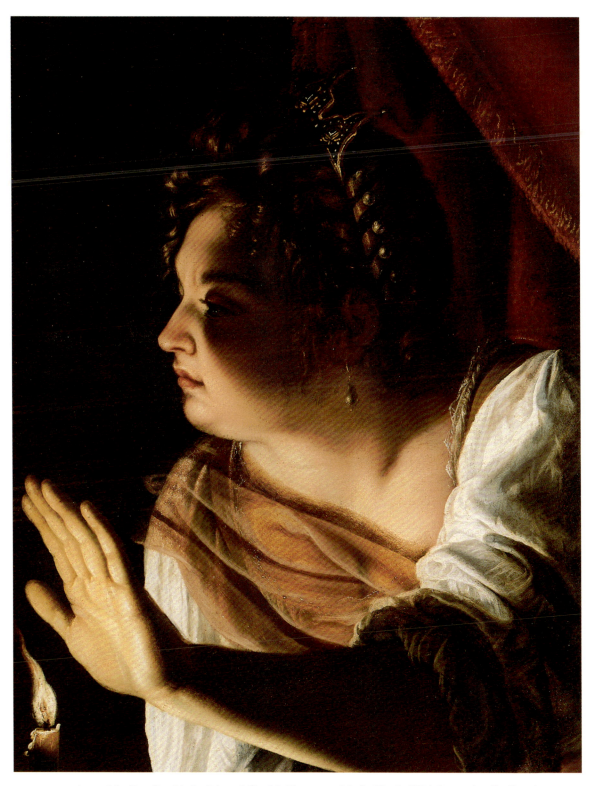

13. Artemisia Gentileschi, *Judith and Her Maidservant with the Head of Holofernes*, detail of head

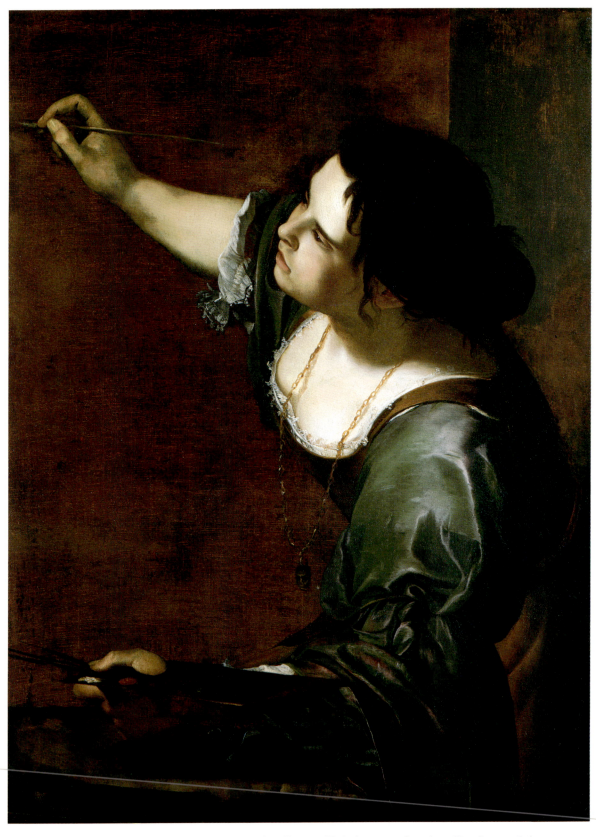

14. Artemisia Gentileschi, *Self-Portrait as the Allegory of Painting*, 1630. London, Kensington Palace,
Collection of Her Majesty the Queen

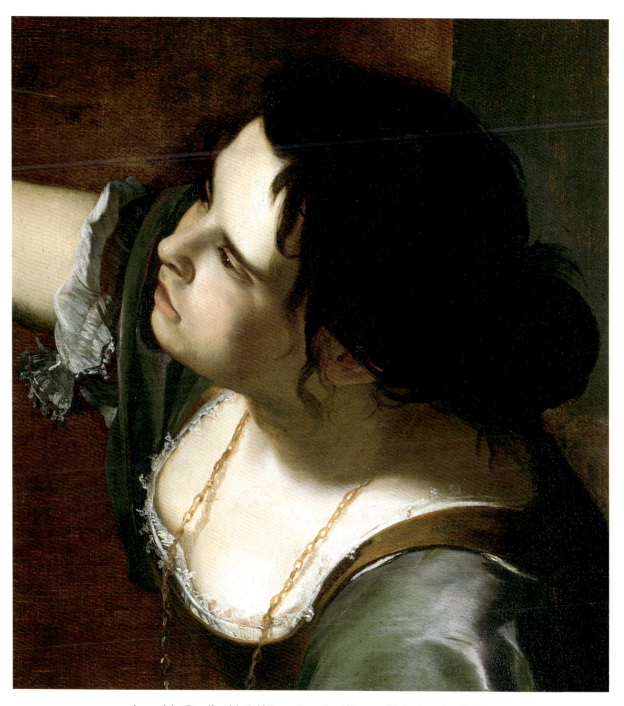

15. Artemisia Gentileschi, *Self-Portrait as the Allegory of Painting*, detail of head

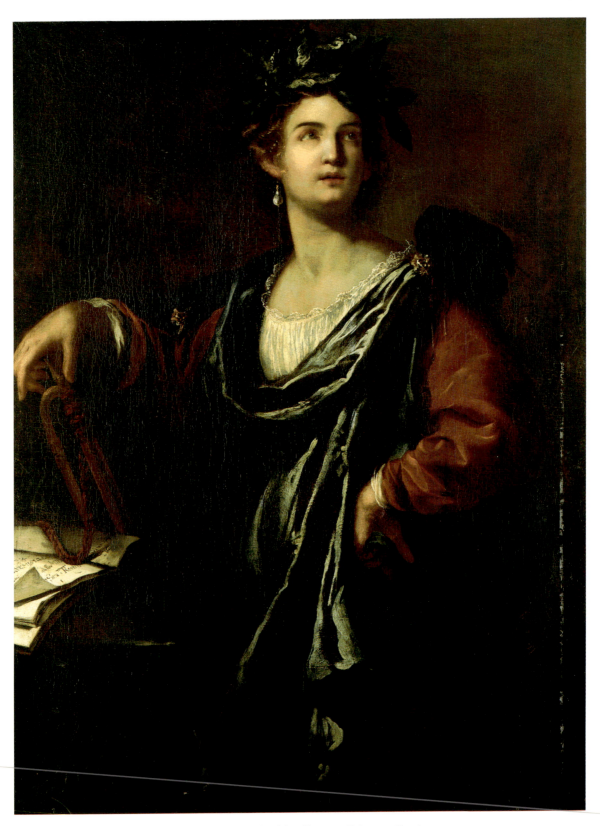

16. Artemisia Gentileschi, *Clio*, 1632. Private collection

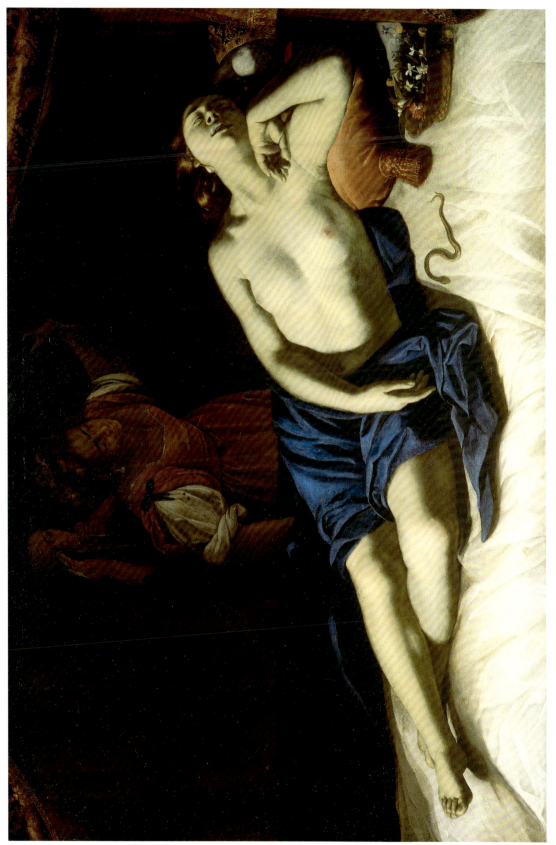

17. Artemisia Gentileschi, *Cleopatra*, early 1630s(?). London, private collection

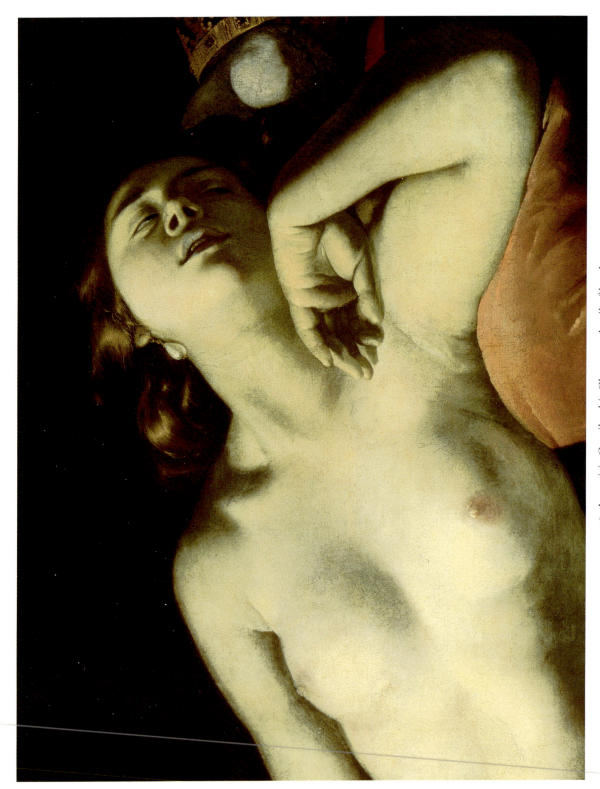

18. Artemisia Gentileschi, *Cleopatra*, detail of head

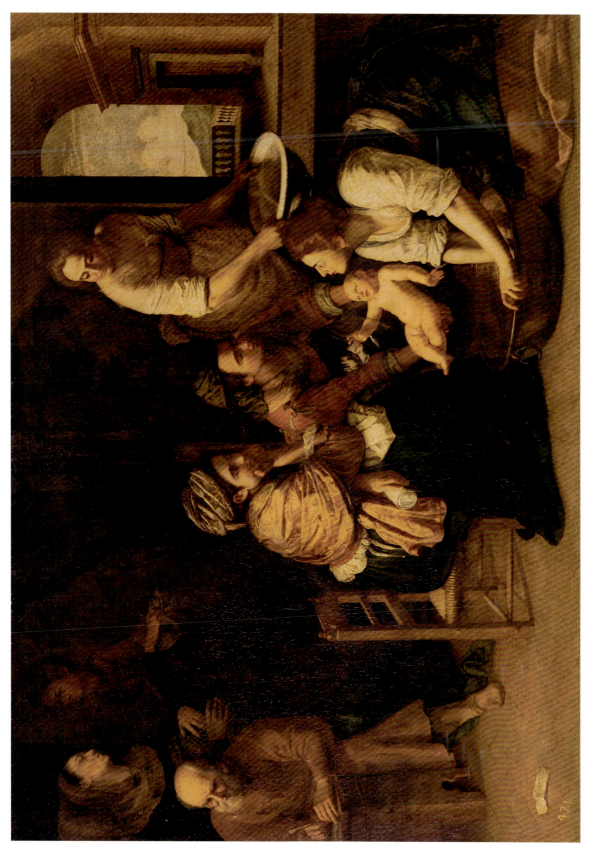

19. Artemisia Gentileschi, *Birth of St. John the Baptist*, 1631–33. Madrid, Prado

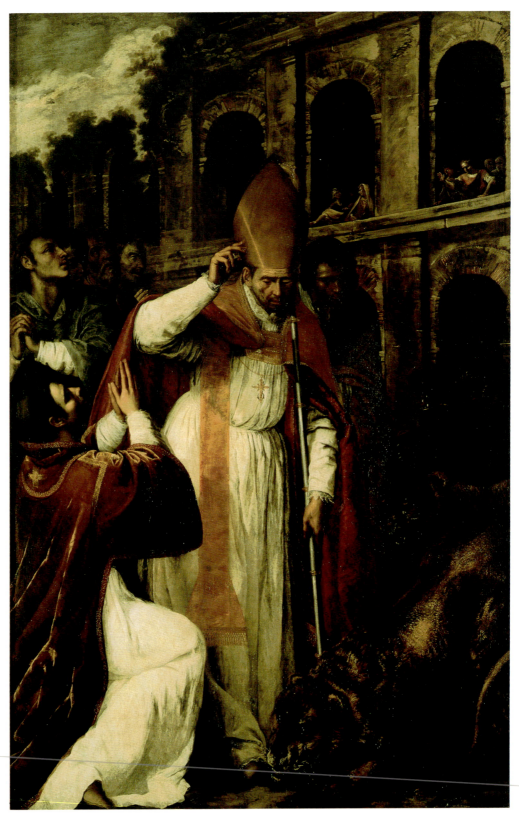

20. Artemisia Gentileschi, *The Martyrdom of St. Januarius in the Ampitheater at Pozzuoli*, 1636–37. Naples, Laboratorio di Conservazione di Capodimonte

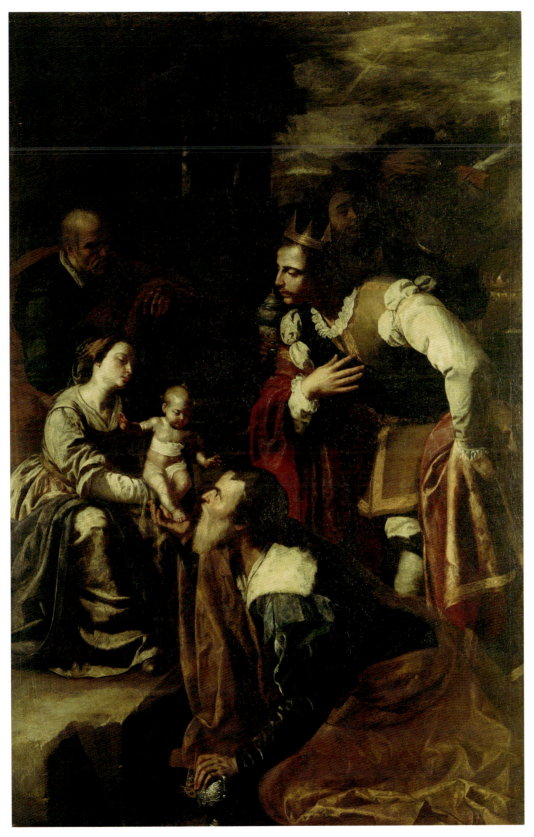

21. Artemisia Gentileschi, *The Adoration of the Magi*, 1636–37.
Naples, Laboratorio di Conservazione di Capodimonte

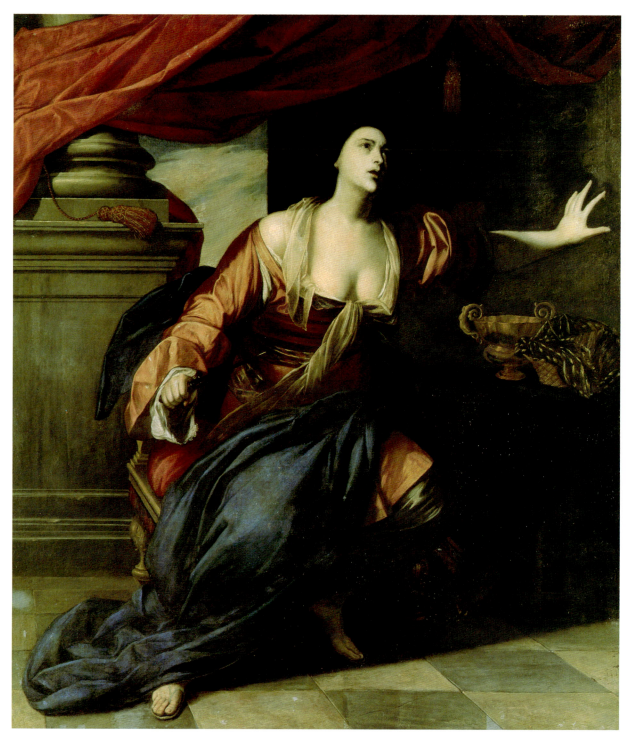

22. Artemisia Gentileschi (here attributed), *Lucretia*, 1642–43. Naples, Museo di Capodimonte

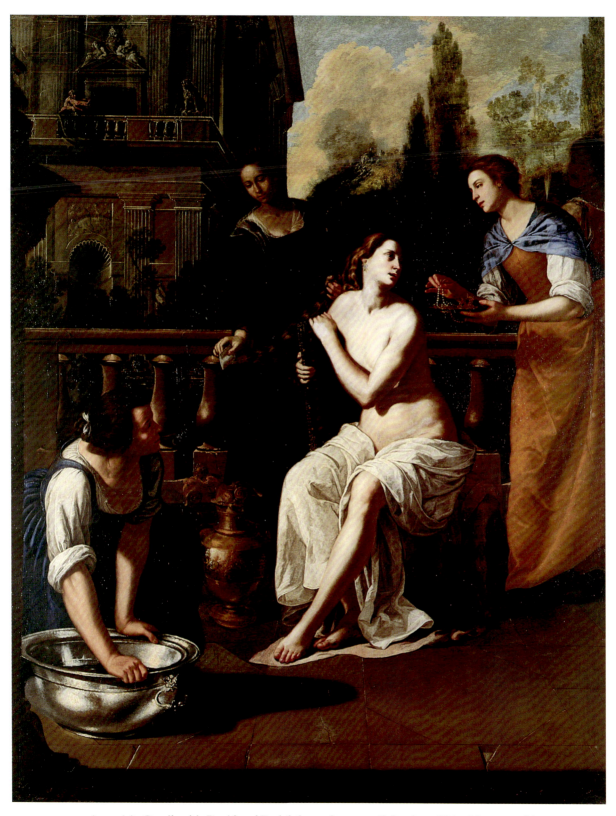

23. Artemisia Gentileschi, *David and Bathsheba*, early 1640s. Columbus, Ohio, Museum of Art

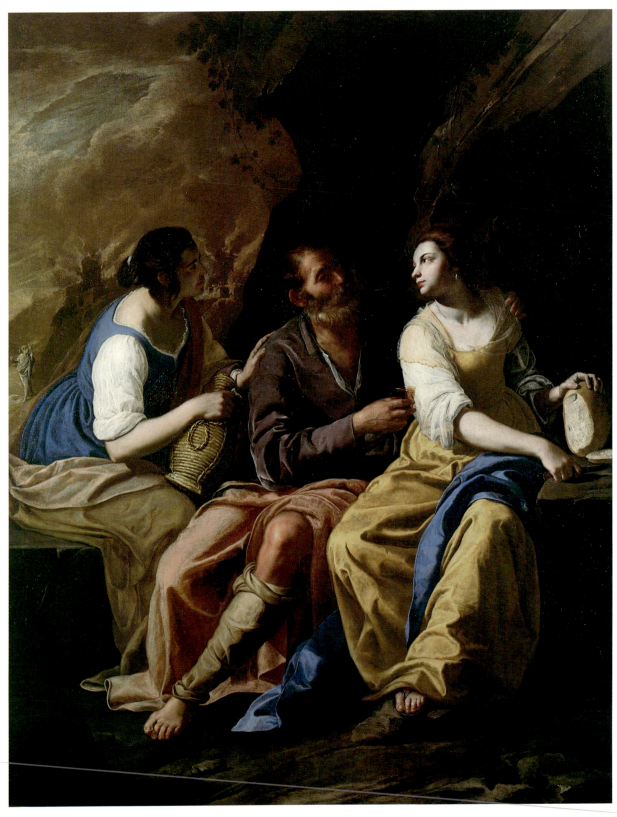

24. Artemisia Gentileschi (here attributed), *Lot and His Daughters*, 1640s(?).
Toledo, Ohio, Museum of Art

# PART III
# Artemisia Gentileschi's Heroic Women

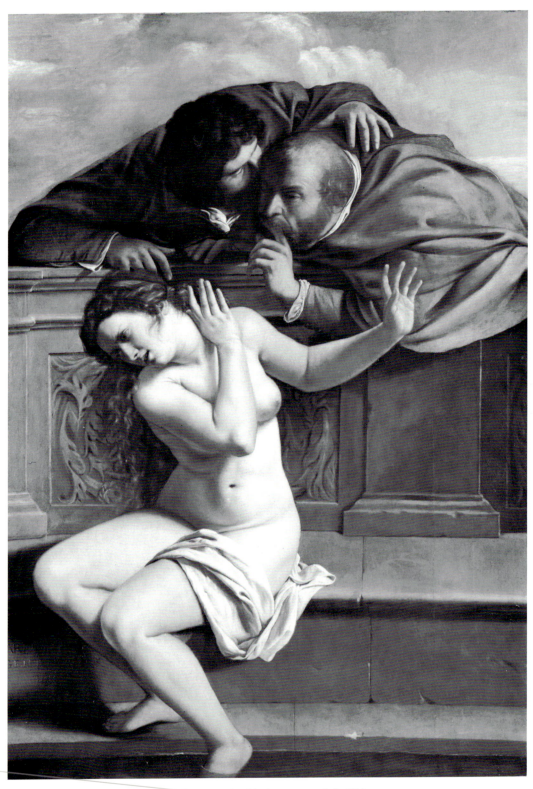

151. Artemisia Gentileschi, *Susanna and the Elders*, 1610.
Pommersfelden, Schloss Weissenstein, Schönborn Collection

# Susanna

I am certain that there are plenty of beautiful women who are virtuous and chaste and who know how to protect themselves well from the entrapments of deceitful men. I am therefore troubled and grieved when men argue that many women want to be raped and that it does not bother them at all to be raped by men even when they verbally protest. It would be hard to believe that such great villany is actually pleasant for them.

—Christine de Pizan[1]

WHEN the germinal feminist exhibition *Women Artists, 1550–1950* travelled to several American cities in 1977, viewers were treated to the spectacle of six paintings by Artemisia Gentileschi, more than had ever been seen together at one time in this country.[2] The rarest sight among these canvases was the painting of *Susanna and the Elders* (Fig. 151 and Color Plate 2), a work long hidden from the public eye in a private collection in Pommersfelden, Germany, and a problematic picture in the Gentileschi *oeuvre*. For although the *Susanna* was included in the *Women Artists* exhibition as a work by Artemisia Gentileschi, that attribution was still widely contested, both by scholars who doubted that she could have painted it and by those who questioned the remarkably early date inscribed on the picture.[3] As the earliest known painting that bears Artemisia's signature, the *Susanna* is a pivotal work for Gentileschi studies, and it is therefore necessary to begin the third and major section of this book with a consideration of the attribution problem presented by the painting.

Although the *Susanna* in the Schönborn collection bears the prominent inscription "ARTEMITIA / GENTILESCHI F. / 1610" on the step at the lower left (Fig. 152), scholars have been divided in their attribution of the work between Artemisia and her father. Orazio was proposed as the artist, first by Longhi, then by others,[4] on the grounds that 1610 was impossibly early for the daughter, who was presumed to have been only thirteen years old at the time. In 1968, R. Ward Bissell established Artemisia's correct birthdate as 1593 rather than 1597, and sustained the attribution of the *Susanna* to her on stylistic grounds. He suggested, however, following an idea earlier advanced by Voss, that the date on the canvas should be read as 1619, when Artemisia's artistic maturity would have more nearly matched the technical sophistication of the painting.[5] In her catalogue entry of the Los Angeles exhibition, Ann Sutherland Harris supported the attribution to Artemisia and reaffirmed the probable date as

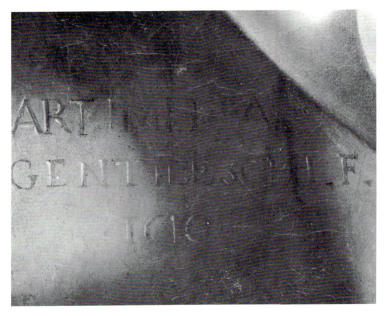

152. Artemisia Gentileschi, *Susanna and the Elders*, 1610, detail
of inscription. Pommersfelden, Schloss Weissenstein

1610, following a reading of the inscription given by the curator of the collection.[6] When the painting came to American museums in 1977, close inspection and laboratory analysis made it possible to confirm beyond doubt that the date indeed reads 1610, and that the signature and date presently visible formed an original part of the picture.[7] All technical evidence pointed, therefore, to the authenticity of the signature and date, and consequently to the authenticity of the Pommersfelden *Susanna and the Elders* as by Artemisia Gentileschi, her earliest preserved signed work, and one of her earliest paintings.

Even with the advancing of Artemisia's age from thirteen to seventeen, however, the picture still confronted scholars with an unusually accomplished technical performance by a young artist who in 1610 had, by her father's account, only been painting about a year.[8] Moir explained this by proposing that Orazio had helped his daughter-pupil extensively in the planning and execution of the work, a suggestion that differs only in degree from Longhi's opinion that Orazio essentially painted the picture and put Artemisia's name on it.[9] From an exclusively stylistic point of view, this is a persuasive argument, since Artemisia's early works are very close to those of Orazio in formal conception and color harmony. As discussed in Chapter 1, many of Orazio's compositions of the 1605–1610 period—the Fabbriano *Magdalen in Penitence*, the *St. Michael Overcoming the Devil*, and the Dublin *David Slaying Goliath*—exhibit a penchant for dramatic gestures and animated facial expressions combined with an angular stiffness of pose that characterizes the *Susanna* as well. Inevitably, a pupil's

first achievement is successful emulation of the master's model, and masters have frequently assisted that imitative artistic education by working directly on the pupil's canvas—improving a contour here, or a turn of drapery there—to a degree that now eludes even the most experienced connoisseur's eye. With this in mind, we must acknowledge Orazio's likely literal participation in many of Artemisia's early works, on a modest technical and stylistic level. On the other hand, we can distinguish more effectively between the two artists, even at this early point in Artemisia's career, if we take into account the expressive character of the *Susanna and the Elders*. Surprisingly, no scholarly attention has yet been devoted to the single most exceptional aspect of this painting, its treatment of the theme.

It may be useful to review the biblical legend. The Apocryphal story of Susanna and the Elders describes an event that reputedly occurred in Babylon during the Jewish Exile of the sixth century B.C.[10] Susanna was the beautiful wife of a wealthy and prominent Jew, Joachim, at whose home the Jewish community was accustomed to gather. Two Elders of the community (sometimes described as judges) who frequented the house became secretly attracted to Susanna and conspired to seduce her. Hiding in the garden where the beautiful woman habitually bathed, they sprang upon her the moment her maids were gone, demanding her sexual submission, and threatening, if she did not yield to them, to denounce her publicly with the accusation that she had had an adulterous relationship in the garden with a young man. Although the crime with which she was to be falsely charged was punishable by death, Susanna stalwartly resisted the Elders' demands, and they accordingly spread the rumor. She was brought to trial on their evidence, convicted, and sentenced to death, but at the last minute, the young Daniel came forward to claim that her sentence was based upon false witness, and to demand a new trial. Daniel himself conducted the investigation, and by the device of interrogating the Elders separately, asking each man under which tree it was that the alleged act took place, was able to elicit the conflicting evidence—one said a holm (or oak) tree, the other a mastic—that proved Susanna's innocence. Accordingly, it was the Elders and not Susanna who were put to death, for the crime of false testimony.[11]

With its inherent symbolic and dramatic possibilities, the Susanna theme had been depicted in art since Early Christian times. In a catacomb painting in the Cemetery of Pretestato, of c. 350, Susanna is shown as a lamb between two wolves (Fig. 153). Susanna (whose name is the Hebrew word for "lily," a flower long associated with purity) is here equated with the Church, as an innocent victim of predators, and the Elders with those peoples, Jews and pagans, who conspired against the Church.[12] The Susanna story is also found among narrative cycles, such as the Brescia *lipsanotheca* (Fig. 154), of the 360s, where the three episodes shown along the lower border—Susanna and the Elders, Susanna before Daniel, and Daniel in the lion's den—form a useful paradigm, in combination with scenes from the life of Christ, of the prevalent early medieval theme of salvation or deliverance.[13] The narrative potential

153. Susanna portrayed as a lamb between two wolves, c. A.D. 350. Artist's rendering after catacomb painting, Cemetery of Pretestato, Rome

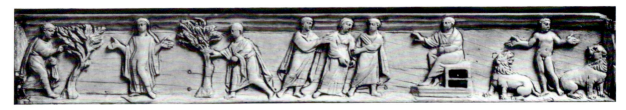

154. Front, lower border of *lipsanotheca*, A.D. 360–70. Brescia, Museo Civico

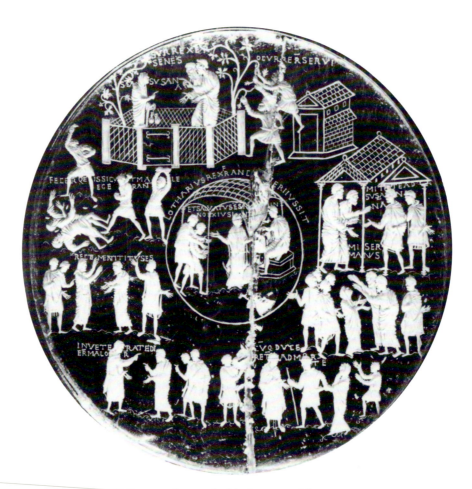

155. The Lothar Crystal, carved with the story of Susanna, A.D. 843–69. London, Trustees of the British Museum

of the theme accounts for its expansion in the Carolingian Lothar Crystal (Fig. 155), on which are carved no less than nine episodes, from Susanna's assault by the Elders in a now well-developed enclosed garden to her vindication before Daniel in the central image of the crystal.[14]

These iconographic types presenting Susanna as an archetypal figure of innocence and purity, first threatened and then miraculously saved, were replaced in the Renaissance by a characteristic preference for a single narrative scene focussed upon the dramatic and pictorially arresting image of the nude heroine surprised by her assailants, in a garden whose landscape elements were often the object of independent aesthetic exploration (Fig. 156). Even in such a context of changing artistic concerns, Susanna continued to serve a symbolic spiritual role, for her stainless purity became assimilated to that of the Virgin Mary, who is evoked in many sixteenth-century Venetian Susanna paintings through attributes that merged naturally with those of the Old Testament heroine, such as the lily or the *hortus conclusus*.[15] Tintoretto's justly famous *Susanna* in Vienna of around 1555 (Fig. 157) may best exemplify the sophisticated duality sustained in such Marian Susannas, for the artist manages subliminally to evoke Mary's purity and divinity not only through such attributes as the rose

156. Anonymous sixteenth-century artist, *Susanna and the Elders*. The Trustees of the Chatsworth Settlement

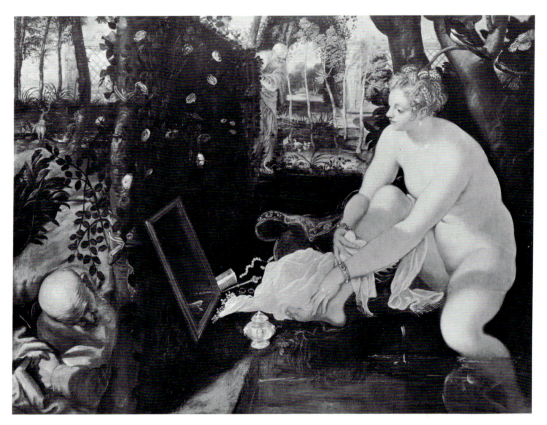

157. Jacopo Tintoretto, *Susanna and the Elders*, c. 1555–56. Vienna, Kunsthistorisches Museum

hedge, the reflective mirror, and the purifying pool of water, but also in the refined, elevated beauty of the heroine's luminous, opalescent—yet unattainable—body.[16]

Despite the survival of a suitably theologized moral identity, however, the growing popularity of the Susanna theme in Cinquecento and Seicento art appears to have been due chiefly to the sensual and purely secular appeal that the image of a nude female in a garden held for the growing class of private patrons who commissioned easel paintings in the Renaissance. By the turn of the seventeenth century, many Susanna pictures were distinguished—if that is the word—by a hard-core eroticism that was sometimes subtle and sometimes hardly so. Especially blatant in its pornographic appeal is a *Susanna and the Elders* of c. 1607, a version of the theme painted only a few years before the Pommersfelden *Susanna*, by an artist who was a family friend of the Gentileschi, the Cavaliere d'Arpino (Fig. 158).[17] D'Arpino's Susanna poses seductively for the viewer, who is encouraged by her overt gaze to imagine himself in the fortunate position of the approaching Elders, though he is evidently much more welcome. She wrings her hair, like Venus in the bath, while a nearby fountain gushes a stream of water, whose sexual suggestiveness is fortified by the visually analogous curve of drapery that spurts between Susanna's nearly naked thighs.

The d'Arpino version of the theme belongs in the general context of a group of Susanna paintings and prints from the Carracci circle, a group that includes Annibale's print of c. 1590 (Fig. 159), and a painting by Annibale of around 1601–1602, now lost but known in a copy or variant by another artist (Fig. 160), who was probably Domenichino.[18] As Ann Sutherland Harris has noted, the Gentileschi *Susanna* at Pommersfelden also belongs among those compositions that originated in the Carracci circle.[19] Yet granting a family resemblance among these works, a direct comparison of them with the Schönborn picture serves principally to establish its essential difference from the others. While Susanna's legs correspond generally in pose with those in Annibale's print, the position of the arms has been decisively changed, and her image accordingly revised, from a sexually available and responsive female to an emotionally distressed young woman, whose vulnerability is emphasized in the awkward twisting of her body. The artist has also eliminated the sexually allusive garden setting, replacing the lush foliage, spurting fountain, and sculptured satyr heads that appear in the Carracci circle works with an austere rectilinear stone balustrade that subtly reinforces our sense of Susanna's discomfort.

By contrast to the cognate images, the expressive core of the Gentileschi painting is the heroine's plight, not the villains' anticipated pleasure. And while one might well

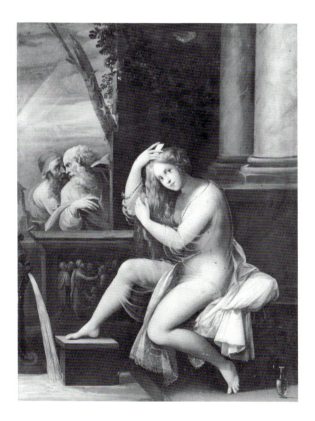

158. Giuseppe Cesari (Cavaliere) d'Arpino, *Susanna and the Elders*, c. 1607. Siena, Ospedale di S. Maria della Scala

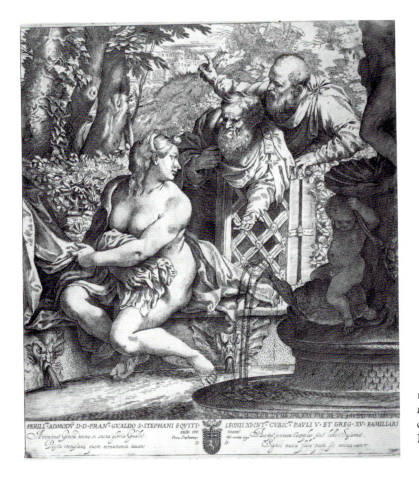

159. Annibale Carracci, *Susanna and the Elders*, etching and engraving, c. 1590. Washington, D.C., National Gallery of Art

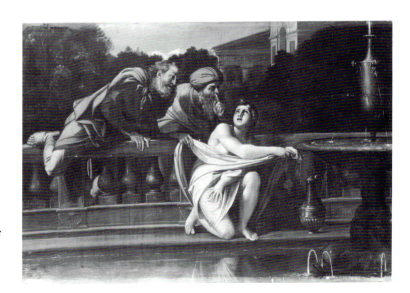

160. Domenichino, *Susanna and the Elders*, 1603. Rome, Palazzo Doria-Pamphilj

expect this to be the case, since Susanna's chastity and moral rectitude were after all the point of the Apocryphal story, it is in fact the Carracci circle pictures, and not Artemisia's work, that represent the more usual treatment of the Susanna theme in Western art.

Few artistic themes have offered so satisfying an opportunity for legitimized voyeurism as Susanna and the Elders. The subject was taken up with relish by artists from the sixteenth through eighteenth centuries as an opportunity to display the female nude, in much the same spirit that such themes as Danae or Lucretia were approached, but with the added advantage that the nude's erotic appeal could be heightened by the presence of two lecherous old men, whose inclusion was both iconographically justified and pornographically effective.[20] It is, indeed, a remarkable testament to the indomitable male ego that a biblical theme holding forth an exemplum of female chastity should have become in painting a celebration of sexual opportunity, or, as Max Rooses enthusiastically described Rubens's version, a "gallant enterprise mounted by two bold adventurers."[21] Tintoretto, whose adventurers stage their advance in a manner more sneaky than bold (Fig. 157), nonetheless offers a representative depiction of the theme in his emphasis upon Susanna's voluptuous body and upon the Elders's ingenuity in getting a closer look at it. Even when a painter attempted to convey some rhetorical distress on Susanna's part, as did the eighteenth-century Dutch painter Adriaan van der Burg (Fig. 161), he was apt to offset it with a graceful pose whose chief effect was the display of a beautiful nude. As the Susanna

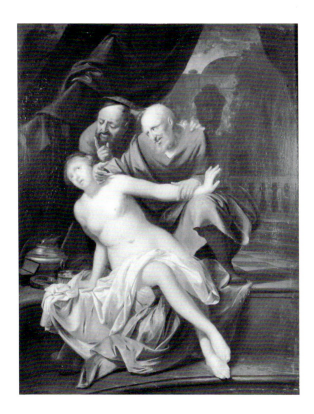

161. Adriaan van der Burg, *Susanna and the Elders*, eighteenth century. Toulouse, Musée des Augustins

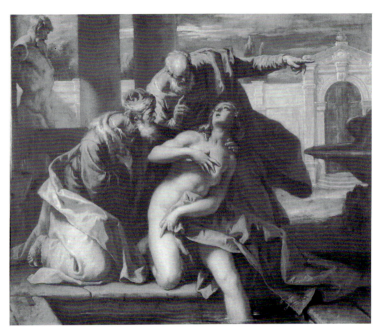

162. Sebastiano Ricci, *Susanna and the Elders*, eighteenth century.
The Trustees of the Chatsworth Settlement,
Devonshire Collection

theme was particularly prevalent in Venice, one more Venetian example—an eight-eenth-century painting by Sebastiano Ricci (Fig. 162)—may suffice to demonstrate that the prevailing pictorial treatment of the theme typically included an erotically suggestive garden setting and a partly nude Susanna, whose body is prominent and alluring, and whose expressive range runs from protest of a largely rhetorical nature to the hint of outright acquiescence.

In that the imagined consequence of the action is possession of a woman who has firmly said "No," the covert subject of the Susanna theme in Western art is not seduction but rape, imagined by artists—and presumably also by their patrons and customers—as a daring and noble adventure. That rape should have been glorified in art is not surprising, in view of the heroic position it has occupied in mythic tradition, serving as the pivotal event in such epics of colonization as the rape of Helen by Paris or the rape of the Sabines, not to mention the inventively diverse forms of sexual conquest performed by Zeus and Apollo, all inevitably sanitized in description as "ab-ductions."[22] And yet "abduction," a word defined as the taking away of women "with or without their consent," is precisely accurate. Language has conveniently removed the need to distinguish between willing and unwilling women, convenient since it is not at all clear what were the attitudes of Europa, Io, Helen, or the daughters of Leucippus toward their abductors. Those artists who have glamorized the act of

rape—among them, Rubens, Bernini, and Poussin—have at least acted in consonance with the masculine bias of the Greek retailers of ancient myths.[23] Susanna, however, as a potential rape victim who emphatically halted the proceedings, is a rare heroine in biblical mythology—her extremism in defense of virtue was topped only by that of Lucretia and Virginia—and the unusually well-defined resistance of Artemisia's Susanna throws into bold relief the extent to which she has been distorted into a half-willing participant in post-Renaissance art.

The biblical Susanna had of course already been distorted in the patristic literature of the Early Christian Church, but in a different direction. Exegetical comparisons were drawn by some theologians between the temptation of Susanna and the temptation of Eve. Hippolytus, the third-century bishop of Rome and martyr, explains: "For as of old the Devil was concealed in the serpent in the garden, so now too, the Devil, concealed in the Elders, fired them with his own lust that he might a second time corrupt Eve."[24] Rubens alludes to this tradition in his Munich *Susanna* (Fig. 163), as Mark Leach has shown, by including an apple tree in the garden instead of the oak or mastic called for in the story. Susanna, whom Hippolytus also associates with the Church, successfully resists this "supreme temptation involving the essence

163. Peter Paul Rubens, *Susanna and the Elders*, 1636–40. Munich, Alte Pinakothek

of human volition" (Leach's phrase), and thus prefigures the Church's redemption of original sin.[25] But the extraordinary underlying assumption on the part of both Hippolytus and Leach is that Susanna-Eve should have found the pair of old lechers as tempting as they found her! Indeed, the Apocryphal account of Susanna and the Elders effectively eliminates the potentially distracting issue of mutual temptation by casting the male assailants as Elders, thus rendering their lust reprehensible and Susanna's voluntary acquiescence unthinkable, in order to concentrate dramatic attention upon the story's climax and denouement, in which Daniel successfully differentiates between her true account and their false ones.

As an Old Testament parable (more accurately, *haggadah*), the Susanna story represents a contest between good and evil, or virtue and vice, mediated by wise judgment. Susanna herself is a personification of the good Israelite wife, whose sexuality was her husband's exclusive property,[26] and Susanna's total fidelity to Joachim is demonstrated in her willingness to accept death rather than dishonor him by yielding to the Elders. Her resistance is heroic because she faces danger; it is not complicated by any conflict of feeling toward her oppressors; and she is crucial to the story, flat character that she is, in the absoluteness of her resolve, her virtue, and her honesty. Renaissance and Baroque artists, however, ignored the fundamental moral of the story—the discovery of truth and the execution of justice that were precipitated by Susanna's action—and focussed instead upon the secondary plot devices of temptation, seduction, and the erotic escapades of the Elders. Tellingly, many more depictions of Susanna and the Elders exist than of either the Judgment of Daniel or the Stoning of the Elders.[27] Both the patristic and the artistic conceptions of Susanna, whether as an Eve triumphant over her own impulses or as a voluptuous sex object who may not bother to resist, are linked by the same erroneous assumption: that Susanna's dilemma was whether or not to give in to her sexual instincts. In art, a sexually distorted and spiritually meaningless interpretation of the theme has prevailed because most artists and patrons have been men, drawn by instinct to identify more with the villains than with the heroine.

Occasionally, there have appeared versions of the Susanna theme that place some emphasis upon her character and her personal anguish. One of these is a painting by Honthorst of 1655, in the Borghese Gallery (Fig. 164), in which a muscular, androgynous Susanna is on her feet, struggling vigorously to escape, her face an image of horror and shock that is as convincing a mirror of inner suffering as that of Artemisia's heroine.[28] In Rembrandt's *Susanna* of 1647 in Berlin (Fig. 165), one of the most sympathetic treatments of the biblical heroine, we find a concern with her youth, innocence, and vulnerability that is thoroughly characteristic of the artist. Yet even Rembrandt is not immune to sexual stereotype, for he implants in the pose of Susanna, whose arms reach to cover her breasts and genitals, the memory of the *Medici Venus*, a classical model that was virtually synonymous with female sexuality (Fig. 292).[29] In the d'Arpino, Carracci, Domenichino, and Rubens *Susannas*, the classical

164. Gerrit van Honthorst, *Susanna and the Elders*, 1655. Rome, Galleria Borghese

165. Rembrandt van Rijn, *Susanna and the Elders*, 1647. Berlin-Dahlem,
Staatliche Museen, Preussicher Kulturbesitz, Gemäldegalerie

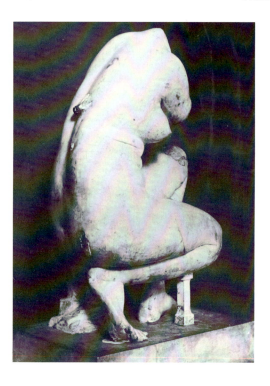

166. Greco-Roman, *Crouching Venus*,
c. 250–240 B.C. Paris, Louvre

model was the crouching Venus Anadyomene, a type known in numerous variants
(Fig. 166), whose association with the bath connects her with Susanna on a luxurious
and erotic level.[30] The frequent echo of these antique prototypes in paintings of the
Susanna theme underlines their use as a device to evoke erotic recollections, in the
classic formulation of having it both ways: adhering superficially to the requirement
that Susanna be chaste, while appealing subliminally to the memory of the Venus
archetype, whose gestures of modesty call attention to what she conceals.

In Gentileschi's *Susanna*, the Venus model has been conspicuously avoided. In-
stead, the artist, evidently as aware as the Carracci circle artists of the possibilities of
*double entendre* through classical allusion, replaces the crouching Venus with an un-
mistakable reference to a different antique prototype. The dramatic defensive gesture
of Susanna's upper body is taken from a figure on a Roman Orestes sarcophagus, the
figure of Orestes's nurse (Fig. 167), who memorably conveys the anguished response
of Orestes to the advent of the Furies. This sarcophagus was known in Rome in at
least three variant versions, in the Lateran, the Vatican, and the Giustiniani Palace
(the latter being Gentileschi's most likely model), and it was the source of endless
borrowings by artists such as Raphael, Titian, and Fuseli.[31] One of the most promi-
nent quotations of the nurse's pose is found on the Sistine Ceiling, where it is used
in reverse by Michelangelo for the figure of Adam in the *Expulsion* (Fig. 168).[32] (As is
discussed in Chapter 1, the color scheme of the *Susanna* may have been inspired by
the Sistine ceiling in general, even as the Sistine *ignudi* may have contributed to the

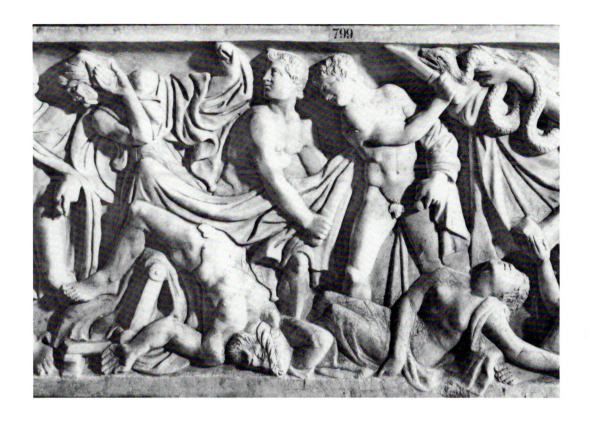

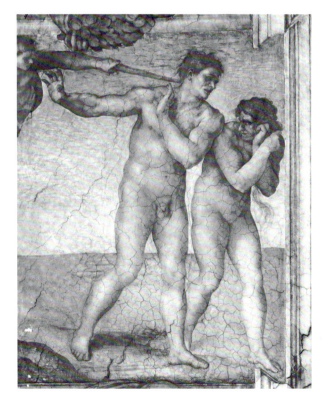

167. Roman sarcophagus, *Orestes Slaying Clytemnestra and Aegisthus*, detail. Rome, Museo Profano Lateranense

168. Michelangelo, *Expulsion of Adam and Eve*, 1509–1511. Rome, Vatican, Sistine Ceiling

image of an emotionally tortured, semi-nude figure seated on a hard stone bench in a twisted pose.) The artist of the Schönborn painting, by incorporating a gesture that carried associations with antique and Renaissance works of epic proportions and tragic overtones, restored to the Susanna theme the tone of high seriousness that it surely deserves.[33]

The Schönborn *Susanna* also carries over from its antique prototype the suggestion that a sympathetic character is being hounded on a psychological level, and the painting differs in this respect from the Sistine *Expulsion of Adam and Eve*, where the relationship between the punished Adam and the moral authority, Gabriel, is direct and physical. At the same time, and again unlike Michelangelo's more straightforward narrative, the painter of the *Susanna* sustains a certain ambiguity about guilt and punishment, right and wrong, that is present in the relief as well. Orestes's action was not a clear-cut instance of either just vengeance or unjustified murder, and the figure of the nurse effectively sets the expressive tone in the relief. Through her gesture of pushing away a thing she cannot face, she establishes a psychological dimension that indirectly recalls the complexity of Orestes's feelings about the deed.[34] Similarly, if we were to read the Gentileschi picture naively, the figure of Susanna might appear, in her position and gestural response, to react to some judgment from the two men who loom high over her. Such evocative ambiguity is brilliantly suited to the Susanna theme, reminding the viewer simultaneously of the Elders' false accusation of the woman and their threat to expose and punish her, and—a subtler echo—of the just punishment that came to the Elders when their own genuine guilt was exposed by Daniel.

The painter of *Susanna and the Elders*, then, avoided traditional allusions to Venus, adopting instead a gestural vocabulary from the Orestes sarcophagus to suggest both the anguish of the heroine and the punitive consequences of the event. I believe that the evidence of the sarcophagus quotation supports the conclusion that it must have been the female Artemisia Gentileschi, rather than the male Orazio, who made such an artistic decision; yet the problem is complicated by the fact that Orazio Gentileschi also borrowed a pose from the Orestes sarcophagus for the figure of David in his Dublin *David and Goliath* (Fig. 169), a picture that is close in date to the *Susanna*.[35] Does this mean that Orazio, who unquestionably painted the *David*, must also have painted the *Susanna*? Or that he brought the sarcophagus to the attention of his daughter who, in borrowing a pose from it for her *Susanna*, was reflecting her father's interests rather than her own? Neither, I think, if we examine closely the nature of the borrowing in each case. Evidently, it was the swashbuckling pose of the male hero, Orestes, and his interaction with fallen bodies, that principally interested Orazio and shaped his conception of this active version of the David theme, a version that is sharply contrasted with the contemplative *David*s of the same period (e.g., the Spada version; see Fig. 266), which were built upon different classical prototypes.[36] But in the Dublin *David*, Orazio has fused two passages from the classical model,

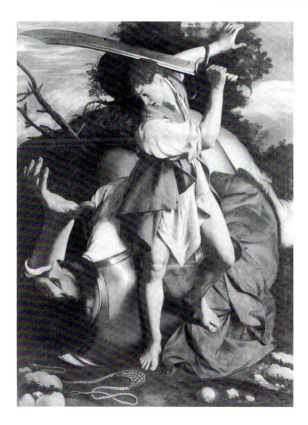

169. Orazio Gentileschi, *David Slaying Goliath*, c. 1605–1610. Dublin, National Gallery of Ireland

incorporating part of the nurse's gesture in the hero's left hand, in order to develop a more energetic and gracefully balanced figure than the Orestes of the sarcophagus. This transplanted gesture differs markedly from its counterpart in the *Susanna*, where it is more functional than decorative, serving by its pivotal placement to interrupt the compositional flow and to convey intense inner feeling.

It is very unlikely that Orazio would make of a single antique prototype two such entirely different expressive uses as are made of the nurse in the *Susanna* and in the Dublin *David*, and particularly not during a single brief period of his career. Orazio's interest in the Orestes sarcophagus may have sparked Artemisia's, but the difference between the pictorial derivations establishes beyond doubt that it is Artemisia's creative imagination we see at work in the *Susanna*. Looking at the sarcophagus with different eyes—female eyes—she saw the gesture of the nurse as of central, not peripheral, importance, and chose it to form the expressive core of the *Susanna*.

Artemisia's conception of the figure of Susanna involved, of course, more than a fortuitous combination of classical and Michelangelesque quotations, since the rudimentary pose and gesture have been developed into a fully realized female nude, and set in a new pictorial context. Nude or nearly nude figures are found in both artists' work, but a point in favor of Artemisia's authorship is the figure's uncompromising

naturalism, since as a woman she had access only to female nude models, while male artists in general during the sixteenth and seventeenth centuries usually worked from male models, improvising their transformation into women where required.[37] Susanna's body is persuasively composed of flesh; it is articulated by specific realist touches that are unflattering by conventional standards of beauty, such as the groin wrinkle, the crow's foot wrinkles at the top of her right arm, and the lines in her neck. The naturalistically pendant breast, the recognizably feminine abdomen, and the awkwardly proportioned legs further attest that this figure was closely studied from life. By contrast, Orazio Gentileschi's relatively rare nude and partly nude figures— for example, the *Danae* in Cleveland of 1621–22 (Fig. 208) and the Vienna *Magdalen* of the late 1620s—are more idealized, with inorganic, molded breasts and little anatomical articulation.

The difference between Artemisia's and Orazio's treatments of female figures is more fundamental, however, than their approaches to anatomical drawing. While women figure prominently in Orazio's paintings, in such themes as Judith and Holofernes, Lot and His Daughters, the Rest on the Flight into Egypt, or St. Cecilia (significantly, no Susannas are known), their range of expression is limited, and the characters are usually passive. Orazio, whose general preference was for quiet and meditative themes, portrayed even his most active female characters, Judith and her maidservant (Fig. 17), in a moment of watching and waiting, and he indicated through the women's anxious glances in opposite directions the existence of a pervasive and oppressive outside threat that has effectively inhibited these heroines's completion of their task. By contrast, Artemisia's Pitti and Detroit *Judith*s (Color Plates 5 and 12) react to a specific danger from a single direction, a change that, combined with their capable presence and psychic energy, implies an enemy who is life-sized and local, perhaps even conquerable. The Schönborn Susanna behaves more like Artemisia's Judiths than Orazio's, in her physically active resistance of her oppressors, and in her expressive intensity. She conveys through her awkward pose and her nudity the full range of feelings—anxiety, fear, and shame—experienced by a victimized woman faced with a choice between rape and slanderous public denouncement. Artemisia's Susanna presents an image rare in art, of a three-dimensional female character who is heroic in the classical sense, for in her struggle against forces ultimately beyond her control, she exhibits a spectrum of human emotions that move us, as with Oedipus or Achilles, to pity and to awe.

The uniqueness of Artemisia's interpretation is further confirmed by the existence of two examples of the Susanna theme that are based in part upon her version. The first (Fig. 170) is a painting by Simone Cantarini dating from 1640–42 in the Pinacoteca, Bologna.[38] In this picture the figure of Susanna repeats Artemisia's pose histrionically and without inner motivation, while the relocation of the Elders makes Susanna's gesture pointless. The work is a classic instance of an artist borrowing a pose without understanding its expressive function. The second picture, in the

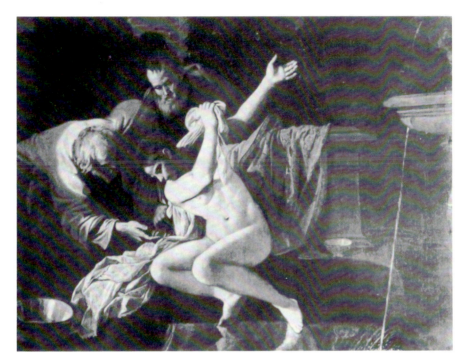

170. Simone Cantarini, *Susanna and the Elders*, 1640–42. Bologna, Pinacoteca

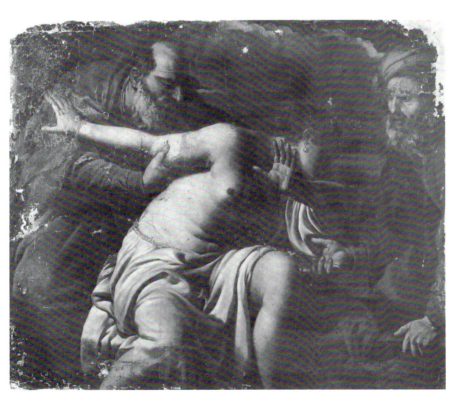

171. Anonymous seventeenth-century artist, *Susanna and the Elders*.
Rome, Galleria Nazionale d'Arte Antica, Palazzo Corsini

Palazzo Corsini, Rome (Fig. 171), by an anonymous Bolognese artist of the seven-teenth century, presents a Susanna whose gesture is more faithful in spirit to Artemisia's prototype, with a more dignified sense of measure and of physical bulk than is seen in Cantarini's flyaway figure. Yet here too the sympathetic treatment of the Elders and the subliminal sexual message suggested through the spotlighted earring betray an essentially masculine conception of the theme. Through their own internal inconsistencies, these paintings reveal their derivative origins, and they dem-onstrate as well that a portrayal of Susanna from the heroine's viewpoint was a rare achievement indeed in Renaissance and Baroque art, unattainable even by imitators of such a model.[39]

There is of course a risk of oversimplification in drawing a characteristic gender distinction between Orazio and Artemisia Gentileschi, and then between Artemisia and her male imitators, on the basis of their respective treatments of a female char-acter. Yet it is rare that we know anything so categoric about two artists' psyches as we do about Artemisia and her father, differentiated as they were by sex, and conse-quently by attitude and experience. Particularly in view of the feminist cast of much of Artemisia's subsequent work, it is reasonable to propose in this instance that the consideration of temperamental probability may be as valid as connoisseurship of style in solving the attribution problem. And the Susanna problem is not an isolated one. We need reliable bases for distinguishing the work of the women artists in his-tory who are now being rediscovered in increasing numbers, and whose artistic iden-tities have so often been subsumed under the names of their fathers and husbands. Stylistic considerations are often of limited value since, as we have seen with Artemisia and Orazio, the pupil was apt to be an eager disciple in the master's style. Yet if Morelli's hypothesis may be applied here, the artist's functioning on the unconscious level betrays personal traits that offer rich evidence for discovering his or her identity, traits in this case happily more interesting than Morellian earlobes and fingernails. This is not to insist that all art by women bears some inevitable stamp of femininity; women have been as talented as men in learning the common denominators of style and expression in specific cultures. It is, however, to suggest that the definitive as-signment of sex roles in history has created fundamental differences between the sexes in their perception, experience, and expectations of the world, differences that cannot help but have been carried over into the creative process, where they have sometimes left their tracks. We need not decide whether sex-role differentiation has been a good thing, or whether art has been the richer or poorer for it, to observe that the sow's ear of sexism has given us at least one silk purse: an art historical tool for distinguish-ing between male and female artists.

These considerations apply in the case of another *Susanna and the Elders* that has been connected with the Gentileschi family. A picture now in the Burghley House Collection (Fig. 172) was earlier exhibited as a work of Orazio and is presently as-cribed to Artemisia.[40] No scholar is known to have vigorously defended the Artemisia

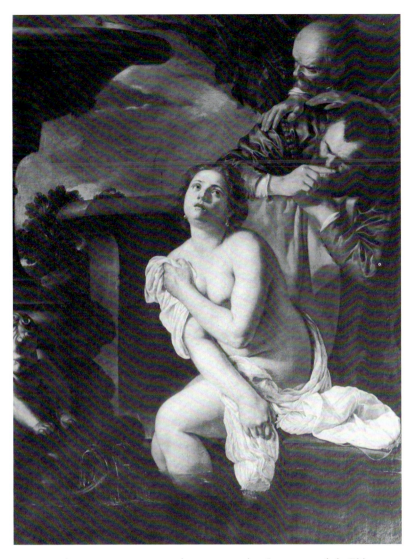

172. Anonymous seventeenth-century artist, *Susanna and the Elders*.
From the Burghley House Collection

attribution; Bissell and Harris have merely considered it "possible," with Harris suggesting a date in the 1620s.[41] Certain features of the painting distinctly recall Artemisia's style: the thick and awkwardly bent knee, the muscular shoulder, the heavy three-dimensionality of the forearm with its backlighted contour. On the other hand, the anatomically unconvincing breasts and the fussy but heavy bathcloth drapery seem alien to her *oeuvre*. Moreover, this English *Susanna* shows no interpretative continuity with the Schönborn picture, but reverts instead to the Carracci and Domenichino prototypes, reintroducing a seductive, Venus pudica pose and up-turned eyes,[42] and an environment swelling with cupids and spurting fountains. If Artemisia were the artist, the concreteness of detail, the firmness of contour, and the

large scale of the figures in relation to format would suggest a dating in the 1620s or early 1630s. Admittedly, we lack a body of work fully representative of her range, yet it is virtually unthinkable that the seductive and dreamily responsive Susanna in the Burghley House painting could be by the same hand and contemporary with the heroic and anti-romantic *Judith and Holofernes* in Detroit, or even with the stoically dignified women seen in the *Birth of the Baptist* of the early 1630s and the *Lucretia* of the early 1640s. Other typological differences, such as the broad noses of the three characters in this picture that contrast markedly with Artemisia's preferred narrow, pointed nose type, serve to confirm one's instinctive reaction to reject this attribution principally because its expressive character is incommensurate with Artemisia's work. And while we must also reject Orazio as the artist on similar formal and typological grounds,[43] it would be difficult to assert with the same confidence as with Artemisia that the nature of expression is sharply out of character for the artist.

ARTEMISIA Gentileschi's uniquely sympathetic treatment of the Susanna theme is more than explained by the simple fact that she was a woman. Yet one important event in the artist's personal history presents a parallel between art and life that is too extraordinary to be passed over. It was in the spring of 1611, close to the date the *Susanna* was painted, that Artemisia was allegedly raped by Agostino Tassi, setting in motion Orazio's lawsuit and the trial that featured Artemisia's own testimony of her torture by thumbscrew, ending in Tassi's punishment by an eight-month prison term. Not only does the Susanna theme correspond to the real-life incident in its components of sexual assault, public trial, conflicting testimony, and punishment, but this particular picture corresponds as well in its emphasis upon the girl's personal anguish and other telling details. In no other version of the subject known to me are the Elders shown whispering to one another. The motif heightens the conspiratorial character of their act, and suggests allusively the whispering campaign that was the Elders' specific threat, to ruin Susanna's reputation through slander. Artemisia's reputation figured prominently in her rape experience, a fact attested by Orazio's speedy arrangement of her marriage to a Florentine shortly after the trial to spare her the glare of publicity in Rome.[44] Artemisia, moreover, like Susanna, had two assailants: according to the testimony of Orazio, Tuzia, and others, Agostino Tassi was joined in his seduction of Artemisia by Cosimo Quorli.[45] And like Susanna, Artemisia was threatened with sexual blackmail by the accusation of sexual congress with others. With such nearly exact biographic correspondences, one is tempted to interpret as an echo of personal experience the peculiarly concrete Elder on the left (Fig. 173), whose depiction as a thick-haired younger man is highly unusual in Susanna pictures.

The most logical explanation for the unusual expressive character of the Schönborn *Susanna* is that it reflects to some degree the real situation in which the young Artemisia found herself. Yet the date, now authenticated, clearly reads 1610, while the rape occurred in the spring of 1611, in May by Artemisia's account.[46] In order to

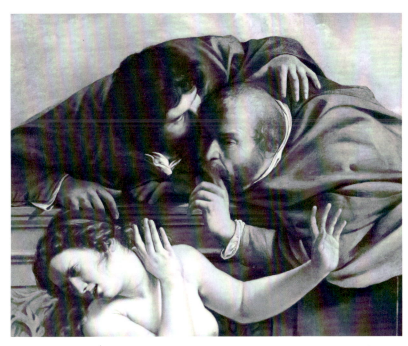

173. Artemisia Gentileschi, *Susanna and the Elders*, 1610, detail of
Elders and Susanna. Pommersfelden, Schloss Weissenstein

understand the manifest connections between the painting and Artemisia's experience, which can hardly be coincidental, we must re-examine the circumstances surrounding the rape, an event that has remained controversial despite Tassi's conviction of the crime.

The truth of Orazio's testimony at the trial has consistently been doubted by the scholars who have touched on the subject of this infamous rape. For many writers, Artemisia's innocence is compromised by the fact that while Orazio claimed at the trial that she was a minor when the rape occurred, she was actually seventeen at the time; and they have also seen as contradictory and incriminating his claim that she had been raped "many, many times."[47] A fuller consideration of rape reminds us, however, that sexual coercion can take a variety of forms. Artemisia was very clear in her own trial testimony about her experience and her subsequent expectations. She stated that she was a virgin at the time she met Tassi, under the strict protection of her father. She asserted that his sexual overtures to her were improper and unwelcome, a claim supported even by Tassi's ally, Tuzia, who graphically described Artemisia's efforts to avoid him. Agostino had evidently planned to seduce Artemisia, but instead took an opportunity when she was alone (Tuzia having obligingly departed) to assault her by force, an assault she resisted vigorously, wounding him in the process.[48] After the rape, Tassi repeatedly pledged to marry her. For that reason, she said, she considered herself subsequently to be his wife, but when he failed to keep his word, she revealed

the incident to her father, who then filed charges against Tassi. That marriage was the expected outcome is further illustrated in Artemisia's gallows-humor outburst at Tassi when she was tortured with thumbscrews: "This is the ring that you give me, and these are your promises!"[49]

Artemisia's testimony makes clear that she continued to have sexual relations with Tassi after the rape, not an unusual consequence under the laws and customs of seventeenth-century Italy, where—as in biblical times, and in Sicily even today—a raped woman was considered "spoiled goods" for anyone other than her violator.[50] After being raped, Artemisia's best chance for salvaging her honor would have been to go along with the sexual demands of the rapist, since that was her only leverage for getting him to marry her. Orazio's accusation, that Tassi raped his daughter "many, many times," was not mere hyperbole or a contradiction in terms, but in fact devastatingly accurate. Tassi's gambit for escaping his obligation was to cloud the issue of who had deflowered Artemisia. His friend G. B. Stiattesi testified that while Agostino loved Artemisia, he could not marry her because Cosimo Quorli was obstructing the progress of their affair.[51] Two weeks after that, Tassi accused Stiattesi of having had sex with her himself, then added later that he (Tassi) had helped to beat up a Modenese painter who had also had Artemisia.[52] All of this "evidence" is too patently self-serving to the cause of the accused Tassi to be taken seriously, yet it exposes the underlying issue in the trial, which was to determine whether or not Tassi was personally guilty of having damaged the legal property of Orazio Gentileschi. Orazio himself made this fact explicit in his initial appeal, describing the rape as an ugly act that brought grave and enormous damage to none other than himself, the "poor plaintiff."[53]

Artemisia's personal sexual feelings were no more relevant to these strictly legal proceedings than were Susanna's toward the Elders, yet historians have dealt with Artemisia in the same way that Susanna was treated by artists and theologians: she has been the butt of one long historical dirty joke. Even Bissell and Spear, scholars who have written perceptively and objectively about Artemisia's life, have each inserted a note of irrelevant skepticism by putting the word "rape" in quotation marks.[54] In his popularized *Lives of the Painters*, John Canaday speaks of the "unsavory—or savory, as you wish—lawsuit," and, hinting broadly that Artemisia's experience with Tassi may not have been "introductory," offers the gratuitous information that "she demonstrated until her death . . . an enduring enthusiasm for the art of love that paralleled her very great talent as a painter."[55] Although Artemisia's reputation as a sexual libertine flourished in the eighteenth century, when she was described by an English commentator as "famous all over Europe for her amours as for her painting,"[56] this legend appears to have been based upon little other than Tassi's self-protecting accusations of promiscuity, and the scandal of the trial.[57] Wittkower caught the bitter irony of the fact that Tassi, whose "escapades" included "rape, incest, sodomy, lechery, and possibly homicide," was remembered by biographers as

a competent painter liked for his good humor and wit, who may eventually even have made up with his old friend Orazio Gentileschi.[58] Yet Wittkower parallels this observation with the extraordinary description of Artemisia as a "lascivious and precocious girl," levying once again upon Artemisia the undeserved defamation of character that Tassi undeservingly escaped. If twentieth-century scholars can unthinkingly perpetuate such chauvinist attitudes, one can only imagine what Artemisia's male contemporaries had to say. Orazio may have redeemed her honor through the arranged marriage, but he could not protect her ultimate reputation from the undying masculine assumption that, if a woman is raped, she must have asked for it.

Looked at from this perspective, the painting of *Susanna and the Elders* may literally document Artemisia's innocence and honest testimony in the trial. Susanna, like Artemisia, endured sexual persecution at the hands of men for the sake of preserving her respectability. Artemisia's protestation of innocence, like Susanna's, was not accepted at face value, and similarly, it took a trial to establish that she had indeed been assaulted. Cosimo Quorli's threat to Artemisia that he would boast publicly of having had her, after she had turned him down (Appendix B, ms. 22), directly parallels the Elders' threat to Susanna. And while each woman was eventually vindicated, both were permanently stigmatized as primarily sexual creatures as a result of sexual acts imposed upon them by others. Artemisia's choice of the Susanna theme and her unorthodox treatment of it formed a perfect vehicle for the expression of the sexual victim's point of view, even though she may well have carried out such a personal statement on a deeply unconscious level.

But how are we to account for the discrepancy between the date on the painting, 1610, and the date of the rape, 1611? One possible explanation is that the picture was painted shortly after the rape, but falsely inscribed with the date of the preceding year, a decision that could have been taken by Orazio for the dual purpose of establishing his daughter's early competence as a painter—which he is known to have wanted to do[59]—and of concealing the direct and potentially embarrassing relation between the picture's content and the artist's personal trauma. Both purposes would have been effectively served by the conspicuous addition of the earlier date beneath Artemisia's name. Moreover, if Orazio were willing to falsify her age at the trial, one presumes he would not have hesitated to falsify a date on a painting.

A more plausible solution, however, is one that does not presume deception. Artemisia may well have experienced sexual harassment for some time before the rape actually occurred. She suggests as much in her trial testimony, in which she describes Agostino's frequent visits to the Gentileschi household in early 1611. Tassi had come to Rome in 1610 and developed a friendship with Orazio in that year.[60] According to Artemisia, Agostino and his friend Cosimo Quorli pressured her for sexual favors with the taunt that she had already given them to a household servant. Cosimo himself, she stated, "made all sorts of efforts to have me, both before and after Agostino had had me, but never did I consent" (Appendix B, ms. 22). Although Artemisia fixed

the period of Tassi's attentions to her as shortly before the rape, it is by no means certain from the trial evidence exactly when their acquaintance began. More important, to interpret the painting as reflecting the experience of personal sexual harassment does not depend upon the identification of Tassi as the only, or even the principal, harasser. The innuendoes about Artemisia's promiscuity made by Tassi and Quorli, and Artemisia's defensive responses to them, suggest that the question of her sexual availability had been of interest to a number of men in her immediate environment, perhaps for quite a while.

What the painting gives us then is a reflection, not of the rape itself, but rather of how one young woman felt about her own sexual vulnerability in the year 1610. It is significant that the *Susanna* does not express the violence of rape, but the intimidating pressure of the threat of rape. Artemisia's response to the rape itself is more probably reflected in her earliest interpretation of the Judith theme, the dark and bloody *Judith Slaying Holofernes*, whose first version (as is discussed in Chapter 1) was probably the painting now in the Capodimonte Museum, Naples (Color Plate 4), of c. 1612–13, an image re-created by Artemisia at the end of her Florentine period in the more famous Uffizi version (Color Plate 8). In this image—as even the most conservative writers have realized—Judith's decapitation of Holofernes provides a shockingly exact pictorial equivalent for the punishment of Agostino Tassi. No painting, of course, and certainly no great painting, is mere raw autobiography. Yet once we acknowledge, as we must, that Artemisia Gentileschi's early pictures are vehicles of personal expression to an extraordinary degree, we can trace the progress of her experience, as the victim first of sexual intimidation, and then of rape—two phases of a continuous sequence that find their pictorial counterparts in the Pommersfelden *Susanna* and the Uffizi *Judith* respectively.

Artemisia's continuing personal interest in the Susanna theme is measured by the fact that four other paintings of Susanna and the Elders by her hand have been recorded.[61] The theme effectively brackets her entire career, since one of these, painted the year before the artist died, is likely to have been her last picture.[62] As part of Artemisia's late *oeuvre*, none of the lost Susannas is likely to have equaled the Schönborn picture in originality and in the intensity of emotional expression. Artemisia's incipient social challenge was developed instead through the Judith theme, in a sequence that stretches from the early teens through the twenties. Ironically, her *Judith*s are routinely characterized as "castrating" and "violent," while the early *Susanna* has, we may assume from critical silence, been regarded as expressively benign. Writers and lecturers who respond with acute sensitivity to a scene in which violence is done to men have passed over a picture that gives full expression to an analogous female fear, the menace of rape, an event that is no less menacing because the act is not shown.[63] Artemisia's *Susanna and the Elders* differs significantly from her *Judith*s, however, in offering not one woman's fantasy revenge, but a sober metaphoric expres-

sion of the broader situation that gives rise to that extreme solution: the reality of women's confined and vulnerable position in a society whose rules are made by men.

Plainly, a seventeen-year-old girl brought up in an unquestioned patriarchal world could not have consciously intended all this. But as great artists are those who can convert unconscious emotions into palpable form without intervention from the socialized brain—and we accept this in a Michelangelo, a Rembrandt, or a Goya as the explanation for their articulation of more deeply human values than those espoused by the cultures in which they functioned—it is not surprising that the young Artemisia Gentileschi, the victim of a traumatic sexual experience, and later the defiant advocate of female capability, should have drawn subconsciously from the wellspring of her female being and experience to humanize the treatment of a biblical theme that men had distorted almost beyond recognition.

# CHAPTER FOUR

# Lucretia and Cleopatra

"Nothing that is human is outside Nature."
—Cleopatra, in Cesari's *Cleopatra Tragedia*
(1552).

LUCRETIA and Cleopatra had in common only the fact that they both committed suicide. There are otherwise vast differences in their historical situations and posthumous esteem. Lucretia, a mythical good Roman wife who killed herself to escape the shame that followed her rape, has long been a paragon of heroic chastity. Cleopatra, a historical queen who took her life to avoid shame as the political prisoner of Augustus Caesar, has stood in the popular imagination as a temptress and sexual libertine, symbol of the dangers of women's power and of Oriental treachery. Yet despite the contrasting legends surrounding these two famous suicides, the visual potential of their self-slaughter appealed to the imaginations of artists on a common ground, and we find numerous similar depictions of Lucretia's self-destruction with a dagger and of Cleopatra's use of the poisonous asp among the staple themes of Renaissance and Baroque art. Sometimes they are presented as nearly interchangeable characters, as we see in two examples ascribed to Guido Reni (Figs. 174 and 175).

Both Lucretia and Cleopatra are typically shown by artists as nude or nearly so at the moment of their suicide (see Figs. 188–191), a feature that contradicts the literary texts, though it is an unsurprising preference in the post-Renaissance artistic tradition, in which themes with women characters have often been taken as a pretext for the display of the female nude body. The image of a naked woman assaulting her own body, frequently the breasts, with a conspicuously phallic object as her instrument, undoubtedly had an additional appeal to some viewers, on a grosser sadopornographic level. And beyond the sexual potential inherent in these themes, there was a manifest attraction for artists and patrons in the very idea of a woman killing herself, for the popularity of images of the suicides of Lucretia and Cleopatra echoes a broader fascination with female suicide seen in literature, typological history, and myth. One thinks easily of other famous heroines who are remembered in large part for their self-destruction: Sappho, Dido, Ophelia, Lady Macbeth, Phaedra, Antigone, Hecuba, Madame Bovary, Madame Butterfly, Hedda Gabler. Vergil devoted a long, graphic passage to the lavish funeral pyre, funeral rites, and death of Dido, whose suicide was

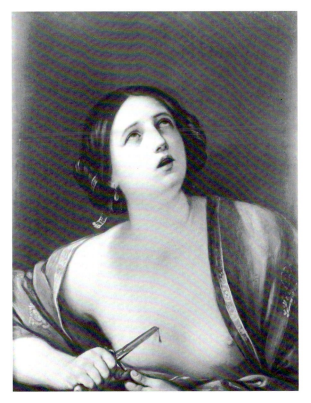

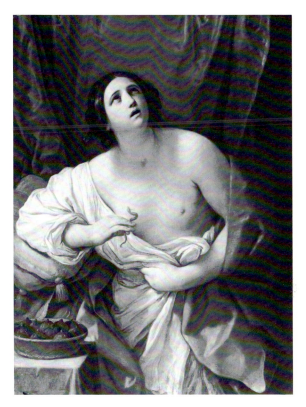

174. Guido Reni (attributed to), *Lucretia*, 1635–40.
Florence, Corsini Gallery

175. Guido Reni, *Cleopatra*, 1638–39. Florence,
Palazzo Pitti

depicted as well by painters such as Guercino (Fig. 176).[1] The deaths of Sappho and
Ophelia were seized upon as pictorial fodder, especially in the eighteenth and nine-
teenth centuries (Figs. 177, 178).[2] The final act of *Madame Butterfly*, and the pathetic
demise of Cho-Cho-San, is the opera's most memorable episode.

    History and myth are of course full of male suicides as well, the most notable
being those of Socrates and Judas, followed by Seneca, Cato the Younger, Mark An-
tony, Brutus, Nero, Othello, and Sardanapalus. Yet art has not dwelt much upon
masculine suicides, and few examples come to mind beyond the famous antique *Seneca
in the Bath*, a handful of medieval images that show Judas hanging himself, David's
celebrated painting of the *Death of Socrates*, and Delacroix's *Death of Sardanapalus*.[3]
Samson, Saul, Demosthenes, Hannibal—all suicides—are remembered for quite dif-
ferent events in their lives. In the interest of redressing the balance, I illustrate here a
rare example of the *Death of Cato the Younger*, a picture in Vienna by an unidentified
Caravaggesque artist (Fig. 179), which offers an unusually non-heroic image of a
dying male, here exploited for its sensational effect, just as dying or self-mutilating
females more typically are shown.

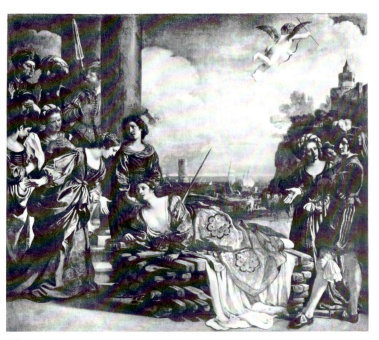

176

177

176. Guercino, *The Death of Dido*,
1631. Rome, Palazzo Spada

177. Antoine Jean Gros, *Sappho at
Leucadia*, 1801. Bayeux,
Musée Baron-Gérard

178. John Everett Millais, *The
Death of Ophelia*, 1852. London,
Tate Gallery

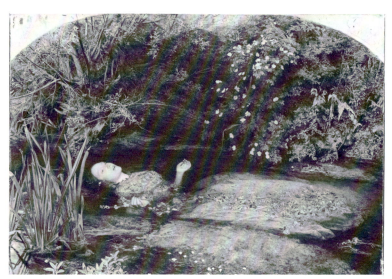

178

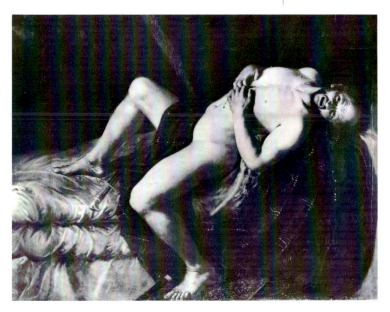

179. Follower of Caravaggio, *The Death of Cato the Younger*,
seventeenth century. Vienna, Gemäldegalerie der Akademie
der bildenden Künste

On one level, the image of female self-slaughter is but another aspect of the
woman-as-victim theme that has been a staple of Western art, along with the equally
popular images of women as slaves (Gerome, Hiram Powers), as martyrs who suffered
sexual disfiguration (St. Agatha), or as victims of rape (the Sabines). The almost ar-
chetypal correlation between women and suicide goes deeper, however, for while we
are now in a position to recognize the extent to which it has suited men's psychic
needs to define women as passive victims in their art, Western civilization also seems
to have nurtured an irrational faith in the artistic rightness of female self-destruction.
Yet there is no connection between the high incidence of mythic female suicide and
reality. Modern statistics show that three times as many men as women commit sui-
cide, and it is doubtful that the ratio was significantly different in earlier periods of
recorded history.[4] On the other hand, there is an obvious correspondence between
the stereotypes of female nature and the classic categories of necessary components in
suicidal theory. Karl Menninger's three requisite elements for suicide—the wish to
kill (sadism), the wish to be killed (masochism), and the wish to die (submission)—
recall some fundamental beliefs about women: their alleged evil nature, their self-hate
and low self-esteem, and their passivity.[5] Freud's definition of suicide as "retroflexed
rage"—hostility felt toward one who is lost, through death or rejection, and turned
inward upon the self—evokes female rather than male paradigms: Dido, whose loss

of Aeneas gave us one of literature's most spectacular suicides, but not Othello, whose self-destruction resulted from the loss of his honor, rather than from his loss of Desdemona.[6]

The suicides of males in art and legend are typically public or political actions, for the sake of philosophical ideals or in face of danger or disgrace; those of females are acts of private desperation. Both result from what modern theorists of suicide have called "dichotomous thinking," the sense of a need to choose between "stark and extreme" alternatives: "if it cannot be some extreme ideal of life, death is the *only* alternative."[7] Yet this situation more frequently and characteristically defines the plight of the female in myth and art, whose range of activity in general is more circumscribed, and whose alternative courses of action in particular situations are far fewer than those of males. Only in love does men's personal desperation equal that of women, but the suicides of lovers, like Romeo and Juliet, are as often mutual as singular. Typical of the disparity in this matter is the case of Portia, wife of Marcus Brutus. Brutus, "the noblest Roman of them all," enlisted a reluctant friend's help to fall on his sword in the last act of Shakespeare's *Julius Caesar*, his final act of heroic devotion to the common good. Portia's solitary suicide, in grief over her loss of Brutus, is not even mentioned by Shakespeare.[8] But although Portia's death did not carry a public significance comparable to that of her husband, her suicide has interested artists a great deal more than did Brutus's. In his *Barockthemen*, Pigler lists fifteen works of art depicting Portia's suicide. There are none listed for the death of Brutus. Both Lucretia and Cleopatra differ from Portia in having held considerable significance in Western thought, yet they are like her in that their suicides have fascinated artists out of all proportion to their meaning. Although Cleopatra's death was only the final act in her long and intricate political career, in Pigler's listings there are about twice as many depictions of Cleopatra's suicide as of all other episodes in her life put together. And if not for her suicide and the extended meanings it acquired, Lucretia would not be known to us at all.

Examples of artistic fascination with female suicide date largely from the sixteenth through nineteenth centuries. Painters of the Renaissance and Baroque periods in particular were obliged—or perhaps more accurately, quite willing—to pander to the tastes of their patrons, and, playing on fixed notions about women's inevitable bent toward self-sacrifice, to show them dying by their own hand, typically as sensual nudes, thus offering a simultaneous gratification of misogynous and erotic impulses. This sadoerotic approach to themes such as Lucretia and Cleopatra represented a significant shift away from late medieval representations of their deaths, which drew inspiration from such exponents of the "woman worthy" tradition as Boccaccio's *De claris mulieribus* and Chaucer's *Legend of Good Women* to cast both Lucretia *and* Cleopatra as heroic good women. In many fourteenth- and fifteenth-century manuscripts (Figs. 180 and 181), Lucretia, Dido, and especially Cleopatra accomplish their suicides in a public setting, functioning simultaneously as admirable

180. *The Death of Lucretia*, c. 1470–83.
London, British Library,
MS. Royal 14 E, v, fol. 121ᵛ

181. *The Deaths of Antony and Cleopatra*,
1410. Paris, Bibliothèque Nationale.
MS. fr. 12420, fol. 129ᵛ

and brave heroines and as figures in a larger moralized drama. It is implied that
Lucretia, executing herself ceremonially before witnesses, holds an important place in
the social order. Cleopatra and Antony are typically depicted in joint suicide, both
regally crowned, and differentiated only in that he dies by the sword and she by the
asp. Images of Cleopatra in these manuscript illustrations as beset by worm-like
snakes, as well as the frequent depiction of both Antony and Cleopatra lying dead in
their grave, may, as V. A. Kolve has argued,⁹ have been intended as *mementi mori* of
a specialized kind: Cleopatra's love for Antony, secular and impure, is destined for
the grave, like all vain human endeavor, yet she could be admitted to the realm of
"good women" because, as a pagan without access to Christian redemption, she
might serve as "a spectacle of courage, self-awareness, and self-definition" since "her
martyrdom is also limited to those values."¹⁰

By the seventeenth century in Italy, this heroic and moral dimension had been
totally eliminated from most painted images of the famous suicides, replaced by a
shallow and superficial eroticism that was elevated to art only by the artist's individual
talent. Exceptional for their reintroduction of heroic imagery and moral values—
though on altered terms—are Artemisia Gentileschi's versions of the two themes,
which differ in important respects from those of her male contemporaries and pred-
ecessors. We shall focus in this chapter upon her first and most extraordinary versions,
the *Lucretia* (Color Plate 9 and Fig. 196) and *Cleopatra* (Color Plate 10 and Fig. 209),

which were painted around the same time, 1620–22, with a brief look at one later treatment of each theme. Our primary examples, while not literal pendants (their formats are very different), were quite possibly commissioned by a single patron, one who may have found the linked themes of the suicides of Lucretia and Cleopatra erotically appealing. Artemisia herself, however, responded to the characters on quite a different level. Retaining the conventional type of the nude or semi-nude heroine, she subtly manipulated the basic imagery to alter the expressive effect, and thus to broaden the iconographic range of meaning for each of the characters. Perhaps most important, in the *Lucretia*s and *Cleopatra*s here examined, the artist offered four rare glimpses of a female perspective on female suicide.

## LUCRETIA

The story of the rape of the chaste Roman matron Lucretia and her heroic suicide in defense of her honor was recounted by classical historians as a model of Roman wifely virtue and as the precipitating event in the ending of kingship in ancient Rome.[11] The Tarquins, sons and kinsmen of the tyrannical ruler Tarquinius Superbus, were gathered late one evening in 509 B.C., during their siege of Ardea, and over food and wine began to debate the relative merits of their wives. Tarquinius Collatinus boasted of the superior loyalty and virtue of his wife Lucretia and challenged the men to return to their homes at that very moment, to investigate what their own wives were doing in their absence. Accordingly, the group rode straight back to Rome, and found Lucretia to be indeed more virtuously engaged than all the king's other daughters-in-law. While these women were having luxurious banquets and were engaged in idle revelry, Lucretia was found alone with her handmaidens, quietly and industriously spinning wool. The clear victor in this contest of wifely virtues, Lucretia—on account of her virtue as much as her beauty—inflamed the ardor of the king's son, Sextus Tarquinius, who was seized with the desire to seduce her or, as Livy describes it, to take her by force. Returning later to Collatinus's household, where as a kinsman he was welcomed by Lucretia, Sextus Tarquinius slipped into her bedroom when the household was asleep, and, drawing his sword, threatened to kill her if she did not succumb to him. When she refused even in the face of death, he added a more ominous threat: he would also kill his own slave, and place their naked bodies side by side in bed, so that they would appear to have been put to death in adultery. At the prospect of such disgrace, Lucretia gave in to Tarquin's rape.

The next day Lucretia, in profound grief over the disaster, summoned her father, her husband, and two of their friends, and told them the story. The men quickly pardoned her, pointing out that it is the mind that sins, not the body, and as she did not want the rape, she was therefore guiltless. Lucretia, however, declared that "though I acquit myself of the sin, I do not absolve myself from punishment; nor in time to come shall ever unchaste woman live through the example of Lucretia."[12] With this,

she drew a knife concealed in her dress and plunged it into her breast. One of the men present, Lucius Junius Brutus, a relative and political enemy of the king, pulled the knife from her dead body and swore by her blood that he would drive the Tarquins out of Rome. When Lucretia's body was displayed in the Roman Forum and Brutus eloquently described the crimes and tyranny of the Tarquins, the people rose up against the king and banished his family from Rome.

The story of Lucretia, and her function as a moral *exemplum* of virtue who triggers the downfall of tyranny, was paralleled by several similar stories in contemporary ancient history, as Ian Donaldson has recently shown in an informative study of the Lucretia theme. The Roman maiden Virginia, for example, was described by Livy as having been killed by her father in 450 B.C. to avert disgrace at the hands of Appius Claudius, a murder that set off an uprising against the tyranny of the Decemvirate. Such stories may or may not have had a basis in historical reality, but as mythic expressions of fundamental Roman beliefs and values, they define, as Donaldson describes, the victory of liberty over tyranny, a victory that functions on both a sexual and a political level.[13] Lucretia symbolizes Rome itself, besieged and violated, and her heroic self-sacrifice for the sake of her honor becomes a rallying cry for Brutus, as he urges the Romans to choose death in defense of their liberty over life under tyranny. And, just as Lucretia chooses to die rather than set a precedent of pardon for *willing* adulterers (whose difference from Lucretia might not easily be distinguished by law), so are the Roman citizens inspired to throw out a king who ruled through complex and murky kinship entanglements, and to establish a good government based upon clear-cut principles of abstract justice. (It was this aspect of the legend that appealed to the leaders of the French Revolution, and this same Brutus's oath and subsequent personal sacrifice of his sons to the higher good of the state that were celebrated by Gavin Hamilton and Jacques-Louis David.[14])

Lucretia's own story finds familiar echoes in those of the heroines of Judaism. Her plight—whether to yield to rape or face the dishonor that would result from a trick to make her appear adulterous—is directly comparable to that of Susanna; only the outcomes are different, with Daniel, a masculine *deus ex machina*, coming along to save the day for Susanna. The juxtaposition of the pure Lucretia with the rapacious Tarquin also recalls that of Judith and Holofernes, as a "triumph of *pudicitia* over *superbia*,"[15] of modesty and chastity over luxury and pride (it can scarcely be accidental that the reigning tyrant of the Roman legend is named Tarquinius Superbus). The parallel between Lucretia and Judith, women who helped overthrow a tyrant, was sometimes stressed in medieval "woman worthy" ensembles.[16] The striking difference between them, noted by Donaldson, is that while Judith takes direct action against the tyrant Holofernes, Lucretia inflicts punishment upon herself rather than her assailant, and revenge is left to the men.

On the simplest historical level, Lucretia's extreme solution can be explained in the light of ancient Roman attitudes about suicide. Romans regarded suicide not as

morally wrong, but simply as the final act of rational choice in a life lived nobly and honorably. The right to choose the time of one's death, when the circumstances of life—whether physical discomfort or the prospect of dishonor—made its continuation intolerable, was fully sanctioned under Roman law for all citizens (except for slaves, whose lives were not their own, and for "irrational" suicides).[17] Thus Lucretia's suicide can be understood, in the context of the time in which she lived, as a thoroughly justifiable action, compatible with concepts of Roman virtue that held for both men and women.[18]

In the Christian era, however, Lucretia's action came into question. In the early Middle Ages, she was taken up as a model of female chastity; she was highly praised by Saint Jerome and Tertullian as a virtuous pagan who valued her sexual honor more than her life, and who might inspire Christian women to martyrdom for the sake of preserving their virginity.[19] But according to another tradition of early Christian thinking, Lucretia's action raised more problems than it solved. Saint Augustine, in *The City of God*, took the lead in exploring the differences between Roman and Christian principles of moral behavior. Lucretia was not adulterous, he observes, because only her body, not her mind, submitted to the rape. But, he asks:

> How is it that she who was no partner to the crime bears the heavier punishment of the two? For the adulterer was only banished along with his father; she suffered the extreme penalty. If that was not impurity by which she was unwillingly ravished, then this is not justice by which she, being chaste, is punished. To you I appeal, ye laws and judges of Rome. Even after the perpetration of great enormities, you do not suffer the criminal to be slain untried. . . . This crime was committed by Lucretia; that Lucretia so celebrated and lauded slew the innocent, chaste, outraged Lucretia. Pronounce sentence. But if you cannot, because there does not compare any one whom you can punish, why do you extol with such unmeasured laudation her who slew an innocent and chaste woman? . . . This case of Lucretia is in such a dilemma, that if you extenuate the homicide, you confirm the adultery; if you acquit her of adultery, you make the charge of homicide heavier; and there is no way out of the dilemma, when one asks, If she was adulterous, why praise her? If chaste, why slay her?[20]

Donaldson has clarified the historical context of Augustine's "dilemma" by pointing out that in his own time, Augustine was reacting to the widespread rape of Christian nuns during the Sack of Rome in A.D. 410, and was attempting to justify in moral terms their decision not to take their own lives. The Church Father stressed the difference between rape and adultery—a distinction not sharply made in Roman law—and argued that injury suffered by the body is nonetheless preferable to death. (Augustine's strong case against suicide was also undoubtedly aimed at restraining the

zeal for martyrdom, believed to insure redemption, that many Early Christian sects displayed.[21]) For Augustine and many later Christian thinkers, Lucretia's suicide was an act of murder, the taking of a soul, and worse, a usurpation of God's right to end our lives.

Although many writers of the later Middle Ages—Dante, Boccaccio, and Chaucer among them—found it possible to ignore the issues raised by Augustine, and to perpetuate the image of Lucretia as a pagan paradigm of chastity, other writers, particularly seventeenth-century Englishmen, focussed upon Lucretia as a model to be avoided by Christians, on account of her wrong-minded decision to take her own life.[22] Writing in 1660, Jeremy Taylor sympathizes with women who choose suicide after rape, but concludes nevertheless that the practice is to be censured. John Sym, who in 1637 wrote one of the first books in English on the subject of suicide, condemns Lucretia not only for adherence to pagan values, but for having killed herself for the sake of worldly honor and fame. Another writer on suicide, William Vaughan, faults her fear of scandal.[23] These writers, Donaldson shows, take up a line of Christian thinking that diverges radically from Roman values. In Roman terms, Lucretia killed herself not out of guilt, but out of shame, concerned for her reputation and for the precedent of pardon that she might set for voluntary adulterers. Christian writers, schooled in a religion that placed the highest premium on the innocence of one's personal conscience, regarded such values as excessively concerned with appearances and the opinions of others. Thus William Tyndale, in 1527–28, could chastize Lucretia for the sin of pride.[24] For some writers, Lucretia's story was an open invitation to reaffirm Christian over pagan values. John Prince, in a treatise on suicide of 1709, cited her story as the origin of a Roman proverb, *praestat emori, quam per dedecus vivere* ("Better far it is to die / Than to live in Ignomy"), to which he added "Whereas 'tis truly better to undergo all the Shame and Contempt in the World than for any to embrue their Hands in their own Blood."[25]

Still another skeptical note was sounded by writers who were not at all sure of Lucretia's alleged chastity. Italian Renaissance writers in particular could not quite believe that she could have been raped by Tarquin without experiencing at least some enjoyment. In Coluccio Salutati and Matteo Bandello's dramatizations of the story, Lucretia admits that, being flesh and blood, she could not help feeling physical pleasure in the act, and thus she must die because she *is* a willing participant.[26] Aretino and Machiavelli—Hugh Hefners of their day—spin out this archetypal masculine fantasy in cynical libertine fashion. "What do you think of Lucretia?" asks Aretino in a letter to a friend. "Wasn't she crazy to take counsel of Honor? It would have been gallant sport to peck at the corn offered to her by Tarquin—and to have gone on living as well."[27] In Machiavelli's comedy *La Mandragola*, following a scheme recommended by her aspiring lover, an impotent husband arranges to have his wife Lucrezia conceive a child with the aid of a mandrake root potion. The plot, which broadly echoes

the theme of Tarquin and Lucretia, hinges on Lucrezia's acceptance in her bed of a man other than her husband, in response to arguments that parody both the classical and Augustinian positions on Lucretia's suicide. And, it turns out, Donna Lucrezia is not raped after all, because she does enjoy her substitute lover, and invites him to return any time he likes.[28]

The later fanciful rewritings of the Lucretia legend tell us a great deal about the story's extended symbolic meaning. Writers from Madeleine de Scudéry and Thomas Heywood in the seventeenth century, to Rousseau and Fielding in the eighteenth, to Noel Langley in the twentieth century perpetuated and embellished the theme.[29] Lucretia is made promiscuous, is lustily fond of Tarquin, is secretly tired of her husband—she is generously endowed by urbane modern writers with a sex life of her own. The tone shifts from tragic to comic, and the crisis of rape is dropped even as the heroine is preserved, now a stock laughable character. The story has become a joke, but as Donaldson observes, "unlike jokes about other crimes—murder, theft, incest, arson—jokes about rape have a special quality: they characteristically imply that the crime may not in fact exist; that it is a legal and social fiction, which will dissolve before the gaze of humour and the universal sexual appetite."[30]

These writers, all but Madeleine de Scudéry male themselves, express a quintessential masculine viewpoint, one that ignores the fact that even if a woman were able to convert a rape to a pleasurable episode by a shift of her mind-set, the real-life consequences of the adventure would still be the same as those of rape: the problem of pregnancy, the question of reputation. From the man's point of view, the significant distinction hinges on what the woman feels about the sexual act, but from the woman's viewpoint, the act itself permanently changes her life. Regardless of what she may feel about the intercourse itself, pleasure or pain, she is personally left to deal with its biological and social consequences.

With their opposite perspective on the phenomenon of rape, women have tended to view the character of Lucretia differently from men, to see her situation and her deed as a ludicrous artificial construct of patriarchal concerns, or to imagine other implications in such a story. Christine de Pizan saw her as a paragon of integrity (it was her integrity for which Lucretia was raped, she reminds us, not for her beauty), whose brave and principled act led to the passing of a new law, "fitting, just and holy," that would punish rapists by death.[31] Lucrezia Marinelli, in her impassioned treatise cataloguing the great and important women of antiquity, finds no reason to mention Lucretia at all, although she was her namesake. Marinelli's heroines are distinguished for their learning, their courage, their judicious counsel, and their heroism in battle— but not for the suicidal defense of their chastity.[32] Sor Juana Ines de la Cruz, the seventeenth-century Spanish-American writer, mocked men's fashioning of Lucretia as the model of marital fidelity in a satirical poem, arguing that "men accuse in women the very thing they cause in them."[33] And Simone de Beauvoir was later to observe, "The suicide of Lucretia has had value only as a symbol."[34]

RENAISSANCE and Baroque pictorial treatments of the Lucretia theme can be divided into two groups, which correspond roughly to those defined in the literary tradition. Like the writers who stressed Lucretia's Roman virtue, some artists depicted the character as stoic heroine plunging the dagger into her breast, an interpretation that is made explicit in a sixteenth-century example from the school of Cranach (Fig. 182), which presents the Latin legend, "Better to die than to live in disgrace," inscribed over Lucretia's head.[35] Lucretia was earlier defined as a virtuous Roman heroine in numerous Italian marriage chests (*cassoni*) of the Quattrocento, notably those of Botticelli and Filippino Lippi (Fig. 183), a marital context in which she figures

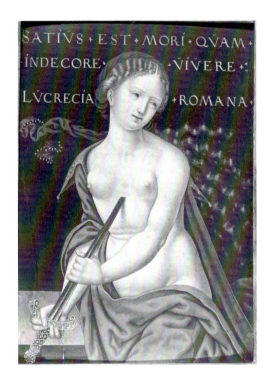

182. School of Cranach, *Lucretia*, sixteenth century. Formerly Serge Philipson Collection

183. Filippino Lippi, *The Death of Lucretia*, fifteenth century. Florence, Palazzo Pitti

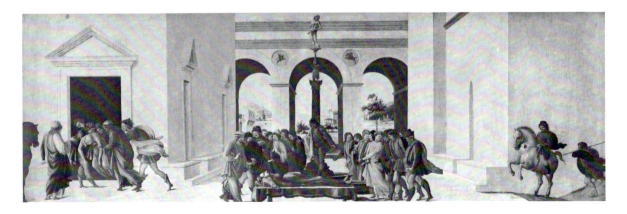

as an *exemplum* of a virtuous wife, side by side with equally popular themes that glorified the institution of the family, such as Susanna, the Rape of the Sabines, and the Continence of Scipio.[36] These Early Renaissance Italian narratives are typically focussed upon the displayed body of the dead Lucretia in an expansive architectural setting, surrounded by a crowd of men, and they frequently illustrate several episodes of the story, down to Brutus's oath. Such a public and civic emphasis, found in Florentine *cassoni* from about 1440, drew upon the political implications of the theme—the replacement of tyranny with law and freedom—to stress Florentine identification with Roman republican ideals.[37]

Early Cinquecento interpretations, such as Marcantonio Raimondi's engraved figure after Raphael (Fig. 184), stressed the classical heroic ideal in a different way, presenting the single figure of Lucretia at the moment of her suicide, in statuesque contrapposto, and, in Marcantonio's case, with Roman architecture and a Greek inscription.[38] The relative popularity of the Lucretia theme in early sixteenth-century

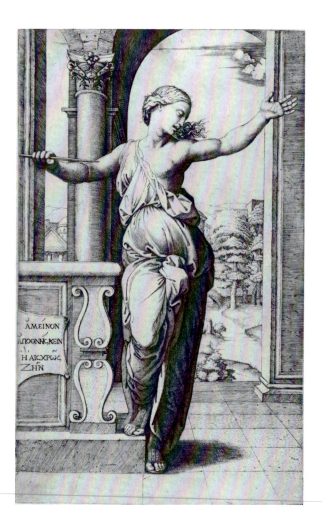

184. Maracantonio Raimondi, after Raphael, *Lucretia*, c. 1510–11. B. XIV.155.192

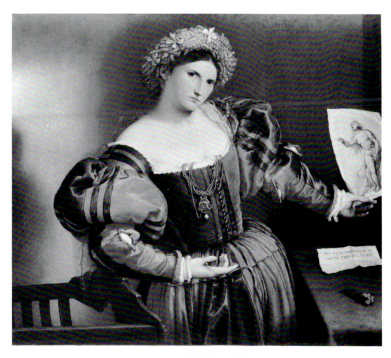

185. Lorenzo Lotto, *Portrait of a Lady as Lucretia*, c. 1534.
London, National Gallery

Italy has been attributed to the fact that some major art patrons were named (or were closely associated with women named) Lucrezia, e.g., Lucrezia Tornabuoni, mother of Lorenzo il Magnifico and grandmother of Pope Leo X; and Lucrezia d'Este-Bentivoglio, patron of one of the earliest single-figure Lucretias, by Francesco Francia.[39] Lorenzo Lotto's *Portrait of a Lady as Lucretia* of c. 1534 (Fig. 185), in the National Gallery, London, is believed to have resulted from such a connection. As Michael Jaffé has shown, the sitter is Lucrezia Pesaro, who married Benedetto Pesaro in 1533, and who is here depicted holding a drawing of a classical Lucretia, with whose chastity (though not her fate) she is shown as wanting to be identified.[40]

On the other hand, an example of the theme painted by Sodoma (Fig. 186), a picture in Turin of about 1516, introduces to us a new conception of Lucretia, overtly sexualized and distinctly non-chaste. The image superficially conforms to the heroic type—Lucretia raises the dagger she is about to plunge, in the presence of her father and husband—yet the lighting focusses attention upon the exposed breasts as objects for delectation, while the unbound curls flow alluringly, artistic decisions that radically shift the interpretative emphasis. The transition may be traced in Sodoma's own *oeuvre*, for we see him less than a decade earlier producing a conventionally heroic and sexually neutral *Lucretia* (Fig. 187), who is expressively closer to Marcantonio's image.[41] Many subsequent Renaissance artists exploited the potential eroticism of the

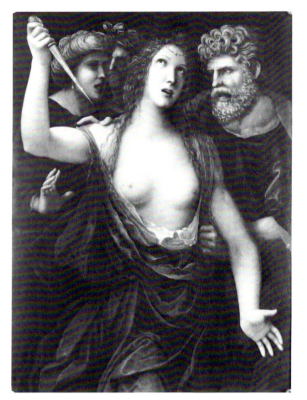

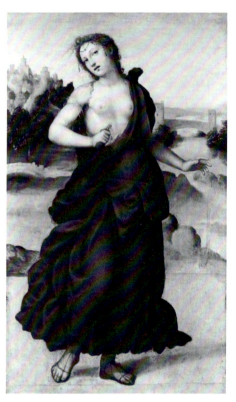

186. Sodoma, *Lucretia Romana*, c. 1516.
Turin, Galleria Sabauda

187. Sodoma, *Lucretia in a Landscape*,
c. 1510. Hannover,
Niedersächsisches Landesmuseum

theme, especially Lucas Cranach, who painted some thirty-five versions of the
Lucretia theme (Figs. 188, 189) that offer almost every possible variation of a pin-up
nude, who presses the phallic dagger, at the point of penetration, onto a variety of
spots on her torso. Many of Cranach's Lucretias gaze seductively at the viewer as they
pose suggestively; in a similar vein, Joos van Cleve painted a Lucretia who, one writer
avows, appears to be "in the throes of orgasm"[42] (Fig. 190). Similarly erotic Lucretias
in ecstatic states recur in the seventeenth century as well, as we see in another of the
numerous examples of this theme that have been ascribed to Guido Reni (Fig. 191).[43]
Such an interpretation of Lucretia as self-conscious sex object, symbolically re-enact-
ing the rape but this time with pleasure, parallels the view of writers like Bandello,
who doubt the heroine's chastity and suggest that she surely must have enjoyed the
experience.

  An iconographic variant of the single-figure Lucretia theme that was also born
in the Renaissance shows the rape itself in dramatic narrative. Perhaps the best known
is the earlier of Titian's two versions of the theme, a picture of 1568–71 in the Fitzwil-

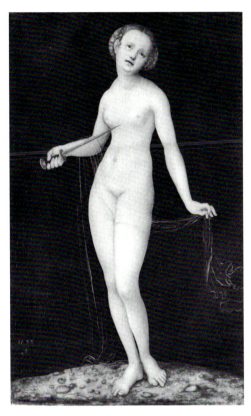

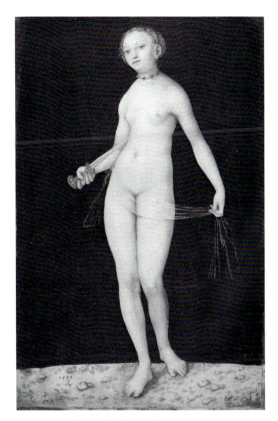

188. Lucas Cranach, *Lucretia*, 1532.
Vienna, Gemäldegalerie der
Akademie der bildenden Künste

189. Lucas Cranach, *Lucretia*, 1533.
Berlin-Dahlem, Staaliche Museen,
Preussicher Kulturbesitz, Gemäldegalerie

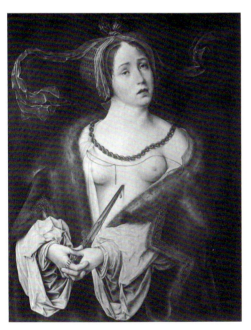

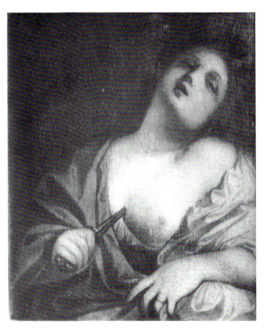

190. Joos van Cleve, *Lucretia*, early
sixteenth century. Vienna,
Kunsthistorisches Museum

191. Guido Reni (attributed to), *Lucretia*,
seventeenth century. Formerly
Lansdowne Collection

liam Museum (Fig. 192), which presents Tarquin's assault upon Lucretia in her
bedchamber, accompanied by the servant who is to be used in the threat (but looking
like a fellow conspirator, as Donaldson has noted).[44] Such pictures lose in porno-
graphic suggestiveness what they gain in sexual literalism, but they have—from the
viewpoint by which these pictures demand to be judged—the advantage of placing
the viewer's surrogate, Tarquin, directly in the thick of the action, touching and hold-
ing his quarry. In a seventeenth-century Florentine depiction of the rape (Fig. 193),
Tarquin menaces a surprisingly responsive Lucretia, who pushes him away with one

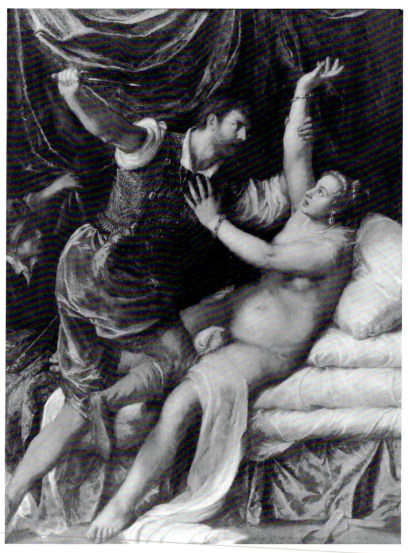

192. Titian, *Tarquin and Lucretia*, 1568–71.
Cambridge, Fitzwilliam Museum

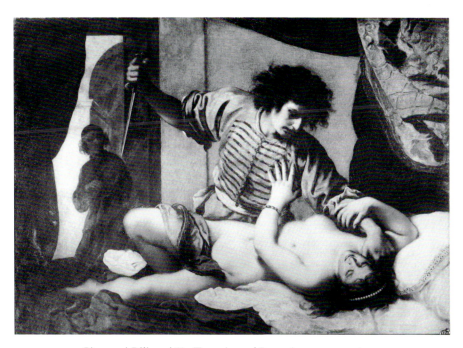

193. Giovanni Biliverti(?), *Tarquin and Lucretia*, seventeenth century.
Rome, Accademia di S. Luca

hand while pulling him closer with the other, contriving at the same time to display her nude body for the viewer.[45] Titian's interpretation of the theme makes an equally overt erotic claim, but nevertheless remains closer to the original story in showing a properly terrified and distressed Lucretia.

The heroine's sense of despair, so prominent an aspect in the accounts of the Roman historians, became the preferred emphasis in Baroque versions of the theme. The single-figure type is the most prevalent in the seventeenth century, often showing Lucretia in her bedchamber about to take her life. Two examples, one after Vouet and another by Reni (Figs. 194 and 195), are representative: the action is compressed; Lucretia is shown in the bed where the rape occurred, plunging or preparing to plunge the dagger into her breast.[46] Unlike the impassive Renaissance figures, Baroque Lucretias emote theatrically, turning their eyes heavenward, anachronistically appealing to the Christian God for help or succor (an anachronism that reflects the Church's ultimate success in absorbing virtuous heathens into the circle of Christian martyrs). Yet the anguish depicted in these versions is usually quite conventional, and the combination of the heroine's helpless upward gaze with a close-up view of her tender flesh penetrated, or about to be, by the sharp blade typically produces an image of erotic submissiveness rather than of profound psychological expression.

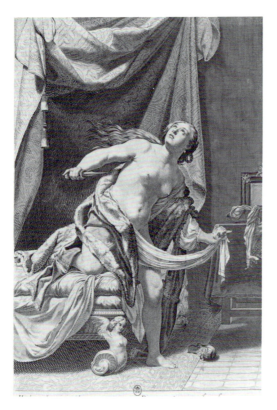 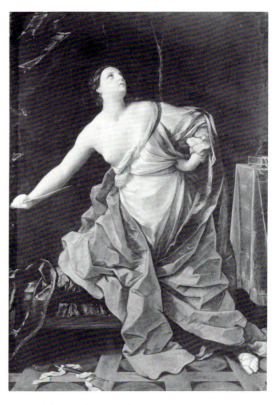

194. Claude Mellan, after Simon Vouet,
*Lucretia Killing Herself* (original painting,
c. 1625–26). Paris, Bibliothèque Nationale,
Cabinet des Estampes

195. Guido Reni, *Lucretia*, c. 1625–26.
Potsdam, Neues Palais

WHEN we examine Artemisia Gentileschi's first *Lucretia* (Fig. 196) against this background of philosophical debates and pictorial prototypes, we quickly recognize the idiosyncratic nature of her interpretation. Like her contemporaries, Artemisia sets the heroine in her bedchamber at close range, and depicts her looking upward. Yet this Lucretia is no seductive, melting beauty. She sits heavily and uneasily, her visible leg athletically muscular and awkwardly prominent—even more so today than in the picture's original format.[47] Psychological tension and emotional anxiety are conveyed in her knotted and anxious brow, her stiff and upright back, the taut grip of her left hand upon the dagger, and the grasping clutch of her breast with the right hand.

The painting also differs from other versions in two significant details. First, Lucretia has not yet stabbed herself, nor is she in the act of doing so. Although she grasps her breast in preparation for the deed, she holds the dagger upward, as if hesitating, or deliberating, at the last moment. And second, the hand that grips the breast holds it in a very unusual manner, pressing hard with two fingers and pushing the nipple

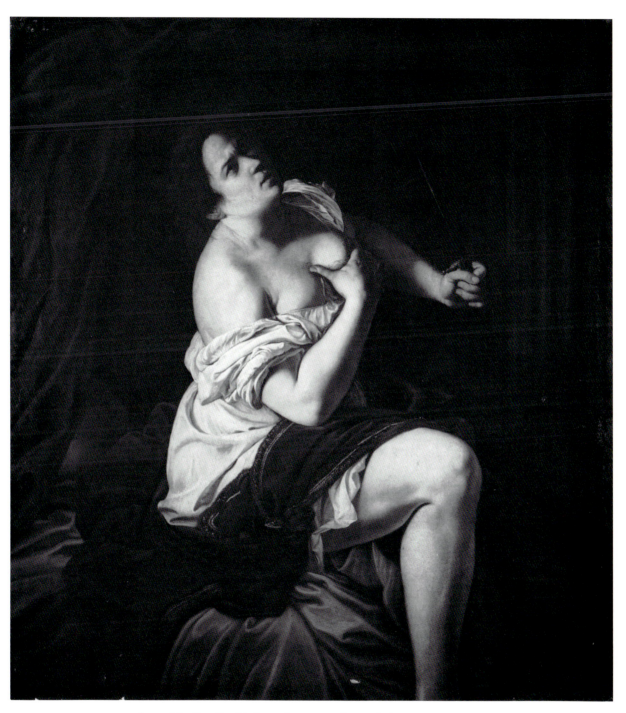

196. Artemisia Gentileschi, *Lucretia*, c. 1621. Genoa, Palazzo Cattaneo-Adorno

forward, a curious yet very familiar gesture: it recalls a mother's preparation to nurse a child, a domestic image familiar in Italian painting through images of the nursing Virgin Mary, the *Madonna lactans*, whose frequent appearance may be traced from the Trecento to the Seicento, often, as in Correggio's influential *Madonna del Latte* (Fig. 197), showing the mother's manipulation of the nipple with her fingers.[48] In fact, we see the mother's palpation of her breast in an earlier painting by Artemisia herself, the Spada *Madonna* of c. 1609 (Color Plate 1), an image that demonstrates the artist's intimate acquaintance with the *Madonna lactans* tradition.

These two features in combination suggest a very different interpretative emphasis from those offered by other painters. Artemisia's Lucretia, with sword rhetorically poised, seems to be questioning whether she *should* commit suicide. The image rekindles memory of Augustine's question, whether Lucretia's suicide was necessary, or even justifiable. In one respect, this is not surprising, since Augustine's dilemma was, as we have seen, very much alive in the seventeenth century, when the debate about Lucretia flourished. The pro- and contra-Lucretia arguments are likely to have been as familiar to Artemisia as they were to her contemporary, the poet Marino, who in a witty epigram summarized their terms.[49] But the artist manifestly avoids the horns of the Christian dilemma—a truly "no-win situation"—as posed by those who saw the

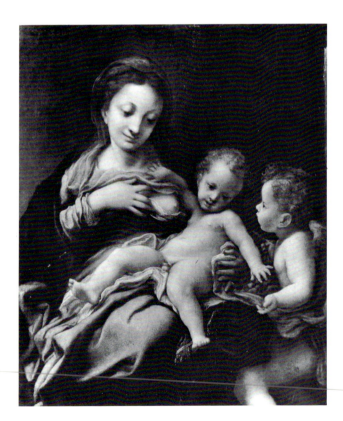

197. Correggio, *Madonna del Latte*, c. 1522. Budapest, Szépmüvészeti Múzeum

suicide as a rash, prideful act if she was innocent, or as proof that she was adulterous if not. Like Augustine, who argued the importance of continuing life against the excessive zeal for martyrdom in Early Christian times, Artemisia juxtaposes the fecund breast, symbol of the ongoing cycle of human nature, with the sword, agent of the suicide that would interrupt the cycle. Female nurture and its centrality to the continuity of life have become the chief protagonists in this dialogue with death. In place of an ideal of chastity or the suspicion of sexual transgression is set an image that evokes not the moral but the biological consequences of an unwanted sexual intercourse.

In one respect, Artemisia's interpretation of Lucretia's situation is on firm historical ground. The Romans believed that a woman's family was contaminated by her adultery, both her husband and her children, whether fathered by the husband or by the rapist.[50] In versions of the Lucretia story that appear as late as the eighteenth century, the question of her possible pregnancy as a consequence of the rape is frequently given as a reason why she should commit suicide.[51] It does not seem likely, however, that Artemisia's heroine is meant to be understood as anguishing over her tainted future as a mother, and on the shadow thus attached to her offspring. Those writers who brought the complication of "transferred pollution" into the story saw it as justifying her death since only that could prevent the uncertain situation—and from the patriarchal point of view, intolerable consequence—that Dr. Johnson called a "confusion of progeny."[52] Artemisia, on the other hand, poses a question that seems to trouble Lucretia herself, not one, like transferred pollution, that would more likely concern her husband and her father.

Moreover, the relation in the picture between the two terms—her potential motherhood and her potential suicide—is not a simple image of cause and effect: not, "I will kill myself rather than dishonor my family," and not even, "I will not kill myself, because I have a higher debt to life itself, and to a nature that is above the self-interested morality of men." The latter viewpoint may of course be hinted at, in Lucretia's hesitation with the knife and meditation on her nurturing capability—and also in the philosophical outlook of the artist that we may extrapolate from the larger message of her *oeuvre*. But in this case, the artist is restricted by the facts of the plot; Lucretia did kill herself, and that part of the story cannot be changed. However, by delaying the act and showing the heroine before the final decision is taken—creating, in fact, a new dramatic episode for the story—Artemisia reminds us that "Augustine's dilemma" is properly Lucretia's. And the new terms of that dilemma broaden its human meaning. It is no longer a scholastic philosophical exercise, but an immediate psychological reality, no longer a question of rules of behavior derived from patriarchal rights of possession, but now of an individual's choice of action in a situation where no course of action is without penalty.

No one could have understood such a situation better than Artemisia Gentileschi herself. Her own experience of rape some ten years before she painted this picture

had exposed her to the same moral criticisms as those leveled at Lucretia. By her own testimony in the trial, Agostino Tassi had raped an unwilling Artemisia, yet her chastity was repeatedly challenged and doubted during the trial. Had she encouraged him? Had he deflowered a virgin? Like Lucretia, Artemisia turned to her father and his friends (in the seventeenth century, the latter were represented by the legal system), to exonerate herself of blame. And while Lucretia commited suicide to save her reputation, that supreme gesture—like Artemisia's ultimate vindication in court—could not permanently save her good name, since for each of these women there remained in the eyes of her self-appointed judges the lingering suspicion that she might have enjoyed it, and thus that it was not "really" rape.

One must be careful not to put thoughts into the mind of the artist, yet it is very difficult to avoid concluding in this instance that as Artemisia conceived, designed, and executed the picture, reinterpreting Lucretia's situation as an anguishing private decision, she must have relived her own experience, voicing once more the ancient moral question, "What ought I to do?" On a personal level, Lucretia's dilemma was solved with the knife, but on a universal level, the problems inherent in her situation have, for women, gone on for centuries. As an artist, Gentileschi relied upon her own gender identification with Lucretia to transform the character entirely, from a two-dimensional emblem of virtue (or of sexuality) into a naturalistically plausible, living expression of the perpetual dilemma, both physical and metaphysical, social and private, that is faced by women who have been raped.

As we have seen (and will see again in Chapter 5), Gentileschi's creation of a fundamentally new character to play a traditional part was sometimes assisted by the use of an iconographically diverse model: for Susanna, a figure on a classical sarcophagus; for the Detroit *Judith*, the *Medici Venus*; for the *Sleeping Venus*, Caravaggio's *Sleeping Cupid*. For the image of Lucretia as well, the artist found inspiration in an unexpected quarter. Her image of Lucretia's agonized moment of moral choice surely recalls, more than any other thematic prototype, that of Christ's Agony in the Garden, the moment in the passion cycle when his human frailty and temporary hesitation are stressed. No specific example of this theme seems close enough in form to Artemisia's *Lucretia* to have been its actual model; indeed, most Baroque versions of the Agony in the Garden tend to emphasize the succor provided Christ by the chalice-bearing angel.[53] Yet this *Lucretia* seems expressively closer to the Mount of Olives theme than to the somewhat more proximate Christian type of the Penitent Magdalen or the Penitent St. Francis, themes of intense devotional meditation, but not of the agony of surrendering to death, such was experienced by Jesus when he weakened and cried: "O my Father, if it be possible, let this cup pass from me."[54]

Moreover, a typological parallel between Lucretia and Christ had been earlier established. It was proposed by a number of Christian writers, beginning with Tertullian, that Christ's own death was a kind of suicide.[55] Marcantonio's image of the dying Lucretia (Fig. 184)—arms outstretched, head dropping, eyes closed—has been

interpreted as intentionally evoking the image of the crucified Christ, to stress the parallel between her passive self-surrender and that of the Christian savior.[56] Other scholars have seen a deliberate correlation in the close formal connection between Baldung Grien's half-length image of Lucretia, a woodcut of c. 1511 (Fig. 198), and his *Christ as Man of Sorrows*, also of 1511 (Fig. 199),[57] perhaps to emphasize the pathetic martyrdom of each. By the later seventeenth century the association was common enough for the Jesuit writer Pierre Le Moyne to compare Lucretia's wound with Christ's, and to think of her as obliged, like Christ, "to die more than once in order to convince unbelievers of her virtue."[58] Artemisia's recollection of Christ's passion in her image of Lucretia can thus be understood in the context of an association that may in her day have been commonplace. Her own inventive use of the analogy, however, is neither mystical nor pathetic; it simply underlines their common dramatic situation: an individual under intense psychic stress faces the decision to die for the sake of a higher cause.

In the second of her preserved *Lucretia*s (Color Plate 22 and Fig. 200), painted some twenty years after the first, key elements of Artemisia's original interpretation recur. The seated woman, her face troubled (though now less intensely), holds the

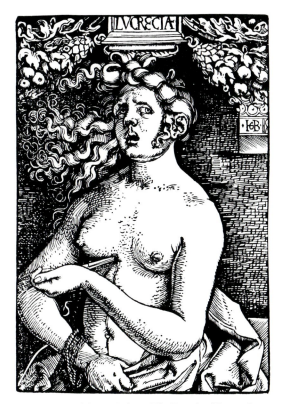

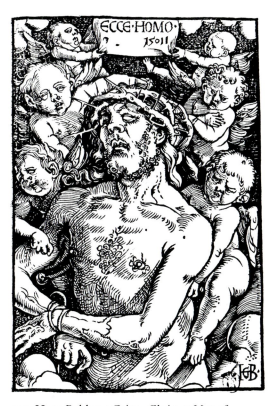

198. Hans Baldung Grien, *The Death of Lucretia*, woodcut, c. 1511. Boston, Museum of Fine Arts

199. Hans Baldung Grien, *Christ as Man of Sorrows (Ecce Homo)*, woodcut, c. 1511. New York, The Metropolitan Museum of Art

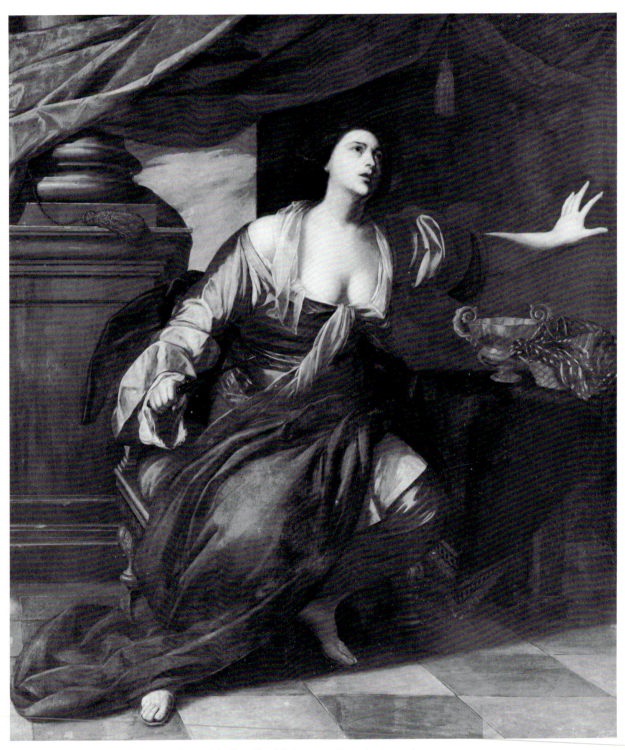

200. Artemisia Gentileschi (here attributed), *Lucretia*, 1642–43.
Naples, Museo di Capodimonte

dagger to one side, suspended, and spreads her other hand in a gesture of heroic resistance, evoking once again the moment before the fact, when Lucretia still struggles to determine to take her life. Despite the numerous differences between these two pictures, in style, setting, and decorum (see pp. 104–105), Artemisia's fundamental conception of the character remains the same; and again, in its focus upon the heroine's dilemma, the Naples *Lucretia* stands apart from contemporary masculine versions, such as a Neapolitan work of approximately the same time (Fig. 201).[59] Artemisia's second *Lucretia* is without question more sophisticated in style and composition, richer in color harmony, and expressively more grand than the ungraceful and abrasive Genoa version. The painting is likely to have pleased its patron more. Yet the very improvements of art conceal the singularity of concept in the Naples version, and the picture lacks the extraordinary vigor, psychic intensity, and startling originality of the artist's first rendition of the theme. Concession to patrons' tastes may also account for Artemisia's turn at least once, and perhaps twice, in later years to the depiction of Tarquin's rape of Lucretia. One of these is known only in documents, and a *Tarquin and Lucretia* now in Potsdam (Fig. 126), though ascribed to Artemisia, is a work whose expressive lewdness and philosophical hollowness make it

201. Massimo Stanzione (attributed to), *Lucretia*, c. 1640s. Naples, Museo di Capodimonte

difficult to place in her *oeuvre*, and in any case, a sad and startling successor to her first essay on this theme in Genoa.[60] Let us, accordingly, return to Artemisia's first *Lucretia*, the prime exponent, to conclude our look at her exceptional artistic interpretation of the theme.

IN CREATING a Lucretia who does not submit to her inevitable choice of death with virtuous passivity or heroic resignation, but who seems instead to question the dichotomized alternatives that face her, Artemisia aligns herself with incipient post-Augustinian thinking, both on the subject of suicide and on the character Lucretia. The sixteenth and seventeenth centuries saw the emergence of distinctly new ideas about self-killing (the word "suicide" did not appear in English until the mid-seventeenth century[61]), that contrast directly with the line of Christian thinking that flatly condemned all suicides and questioned even Lucretia's. Some Renaissance writers, reassessing the question of suicide in a new philosophical context that stressed individual choice and a new cultural context that looked favorably on classical thought, were led to write sympathetic defenses of the human right to suicide. In his *Utopia* (1516), Thomas More presented an argument in favor of rational suicide, based upon the Epicurean and Stoic philosophy that formed the Utopians' creed.[62] Montaigne (1573–74) and Pierre Charron (1601) wrote treatises sanctioning legal suicide, modelled upon Cato and the Stoicism of Seneca.[63] And in his *Anatomy of Melancholy* (1621), Robert Burton explored the connection between melancholy and suicide, taking a sympathetic view of the latter.[64]

More than these, however, it was John Donne who reflected a new world outlook on classic moral problems, an outlook that saw the issues as more complex than previous scholastic argumentation had suggested. Donne's *Biathanatos*, written in 1608 (though not published until 1644, thirteen years after his death), is the first English defense of suicide. In this treatise, Donne uses none of the Roman arguments, offering instead a modern position that admits new terms: the possibility of an uncertain conscience and the reality of doubt. In his thinking, Donne drew heavily upon casuistic divinity (a case-by-case approach to moral issues), which paid special attention to the circumstances attendant to particular moral choices. Donne's own sources have been identified among several Spanish and Italian theologians, including Ioannes Azorius, a Jesuit who taught theology at Alcalá and in Rome, and Ludovico Carbo, a Venetian layman. The moral treatises written by these men in the first decade of the seventeenth century directly address the question of suicide in these new terms, and they exemplify both the authority and the popularity of casuistic divinity in early seventeenth-century Italy.[65]

The conflict between the new endorsements of the right to self-murder under certain conditions and the older, more orthodox arguments against it found expression in some art and literature. The temptation of suicide, combined with the lingering force of the Christian interdiction against it, is a recurrent theme in the drama of

Shakespeare, where we find fourteen successful suicides in eight plays.[66] Hamlet embodies the contradictory outlooks: "O, . . . that the Everlasting had not fix'd his canon 'gainst self-slaughter!" and the "To be or not to be" soliloquy, an expressly modern musing on what "undiscovered country" might follow death. By the late sixteenth century, unwavering belief in the prospect of a Christian afterlife was no longer strong enough to control all human action (if it ever was), and decisions were taken in art and in life that pragmatically disregarded theological consequences (Macbeth: "that but this blow / Might be the be-all and end-all here . . . We'd jump the life to come").[67]

In Shakespeare's poem *The Rape of Lucrece*, the heroine similarly reflects (in Donaldson's interpretation) a "new interior world of shifting doubts, hesitations, anxieties, anticipations, and griefs." She is troubled—both she and Tarquin—because it is no longer clear "what kind of moral universe they inhabit." Examining the issues from both Roman and Christian viewpoints, Lucrece applies the values of both, and finds herself consequently in a dilemma that has no possible satisfactory resolution: the shame brought upon her body by the rape calls for honorable suicide by Roman standards, yet to take her own life is to condemn her Christian soul:

> "To kill myself," quoth she "alack what were it,
> But with my body my poor soul's pollution?
> They that lose half with greater patience bear it
> Than they whose whole is swallowed in confusion.
> That mother tries a merciless conclusion
> > Who, having two sweet babes, when death takes one,
> > Will slay the other and be nurse to none.
>
> "My body or my soul, which was the dearer,
> When the one pure, the other made divine?
> Whose love of either to myself was nearer,
> When both were kept for heaven and Collatine?"

<div align="right">(ll. 1156–66)</div>

Struggling to resolve this irresolvable conflict of priority, Lucrece tries out other moral perspectives—has the rape poisoned her soul as well as her body (an argument for the deliverance of both), or has the body indeed suffered any real damage at all? When she finally applies the dagger to end the debate, she does so for no specific philosophical reason. For Donaldson, at least, such shifts of thinking reveal "a basic indecisiveness over the story's central moral issues" in a poem that "raises more questions than it manages to answer."[68] For other scholars, Lucrece assumes the burden of a tragic dilemma that Shakespeare gave to no other female character, comparable to the psychic burdens borne by Hamlet and Lear.[69]

Artemisia's Lucretia appears to suffer from the same discomfort as Shakespeare's Lucrece, an uneasy awareness that the terms of the decision she faces have become

implausible and anachronistic. Both characters propose an altered dilemma, one that, like the debate over suicide itself, takes into account a larger measure of practical human concerns. Like Lucrece, who pits an ideal of wholeness—a whole either sacrificed or preserved—against the need for a decision that forces a choice between body and soul, Gentileschi's Lucretia sets in opposition the sword, which is the instrument of that choice, and her maternal breast, a universal symbol of wholeness that is here the representative of coherent, ongoing life. In questioning the absolute need to decide between suicide and shame, both characters open the way to a new possibility: the heroine's right to self-determination. Lucretia in her vigorous insistence on the authority of her own anatomy, and Lucrece in her lament that she herself is dispossessed of both her body and soul "when both were kept for heaven and Collatine," have outgrown the boundaries of the original story; they have come to life.

Artemisia's human, reasoning Lucretia is nearly as rare in the visual arts as is Shakespeare's Lucrece in literature. One other important version of the theme in painting is perhaps comparable. Rembrandt's second interpretation of Lucretia, the picture in Minneapolis painted in 1666 (Fig. 202), presents the figure in grand dignity, standing in her bedchamber, meditatively gripping the lowered knife, hesitant and

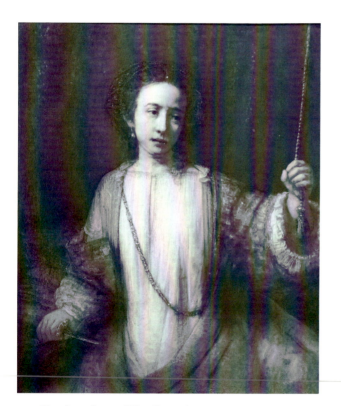

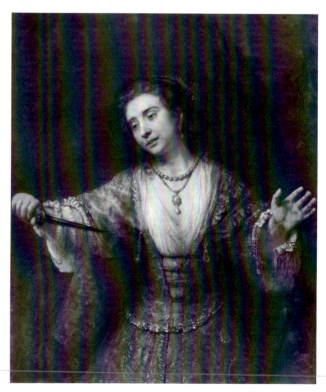

202. Rembrandt van Rijn, *Lucretia*, 1666. The Minneapolis Institute of Arts

203. Rembrandt van Rijn, *Lucretia*, 1664. Washington, D.C., National Gallery of Art

perhaps indecisive, but certainly experiencing inner tension, as is clearly conveyed in the action of her left hand pulling taut a tasseled cord suspended from above. In this late work, Rembrandt assigns to the character a very different emotional response from that given the Lucretia he painted just two years earlier (Fig. 203).[70] The Washington heroine is already moving the dagger toward her breast, her acceptance of her fate indicated in the gesture of resignation implied in the extended left hand (once more, the figure's cruciform silhouette recalls Christ's sacrifice). By contrast, the Minneapolis Lucretia is absorbed in profound and disturbed meditation, and though we have fewer clues to guess her thoughts, she is at least in possession of her own mind. With the deep expressive resonance that Rembrandt was able to give his meditative characters, she assumes philosophical significance.

IN DIFFERENT ways, the Lucretias of Artemisia Gentileschi, Rembrandt, and Shakespeare transcend the absurd flat character whose stereotyped self-sacrifice to an outworn idea had echoed endlessly in the imagery of less thoughtful or imaginative artists. The images created by Artemisia and Rembrandt have little in common except the artists' shared interest in expressing the seriousness of the dilemma faced by the heroine; the manifestation of her conflict takes extremely different forms—anguished immediacy in the Gentileschi painting, meditative subtlety in the Rembrandt. In this instance, women—young women especially—may perhaps be forgiven a preference for Artemisia's heroine over Rembrandt's, for the latter seems ultimately to possess an unnaturally mature, even premature, sense of tragic resignation to her fate. The tense, angrily defiant Lucretia in Genoa, by contrast, might well say of the long line of her sister saints and martyrs in the Western tradition, in the words of a modern poet:

> Into the darkness they go, the wise and
> the lovely. Crowned
> With lilies and with laurel they go;
> but I am not resigned.[71]

## REMBRANDT AND THE GENTILESCHI

In comparing the *Lucretia* of Artemisia Gentileschi's youth with Rembrandt's late work, we connect two artists who seem in many ways to be worlds apart. In fact, the Dutch artist and the Italian painter who was thirteen years his senior had a great deal in common in their youth, in their mutual aversion to rhetorical classical formulae and in their shared early influence from Caravaggio. (We are obliquely reminded of Caravaggio in Rembrandt's Minneapolis *Lucretia*, in fact, since that picture's composition has been shown to reflect a distant memory of the Borghese *David and Goliath* [Fig. 267].)[72] It was surely the Caravaggism of Artemisia's first *Judith Slaying Holofernes* (c. 1612–13) that appealed to Rembrandt, and influenced both the explicit violence and

the dramatic composition of his *Blinding of Samson* of 1636 (see above, pp. 58–59, and Figs. 18 and 42). Rembrandt's informed familiarity and fascination with Italian art is well known, and Kenneth Clark in particular has demonstrated the range and variety of his creative borrowings from Italian paintings and prints.[73] Yet the influence of Italian art upon Rembrandt, as Clark describes it, was largely a classical tempering of his anti-classical tendencies, and for the Baroque naturalism of Rembrandt's early work only the stimulus of Caravaggio has been noted. Granting that the Dutch painter did not necessarily need art to show him life, one may still observe that he could have found in Artemisia's intimately naturalistic and highly unclassical female nudes a welcome encouragement in a direction he was already going.

Rembrandt's nude female figures of the 1630s, such as the *Woman Seated on a Mound* etching of 1631 (Fig. 204) and the *Diana Bathing* etching (Fig. 205), shocked and excited his Dutch contemporaries, who were as accustomed as their Italian counterparts to seeing smoothly idealized female bodies in art. Without doubt, these are figures studied from life, as we are often told; yet Rembrandt has clearly made a selective discovery of feminine nature, seeking out a fleshy, wrinkled figure type, with pendant breasts and full belly, the better to counter the remote, unreal perfection of the classical tradition.[74] These figures, who parade their anti-classicism as vigorously as they do their fidelity to nature,

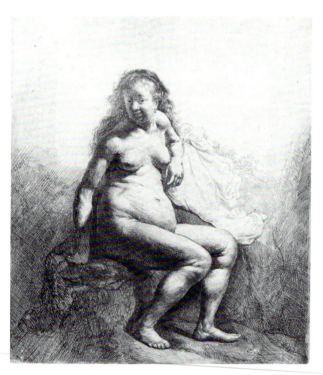

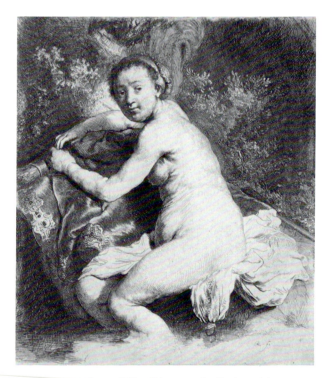

204. Rembrandt van Rijn, *Woman Seated on a Mound*, etching, 1631. London, Trustees of the British Museum

205. Rembrandt van Rijn, *Diana at the Bath*, etching. Washington, D.C., National Gallery of Art

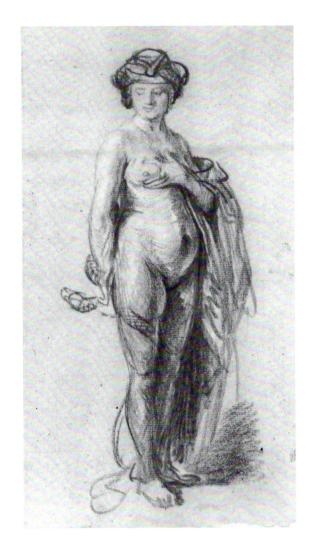

206. Rembrandt van Rijn, *Cleopatra*, red chalk drawing, c. 1637. Los Angeles, Calif., J. Paul Getty Museum

could not have been inspired by Caravaggio himself, who painted no naturalistic female nudes; nor do they have conspicuous antecedents in Italy or Holland. We cannot say with certainty that Rembrandt knew Artemisia's female nudes; we can say, however, that such figures as the Pommersfelden *Susanna*, the Genoa *Lucretia*, and her counterpart, the *Cleopatra* (Color Plate 10 and Fig. 209) would surely have interested him, for they presented images of the naked female then almost unique in European art—full-bodied, lumpy, and plain-featured—whose deviation from the classical norm marked them for description as vulgar.[75]

In one of Rembrandt's early figure drawings (Fig. 206) we see a hint of the artist's possible familiarity with Artemisia's *Lucretia* and *Cleopatra*. This standing female figure, whose swollen abdomen and stocky, unglamorous proportions connect her with Rembrandt's female nudes of the 1630s, has been identified as a study for an unrealized Cleopatra, because of the large serpent she holds as an attribute.[76] The figure combines motifs

from both of the Genoa pictures: it shares with Artemisia's *Cleopatra* a hand grasp of the serpent coiled around her leg and wrist that is quite unusual in painting, as we shall shortly see; and like *Lucretia*, the figure holds her breast with fingers spread around the nipple, a specific and unusual gesture rarely if ever seen in Cleopatra images. Rembrandt's Cleopatra drawing has been dated around 1637, which is about the date of his first major painting centered upon a nude female figure, the *Danae* in the Hermitage (Fig. 207). In this picture (dated 1636) we see the artist's first successful transformation of physical plainness into sensuous beauty, a transformation that may have been aided by Rembrandt's own intimate knowledge of his young wife Saskia,[77] but that was also complemented by his compositional transformation of one or more Italian models of the Danae theme, including Orazio Gentileschi's *Danae* (Fig. 208) painted for Giovan Antonio Sauli of Genoa in about 1621, a work contemporary with Artemisia's *Lucretia* and *Cleopatra*.[78]

Although the female nude reclining on a bed was a familiar type by seventeenth century (thanks to sixteenth-century Venetian painters), Rembrandt took the raised arm and frontal pose of his *Danae* from more recent sources, one of which must have been Orazio's *Danae*. Not only do the poses of the reclining women closely correspond, but Rembrandt's intimate bedroom setting more closely resembles that of Orazio than of other prototypes that have been proposed.[79] Unquestionably, Rembrandt has transcended his compositional source in naturalism and expressive subtlety, bringing Danae's lover to her in the form of light rather than a shower of gold coins, rendering her body as warm living flesh, and making the gesture of the upraised arm appear both natural and personal.[80] Yet considering the common location of Orazio's *Danae* and Artemisia's *Lucretia* and *Cleopatra* in Genoa in the 1620s, Rembrandt may have been familiar with all three, and Orazio's painting may have inspired the design of his *Danae*, while Artemisia's interpretations may have given the Northern painter encouragement to paint her as an earthly creature. This correspondence, as well as the relations between Rembrandt's Cleopatra drawing and the Genoese nudes, and between the *Samson* and the *Judith*, collectively point to the possibility of Rembrandt's acquaintance with replicas or copies of Gentileschi works, especially those painted in Genoa in the early 1620s, a knowledge that could have played a significant part in the development of Rembrandt's own version of anatomical naturalism.

Rembrandt's extensive acquaintance with Italian art, summed up in his famous remark to Constantin Huygens that he didn't need to go to Italy since in Amsterdam he could see all the Italian pictures he wanted, is demonstrated as well by the rich contents of his own collection.[81] The 1656 inventory of Rembrandt's art holdings contains no direct mention of Orazio or Artemisia, yet there are many possibilities for Rembrandt's knowledge of Gentileschi pictures. One is through art dealers such as Anthony Van Dyck's friends, the brothers Cornelis and Lucas de Wael, who were Flemish art handlers in Genoa, and who no doubt traded with their counterparts in Holland. Van Dyck himself was well acquainted with Orazio, whose image he included in his *Iconography*,

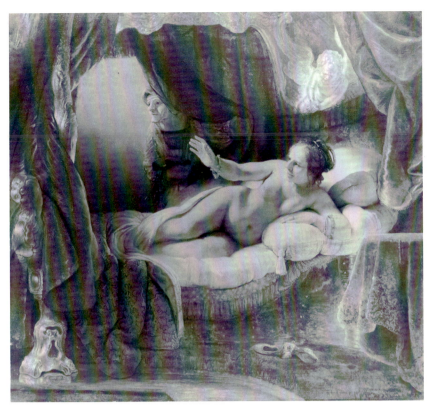

207. Rembrandt van Rijn, *Danae*, 1636. Leningrad, Hermitage

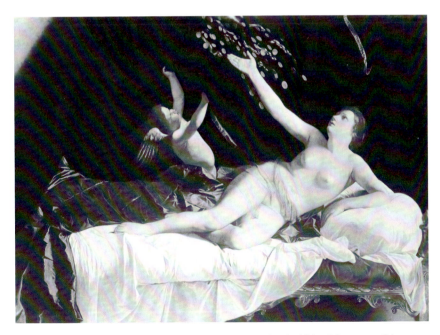

208. Orazio Gentileschi, *Danae*, c. 1621. Cleveland, Ohio, Museum of Art

and whom he probably first met in Genoa in about 1621.[82] Van Dyck must also have known Artemisia in Genoa and Rome in the early 1620s, and he seems to have been familiar with her *Susanna* as well as her *Lucretia*, to judge from the *Susanna* he painted a few years after his stay in Genoa (see above, p. 57). Van Dyck went twice to Holland, in 1628 and 1631, to work for Prince Frederick Henry of Orange. The latter's artistic advisor was Huygens, the man who told Rembrandt to go to Italy.[83] A definite link between Artemisia and Rembrandt was available through Joachim von Sandrart, who knew them both. Sandrart's travels in Italy, from 1628 to 1635, put him in contact with Artemisia, whom he visited in Naples in 1631, painting for her a replica of one of his own pictures, and praising her greatly in his later *Teutsche Academie* (see above, p. 109). By 1637, Sandrart was in Amsterdam, where he remained until 1642, in close contact with Rembrandt—whom he described for posterity as an ignorant man who had not visited Italy, who opposed and contradicted "our rules of art," and who "associated with the lower orders."[84] It is not difficult to imagine that Rembrandt would have heard a few things from Sandrart about the fearsome Italian female prodigy, nor that he might have seen in Amsterdam replicas, perhaps even examples, of her work. The pursuit of Gentileschi paintings in Holland is not within the scope of this study, but remains a field of potentially fruitful investigation.

## CLEOPATRA

That Artemisia's first *Cleopatra* (Color Plate 10 and Fig. 209) and Orazio's *Danae* (Fig. 208) represent the first depictions by each artist of a completely reclining nude may reveal more about the artistic and erotic interests of their Genoese patrons than about their own. Judged as a nude, Artemisia's *Cleopatra* is perhaps more satisfactory than her *Lucretia* and *Susanna* in that she displays a overtly erotic pose, which conforms at least superficially to the stereotype of the recumbent female nude. The dying Cleopatra reclines expansively upon rumpled bedclothing, her legs crossed, her arm raised over her head, brilliantly illuminated against a lush dark red ground. The figure might easily be interpreted as yet another sensuous beauty of the type displayed for masculine delectation, whose framed image would move in future centuries from the palace wall to the barroom shelf, to the "art" calendar, and finally, to the centerfold.

Yet Artemisia's *Cleopatra* deviates significantly from the tradition it may have helped to sustain. There is in the figure a curious disjunction between general pose and specific anatomy, as if the artist had begun with a type and wound up with an individual. Her torso is thick, her breasts flattened and volumeless (though breasts indeed do naturally flatten when a woman lies on her back), and her rather homely face is slightly distorted by the force of gravity. Although the figure's legs offer a more conventional version of ideal feminine curves, they join the body very uncomfortably, creating, where they meet the oddly angular abdomen, an abruptly broken transition, instead of the smooth continuous flow that we have come to expect from reclining

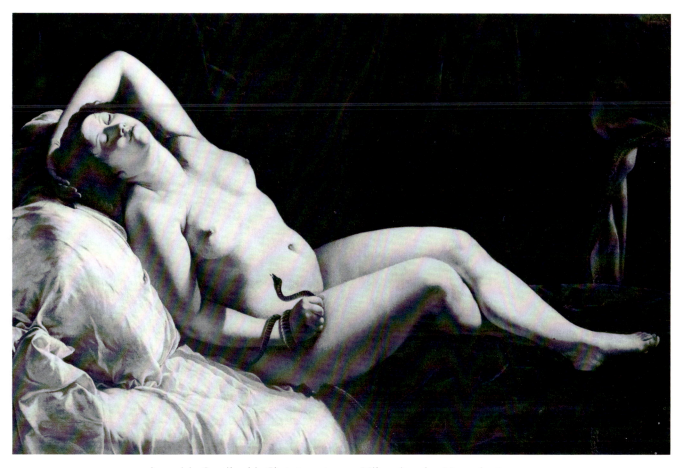

209. Artemisia Gentileschi, *Cleopatra*, 1621–22. Milan, Amedeo Morandotti

nudes such as Giorgione's *Sleeping Venus* (Fig. 220) or Titian's *Venus of Urbino*. Indeed, one suspects that instead of a later bowdlerizer *adding* drapery to the figure's pubic area, as has been suggested (an addition, it has been said, that was subsequently removed), a restorer may have *removed* a drape that was original to the picture and repainted this passage crudely. Certainly the evidence of Artemisia's second *Cleopatra* (Color Plate 17 and Fig. 242), in which the pubic area is decorously covered, as it is in the *Susanna* and the *Lucretia*, would suggest a preference on the artist's part for a draped rather than fully nude figure.[85]

Despite its curious and conspicuous awkwardnesses, and its ample measure of what John Berger has described as the welcome banality of nakedness[86]—or perhaps because of these factors—the *Cleopatra* exerts a strangely hypnotic force upon the viewer, a power of mood and suggestion that is partly in the realm of the erotic and partly beyond. The dominant effect is an almost hallucinatory clarity of form. The volumes of the figure and the folds of the luminous white bedclothing emerge with

palpable exactness, aided by a judicious use of cast shadows—seen especially on Cleo-
patra's right elbow, her right cheek, and her left hand—and of light reflections, such
as the luminous rosy glow given by the red bedcloth to her hip, underthigh, and heel.
Unlike similarly disjunct figures in hastily assembled paintings, whose proportional
deviations from an ideal norm result from the artist's carelessness or ineptitude, this
ungainly figure of Cleopatra is given three-dimensional reality with great precision
and care. The intensely charged atmosphere of the picture is created as well, however,
by the strangely contradictory messages given by Cleopatra herself, whose body seems
tense and alert even as she reclines in sleep or death, whose eyes appear to be closed
and yet are slightly open.

    This small detail, the partly open eyes (Fig. 210), changes the figure from a lifeless
object to a haunting human presence. Though dying, she is not yet dead. Her descent
into the dreamy slumber that accompanies death by snakebite is reflected in the heavy-
lidded, crescent-slitted eyes. But if Cleopatra is here shown succumbing to the

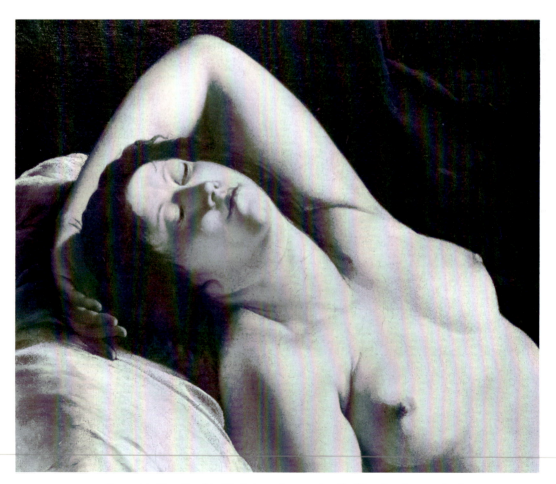

210. Artemisia Gentileschi, *Cleopatra*, 1621–22, detail of head and upper body.
Milan, Amedeo Morandotti

poisonous bite of the asp she holds in her hand, then where are the marks of the bite? Perhaps, like Lucretia, Cleopatra is seen in the moment before the decisive act of suicide, and has not yet been bitten. But if this is so, why is she already falling into her lethal slumber? To explain the apparent contradictions in this deceptively simple, yet provocatively mysterious image, we must explore its relation to the story of Cleopatra's death, and to a set of specific artistic sources.

THE suicide of Cleopatra—unlike that of the semimythic Lucretia—was a historical event, described for us most completely by Plutarch and Dio Cassius.[87] Cleopatra VII, Queen of Egypt, met death in 30 B.C. at the age of thirty-nine, in the mausoleum she had constructed for herself and Mark Antony in Alexandria. Cleopatra, whose active and dramatic political life centered upon the struggle by Rome to rule Egypt, had as consort first Julius Caesar and then Antony, by each of whom she bore children. After the assassination of Caesar in Rome, Antony joined forces with Cleopatra in Alexandria, carrying on with her a splendidly extravagant love affair (described by the participants as the Society of Inimitable Livers). Together they established a strong Eastern power base. The Battle of Actium, however, saw the defeat of Cleopatra and Antony by the forces of Octavian (Augustus) and eventually, Antony's suicide. With the troops of Octavian at hand, Cleopatra attempted suicide herself, first by sword, and then by an effort to starve herself to death, but she was thwarted by Octavian, who wanted to take her alive to be paraded in his triumphal procession in Rome. Eventually, it was speculated by the historians, Cleopatra may have arranged to have an asp brought to her concealed in a basket of figs. Sending away all but her two faithful maidservants, she retreated to her chamber where, it was subsequently concluded, she must have allowed the poisonous snake to deliver her to death. She was found by Octavian and his guards lying dead upon a golden couch, dressed in royal attire, attended by her two dying servants, one of whom was arranging a diadem on the queen's head.

Post-Renaissance narrative images of the death of Cleopatra tended to concentrate upon the episode in this dramatic account that occurred in private, without surviving witnesses: the moment when the snake bites Cleopatra's breast. Examples such as the painting by Guido Reni reproduced above (Fig. 175), a sixteenth-century engraving from the School of Fontainebleau (Fig. 211), in which the heroine struggles against two snakes who simultaneously attack her breasts in decorative symmetry; an especially orgasmic version by Sebastiano Mazzoni (Fig. 212); and a highly artificial Neapolitan example (Fig. 213)[88] may suffice to convey the characteristic focus of most artists upon the sadoerotic possibilities implied in Cleopatra's suicide. The snake takes on the phallic overtones suggested by the dagger in Lucretia's suicide, with the sexual implications underscored by its invariable attraction to Cleopatra's breast.

Less overtly narrative versions of the theme, more typical of the sixteenth century though continuing into the seventeenth, present the isolated figure of Cleopatra with

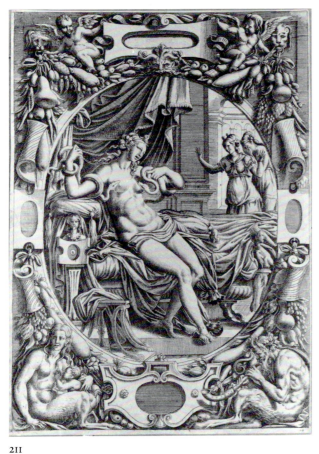

211

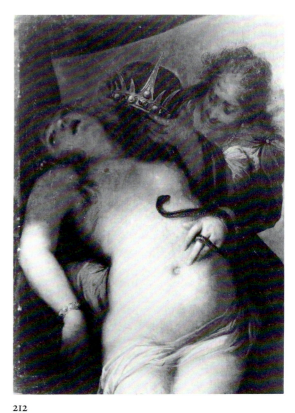

212

211. School of Fontainebleau,
*Cleopatra*, engraving, sixteenth
century. B. XVI.392.41

212. Sebastiano Mazzoni, *Cleopatra*,
seventeenth century. Munich,
Alte Pinakothek

213. Domenico Muratori, *Cleopatra*,
seventeenth century. Rome,
Spada Gallery

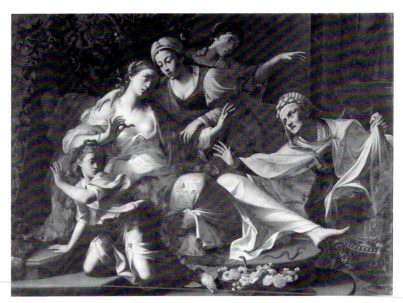

213

the snake as an attribute, but also tend to juxtapose the snake and the breast, either suggestively or directly. Examples of this type include an engraving by Agostino Veneziano, after Bandinelli (Fig. 214), and a *Cleopatra* by Guercino (Fig. 215) that is contemporary with Artemisia's picture, in which the fully dressed heroine decorously exposes her breast as she reaches for the snake.[89] Noteworthy for its difference from these traditions is a picture by Cagnacci in Vienna (Fig. 216), which shows the diademed queen sitting upright in a chair, attended by weeping maidservants as the snake bites her arm. Except for its plethora of servants, this image conforms more accurately to the historical accounts of Cleopatra's death, for according to Plutarch, the reptile did bite her in the arm, and not the breast.[90] Cagnacci's version also unusually emphasizes Cleopatra's queenship by showing her seated in the golden throne described by Plutarch, a feature that links his interpretation with similarly positive and dignified images of the late Middle Ages (e.g., Fig. 181).

By far the most popular conception of Cleopatra in the seventeenth century, however, was a romantic and sexual one; she was an archetype of love, whose beauty

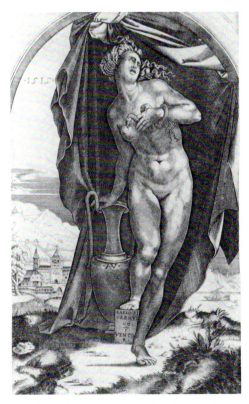

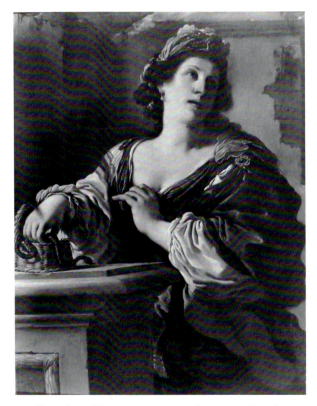

214. Agostino Veneziano, after Bandinelli, *Cleopatra*, engraving, 1515. B. XIV.158.193

215. Guercino, *Cleopatra*, seventeenth century. Pasadena, Calif., Norton Simon Museum

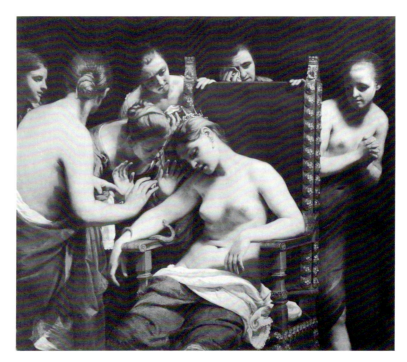

216. Guido Cagnacci, *Cleopatra*, seventeenth century.
Vienna, Kunsthistorisches Museum

was heightened in pictorial juxtaposition with the deadly serpent. One such *Cleopatra*,
by Guido Reni, for which the patron's beautiful wife allegedly served as model, was
celebrated in a contemporary poem:

> Ingenious brush
> That giving life to Egypt's Queen has made
> Her so alive that some before her bow:
> Fair monarch, not by asp but love betrayed.
>
> Love kills her.
> The way to give her life the painter knows:
> The brush breathes vital spirits in her,
> The serpent then upon her death bestows.[91]

In this poem it is suggested that Cleopatra's living presence is an accomplishment of
the painter; the queen exists, however, as victim—of her love for Antony and of the
snake that brings her death. Such an understanding of the character directly parallels
the numerous pictorial images of the period, in which Cleopatra's distress in an

indecorous struggle with writhing serpents is both cause and mode of her existence in paint.

Artemisia's *Cleopatra*, while retaining prominent snake and breast imagery, nevertheless departs from the central tradition thus outlined in two important respects. First, she is not shown emotionally reacting to the bite—or the anticipated bite—of the snake, but rather exhibits an unusually relaxed and serene calm as she sinks into oblivion. Those few Cleopatras shown in a state of sleepy torpor, such as that of Cagnacci (Fig. 216), are characteristically upright, seated figures.[92] As a recumbent nude figure, Artemisia's *Cleopatra* also differs from other Cleopatras of the period, for we find her supine in only a few of the numerous interpretations of this popular theme. One such reclining *Cleopatra* is another picture by Guercino (Fig. 217), which presents the queen lying on her bed administering the asp to her breast. This painting, datable around 1648, was painted for a Genoese patron, and the pose of its heroine may have been influenced by Artemisia's picture.[93] Guercino emphasizes the narrative aspect more strongly, however, in his focus upon the asp's bite, and his figure does not overtly express the dreamy death state.

Artemisia's image of Cleopatra is thus to be distinguished from the narrative tradition, which became increasingly histrionic in the seventeenth century, and should be connected instead with an earlier, more vital artistic tradition, that of the "sleeping nymph." For in envisioning Cleopatra as a reclining nude, with legs crossed and arm around her head, Artemisia drew upon several particular artistic prototypes that were

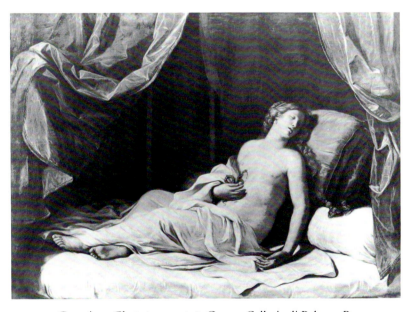

217. Guercino, *Cleopatra*, c. 1648. Genoa, Galleria di Palazzo Rosso

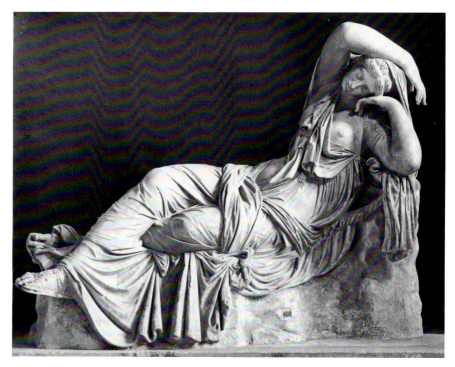

218. Hellenistic, *The Sleeping Ariadne*, c. 240 B.C. Rome, Museo Vaticano

known to her as Cleopatras, but that in fact represented a broader—and as we shall see, more profoundly evocative—current of imagery.

One of her sources, surely, was the famous classical statue in the Cortile Belvedere of the Vatican, the *Sleeping Ariadne* (Fig. 218). From this well-known work, which was in Artemisia's day prominently exhibited in its specially created niche in the *Stanza della Cleopatra* in the Vatican,[94] would have come the principal outlines of the pose, with the crossed legs and arm curved over the head (an antique convention indicating sleep[95]). The artist's attention would logically have been drawn to this figure as an appropriate source, since the statue was believed until the eighteenth century to have represented not Ariadne but Cleopatra, because of the snake wrapped around the statue's upper left arm.[96] This misidentification of the Vatican statue, which apparently originated with its excavation in 1512, soon led to the creation of numerous Cleopatra images based upon the classical figure, particularly from the school of Raphael. Exemplary is the engraving by Agostino Veneziano (Fig. 219), in which a more active role for the snake is fashioned and a grieving Cupid is added, a clear allusion to Cleopatra's popular identity as a goddess of love.[97]

The Vatican *Ariadne* does not account, however, for the total nudity of Artemisia's *Cleopatra*, nor for her facing the opposite direction. In these respects, other images of sleeping nude female figures may have joined the *Ariadne* in the artist's

219. Agostino Veneziano,
after Raphael (?), *The Death of
Cleopatra*, engraving,
sixteenth century.
B. XIV.161.198

memory. The best known of these, Giorgione's *Sleeping Venus* in Dresden (Fig. 220),
is the central image of the "sleeping nymph" tradition that found its most vigorous
expression in Venice in the early sixteenth century. Artemisia's stiffly angular
*Cleopatra*—a far cry from the harmoniously composed, classically ideal *Venus* of
Giorgione—resembles more closely another Giorgionesque figure type: the sleeping
female nude seen from the rear, an image that appears in engravings by Giulio
Campagnola and Marcantonio (Figs. 221 and 228), and which is believed to have
originated in a lost Giorgione prototype.[98] Artemisia's familiarity with the Venetian

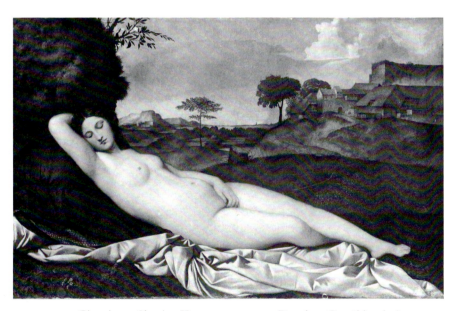

220. Giorgione, *Sleeping Venus*, c. 1505–1510. Dresden, Gemäldegalerie

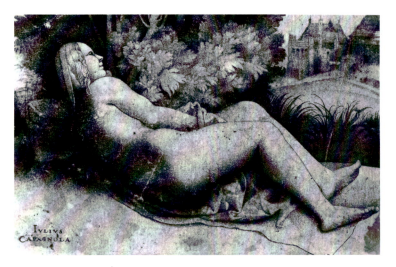

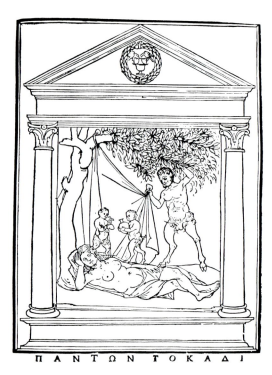

221. Giulio Campagnola, *Sleeping Woman*, engraving, sixteenth century. Cleveland Museum of Art

222. Naiad-Venus with Satyrs, from *Hypnerotomachia Poliphili*, woodcut, 1499

Renaissance "sleeping nymph" tradition is thus indicated, and would fit with the likelihood of a visit to Venice by the artist around the time the Genoa *Cleopatra* was painted.[99]

Perhaps not coincidentally, Giorgione's *Venus*, along with its sources and analogues, shares a basic iconography with the Vatican *Ariadne*, in the terms that the Renaissance understood the antique statue. The Dresden *Venus* is believed to have been influenced, or even directly inspired, by a woodcut illustration in the *Hypnerotomachia Poliphili* (Fig. 222), the popular romance by Francesco Colonna published in Venice in 1499.[100] This image illustrates a passage in the text that describes a fountain with a sleeping nymph at its center, from which it deviates in showing a nearly nude female sleeping under a tree, approached by an ithyphallic satyr, in the presence of two fauns *(satirini)*. As Millard Meiss has pointed out, the woodcut image joins with the fountain nymph another ancient theme, that of a sleeping nymph or goddess— Lotis, Vesta, or Ariadne—who is approached by a satyr or male god. Bacchus's approach to Ariadne was depicted frequently by Roman artists (Fig. 223), and she is unveiled by a satyr on a number of antique sarcophagi.[101]

The Vatican sculptural *Ariadne*, thought to be Cleopatra, was deliberately connected with the *topos* of the sleeping nymph when a fountain setting was created for it in 1512, and the statue was placed in a simulated grotto that spilled water into a

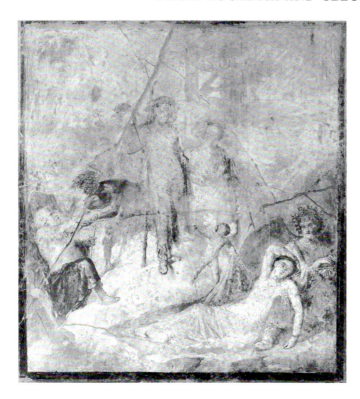

223. Roman, *Bacchus and Ariadne*, from Pompeii. Naples, Museo Nazionale

sarcophagus basin.[102] This reconstructed environment, whose appearance is preserved in a drawing by Francesco de Hollanda dated 1538–39 (Fig. 224), intentionally evoked a famous pseudo-antique epigram (now known to have been written in the late fifteenth century) that allegedly accompanied a sculpture of a nymph in a fountain on the banks of the Danube:

> *Huius nympha loci, sacri custodia fontis*
> *Dormio dum blandae sentior murmur aquae.*
> *Parce meum quisquis tangis cava marmora somnum*
> *Rumpere: sive bibas, sive lavere taces.*

> (Nymph of the grot, these sacred springs I keep,
> And to the murmur of these waters sleep;
> Ah, spare my slumbers, gently tread the cave!
> And drink in silence, or in silence lave.)[103]

The image evoked in this epigram was given pictorial form by Dürer (Fig. 225), Cranach, and many other artists. Numerous variants of the sleeping nymph in a wooded setting include a sleeping Diana relief of the late fifteenth century (Fig. 226), and diverse images of sleeping mothers—Amymone, Abundance, Venus—often

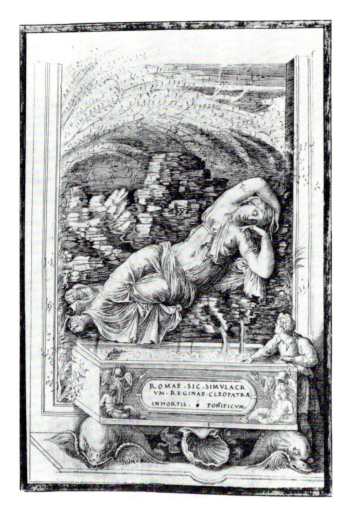

224. Francisco de Hollanda,
*"Cleopatra" (The Sleeping Ariadne)*,
the Escorial sketchbook,
fol. 8ᵛ, 1538–39

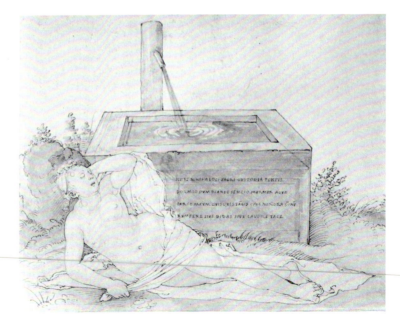

225. Albrecht Dürer, *Sleeping
Nymph*, drawing, c. 1514.
Vienna, Kunsthistorisches Museum

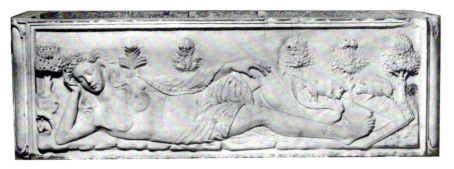

226. *Diana(?) Sleeping*, relief, fifteenth century. Rome, Palazzo Odescalchi

approached by satyrs.[104] The relevance of forest iconography to Cleopatra herself in the Renaissance, a relevance perhaps established by the Vatican statue and its fountain setting, is shown in a painting by Jan van Scorel (Fig. 227), which shows Cleopatra in a landscape, an image that draws—like Artemisia's *Cleopatra*—jointly upon the Vatican *Ariadne* and Giorgione's *Venus*.[105]

Many sleeping nymph fountains appeared in European gardens in the sixteenth century, often sustaining, as Kurz has pointed out, the solemn and serious mood suggested in the famous epigram. The ubiquitous message that these were sacred places is conveyed especially in the shortened version of the epigram found in one such fountain:

NYMPHIS LOCI

BIBE LAVA

TACE[106]

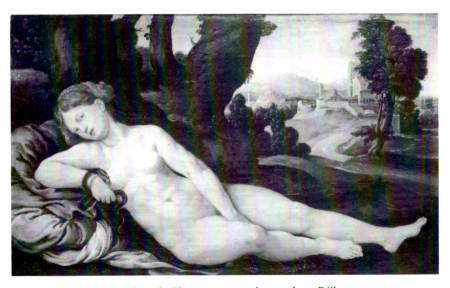

227. Jan van Scorel, *Cleopatra*, 1520s. Amsterdam, Rijksmuseum

What is the sacred meaning of this sleeping nymph, whose presence demands our silence, and whose broader identity embraces such disparate characters as Venus, Cleopatra, Ariadne, Diana, and many others? As the question was once memorably posed, *why* do nymphs sleep?[107] This question has perplexed all the scholars who have examined these images. Meiss found evidence that Renaissance humanists interpreted the sleeping nymph as symbol of the Muses, awakened by the writers and poets of the new academies of learning.[108] Elisabeth MacDougall, seeking to explain the antique origins of the type, traced all the fountain figure variants to the single ancient figure type of Ariadne, whose sleeping pose is called for by the story of her awakening by the god Bacchus, an image reinforced by related antique myths and literary descriptions.[109] Otto Kurz traced the ancient type farther back, to Greek images of goddesses of springs, and beyond, to the Maenad from the Dionysiac troupe, "prostrate in drunkenness."[110] We are faced here, however, with explanations that do not explain, that seek origins without accounting for the peculiarly insistent force of the image of the sleeping woman, who appears in art in the guise of Rhea Silvia, Amymone, Ariadne, Cleopatra, Venus, Diana, and Michelangelo's *Notte*, and who persisted in the imagination of Western artists, from Piero di Cosimo, Dürer, Claude Lorraine, and Poussin, to Alexander Pope and Thomas Jefferson.[111] How can we account for the archetypal power of this image?

Psychologists might tell us that nymphs sleep because we do not want to know what they mean. Sleep, on the most basic level, connotes dreams, the hidden part of our minds, and the image of sleep symbolizes that mysterious part of ourselves that is inaccessible to, or suppressed by, our conscious intelligence. And while we might say that the image of a sleeping figure shows a person whose consciousness is suppressed, it would be equally true to say that the sleeper is in contact with her own unconscious through her dreams. Hence the strange and paradoxical power that a sleeper's image holds over the conscious viewer—despite her apparent vulnerability— is the magical force of her mysterious dream life, hidden from the viewer, but affording a deeper level of knowledge, and thus power, to the sleeper. The magic realm of dreams is suggested in such images as Marcantonio Raimondi's engraving *The Dream of Raphael* (Fig. 228),[112] in which alarming natural disasters and strange animal metamorphoses are juxtaposed with two sleeping women, who might be dreaming—or causing—the fantastic and unnatural havoc nearby. The recurring image of a sleeping woman is both an acknowledgment and a denial of her power: an acknowledgment that she might be dangerous awake, and a denial of the mysterious knowledge that she is forced, through the artist's own magic, to keep to herself.

The hinted meanings and associations that cluster around the sleeping female figure imply quite clearly that the realm of her secret knowledge is nature itself, its woods, springs, animal fecundity and human sexuality. One form of the Renaissance understanding of the relation between woman and nature is given to us through the reasoned Neoplatonist exposition of the idea of the terrestrial Venus, "Venus *Vul-*

228. Marcantonio Raimondi, "The Dream of Raphael," engraving,
sixteenth century. B. XIV.274.359

*garis,*" who is embodied in the corporeal world, the inferior natural counterpart of
the celestial Venus whose dwelling is in the Cosmic Mind.[113] Yet such explanations
function largely to rationalize and to dissipate the power of the awesome secret bond
between women and nature.[114] The sense of mystery, strangeness, and otherness that
men apparently have felt before the woman/nature union—conveyed more in the ob-
sessive depiction than in the individual example of the sleeping nymph theme—is
epitomized in the Cleopatra of literature and myth, an exotic figure created over the
centuries out of the rich textual material of the historical account, whose archetypal
characteristics help to explain some of the artistic images of her that we confront.

IN THE Western masculine imagination, Cleopatra has embodied all of the qualities
of the quintessential female, and those of Egypt itself. As Queen of Egypt—"serpent
of old Nile," Shakespeare's Antony calls her—Cleopatra indeed *was* Egypt. Egypt in
turn has been in Western eyes identified with the feminine principle, an identification
pointed up sharply in Shakespeare's play, where the Egyptian world is set in contrast
to that of masculine Rome, with its competitions, wars, rivalries, and aggressive
power plays.[115] Rome is practical and direct: the embodiment of cold and abstract
reason. Egypt, like women in general and Cleopatra in particular, is, in the masculine
Roman vision, mysterious, sinister, changeable, irrational, unknowable. Close to na-
ture at its procreative, sensuous roots, Egypt is luxurious, amoral, pleasure-centered.
Paradox and mystery are at the heart of Egypt, for, in Marilyn French's words, "It is
thus anti-civilization, yet it is the principle of life." When Shakespeare's Antony gives

up the Roman world for a sybaritic life with Cleopatra in Egypt, he acknowledges, "I have not kept my square" (*Antony and Cleopatra* 2.3.6).

Above all, Egypt, Cleopatra, and woman are magical. The ancient civilization itself is summed up for Europeans in its secret rituals and burial rites, its potent poisons, and its cryptic Sphinx. Cleopatra, described by Antony as "cunning past man's thought," lives in literary memory in the extraordinary image of seductive luxury framed by Shakespeare:

> The barge she sat in, like a burnish'd throne,
> Burn'd on the water: the poop was beaten gold;
> Purple the sails, and so perfumed that
> The winds were love-sick with them; the oars were silver,
> Which to the tune of flutes kept stroke, and made
> The water which they beat to follow faster,
> As amorous of their strokes. For her own person,
> It beggar'd all description: she did lie
> In her pavilion—cloth-of-gold tissue—
> O'er-picturing that Venus where we see
> The fancy outwork nature: on each side her
> Stood pretty dimpled boys, like smiling Cupids,
> With divers-colour'd fans, whose wind did seem
> To glow the delicate cheeks which they did cool,
> And what they undid did.[116]

Cleopatra's magic, like that ascribed to eternal woman, comes from her fatal powers of seduction, operative even through her inanimate *accoutrements*, which worked their effect upon Julius Caesar, Mark Antony, and—according to legend—a host of other young men who were put to death after one night of love with the deadly queen.[117] Descriptions of Cleopatra's incredible beauty and delightful charm thus assimilate to a more enduring and negative stereotype, that of the *femme fatale*.

We know Cleopatra in the twentieth century almost completely through the exotic filter provided by nineteenth-century Romantics, such as we find in Théophile Gautier's *Une Nuit de Cléopâtre*, where she is an unattainable praying mantis, a sexual cannibal, a Fatal Woman, and in Swinburne's *Cleopatra*, where she becomes, like Walter Pater's Mona Lisa, a vampire:

> Under those low large lids of hers
> She hath the histories of all time . . .
>
> Dank dregs, the scum of pool or clod,
> God-spawn of lizard-footed clans,
> And those dog-headed hulks that trod

II, like Caesar, had conquered the Nile, this time by diverting its waters (symbolically) to the fountain that enshrined the queen in Rome.[125] Pope Julius, who cultivated associations between himself and imperial Roman predecessors,[126] was also compared in the poems to Octavian (Augustus Caesar) in the resemblance between his own display of the image of the dying *Cleopatra* and the effigy of the dying Cleopatra that was carried in Octavian's triumphal procession in Rome, celebrating his conquest of Egypt.[127] Strongly implied in these descriptions is an attitude surely officially endorsed, that the *Cleopatra* statue was for Julius II precisely what the image of Cleopatra (a vicar of the queen herself) was for Octavian: a trophy of conquest. It is a formulation more brutal and transparent than that of the depicted sleeping nymphs, who at least serve as respectful propitiations of the mysterious powers they symbolize. The exhibition of the Vatican *Cleopatra*, caged in its grotto like a wild beast on display, nature possessed by culture, closely paralleled in intent the parading of the ancient effigy of the captured and defeated Queen of Egypt through the streets of Rome in 30 B.C. In much the same spirit, Egyptian obelisks were brought to Rome by Augustus and, centuries later, by Pope Sixtus V, as captive trophies symbolizing dark and mysterious Egypt, which held for Rome and the West such perennial fascination and such fear.[128]

The Renaissance understanding of Cleopatra as a bewitching and luxurious temptress was founded upon a long literary tradition, one that stretched back to the queen's own day. The most proximate texts for Michelangelo or for any literate Italian would have been Dante, who placed "luxurious Cleopatra" in his Inferno among the carnal sinners, and Boccaccio, who defined her as greedy, cruel, and lustful, with an insatiable craving for kingdoms.[129] Boccaccio's interpretation of Cleopatra relies more upon Dio Cassius's characterization of her than upon Plutarch's, and it parallels other Roman writers in its harsher assessment of the queen's character. She was described as a prostitute and harlot not only by Dio, but also by Propertius and Josephus; she was called amoral by Seneca, Julian, and Symmachus; and the association of Cleopatra with excessive luxury is established by Valerius Maximus, Macrobius, and Juvenal.[130]

This definition of Cleopatra is made possible, of course, by its implied opposite—those specifically Roman virtues of chastity, morality, loyalty, and stoic restraint—and the Roman historians' accounts of the Egyptian queen's political career are deeply imprinted by moral, national, and sexual stereotype. Vergil saw the Battle of Actium as the climax of Roman history, in which the wealthy, treacherous, and perfidious East, represented by Cleopatra and Antony, is conquered by the sternly heroic and moral West in the person of Octavian.[131] The Roman understanding of Cleopatra, with its sense of a historic conflict between virtue and vice, combined with a deep fearful respect for the enemy, is perhaps best summed up by Horace, who may himself have been with the Roman fleet at Actium:

> A Queen had planned in hate
> to smash the Capitol and sack
>     the conquered Roman State.
> She and her plotting gang, diseased and vile,
> went mad with heady dreams of baseless pride:
>     drunk with their luck were they awhile,
>     but soon the frenzy died
> when not a single ship of hers escaped.
> Though Mareotic juices dazed her head,
>     back to true terrors she was raped
>     by Caesar when she fled
> from Italy. . . . But more bravely she
> turned to her death, no woman's part she bore,
>     the swordblades did not make her flee
>     to find some hidden shore.
> Seeing her ruined court with placid eyes,
> she grasped the asps and did not feel the pains,
>     wishing the venom to surprise
>     and brim at once her veins;
> for brooding arrogance had nerved her thought.
> She grudged in triumph-shackles to be seen,
>     by the Liburnian galleys brought
>     to slavery, a queen.[132]

The interpretation of Cleopatra as a sensual, amoral, evil temptress, which has prevailed in art and literature with varying inflections for nearly two thousand years, began then in her own day. It was created by her political enemies, who defined her as wicked because she opposed them, and they regarded themselves as virtuous. Seen through Roman eyes, she was measured by Roman values. Even Horace's effort to heroize her suicide draws upon esteemed Roman character traits: courage, calm, pride in independence. Scholars seeking to discover the historical Cleopatra under this cobweb of distortions, projections, and fantasies have been disadvantaged by the absence of texts that would explain the events of 51 to 30 B.C. from the queen's own viewpoint. For apart from a few impersonal references in Julius Caesar's *Civil War*, almost no contemporary historical evidence of the life and reign of Cleopatra survives. What remains has been described as second-hand, pro-Augustan propaganda.[133]

Yet some historical re-creation is possible. Let us now look, in this account presented in reverse, at the final episode—the historical Cleopatra and her mythic ancestry—so that we may complete our reconstruction of the context of Artemisia Gentileschi's painting.

Cleopatra, the seventh Egyptian queen of that name, was the last member of the

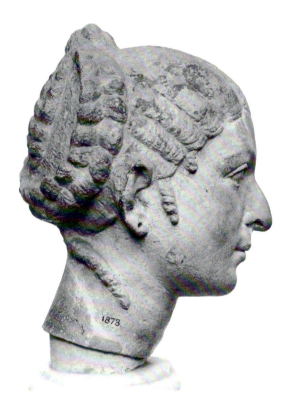

231. Cleopatra VII of Egypt, bust, Roman(?).
London, Trustees of the British Museum

Ptolemaic dynasty that had ruled Egypt for nearly three centuries (Fig. 231). Successor
to a series of active and powerful queens who had shared significantly in governing
Egypt since the time of Alexander, Cleopatra VII was famed in her day not so much
for her beauty as for her magnetic charm, her acute intelligence and wit, her facility
with languages, and her extraordinary political ability.[134] Cleopatra's political aim was
consistent with that of the Ptolemies who preceded her on the throne: to keep Egypt
free from Roman domination, and beyond that, to restore the Ptolemaic empire to
its original size and strength. More than this, she seems to have wanted to extend her
kingdom to Rome itself, for according to Dio Cassius, one of Cleopatra's favorite
oaths was, "As surely as I shall one day dispense justice on the Capitol. . . ."[135] Her
liaisons with Caesar and Antony may well have served her primarily as practical
expedients to achieve her political ends (as of course theirs with her had done
for them).[136]

Scholars acknowledge that it was probably as much through Cleopatra's state-
craft as Antony's that the Eastern empire was enlarged, with Cleopatra at its center as
queen of Egypt, co-regent with Caesarion, her son (allegedly) by Julius Caesar. For a
while, the divine monarchy created by Cleopatra and Antony out of the mythic divin-
ity of both Caesar and Cleopatra served Roman territorial ambitions as well as Egyp-
tian ones, but the breakup of the uneasy alliance between Antony and Octavian

(Augustus), which found resolution in the Battle of Actium, seems to have come ultimately over the intolerability to Rome of the flagrant independent power of the Egyptian queen, and the Hellenistic values that, with Antony, she espoused. Cleopatra was both political exponent and embodiment of the Eastern ideal of Homonoia, a Concord between Peoples, which saw Hellenized Easterners as equals of Latin Westerners, rather than inferior subjects under Roman rule.[137] Within the Eastern world itself, however, Cleopatra was simply the queen, in a monarchic Hellenistic tradition that went back to Alexander the Great, queen not just of Egypt, but generically and absolutely.[138]

Cleopatra's queenship was buttressed by her deliberate self-identification with Egyptian divinity, a connection she emphasized in a prominent public ceremony in which, Plutarch tells us, she "assumed a robe sacred to Isis, and was addressed as the New Isis."[139] She was described frequently as Cleopatra-Isis, and is depicted in this guise in statuettes and reliefs.[140] Similarly, Antony chose to assume the identity of Hercules, and also Dionysos, stressing in the case of the former his well-known physical strength, and in the latter, his difference from the more Apollonian temperaments of Octavian and other Romans, expressed also in his adoption of Alexandrian luxury and Eastern philosophy as a way of life.[141] In calling himself the "new Dionysos," Antony followed Cleopatra's father, Auletes, who chose the same designation for himself, as indeed had the entire Ptolemaic dynasty, which had assimilated the Dionysiac mystery religion into the old Pharaonic Egyptian religion, identifying Dionysos with their god Osiris.[142] Similarly, the Greek Aphrodite was identified with Isis in the East, and this single female deity was represented in numerous statuettes as Aphrodite/Isis.[143] Cleopatra identified herself with Aphrodite as well; this was the guise in which she came to Antony at Tarsus, and in which she was enshrined by Julius Caesar.[144] It was therefore both timely and traditional for Cleopatra and Antony to associate themselves with Isis/Aphrodite and Osiris/Dionysos, divine partners in the Egyptian pantheon.

There was a difference, however, in their forms of god-masking, for Cleopatra's identity with a goddess was believed in the East to be innate, not assumed, a legacy of ancient Egyptian belief that reflected the peculiarly Egyptian survival of the institution of matrilineal descent. From the earliest dynasties, some scholars have posited, Egyptians had followed the Neolithic practice of passing both the essence of divinity and also property through the female line. It may have been for this reason that Egyptian queens were often married to their brothers, in order that the males could legitimately rule as pharaohs, obtaining the mystic power that only a female inherently possessed, as "wife of the god."[145] The pharaoh-consort was, as Briffault has explained, the "temporary incarnation of the deity" only while he was the spouse of the queen. This Egyptian tradition of ceremonial intermarriage, often misinterpreted by Westerners as a peculiar taste for incest in a "degenerate" foreign culture, would explain why there were, even as late as the Ptolemaic dynasty, so many cases of broth-

ers who theoretically should have been kings in their own right, but who inexplicably married their "sister-wives," and often shared power with them.[146] It may have been in conformity with this principle that Cleopatra, who became queen on the death of her sister Berenice IV, was married first to her brother Ptolemy XIII, and then on his death to her younger brother Ptolemy XIV, so that the brothers might share the throne with her, for in a system of matrilineal succession they would have had no independent right to it.

Egyptian queens were considered to be incarnations of the principal deity Isis (also known as Hathor), who in ancient myth mated with and gave birth to Osiris (as the divine son Horus, also identified with the sun god Re), thus providing the model for the Egyptian dynastic structure, with its permanent female and changing male figures.[147] A prominent emblem of the pharaonic succession in Egyptian imagery was the uraeus, or hooded cobra (translated into Greek as an asp), which appeared on the royal diadem in pictorial images of Egyptian queens, as visible reminders of the principle of hereditary queenship (Fig. 232). While other symbols, such as the vulture Nakhbet, stood more specifically for the idea of matrilineal descent, the snake became the favored symbol for the goddess Isis herself.[148] In Hellenistic sculpture from Egypt, especially, and in images produced and circulated in Rome after about 80 B.C., when the cult of Isis came there, the goddess appears as a snake, or is shown holding a snake.[149]

In the imagery attending Cleopatra's suicide, there has lingered a basic ambiguity as to whether the snake is merely the agent of the suicide or an attribute of her more

232. Queen Hatshepsut drinking from the udder of the Hathor cow, 1504–1483 B.C. Temple of Queen Hatshepsut at Deir-el-Bahari

fundamental identity as Queen of Egypt, Isis incarnate. Plutarch hints at the idea that her means of suicide had symbolic significance when he recounts that, in response to the cry at Cleopatra's death, "A fine deed this!" her maid Charmion answered, "It is indeed most fine, and befitting the descendant of so many kings" (*Lives* 9.85.4; correct in principle, yet an expression that indicates Plutarch's failure to grasp the Egyptian custom of matrilineal descent). Some modern writers have suggested that her death by the asp was an act of apotheosis, a symbolic expression of her union with the god in death.[150] We cannot now know the truth from Cleopatra's viewpoint, yet we may observe that if Octavian indeed did display in his triumphal procession the portrait of Cleopatra with a serpent clinging to her arm,[151] he may at that moment have initiated her historical defamation, or more precisely, her aesthetic depowering, for through visual imagery, he detached her from a symbolic identity with Egypt and all that Egypt stood for, and reduced her to a mere example of a treacherous woman. The serpent in that portrait would no longer have been seen as the uraeus, but instead as the eccentric tool of a foreigner's suicide. In separating the queen-goddess from her attribute, Octavian and Plutarch (who attested the historical reality of the serpent portrait) created the basis for a pattern that would be carried on in art for nearly two millenia: Cleopatra and the asp as interactive characters in a time-bound narrative, depicted trivially as a terrified or sexually excited naked woman wrestling with an aggressive, writhing snake, in place of the older Egypto-Roman image of a queen eternalized by the uraeus symbol of her royal house.

Artemisia's image of the dying Cleopatra, wittingly or not, restores in a small way the ancient idea of the meaning of that suicide. As we have seen, this sleeping figure differs from other Cleopatras in that she grasps the snake, coiled twice around her wrist, in a gesture of deliberate and secure control. The artist did not derive this motif from the Vatican *Cleopatra/Ariadne*, but she could have seen it in other Vatican sculptures. A number of Isis-snake images are to be found in the Vatican Museum, for example, a relief (Fig. 233) depicting a sequence of priests and priestesses led by Isis, which presents the goddess with her hand outstretched and the serpent wrapped around her wrist, the dominant, self-possessed director of her own attribute.[152]

A more likely visual source, however, is a statue that presently stands in the Cortile Belvedere of the Vatican (Fig. 234), a sleeping female figure who holds a very prominent snake wrapped around her forearm. This figure does not represent Cleopatra (whose suicide was not depicted in antiquity), but may instead be Ariadne, like the more famous sleeping woman also in the Vatican.[153] The resemblance of this Ariadne holding her coiled serpent both to Isis images and to the familiar snake goddesses of Late Minoan Crete (Fig. 235) is not accidental, since the "snake goddess" figurines have been identified with the Mother Goddess religion that flourished on Crete in the Late Minoan period. Ariadne herself, though known in the Renaissance primarily as the bride of Bacchus, immortalized by him,[154] was in fact a Cretan princess, also identified with the principal Cretan deity, the Moon and Birth Goddess.

233. Roman, *Procession in Honor of Isis*, 2nd century A.D.
Rome, Museo Vaticano

234. Roman, sarcophagus with sleeping nymph (Ariadne?).
Rome, Museo Vaticano

235. Faïence figure of snake
goddess, c. 1600 B.C. From
Palace of Knossos, Crete

The Cretan deity shared with Isis a common derivation from the Neolithic Great
Goddess, from whom their common snake imagery is also derived. It is because of
this distant ancestry that the Vatican *Ariadne* wears a snake as her attribute, as she
does in some Pompeian wall-paintings.[155]

Alternatively, in envisioning Cleopatra's grasp of her snake, Artemisia may have
been inspired by a distant iconographic cousin of Isis and Ariadne—the allegory of
Dialectic (or Logic). The serpent, Ripa explains, is the attribute held by the woman
who symbolizes Logic: "signifying the prudence necessary for logical thought, and
also the poisonous inaccessibility of logic to those without sufficient intelligence,
which, like the snake, kills those who dare to oppose him."[156] Images of Dialectic with
her snake were abundant by the early seventeenth century (Fig. 236), and Artemisia
could have seen a similar image of Prudence in the Casa Buonarroti in Florence,
where she was working in 1616 (Fig. 237).[157] Regardless of her specific source of
inspiration, however, the significant point is that Gentileschi independently con-

236. Giulio Bonasoni, *Dialectic*, engraving,
in Bocchi, *Symbolicarum quaestionum de
universo genere* (Bologna, 1574) LXII

237. Matteo Rosselli, *Michelangelo in His Study and Prudence*,
early seventeenth century. Florence, Casa Buonarroti

ceived the coiled snake around the wrist as an appropriate gesture for the queen's
suicide. It is uncanny that in doing this she should have reconnected Cleopatra with
Isis and Ariadne, to weave larger mythic sense out of the separate strands to which
she was heir.

ARTEMISIA's queen in the Genoese picture may disappoint us *in toto* as an all too
human, almost vulgar image of the divine and the mortal Cleopatra, an unhappy
blend of the literal and the mythic. Yet in its stark simplicity, the figure speaks the
forceful, magic language of what Bernard Berenson once called "the ineloquent in
art."[158] In this picture, the prosaic, ungainly body sets off as a hypnotic focal point the
asp that Cleopatra holds so calmly, even heraldically, a multivalent image that can be
understood as both the agent of her passage from this life to the next and the symbol
of her divine immortality. There is no sign of a bite on her body, because this is a
mystic, not a physical, transition. Her body relaxed and her eyes slightly open, she
looks upward, toward the light at the upper right of the picture, awakening in death,
to receive the god with whom she is to be reunited: as Cleopatra rejoined Antony in
their joint burial in Alexandria, so Isis rejoins Osiris, and Ariadne will awaken
to Dionysos.

Strange as this idea may seem, it can be situated in history. Orazio Gentileschi's *Danae* (Fig. 208), also painted in Genoa, probably in the same year as Artemisia's *Cleopatra*, is a comparable, though more orthodox, image of a nude female receiving the visitation of an invisible male god from above. Moreover, the meaning of Artemisia's painting in terms of divine apotheosis may well have been clear in an era distinguished for its religiosity and Egyptomania. The association between Cleopatra and Isis, mentioned frequently by Plutarch, was certainly known in the Renaissance. In Jodelle's *Cléopâtre Captive* (1552), Cleopatra is described as "She who with vanity of pride, / Bore the great goddess' name / Standing as deified, / Clad in a white flame / As Isis and no other, / The great Earth-mother. . . ."[159] Shakespeare's Cleopatra was intentionally identified with both Venus and Isis, as recent scholars have pointed out. The recurrent moon, cow, and nursing imagery that surround Cleopatra in Shakespeare's drama evoke the image of Isis created by Apuleius in *The Golden Ass*, that seminal text for humanist and hermetic literature, in which Isis is enshrined as the reigning deity, to whose service the hero Lucius dedicates his life.[160] Apuleius explained Isis, whose arrival is heralded by the rising moon, as the "natural mother of all things, mistress and governess of all the elements, the initial progeny of worlds, chief of the powers divine," and described her different names in various parts of the world—Minerva, Venus, Proserpina, Ceres.[161] This understanding of Isis as the archetypal female divinity, identical with Diana and many others, was shared by Ovid and other ancient writers, and their texts along with that of Apuleius formed the basis of knowledge and imagery for Renaissance handbooks such as those of Conti and Cartari (see Fig. 240).[162]

Osiris, who was similarly understood in the Renaissance to be the Egyptian counterpart of Dionysos, was known to fifteenth-century humanists through Plutarch's *Isis and Osiris* and was popularized by Ennius, whose writings inspired Pinturicchio's Osiris and Isis fresco cycle in the Borgia Apartments of the Vatican (dated 1492; Fig. 238).[163] The union of Isis and Osiris, their respective correspondences to the sun and moon, and their polar relationship as embodiments of the positive and negative forces of the universe were already familiar in hermetic and alchemical literature by the early seventeenth century, when these relationships were articulated by Egyptologists like Pietro della Valle, Athanasius Kircher, and Thomas Obicini, whose writings on hieroglyphics and obelisks were guided by an understanding that Egyptian thought offered a philosophical key to the deeper meaning of both Greek and Christian mythological figures.[164] Kircher's emblematic image of Isis (Fig. 239), a synthesis of Apuleius's description and Cartari's image (Fig. 240), both reflected and assisted widespread familiarity with the Egyptian goddess.[165]

Such treatises, however, describe only the fixed identities of gods such as Isis and Osiris; it remained for Baroque artists to define their dynamic and mystic interaction. More than almost any other antique concept, the idea of metamorphosis was dear to seventeenth-century thought; one need only recall the responses of Rubens, Bernini,

238. Pinturicchio, *Meeting of Isis and Osiris*, 1492. Rome, Vatican, Appartamento Borgia

and Poussin to Ovid's tales of transformation. Caravaggio's pictures also involve metamorphosis, but as spiritual, not physical transformation. His first *Supper at Emmaus* (Fig. 241) and the late *Adoration of the Shepherds* in particular concern the idea of theophany, the god manifesting himself in the guise of an ordinary human. In Caravaggio, it is not Christ who is mystically transformed, it is rather we ourselves, and our surrogates, the humble disciples and shepherds, who undergo spiritual transformation in the moment of recognition. The underlying meaning of the story of the Supper at Emmaus is given concentrated expression by Caravaggio: if we expect to recognize a god who appears among us by his divine outward appearance, we will inevitably fail to see him in a plainfaced, beardless Jew.[166] Once he was recognized, Christ vanished from the sight of his surprised disciples, leaving only the memory of his inflammation of their hearts on the road. The paradox that the masks of god keep changing—we neither see what we expect, nor understand what we see—is at the heart of Christianity and other mystic religions. A brief and profound vision of divinity is granted in the form of the mundane; but the vision is never predictable and never repeated. Artemisia's *Cleopatra* is surely conceived in the same spirit. The legendary, glamorous Cleopatra is seen as a homely young woman, a privileged mystic glimpse that we are given just as she reverts through apotheosis—theophany in reverse—to her fundamental and eternal identity as the goddess Isis.

239. *Isis*, from Athanasius Kircher, *Oedipus Aegyptiacus*, 1652–54

240. *Isis*, from Vincenzo Cartari, *Le vere e nove imagini* (first illustrated edition, 1571)

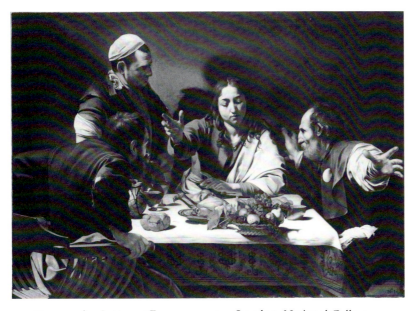

241. Caravaggio, *Supper at Emmaus*, c. 1601. London, National Gallery

ARTEMISIA treated the Cleopatra theme at least once more, in a painting that has only recently been attributed to her (Color Plate 17 and Fig. 242).[167] The second *Cleopatra*, probably painted in the early 1630s, can readily be recognized as a work by Artemisia's hand, not only in its style, but in its restatement of her original interpretation of the theme, though now in terms less unorthodox and more subtle. The nude figure of the queen, here reclining in the opposite direction, is more gracefully and nobly disposed than her awkward Genoese counterpart. Draped with an ample royal blue cloak, she is given a richer, more specifically regal setting, for her head rests on a rose velvet cushion with red and gold tassels, and she is framed by a purple-red curtain with a gold brocade design—a creative rendition of the golden couch mentioned by Plutarch.[168] Cleopatra's queenship is here stressed in the elaborate golden crown that lies next to her head. Yet despite these trappings of royalty, and despite her more conventionally beautiful body, she is once again depicted with the face of an uncomely woman, whose girlish, irregular features are heightened by the foreshortening of the face and its intense illumination (as in the Genoa *Cleopatra*, the *Esther*, and the *Self-Portrait*). The painter appears to have wanted to reiterate the central meaning of the first *Cleopatra*, that divinity assumes ordinary human form, even—or especially—in the case of the legendary Egyptian queen. This image thus joins other characters created by Artemisia to exemplify her radical reconception of female excellence, as a reflection of inner worth rather than of conventional external beauty, for she suggests in the image that Cleopatra possessed a beauty of spirit, that might be found in plain women as well as queens.

Completely innovative in Artemisia's second *Cleopatra* is the appearance of the two maidservants who enter the chamber to discover the dead body. Other artists showed two or more servants with Cleopatra, sometimes grieving, as here (see Figs. 211, 213, 216), but these invariably bore witness to the climactic moment when the queen applied the snake(s) to her breast or arm. In Artemisia's version, Cleopatra is indisputably dead, for her lips are cold and gray, her eyes lifelessly blank, and the crown has fallen from her head. Artemisia deviates no less than other artists from Plutarch, who said that the Romans found Cleopatra dead, with her servants also dying from poisoning by asps and the falling Charmion in the act of arranging her mistress's diadem. Yet this deviation carries an implication of deeper meaning. Since it is evident that Cleopatra must have assumed her own crown (or positioned it on her bier) in her unassisted suicide, Artemisia artfully alludes to the prior ritual of self-crowning that reifies her natural queenship—hers by divine, not worldly, right. This divinity is also expressed in the fact that, as in the Genoa *Cleopatra*, no marks of the asp's bite appear on her body. Here again, the serpent is depicted as a discrete attribute, now carefully displayed on the bed. We are thus given once more to understand that the asp, the divine uraeus of Isis, was the symbolic and not literal means of her apotheosis.

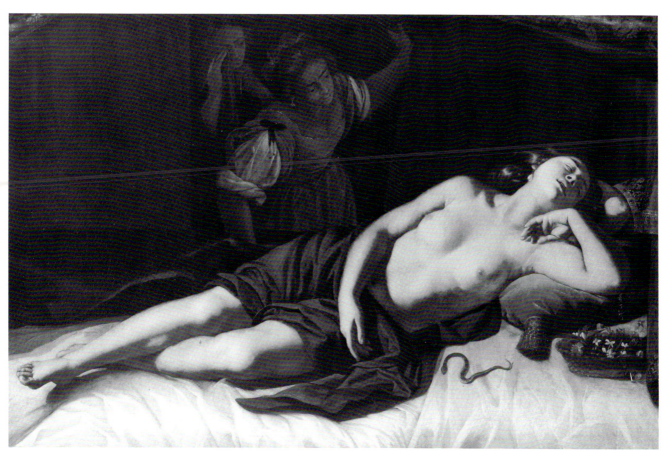

242. Artemisia Gentileschi, *Cleopatra*, early 1630s(?). London, private collection

But what are we to make of the other object on the bed, the basket of flowers? Artemisia surely must have known, as did other painters of her period, that the asp was hidden in a basket of figs, not flowers (see Fig. 175). Are we perhaps permitted to conclude—recognizing the consummate sophistication of this artist's pictorial strategies—that she has deliberately changed this attribute into a time-honored symbol of rebirth, suggesting through the inclusion of flowers not only the rebirth in death of Cleopatra-Isis in her eternal reunion with Antony-Dionysos, but more profoundly, the ancient mythological association of Isis-Diana with all human and vegetal regeneration, and with Nature itself? Certainly the iconographers Cartari and Kircher understood that Isis was another form of Diana and Natura, as did sixteenth-century dramatists of the Cleopatra legend, notably Spinelli and Cesari.[169] And a follower of Bernini could acknowledge, in a sculptural image of the reclining, sleeping Diana (Fig. 243)—whose crescent moon prominently adorns her brow—the iconographic union of the goddess of the moon and hunt with the tradition of the sleeping

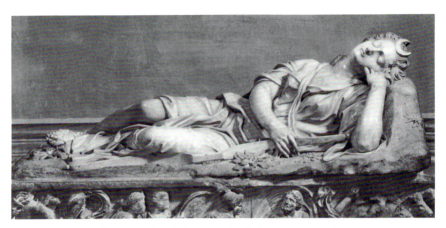

243. Follower of Bernini, *Diana Reclining*, seventeenth century.
Rome, Palazzo Barberini

nymph.[170] Artemisia Gentileschi thus joined a Renaissance tradition in which various female divinities were commonly understood as allegorical personifications of "Nature" (as distinguished from masculine civilization and culture). Yet, unusual for the visual arts, she deliberately linked with that tradition its most powerful human exponent—Cleopatra, Queen of Egypt—demonstrating that what many artists had wanted to interpret figuratively might also be understood historically, and that among goddesses no less than gods, the immanent and the transcendent could be one.

THE historical Cleopatra's death was her moment of ultimate triumph, in a sense quite different from Lucretia's model of absolute self-sacrifice. She was neither a creation nor a victim of her masculine Roman opponents, and she never played by Roman rules. We do not know why she turned and set sail at Actium, but in doing so, she avoided losing face, as Antony had not. When cornered by Octavian, trapped in the military sense and faced with shameful submission to him on terms unbefitting a queen, she accomplished her own suicide as she had assisted Antony's, through a series of skillful manipulations: a hunger strike, a deliberately misleading funeral speech at Antony's grave, and finally, the secret acquisition of the asp, which no one even saw. That "fine deed," her death, was in a symbolic sense perfectly accomplished, for she escaped by departing history itself, slipping into that eternal death and permanent godhood that is perhaps Egypt's most vital state of being, accompanied by the serpent, potent symbol of the principle of matrilineal succession that had guided the Egyptian royal house for three millenia, and symbol before that of the female goddess who was humankind's first deity. Cleopatra's suicide held considerable historical and mythic significance, for with her death came the end of the Ptolemaic line, the eventual annexation of Egypt as a Roman colony, and the final, clear-cut ascend-

ancy of patriarchal succession. Thus in a sense both historical and symbolic, the death of Cleopatra was the death rattle of the prehistoric Mother Goddess.

Gods and goddesses do not die, however; they simply change their names. The Great Goddess went underground (quite literally in the case of Persephone), reproducing herself in successive mythic avatars—Inanna, Ishtar, Isis, Gaea, Rhea Silvia, Diana, Venus, Cleopatra—who were perpetuated in post-antique art in images created so obsessively by Renaissance artists, most notably the sleeping women, who kept their secret well. Civilization's covert knowledge of its own origins, no longer acceptable to the conscious mind, was yet kept safe and kept alive in the recesses of its dreams.

# Judith

THE theme of Judith and Holofernes occupies a larger place in Artemisia Gentileschi's *oeuvre* than any other subject. In part, this may be an accident of survival, for although the artist is known to have painted more than one version of several themes—at least four Susannas, two Dianas, two Davids—many of these examples are lost or unknown to us today. But at least five autograph Judiths have been preserved, three of which are deservedly placed among her finest works. Moreover, the theme is likely to have held personal importance for the artist, for of all the female characters that she painted, Judith was the most positive and active figure, whose heroic deed held for Artemisia the greatest potential for self-identification.

Many writers have interpreted the gory decapitation shown in Artemisia's Uffizi *Judith* (Color Plate 8) in psychosexual terms, as an expression of imagined revenge against her rapist Agostino Tassi. The evidence for this interpretation resides simultaneously in the image of the executioner-heroine—for some, a presumed self-portrait of the artist—and in an equation that is both biblical and Freudian, between decapitation and castration: the just punishment for rape in an eye-for-an-eye tradition.[1] It is impossible to ignore the echo of personal experience in this *Judith*, even more overt than in the *Susanna* and *Lucretia*; indeed, the very imagery of the bloody bedroom scene invokes Artemisia's own description of Tassi's bedroom assault upon her, with its tangle of knees, thighs, blood, and knives (see Appendix B, ms. 18–19). Yet it is an oversimplification to interpret the Uffizi *Judith* purely as an expression of fantasy revenge against a rapist. Sensationalist fascination with the melodrama of Artemisia's rape, as well as facile association of stormy biography with violent pictorial imagery, have obscured for us not only the aesthetic complexity of the artist's identification with her depicted character, but also the fact that such artistic self-projection was by no means unusual. For if Artemisia included something of herself in the image of Judith slaying Holofernes, she followed a tradition already venerable in her day.

Giorgione, Titian, Michelangelo, and Caravaggio are known to have united their own literal self-images with the characters of their art: Giorgione painted himself as David, Titian as St. Jerome; and Michelangelo included himself as vanquished victim of his sculptural *Victory*, as the flayed skin of Bartholomew in the *Last Judgment*, and as Nicodemus in the Florentine *Pietà*.[2] The youthful Caravaggio may have portrayed himself as Bacchus and Medusa; and in the Borghese *David*, one of his final pictures (Fig. 267), he unquestionably conceived the suspended head of the stunned Goliath

in the image of his own mature physiognomy.[3] With a variety of expressive results, these major artists of the Italian Renaissance sought to convey, through autograph images that attest their psychic involvement with their characters, something about the eternal relevance of those mythic characters as spiritual role models for modern men. It is not surprising, then, that Artemisia Gentileschi, who had already demonstrated her sense of artistic connection with Michelangelo and Caravaggio, would now approach the Judith theme in a similar participatory spirit, recognizing the value of her iconographic character as a spiritual model.

For Artemisia, however, identification with the female character Judith had both a different personal meaning and innovative expressive implications. In contrast to many of the masculine examples of the "included self" (in Leo Steinberg's phrase), which frequently center on figures of penitence, remorse, and guilt, the woman painter Artemisia finds in her female characters—not only, but especially, Judith—models of psychic liberation, *exempla* for an imagined action upon the world, not meditative retreat from it. It is essential that we recognize the positive and healthy elements of the artist's identification with her character, all the more as they have been hidden by the prevailing and almost obsessive interpretations of the painting as savage revenge. For it is not so much the male character who is acted upon, but the female character who acts, that is of interest to Artemisia, and who offers her an avenue for psychic self-expansion. Through the central character of the Uffizi *Judith and Holofernes*, Artemisia was able not simply to carry out psychic vengeance against her sexual oppressor, but also to justify rebellious, antisocial instincts—which she understandably may have held—through the celebration of the *legitimate* aggressive deeds of the famous biblical character, heroic avenger of the Jewish people. It is pertinent to compare an important recent analysis of the female writer, who, as the authors of *The Madwoman in the Attic* have pointed out, "searches for a female model, not because she wants dutifully to comply with the male definitions of her 'femininity,' but because she must legitimize her own rebellious endeavors."[4]

In her paintings of Judith Slaying Holofernes, Artemisia appears to have drawn personal courage from her subject, to go farther than any woman artist had ever gone—or would go, before the twentieth century—in depicting a confrontation of the sexes from a female point of view. The Uffizi *Judith* inevitably chills us, and it has offended many who commented on it, but not because of its violence, for violence is a staple of art. It offends and shocks because it presents an antisocial and illegitimate violence, the murder of a man by a woman. Beneath the rational veneer of the moralized biblical story lies a lawless reality too horrible for men to contemplate. Holofernes is not merely an evil Oriental despot who deserves his death, he is Everyman; and Judith and her servant are, together, the most dangerous and frightening force on earth for man: women in control of his fate. Other works of art show women exercising power over men, some of them *Judith*s, as we shall see. Artemisia's pictures differ from all of these categorically, including some by women, because she uniquely

has given imaginative life to a fully antipatriarchal female character. In narrow icon-ographic terms, her Judith is the heroic and strong defender of her people. In meta-phoric terms, however, she symbolizes female defiance of male power.[5]

BEFORE examining the individual paintings of Judith by Gentileschi, it will be help-ful to establish at some length the conceptual conventions that shaped the numerous presentations of the Judith theme in artistic, theological, and literary tradition. The subject of Judith and Holofernes has been enormously popular, in all art forms and in all periods. It was treated in medieval manuscripts, sculptures, and frescoes, and in an Old English poem; by painters, sculptors, and printmakers from the fifteenth cen-tury on; in sixteenth- and seventeenth-century drama and in an eighteenth-century oratorio; in nineteenth-century poetry and romantic fiction; and in twentieth-century plays by Arnold Bennett and Jean Girardoux, and an opera by Arthur Honegger. The popularity of the story in all these media may be ascribed in part to its extraordinary visual and narrative possibilities, for it is a story with multiple and visually vivid episodes, all of them important to its outcome and meaning.

The story that we read in the Apocrypha has a complex and already well-shaped plot.[6] The Assyrian general Holofernes, having blazed a destructive path through Judaea in his drive from Ninevah to Jerusalem, at last lays siege to the Israelite town of Bethulia. The inhabitants are on the point of surrender when Judith, a widow, volunteers to act to save the nation. Without explaining her plan, she dresses in her finest clothes and takes her maid, Abra, with her to the enemy camp, telling the guards, who are smitten by her beauty, that she has come to offer help to Holofernes. Confronting the enemy general himself, she explains that the Israelites cannot be de-feated unless they sin against their God, thus confirming what the Ammonite com-mander Achior had earlier told him. But, she says, they are at the point of committing the fateful sin, for in their desperation, they are about to consume the food and wine that had been consecrated for the priests. Accordingly, Judith counsels Holofernes to sustain the siege.

On the fourth day of her stay in his camp, Holofernes invites Judith to eat and drink with him. Donning her fine clothes and ornaments, she goes to his tent and they dine. In the course of the meal, Holofernes begins to desire her sexually, but as he had drunk more wine "than he had ever drunk in one day since he was born" (Judith 12:20), he falls asleep. Judith tells Abra to stand outside the bedchamber and wait for her. Left alone with the sleeping libertine, she takes his scimitar and severs his head. She then goes out, gives the head to the maid, who puts it in her bag of food, and they leave the camp, returning to Bethulia. On her return, she is welcomed by the people of Bethulia, to whom she presents Holofernes's head, advising them to hang it outside the city walls. The Assyrians, frightened and confused by reports that Holofernes had been slain by Judith, start to disperse and are easily defeated by the Bethulians. After a prayer of thanksgiving led by Judith, the citizens go to Jerusalem,

where she dedicates the spoils of Holofernes to the temple. Returning to Bethulia, Judith remains honored and famous—and unmarried, despite many offers—until her death at the age of one hundred and five.

The Book of Judith, composed anonymously toward the end of the second century B.C., was excluded from the Hebrew canon and rejected as apocryphal by the Protestants.[7] Martin Luther, in his commentary on the Book of Judith, saw it as allegory, not history, and accordingly placed Judith, along with the rest of the Apocrypha, outside the canon of the Old Testament.[8] In a literal sense, Luther was probably right, for while some writers have argued that a historical incident may lie behind the legend of Judith, the story is unlikely to have had any basis in historical fact. The Roman Jewish historian Josephus was unfamiliar with a Jewish heroine by that name; there is no geographic Bethulia, and there was no Assyrian general named Holofernes. It has been suggested that "Judith" was, in fact, a personification of Judaism itself, and that "Bethulia" is a variant of the Hebrew *Beth Aloa*, "House of God."[9] Such an allegorical interpretation of the Judith story is consistent with other biblical *topoi* that symbolize the Jewish people in the figure of a matron or virgin, and Israel's affliction in the form of a widow.[10] Moreover, it is historically fitting that Israel, defined as frail and weak against her foes, her survival a function of intelligence rather than strength, should have come to be personified by a woman, Judith, and a boy, David.

Yet the biblical legend is not without broader mythological foundation. Several elements of the Judith story find striking parallel in a Greek legend relayed in Herodotus's Lindian Chronicle, of an Hellenic spiritual elect under assault from Oriental barbarians (the Persians) who were saved by a female hero, Athena, after a specified five-day wait following the cut-off of water. Moses Hadas has concluded that the Judith story is a late creation of the Maccabean period, influenced from older Hellenic prototypes.[11] The story also conforms to an archetypal pattern of heroic myth. As in the Grail legend, the land—in this case, Bethulia under siege—is parched, deprived of water, and awaits rejuvenation by a heroic figure.[12] Judith, functioning as liberating hero, follows the three-stage pattern of heroic adventure: departure, contest with and slaying of the dragon (here, a bestial opponent), and triumphant return to the community. Like other mythic heroes, she is the "agent of life" who rescues and rejuvenates the kingdom.[13]

Despite the heroic potential of the story of Judith, however, and despite her close resemblance to masculine heroes of legend, the character of Judith has been subtly diminished and distorted in Western art and literature. She suffered at the outset from her absorption into the patriarchal Old Testament tradition, which had always subordinated its female heroes. The opening lines of Ecclesiasticus 44 are characteristic: "Let us now praise famous men, and our fathers that begat us." The list of famous forefathers is long—Abraham, Isaac, Moses, David, Solomon, et cetera—and there are no women in this encomium to the heroes of Israel. Quite literally, these were

self-fulfilling prophets, whose stories became the canonical Hebrew texts, while the texts that bore female names were among those subjected to greater rabbinical scrutiny.[14] Such female paragons of Jewish heroism as did appear—Judith, Esther, and Jael—were construed to serve God by use of their seductive wiles, in keeping with the misogyny that shaped the earliest parable of Genesis, when woman was defined as a seducer of man and the cause of evil.[15] The highest conceivable achievement for a woman of the Old Testament was to turn her stereotypical ability—her only ability, in the Hebraic tradition—to the disadvantage of Israel's enemies. Thus, although Judith has continuously been perceived as heroic, her heroism was defined by ambivalent virtues and her character perceived as problematic, under the sharp critical scrutiny given her by masculine artists and writers. We may observe, consequently, that while heroic archetypes can and do apply to female characters,[16] art and literature have often worked to modify and change even those heroic women who survived the misogynist shaping of the Old Testament canon.

Early depictions of the Judith theme in manuscripts explored its full narrative range. The Bible of Charles the Bald, of the second half of the ninth century, contains one of the earliest preserved Bible illustrations of the whole Book of Judith (Fig. 244).[17] Here the entire story is recounted in continuous narrative episodes, beginning with Judith's exit from Bethulia and ending with her homecoming. As in other medieval depictions of the theme—e.g., an eighth-century fresco in S. Maria Antigua and a twelfth-century capital relief at Vézelay—special importance is given to the heroine's triumphant return to the walled city with the trophy of Holofernes's head. Since the city is identified with the Jewish nation, this emphasis underlines the importance of Judith's deed as a heroic act of national importance, the salvation of her people.[18] In their breadth of treatment, the manuscript illustrations of Judith are comparable to an Old English Judith poem of the tenth century, a work that has been described as an epic narrative.[19] Yet unlike other epic heroes such as Beowulf, the Judith of the manuscripts is an agent of the Lord, to whose will she subordinates her own. She acquires the necessary strength for her deed by praying for divine assistance and humbly covering her head with ashes, an episode illustrated in an archivolt on the north portal of Chartres (Fig. 245).[20] In these medieval conceptions of Judith, the spiritual message of the story is the miraculous power of weakness against strength, when armed by God.

The narrative approach continued in Renaissance art, but the emphasis changed from "epic narrative," in which the whole sweep of the story and its public conclusion is suggested, to a preferred focus upon the climactic event, the slaying of Holofernes and the removal of his head to a bag. Several versions of the theme by Mantegna concentrate upon this episode (Fig. 246), as does Michelangelo's *Judith* pendentive of the Sistine Ceiling (Fig. 247). In each of these examples, Judith's courage is expressively heightened in the juxtaposition of the formerly powerful, now helpless, body of Holofernes and the physically agile women who carry out the deed. Although

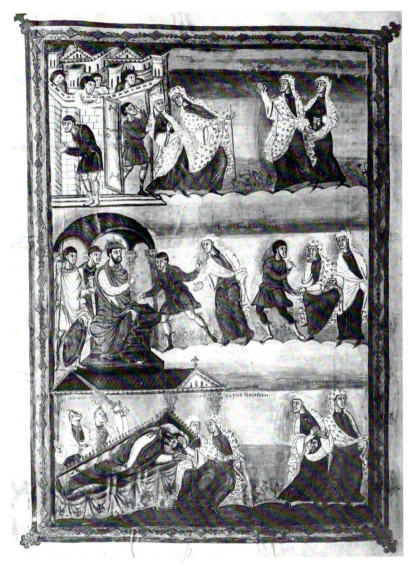

244. *Judith Departing Bethulia, Judith before Holofernes,*
*Judith Slaying Holofernes*, c. 870. Bible of Charles the Bald, fol. 231ᵛ.
Rome, S. Paolo fuori le Mura

245. *Judith Praying for Divine Guidance*,
c. 1220. Chartres Cathedral,
north porch, archivolt

the story of Judith might have lent itself to effective treatment in a fresco cycle, it was never given a public and heroic format in the Renaissance; in fact, examples of sequential narrative images of the theme became increasingly rare after the Middle Ages.[21] Botticelli's Uffizi diptych of c. 1470–72 (Figs. 248 and 249) is unusual for showing two episodes of the story, and also for its now rare recollection, in the background of the Judith panel, of the importance of the event for her city.[22]

Like many other biblical characters, Judith assumed typological importance as a precursor of Christian triumphs. She appears, for example, as a niche statuette on

246. Andrea Mantegna, *Judith and
Holofernes*, c. 1495. Washington, D.C.,
National Gallery of Art

247. Michelangelo, *Judith Slaying Holofernes*, pendentive, 1509–1511.
Rome, Vatican, Sistine Ceiling

Ghiberti's Paradise Doors, to the left of the David panel, joining David (whose ty-
pological meaning is closely linked with Judith's) and other Old Testament heroes as
prefigurations of Christ's victory over death and salvation of mankind.[23] Along with
Jael, Esther, and other biblical female paragons, Judith was often apostrophized in
the Middle Ages as a prototype of the Virgin, especially the Virgin victorious over
the devil, in keeping with the description of St. Bonaventura, who explains that the
Virgin, like Judith, cut off the head of the devil, of whom Holofernes was the incar-
nation.[24] Judith appears in this capacity, conjoined with the Virgin, in the *Speculum
humanae salvationis*, and in a manuscript in Leipzig of 1436.[25] Through her association
with the Virgin and her triumph over the ruler of the underworld, Judith became as
well a prototype of the Church itself, in the established tradition by which militant
women of the Bible were interpreted as types of the woman of Genesis (3: 15), who,
God told the serpent after the Fall, "shall crush thy head, and thou shalt lie in wait
for her heel." The *mulier* of Genesis was, along with the *mulier fortis* of Proverbs

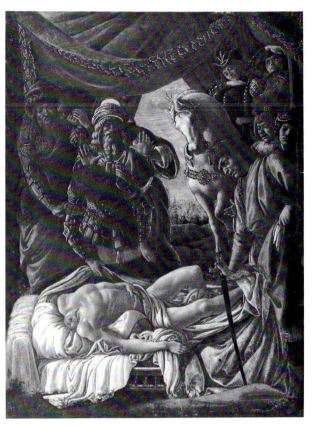

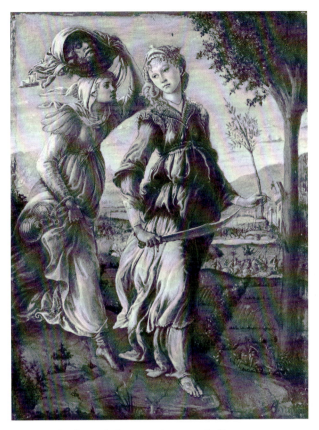

248. Botticelli, *The Slain Holofernes*, c. 1470–72.
Florence, Uffizi

249. Botticelli, *Judith Returning to Bethulia*,
c. 1470–72. Florence, Uffizi

31: 10 ff., understood by the early church fathers as both the Church and the Virgin, whose separate triumphs over Satan are echoed in Judith's defeat of Holofernes.[26]

In a related tradition that also originated in the Middle Ages, Judith became the embodiment of Chastity and Humility, victorious over Luxury and Pride. She is celebrated thus in a fifth-century Latin poem, the *Psychomachia* of Prudentius, and in some medieval manuscripts.[27] The most memorable and important example of this allegorized conception of Judith is Donatello's bronze group in the Piazza Signoria, Florence (Fig. 250), in which Judith surmounts the drunken Holofernes whom she has conquered, in the ancient psychomachia formula of Good standing over Evil. No longer must we believe that her strength was solely the miraculous gift of God; this unusually heroic Judith has plausibly outwitted her dull and degenerate foe through her own continence, intelligence, and personal strength of will. In keeping with the values of the Quattrocento humanists, the polarity is here extended to include the victory of reasoned moderation over barbaric excess; and, as early inscriptions at-

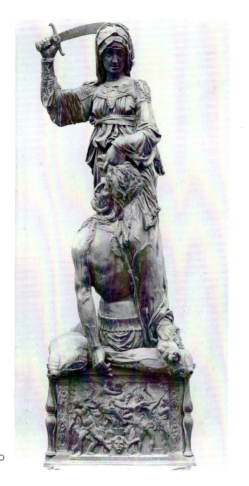

250. Donatello, *Judith and Holofernes*, c. 1456–60. Florence, Piazza Signoria

251. Giorgione, *Judith*, c. 1500–1504. Leningrad, Hermitage

252. Hendrick Goltzius, after Bartholomaeus Spranger, *Judith*, c. 1585. B. III.83.272

250

tached to the statue attest, Donatello's *Judith* was employed in the fifteenth century, first by the Medici in support of their family association with enlightenment and virtue, and then as a civic emblem for the Florentine republic against her enemies.[28] As a public monument symbolizing the triumph of Humilitas (and also Fortitudo) over Superbia—the victory of a small but forceful figure over a luxurious, barbaric giant—the *Judith* of Donatello could fill, as did other Quattrocento *David*s, a metaphoric role first conceived for an ancient chosen people, the Israelites, and now suited to a Renaissance city-state in its struggle against modern political tyrants.

In certain High Renaissance paintings that extend Donatello's tropological emphasis, the character of Judith stands outside time. She comes to represent the distilled essence of the story's potential broader application: the heroine as an emblem of Virtue itself. Such is the case with Giorgione's *Judith* of about 1500–1504 in the Hermitage (Fig. 251), in which the heroine stands, monumental as a statue, with foot planted on the head of Holofernes.[29] Many late sixteenth- and seventeenth-century images sustain the psychomachia concept of Judith as an *exemplum* of Virtue, but with

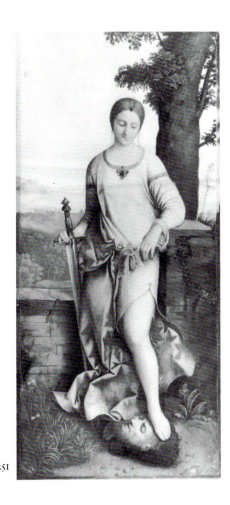

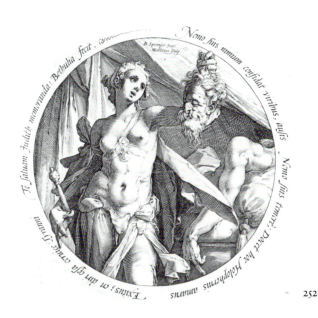

251

252

less concentrated effect. One example is a print by Goltzius, after Spranger (c. 1585; Fig. 252), in which Judith displays the head in a triumphant gesture reminiscent of Cellini's *Perseus* (which was itself inspired by Donatello's *Judith*).[30] The display of the head is later given a broader context that stresses Judith's role as civic heroine, while also satisfying a *maniera* taste for elaborate figure compositions, as we see in a small group of related drawings by Giorgio Vasari and Battista Naldini (Fig. 253). These drawings were carried out in apparent response to a request for a Judith painting by Borghini, who outlined in detail the expanded cast of characters and features that he wanted to see in this *historia*, to give it verisimilitude.[31] The display of Holofernes's head is the subject of Domenichino's design for a pendentive fresco in S. Silvestro al Quirinale, Rome, of c. 1625, and later still of Francesco Solimena's *Judith* in the Kunsthistorisches Museum (Fig. 254), where the walls of Bethulia are the backdrop for a large crowd scene.[32] Such images, despite their pictorial expansion of the scene, retain an essential link with the psychomachia tradition in their heraldic emphasis upon the statuesque victor and her trophy.

253. Battista Naldini, *Judith Displaying the Head of Holofernes*, drawing,
c. 1564. Lille, Musée des Beaux-Arts

254. Francesco Solimena, *Judith Displaying the Head of Holofernes*, early
eighteenth century. Vienna, Kunsthistorisches Museum

As AN adaptable symbol for Virtue or Good, the figure of Judith saw a variety of political and religious applications in the sixteenth and seventeenth centuries. Although, following Luther, Protestants never accepted the Apocrypha as canonical, they nevertheless found the story metaphorically useful. In a play by Joachim Greff of 1536, Judith symbolizes the protection of God against papal tyranny; in Sixt Burck's drama of about the same date, Holofernes is identified with The Turk, who, like Holofernes, will be defeated by Christians through penitence and reform.[33] According to the investigations of Werner Schade, Judith was the protective patroness in the early sixteenth century of the Swabian league of cities, a league founded in 1513 by Protestant dukes against Charles V and his Catholic allies, a circumstance that may account for Cranach's depiction of the Judith story as heroic tyrannicide on panels at Gotha.[34] A particularly imaginative invocation of the Judith theme is that of the *Nicodesmi*, sixteenth-century followers of Calvin in Italy, who lived outwardly as Catholics while secretly rejecting Catholic doctrines and sacraments. When they came under scrutiny of the Council of Trent, the *Nicodesmi* invoked the paradigm of Judith, whose deception of Holofernes was not sinful because it was part of a higher, divine plan, thus using her story to justify deception itself.[35]

The voice of the Counter-Reformation also spoke through the figure of Judith. For the Catholic South, Judith's defeat of Holofernes was compared to the triumph of Truth over Heresy (the latter equated with Protestantism), and the story of Judith was, consequently, a frequent theme in the numerous Jesuit school dramas of the later sixteenth and seventeenth centuries. A characteristic example was the *Juditha* of the Jesuit Stefano Tuccio, produced in his native Messina several times in the 1560s, and eventually in Rome. In this and similar didactic plays, Judith is interpreted as a model of purity and chastity, whose typological connections with the Virgin Mary are re-emphasized.[36] Elena Ciletti has recently brought attention to the spate of Latin commentaries on the Judith theme that appeared following the inclusion of the Book of Judith and other Apocryphal stories in the Latin *Vulgate* of St. Jerome (sanctioned by the Council of Trent in 1546) and in the Sixto-Clementine Bible of 1592. In these Jesuit exegeses, Ciletti pointed out, the vigorous efforts devoted to reinforcing the identification of Judith with Mary extended to the assertion of Judith's own virginity and innocence of original sin.[37] The Church's political application of the Judith theme is exemplified in the *Tragoedia Mundi*, a Judith drama of 1647, whose performance lasted two days, in which Act 3, following the Judith and Holofernes episode of Act 2, presented the symbolic triumph of Religion in the world over the forces of Evil.[38] This association of Judith with the Church Militant was implicit in numerous other plays devoted to the Judith and Holofernes theme, many of them Jesuit school plays, that were written and performed with particular frequency from the end of the sixteenth to the mid-seventeenth century.[39]

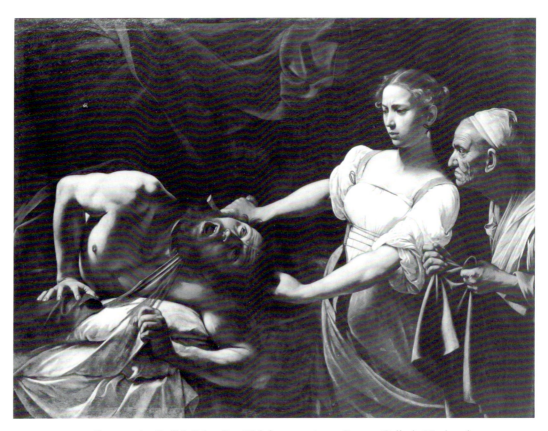

255. Caravaggio, *Judith Beheading Holofernes*, 1598–99. Rome, Galleria Nazionale
d'Arte Antica, Palazzo Barberini

A SIGNIFICANT change in the artistic treatment of the Judith theme was brought
about by Caravaggio. In the *Judith Beheading Holofernes* of 1590–95 (Fig. 255), Cara-
vaggio reintroduced a narrative emphasis, but focussing now upon the dramatic
rather than the epic features of the story, and upon the human conflict between the
two principal characters.[40] By contrast with the serially expansive field of action seen
in manuscript illustrations, and with the spatially expansive ambients of many
Renaissance paintings, the environment is now made intimate, closed, and dark. As

in contemporary theater, Caravaggio preserves the classical unity of time, place, and action,[41] making his fictive space an explicit description of the interior of Holofernes's tent, with the bed occupying nearly a quarter of the picture surface. The half-length figures are positioned close to the picture plane; we see them at close range, vividly, and in graphically concrete detail. The result is a fuller presence and a deeper psychological resonance of the characters themselves.

Caravaggio's characters have been developed as dramatic opposites, in keeping, it has been suggested, with the sixteenth-century theory of contrapposto, in which contrasts of age, sex, and appearance were recommended.[42] The youthful, graceful Judith is contrasted with an elderly, weatherbeaten Abra, and in her delicate femininity, she is an antipode to the rough virility of the startled Holofernes. And yet Judith and Holofernes, the chief protagonists, are hardly equivalent in their degree of human realization. Holofernes, shown at the very moment his neck is being severed, is not yet dead, and he screams in outraged protest, a forcefully vital counterpart to the functionally effective but facially inexpressive Judith. His physically explicit, unidealized features contrast extremely with the emotionless, late *maniera* beauty of the mannequin-like heroine, whose wrinkles are grafted inorganically upon her marmoreal face. Caravaggio's rendering of such aesthetically imbalanced types—the female conventional, the male real—is less likely to be explained by Renaissance art theory or Jesuit theology than by the influence of gender on the practice of an artist who happened to be male. We need not imagine Holofernes to be a spiritual self-portrait of Caravaggio to recognize that for the artist, Holofernes's pain and surprise were more easily imagined than Judith's feelings at that moment. Like the assailants of Susanna in art created by men, the male character, even a villainous one, was simply more accessible and comprehensible to the male artist.

Yet Caravaggio's focus upon Holofernes was not an isolated phenomenon. As a moral example, the demise of the Assyrian general on account of his own vices was frequently as interesting to artists and writers as the heroism of Judith. Chaucer, in the Monk's Tale, used the story as an example of Nemesis, to illustrate the principle of retributive justice, "the sudden fall of man from power to impotence."[43] Didactic writers frequently employed Holofernes to exemplify the danger to man of lust, an emphasis borne out as well in manuscript illustrations in which the Judith and Holofernes story as a whole is taken to symbolize the vice of *luxuria*.[44] The cautionary message to men is also sustained in inscriptions that accompany prints depicting the theme, as, for example, an engraving after Goltzius that is inscribed FASTUS PRAECEDIT LAPSUM ("pride goes before a fall").[45] Here, Holofernes comes perilously close to being a tragic hero, whose hubris brings about his downfall. Indeed, sixteenth- and seventeenth-century dramas devoted to the Judith and Holofernes theme were quite often entitled "Holofernes," or "The Tragedy of Holofernes," rather than "Judith."[46]

As a negative moral example, then, Holofernes had greater relevance to the lives of men than did Judith, and it is thus not surprising that she is often depicted in art

as an uninspiring and unmemorable creature of bland and vapid beauty. It is true, of course, that vice is usually more interesting than virtue, but virtue can become interesting if it is made heroic. David and Hercules embody goodness through their power and strength, and as positive moral examples, they exhort men to good through the implied concomitant of physical power. Judith, on the other hand, though she triumphs over her barbaric foe through heroic courage as did David, can be defined as strong and powerful only with a great attendant risk: that her power will be seen as threatening to men, rather than a virtue they can imaginatively share. For the more physically vigorous and ferocious Judith appears in her act of slaughter, the more she approaches the virago, the unnaturally manly woman. Men's sensitivity to the Judith and Holofernes theme is acute, for while a Semiramis, a Queen Elizabeth, or a Vittoria Colonna might be called a virago on account of her "masculine" deeds, this biblical woman of manly strength wields her sword against man himself.[47] Not surprisingly, Judith and Holofernes were frequently included in artistic and dramatic cycles of the *Weibermacht* ("Power of Women") *topos*, in which examples of the dangers of powerful women to men were often indiscriminately combined with exemplary female figures meant to be seen positively. In 1511 in Metz, for example, a carnival procession included chariots carrying Judith and Holofernes, Hercules and Omphale, Samson and Delilah, Aristotle and Phyllis, followed by chariots conveying the Nine Worthies (a category for which Judith would also have qualified).[48]

Because of its conflicting psychological messages, Judith's decapitation of Holofernes has been regarded ambivalently through the ages. In its biblical and exegetical context, it is a "good" act, carried out decisively by a heroic patriotic woman who saves her people through her courageous deed, one that prefigures the triumph over the Devil by the Virgin and the Church. Yet Judith is not heroic in a straightforward way. Her conquest of Holofernes is made possible by her deception and seduction of him, and by her double talk,[49] strategies that evil women employ against good men as well. Salome, for example, the indirect agent of John the Baptist's decapitation and thus a morally negative figure, has enjoyed an iconographic tradition in art almost identical to, and sometimes confused with, that of Judith.[50] The story of Delilah's undoing of Samson very closely parallels that of Judith and Holofernes, though from a different moral perspective. Samson's vengeful assault upon the Philistines resembles Holofernes's attack of the Israelites, just as his sexual indulgences in Gaza and with Delilah recall those of the Assyrian general. Delilah's deception and betrayal of Samson and her emasculative cutting off of his hair established her as the arch-exponent of the duplicity of women. Yet while virtue is represented by Samson and vice by Delilah, an opposite situation to that of Judith and Holofernes, the secondary emotional messages conveyed by the two stories are very similar. Both Samson and Holofernes are victims of duplicitous women who betray their trust and exploit their sensual excesses; both Delilah and Judith are perceived as typical of their sex in their crafty and fatal deception of men.[51] The extended symbolic meaning

of these two female characters is sometimes fundamentally the same. A modern writer, for example, laments: "The cool ferocity of some young women is awful. Judith, Jael, Delilah, and Athaliah were not mythical. Is there a man who has not wakened from his dreams to find that the woman he trusted has stolen his strength or is just about to hammer the great nail through his temples?"[52]

Perhaps the clearest expression of masculine ambivalence about Judith as heroine is found in Chaucer, who presents her story from several different viewpoints in the *Canterbury Tales*. In the Merchant's Tale, the misogynist Merchant ironically cites the biblical figures of Rebecca, Judith, Abigail, and Esther as examples of good counsel offered men by women. Judith, he says, "By wys conseil she Goddes peple kepte, / And slow hym Olofernus, whil he slepte." As Emerson Brown, Jr. has pointed out in an admirable study of Chaucer's text, the Merchant has eliminated from his example the detail "that both mitigates the crime and explains its necessity," the fact that Holofernes had besieged and would have destroyed Judith's city, and, through ironic juxtaposition, he implies that the violent act was both gratuitous and treacherous.[53] Chaucer, Brown suggests, forces the audience to collaborate actively with the poet, obliging us to balance against the Merchant's cynical vision of the world the long exegetical tradition that saw Judith, Rebecca, and Esther as pure heroines of great typological and moral significance. Yet Chaucer, Brown explains,

> insists through the Merchant that we keep in mind the treachery as well as the virtue and typal significance of the Old Testament heroines. By having the embittered Merchant sarcastically introduce them as tainted examples of feminine virtue, Chaucer forces us to maintain a multileveled viewpoint on them, on their function in his tale, and, indeed, perhaps on all ostensibly virtuous women. We may recognize ultimately that the Merchant's view of the women is inadequate, but we can neither ignore the force of that view nor totally deny its insidious appeal to all male vanity and some male experience.[54]

Chaucer's dual vision of Judith was to be sustained in Renaissance and modern images of Judith in art and in commentaries on them. Botticelli's gentle figure (Fig. 249), praised by Ruskin as the only true image of the noble biblical heroine,[55] offers us the visual counterpart of the figure we may call the "good" Judith, who embodies (to borrow Gilbert and Gubar's description of such female paragons) the " 'eternal feminine' virtues of modesty, gracefulness, purity, delicacy, civility, compliancy, reticence, chastity, affability, politeness."[56] The good Judith appears in sixteenth- and seventeenth-century art, from Veronese to Elisabetta Sirani (Figs. 256, 257), and the latter example—if it is by Sirani[57]—reminds us that even women artists may have shared in sustaining the image of an eternally feminine Judith. Caravaggio's virginal Judith also upholds this saintly vision; he underlines it, in fact, by juxtaposing the ideal Judith with the real Holofernes. Both in her theological use as precursor of the

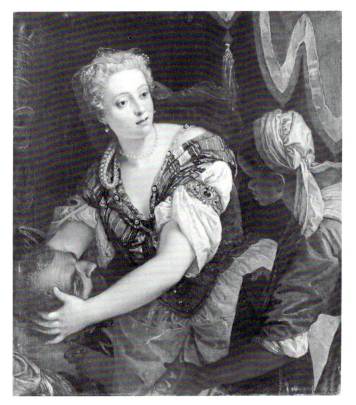

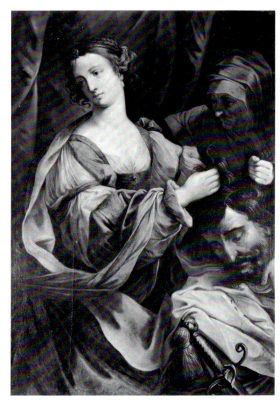

256. Veronese, *Judith*, c. 1570. Vienna,
Kunsthistorisches Museum

257. Elisabetta Sirani (attributed to),
*Judith*, seventeenth century.
Baltimore, Walters Art Gallery

perfect woman, the Virgin Mary, and in her supporting function as the agent by
which Holofernes's pride is brought down, Judith is the "angel in the house," as this
female type was to be described in the nineteenth century,[58] whose essential virtue is
her moral perfection, and her capacity to bring spiritual redemption.

Seen from this viewpoint, Judith assumes a special psychological function as the
purifier of man's dark and bestial side. In the many artistic images in which a gro-
tesque, shaggy Holofernes is brutally decapitated by an incongruously delicate and
beautiful maiden, Judith is not so much a fearless heroine as she is the symbol of
restraint and civility, refinement and good taste, who helps to contain the grosser
impulses of the masculine sex by performing a violent, dream-like act of psychic re-
straint, like the terrifying fairy tale that frightens a child into acceptable social behav-
ior. In this guise, Judith is a thoroughly positive, though personally neutral, figure.
As the cultural guardian of the biblical Bethulia, symbol of civilization itself, who
defends its values against uncivilized barbarians, she is a kind of culture princess, who

antiseptically neutralizes the antisocial forces of unbridled sexuality, drunkenness, and aggression that threaten both private lives and societies as a whole.

But if there is an angel in the house, there is also a monster. In the Florentine debate of 1504 over the placement of Michelangelo's *David*, Francesco di Lorenzo Filarete, herald of the Signoria, proposed having the new statue replace Donatello's *Judith* in front of the Palazzo Vecchio because

> the Judith is an omen of evil, and no fit object where it stands, as we have the cross and lily for our emblems; besides, it is not proper that the woman should kill the male; and, above all, this statue was erected under an evil star, as you have gone continually from bad to worse since then.[59]

Needless to say, no such superstitions attached to the statues of men that were subsequently placed in the same square—Cellini's *Perseus*, murderer of Medusa, or Giambologna's rapists of the Sabine women. Male violence toward females has been traditionally perceived as normal or heroic, even when the accompanying story is not clearly so; female violence, even when iconographically legitimate, is always questionable. Judith's deed has been described as distasteful rather than heroic by many writers. Balzac called Cristofano Allori's *Judith* "the immortal homicide."[60] Ruskin spoke of the "millions of vile pictures" of Judith in Florence, while Anna Jameson called Artemisia Gentileschi's Uffizi picture (then in the Pitti Palace) a "dreadful picture . . . proof of her genius and its atrocious misdirection."[61] W. R. Valentiner, writing in 1935 of Titian's *Judith* in Detroit, spoke of "the monstrous theme" and "the gruesomeness of the act."[62] And, lest one imagine these to be dated views, the 1986 edition of a popular art history textbook compares the ambient of Artemisia's Detroit *Judith* to a dark cellar "where unspeakable things are happening."[63]

Such misinterpretations of Judith's just tyrannicide may have been assisted by pictorial cues, however, for artists often collaborated in subtle ways to suggest that Judith was a negative figure. Her frequent depiction in Italian Renaissance and Baroque art in the closed, dark interior that is the enemy territory, killing or having just killed her foe, is a recurrent artistic choice that blocks from the viewer's mind the final triumphant consequence of her heroic deed, the liberation and protection of her people. The curtain, the tent, and the dark suggest a clandestine act, carried out in secrecy, against the law—though only a small part of this story occurs in the privacy of Holofernes's tent. The plot requires Judith to depart from and return to her city, which in mythic terms is not only a power base, but also a symbol of orthodoxy, stable social order, and the seat of justice and righteousness. After the Middle Ages, however, we see little of Bethulia. We see mainly the enemy camp of Holofernes, whose murky, ominous, and claustrophobic environment becomes, in art, Judith's own and only realm. Unlike David, who was adopted by the Florentines as a civic emblem, depicted (most notably by Michelangelo) as the watchful guardian, and centered in a

square he almost literally patrolled, Judith, the civic defender of the Israelites, has not enjoyed a metaphoric afterlife in art as cultural hero.

Other artists created pictorial interpretations of Judith that reflected the associations of evil intent and danger to men that had steadily accrued to the character at least since the misogynous description by Chaucer's Merchant.[64] For Baldung Grien (Fig. 258), the heroine of Bethulia is cast as a seductive, crafty nude with crossed legs (an image of female allurement, but also deception), who boldly flaunts her victim's head and her castrating dagger, as conspicuous a sexual instrument as the phallic knives of Cranach's *Lucretia*s (Figs. 188, 189). As Charles Talbot has suggested, Baldung's painted *Judith* is presented with the attributes of fatal beauty that connect her with the characters of Eve and Venus, and with Dürer's figure of Nemesis, the latter seen not in her ancient identity as agent of retribution (which might have made her directly and positively relevant to Judith), but as the powerful female controller of fortune.[65] Baldung's *Judith* reflects the *Weibermacht* theme (especially popular in Northern Europe) and the concomitant folly of man in succumbing to lust, expressed also in his images of Aristotle and Phyllis and the Fall of Man.[66] Other artists depicted Judith as a cold-blooded executioner (e.g., Valentin; see Fig. 61), or as an evil figure

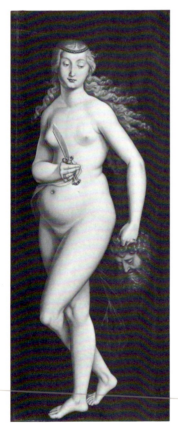

258

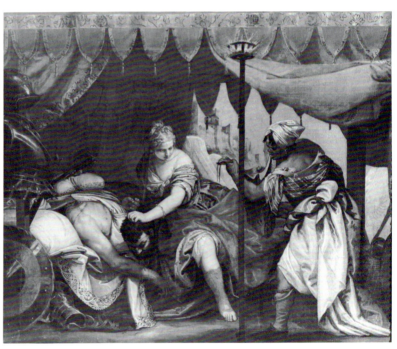

259

258. Hans Baldung Grien, *Judith*, 1525. Nuremberg, Germanisches Nationalmuseum

259. Attributed to Veronese, *Judith*, sixteenth century. Caen, Musée des Beaux-Arts

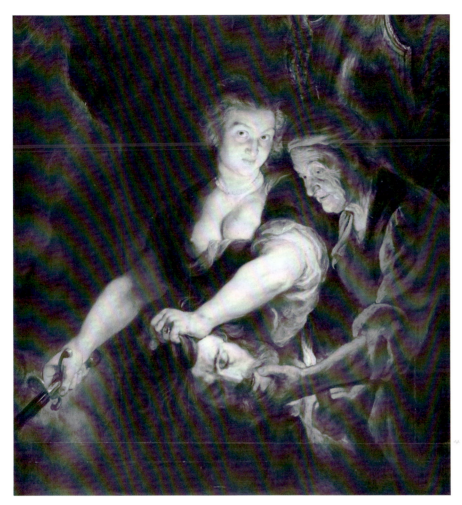

260. Rubens, *Judith with the Head of Holofernes*, early 1630s. Herzog Anton
Ulrich-Museum, Braunschweig

whose face projects guile and deceit. Such is the case in a variant in Caen of Veronese's
Vienna *Judith*, also attributed to the artist (Fig. 259), whose heroine contrasts signif-
icantly in type with her immediate model (Fig. 256). Perhaps the most unforgettable
"evil" Judith of art (at least, before the nineteenth century) is that of Rubens, in his
Braunschweig picture of the early 1630s (Fig. 260). Here, a sinister, powerful protag-
onist glares out of the picture, menacing the viewer both through her gaze and
through her militant gesture, even as the bared breasts are thrust upward, a com-
bination that recalls simultaneously every negative association that has attached to
Judith—her sexual entrapment of Holofernes (who looks unusually innocent here),
her deceitful manipulation of him, and the unnatural masculine strength through
which she confirms the inevitability of her victory over him.[67]

The innuendo of crime frequently conveyed in images of this heroine and her

heroic deed is often sustained by the figure of the maidservant, Abra. From the fifteenth century on, as early as the characters were at all individualized, Abra was traditionally shown either as an older woman or—a Venetian variant—as a black woman. In Correggio's tiny but powerful painting in Strasbourg (Fig. 261), the grotesquely distorted face of Abra vividly connotes an atmosphere of evil and wrongdoing, even as Judith herself, a pure-profile, beautiful maiden, sustains the sense of virtue.[68] In such an image, the erstwhile "good" character of Abra, who loyally aided and abetted her mistress's brave deed, is made to personify the evil and negative aspects of Judith's character, a transference that ingeniously makes possible the inclusion of both the good and evil Judiths within the same painting.

As Abra became more emphatically hag-like around the beginning of the seventeenth century (characteristic are the versions of Caravaggio and Rubens), she served another subterranean expressive function. As an old and ugly companion of Judith, she is like the crone who frequently accompanies Delilah, a figure who, as Kahr has noted, may be understood at least subliminally as a procuress, thus underlining Delilah's sexual duplicity.[69] The procuress implication takes a somewhat different

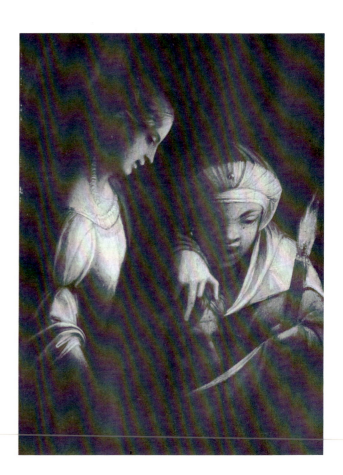

261. Correggio, *Judith*, 1512–14.
Strasbourg, Musée des Beaux-Arts

form in the Judith paintings, for here the old servant serves to modify the potentially terrifying aspect of Judith's identity as castrating virago. She reminds us, albeit irrationally, that Judith is, after all, *only* a woman, a sexual creature who may be seen in the painting as exorcising the beast of man's darker nature, yet who remains, by virtue of the imagined intercession of the procuress-servant, perpetually available to the beneficiary of the exorcism—the refined and civilized male viewer of the painting. The Judiths of Correggio and Caravaggio are such creatures of masculine fantasy, sexual objects who lack sexual awareness, delivered to the viewer by their worldly-wise maidservants, who are agents of their mistresses' innocent sexual promise and neutralizers of their independent power.

There is, however, another class of Judiths who are not merely generically erotic, as with Baldung Grien, nor passively available to the viewer on his own terms, as in Correggio, but who instead exercise their seductive powers directly upon the spectator, as if *he* were Holofernes. Rubens's Braunschweig Judith is to some degree such a figure, though her primary effect is more militant than seductive. The sexually self-aware Judith is personified most fully in the Pitti Palace version of the theme painted by Cristofano Allori (Fig. 262), in which we see a calculating and powerful woman who takes measure of the viewer, dominating him exactly as she has dominated Holofernes. In this instance, it is not only we, the viewers, who are the victims of her wiles, but the artist as well. Allori, we learn from his contemporary Baldinucci, painted Judith with the features of his mistress, La Mazzafirra, and depicted Holofernes as himself.[70] La Mazzafirra, it now appears, was the inspiration, not for the artist's well-known Pitti *Judith*, but rather for an earlier version, identified by John Shearman with the *Judith* at Hampton Court (Fig. 263).[71] Although the Pitti picture may be one step removed from the painful personal experience that prompted Allori's first autobiographical conception of the Judith theme, it nevertheless preserves the artist's idea of Judith as a cool and heartless mankiller.

Allori's self-image as Holofernes, the victim of emotional tortures imposed by the beloved, echoes Caravaggio's self-image as Goliath in his Borghese *David and Goliath* (Fig. 267), a conception that may have had as its own model Michelangelo's *Victory*.[72] Yet the lover-tormenters in the latter instances were male, the affairs homosexual, and perhaps for that reason, the victors were not presented as generic representatives of their sex. Allori, by contrast, painted his Pitti *Judith* as a deliberate and more generalized second draft, replacing his first image of himself as the victim of La Mazzafirra with a broader concept—Man as the victim of Woman. Allori's contemporary, the poet G. B. Marino, confirmed this universal masculine meaning of Allori's *Judith* in a poem written about the painting for his *Galeria*. The "beautiful, ferocious widow of Bethulia," he says, kills Holofernes twice, with Cupid's darts and with the sword, and she destroys the "felon" first with her beautiful gaze and then by her strong hand.[73] Judith's powerful and dangerous dual weapons, her sexual allure and her sword, invoke a Petrarchan juxtaposition of Love (or insidious beauty) and Death

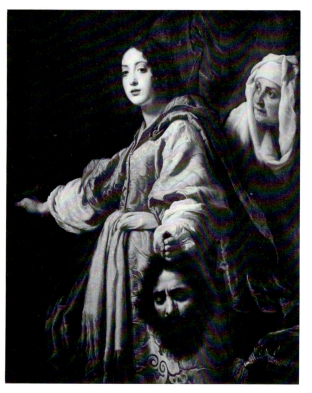

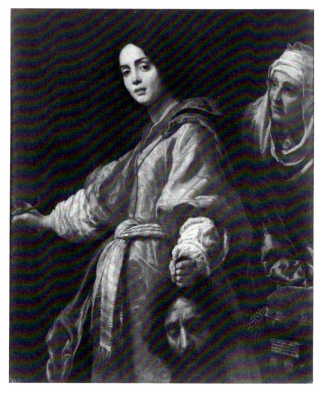

262. Cristofano Allori, *Judith with the Head of Holofernes*, 1616–20. Florence, Palazzo Pitti

263. Cristofano Allori, *Judith with the Head of Holofernes*, signed and dated 1613. Hampton Court

that was popular with early seventeenth-century poets,[74] and would continue to flourish as a favorite nineteenth-century *topos, la belle dame sans merci*.

The residual anxieties and ambivalences provoked in male artists for centuries by the character of Judith received full and overt expression in the nineteenth century, when writers and artists treated Judith as a tragic but dangerous heroine, potentially independent of God's will (and, not incidentally, of men's as well). In Horace Vernet's painting of 1831 (Fig. 264), Judith broods majestically as she contemplates her deed, and Vernet's figure was the immediate inspiration for the 1840 Judith drama of Friedrich Hebbel, in which the theme was treated, on one level, as a battle of the sexes, with Judith cast as a tragically willful and self-assertive woman.[75] It remained for the "decadents" of the *fin de siècle*, with their avowed interest in the diabolic and satanic, to fully articulate man's anxious fantasies of the seductive woman's powers, in what for them were positive terms. Heine's conversion of Herodias from an evil woman into a grand character, and Wilde's transformation of Salome into the symbol of an amoral philosophy of beauty,[76] found their visual counterpart in Gustav Klimt's

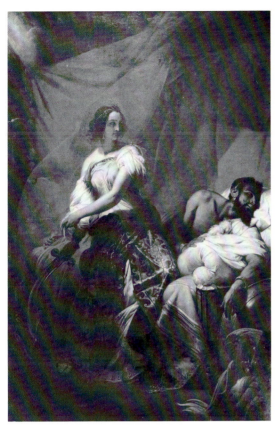

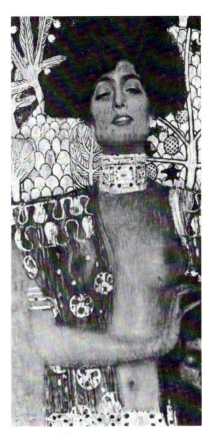

264. Horace Vernet, *Judith*, 1831.
Paris, Louvre

265. Gustav Klimt, *Judith*,
late nineteenth century. Vienna,
Osterreichische Galerie

portrayal of Judith as a supremely powerful, lasciviously triumphant fatal woman (Fig. 265), an openly erotic image that his contemporaries persistently mistook for Salome.[77]

And so the image of Judith in art changed gradually from that of a paragon of chastity, strength, and courage to a dangerous and deceitful *femme fatale*, a transformation that was well underway in the sixteenth and seventeenth centuries, when she was already presented ambivalently, as a beautiful but vacuous mannequin, or as a subtly evil figure. During that period, by contrast, Judith's biblical counterpart, David, continued and even developed as an uncompromised hero. In seventeenth-century painting, David became a more contemplative figure, who is often seen reflecting upon the decapitated head, silent and thoughtful. These images may convey the hero's intense meditation upon his deed, as we see in Orazio Gentileschi's Spada *David* (Fig. 266). Or, they may serve as vehicle for a profound spiritual commentary upon the self, as in Caravaggio's Borghese *David* (Fig. 267), in which the artist has incorporated in the figures of both David and Goliath elements of his own identity—

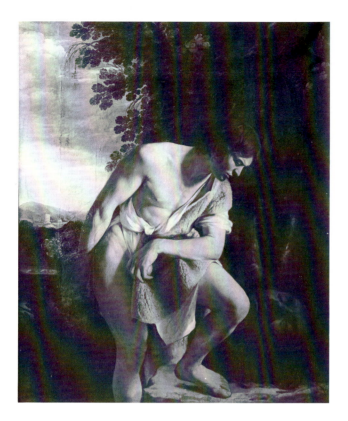

266. Orazio Gentileschi, *David in Contemplation after the Defeat of Goliath*, c. 1610.
Rome, Spada Gallery

young and mature, heroic and penitent.[78] Following Caravaggio's conflation of himself with the biblical hero, an artist like Guido Reni could further enlist the David theme for personal expression (Fig. 268), suggesting, in an image that combines pride of conquest with contemplative speculation, the painter's stylistic triumph over Caravaggio himself.[79] Such introspective, private interpretations of David were enabled, however, through knowledge and through memory of the biblical hero's public, heroic side, so that we come to understand these changes in his depiction as a deepening of his personality. The meditative David acquires resonance in his new association with the philosopher, a figure whom we encounter in the paintings of Rembrandt, among others, and in his potential for conveying aspects of the painter's personal or artistic identity—recurring echoes that reflect the widespread seventeenth-century admiration of the contemplative man and interest in the melancholic artistic temperament.[80]

Such meditative Davids are not paralleled by a category of meditative Judiths. It is rare, even in the seventeenth century, to find a Judith who is not in some way a variant of the types that we have examined, whether she is a passive beauty (Saraceni, Fig. 56), a pious maiden (Stanzione, Fig. 269), or an ominous virago (Vouet, Fig. 270). One exception is the pensive, monumental *Judith* of Anteveduto Grammatica,

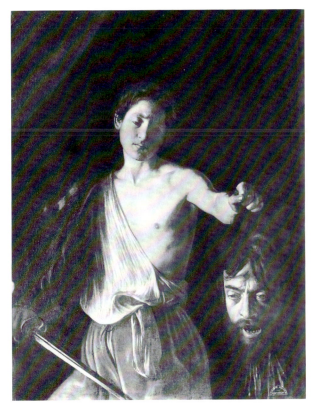

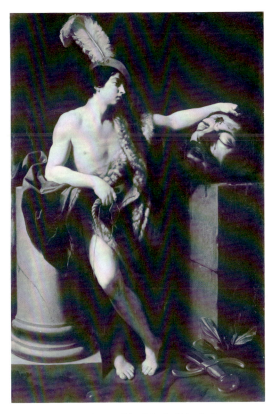

267. Caravaggio, *David with the Head of Goliath*,
c. 1605–1606(?). Rome, Borghese Gallery

268. Guido Reni, *David with the Head of
Goliath*, c. 1605–1606. Paris, Louvre

in Stockholm, c. 1620–25 (Fig. 271), whose queenly bearing and thoughtful absorption
connect her at least superficially with Davids of the period.[81] But unlike the Davids,
the object of this Judith's meditation is not the head of her enemy (in which she would
have seen no mirror of herself). Yet the artist has not made clear what it is that has
plunged the heroine into deep thought at the very moment when her companion
anxiously urges their escape. We cannot understand this Judith's inner motivation, we
can only apply such stereotypical concepts as the notion of Fortitude or Chastity. By
contrast with David, Judith is not permitted to grow into a multi-dimensional char-
acter defined by psychological or philosophical complexity, because she could not be
regarded by male artists as an heroic extension of themselves. Unlike David, she was
not invested with the aspirations, doubts, and meditations of the dominant sex.

The four major *Judith*s of Artemisia Gentileschi present a concept of the heroine
that differs significantly from the types that we have traced. In each of her inter-
pretations of the theme—seen in the Pitti version, the Naples and Uffizi pictures, and
the Detroit version—the character of Judith is an individualized figure who is neither
glamorous nor manly, and who is convincingly engaged in a specific action. By con-
trast with most earlier images of the heroine, who functioned primarily on an

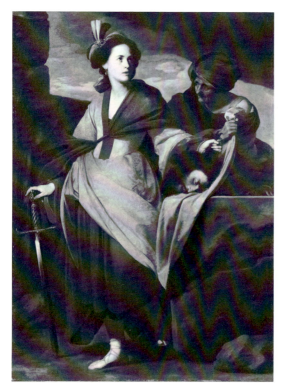

269

269. Massimo Stanzione, *Judith with the Head of Holofernes*, early seventeenth century. New York, The Metropolitan Museum of Art

270. Simon Vouet, *Judith*, c. 1618–20(?). Vienna, Kunsthistorisches Museum

271. Anteveduto Grammatica, *Judith with the Head of Holofernes*, c. 1620–25. Stockholm, National Swedish Art Museums

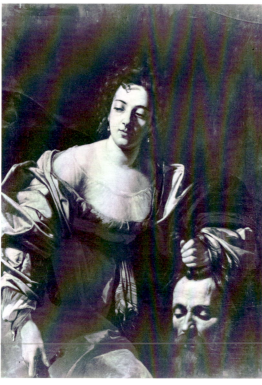

270

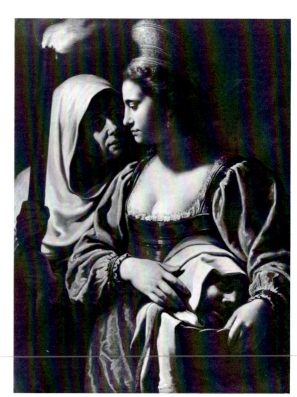

271

emblematic or tropological level, Artemisia's Judiths are imbued with a spirit of self-determination, and they project psychic complexity. In consonance with her era's interest in psychological development of character, and drawing upon her own inner resources, this female artist has developed Judith as a powerful three-dimensional heroine, but—by contrast to the Davids—she presents her as an active rather than a contemplative figure. In this construction of Judith, the artist suggests to us that the very dimension of female character that was inaccessible to male artists—more accurately, undesirable for them to contemplate—the realm of autonomous, independent action, was in fact the effective counterpart of a meditative David. For if the stereotype of the male hero is as a mindless doer of deeds who acts upon the world without reflecting on the consequence of his actions, the stereotype of the female is as a passive beauty who does not positively affect or change the world. If, in the interest of greater fidelity to human nature and experience, it is desirable to show that David can think, it is mandatory to show that Judith can act. The three Judiths invented by Artemisia Gentileschi, who drew creative inspiration from her own sense of personal autonomy, are possibly the freest of masculine stereotype in the entire genre of Judiths. They may also be the most completely developed female heroes existing in art.

AMONG Artemisia's extant works, the *Judith with Her Maidservant* in the Pitti Palace (Color Plate 5) has traditionally been regarded as her earliest interpretation of the Judith theme.[82] It now appears, however, that the Naples version (Color Plate 4) of the composition made famous by the Uffizi picture (Color Plate 8) may instead have been the first version of the latter composition, since x-radiophotography has shown a wealth of pentimenti and a slightly different design under its surface. The Naples *Judith Slaying Holofernes*, with its numerous sources in Roman art and its expressive relationship to the traumatic events of 1612, is likely to have been painted in 1612–13, before Artemisia left for Florence, probably predating the Pitti *Judith with Her Maidservant* by about a year. The continuous history of the Pitti *Judith*'s location in Florence, combined with strong Florentine allusions in the painting, point to her having painted the *Judith* shortly after her arrival in Florence in 1613. The Uffizi *Judith*, as discussed above, should be seen as a replica of the Naples *Judith*, carried out around 1620 at the end of Artemisia's Florentine period. The Detroit *Judith* (Color Plate 12) was painted about five years later, in the middle of the artist's second Roman period. In the discussion that follows, we may observe the growth and development of Artemisia's characterization of the biblical heroine over an approximately thirteen-year period.

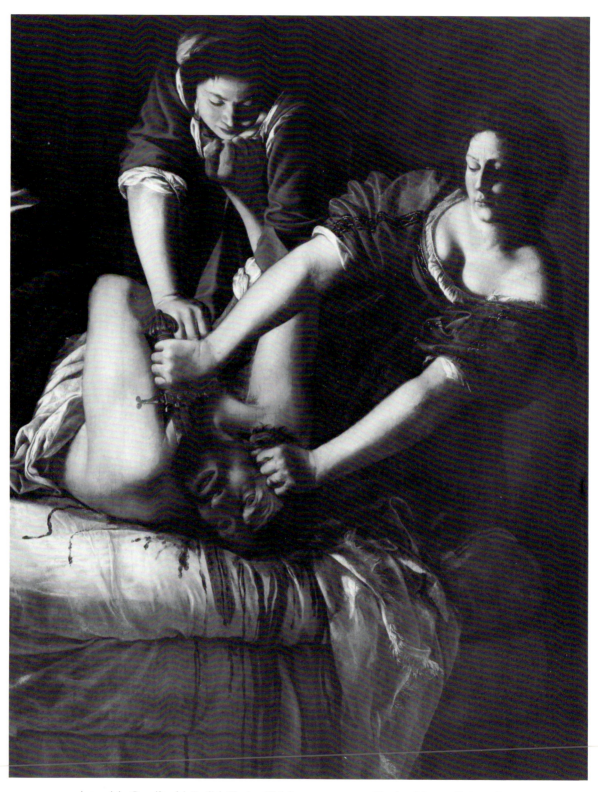

272. Artemisia Gentileschi, *Judith Slaying Holofernes*, c. 1612–13. Naples, Museo di Capodimonte

And [she] approached to his bed, and took hold of the hair of his head, and said, Strengthen me, O Lord God of Israel, this day. And she smote twice upon his neck with all her might, and she took away his head from him.

—*Book of Judith* 13: 7–8.

THE Naples *Judith Slaying Holofernes* (Color Plate 4; Fig. 272) represents Artemisia's first independent conception of the Judith theme. Although she found in Caravaggio her primary inspiration for the image, she demonstrated in this work a mature capacity to assimilate several pictorial sources, and to create a forceful original composition. Her debt to Caravaggio's *Judith* (Fig. 255) is evident in the clear, hard, tenebrist lighting and realist physiognomies, in the parallel diagonals of Judith's arms, and in the blood-spurting melodrama of the decapitation.[83] As Frima Fox Hofrichter pointed out (in a discussion of the Uffizi *Judith* that pertains equally to the Naples painting), Artemisia's composition is also closely related to a lost painting by Rubens, the so-called "Great Judith," whose composition is preserved in an engraving by Cornelius Galle I dated 1610 (Fig. 273).[84] Certain elements of Artemisia's design, such as the intricate interlocking of arms, may have been suggested by Rubens's work and combined with Caravaggio's model. Yet she decisively rejected from Rubens's prototype the image of the expansive and heroically outstretched arms of Holofernes. Instead, as we can see in the x-ray image of the Naples *Judith* (Fig. 274), the painter experimented independently with her composition, trying several positions for Holofernes's struggling arms,[85] and she wound up with an entirely new image for the figure of the Assyrian, more ignominious and powerless than in either Rubens or Caravaggio. Although Holofernes's legs are not now visible in the Naples painting, they are likely to have been included in the original composition. Technical examination has revealed that the canvas was cut on the left side (though not at the top), and we may infer that the missing portion of the painting resembled the left side of the Uffizi version, particularly since the foreshortened, diagonal position of Holofernes's legs, with raised knee, may be seen in Rubens's image. Artemisia's retention of this pose for the tyrant's legs—a vivid image of physical strength overturned—may have been influenced by other works as well, for we see it in the figure of Paul in Caravaggio's *Conversion of St. Paul*, and in the figure of the slain Aegisthus on the Orestes sarcophagus that served as a treasure chest of motives for Artemisia and Orazio (Fig. 167). And, as Keith Andrews has shown, Rubens's robust, sprawling Holofernes was itself inspired by a *Judith* composition of the Northern painter Adam Elsheimer dating 1601–1603 (Fig. 275), a picture that Rubens owned, by an artist he deeply admired.[86] Artemisia herself may have known the Elsheimer, since, as we shall see, she later echoed other aspects of its design in the Detroit *Judith*.

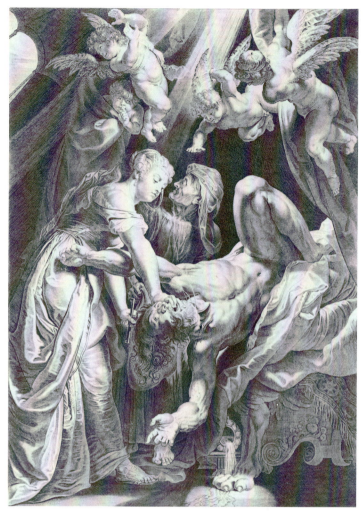

273. Cornelius Galle I, after a lost work by Rubens,
*Judith Beheading Holofernes, known as "The Great Judith,"*
engraving, 1610. New York, The Metropolitan Museum of Art

275. Adam Elsheimer, *Judith Slaying Holofernes*,
1601–1603. London, Wellington Museum,
Apsley House

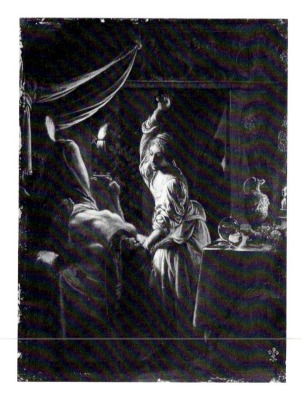

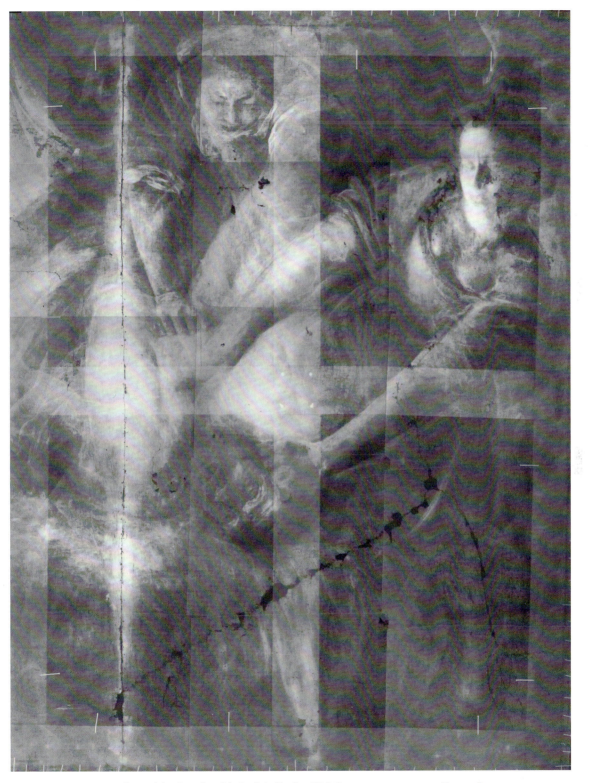

274. Artemisia Gentileschi, *Judith Slaying Holofernes*, c. 1612–13, x-radiograph. Naples, Museo di Capodimonte

Artemisia's image of the killing of Holofernes by Judith differs significantly from all of these precedents, however, in its powerful composition, which is more formally and dramatically concentrated than those of Caravaggio, Rubens, or Elsheimer. If, as it seems safe to assume, the Naples painting was centrally focussed like the Uffizi replica, its original format would have been roughly square, expansive horizontally, but compressed at the top. In such a format, the diagonals of arms and legs would have led, as they do in the Uffizi version, to a central nodal spot, from which the blood spatters and flows out, reinforcing the pinwheel structure. In Artemisia's first version of the decapitation imagery, centripetal and centrifugal forces are held in dramatic balance, heightening our sense of the precise moment as do none of the cognate images of the slaying. The x-ray also reveals that at one stage in the evolution of the design, Gentileschi indicated the setting through an open curtain flap on the left (with the loss of the left side of the painting, we can no longer determine how this might have related to Holofernes's legs). It is especially unfortunate that the overpainting and cutting down of this painting have obscured the original image, for what we may reconstruct from the x-ray and the Uffizi replica suggests that in its lightning-flash, split-second unity of light, action, and time, it was Artemisia's and not Caravaggio's *Judith* that offered the quintessential Baroque version of this theme of slaying. By comparison, both the Apsley House and Casa Coppi *Judith*s appear immature, awkward, and stilted, while in the Rubens *Judith* action is diffused in fluid and bombastic rhetoric.

Originality is also evident in the Naples *Judith* in the revision of the figure of Abra the maidservant. By contrast with the conventional passive, waiting crone, who appears in most versions merely as a foil to the active Judith, Artemisia's Abra is a vigorous young woman. The idea of a youthful Abra originated in Orazio's Hartford *Judith* (Fig. 277), but in Artemisia's reworking, she has become a critical figure, given special importance by her placement at the apex of the composition, actively assisting in the execution. For this memorable image of a determined young figure reaching down to a dismembered, bearded head, Artemisia may have drawn inspiration from the *David with the Head of Goliath* now in Madrid, an image by or after Caravaggio (Fig. 276),[87] but the figure is visualized from a different angle and smoothly integrated into a new context. Directly above and looking down upon Holofernes, with whom she is axially connected by the vertical thrust of his struggling right arm, this Abra might be mistaken at a glance for Judith herself—her own right arm could almost be wielding the sword. (Indeed, Abra's right hand is more fully exposed in the Naples than in the Uffizi version, and as the x-ray shows, this hand was completely defined before the sword pommel was painted in.) Judith, on the other hand, seems oddly subordinated to Abra, pushed off to the side. Moreover, she could not easily have accomplished the decapitation with arms in that position (the spurting blood tells us that the sword has passed through the neck, moving away from Judith's body). Having preserved the arm position of Caravaggio's Judith while changing the direc-

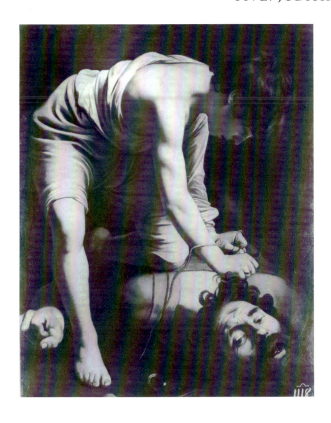

276. Attributed to Caravaggio,
*David with the Head of Goliath*,
c. 1603–1604(?). Madrid, Prado

tion of the stroke, Artemisia uses Abra to make the action more physically plausible, as well as more complex. Abra holds down Holofernes, and has pinned his left arm against his chest, allowing Judith to move in front, wedging her knee on the bed, to sever the head as efficiently as a surgeon aided by a nurse.[88]

The intensity of the women's engagement in their deed is perhaps better read in the x-ray than in the present surfaces of the Naples painting, which have suffered significant overpainting.[89] In her original form, Judith would not have been so bland and wooden in appearance, and she may have more nearly resembled Artemisia's *Susanna*, with a brow furrowed in concentration, a nose that may have been narrower and more pointed, and more loosely flowing hair. Abra too, to judge from the x-ray, wore a look of focussed concentration, and not the serene half-smile we now see. Working together like experienced professionals, the two women effectively accomplish the deed. Their performance is an ironic reversal of the persecution of Susanna by the two Elders, and also of Artemisia's own experience as the victim of Agostino Tassi and Cosimo Quorli. Given the artist's unusual biography, and given the validation by modern psychology of the Aristotelian principle of catharsis, it is surely justifiable to interpret the painting, at least on one level, as a cathartic expression of the artist's private, and perhaps repressed, rage.

Few artists have had so open an invitation to identify personally with their cre-

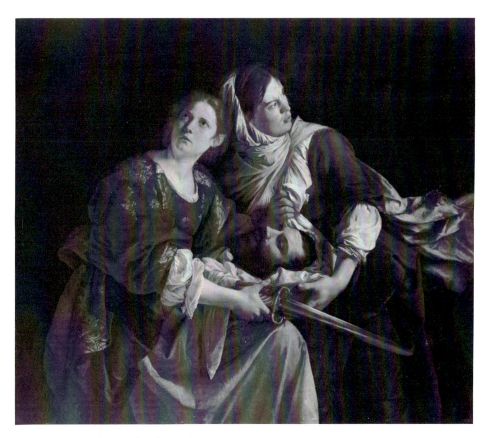

277. Orazio Gentileschi, *Judith and Her Maidservant with the Head of Holofernes*,
1610–12. Hartford, Wadsworth Atheneum

ated characters as Artemisia with Judith. Out of a manifest need to exorcise her own demon, the man who sexually exploited her and against whom her expressed anger is recorded, Artemisia depicted the killing of Holofernes in an unprecedented way, as a bloody murder carried out with clinical precision by two women whose cold determination is almost vengeful. Between them, the two women carry the burden of feelings that Artemisia must have brought to the painting of this picture. The important role played by the maidservant in the painting, as a supportive *aide-de-camp* to a lone woman, might well be understood as an inverted echo—a kind of redress— of Artemisia's personal isolation during the rape experience, and her betrayal by an older woman companion, Tuzia. We may thus see Artemisia's projection of self not only into the figure of Judith, but also, and perhaps more significantly, into Abra, the loyal and supportive young companion of her imagination.

The figure of Judith is not unquestionably a self-portrait, in either the Naples or Uffizi versions of this theme. She perhaps slightly resembles the image of Artemisia

in David's engraving (Fig. 51), yet it is Abra's face that more closely resembles the later Kensington Palace *Self-Portrait* (Color Plate 15). And as Richardson has noted, the pose of the maidservant in the Detroit *Judith* (Fig. 53), a work nearer in date to the *Self-Portrait*, is almost identical to that in Artemisia's self-image.[90] Why would Artemisia have identified more overtly in these paintings with the servant than the heroine? She might well have refrained from a too direct and exclusive identification with the executioner herself, the figure whose action could have been dangerously close to her own repressed fantasies. In painting the Naples canvas so soon after the rape experience, Artemisia might have subconsciously distributed her psychic participation in the picture between the two characters, who could embody complex feelings in a more elaborated, yet clarified, manner. In both the Naples and the Uffizi paintings, Abra is a double of Judith, and the energetic, individualized presence of both figures may result from the dichotomized projection of the personality of the artist, Artemisia Gentileschi.[91]

IN HER second independent version of the Judith theme, the painting in the Pitti Palace, Florence (Fig. 278), Artemisia turned away from the bloody violence of the decapitation scene to create an image of classic restraint. The Pitti version presents a later moment in the narrative when, after the slaying, the two women have gathered the head into a basket and are preparing to leave the enemy camp. Again, Orazio's Hartford *Judith* (Fig. 277) was germinal, not only for the idea of a youthful Abra, but also for the innovative moment chosen, one rarely if ever isolated in painting before this time. Although other artists of his era had shown the two women with the decapitated head—for instance, Fede Galizia (Fig. 279), in a painting of 1596[92]— Orazio managed to transmit a greater sense of narrative urgency than is found in many images of this type. Unlike Galizia's timelessly static heroine, whose maidservant is a mere subordinated attribute, Orazio's Judith and Abra impart, in their exchange of the head and their alertness to danger, the sense that this is a significant dramatic moment. Yet the figures' awkward interaction (perhaps a negative legacy of their classical prototype) inhibits their full psychological unity, and it is all too easy to see them as static, posed models, whose intensity comes not from a heroic crisis, but from holding the pose too long.

In her Pitti painting, Artemisia builds upon the atmosphere of watchful suspense seen in the Hartford *Judith*, but she develops a far more forceful image of the heroine and her youthful servant. The two figures, standing monumentally tall and acting in psychic unanimity, freeze in their leftward movement as they respond to a sound or threat from the right. The women dominate their space, self-possessed and centered around an axial core defined by their contrasting positions. The pairing is reminiscent of, and may have been inspired by, another Caravaggesque source: the pair of figures, Christ and a disciple, on the right side of Caravaggio's *Calling of St. Matthew* (Fig. 280), a recollection that vitalizes this dramatic narrative by implying a focus for the

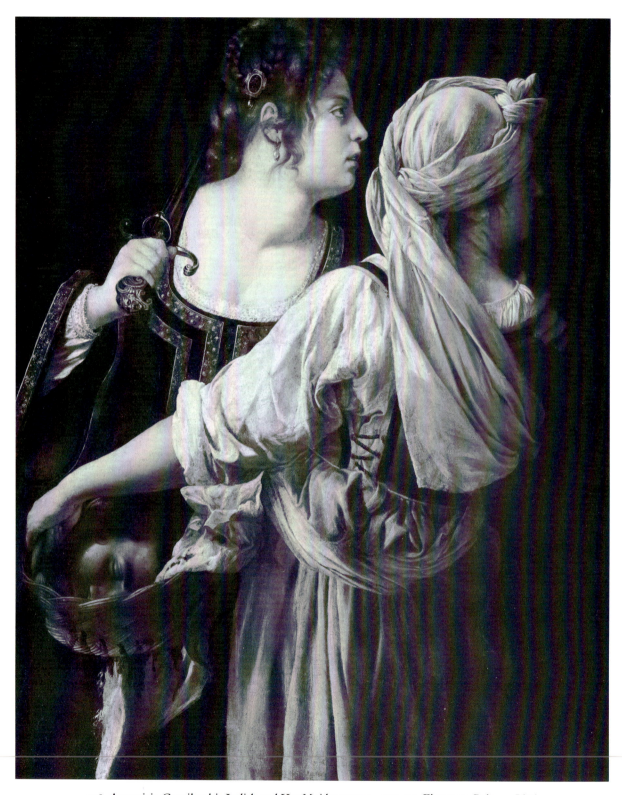

278. Artemisia Gentileschi, *Judith and Her Maidservant*, c. 1613–14. Florence, Palazzo Pitti

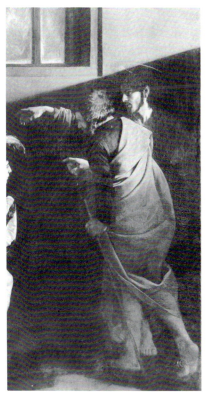

279. Fede Galizia, *Judith*, 1596. Sarasota, Fla.,
John and Mabel Ringling Museum of Art

280. Caravaggio, *Calling of
St. Matthew*, 1599–1600, detail.
Rome, S. Luigi dei Francesi,
Contarelli Chapel

women's attention outside the frame. Their response to a specific danger from a single
direction—a danger the armed Judith is implicitly prepared to meet—distinguishes
them from the timid characters of the Hartford picture, who are seen from slightly
above, huddling together fearfully, as if controlled by unseen superior powers.
Artemisia's Pitti painting also portrays a more precise moment in the narrative: not
merely the period of generalized anxiety following the women's deed, but, more sub-
tly, the moment when, beginning to leave the enemy camp, they hear a sound that
signals danger. Orazio's Hartford *Judith* is not so decisively positioned in time.

In her radical deviation from Orazio's model, Artemisia reveals a talent for char-
acter development and dramatic tension that may fairly be said to exceed her father's.[93]
Her painting, in its precise definition of the frightful moment when the ominous
sound is heard, simply makes for better theater. Indeed, the picture may literally draw
inspiration from the theater, since the figures' response to a sound from the side, in
the lateral plane, recalls the conventions of the stage, and especially those of the seven-
teenth century, when noises and music were usually produced in the wings, which

accommodated many entrances and exits as well.[94] Artemisia's simple focussed image would not have been literally derived from the elaborate, spatially deep and visually complex stage set designs of her day, especially not those marvels of fantasy and extravagant tricks of light, sound, and effect produced at the Florentine court (though the Roman stage was in her day shallower and more restrained).[95] Rather, she may have responded more generally to theatricality itself, and to the dramatic conventions that permitted events to occur both on and off the stage. In the numerous Judith dramas of the sixteenth and seventeenth centuries especially, the device of offstage action was employed for an obvious logistic reason, since the execution of Holofernes was not often attempted on stage.

Tellingly, however, dramatic attention was not normally given in the theater to the immediate aftermath of the execution. In the Judith plays of the sixteenth century, far more time is given to the earlier verbal interchanges between the men, Nebuchadnezzar and Arphaxad, Ozias and Holofernes. The killing itself is typically followed by a swift denouement in Judith and Abra's return to Bethulia.[96] The moment in time that was tentatively isolated by Orazio and creatively explored by his daughter—when Holofernes has been killed and the two women prepare to leave his camp—finds no major theatrical counterpart before Federico Della Valle's *Iudit* of 1627, a drama that was notably more complex, both aesthetically and psychologically, than its predecessors.[97] In this play, a full scene is given to the women's preparation to leave Holofernes's tent. Judith's cautionary remarks to her accomplice following the execution, "*Abra, esci cheta; ascolta: / è giunta l'ora a l'opra / destinata, pregata . . .*" ("Abra, leave quietly; listen: / the hour has come for our divinely mandated work"), and a few lines later, "*Or qui ti ferma, e s'alcun viene, avvisa*" ("Now stay here, and if anyone comes, warn me"),[98] strikingly evoke the visual imagery of Artemisia's *Judiths*, not only the Pitti version, but also the Detroit painting, which may have preceded Della Valle's drama by a year or two. Thus Artemisia's innovative Judith images—which must have been known fairly widely through replicas—may well have held dramatic power sufficient to stimulate dramatists in their own trade.

The visual force of Artemisia's Pitti *Judith* is carried by the simple, archetypal clarity of the characters, viewed at close range (as they would not have been in a real theater).[99] In the figure of Judith, particularly, Artemisia established important associations with heroic tradition. The motive of the sword resting on the shoulder establishes her as vigilantly on her guard, and also evokes the allegorical figure of Justice, as seen, for example, in an early painting by Orazio (Fig. 281), an association that establishes this Judith as the agent of justice and, like David, the *manu fortis*, strong hand of God.[100] With a stroke, Artemisia reconnects her Judith with Donatello's heroic figure, whose powerful sword-lifting right arm creates an inspired fusion of Judith, Justice, and Fortitude, and also with the ancient Judith, paragon of righteousness who, as Prudentius described her, fought under the shade of the law (*sub umbra Legis adhuc pugnans*).[101]

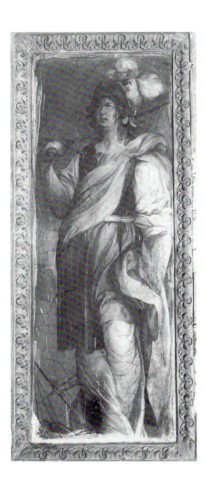

281. Orazio Gentileschi, *Justice*, fresco, 1597–99. Farfa, Abbazia

Our full attention is focussed upon Judith's head (Fig. 282), an unidealized, shaggy-haired, toothy figure, whose pure profile has the force of iconic simplicity. The physical type was perhaps suggested to Artemisia by one of the numerous images of Judith in circulation by her day, such as an engraving of 1528 by Jacques Bink (Fig. 283) in which a monumental Judith looks to the right, her lighted profile silhouetted against a dark ground.[102] Here, as with Artemisia's figure, loose locks of hair fall in front of the ear, and here too the lips are slightly parted. Yet there is another model whose physical resemblance to Artemisia's Judith is less obvious, but whose relevance may have been more compelling. Judith's bulging, upturned, and shadowed eyes, her intense gaze out toward danger, the weapon-holding hand close to the shoulder, and the imperious strength of the profile, inevitably call to mind Michelangelo's marble *David*, and the most memorable view of his upper body (Fig. 284). Artemisia's intentional association of her Judith with a masculine hero is confirmed and reinforced in the tiny image on the ornament in her hair (Fig. 285), an armed male figure with a lance and a shield, who might be a small replica of Donatello's *St. George*, or possibly one of the many sculptural and painted *David*s who, along with St. George, represented the heroic guardian ideal of Quattrocento Florence.[103]

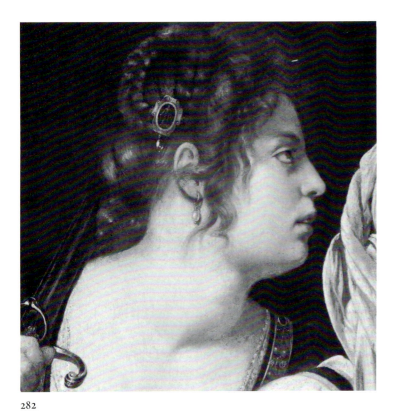

282

282. Artemisia Gentileschi, *Judith with Her Maidservant*, c. 1613–14, detail of head. Florence, Palazzo Pitti

283. Jacques Bink, *Judith*, engraving, copy from H. S. Beham, 1528. B.VIII.263.8

284. Michelangelo, *David*, 1501–1504, detail of head in profile. Florence, Accademia

285. Artemisia Gentileschi, *Judith with Her Maidservant*, c. 1613–14, detail of brooch in hair. Florence, Palazzo Pitti

286. Artemisia Gentileschi, *Judith with Her Maidservant*, c. 1613–14, detail of sword pommel. Florence, Palazzo Pitti

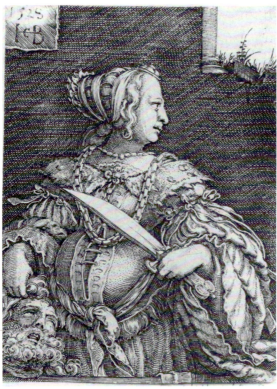

283

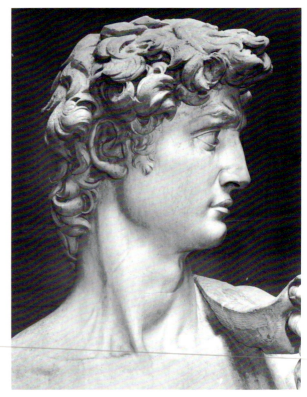

284

285                                        286

Another heroic analogue is indirectly evoked in the prominent image on the pommel of Judith's sword (Fig. 286) of an open-mouthed, screaming head, a Gorgon or Medusa, which recalls Caravaggio's *Medusa* (then, as now, located in a Florentine collection). In a general way that is given focus by the Medusa reference, the Pitti *Judith* recalls Cellini's *Perseus* statue in the Piazza Signoria, who holds forth the bloody severed head of Medusa as Judith and Abra hold the blood-dripping head of Holofernes. Yet the Medusa association has undergone a sea-change with the reversal of sex roles, for Judith's opponent was not the female Medusa or Gorgon, but the male Holofernes—and women are immune to the Gorgon's fatal stony gaze. The head on her sword's pommel is not a trophy of conquest, but a talisman, like the brooch in her hair, that complements and extends her own identity. One would not want to make too much of an ornamental detail, yet in light of Artemisia's other astonishing evocations of female archetypes, it is suggestive that this Medusa or Gorgon head, lacking the traditional snakes that so frightened male heroes Perseus and Odysseus, is more appropriately linked with a broader iconographic type, of Medusa as powerful mother image, a positive Medusa type that apparently survived into the Renaissance in gems and jewelry.[104] Artemisia's adaptation of a benevolent Medusa head as personal female emblem thus complements the male David/St. George emblem in her hair, a balance that helps to support the image of Judith as an androgynous hero. In a broader perspective, the painter's use of the Medusa image in support of female

heroism is in keeping with a later literary tradition traced by Gilbert and Gubar from George Eliot to May Sarton, in which Medusa is associated with female power and creativity.[105]

Judith's electric concentration and intense readiness dominate the Pitti painting. But Abra, too, is an important figure, whose relationship with Judith is heightened through contrast. Her left arm, for example, is slightly more relaxed than Judith's sword-bearing arm, to set off Judith as the bolder and more forceful of the two. The taut cloth of Judith's sleeve is similarly contrasted with the more randomly flowing folds of Abra's sleeve, initiating a descending drapery sequence, to the softer, more inert fabric supporting the head of the dead Holofernes, and finally, to the completely limp cloth that hangs from the bottom of the basket. This gloss of the differing levels of vitality among the characters is echoed on the right side in a more purely formal cadenza, which begins with the tightly knotted folds surrounding Abra's head, and flows down, broadening and loosening, to her waist. Yet the tensely gathered knots embracing Abra's head remind us that the maidservant, too, is psychically engaged in the dangerous adventure, and that her own acute alertness, though expressed obliquely, closely parallels Judith's own. As in the Naples *Judith*, though it is there differently expressed, the artist emphasizes the union of the two women as collabo-rators. Contrasted in some respects, they are made equal in others. Judith, sword-wielding, her fully lighted face in heroic profile, is the chief protagonist, but Abra's statuesque, counterpoised body is more fully seen than Judith's, and she carries the head with authority and strength, matching Judith in heroic capability. The women's intimate psychic linkage in the adventure is conveyed in the rhythmic echo in Judith's neckline of the curves of Abra's drapery and her own neckline. The echo of Judith's pure profile in Abra's shadowed lost profile sustains their essential unity as a pair, even as it acknowledges a slight hierarchic difference. A telling detail confirms the solidar-ity between the two: Judith's firm but intimate grasp of Abra's right shoulder, a ges-ture that closes the group, emphatically redefines the women's relationship. At this moment, Abra is not her servant but her sister.

Although the Pitti *Judith* is less overtly dramatic than the Naples *Judith*, Arte-misia nevertheless preserved in it, now through more subtle means, an emphasis upon the heroic action of the chief character and her formidable lieutenant. In both works, the artist reinstated the positive heroine of the biblical legend, eliminating any hint of sexual appeal or availability, while emphasizing through pose, countenance, and attributes those qualities that reflect strength, both moral and physical. The character she has created—neither beautiful, nor virginal, nor seductive—is nothing less than a reintegrated female hero, no longer dichotomized into saint or sinner, Mary or Eve, "good" or "evil." She is, rather, a lifelike individual transformed by a courageous action into a larger-than-life figure who, through her deed, has acquired the power that we associate with the heroic consciousness.[106]

Then he called hastily unto the young man his armour-
bearer, and said unto him, Draw thy sword, and slay
me, that men say not of me, A woman slew him.
                                                —Judges 9:54

THE relative unpopularity of Artemisia's Uffizi *Judith* (Fig. 287)—reflected in the fact
that this major Baroque painting has been literally banished to dark corners and in-
accessible museum stairwells for several centuries[107]—may be partly explained by the
image of psychological terror and shame that it holds forth for men. To be defeated
by a woman was explicitly defined as humiliating in the Old Testament and in the
Talmud, and inscriptions accompanying Judith images often hint openly of scorn in
their descriptions of mighty forces being brought down by the hand of a woman.[108]
In our patriarchal culture, there is no such thing as a fair fight between a man and a
woman: if he wins, he is brutal; if she wins, he is shamed. Perhaps for this reason,
artists have painted, on the whole, relatively few images of the killing itself,[109] and
even fewer that show an intact and physically capable Holofernes, since such an image
calls to mind the acute and shameful pain experienced by the male victim of the con-
test, whose struggle against mere women is to no avail.

Artemisia presented this image not once but twice, in her Naples and Uffizi ver-
sions of Judith Slaying Holofernes. The second version was apparently ordered by
Cosimo II de' Medici, and although we do not know why her patron might have
requested a replica of the Naples *Judith*, it is difficult to imagine its having had a
favorable reception.[110] Through slight but significant reworkings of the composition,
the artist has heightened the very qualities likely to have induced masculine dread. In
pitch darkness, outlined by a cold spotlight, two determined women efficiently de-
capitate a stunned and struggling man. One would not know, from a naive reading
of the painting, that Holofernes is a drunken beast, nor that the two women are nec-
essarily doing a good deed. They might be, as Germaine Greer has observed, "two
female cut-throats, a prostitute and her maid slaughtering her client."[111] Unlike Cara-
vaggio's carefully balanced antithesis of beauty and beast, and unlike Artemisia's Pitti
*Judith*, which, though its heroines are not conventional beauties, nevertheless pre-
serves an unthreatening focus upon the virtuous figures rather than upon their deed,
the Naples and Uffizi *Judith*s offer no conventional moral cues. In them, we witness
an existential killing, with no heroes and no villains, a murder in a realm outside the
law. There are precedents, as we have seen, for the violent physicality of Artemisia's
Naples version of the Slaying of Holofernes, but not for the moral neutrality that is
implied in it, a quality distinctly heightened in her second version.

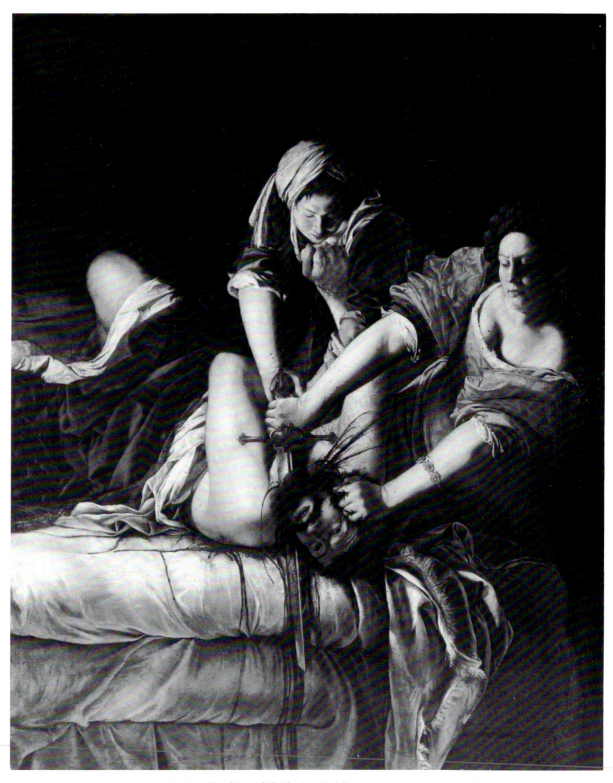

287. Artemisia Gentileschi, *Judith Slaying Holofernes*, c. 1620. Florence, Uffizi

In creating the Florentine replica, Artemisia made one major compositional change—the augmentation of the space above the figures. She may have revised the setting as well, defining the back plane as totally blank and dark (a revision, if the open curtain flap at the left of the Naples version that is visible in the x-ray was pre-served in the completed painting). And in the second version, the blood does not merely stain the bed, but spurts explosively from Holofernes's neck. These decisions are significant, for she has replaced the compressed intensity and temporal immediacy of her first draft with an image of high theater, grander in setting and scale, yet more chilling in its evocation of absolute silence and a horrible moment forever frozen in time. Like her Pitti Judith, Artemisia's Uffizi heroine displays virility and phallic power in the wielding of the sword, yet she is given a new dimension in being clearly defined as a sexually developed woman. Her female sexuality, indicated in the curve of a breast, is a natural aspect of her body, neither modestly concealed nor flagrantly offered to the viewer. (Significantly, no writers have commented on the sexual *appeal* of Artemisia's Judiths, despite their decolletage.) In contrast to Caravaggio's paragon of chaste morality, and also in contradistinction to Rubens's virago, Artemisia estab-lishes her heroine as a fully-sexed, mature woman, who is physical without being beautiful, a rare female character who escapes the stereotypes of maiden, virago, and crone. This Judith is plausibly the sexually experienced widow of the biblical account, whose sexuality could be drawn upon in the entrapment and conquest of Holofernes but was not accessible to others—not even the connoisseur-voyeur of the painting.

The frowning face of Judith, with half-closed, slanting eyes, is distinctly less idealized than that of the earlier Pitti Judith. Distorted by the lighting into unglam-orous harshness, the face is hard, expressionless, betraying no emotion except con-centration on the work at hand. Measured by conventional expectations of female characters, especially heroic and devout ones, Judith seems almost a sinister figure, who takes cruel satisfaction in her deed. Yet it is the discrepancy between the brutality of her action and traditional female decorum that makes her seem so. This Judith violates all our socialized expectations of woman's behavior in appearing neither modestly indifferent to her action nor piously noble about it, and it tells us a great deal about our sex-role socialization that into this moral void we so readily project malice. Even so, the artist has drawn a distinction between the images of Judith and Abra in the Uffizi version that was not discernible in the Naples painting. Judith's face seems slightly older now, and her hair more stylized, its stiff, smooth contours suggesting a wig, by contrast to the free-flowing locks of her earlier counterpart. Abra has not comparably aged, and although Judith now wears a somewhat finer dress than previously, Abra's dress is perhaps plainer, while her identity as servant is stressed by the fully defined and more prominent headdress. The differences between the women in age and social status have consequently become more pronounced.

These subtle changes point to a new expressive dimension that is developed in the Uffizi painting, one that must have resulted from a deeper understanding of the

story. Just as Judith seems sinister to our eyes, though we know she is not, so the discrepancy between appearance and reality, expectation and consequence, has become the core of the painting's meaning. Judith's luxurious appearance and her feminine refinement (she here wears a delicate bracelet) are now more shockingly juxtaposed with the brutal act of decapitation. Indeed, the blood spurting from Holofernes's neck has begun to spot her dress. Artemisia points up the fine dress and exposed bosom (and, perhaps, the wig), contrasting the elegant costume with the act of butchery, to underline the strategic use of clothing by Judith as her mask, the disguise that is essential to the success of her campaign. The irony is that while to Holofernes, Judith's elegant dress seemed natural, in reality, it was the artificial bait. And Judith's grimacing face is not, as Holofernes might think if he could see it, the face of evil or cruelty; it is, rather, the face of an ordinary woman who has suddenly dropped the mask of seduction and allurement to carry out a forthright action.

Here, as in Shakespearean tragedy, things are not what they seem, and in this image of duplicity and reversal we are particularly reminded of *Macbeth*: "fair is foul and foul is fair" (Act 1, Scene 1), and "False face must hide what the false heart doth know" (Act 2, Scene 1). In Artemisia's painting, however, the contradiction is not between real evil and apparent good, but within an apparent good (Judith as temptress) that conceals both an apparent evil (her sinister danger for Holofernes) and an ultimate good (her heroic deed). The abrupt transformation of the heroine from temptress to executioner—a moment of horror for Holofernes, but of triumph for Judith—is expressed in the painting with electrifying swiftness, paralleling very closely the extraordinary lines in Judith's hymn at the end of the biblical narrative:

> Her sandal ravished his eye,
> Her beauty made captive his soul,
> The sword passed through his neck.
> ( *Judith*, 16:9)

In these lines, as in the painting, there is a symmetry between Judith's artful female weapons and the deadly sword; but more than that, there is a causal sequence in which the apocalyptic finality of the latter redeems the moral questionableness of the former. In this respect, it is as if Artemisia cast Judith as that part of herself which experienced personal satisfaction in the act of retribution, not only against the specific man who had raped her in her youth, but also, privately, against the patriarchal world that had imposed upon her a need to dissemble and to trick.

In reconceiving the two characters, Artemisia has set up a subtle echo, in reverse, of the traditionally dichotomized women of the Judith theme, the innocent heroine and the wizened crone maidservant. For if Judith is, contrary to our expectations, the darker figure, Abra is more overtly righteous. Younger and less worldly in appearance, Abra bends over Holofernes in direct vertical alignment with the sword, and in spite

of Judith's intervening arms, our eyes run from Abra down the blade of the sword and back. The ultimate moral justification for the bloody deed is offered us subliminally through this sword, for the artist has designed its blade and straight quillon in the shape of a cross. Artemisia's cruciform rendering of the sword is surely calculated here, since she has explicitly rejected the curved scimitar blade used by Rubens and the falchion of Caravaggio,[112] and she has also replaced the S-shaped quillon of her own Pitti *Judith* with a straight bar, whose flaring ends recall the terminals of a liturgical crucifix. This instrument by which Judith triumphs over Holofernes is thus clearly meant to recall Christ's victory over Satan as well. The Christian analogy was similarly invoked in a Judith drama of 1607, the *Meysterlied von der Gottsfortigen Frawen*, whose moral epilogue explains that Holofernes is the devil, from whom we are delivered by Christ, and that Christ's death is the holy sword used by Judith.[113] The idealistic part of herself, the humble agent of the Lord who carried out God's will, Artemisia assigned to Abra the maidservant, whose dramatic function in the painting is to balance and justify—quite literally to rectify—Judith's devious and slanted behavior. In this painting, Abra represents divine justice, while Judith is allowed to stand for human vengeance.

Artemisia's interpretation of Judith as nether-heroine and Abra as Christ-hero stands out as especially unusual in the context of Counter-Reformation doctrine and imagery, in which, as we have seen, the medieval association between Judith and the Virgin Mary was revived and heightened. If we follow Artemisia's independent way of thinking, the connection of Judith, instrument of a people's salvation, with Mary may have seemed less pertinent than an association with Christ. (The contradiction is partly acknowledged in the rather strained efforts of theologians to characterize Mary in relation to Judith—in the interest of sexual symmetry, no doubt—as "savior of her people."[114]) Given Gentileschi's patent reluctance to depict Judith as chaste and bland (as did her contemporaries), one is encouraged to imagine that she saw a discrepancy between Judith's active heroism and her definition in Tridentine theology in the terms of Mary's passive virtues—her modesty and humility (when Judith displayed exceptionally aggressive courage), her purity and chastity (when her deed's success depended upon her sexual experience). To be compared to the Virgin is, of course, the highest compliment Christian theology is prepared to pay any woman, but ultimately, as modern feminists have recognized, comparison with a paragon of sexual perfection can be as restrictive for living women as its opposite parallel with Eve.[115] Artemisia Gentileschi's response to the potentially confining equation between Judith and Mary popular in her day was to go for something better, to enlarge upon the heroic associations of Judith and Abra by invoking Christ himself. In an image rich with associational attributes and shifting secondary identities, Judith and Abra play a variety of roles that both draw upon and aesthetically broaden the traditional Christian categories. Wielding the sword of just deliverance with powerful arms, Judith is David/Hercules, combining moral right with physical strength,[116] just as she is also

the Lord stamping out the Antichrist. Abra, who resembles a David but also evokes Christ, plays to Judith's Christ the *ancilla Dei*, handmaiden of the Lord.

Artemisia's references to masculine models in the Uffizi *Judith* are consistent with her evocation of Michelangelo's *David* in the Pitti *Judith*, and of Christ's agony in her anguished *Lucretia*. Because of Judith's longstanding position as an ambivalent and tainted heroine, and in the light of her recent vindication by the Church as a paradigm of the milder Marian virtues, it is understandable that Gentileschi would have wished to stress Judith's identification with paragons of moral clarity and active strength, models afforded chiefly by male heroic figures. Yet in her insistent blending of male gender traits with female characters, the artist has gone beyond a mere impatience with empty feminine stereotype to give us images of an androgynous whole: manly courage in a woman's body.

For such a creation, there are few prototypes. But Artemisia may in effect have "signed" this painting with a clue to her own sources of inspiration, from both without and within. The bracelet worn by Judith in the Uffizi painting bears two partly legible images (Fig. 288). The upper figure looks rather like a female holding a bow, the lower one is a human figure, one arm raised, with an object or animal at her foot. These hazy but suggestive sketches together recall separate well-known images of one

288. Artemisia Gentileschi, *Judith Slaying Holofernes*, c. 1620, detail of bracelet. Florence, Uffizi

character: Diana, or Artemis (Figs. 289, 290), ancient goddess of the hunt, the moon, of animals, forerunner and prototype of the Virgin Mary, whose own virginity was the sign of her independence from masculine domination. Her indirect namesake, Artemisia, would hardly have been unaware of the legend of Artemis,[117] and I think it not unlikely that she added the images as a kind of signature, revealing her proud identity with a strong and independent female mythological figure, and her formidable self-confidence as well.

289. Domenichino, *Diana with Nymphs at Play*, detail, 1616–17. Rome, Galleria Borghese

290. "Diana of Versailles," Paris, Louvre, line drawing from Oskar Seyffert, *Dictionary of Classical Antiquities*

If a woman fights,
she must fight by stealth,

with invisible gear;
no sword, no dagger, no spear
in woman's hands

can make wrong, right:
                    —H. D., *Helen in Egypt*.

THE inverted distinctions between Judith and her maidservant, in a context of con-
certed teamwork between the two women, are repeated and strengthened in the
fourth major *Judith* by Artemisia, the painting in the Detroit Institute of Arts that is
considered by many to be her masterpiece (Fig. 291). This large work, whose figures
are more than life-size, was painted in the 1620s, when Artemisia had returned to
Rome after her brief sojourn in Genoa, and it represents the climax of the Caravag-
gesque realism of her early career.[118]

In her third staging of the event, Artemisia continues to explore the range of
dramatic variations that the Judith theme afforded. Again, but now with full and elab-
orate orchestration of the imagery, she restates her interest, nearly unique among her
contemporaries, in the story's suspenseful climax, as experienced by its heroines. In
the Detroit painting, the artist avoids once more the bloody moment of the slaying,
as she had done following the Naples version, choosing to focus this time upon the
moment just after the decapitation, and just before that seen in the Pitti *Judith*. The
women are still in Holofernes's tent, as we are informed by the overhanging canopy
and the table with candle, scabbard, and glove of armor; and as Abra gathers up the
head from the floor, Judith, clenching the sword she has just used, turns from the act
completed to face an implied intruder.[119]

The amplified physical setting may have been partly inspired by Elsheimer's
Apsley House *Judith* (Fig. 275), which it resembles in such details as the curve of
curtain in an upper corner, the windblown candle flame, and the table with assembled
objects, their edges picked out in tenebrist light. In the figures, however, Artemisia
demonstrates studied indifference to Elsheimer's gentle characters, and pursues in-
stead the more innovative, and for her more fruitful, implications of the Uffizi paint-
ing. Again we see a graceful, noble Abra, whose fully lighted profile is contrasted with
that of the frowning, dark, and again somewhat harsh-featured Judith. As in the Uffizi
version, Judith's face is illuminated in irregular patterns of light and dark, which here
break down the volume of the head, giving a sense of the incomplete, of a heroine
strangely eclipsed in her own theater. In physiognomy, Judith is equally antiheroic.
The exaggerated facial features, the painted curve of her lips, the heavy brows, the

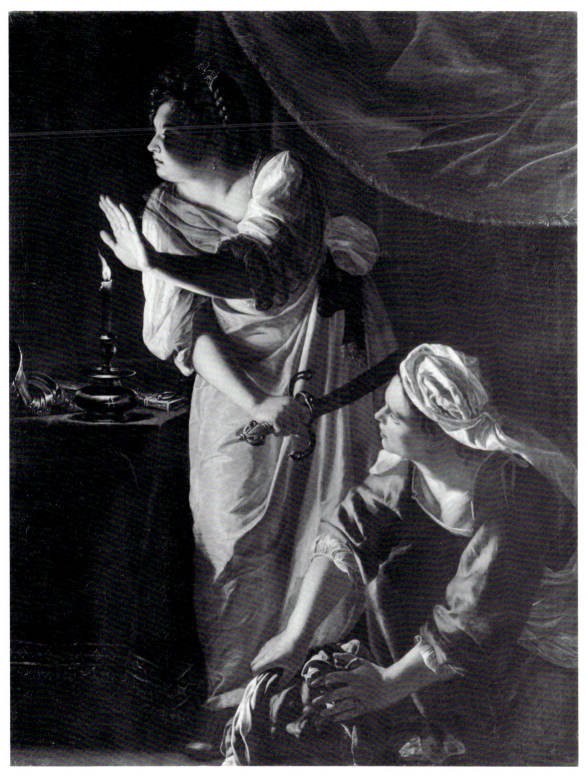

291. Artemisia Gentileschi, *Judith and Her Maidservant with the Head of Holofernes*, c. 1625.
Detroit Institute of Arts

scowl, convey the sense of a woman hardened by experience, or—perhaps more accurately—of an actress dressed up for a part. As in the Uffizi version, Judith has gotten herself up as the kind of beauty who would attract Holofernes, but more make-up is now required. The Judith of the later painting is older than the figure in the Uffizi painting, who in turn is decisively older than both the Naples and Pitti Judiths, and Abra has matured correspondingly, a progression consistent with the maturing painter's self-identification with her characters. The contrast in the Detroit painting between Judith and Abra poignantly suggests the distinction in two major phases of Artemisia's own life thus far: between her present self, toughened by experience in the decade or more since the rape, and the sexually innocent, perhaps idealistic young girl that she may have been before the rape.

Artemisia's growing understanding of woman's life experience is registered for us quite tellingly in her Judith paintings. Like Judith, she would not have been unaffected by the obligations imposed by a woman's life in a man's world, obligations to play roles in relation to men that increasingly diverge from, but also subtly erode, one's natural sense of self. When the painter copied her father's Hartford *Judith* in the Vatican replica, she ascribed to the maidservant a tough worldliness she could not yet herself have acquired, while sustaining in Judith the innocent countenance, though not the physiognomy, of the model for Orazio's picture, who may have been Artemisia herself. Increasingly, in the four independent paintings of the theme that postdate the rape, Artemisia reverses this understanding of character, attributing to Judith the world-weariness, and to Abra the innocence, revealing to us a fuller dimension of the biblical heroine than the text allows us to see. For if through identification with her Judith and Abra the artist Artemisia found a liberating courage inspired by a heroic model, identification also permitted her to apply her own life experience to liberate Judith from the confining stereotypes of heroine and seductress, and to imbue her with human complexity.

Such autobiographical implications are at most an undercurrent in the painting, for this last Judith created by Artemisia is one of the grand figures of art, a formally and allusively rich image that stands on its own, quite independent of our knowledge of the artist's life. With heavy, powerful gestures, she assumes a posture of combat readiness, like the Pitti Judith, but with more specifically militant bearing. Her vigorous contrapposto is implied rather than stated, since the body itself is concealed, conveyed through contrasting arm movements and summarized in the S-shaped quillon of the sword and its curved blade. Judith's pose in this painting embodies, in fact, a classical reference, as did Artemisia's figure of Susanna. In this case, it is the type of the Venus Pudica, whose best-known example—one that the artist would have known in Florence—is the *Medici Venus* in the Uffizi (Fig. 292). Artemisia's almost ironic transformation of the antique goddess of love into a female warrior heightens our sense of Judith's angry defiance, even as the subliminal association with Venus underlines the heroine's manipulative use of her feminine attributes—the fine dress, dia-

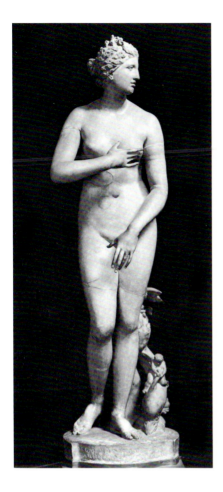

292. Greco-Roman, *Venus dei Medici*.
Florence, Uffizi

dem, and earrings. (Judith's neckline may originally have been more fully exposed, for according to one conservator, the drapery across the breast could be a later addition.[120]) As in the Uffizi painting, but in a more dramatically staged manner, Judith is characterized as a physically powerful woman whose sexuality is her real weapon, a weapon more powerful and dangerous than the sword she wields. On both levels, the words of the Talmud are recalled: "Woman had an army with her, that is sex."[121]

That Judith's dress, tiara, and make-up have disguised a warrior whose true identity is revealed in her violent deed is tellingly conveyed in a small but critical detail. Judith's foot is exposed, permitting us to see that she wears a heavy shoe. Normally, in paintings of this period, either a female figure's feet are bare, especially but not only mythological characters (e.g., the queen in Orazio's *Finding of Moses*), or else her dress covers her feet. The feet of most Judiths are not shown, but when they are, as in Rubens's "Great Judith," they are sandaled (perhaps in accord with the biblical text).[122] The expressive consequence of Artemisia's decision to expose Judith's booted foot is our recognition of the garments as disguise. With her feet firmly rooted and sword in hand, she is equipped for the second phase of her task, to make her escape swiftly and safely. Artemisia's Judith seems prepared to shed her deceptive

garments, just as she has shed her stylized "feminine" behavior, and one senses that this massive, heavy, strong woman is in both respects larger than the skins she has temporarily worn.

The themes of appearance and reality, deception and revelation, first developed by Artemisia in the Uffizi *Judith*, are sustained in the Detroit version by means of inventive visual variations. Through the boots beneath the fine dress, Judith reveals her real identity to the viewer on a naturalistic level. Yet this same image could have had another resonance for the seventeenth-century viewer, for it might have evoked the image of *Hippocrisia*, Hypocrisy or Deceit, who, as described by the sixteenth-century iconologist Cesare Ripa, has feet like a wolf concealed under her fine clothes.[123] Judith's crossed arms—the most singular aspect of this striking visual image—would reinforce the allusion to deceit in the Renaissance iconographic imagination, since crossed arms, hands, or even legs were sometimes used by artists to indicate treachery or deceit.[124] A combination of these motifs may be seen in a painting very likely known to Artemisia—Bronzino's *Allegory* (Fig. 293), now in the National Gallery, London, a work painted for Cosimo I de' Medici, grandfather of

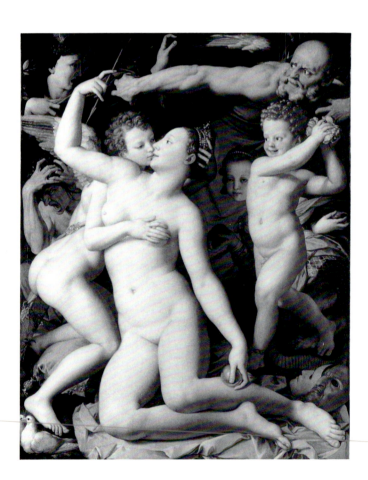

293. Bronzino, *Allegory*, c. 1545. London, National Gallery

her own Florentine patron. The specific meanings of the figures in this subtle and complex picture remain in dispute, but Panofsky was certainly correct in recognizing Hypocrisy, or *Fraude* (Deceit), in the partially hidden woman on the right, who has animal legs under her dress, and makes her duplicitous offering to the viewer with crossed hands, whose crossing is concealed by an intervening body.[125]

Gentileschi's formulation of the crossed arm motif, dramatically emphasized by intense chiaroscuro, bears a closer formal relationship to the temptress in Vouet's *Temptation of St. Francis* (Fig. 58), a figure who is graphically engaged with the object of her sexual deception. Since Vouet's temptress closely predated—or, less likely, closely followed—Artemisia's *Judith*, we may gauge as deliberate Gentileschi's subtle conflation of an image of sexual trickery with one of heroic resolve, and we may better understand the brilliance of her creation of a character whose heroism is built upon the imagery of masculine misunderstanding. Iconographic conventions are inverted in the *Judith*, the crossed arms and booted feet that to the male eye symbolize entrapment and deceit have been converted by the female artist into symbols of power and mobility. The resulting dramatic tension, between allusions to good and evil in the same image, reminds us once more that masculine and feminine perceptions of "good" and "bad" women may not only differ, but blindly coexist.[126]

The psychological interplay between Judith and Holofernes, metaphoric and archetypal, is subtly suggested in the painting. Although we do not see Holofernes's body, we are shown the physical reminders of his power and his aggressive intentions. On the table are his scabbard and part of his armor, indicating that it is his sword that Judith holds, which would have been used against the Israelites but has been turned against the villain himself. Yet Judith, who fills the vacuum left by Holofernes, armed with his own destructive tool, parodies the qualities of her antagonist in her aggressive stance, and in the echo of his metal glove in her right hand. In this, Artemisia is surely responsive to the aesthetically rich implications of the biblical story, whose characters echo each other with fine literary irony. Holofernes's sensual luxury, the immediate cause of his loss of physical power, was his ultimate undoing, even as Judith's seductive luxury—her fine dress, her beauty—were her compensations for lack of physical power, and the instruments of her physical conquest of him. These two characters, the story implies, were mirror opposites of each other, the one positive, the other negative, yet they were made up of the same elements, differently valued.[127] Through the transference and mimicking of attributes and traits, Artemisia demonstrates that pictorial theater can be psychologically richer, and more aesthetically satisfying, than conventional moral stereotypes.

Also invisible, though thematically as significant as Holofernes, is the threat from outside the picture that has riveted the protagonists' attention. As in the Pitti painting, Judith does not see this threat, she hears it. In this painting, however, the point is made more dynamically. Judith's body turns away from the right side of the space where the decapitation occurred and toward which her armed right hand still points,

and rotates to the left, toward which she suddenly looks, the instantaneity conveyed by the momentary gesture of the left arm. Facing in the opposite direction as she was, her attention could only have been caught by something heard and not seen, and the extended hand seems quite literally to say, "Stop, hush, I hear something." The extended hand also serves to block the strong light from her visible eye, and to cast a dramatic shadow over most of her face. Strictly speaking, the shadow is not cast by her hand, which would create a more irregular contour, and would not intercept the light of the candle, positioned farther back, near Judith's shoulder. The shadow over the face is more plausibly caused by the swag of curtain, the opening of the tent, which must be in front of the figures. Yet the advanced hand, boldly relieved in intense chiaroscuro, is so implicated in the optical and metaphoric drama of light and shadow in this painting, and so positioned (in the two-dimensional plane) between the candle and the head, that we instinctively read it as the agent by which Judith shades her face from the light.

Artemisia's decision to cast Judith's head in nearly complete shadow may be understood simply as a theatrical Caravaggesque device. Or, with full respect for the artist's inventive powers, we may be prepared to see in this curious subordination of the heroine a stroke of startling originality, and a personal imprint of the artist. Judith's head, a rounded shape overlaid by a regular circular curve, strikingly resembles a crescent moon whose spherical wholeness is partly obscured by the earth. The crescent moon is, of course, the principal attribute of Diana, or Artemis, as Domenichino (Fig. 289) so conventionally demonstrated. Having placed Artemis images in her Uffizi Judith's bracelet, Artemisia now creates a more indirect allusion to her namesake goddess, one that draws strength from its understatement. By an accident of shadow, Judith temporarily becomes Artemis, as she becomes Artemisia, in some fundamental—or perhaps only apparent—way that transcends literal explanation. The artist's means of alluding to the moon, astronomical rather than symbolic, is naturally explained if we recall her friendship with Galileo, formed in Florence where both were members of the Accademia del Disegno (see above, pp. 37–38), soon after he had published his telescopic studies of the moon's surface in the book *Sidereus nuncius* (1610). Galileo's own wash drawings of the moon (Fig. 294), which have been recently published by Samuel Edgerton, are remarkably accomplished chiaroscural images, more luminescent than the published engravings,[128] and on this sheet they are contextualized pictorially in separate *quadri*. These drawings, recalled a scant decade later, may have been the stimulus for a highly sophisticated personal conceit on the part of his friend Artemisia, who was able to translate scientific fact into a poetic private emblem.

Artemisia's complex arrangement and lighting of solid objects in an airless space does more than evoke Galileo's moons, however, for in the light and dark imagery of the Detroit *Judith*, intricately developed in the juxtaposition of candle, hand, and face, we are directed to another reading of the painting. Judith blocks the light from her

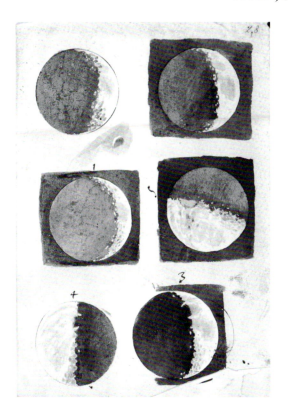

294. Galileo, drawings of the moon, c. 1610.
Florence, Biblioteca Nazionale,
Gal. 48, fol. 28ʳ

eye, the better to hear what is approaching. The shading of the eye, to enhance her other senses, reminds us that in this world of deception and danger, light is not the agent of good, but itself betrays, by exposing the assassins to discovery, and by inhibiting hearing, in this instance the more acute and reliable perceptory sense. For the guerrilla invader of the enemy camp must operate by stealth, under protection of night, not by the direct strategies of daylight military combat. While vision is the adjutant of the open aggressor and the entrenched army—to see is to measure, to control, to possess what is before you—hearing is the friend of the guerrilla, who must adjust and react to the dominant force, learning about it what it does not wish to reveal through surreptitious, indirect methods. In the story of Judith, it is darkness, not light, that supports the women's courageous deed.

The richly developed imagery in the Detroit *Judith*, juxtaposing light and dark, deception and revelation, seeing and hearing, takes us to a more universal plane on which this painting and Artemisia's other *Judith*s can be understood. Her guerrilla warriors, functioning heroically in an alien territory, are the surrogates of women in male-dominated societies. In the broadest metaphoric sense, these *Judith*s present a fully realized, archetypal expression of the female hero, from the viewpoint of the female artist. Artemisia's Judiths are not simply Davids in female dress, viragoes who

mimic the postures and powers of the male in a straightfaced, serious way. Rather, they defy our conventional sense of the morally responsible hero in their unidealized faces, their stealthy and uncivilized behavior, and their alliance with darkness. These Judiths, amoral from the patriarchal point of view, trailing no associations with the culture princesses whose task it is to civilize men, nor even with the mandate of the father God of the Israelites, challenge by omission the value structure of the society in which they were produced. Artemisia's Judiths are neither glamorous, nor pious, nor humble; they are, in a figurative sense, women beyond social or theological masculine control, whose independent power is subject to only one force: the immediate worldly threat outside the tent.

And in this specifically delimited vulnerability lies the paintings' symbolic truth and their universal relevance to the experience of women. Unlike the male hero, whose power, pride in power, and blindness to vulnerability are both the qualities of his greatness and the cause of his downfall (the concept of hubris is relevant to male heroes only), the female hero is by social decree perpetually aware of her essential vulnerability. It is her obligation to adapt imaginatively to alien and repressive environments, and her ability, not to control, but to transform such environments constitutes her heroism. The male viewer, perceiving the Judith and Holofernes theme from the viewpoint of Holofernes's world, sees only the subversive power of Judith; for the female viewer, the story is a metaphor for the real life of women. Unable to master and dominate openly, women live by their wits, their alertness, and their acumen; and in the real world, the man's world, of which Holofernes's camp is the symbol, Judith/woman who defies its values, strikes down its chief, is always in great danger. Her survival is the measure of her success, and to survive, she must be constantly vigilant. Holofernes has been killed, but there are other guardians of this temple, outside the tent, threatening that survival. Artemisia's Judiths, poised between the death blow they have delivered the patriarch and their potential capture by his lieutenants, driven by danger to the height of their courage and strength, embody the only kind of heroism realistically available to women in a patriarchal world. The female hero is perhaps less exalted than the male, but she at least does not exploit the weak, and as survivor, creative coper, and resourceful protector of alternative values—the values of minorities and underdogs—she may yet speak for a broader segment of humanity. For it is only in patriarchal myth that the underdog hero wins; in the world of women the underdog's triumph is self-realization.

# CHAPTER SIX

## The Allegory of Painting

> You see me holding this shiny mirror which I carry in
> my right hand in place of a scepter. I would thus have
> you know truly that no one can look into this mirror,
> no matter what kind of creature, without achieving
> clear self-knowledge.
> —Lady Reason to Christine de Pizan,
> from the *Cité des Dames*.

THE painting that hangs today in Kensington Palace, Artemisia Gentileschi's *Self-Portrait as the Allegory of Painting* (Color Plate 14 and Fig. 295), may well be her major achievement. The importance of this deceptively modest work of art lies in its audacious claim upon the core of artistic tradition, as a sophisticated commentary upon a central philosophical issue of later Renaissance art theory. Artemisia indicates in the picture, her only preserved self-image, a special personal identification with her profession in terms that were quite literally unavailable to any male artist. Whereas in her individualized treatments of other iconographic themes she was concerned to offer uniquely female interpretations that were alternative to men's versions, in the *Allegory of Painting* she demonstrated not an alternative understanding of a subject, but a fusion of two themes that, under existing conventions, only a female artist could have combined.

The painter who imaginatively entered the stories of Susanna, Lucretia, and Judith as empathizing spectator, charging her interpretations of their lives with an expressive authenticity born of shared female experience while sublimating herself in the identity of the mythic heroine, now depicts herself directly, the subject in her own right. In the *Judith*s she had set her personal stamp in the form of an Artemis bracelet or a passing moon shadow, but here she imprints the fully lighted face with her own features and includes a signature for the first time (among preserved works) since the Uffizi *Judith*, inscribing on the table the simple initials "A. G. F." (*Artemisia Gentileschi fecit*). Yet even here, the artist's own presence is mediated by another iconographic figure. Artemisia presents herself as artist, engaged in the act of painting, accompanied by several, though not all, of the attributes of the female personification of Painting as set forth in Cesare Ripa's *Iconologia*. These include a golden chain around her neck with a pendant mask, which stands for imitation; unruly locks of hair, which

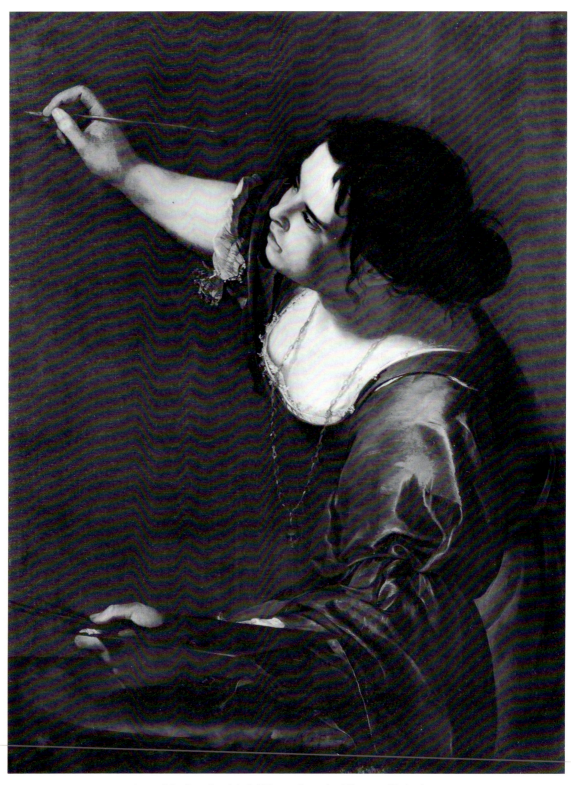

295. Artemisia Gentileschi, *Self-Portrait as the Allegory of Painting*, 1630.
London, Kensington Palace, Collection of Her Majesty the Queen

symbolize the divine frenzy of the artistic temperament; and *drappo cangiante*, garments with changing colors, which allude to the painter's skills.[1]

Gentileschi's decision to conjoin her self-image with the Allegory of Painting may have been prompted by an earlier exercise in a similar vein, for in 1611 a portrait medal commemorating the Bolognese painter Lavinia Fontana was struck (Fig. 296)—the work of Bolognese-Roman artist Felice Antonio Casoni—which shows the artist in profile on the obverse, and on the reverse, an image of a female painter at work whose Ripan attributes (the wild locks of hair, medallion, and bound mouth) clearly identify her as the Allegory of Painting. While the Fontana medal follows numismatic convention in showing a historical individual on the face and an allegorical abstraction on the reverse, it also carries an implied possibility of interpreting Fontana the artist and the Allegory of Painting as overlapping identities, in the fact that both are female.[2] If Artemisia found the medal's iconography suggestive, she nevertheless took the idea one step farther, fusing artist and allegory in a single image to create an aesthetically richer and philosophically more significant application of Ripa's iconography. By joining the types of the artist portrait and the Allegory of Painting, she managed to unite in a single image two themes that male artists had been obliged to treat separately, since by tradition the art of painting was symbolized by an allegorical female figure, and thus only a woman could identify herself with the personification. A brief look at some of the concerns reflected in pictorial treatments of these two themes will shed light upon the dilemma faced by male artists who had to keep them separate. It will also clarify for us Artemisia's own intention in this work and, more generally, her ideas on the art of painting.

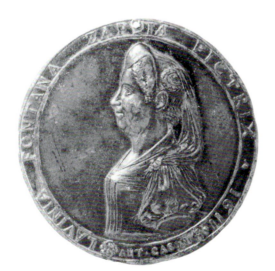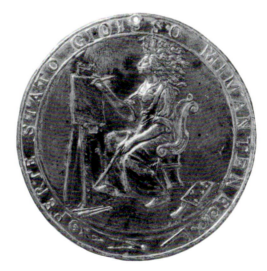

296. Felice Antonio Casoni, *Portrait Medal of Lavinia Fontana,*
*recto* and *verso*, 1611. Imola, Biblioteca

PITTURA, or the allegorical representation of the art of painting as a female figure, made her appearance in Italian art in the first half of the sixteenth century, along with the equally new female personifications of sculpture and architecture. The monument that is likely to have contained the first visual images of the plastic arts as female allegories—Michelangelo's first project for the tomb of Julius II—was never carried to completion, though its wooden model must have set the type for the imagery that shortly followed.[3] Vasari was the first artist to make systematic use of female personifications of the arts. We find them in the decorations of his house at Arezzo (Fig. 297), in those for his house in Florence (Fig. 301), and on the frames of the individual artist portraits that head the chapters of the *Vite*.[4] Vasari's image of Pittura in the Stanza della Fama of his Arezzo house, painted in 1542, is presented—like the concomitant images of *Scultura*, *Architettura*, and *Poesia*—as an isolated female figure, seated and shown in profile, engaged in practicing the art she symbolizes. Vasari's archetypal Pittura is closely echoed in a mid-sixteenth century engraving by Bartolommeo Passarotti representing Pittura (Fig. 298), and she appears in art with increasing frequency in the later sixteenth and seventeenth centuries.[5]

297. Giorgio Vasari, *La Pittura*, 1542. Arezzo, Casa Vasari

298. Bartolommeo Passarotti, *La Pittura*, sixteenth century. New York, The Metropolitan Museum of Art

The sixteenth-century creation of a noble personification for the art of painting constituted a kind of status symbol for that art, indicating the moment of its social and cultural arrival. In the Middle Ages, painting, sculpture, and architecture had not been included among the Liberal Arts. The Trivium (Dialectic, Rhetoric, and Grammar) and Quadrivium (Arithmetic, Geometry, Music, and Astrology) were established as the canonic seven arts in the fifth-century allegorical treatise of Martianus Capella, and in manuscripts and sculptural cycles they were usually depicted as female figures, following the Roman tradition of allegorical personification (although the *artes liberales* themselves were not personified in antiquity).[6] Painting and Sculpture were occasionally included in Liberal Arts cycles on the porches of medieval cathedrals, specifically those of Sens, Laon, and Chartres (north), and on the Florentine Campanile. Invariably in these last instances, however, the personifying figure for Painting or Sculpture is not female but male, even when, as at Laon (Fig. 299), all of the other arts are shown as women.[7] The distinction is significant. These figures do

la Géométrie (13). La quatrième, l'Astronomie (14). Il est à propos de

remarquer que le disque que tient cette statue de l'Astronomie est coupé

299. Laon Cathedral, figures from Liberal Arts cycle, 1210–30. Laon, France. From Viollet-le-Duc, *Dictionaire raisonné*

not represent the Fine Arts, which did not yet exist as a concept, but rather the Mechanical Arts, or what would later be called the crafts.[8] In contrast to their female neighbors, the male figures who stand for the guild-controlled crafts of painting and sculpture are not really personifications; rather, they represent artisans, human practitioners of the activities to which they refer. And this in turn reflects the status of these arts. Painting was not yet conceived as an intellectual or spiritually significant activity, tied as it was to the realm of the material and of manual labor, and thus it was not yet considered worthy of personification as an abstract entity, even though its progress toward that level was indicated by its occasional inclusion in medieval Liberal Arts cycles.[9]

In the fifteenth century, the seven Liberal Arts were raised to ten with the addition of Poetry, Philosophy, and Theology, as can be seen in the *Tarocchi* engravings published in the 1460s, and on Pollaiuolo's Tomb of Sixtus IV in the Vatican of c. 1490, where Poetry was replaced by Perspective. Painting and sculpture were still not included among the Liberal Arts,[10] despite the earlier efforts of Ghiberti, Alberti, and the humanists to secure the position of these arts as noble pursuits.[11] The inferior position of painting in the Quattrocento, both in the intellectual order and in the popular imagination, is documented graphically in the scheme of the *Tarocchi* engravings, with its fixed sequence of levels of being and value.[12] In the hierarchy of the *Tarocchi*, painting is not a Liberal Art; indeed, the Artisan (Fig. 300) appears in the very lowest category, the so-called Conditions of Man, where he is superior only to the Servant. The Conditions of Man, in turn, is separated from the third highest category, the Liberal Arts, by the intermediate class of Apollo and the Nine Muses, who also symbolize the arts, but again, not the visual arts.[13] The structure of the *Tarocchi* vividly illustrates the traditional position of the arts of painting and sculpture in the social order, before they joined the Liberal Arts in the early sixteenth century as a consequence of the successful efforts of Leonardo da Vinci and Michelangelo to elevate them from manual to intellectual activities.

Leonardo's famous argument for the inclusion of painting (though not sculpture) among the Liberal Arts on account of its genesis in the imagination need not be recounted here.[14] Less familiar is one practical result of the acceptance of Leonardo's point of view: only when the art of painting was understood to involve inspiration and to result in a higher order of creation than the craftsman's product did it become appropriate to symbolize the art with an allegorical figure. It must remain an open question how female personifications originally came into being,[15] yet on an expressive level a female personification for Pittura could usefully signal, through the very unusualness of her connection with an activity largely practiced by men, that she stood for Art, an abstract essence superior to the existence of mere artists. Thus she could assist in conveying the concept that art was separate from the manual labor connected with its making.

The pictorial elevation of the position of art above that of individual artists held

300. Tarocchi Engravings, The Ranks and
Conditions of Man: *The Artisan*, E Series,
1460s. Washington, D.C.,
National Gallery of Art

immediate advantages for artists themselves who, in enlightened self-interest, sought
to raise the status of their profession. As Charles de Tolnay has pointed out,[16] the
theoretical separation between the fine and the mechanical arts during the Renais-
sance was intimately bound up with the social separation between artist and artisan.
Anthony Blunt's classic account extensively describes both the social problems posed
for the later sixteenth-century Florentine artist by the association with manual arts
that still attached to him—despite the personal attainments of artists like Leonardo,
Michelangelo, and Titian—and the theoretical defenses developed by artists to com-
bat this stigma.[17] Similarly, Nikolaus Pevsner has characterized the official formation
of the Florentine Academy in 1563 as the outcome of a series of efforts by artists to
raise their own social status by creating a new organization that would effectively free
them from their dependence on individual guilds, and from an essentially medieval
system that still lingered in Florence.[18] The inevitable consequence of these concerns
and efforts—an aspect that has received somewhat less focussed art-historical atten-
tion—was that art itself was drawn into the service of propaganda, for the greater
glory not of God, but of art and artists.

   It was surely for this purpose that, about the time the Academy was founded,
Vasari created a full-blown Allegory of the Arts in the painted decoration for the *Sala*

301. Giorgio Vasari, *Sala della Fama*, 1560s. Florence, Casa Vasari

*di Fama* in his house in Florence. In this cycle, Vasari alternated personifications of the arts with narrative scenes from the life of Apelles, and added a row of portraits of famous painters along the tops of the walls (Fig. 301).[19] The campaign to elevate the status of art was extended to Rome, where a counterpart for Vasari's cycle can be seen in the residence of Federico Zuccaro, who was the principal founder of the Accademia di San Luca, the institutional successor to the Florentine Academy. Zuccaro's ceiling fresco of 1598 in the Palazzo Zuccaro depicting the Apotheosis of the Artist (Fig. 302) presents an idealized male artist accompanied by Athena and Apollo, the protectors of the arts, who also serve here to sustain the allegorical mode.[20] The spreading effort to propagandize on behalf of the elevated status of art paralleled and sometimes preceded the foundation of art academies, a phenomenon exemplified in a painting by Hans von Aachen, *Athena Introducing Pittura to the Liberal Arts*, (Fig. 303), executed in Cologne around the turn of the seventeenth century.[21] In this work, as in the Italian examples, the glorification of art is coupled with enhancement of the social position of the artist through the use of personifications, generally female, to set the narrative on an ideal plane.

Once created and made popular through pictorial imagery, the female personification of Painting could assert, through her depiction alongside other Liberal Arts

302. Federico Zuccaro, *Apotheosis of the Artist*, 1598.
Rome, Palazzo Zuccaro, ceiling

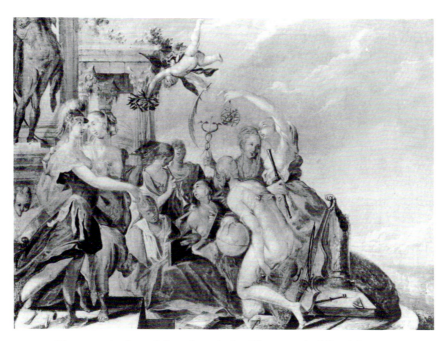

303. Hans·von Aachen, *Athena Introducing Pittura to the Liberal Arts*, c. 1600.
Brussels, collection of Mrs. Sonia Gilbert

personifications, the equal status of the art of painting with the traditional *artes*—
most especially with Poetry (Fig. 304), with whom writers and theorists since Aris-
totle and Horace had linked her. Rensselaer Lee has provided the classic exposition
of the history of Painting and Poetry as sister arts, tracing this concept from their
rhetorical comparison in antiquity, reflected in the ancient saying that painting is
mute poetry, and poetry a speaking picture, and in Horace's famous simile, *ut pictura
poesis* ("as in painting, so in poetry").[22] This formulation was invoked in the Renais-
sance by theorists such as Dolce and Lomazzo, not merely as poetic metaphor, but to
advance Painting's claim to be counted among the Liberal Arts. The claim's validity
was given doctrinal reinforcement through detailed exposition of the parallel con-
cerns of Painting and Poetry—topics borrowed from ancient literary theory, which
were to constitute "the humanistic theory of painting": imitation of nature, inven-
tion, expression, decorum.[23] The extended art-historical consequences of Painting's
raid on Poetry's theory are a story separate from ours, yet the visual reflection of their
asserted sisterhood in the sixteenth and seventeenth centuries (which may be seen in
Francesco Furini's *Pittura and Poesia* [Fig. 304] and in images of the Allegory of
Painting with a bound mouth—like mute poetry—draped with the mask of Imitation
[Fig. 305]), represents another prevalent use of the female allegory to elevate the art
of painting.[24]

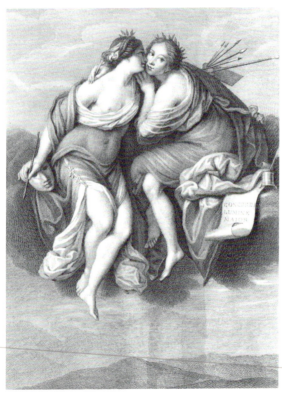

304. Engraving after painting by Francesco Furini,
*Pittura and Poesia*. 1626. Florence, Uffizi, from
Marco Lastri, *Etruria Pittrice*, Florence, 1791.

305. Marco Boschini, *Allegory of
Painting*, engraved frontispiece to
"Ricche Minere della Pittura
Veneziana," in Marco Boschini,
*La Carta del Navegar Pittoresco*.

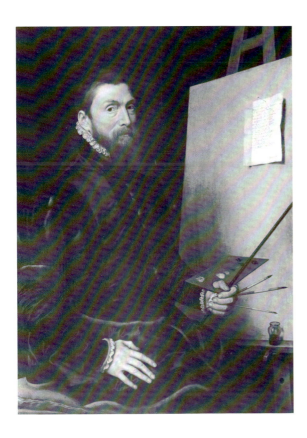

306. Antonio Moro, *Self-Portrait*, 1558. Florence, Uffizi

ANOTHER mode of propagandizing for the status of art, and the second thematic tradition we shall examine, was self-portraiture in which the artist's personal status as a gentleman was emphasized. Self-portraits such as that by Antonio Moro in the Uffizi (Fig. 306), in which the artist stands before his easel holding palette, brushes, and mahlstick, yet with the menial implications of these tools offset by his fine clothes and by the attachment to the blank canvas of a poem written in Greek, were clearly intended to place the painter among the learned and to differentiate him from the mere artisan.[25] An even more pointed expression of the social prestige of the artist can be found in the numerous sixteenth- and seventeenth-century self-portraits that depict the artist wearing a golden chain, a reminder of the rank conferred upon him by a ruler. Perhaps the noblest example of this genre is Titian's *Self-Portrait* of c. 1550 in Berlin (Fig. 307), which shows the painter wearing the tokens of rank given him twice by the Emperor Charles V.[26] Such an expression of the social exchange between ruler and artist, and of their comparable prestige, had as its original prototype the relationship between Alexander the Great and Apelles, symbolized in the story of Alexander's giving Campaspe, the king's favorite mistress and the painter's model, to the artist. This legend became not only a popular theme in its own right in Renaissance art, but also a metaphor for the exalted status of painting, a development illustrated in a print designed by the seventeenth-century French artist Sebastien Bourdon (Fig. 308) in

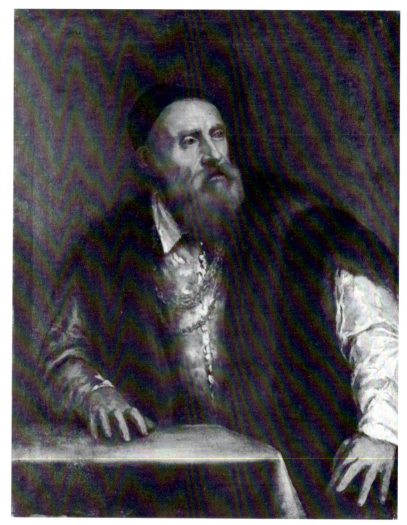

307. Titian, *Self-Portrait*, c. 1550. Berlin-Dahlem, Staatliche Museen,
Preussicher Kulturbesitz, Gemäldegalerie

which the Apelles and Alexander theme is used to symbolize the art of painting, as its label PICTURA makes clear.[27]

These few examples must stand for many others to demonstrate the propagation in the Renaissance of the two modes of expressing the nobility of the art of painting and the dignity of the artist. Unfortunately for artists, however, each of the modes carried certain inherent disadvantages. In the first place, indirect allegorical expression, whether through the personification of Pittura or the legend of Apelles, did not permit the painter to enhance his own personal status directly by the image he had created unless, like Vasari or Zuccaro, he could place it on the walls of his own house. On the other hand, a self-portrait that included a badge of social distinction like the golden chain did not make immediately clear that the sitter was an artist unless he was already famous enough to be recognized on sight, since other kinds of noblemen were

308. Sebastien Bourdon,
*Apelles Painting Campaspe*,
labeled *Pictura*, engraving,
seventeenth century

awarded golden chains and medallions by princes and rulers.[28] Yet if the artist resorted
to including studio paraphernalia in the picture, he risked evoking the very associa-
tion with manual labor that he sought to escape, no matter how fine his clothes; and
the finer the clothes, the more out of place he looked in the studio, as a Northern
example amusingly reveals (Fig. 309).[29] In short, whereas the inclusion of artists' at-
tributes tended to undermine the message that art was a noble occupation, the use of
an allegorical personification tended to exclude the individual artist.[30]

Baccio Bandinelli stands out in the sixteenth century as one artist who was able
effectively to convert the image of the artist's studio into a metaphor for art itself in
its higher, unmechanical aspects. The engraving of 1531 by Agostino Veneziano of
Bandinelli's "academy" (Fig. 310), and a counterpart engraved some twenty years later
by Aenea Vico, are both presumed to follow Bandinelli's own designs. These prints
illustrate yet another way in which the artist might attest the noble and intellectual
character of his profession: by showing the workshop as a place where the arts were
debated and compared as well as practiced.[31] This idea is expanded upon in an early
seventeenth-century engraving by P. F. Alberti that depicts an academy of painters,
as the inscription states (Fig. 311), whose specific groupings and spirit of analytical
discourse intentionally recall Raphael's *School of Athens*.[32] That august association can
only have boosted the image of the arts, yet in both these examples the connection of
the artist-author with the academy he has depicted remains tenuous, depending for

309. J. C. Droochsloot, *Self-Portrait in the Studio*, 1630.
Mâcon, Musée Municipal des Beaux-Arts

310. Agostino Veneziano, *Baccio Bandinelli's "Academy" in Rome*,
engraving, 1531

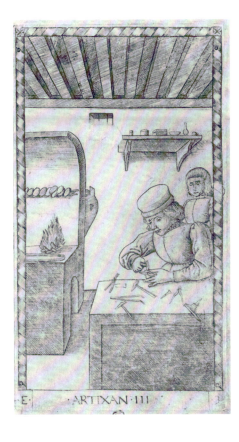

300. Tarocchi Engravings, The Ranks and
Conditions of Man: *The Artisan*, E Series,
1460s. Washington, D.C.,
National Gallery of Art

immediate advantages for artists themselves who, in enlightened self-interest, sought
to raise the status of their profession. As Charles de Tolnay has pointed out,[16] the
theoretical separation between the fine and the mechanical arts during the Renais-
sance was intimately bound up with the social separation between artist and artisan.
Anthony Blunt's classic account extensively describes both the social problems posed
for the later sixteenth-century Florentine artist by the association with manual arts
that still attached to him—despite the personal attainments of artists like Leonardo,
Michelangelo, and Titian—and the theoretical defenses developed by artists to com-
bat this stigma.[17] Similarly, Nikolaus Pevsner has characterized the official formation
of the Florentine Academy in 1563 as the outcome of a series of efforts by artists to
raise their own social status by creating a new organization that would effectively free
them from their dependence on individual guilds, and from an essentially medieval
system that still lingered in Florence.[18] The inevitable consequence of these concerns
and efforts—an aspect that has received somewhat less focussed art-historical atten-
tion—was that art itself was drawn into the service of propaganda, for the greater
glory not of God, but of art and artists.

It was surely for this purpose that, about the time the Academy was founded,
Vasari created a full-blown Allegory of the Arts in the painted decoration for the *Sala*

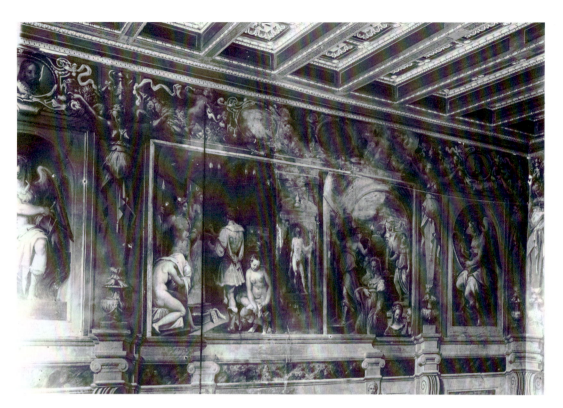

301. Giorgio Vasari, *Sala della Fama*, 1560s. Florence, Casa Vasari

*di Fama* in his house in Florence. In this cycle, Vasari alternated personifications of the arts with narrative scenes from the life of Apelles, and added a row of portraits of famous painters along the tops of the walls (Fig. 301).[19] The campaign to elevate the status of art was extended to Rome, where a counterpart for Vasari's cycle can be seen in the residence of Federico Zuccaro, who was the principal founder of the Accademia di San Luca, the institutional successor to the Florentine Academy. Zuccaro's ceiling fresco of 1598 in the Palazzo Zuccaro depicting the Apotheosis of the Artist (Fig. 302) presents an idealized male artist accompanied by Athena and Apollo, the protectors of the arts, who also serve here to sustain the allegorical mode.[20] The spreading effort to propagandize on behalf of the elevated status of art paralleled and sometimes preceded the foundation of art academies, a phenomenon exemplified in a painting by Hans von Aachen, *Athena Introducing Pittura to the Liberal Arts*, (Fig. 303), executed in Cologne around the turn of the seventeenth century.[21] In this work, as in the Italian examples, the glorification of art is coupled with enhancement of the social position of the artist through the use of personifications, generally female, to set the narrative on an ideal plane.

Once created and made popular through pictorial imagery, the female personification of Painting could assert, through her depiction alongside other Liberal Arts

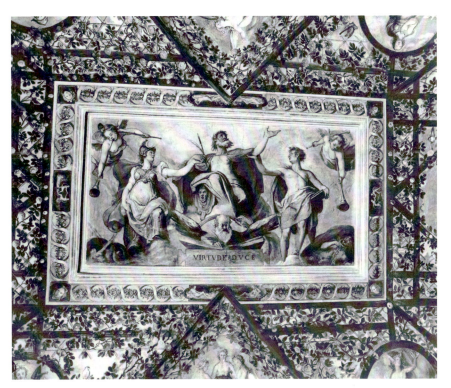

302. Federico Zuccaro, *Apotheosis of the Artist*, 1598.
Rome, Palazzo Zuccaro, ceiling

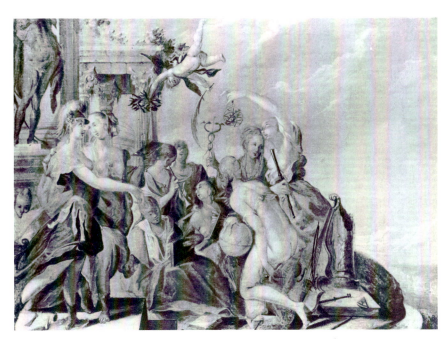

303. Hans-von Aachen, *Athena Introducing Pittura to the Liberal Arts*, c. 1600.
Brussels, collection of Mrs. Sonia Gilbert

personifications, the equal status of the art of painting with the traditional *artes*—most especially with Poetry (Fig. 304), with whom writers and theorists since Aristotle and Horace had linked her. Rensselaer Lee has provided the classic exposition of the history of Painting and Poetry as sister arts, tracing this concept from their rhetorical comparison in antiquity, reflected in the ancient saying that painting is mute poetry, and poetry a speaking picture, and in Horace's famous simile, *ut pictura poesis* ("as in painting, so in poetry").[22] This formulation was invoked in the Renaissance by theorists such as Dolce and Lomazzo, not merely as poetic metaphor, but to advance Painting's claim to be counted among the Liberal Arts. The claim's validity was given doctrinal reinforcement through detailed exposition of the parallel concerns of Painting and Poetry—topics borrowed from ancient literary theory, which were to constitute "the humanistic theory of painting": imitation of nature, invention, expression, decorum.[23] The extended art-historical consequences of Painting's raid on Poetry's theory are a story separate from ours, yet the visual reflection of their asserted sisterhood in the sixteenth and seventeenth centuries (which may be seen in Francesco Furini's *Pittura and Poesia* [Fig. 304] and in images of the Allegory of Painting with a bound mouth—like mute poetry—draped with the mask of Imitation [Fig. 305]), represents another prevalent use of the female allegory to elevate the art of painting.[24]

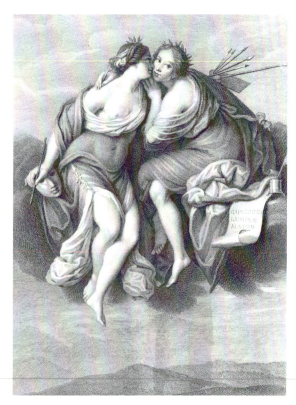

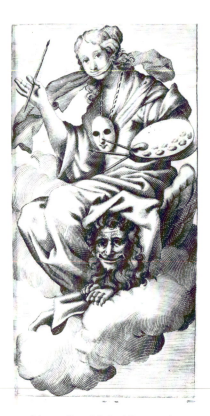

304. Engraving after painting by Francesco Furini, *Pittura and Poesia*. 1626. Florence, Uffizi, from Marco Lastri, *Etruria Pittrice*, Florence, 1791.

305. Marco Boschini, *Allegory of Painting*, engraved frontispiece to "Ricche Minere della Pittura Veneziana," in Marco Boschini, *La Carta del Navegar Pittoresco*.

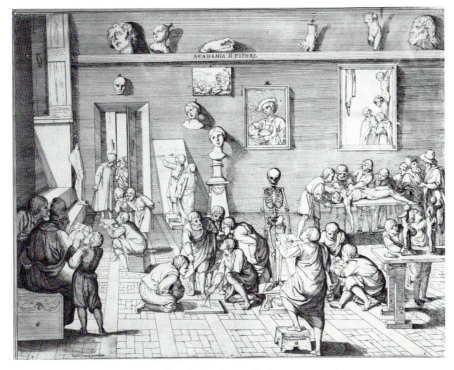

311. P. F. Alberti, *Academy of Painters*, engraving,
early seventeenth century

the Bandinelli upon the inscription alone. It is in some measure indicative of a lingering problem for the artist who sought to associate himself with the rising status of his profession that one of the culminating examples of this workshop/academy tradition, Pietro Testa's *Liceo della pittura* engraving of c. 1638 (Fig. 312), contains a poignant personal emblem, a snake and stone in the lower right corner, to stand for Testa himself, who as a living artist had no place in the ensemble of ideal characters he had created.[33]

Ironically, then, although the idea of painting as a noble pursuit had acute personal relevance for every practicing artist of the sixteenth and seventeenth centuries, direct personal identification with the elevated status of art was only possible for the male artist through indirect and sometimes very awkward combinations of attributes. Three more examples may help to confirm this point. In one of several self-portraits that include his golden chain (Fig. 313), Van Dyck displays his trophy with naive pride, at the same time pointing very self-consciously to a giant sunflower. Both attributes symbolize the art of painting, and form a composite expression of the artist's devotion to "his King, to God and to the art of painting."[34] An equally ingenious, if aesthetically deficient, solution was offered by G. D. Cerrini (Fig. 314), who, in a painting of the mid-seventeenth century, combined the Allegory of Painting with a

312. Pietro Testa, *Liceo della pittura*, engraving, early 1640s

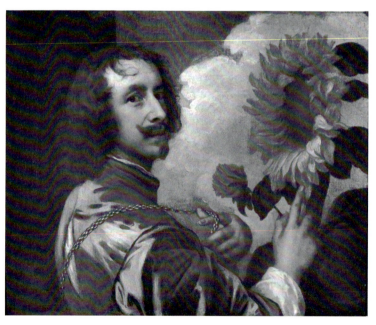

313. Anthony Van Dyck, *Self-Portrait with Sunflower*, 1633–35.
By kind permission of His Grace, The Duke of Westminster

314. G. D. Cerrini, *Allegory of Painting with Self-Portrait of the Artist*, mid-seventeenth century. Bologna, Pinacoteca Nazionale

self-image by having the female personification hold forth a portrait of the artist.[35] When, in his *Self-Portrait* of 1650 (Fig. 315), Poussin reversed this arrangement, positioning himself as the living character in the center and alluding to Pittura in a painted image behind,[36] he created what is surely a superior work of art, and a more naturalistically plausible combination of artist and allegory; yet these entities still, of necessity remain separate.

The prevalence of combined images such as these illustrates a continuing desire on the part of artists to link themselves with the elevated concept of art, yet in the very period when it mattered most, the allegorical conventions employed to promote that concept proved resistant to the inclusion of the living artist. Self-portraits might contain allusions to art; allegories of the arts might stand next to artists' portraits; Apelles, Minerva, or Poesia might be invoked; yet all possible forms of joining the two components were inevitably elliptical. And although elliptical or proliferated forms of expression, mixing ideal and real, were compatible with the tastes of *maniera* artists, the general preference in the seventeenth century for rendering complex abstract ideas sensate and clear through simple, cohesive images invited a more direct and naturalistic means of combining *pittore* with Pittura.

315. Nicolas Poussin,
*Self-Portrait*, 1650.
Paris, Louvre

IN THESE terms, Artemisia Gentileschi's *Self-Portrait as Pittura* may be considered the prime Baroque version of the theme of the Allegory of Painting. In Artemisia's radically simplified picture, by contrast with every other example we have discussed, the artist emerges forcefully as the living embodiment of the allegory. Painter, model, and concept are one and the same, and the environment of the artist's studio is evoked by the barest of means. Unself-consciously engaged in the act of painting, the artist appears oblivious of the golden chain that has slipped aside on her breast, as if to indicate that the chain is hers by natural right, an attribute of the personification whose identity she may rightfully claim. Similarly, the unruly locks of her hair are more than a symbolic reference to inspiration, as Ripa had it;[37] they suggest, in this context of concrete naturalism, the painter's guileless indifference to personal appearance while caught up in the heat of work, an attitude that contrasts sharply with the efforts of contemporary male artists to look like gentlemen in their self-portraits. Because she was a woman, Artemisia was in a position to take creative advantage of the allegorical tradition—indeed, to restore the ancient vitality that allegory was meant to have[38]—and to make a statement that was at once less pompous and more profound.

Writers on Artemisia's *Self-Portrait* have suggested that the picture's subject, dependent as it is upon Ripa, must have been dictated to the artist by a learned patron like Cassiano dal Pozzo.[39] There is no evidence, however, that the painting ever joined Cassiano's collection, nor, despite the fact that she promised to give him the work, does their correspondence suggest that he specified its theme (see above, p. 85). We must resist the notion that a painting that draws upon Ripa's *Iconologia* necessarily displays a scholar's erudition, for while Ripa composed the *Iconologia* as an academician interested in the complex literary and artistic strands that made up the composite images, he drew his imagery from a living artistic tradition.[40] Many artists subsequently consulted the book, but quite frequently, one presumes, for the purpose of creating broadly comprehensible images, and not for the sake of arcane or erudite allusions. Moreover, the first edition of Ripa's *Iconologia* was published in the year that Artemisia Gentileschi was born; the third edition appeared in Rome in 1603, accompanied by its first set of illustrations, which were largely designed by Cavaliere Cesari d'Arpino, a Gentileschi family friend (see above, p. 14). As an artist, Artemisia must have grown up with this work like mother's milk, and would surely have studied its texts and images attentively. In creating her *Allegory of Painting*, however, Artemisia worked directly from Ripa's text, since no images of Pittura were provided in the early illustrated editions of the *Iconologia*.[41]

A close study of Artemisia's painting in relation to Ripa's description of Pittura reveals that the artist made purposeful and selective use of her text, extracting from it for emphasis precisely those features which were of greatest philosophical interest to artists. Ripa had called, for example, for Pittura's dress to be of *drappo cangiante*, a phrase that can be traced to Lomazzo, who in his treatise of 1584 describes it as a virtuoso technique practiced by painters of his day to demonstrate their skill in handling color. To play the changes, Lomazzo explains, an artist painted a passage of cloth with one color in the lights and a different hue in the shadows.[42] As Artemisia runs magnificent violets and greens through the cloth of the sleeves (Color Plate 14), she demonstrates a knowledge of this technique, as well as an ability to handle color with skill and flourish. Yet more subtly, she develops rich, carefully adjusted color relationships throughout the painting, sustaining the dominant red-brown of the background in the bodice and skirt, harmoniously balanced with the dark green of the blouse and the blue-violet highlights of the sleeves. With great precision, she modulates flesh to white highlights to establish spatial planes, and she recapitulates the color scheme of the painting in the five patches of color on her palette.

The color changes employed in the *Self-Portrait* are not simply embellishments added to make it conform to an iconographic specification; rather, they reflect Artemisia's use of Ripa's suggestive phrase as an opportunity to display, through her own interest in and command of color, the technical skill appropriate to Pittura herself. The painter also takes a firm position on a continuing controversy of art theory, for the importance of color in this picture and in Gentileschi's art in general, no less than

her reflection of Lomazzo's theories here, suggests her alignment with the partisans of *colore* over *disegno*. The heated sixteenth-century debate over whether color or design was of greater importance in art was given new impetus around the time the Accademia di San Luca was opened in 1593, when Federico Zuccaro didactically promoted *disegno* in opposition to Lomazzo's theoretical advocacy of *colore*.[43] Artemisia, like Caravaggio, was evidently averse to academic discourse (which tended to favor design), and it is possible that she was castigated as he had been (both shortsightedly) for deficiency in *disegno*. Yet if Caravaggio was regarded by academicians as a colorist chiefly by default, on account of his naturalism, Gentileschi's devotion to the expressive and aesthetic properties of color, manifested in all of her works, was made quite explicit in this painting.[44]

In a theoretical vein quite contrary to Artemisia's expressive emphasis, Ripa had stipulated that Pittura wear a long dress covering her feet, in order to establish a metaphorical relationship between the covered female body and the ideal proportions of painting, set down in the underdrawing but disguised in the final work, when the color—the clothing, as it were—is added. In this formulation, Ripa followed a set analogy between female beauty and perfection of proportions that frequently appeared in sixteenth-century Italian theoretical treatises, in which, as Elizabeth Cropper has shown, female beauty served as a metaphor for the perfection of urns, columns, and even art itself.[45] Gentileschi, however, disregarded this focus upon *disegno* and proportionate anatomical form as the essence of painting. Pointedly ignoring Ripa's suggestion that she convert the female image into a vehicle for a rhetorical conceit, she omitted the long skirt and feet altogether, placing herself in a foreshortened, transitory, and active pose that prevents the viewer's discovering conventional beauty, symmetry, proportion, or even the arched eyebrows that Ripa had emphatically specified. With good aesthetic judgment as well as self-respect, Artemisia also saw fit to eliminate the cloth binding the mouth of Pittura that is found in many images of her (Fig. 305), which is also called for by Ripa (a specification preserved in the illustrated editions [Fig. 316]), in keeping with the antique description of painting as mute poetry.[46]

Throughout his entry on Pittura, Ripa carefully interweaves the themes of the pure intellectual beauty of painting and the physical beauty of women, in order to reinforce the cerebral, and therefore noble, character of the art of painting. In this, he adopts the device of the Mannerist painters, namely, the creation of a formula by which women's bodies stand for men's minds. Women, in this conception, are not perceived as sharing in the cerebral bounty of the art they symbolize. The female personification is shown with a gagged mouth, ostensibly to express the elevated association between painting and poetry, yet the image conveys a clear subliminal message of hostility to female speech, and thus to independent female thought. The misogynist basis of the lofty theme sounded by Ripa is revealed in a satirical Italian print of the seventeenth century, a woodcut (Fig. 317) illustrating a popular maxim: "Women

316. "Peinture," from Cesare Ripa, *Iconologia* (Paris, 1644)

317. G. M. Mitelli, satirical woodcut, seventeenth century. Milan, Bertarelli Collection

often have long dresses and short intellects."[47] This particular piece of popular misogyny, which can be traced as far back as the Rig Veda ("The mind of woman brooks not discipline. Her intellect has little weight"[48]), found expression in countless Renaissance treatises and commentaries (see Chapter 2, especially pp. 174 ff.). The masculine superstition that women are weaker in reason than men has survived, in the Gentileschi literature alone, down to Longhi's appraisal of 1916 that she was "a first-rate painter technically, but intellectually inferior, even to her father."[49] Although contemporary judgments of Artemisia's intellectual capacities have not survived, we find in the artist's correspondence occasional expressions of a heightened sensitivity to conventional views of woman's ability. Writing in 1649 to her Sicilian patron Don Antonio Ruffo, she described to him some of her forthcoming paintings, asserting almost defiantly: "And I will show your Most Illustrious Lordship what a woman can do" (Appendix A, no. 21). In another letter written to Ruffo in the same year, Artemisia remarked expansively, "You will find the spirit of Caesar in this soul of a woman" (no. 24). The claim boldly transcends sex differences, for she applies to herself a literary formula that was typically used to characterize important men in the Renaissance, in which the contemporary figure is compared to Alexander the Great, Caesar, or another antique luminary. Ambition was seldom made of sterner stuff.

As if to combat the misogynist stereotype of woman as unintellectual, Gentileschi in her *Self-Portrait* depicts herself, the artist, not as a coquettish mannequin, but as intensely and thoughtfully absorbed in her work. She indicates through her pose as well a reasoned response to the central philosophical issue raised in Ripa's entry on Pittura: the nature of the art of painting. While insisting that painting requires the steady application of intellect, Ripa also concedes that the art is rooted in material things, especially in comparison with poetry, since the painter is involved with brushes and pigments and with the visible effects of nature. In this, Ripa reflects the thinking of later sixteenth-century theorists such as Lomazzo and Zuccaro, who emphasize the distinction between an idea in the mind of the artist, the *disegno interno*, and its material realization, the *disegno esterno*.[50] It is a distinction that provides a theoretical counterpart for the social separation between artist and artisan, with art itself now exclusively identified with fine art and subdivided into its higher (intellectual) and lower (manual) aspects. Pietro Testa, Artemisia's contemporary who shared her interest in Ripa's *Iconologia* as a source of ideas rather than as a catalogue of attributes, introduced this distinction into his *Liceo* in a form that helps to clarify Artemisia's echo of it in her painting. Theory and Practice, personifications that entered Ripa's *Iconologia* in an edition of 1618, were included in the *Liceo* at the suggestion of Testa's friend, academician Fulvio Mariotelli, who was also a friend of Ripa.[51] Following Mariotelli's idea, Ripa presented *Prattica* as bending over, directing her compass toward the ground, rooted as she is in terrestrial things, while *Teoria* looks and points her compass upward, deriving inspiration from the heavens, the source of eternal superior guidance (Figs. 318 and 319). When Testa inserted the pair into his *Liceo*, on the far left and right (Fig. 312), he did not preserve Mariotelli's hierarchic relationship between Theory and Practice (pessimistically, he conceived Practice as blind and Theory as bound), but he did retain the upward and downward orientation of the figures.[52]

Without recourse to complex personification, Artemisia evokes the contrast between Theory and Practice in her *Self-Portrait*. She has posed herself with one arm raised upward, the hand stretched toward the top of the canvas, suggesting the higher, ideal aspirations of painting, and with the other arm resting firmly on a table, the hand holding the brushes and palette, which are the physical materials of painting. Yet unlike her Mannerist predecessors and her academic contemporary, Testa, Gentileschi does not separate, but integrates the concepts to which she alludes.[53] The two arms form one continuous arc in the composition, and the plane of the palette and the line of the brush are precisely parallel. Art and craft, concept and execution, inner vision and outer manifestation, all are equally essential to painting, this work asserts, and they are joined in the mind of the artist, here the head of Artemisia Gentileschi (Color Plate 15), which intersects the curve of the arms and, as the compositional fulcrum, provides the point of resolution for the two aspects of painting.

318. "Theory," from Cesare Ripa, *Iconologia* (Padua, 1625)

319. "Practice," from Cesare Ripa, *Iconologia* (Padua, 1625)

In defining art as an integrated whole, Gentileschi offers a revision of the lingering concept of the artistic temperament as melancholic, a concept preserved by Ripa in his entry on Pittura in order to sustain its intellectual associations.[54] Melancholy, the temperament associated with sensitivity, meditative absorption, solitude, and genius, was claimed by and for numerous Renaissance artists for its "snob value," as Wittkower has observed.[55] We see the melancholic keynote offered as a synonym for artistic genius in Dürer's *Melencolia I* (Fig. 320), whose central figure is paralyzed by excessive thought; in the brooding, solitary figure who secondarily represents Michelangelo in Raphael's *School of Athens*; and in Testa's Theory and Practice, who are mutually blocked from fulfilling a single unified function. Annibale Carracci's late *Self-Portrait on an Easel* (Fig. 321) offers an extraordinary, moving example of the artist's self-presentation in melancholic isolation, combined with the use of the artist's studio as a metaphor for art.[56] Although the despair and isolation expressed in Annibale's *Self-Portrait* are likely to reflect genuine feeling rather than aesthetic posturing, this work too partakes of the tradition of the artist as perhaps blocked, but nevertheless ennobled by his melancholia. In direct and probably conscious opposition to this tradition, Artemisia depicts herself, the living artist, acting freely and without inhibition—her forward, initiating motion preserved forever in a bold Baroque

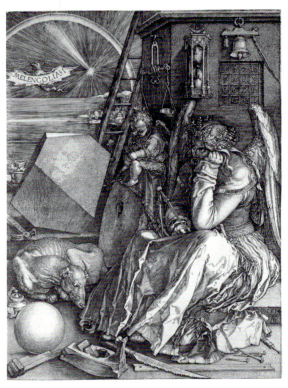

320. Albrecht Dürer, engraving, *Melencolia I*,
1514. Washington, D.C.,
National Gallery of Art

321. Annibale Carracci, *Self-Portrait on an
Easel*, c. 1604. Leningrad, Hermitage

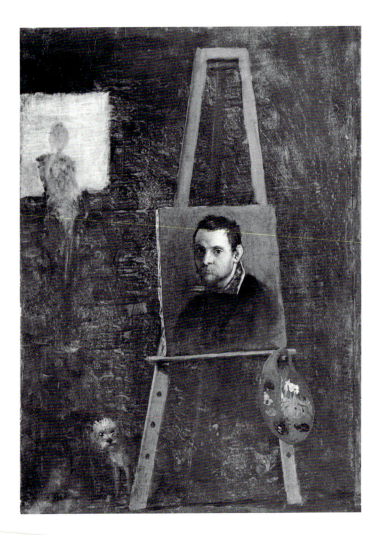

diagonal. She thereby suggests that the worth of the art of painting derives neither from a precious temperament nor from theoretical pretensions, but from the simple business of the artist doing her work, and further, that in this unimpeded and unself-conscious performance, theoretical obstacles evaporate.

THE image that Artemisia created of herself is not as simple as it appears. It was not even simple to create, since in order to paint herself in near-profile, she would have had to use a double mirror.[57] But whether or not we stop to consider *how* she managed to paint herself in profile, we nevertheless recognize that the image of the artist in the act of painting (or rather, about to begin a painting) is a faithful reflection of the actual means by which this picture was created: the artist looks into the light, bending around the canvas to see her model, which is her own reflection in a mirror. All self-portraits require the aid of mirrors, of course, yet we are made more conscious of Artemisia's use of the mirror by the profile self-image, and by our perpetual confrontation by the artist's searching gaze at her model, implicitly herself. This highly calculated self-image—an image, we must keep in mind, that has been announced by the artist to be identical with the art of painting—is thus not only a comment on the value of the artist's work as process rather than product; it also tells us something about Artemisia's idea of artistic inspiration, and her thoughts on the doctrine of imitation.

The ancient association between mirrors and truth, encapsulated in the expression that "the mirror does not lie," was a popular concept in Baroque art. The *topos* of the mirror—which faithfully reflects nature—as a source of enlightenment could even become the subject of a painting, as we see in Pierfrancesco Mola's *Pedagogue* (Fig. 322), in which the teacher holds up a mirror for his pupils to look into. Mola's painting reflects, and may illustrate, the dictum of Socrates to his pupils, that they should look often at themselves in mirrors, in keeping with the famous inscription on the Temple of Apollo at Delphi, *Gnothi Seauton*," know thyself." Socrates's teaching, as interpreted by his biographer Diogenes Laertius, was directed toward moral improvement, for he was said to advise his disciples to look into the mirror to "make themselves worthy of their beauty, or if they were ugly to compensate and to cover their imperfection through education."[58] This understanding of the mirror as behavioral corrective is found in Ripa's definition: "The act of looking at oneself in the mirror signifies understanding of the self, since one cannot govern one's own actions if he does not recognize his own defects."[59] Mola's painting similarly emphasizes the mirror as a source of moral inspiration for the rapt pupils, under the stimulus of their teacher, for while they presumably see their own true images in the glass, reflected for the viewer of the painting is a hand that echoes the rising, guiding motion of the teacher's right hand, presiding over and directing the group.

This moral interpretation of the philosophical precept "know thyself" has an affinity with the thinking of the academic classicists of art, who held that the successful imitation of nature depended upon the artist's improvement of it. Aristotle's influ-

322. Pier Francesco Mola,
*Pedagogue (Socrates Teaching)*,
mid-seventeenth century.
Lugano, Museo Civico

ential dictum, that the artist's task is to present nature as it ought to be rather than as it is, was dutifully repeated by many sixteenth- and seventeenth-century theorists, from Lomazzo to Bellori, who shared intensely the antique view, more particularly found in Platonic thought, that art surpassed nature through its engagement with ideas.[60] However, the Platonic concept of the primacy of ideas in art was, as Panofsky has observed, fundamentally irreconcilable with the artist's other task, the careful rendering of sensory appearances in the material world.[61] Thus, although the mirror might be understood as an aid to self-improvement (or—as Ripa proposed in another passage—as a medium for the creative invention of images not seen in nature[62]), the fact remains that ordinary mirrors faithfully reflect the visual data before them, which is why they were employed and recommended by Brunelleschi, Alberti, Jan van Eyck, Leonardo, and a host of other artists. It was in both these senses—contradictory though they may be—that the mirror came to be associated with *veritas*, as an implement for the revelation of both optical and philosophical truth.[63]

Artemisia Gentileschi, heir both to the practical studio use of the mirror as a visualizing tool and to the symbolic tradition associating mirrors with *veritas* and self-

knowledge, offered in her *Self-Portrait as the Allegory of Painting* a distinct statement on the nature of what the mirror reveals. A close reading of the painting suggests that in this respect, as in other respects we have already discussed, the painter was intent upon distinguishing her own ideas from the theories on art, nature, and imitation that were propounded by the academicians of her day. A brief review of the thinking of the latter will assist our understanding of Artemisia's difference.

The greatest asset that the academic painter could claim was his privileged vision of the mundane world from a higher vantage point. *Disegno interno*—which meant, in Zuccaro's intricate theological amplification, *segno di dio in noi* ("sign of God in ourselves")[64]—represented the divinely inspired concept or idea that guided the transformation of the natural world into art. Art itself, the *disegno esterno*, though elevated above nature, was nevertheless one level beneath the divine incorporeal idea that floated sublimely above any specific physical and material form that it might happen to take in a painting or drawing. However, inasmuch as (in Ripa's words) "the good painter is in continuous thought on the imitation of nature," the bind for the artist was his need simultaneously to be engaged with and to keep his distance from the subject of his art, the subject *matter*, literally, which was as much a part of physical nature as the brushes and paints that were his *materials*. It will be no surprise that the academician's method of holding nature (and matter) at a distance while still acknowledging its importance was to personify it: for Ripa, for Vasari, and even for the Seicento theorist Vincenzo Carducho, Nature was emblematized as the multi-breasted Diana of Ephesus, symbol to the Renaissance of natural abundance and all earthly things. In the Apelles scene in his Florentine house (Fig. 301), Vasari included an image of Diana of Ephesus in the right chamber, the realm of Nature (more clearly visible in a preparatory drawing Fig. 323), an image that is symbolically "captured"

323. Giorgio Vasari, *Studio of the Painter*, drawing, 1560s. Florence, Uffizi

by the painter Apelles in the left room as he re-creates on his canvas the likeness of the female model before him, and is elevated on the canvas to the chaste, moon-crowned Diana of the hunt—a higher version, both of raw nature (the model) and emblematic raw nature (Diana of Ephesus).[65] Vasari's message is unmistakable: the artist, inspired by an enlightened superior vision, transforms nature into art.

That many seventeenth-century artists were considerably more hospitable to nature in its unimproved state—Ribera, Rembrandt, Velázquez, to name but a few—is due in large measure to Caravaggio's revolutionary challenge to the idealist tradition. No expression of the relation between man and nature could be farther from Vasari's than Caravaggio's *Narcissus* (Fig. 324), which, though not directly about the artistic process, is yet deeply concerned with the form of truth found in a reflected image, and thus has bearing on Artemisia's *Self-Portrait*. In keeping with the myth, Caravaggio's Narcissus looks at his own image reflected in the water and falls in love with it. As recently interpreted by Maurizio Marini, the painting may have been shaped by certain Neoplatonic texts concerning the relationship between Man and Nature, particularly the Hermetic *Poimandres*, where "Man, having seen a form similar to his in nature—reflected in water—fell in love with it and wanted to live with it."[66] Embedded in Caravaggio's construction of the picture is an acknowledgment of a harmonious unity between man and nature, and of their reciprocity, for the open curve formed

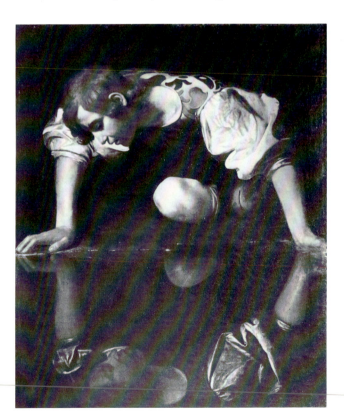

324. Caravaggio(?), *Narcissus*,
c. 1600. Rome, Galleria Nazionale
d'Arte Antica, Palazzo Corsini

by Narcissus's body is supported and completed by its reflection in the water. Staring into the waters of this world, Narcissus sees his own image, caught up in matter. His realization that he cannot possess the object of his love, since it is himself, will lead to his death. Caravaggio's painting, like the myth, can be read in many ways, yet the simple and direct image openly invites our recognition of an unorthodox yet deeply philosophical meaning. Narcissus is granted a self-awareness that runs deeper than ego; protected by innocent ignorance, he is permitted first to love, then gradually to comprehend, his participation in a natural order whose myriad physical forms include his own. The youth's recognition of his own nature as part of Nature is enabled by the reflection in the water, a mirror that reveals the truth. His subsequent death, which is also pictorially evoked in the dark watery reflection, is not here presented as tragic punishment, but as the cyclical complement of life. Narcissus contemplates with understanding, and virtually joins hands with, the image of himself in a Nature that embraces both life and death, and it is this form of self-knowledge that Caravaggio presents in the painting.[67] Caravaggio's inclusive rather than exclusive view of the relation between man and nature was scorned by most of his articulate contemporaries. He was dismissed as "unintellectual" by Bernini and Bellori, and even his defenders— Giustiniani, Baglione, Scannelli—failed to credit him with an ability to invest his naturalistically rendered forms with cognitive or philosophical significance.[68]

The structural resemblance between Artemisia's *Self-Portrait* and Caravaggio's *Narcissus*—seen in the arched arms framing an intensely gazing face—is likely to be more than coincidental. In fact, the visual relationship between these pictures lends support to the idea that the Narcissus legend was understood by Caravaggio and others as metaphorically related to the art of painting. This notion had been voiced by Alberti, who claimed that Narcissus was the inventor of painting (since "What is painting but the act of embracing by means of art the surface of the pool?"); it is implied as well by Marino, who devoted five poems in his *Galeria* (1619) to pictures of Echo or Narcissus; and it has been suggested by later commentators on both the Ovidian legend and Caravaggio's painting.[69] Gentileschi's *Self-Portrait* appears thus to confirm that Caravaggio's *Narcissus* was on one level about art, for it develops explicitly what was implied in the *Narcissus*, offering a meditation on the nature of the art of painting that draws upon a similarly inclusive understanding of the symbiotic relationship between the human, natural, and artistic realms.

The painter is shown imitating nature, which is understood to be identical with herself. Artemisia's invocation of the natural model in this painting is assisted by the terms of female personification, and by conventional Renaissance concepts that parallel art and female beauty. Such an idea was made explicit in other Allegories of Painting, for example that of Domenico Corvi (Fig. 325), in which a lovely female allegory looks into a visible mirror, to draw aesthetic inspiration from her own beauty.[70] Artemisia's self-image differs, however, in that the artist does not present herself as beautiful; rather, as we have seen, she offers an unconventional and rela-

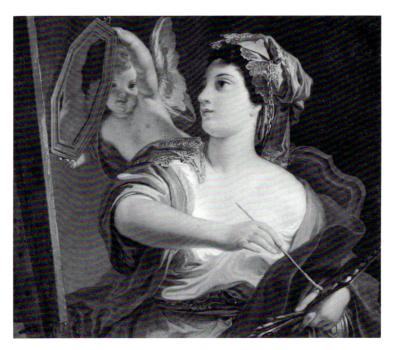

325. Domenico Corvi, *Allegory of Painting*, 1764.
Baltimore, Walters Art Gallery

tively unflattering self-image. The implication is that it is her natural, not "beautiful," self that is her model and source of artistic inspiration. The distinction is significant, for in her insistence upon the naturalistic self-image, the painter reinforces the ancient association between the mirror and Veritas, even as she explicitly disavows the alternative tradition that linked the mirror with Vanitas (a convention heavily dependent upon stereotypes of female vanity).[71] With the aid of the mirror, she asserts, the artist arrives at self-knowledge or wisdom, and in art as in philosophy—as Socrates may indeed have meant—the understanding of self and a truthful vision of nature are the same thing. Artemisia is also assisted by a traditional association deeper and older than that between women and beauty, which is that between women and nature. By contrast to male artists, who cannot be both artist and subject, since they are normally neither paragons of beauty nor identified with nature, thanks to the cultural habit of masculine self-distancing both from the artist's model *and* from nature (see Chapter 4, esp. pp. 258 ff.), Artemisia, as a female artist, is able to limit the depicted image to the unusual aspect of her identity—her role as artistic creator—and to permit the viewer's instincts of association to supply the invisible complement, which is this woman's reflected image—the female model, Nature herself.

The unseen natural model, whose very naturalness is implied in the stylistic naturalism of the entire painting, is balanced, however, by the intense, meditative con-

centration of the visible artist. With brush poised above the empty canvas, the painter looks thoughtfully at her model, and she is caught—has caught herself—at the precise moment of artistic transformation, when the received visual image from the external world is being reassembled in the artist's mind, as the *disegno interno* to be re-created on the canvas. Artemisia, no less than Vasari, Zuccaro, and other advocates of the profession, celebrates the artist as reasoning creature, yet she does not do this at the expense of Nature and the visible world. The balance between the two realms is sustained in an intricate way, for that aspect which concerns corporeality (the natural model) is in this painting invisible, while the dimension of the abstract intellect is given tangible physical substance in the visible central image. Through an ingenious reliance upon the unique advantages that convention afforded the female artist, she is able to emphasize in the picture the identity of the outer and the inner, and the unity between artist/mind and subject/matter.

In a similar spirit, the blank depicted canvas, which occupies a large area of the painted surface, is made to appear identical with the actual canvas upon which the image was painted. Depicted as primed with a red ground and paralleling the picture plane, the red-brown canvas surface is only barely recognizable as a fictive plane, for the woven texture, nubs, grain, and irregularities of the real surface simultaneously support and break down the illusion of the depicted surface. Artemisia has clarified her illustration of a canvas only by occasional small black strokes that subtly heighten the illusion of the warp and welt of the fabric. Physical matter, in the form of the artist's most basic piece of studio equipment, is here not only frankly acknowledged, its nature is defined as inseparable from the illusion on its surface, an illusion that normally in post-Renaissance art converts the canvas from a dull and opaque object into a window on an imaginary world. Here, by contrast, the primary physical essence of the canvas is not denied.

Artemisia's prominent empty canvas alludes, however, to the intellectual as well as the physical sphere. Unusual for an artist's self-portrait is that she works before a *tabula rasa*, a blank surface,[72] presumably to stress the primacy of the artistic idea, as superior to the particular depicted image on the canvas that follows in its wake. This favoring of concept over its material realization, in combination with a relish for the materiality and pure promise of the primed physical canvas that awaits the image, would seem to echo the current of Neoplatonic thought that led Michelangelo, in a famous sonnet, to assert:

> The excellent artist has no *concetto*
> that one single marble does not enclose
> with its excess; and that [*concetto*] is only attained
> by the hand that obeys the intellect.[73]

Artemisia's conjunction of the *tabula rasa* with the raw materials of art joins with the fusion of the intellectual and material that permeates the painting to present a new

pictorial form for the expression of the capabilities of the art of painting. Instead of regarding painting's physical and material aspects as limitations, she presents them as virtues, exulting in her art's firm roots in the visible natural world and in tangible, earthy matter. Yet she emphasizes, through the picture's pivotal focus upon the contemplative head of the artist-creator, the coordinate roles of mind and matter in the creation of art. Seen in this light, the painting is a pictorial testament to the artistic legacy of Caravaggio, and in it Gentileschi demonstrates a depth of understanding of his art that was equalled by few of his followers.

Three years after Artemisia's *Self-Portrait as the Allegory of Painting* was painted, its central idea was given more literal expression in the engraved end-piece to Vincenzo Carducho's *Diálogos de la Pintura*, published in Madrid in 1633 (Fig. 326). The image of an empty canvas, touched at an angle by a paintbrush, is encircled with a laurel wreath, whose interlaced ribbon and accompanying inscription proclaim and explain the power of the *tabula rasa*: "The blank canvas surpasses so many things because it sees all things *in potentia*; only the brush with sovereign science can reduce this potential to actuality."[74] Carducho's formulation of this idea was undoubtedly as dependent upon Italian art theory as were the engraved *Allegories of Painting* that illustrate his dialogues, and it may well be that the *maniera* theorists were his source for the idea of the *tabula rasa*.[75] Yet it is not impossible that familiarity with Arte-

326. Vincenzo Carducho, engraved end-piece to *Diálogos de la Pintura* (Madrid, 1633)

misia's painting may have sharpened the image of his end-piece, the most graphic and least abstruse image in the *Diálogos*. Knowledge of the *Pittura*, which was with the artist in Naples in the early 1630s, could have come through the Duke of Alcalá, Fernando Enríquez Afán de Ribera, a major art patron who had purchased at least one picture by Artemisia in Rome in the 1620s (see above, p. 91), and who would likely have kept abreast of her activity while he served as Spanish viceroy in Naples between 1629 and 1631.[76]

Gentileschi's *Pittura* could also have been described to Carducho by Diego Velázquez, an artist who would have been capable of drawing a deeper form of inspiration from its example. Velázquez undoubtedly met Artemisia and very likely saw the painting on his visit to Naples late in the year 1630, when the two painters were both working in the Neapolitan court for Maria of Austria (see above, p. 91).

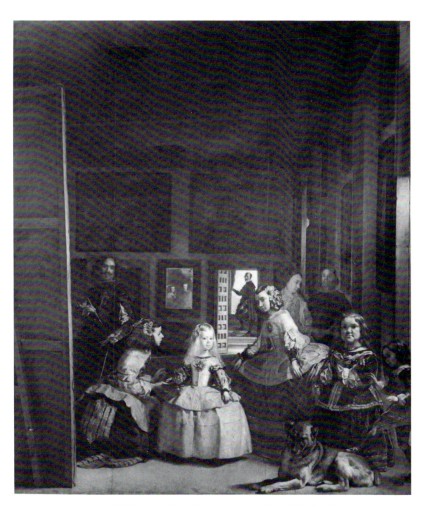

327. Velázquez, *Las Meninas*, 1656. Madrid, Prado

Velázquez left Naples for Madrid on December 18, three days before Artemisia wrote to Cassiano dal Pozzo that she was about to send him the self-portrait she had just finished. Velázquez would surely have seen much to interest him in this pictorial meditation on the art of painting, since he himself had been steeped in Spanish theoretical discourses on the nobility of the art of painting, advanced in particular by his teacher Pacheco, both in his informal academy and in his treatise, *El arte de la pintura*. Velázquez, a favored and intellectual court artist, embarked on his Italian journey in 1629, a moment when arguments on behalf of the dignity of the art of painting, and its claim to be considered a Liberal Art, were loudly heard in Madrid.[77] An intelligent contemplation of Artemisia's *Self-Portrait as the Allegory of Painting* could have suggested to the obviously receptive Spanish painter many of the ideas that would later surface in his *Las Meninas* (Fig. 327): the concept of depicting the artist engaged in work as a living allegory of art, the intrinsic dignity of the art of painting, and the union of its intellectual and material aspects in a single naturalistic image.[78]

Within the existing conventions, however, only a woman artist could have sustained the specific idea of a unity between art and the artist in naturalistic terms. For all that *Las Meninas* may be claimed in its entirety as the supreme expression of the nobility of the art of painting, even Velázquez was compelled to depict himself wearing at his belt the keys that symbolized his status in the royal court, and on his chest the cross of Santiago to represent his knighthood[79]—signs of worldly rank and royal favor, yet a symbolic elevation of the artist that functioned on a separate plane from the more subtle argument for the conceptual worth of the art of painting that is indirectly demonstrated in the design and execution of the entire painting. As a female, Artemisia Gentileschi, without an outward sign of status, could inevitably bring to mind the noble allegory of the art of painting, and as an earthy, physical embodiment of the spirit of the profession she could convey, through her self-portrayal as modestly adorned but profoundly absorbed, the idea that the act of painting in itself had both dignity and philosophical significance. Gentileschi's *Self-Portrait as the Allegory of Painting* thus joins other masterpieces by Caravaggio and Velázquez to bear silent but eloquent witness to the proposition that there is nothing "mere" about artistic practice, and nothing "unintellectual" about an ability to see in natural life raw metaphors for profound human concerns. Finally, there is nothing unintellectual about a painting by a woman that offers both recognition of and a solution for an aesthetic dilemma that had troubled artists for nearly a century.[80]

# APPENDICES

*Documents Translated from Italian by Efrem G. Calingaert*
*Edited by Mary D. Garrard*

# The Letters of Artemisia Gentileschi

TWENTY-EIGHT letters written by Artemisia Gentileschi, two responses from one of her patrons, and a brief exchange of notes with another constitute the entire known correspondence of the artist. This correspondence, presented here for the first time in English translation, documents Artemisia's relations with six of her patrons and friends over a thirty-year period, from 1620, when she was twenty-seven years old, to 1651, the penultimate year of her life. The first preserved letter (Fig. 328), written only eight years after Artemisia declared in court that she could not write and could read only a little, amply demonstrates that she had gained literacy in the intervening years. As she herself pointed out (no. 19), many of her letters were dictated while she painted, and thus we find varied orthography among the documents.

In fact, the letters display impressive linguistic and rhetorical skills—an ability to use the flowery and elegant courtly language of her day, and at the same time to manipulate it, so that she delivers some hard truths with grace and wit. In letters no. 8 and no. 15a, for example, while drawing upon conventions of self-deprecation inherent in the artist (vassal) and client (lord) relationship, Gentileschi speaks openly of her great ambitions for personal achievement and fame. An artist who played with color and form relationships, Artemisia evidently also enjoyed word play, as we see in letter no. 10, in which she uses the words *sicura* and *sicurissimo* with shifting meanings, or in letter no. 25, where the idea of merit (*merito, merentia*) is given shades of meaning. She also employs certain metaphors that may have been conventional in the seventeenth century—e.g., the barren tree (no. 6a)—but which are no longer familiar idioms.

Artemisia's preserved correspondence includes a representative sampling from her major known patrons and supporters. There is one letter to Cosimo II dei Medici in Florence (Fig. 328), and four letters to Andrea Cioli, Cosimo's Secretary of State and Artemisia's friend (Fig. 329). A single note written by Artemisia survives from her Florentine years, written to Michelangelo Buonarroti the Younger, among his account records of 1515–16 (reproduced, along with surrounding materials, in Chapter I, note 42). One letter remains from the painter to another Florentine friend, the eminent mathematician-astronomer Galileo Galilei. There are six letters to her friend and patron Cassiano dal Pozzo in Rome; three letters to Duke Francesco I d'Este in Modena, and two replies from her Modenese patron to Artemisia. The final thirteen letters to her Sicilian patron Don Antonio Ruffo in Messina, written in a short period

Acciò non sia dicontra a V.A.S. Un puo di Viaggio
che misono risoluta di fare In sino a Roma
ho uoluto con lapresente farlo sapere a V.A.S. essendo
q[ues]ta mia mossa cagionata dalle molte mie indispositioni
passate alle quali sicono giunti anche non pochi
trauagli della mia casa e famiglia, che la restaura-
re l'uno e l'altro mio danno mela fassero cola sua aⁿ[?]
miei qualche mese nel quale tempo e indua
mesi al piu Io assicuro V.A.S. di quanto deuo
lacaparra delli scudi Cinquanta di suo ordine
riceuti: e mentre resti pregando Idio lacompita
felicita, e salute di V.A.S. umilissima mente
fine melinchino, e nella sua buona grazia di
tutto core meracomando di casa In Fiorenze il 10.
di Febraio 1619.

D.V.A.Ser<sup>ma</sup>

Vmiliss<sup>ma</sup> e deuotiss<sup>ma</sup> Serua
Artimisia Lomi

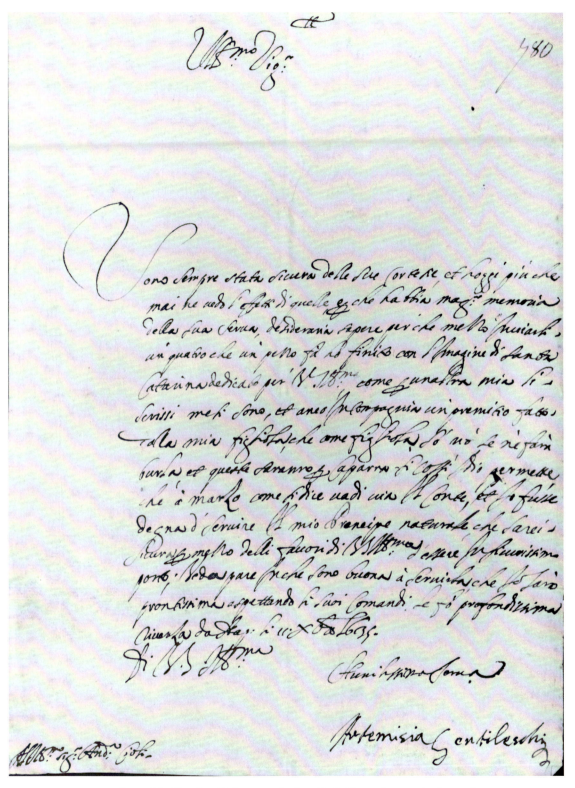

Illmo Sigr:

Sono sempre stata sicura delle sue cortese, et hoggi più che mai ne vedo l'effetto di quelle, et che habbia magg:r memoria della sua serva, desiderarei sapere per che mezzo inviarli un quadro che un pezzo fà lo finito con l'imagine di Santa Catarina dedicato per V. S. Illma come curatrice mia si scrissi mesi sono, et anco in compagnia un ovennio fatto dalla mia figliolina, che come figliola, sò nó se ne farà burla et questo saranno, a gastiga di lossi se non permette che à marzo come si dice vadi con il Conte, et se io fusse degna d'servire il mio Prencipe naturale che sarei sicura, meglio delli favori di V. S. Illma d'essere favoritissima però Veda a pare in che sono buona à servirla che io sarò prontissima aspettando li suoi Comandi, e io profondissima Riverenza da Napoli li 11 Xbre 1635.

di V. S. Illma

Humilissima serva

Artemisia Gentileschi

329. Artemisia Gentileschi, letter to Andrea Cioli, December 11, 1635 (no. 10)

of time (twelve in one year, two on the same day), provide a graphic picture of the push and pull of artist-patron relations—haggling over prices, pressure to finish a work more quickly, complaints about the high cost of models and unscrupulous buyers.

All but the letters to Cassiano dal Pozzo and Don Antonio Ruffo are still preserved. Artemisia's letters to the Grand Duke of Tuscany, to Andrea Cioli, and to Galileo are found in the Archivio di Stato and the Biblioteca Nazionale, Florence; the correspondence with Duke Francesco I d'Este is found in the Modenese archive. At present, we must conclude that Artemisia's original letters to Cassiano dal Pozzo and to Don Antonio Ruffo are lost. Cassiano's volumes of correspondence containing artists' letters, used by Bottari in preparation for his first volume (published 1754), were apparently looted during the Napoleonic invasions but largely recovered by an heir to the Albani family. They were probably in the hands of Léon Dufourny until the sale of 1823, after which they must have been widely scattered. I am grateful to Sheila S. Rinehart, who provided this information; and who cites a source not available to me: Philippe Chennevières-Pointel, *Collection de lettres de Nicolas Poussin* (Paris, 1824), 366. Artemisia's letters to Ruffo are not to be found in the state archives of Messina, Reggio di Calabria, or Naples. According to Dottoressa Maria Antonietta Martullo-Arpago, Director of the Archivio di Stato, Naples, that archive holds records concerning two branches of the Ruffo family, di Bagnara and di Scilla (which, however, only begin around 1700). The location of records from the di Scaletta branch, the line of Don Antonio Ruffo, is not known, and Dottoressa Martullo-Arpago believes they may have been destroyed during World War I, that is, soon after Vincenzo Ruffo published the artists' letters. (My thanks to Efrem G. Calingaert for her inquiries about the Ruffo correspondence.)

This English translation of the letters was made by Efrem G. Calingaert, with editing and footnotes by me. Our translation is based upon the published versions of the letters; individual sources for the Italian texts are noted below. In 1981 Eva Menzio published the Italian texts of the letters, collected by her for the first time, along with her transcription of the rape trial. Menzio's edition presents the letters in nearly complete form; only letters no. 9 and no. 28 are missing. In 1984, I published an article that included our translations of six of the Gentileschi letters, in slightly different form (Mary D. Garrard, "Artemisia Gentileschi: The Artist's Autograph in Letters and Paintings," in Donna C. Stanton, guest ed., *The Female Autograph*, New York Literary Forum, no. 12–13 [New York: New York Literary Forum, 1984], 91–105).

We have taken the liberty of punctuating run-on sentences and adding occasional commas for clarification. When exact language of a particular passage is especially important, the original Italian is given in parentheses or a footnote.

1

Letter to Grand Duke Cosimo II dei Medici, in Florence.
Written in Florence, February 10, 1619 [1620].[1]

Most Serene Lord and My Most Honorable Master,

So that you will not be displeased by a short trip to Rome that I have decided to take, I wish to inform Your Most Serene Highness of it with this letter. The many minor illnesses I have suffered, as well as the not inconsequential worries I have had with my home and family, have prompted me to this decision. In order to recover from my troubles, I shall spend a few months there with my friends.[2] During that time and within two months at the most, I assure Your Most Serene Highness that you shall have what you ordered, for which I received an advance of fifty *scudi*.[3]

While I pray to God for the happiness and good health of Your Most Serene Highness, in closing I bow to you most humbly and I entrust myself to your benevolence with all my heart.

Florence, the 10th of February, 1619.

The most humble and devoted servant of Your Most Serene Highness,

Artimisia Lomi[4]

2

Letter to Commendatore Cassiano dal Pozzo, in Rome.
Written in Naples, August 24, 1630.[5]

I have seen the measurements [*misura*] which Your Most Illustrious Lordship so kindly sent me. I would serve you immediately if I didn't have to do some paintings for the Empress [*Imperatrice*], which must be finished by the middle of September.

[1] Autograph letter, original in Archivio di Stato, Florence, *Fondo Mediceo*, Filza 998, c. 204. Published in Crinò, 1954. This letter is dated in the Florentine style. It bears the date 1619, but because it was written before the beginning of the Florentine new year (March 25), the actual year was 1620. Artemisia was then in the employ of Grand Duke Cosimo II (see Chapter 1 above).

[2] Crinò gives this as *tra miei*; Menzio, as *tra mici*.

[3] This ordered work was probably the *Judith Slaying Holofernes* now in the Uffizi; see above, pp. 51–53.

[4] Lomi was Orazio Gentileschi's paternal name, and the name used in Florence and Pisa by his father (Giovanni Battista Lomi) and his older brother (Aurelio Lomi), who were a goldsmith and a painter respectively. Presumably to stress the family's Tuscan origins, Artemisia used Lomi as her surname during her Florentine period, but not thereafter (the Uffizi *Judith* and the *Magdalen* are signed with this name; the next signed work, the *Condottiere* painted in Rome in 1622, bears the name Gentileschi). She is called "Lomi" or "Stiattesi" in Florentine documents, and "Gentileschi" in Roman and Neapolitan documents.

[5] Original letter lost (see headnote). Published in Bottari-Ticozzi, 1822–25, 1:348–49 (no. 137). The relation between Artemisia and Cassiano dal Pozzo, prominent Roman patron, collector and scholar, is discussed above, pp. 84 ff.

As soon as these are done, my first priority will be to serve Your Most Illustrious Lordship, to whom I am so indebted.

I must beg you to send me by messenger six pairs of the finest gloves, because I need gifts for some of the ladies. For the time being I do not need anything else.

Bowing to you in reverence, I pray that God grant you much happiness.
From Naples, 24 August 1630.

### 3

Letter to Commendatore Cassiano dal Pozzo, in Rome.
Written in Naples, August 31, 1630.[6]

I must beg Your Most Illustrious Lordship to write to Monsignor Herrara, the Nunzio here in Naples, in the proper form so as to obtain a license to carry arms for the cleric Diego Campanili who works in my household.[7] Since this would serve my own interests, I would indeed appreciate such a favor. But again, I beg you not to fail me, Your Most Illustrious Lordship, and to send the letter to me immediately. This will be one of the greatest favors you could grant me.

As for the portrait, as soon as I finish some paintings for the Empress, I shall serve you. When the weather gets cooler, I hope to come and serve you in person.

While I await your answer and your favor, I pay you reverence.
From Naples, 31 August 1630.

### 4

Letter to Commendatore Cassiano dal Pozzo, in Rome.
Written in Naples, December 21, 1630.[8]

On my return to Naples, having been away with the opportunity of serving a duchess by painting her portrait, I found Your Lordship's most kind letter with the enclosed letter for the monsignor Nuncio. I beg you to accept my apologies for send-

[6] Original letter lost (see headnote). Published in Bottari-Ticozzi, 1822–25, 1:349–50 (no. 138), where the date is printed erroneously as 1620.

[7] Herrara was the papal ambassador to Naples. The purpose of the requested arms for her assistant appears to have been to provide physical protection for Artemisia; later (no. 11 below) she wrote of the fighting (*tumulti di guerra*) and hard life in Naples. Although the city was not literally at war, continuous massive immigration into Naples had

created overcrowded conditions, extreme poverty, and the typical physical dangers associated with congested urban life. See Giuseppe Galasso, "Society in Naples in the Seicento," in Whitfield and Martineau, 1982, 24–30; and Galasso, "Napoli città e capitale moderna," in *Civiltà*, 1985, 23–28.

[8] Original letter lost (see headnote). Published in Bottari-Ticozzi, 1822–25, 1:350–51 (no. 139), where the date is printed inaccurately as 1530.

ing my thanks to you now, which I would have done earlier if I had been here when your letter arrived. I cannot tell you the outcome, because Signor Diego Campanile [*sic*] has been dangerously ill, and for that reason the letter has not been delivered.

To serve Your Lordship, I have painted my portrait with the utmost care, and I shall send it with the next messenger. Please accept my ready willingness to serve you, and if all that doesn't satisfy you, you may at your convenience lash the image of the artist, who, still aching from the cold suffered in doing this work, nevertheless will expect Your Lordship's innate kindness to relieve her of this misfortune by sending her gloves and slippers to prevent further discomfort.[9]

I cannot express on this sheet how deeply I wish you a most happy holy Christmas holiday, and many more in the future. But the good judgment of Your Lordship, whom I so much respect, can certainly appreciate it.

Respectfully, and with much love, I kiss your hands.
Naples, 21 December 1630.

5

Letter to Commendatore Cassiano dal Pozzo, in Rome.
Written in Naples, January 21, 1635.[10]

My brother Francesco is coming there to bring a painting of mine, as a gift from me to His Eminence Cardinal D[on] Antonio,[11] with the hope that it is to his liking. Now, because in that city [Rome] I have no other protector but Your Lordship, to whom I have always entrusted my interests, I turn to you and ask that you make every effort to help me in this matter. I beseech you with the greatest urgency to take my brother to His Eminence, and to arrange at the same time that he be quickly dismissed, since I need him badly because he manages all my business.

Therefore I must appeal to you to look after his expedition, since of necessity I cannot allow him to stay in Rome longer than four days. Please consent, Your Lord-

---

[9] *Resterà servita d'accettare la prontezza dell'animo, che tengo di servirla, e quando tutto ciò non la soddisfaccia, potrà a suo bell'agio sferzare l'immagine dell'autrice, la quale, agitata dal freddo patito in tale operazione, starà nondimeno attendendo che l'innata cortesia di V.S. la sollevi da questo accidente con rimessa di guanti e di pianelle, perchè non le causasse maggior male.* In this letter Artemisia employs playful hyperbole, as she would do occasionally in writing to other patrons, here achieving a subtly comic effect in her swift transition from grand to mundane concerns in the same sentence. She also invokes a conceit particularly common to women

artists, the imaginary substitution of the self-image for the self (cf. above, pp. 173–174).

[10] Original letter lost (see headnote). Published in Bottari-Ticozzi, 1822–25, 1:351–52 (no. 140).

[11] Cardinal Antonio Barberini and his brother Cardinal Francesco Barberini, nephews of Pope Urban VIII, were, like their uncle, major Roman art patrons and collectors; see above, pp. 83 ff. For the possibility that this painting is to be identified with the *Sleeping Venus* in Princeton, see above, pp. 108–109. Her brother Francesco's service as courier for Artemisia is discussed in Chapter 1.

ship, to intercede for me in this affair, and to look after my interests as you have always done on other occasions, so that my brother and I may with your assistance achieve our objective. We shall both always be grateful to you for your benevolence, for which I am deeply indebted.

And here, with due reverence, I kiss your hands affectionately.

Naples, 21 January 1635.

6a

Letter to Duke Francesco I d'Este, in Rome.
Written in Naples, January 25, 1635.[12]

Most Serene Lord,

As I am sending His Eminence Cardinal D[on] Antonio [Barberini] some paintings by my hand, I take this opportunity also to send to Your Most Serene Highness those works which I did for you with great pleasure. I am sending these works with the bearer, my brother, dispatched by His Majesty the King of England to take me into his service.[13] However, it seems to me that for three reasons I rightly should devote part of my meager [*fiacco*] talent to Your Highness. First, because my most humble house is at the service of your illustrious house.[14] Second, because I have served all the major rulers of Europe, who appreciate my work, even though it is the fruit of a barren tree [*arbor impotente à partorirli*].[15] And third, because it would provide the evidence of my fame [*il complimento delle mie glorie*].

Therefore please forgive my daring but ambitiously honorable gesture, and please accept these small works which I am sending with my brother. Disregard their

[12] Archivio di Stato, Modena; Archivio Segreto Estense, Cancelleria Ducale, Archivio per materie, Arti Belle e Pittori, Busta 14/2. Published in Imparato, 1889, 423–25. Although the Duke of Modena cannot be counted among Artemisia's patrons, since he seems never to have taken up her offers to join his service, she sent him several pictures, as their correspondence indicates (nos. 6a, 6b, 15a, 15b). No Gentileschi paintings have been identified in the Modenese collections.

[13] The paintings for Cardinal Antonio Barberini and Francesco I d'Este mentioned in this letter have not been identified. Artemisia's summons to the English court is discussed in Chapter 1.

[14] Artemisia juxtaposes her house (*casa*) and that of the Duke of Modena with ironic but telling effect, presenting her house as "humble" in the same spirit that she describes her talent as "meager."

Since the word *casa* implied in Renaissance Italy not only the domestic unit but an entire genealogical lineage, of which a male was normally the head, Artemisia's promotion of her own *casa* (which included Francesco, and by extension, Orazio) must have been rather unusual for a non-aristocratic woman. On the extended meanings of the Renaissance *casa*, see Christiane Klapisch-Zuber, *Women, Family, and Ritual in Renaissance Italy*, trans. by Lydia Cochrane (Chicago and London: The University of Chicago Press, 1985), 117 ff.

[15] Perhaps a play on the relation between artistic creation and procreation (in 1635, Artemisia was forty-two years old, past normal childbearing years). The metaphor is sustained in the next paragraph, where she uses the verb *partorire* ("to give birth, produce") to describe the making of paintings. Cf. above, p. 173.)

faults and consider them in relation to the person who made them [*l'ha partorite*], noting only the devotion with which I offer them.

I beseech you to accept this gift as a tribute that I owe you, and so that I may fulfill my debt, please, Your Highness, be so kind as to honor my wishes. In the meantime, I humbly bow to you and pray to the Divine Majesty for the prosperity of Your Serene Highness's household.
From Naples, 25 January 1635.
The most humble servant of Your Most Serene Highness,

<div align="right">Artemisia Gentileschi</div>

<div align="center">6b</div>

<div align="center">Letter from Francesco I d'Este, Duke of Modena,
to Artemisia Gentileschi, in Naples. Ducal draft,
written in Modena, March 7, 1635.[16]</div>

Madam [*Signora*] Artemisia Gentileschi,

I have received from your brother the paintings that you sent me, and I have recognized in their beauty your skill, and in the gift of them your generosity. I thank you for the gift, and I assure you that in addition to being touched by your loving kindness [*amorevolezza*], I am equally obligated to compensate you for your worth [*merito*] with tokens of my gratitude. And with this I wish you all prosperity from Heaven, et cetera [*sic*].

<div align="center">7</div>

<div align="center">Letter to Francesco I d'Este, Duke of Modena.
Written in Naples, May 22, 1635.[17]</div>

Most Serene Highness,

Your Most Serene Highness calls a gift of generosity what is actually a tribute of my vassalage; you consider a gesture of affection and an act of courtesy what is due Your Grandeur as a sign of obedience. This devoted respect to which I am now giving expression I have borne in my soul since long before I manifested it in letters, not so much for the obedience that I declare to Your Most Serene House, as for the happy

---

[16] Archivio di Stato, Modena; Archivio Segreto Estense, Cancelleria Ducale, Archivio per materie, Arti Belle e Pittori. Published in Imparato, 1889.

[17] Archivio di Stato, Modena; Archivio Segreto Estense, Cancelleria Ducale, Archivio per materie, Arti Belle e Pittori. Published in Imparato, 1889.

memory of His Eminence Cardinal d'Este, whose generosity I greatly enjoyed.[18] I thank Your Most Serene Highness for magnifying my paintings by accepting them, showing yourself to be generous even in the receipt of small things.

Until now I had no idea that my canvases had met with such good fortune, not having had word from my brothers, whom I had commissioned to present them to you. Meanwhile, I beg Your Most Serene Highness to keep me informed, by means of your authority, and to give me the opportunity in the future to add to the merit of my promptness that of my obedience. Wishing beyond measure to receive your orders, I hope one day to be able to express to you in person that devotion which now from afar I can only indicate with my pen. When I go to Florence, I will extend my journey as far as Modena, and in Your Most Serene Highness's presence, I will fulfill my vow as to my own private deity. And here, with profound reverence, I pray to heaven for your great prosperity.
From Naples, 22 May 1635.
The most humble servant of Your Most Serene Highness,

Artemisia Gentileschi
(outside address) To the Most Serene Duke of Modena

8

Letter to Andrea Cioli, in Florence.
Written in Naples, September 20, 1635.[19]

To your most affectionate letter of the twenty-fourth of September,[20] I replied that in the person of Your Illustrious Lordship my hopes were well placed, and that consequently I should put my total trust in you, both because your kindness is beyond

---

[18] Probably Cardinal Alessandro d'Este, who died at Tivoli in 1624, and who was also a significant art patron. The Cardinal's collections were transported to Modena from Rome in 1625; no works by Artemisia have been identified among the paintings. See Rodolfo Pallucchini, *I Dipinti della Galleria Estense di Modena* (Rome: Cosmopolita, Casa Editrice, 1945), 17; and Venturi, 1882, 157 ff.

[19] Original in Archivio di Stato, Florence, *Fondo Mediceo*, 1416, ins. 8, c.748. Published in Crinò, 1960. Andrea Cioli was Secretary of State to Cosimo II, Grand Duke of Tuscany, and Artemisia's patron and principal contact at the Florentine court (see above, p. 34). It was Cioli who in 1615 wrote to Piero Guicciardini, the Grand Duke's am-

bassador in Rome, inquiring about the Roman reputation of Orazio Gentileschi, whom he was prepared to believe to be a good artist on the strength of the work of Artemisia, his daughter, which Cioli already knew in Florence (Crinò, 1960, 265).

[20] Artemisia speaks of having received Cioli's letter "*delli vintiquattro di sett.e*," or the seventh month, which would be September 24 in the Florentine calendar and according to the system of month-naming and -numbering used by Artemisia herself in this and other letters. But since that would place Cioli's letter later in date than this letter of September 20, she must either have meant July (the seventh month by the new calendar), or else she erred in the month or day.

all expectation, and also because of my Master the Most Serene Grand Duke's gracious willingness to protect me. I wish to know from Your Most Illustrious Lordship if His Most Serene Highness[21] was pleased by my works, so that when in due time the opportunity arises, I may fulfill my wishes. If it suits Your Most Illustrious Lordship, please keep me fully informed.

Wishing you a thousand years of good health.

From Naples, the 20th of September, 1635.

The most affectionate servant of Your Most Illustrious Lordship,

Artemisia Gentileschi

## 9

Letter to Galileo Galilei, in Arcetri.
Written in Naples, October 9, 1635.[22]

My Most Illustrious Sir and Most Respected Master,

I know that Your Lordship will say that if I had not had the occasion to avail myself of your assistance, I would never have thought of writing to you; and, indeed, because of the infinite obligations I have toward you, you could draw that logical conclusion,[23] since you did not know how often I tried to have news of you without being able to obtain reliable information from anyone. But now that I know you are there in good health, thank God, I want to disregard other possible avenues and appeal to you, whom I can depend on for favorable assistance, without relying on any other gentleman. And I do this all the more spontaneously because another situation has developed similar to the one concerning the painting of that Judith which I gave to His Serene Highness the Grand Duke Cosimo of glorious memory, which would have been lost to memory if it had not been revived by Your Lordship's assistance.[24] By virtue of that [assistance] I obtained an excellent remuneration. Therefore I beg you to do the same thing now, because I see that no one is mentioning the two large

[21] Ferdinando II, son of her former patron Cosimo II (see above, p. 89). In this letter Artemisia initiates an inquiry that she pursues in the next letter (no. 9) to Galileo, about two unacknowledged paintings sent to the Grand Duke. The first line of letter no. 10 suggests that Cioli may have obtained a ducal response for her. She also explores here the prospect of returning to service at the Florentine court.

[22] Autograph letter, Biblioteca Nazionale, Florence, Mss. Gal., P. I. T. XIII, car. 269–270. Published in *Le Opere di Galileo Galilei* (Florence: G. Barbèra, 1929–39) 16:318–19.

[23] *"Ne potrebbe fare infallibile argomento."* Artemisia seems to intend a joking reference to the proposition-and-proof structure of such philosophical and mathematical writings as Galileo's own *Dialogue on the Two Chief Systems* [1632]. At the time this letter was written, Galileo was at his villa in Arcetri, where he was allowed to return in 1633, having been held for five months in Siena by papal authorities on the charge of heresy. See Drake, 1978.

[24] The Uffizi *Judith*, painted for Cosimo II dei Medici shortly before his death in 1621; see above, pp. 51 ff.

paintings that I recently sent to His Serene Highness with one of my brothers.[25] I don't know whether he liked them; I only know, through a third person, that the Grand Duke has received them, and nothing else. This humiliates me considerably, for I have seen myself honored by all the kings and rulers of Europe to whom I have sent my works, not only with great gifts but also with most favored letters, which I keep with me. Most recently, the Lord Duke of Ghisa gave my brother 200 *piastre* in payment for a painting of mine which my brother had brought him,[26] but I never received [the money] because my brother went on somewhere else. From His Most Serene Highness, my natural prince [i.e., Ferdinando II], I have received no favor. I assure Your Lordship that I would have valued the smallest of favors from him more than the many I have received from the king of France, the king of Spain, the king of England, and all the other princes of Europe, given my desire to serve him and to return to my home city,[27] and in consideration of the service I rendered His Serene Highness his father for many years.

His Most Serene Highness's generosity, to which all skilled and learned persons [*li virtuosi*] resort, is well known. It is no wonder then, that I, having placed myself among them, should have resolved to dedicate some product of my efforts [*parto delle mie fatiche*] to him: indeed, it is I more than anyone who ought to pay him this debt, on account of both vassalage and servitude. So I cannot believe that I have not satisfied His Highness, since I have fulfilled my obligation. Therefore, I wish to learn the truth from you, including every detail regarding the Prince in this matter. This will alleviate the displeasure I feel, that this most devoted demonstration of mine was passed over in so deep a silence. You will be doing me a great favor, which I will value above any other I have received from Your Lordship. I kiss your hands a thousand times and I shall live always as your grateful servant. And here I pay my profound reverence.

From Naples, the 9th of October, 1635.

From the most obliged servant of Your Most Illustrious Lordship,

Artimitia [*sic*] Gentileschi

If Your Lordship will be so kind as to answer me, please write to me in care of Signor Francesco Maria Maringhi.[28]

---

[25] Ferdinando II de' Medici, Cosimo's son (see note 21). The two paintings sent to the Grand Duke in 1635 through Artemisia's brother Francesco, mentioned in her previous letter to Andrea Cioli (no. 8), have not been identified.

[26] Charles of Lorraine (1571–1640), Duke of Guise and Joyeuse, who, after an active political and military career in France, retired to Florence in 1622, following some differences with Richelieu. The painting has not been identified, but it may

have a connection with Artemisia's *Clio*; see above, pp. 89 and 92ff.

[27] That is, Florence. Artemisia understandably stresses her Tuscan ancestry in this letter to a Florentine. She was in fact born in Rome, as she emphasizes in her letters to Cassiano dal Pozzo and Don Antonio Ruffo.

[28] Maringhi may have been Artemisia's clerical assistant, or perhaps a close friend; documents show that he was associated with her in Florence in 1620 (see Chapter 1, note 78).

## 10

Letter to Andrea Cioli, in Florence.
Written in Naples, December 11, 1635.[29]

I have always felt confident of your favor, and today, more than ever, I can see the results. So that you can better remember your servant, I would like to know by what means to send you a painting of St. Catherine that I finished some time ago [*un pezzo fa*], dedicated to Your Most Illustrious Lordship, as I wrote you in another letter of mine some months ago.[30] Along with it [I will also send] a youthful work done by my daughter. As she is a young woman, please don't make fun of her. These will be a token of my pledge to you.

If, God Willing, the Count goes away in March, as they say he will,[31] and if I am worthy of serving my natural Prince, I will be certain, with the support of Your Most Illustrious Lordship, of being in the safest harbor. Whenever you think I can be of service to you, I will be most anxiously awaiting your command.

I pay you the most profound reverence.
From Naples, the 11th of December, 1635.
The most humble servant of Your Most Illustrious Lordship,

Artemisia Gentileschi

## 11

Letter to Andrea Cioli, in Florence.
Written in Naples, February 11, 1636.[32]

Most Illustrious Sir,

After hearing of Your Most Illustrious Lordship's illness, my grief was such that since then I have asked all the people I trust to pray to God for mercy. I have heard that you are a little better, thanks to the good Lord. I wish to inform Your Most Illustrious Lordship that, if I can carry out my plans, you will not receive my letters from other hands, but I will deliver them myself. Let me know whether you want me

[29] Original in Archivio di Stato, Florence, *Fondo Mediceo*, Filza 1416, ins. 8, c.780. Published in Crinò, 1960.

[30] The *St. Catherine* painted for Cioli cannot be positively identified; see Chapter 1, n. 72.

[31] "The Count" was probably the Count of Monterrey, brother-in-law of Philip IV's lieutenant, the Count-Duke Olivares. Monterrey, who served as Spanish ambassador to Rome from 1628 to 1631, and as viceroy in Naples thereafter, was an active patron and purchaser of art. He commissioned a number of paintings in Naples for the Spanish king's Buen Retiro Palace, including Artemisia's *Birth of St. John the Baptist*. In two shipments (1633 and 1638), Monterrey brought a major sampling of Italian art, especially Neapolitan painting, to Spain. See above, p. 97; also Brown, 1986, esp. 91.

[32] Original in Archivio di Stato, Florence, *Fondo Mediceo*, Filza 1416, ins. 9, c.860. Published in Crinò, 1960.

to send you the painting or whether you prefer that I bring it myself, for ever since I wrote you it has been ready to be shipped.[33] Whenever you have the opportunity to talk to His Most Serene Highness, please do not forget what I mentioned in my last letter, as I have no further desire to stay in Naples, both because of the fighting [*tumulti di guerra*], and because of the hard life and the high cost of living.[34] Please be so kind as to reply to me, since I have no other desire in this life.

I pray all the best from Heaven for you.

From Naples, the 11th of February, 1636.

The most devoted servant of Your Most Illustrious Lordship,

Artemisia Gentileschi

## 12

Letter to Andrea Cioli, in Florence.
Written in Naples, April 1, 1636.[35]

Most Illustrious Sir and most Honorable Master,

Your Most Illustrious Lordship's illness these past months brought great grief to my heart. But as much as I grieved over your illness, I am now equally overjoyed at your recovered health. I will thus beseech you to recommend me to His Most Serene Highness of Tuscany and to carry out for me what so many times Your Most Illustrious Lordship has promised.

As I have to marry off a daughter of mine [*Io per collocare una mia figliuola*], this May I will go to Pisa to sell some property [*alcuni miei beni*], and I will take this opportunity to come to Florence.[36] I wish to ask your assistance in obtaining for me, when I come, the royal patronage and the protection of The Most Serene Grand Duke for four months.

[33] Presumably the *St. Catherine* offered to Cioli in letter no. 10.

[34] Under the Spanish viceroys, Naples endured economic instability, overpopulation, epidemics, famine, riots, and misgovernment, culminating in Masaniello's revolt of 1647 and the plague of 1656, which took about 60 percent of the Neapolitan population. See also note 7 above. The "hard living" mentioned by Artemisia is typified in the artists' world—though she may not have personally been affected—by the activities of the "cabal" of Caracciolo, Ribera, and Belisario Corenzio, who according to De Domenici violently tyrannized non-Neapolitan artists, notably Reni, Domenichino, and Annibale Carracci; see Harold Acton, Preface to Whitfield-Martineau, 1982.

[35] Original in Archivio di Stato, Florence, *Fondo Mediceo*, Filza 1416, ins. 10, c.892. Published in Crinò, 1960.

[36] Artemisia's possessions in Pisa—most likely property—were probably part of her dowry from Orazio, whose family came from Pisa. Although in principle the dowry a wife brought her husband was hers for life, it was quite unusual in Renaissance Italy for a woman to maintain independent control of property unless she was widowed. Klapisch-Zuber, 1985, 117–31. Artemisia's query in the next letter (no. 13) as to whether her husband was alive establishes that she and Stiattesi were by this time separated. Her exceptional independence was an evident consequence of her ability to earn her own living.

With the most profound reverence, I affectionately kiss Your Most Illustrious Lordship's hands.

From Naples, the 1st of April, 1636.

The most devoted servant of Your Most Illustrious Lordship,

Artemisia Gentileschi

## 13

Letter to Cassiano dal Pozzo, in Rome.
Written in Naples, October 24, 1637.[37]

The confidence that I have always had in Your Lordship's kindness, and the now-urgent matter of placing my daughter in marriage, impel me to appeal to your generosity and to ask your assistance and advice, which I trust I will obtain, as on other occasions. My Lord, to bring this marriage to conclusion, I need a small amount of money. I have kept for this purpose, since I do not have any wealth [*capitale*] or income [*assegnamento*], some paintings measuring eleven and twelve *palmi* each. It is my intention to offer them to Cardinals Francesco *padrone* and D[on] Antonio [Barberini].[38] However, I do not want to carry out this plan without Your Lordship's excellent advice, as I wish to act only under your auspices and not otherwise. With my greatest affection, I thus beg you to honor me with your reply, giving me your opinion on the matter, so that if necessary I can dispatch someone immediately with the abovementioned paintings. Among the paintings, there is one for Monsignor Filomarino and another for Your Lordship, in addition to my portrait, which you once requested, to be included among [your] renowned painters.[39]

I assure you that as soon as I have freed myself from the burden of this daughter, I hope to come there immediately to enjoy my native city and to serve my friends and patrons.

And now, to end, I kiss Your Lordship's hands with affection, and I pray for all good things from Heaven.

[37] Original letter lost (see headnote). Published in Bottari-Ticozzi, 1822–25, 1:352–53 (no. 141).

[38] These paintings are described in the next letter (no. 14). On Cardinals Francesco (here described as Artemisia's chief patron) and Antonio Barberini, see note 11 above.

[39] "*Conforme ella una volta mi comandò, per anoverarlo fra' pittori illustri.*" The *Self-Portrait* painted by Artemisia for Cassiano, here identified with the Kensington Palace painting (Color Plate 14) is discussed above, pp. 84 ff. and Chapter 6. The other paintings mentioned in this letter, including the *Woman of Samaria* and the *John the Baptist*, are not known today. Ascanio Filomarino, an active art patron, became archbishop of Naples in 1641–42, following many years in Rome (partly in the service of the Barberini), where he collected works by Annibale Carracci, Poussin, Vouet, and others; (see above, p. 110; Whitfield-Martineau, 1982, 43, 63; and *Civiltà*, 1985, 45ff.

Naples, 24 October 1637.

Please send me news of whether my husband is alive or dead.[40]

## 14

Letter to Cassiano dal Pozzo, in Rome.
Written in Naples, November 24, 1637.[41]

In my previous letter to Your Lordship I mentioned that the paintings that I have ready to send measure twelve *palmi* in height and nine in length. However, I didn't name the subjects. Now I will tell you that one painting represents the Woman of Samaria with Christ and the twelve apostles, in a deep landscape [*con paesi lontani e vicini*], et cetera, rendered [*ornati*] very beautifully; and another painting represents St. John the Baptist in the desert, measuring nine *palmi* in height and of proportionate length.[42]

This is all I can tell Your Lordship on that matter. There remains only for you to try to assist me as much as you can, as I have asked, so that with your help I may feel, as I hope, that I have accomplished something useful that will bring me peace by placing my daughter in marriage as soon as possible. And as soon as this is finished [*sbrigata*] I shall come, as I've said, to enjoy my native city and to serve my friends and patrons.

And now to end I kiss Your Lordship's hands with affection, and I pray to Heaven for all great success.

Naples, 24 November 1637.

## 15a

Letter to Duke Francesco I d'Este, in Modena.
Written in London, December 16, 1639.[43]

Most Serene Highness,

Great Princes, such as Your Most Serene Highness, stimulate those creatures in

[40] "*Sia servita darmi nuova della vita o morte di mio marito.*" Artemisia could have been separated from her husband Pietro Antonio Stiattesi as early as 1620, when she left Florence permanently. On the other hand, her inquiry directed to Cassiano in Rome suggests that he had joined her in that city, though by the mid-1620s she was already head of her household in Rome (see above, p. 63). Artemisia's query may have been prompted by a concern about Stiattesi's legal responsibility for their daughter Prudentia's forthcoming marriage.

[41] Original letter lost (see headnote). Published in Bottari-Ticozzi, 1822–25, 1:354 (no. 142).

[42] These paintings have not been traced. One *palmo* equals 26.5 cm, thus the *Woman of Samaria* would have measured approximately 318 × 238.5 cm; and the *St. John the Baptist in the Desert* would have been about 238.5 cm in height.

[43] Original in the Archivio di Stato, Modena; Archivio Segreto Estense, Cancelleria Ducale, Archivio per materie, Arti Belle e Pittori, Busta 14/2. Published by Imparato, 1889.

Lordship with the assurance that as long as I live I am prepared to carry out your every command. To end, I kiss your hands. Naples, 30 January 1649.

The most humble servant of Your Most Illustrious Lordship,

<div align="right">Artemisia Gentileschi</div>

<div align="center">17</div>

<div align="center">Letter to Don Antonio Ruffo, in Messina.<br>Written in Naples, March 13, 1649.[52]</div>

My Most Illustrious Sir,

I wish to inform you that I received your letter of 21st February, so full of that kindness which Your Most Illustrious Lordship habitually conveys to your servant Artemisia, and with the enclosed note of exchange [*polizza di cambio*] for one hundred ducats. I acknowledge also your commission for a work that I am to do for you.[53] I hope with God's help to make something greatly to your liking, and Your Most Illustrious Lordship will see how much I value kindness in a noble heart [*quanto vaglia la cortesia in petto virtuoso*].

I am very sorry that the Galatea [*Calatea*] was damaged at sea. This would not have happened if I had been permitted to carry out your orders myself, as I would have taken care of it with my own hands. But this will not happen again with the other work, as I will take it upon myself to follow your instructions.

As soon as possible I will send my portrait, along with some small works done by my daughter, whom I have married off today to a knight of the Order of St. James.[54] This marriage has broken me. For that reason, if there should be any opportunities for work in your city, I ask Your Most Illustrious Lordship to assist me with your usual benevolence and to keep me informed, because I need work very badly and I assure Your Most Illustrious Lordship that I am bankrupt.

Further, I want Your Most Illustrious Lordship to promise me that as long as I live you will protect me as if I were a lowly slave born into your household. I have never seen Your Most Illustrious Lordship, but my love and my desire to serve you are beyond imagination. I shall not bore you any longer with this womanly chatter

[52] Original letter lost (see headnote). Published in Ruffo, 1916.

[53] This was to be the *Bath of Diana*, a painting under discussion in the next seven letters, which was delivered eight months later.

[54] The daughter who married a knight of St. James in 1649 was probably a second daughter (the first daughter, Prudentia, was to be married thirteen years earlier), born sometime after 1624, when a Roman census showed only one child in the household. See above, p. 63. Evidently, both daughters were painters (see no. 10).

[*chiacchiere femenili*]. The works will speak for themselves. And with this I end with a most humble bow.

Naples, today the 13th of March, 1649.

The most humble servant of Your Most Illustrious Lordship,

Artemisia Gentileschi

Please send any letters that you write to me in the name of Signor Tommaso Guaragna.

## 18

Letter to Don Antonio Ruffo, in Messina.
Written in Naples, June 5, 1649.[55]

My Most Illustrious and Most Honorable Sir,

I welcomed your most kind letter of the 24th of May with that respect that I owe you, inasmuch as every day I am more indebted to you for the many favors that I receive from Your Most Illustrious Lordship's kindness. You should know that the painting is more than half done, and I hope it will be to your full satisfaction.[56] It is not completely finished at this moment because my model has not been well. As for my portrait which, though I am not worthy [*contra mio merito*], Your Most Illustrious Lordship desires, I will send it with the painting.

In the meantime, I wish to express how greatly obliged I am to you for your concern in trying to find work for me, which is very scarce these days. The Prior [*Signore Priore*][57] honors me from time to time with the most singular favors, and I did three paintings very much to his taste, which is about all I need for now.

After paying Your Most Illustrious Lordship most humble reverence, I pray to the Divine Majesty for all the prosperity that you deserve and wish.

Naples, 5 June 1649.

The most devoted and grateful servant of Your Most Illustrious Lordship,

Artemisia Gentileschi

[55] Original letter lost (see headnote). Published in Ruffo, 1916.

[56] The *Bath of Diana, with Five Nymphs, Actaeon, and Two Dogs,* measuring 8 by 10 *palmi* (212 × 265 cm). Don Antonio Ruffo paid 230 ducats for the picture of this description, which he received on April 12, 1650, through his brother the abbot Don Flavio Ruffo (Ruffo, 1916, 50 n. 1; confirmed in Ruffo, 1919, 52, through a payment record dated April 30, 1650). The relation of this painting to the *Galatea* is discussed in Chapter 1.

[57] The Prior, mentioned again in letter no. 23, is identified by Vincenzo Ruffo as Don Fabrizio Ruffo, prior of Bagnara and nephew of Don Antonio, who maintained a private gallery in Naples. In his later-published will of 1692, Fabrizio Ruffo named the relatives who were designated to inherit his collection of paintings (see Ruffo, 1916, 49 n. 3).

## 19

Letter to Don Antonio Ruffo, in Messina.
Written in Naples, June 12, 1649.[58]

My Most Illustrious Sir,

Last week I answered your letter, which I received from the hand of Don Pietro. Now, I am compelled by two circumstances—first, to finish your painting soon,[59] and, second, not having enough money to finish it—to ask Your Most Illustrious Lordship, as one in his service, to send me a note [*poliza*] for fifty ducats. When I receive the note I will finish the painting, because the expenses for hiring nude women [models] are high. Believe me, Signor Don Antonio, the expenses are intolerable, because out of the fifty women who undress themselves, there is scarcely one good one. And in this painting I cannot use just one model because there are eight figures, and one must paint various kinds of beauty. Forgive my daring to ask this of you, my patron.

I kiss your hands with all reverence.
Today the 12th day of June, 164[9].
The most humble and grateful servant of Your Most Illustrious Lordship,

Artemisia Gentileschi

Please do not wonder about the different handwritings, because I dictate my letters while I am painting. When you see my signature you will be sure that this letter is mine.[60]

## 20

Letter to Don Antonio Ruffo, in Messina.
Written in Naples, July 24, 1649.[61]

Most Illustrious Sir,

I received your most kind letter with the bill [*litera*] of exchange. I thank you profoundly for the timeliness with which Your Most Illustrious Lordship graciously sent it.

---

[58] Original letter lost (see headnote). Published in Ruffo, 1916. The final digit of the date is missing, and the letter was originally placed earlier in the sequence by Ruffo, with the date 1647. In the appendix published in 1919, Ruffo correctly dated the letter to 1649. (Menzio, 1981, has retained the inaccurate placement, and supplies the erroneous date 1648.)

[59] The *Bath of Diana*; see note 56.

[60] "*Quando vedera la mia sottoscritta mano da suo . . . se cura chè la mia*" (with break in transcription, as recorded by Ruffo, 1916).

[61] Original letter lost (see headnote). Published in Ruffo, 1916.

As for my being able to finish the painting by the tenth of next month, it is impossible, because this painting[62] requires three times as much work as the *Galatea*. I work continuously, and as fast as I can, but not so [fast] as to jeopardize the perfection of the painting, which I think will be finished by the end of August.

I would like to know what happened to Titta Colimodio, since I have not received a reply to the letters I sent him a long time ago.[63] Would Your Most Illustrious Lordship please instruct him to write to me because I have to discuss by letter a matter of great importance. Please have him write immediately.

With this I end, kissing your hands and wishing you every happiness.
Today the 24th of July, 1649.
Your servant,

                                                        Artemisia Gentileschi

The portrait will be sent with the painting.

## 21

Letter to Don Antonio Ruffo, in Messina.
Written in Naples, August 7, 1649.[64]

Most Illustrious Sir and My Most Honorable Master,

I received Your Most Illustrious Lordship's most kind letter with the bill of exchange that was paid to me immediately, and for this I thank you especially. As of now, I must tell you that the painting is coming along well and will be finished by the end of this month, with eight figures and two dogs,[65] which to me are even better than the figures. And I will show Your Most Illustrious Lordship what a woman can do,[66] hoping to give you the greatest pleasure.

As for the rest, I am waiting to hear good news about the health of Your Most Illustrious Lordship, and to be honored with your commissions. I kiss your hands affectionately, with reverence to you and to your wife.
Naples, 7 August 1649.
The most devoted and grateful servant of Your Most Illustrious Lordship,

                                                        Artemisia Gentileschi

[62] The *Bath of Diana*; see note 56.
[63] Titta Colimodio has not been identified.
[64] Original letter lost (see headnote). Published in Ruffo, 1916.
[65] Artemisia here projects one figure more than the number of figures she actually included in the painting, if the title recorded for the *Bath of Diana* in the April 2 document is accurate (see note 56).
[66] "*E farò vedere a V.S. Ill.ma quello che sa fare una donna. . . .*"

22

Letter to Don Antonio Ruffo, in Messina.
Written in Naples, September 4, 1649.[67]

Most Illustrious Sir and Honorable Master,

It will seem strange to Your Most Illustrious Lordship that the painting is taking so long, but this is due to my desire to serve you better, as is my duty. While painting the landscape, establishing the [vanishing] point of perspective, it became necessary to redo two figures, which I am certain will be to Your Most Illustrious Lordship's great satisfaction and liking. Please forgive me because, with the excessive heat and many illnesses, I try to keep well by working a little at a time. I can assure you that this delay will be of the greatest benefit to the painting, and will bring special pleasure to Your Most Illustrious Lordship, to whom I pay reverence and commend myself. Naples, 4 September 1649.
[Your] most devoted and grateful servant,

Artemisia Gentileschi

23

Letter to Don Antonio Ruffo, in Messina.
Written in Naples, October 23, 1649.[68]

My Most Illustrious Sir,

I received your letter of the 12th of this month, filled with your customary kind words. However, I was mortified to hear that you want to deduct one third from the already very low price that I had asked. I must tell Your Most Illustrious Lordship that this is impossible and that I cannot accept a reduction, both because of the value of the painting and of my great need. Were this not so, I would give it to Your Most Illustrious Lordship as a present. And I am displeased that for the second time I am being treated like a novice. It must be that in your heart Your Most Illustrious Lordship finds little merit in me, and truly, as Your Most Illustrious Lordship saw that I originally put a low price on it, you must believe in your mind that the painting is not worth much. I thought I was serving you well to charge you 115 less than I asked for the painting for the Marchese del Guasto,[69] and [for a work] with two more fig-

---

[67] Original letter lost (see headnote). Published in Ruffo, 1916.

[68] Original letter lost (see headnote). Published in Ruffo, 1916.

[69] Alfonso d'Avalos, Marchese of Guasto (or Vasto) and of Pescara, was (according to Ruffo, 1916, 51 n. 1) chief treasurer/steward (*gran camarlengo*) of the King of Naples. The painting mentioned by Artemisia remains unidentified.

ures. However, so that you are not left with the wrong impression of me, I think it would be a good idea for you to have it appraised.

As for my doing the Prior[70] special favors, whenever I have done any paintings for him, until today he has paid me what I asked for them. We have to make a new agreement about the ones that remain to be done, because the terms that we set resulted from my extreme need to collect the money in advance, to attend to a very important matter. With God's help, I was able to take care of it without bothering the Prior. Therefore, Your Most Illustrious Lordship has no reason to complain about me and to say that I care more about [working for] your nephews than for you. As for me, I have strongly resolved always to be a vassal and subject of Your Most Illustrious Lordship as long as I live, and you will indeed see that of this little talent which God has given me, a small part I will continually dedicate to Your Most Illustrious Lordship. If, then, Your Most Illustrious Lordship does not want to accept my services, I shall resign myself to it and endure my bad fortune.

And with this I close, wishing you great happiness from Heaven.

Today, from my house in Naples,[71] the 23rd of October, 1649.

The most humble servant of Your Most Illustrious Lordship,

<div align="right">Artemisia Gentileschi</div>

<div align="center">24</div>

<div align="center">Letter from Artemisia Gentileschi to Don Antonio Ruffo, in Messina.<br>Written in Naples, November 13, 1649.[72]</div>

My Most Illustrious Sir,

I would prefer not to discuss our business in this letter, in case that gentleman [the bearer] should read it. However, I say to Your Most Illustrious Lordship, with regard to your request that I reduce the price of the paintings that I had quoted, [I can do] a little, but [the price] must be no less than four hundred ducats, and you must send me a deposit as all the other gentlemen do.[73] But I can tell you for certain that the higher the price, the harder I will strive to make a painting that will please Your Most Illustrious Lordship, and that will conform to my taste and yours. Concerning the painting that I have already finished for Your Most Illustrious Lordship, I cannot give it to you for less than I asked, as I have already overextended myself to

---

[70] See letter no. 18.

[71] "*Di Casa Napoli,*" a formulation used by Artemisia only in this letter. Cf. note 14.

[72] Original letter lost (see headnote). Published in Ruffo, 1916.

[73] Artemisia seems to be describing a newly com-missioned picture, as yet unpainted, in addition to the *Bath of Diana* (mentioned a few lines later), and to be asking 400 ducats total for the two. She was eventually paid 230 ducats for the *Diana*. The other work has not been identified.

give the lowest price. I swear, as your servant, that I would not have given it even to my father for the price that I gave you. Signor Don Antonio, my Lord, I beg you for God's sake not to reduce [the price] I stated, because I am sure that when you see it, you will say that I was not presumptuous. Your nephew the Duke[74] thinks that I must hold great affection for Your Most Illustrious Lordship to charge you such a price. I only wish to remind you that there are eight [figures], two dogs, and landscape and water. Your Most Illustrious Lordship will understand that the expense for models is staggering.

I will say no more, except what I have on my mind, that I think Your Most Illustrious Lordship will not suffer any loss with me, and that you will find the spirit of Caesar in this soul of a woman.[75]

And with this, I pay you most humble reverence.

From Naples, the 13th of November, 1649.

The most humble servant of Your Most Illustrious Lordship,

Artemisia Gentileschi

## 25

Letter from Artemisia Gentileschi to Don Antonio Ruffo, in Messina.
Written in Naples, November 13, 1649.[76]

My Most Illustrious Sir,

I have received a letter of October 26th, which I deeply appreciated, particularly noting how my master always concerns himself with favoring me, contrary to my merit [*contro ogni mio merito*]. In it, you tell me about that gentleman who wishes to have some paintings by me, that he would like a Galatea and a Judgment of Paris, and that the Galatea should be different from the one that Your Most Illustrious Lordship owns. There was no need for you to urge me to do this, since by the grace of God and the Most Holy Virgin, they [clients] come to a woman with this kind of talent [*vengono ad una donna che è piena di questa merentia*], that is, to vary the subjects in my painting; never has anyone found in my pictures any repetition of invention, not even of one hand.[77]

---

[74] According to Vincenzo Ruffo (1916, 51 n. 3), this was Don Carlo Ruffo e Ruffo di Calabria, Duke of Bagnara and Prince of S. Antimo (1641), son of Don Francesco, Duke of Bagnara, the older brother of Don Antonio.

[75] "*Io non gli starò a dire altro solo, che quello che tengno* [sic] *nel mio pensiero, che V.S. Ill.ma non perderà con me, e ritrovera uno animo di Cesare nell'anima duna donna. . . .*"

[76] Original letter lost (see headnote). Published in Ruffo, 1916.

[77] In this passage Artemisia affirms both a reputation for, and her pride in, producing varied pictorial versions of the same theme, an ability that (in the surviving *oeuvre*) we see demonstrated principally in the *Judith*s, but also in the two *Cleopatra*s and two *Lucretia*s. She also seems to develop word play on the idea of her merit or talent (*merito, merentia*), perhaps in response to something Ruffo had written her.

As for the fact that this gentleman wishes to know the price before the work is done, believe me, as I am your servant, that I do it most unwillingly, since it is very important to me not to err and thus burden my conscience, which I value more than all the gold in the world. I know that by erring I will offend my Lord God, and I thus fear that God will not bestow his grace on me. Therefore, I never quote a price for my works until they are done. However, since Your Most Illustrious Lordship wants me to do this, I will do what you command. Tell this gentleman that I want five hundred ducats for both; he can show them to the whole world and, should he find anyone who does not think the paintings are worth two hundred *scudi* more, I won't ask him to pay me the agreed price. I assure Your Most Illustrious Lordship that these are paintings with nude figures requiring very expensive female models, which is a big headache. When I find good ones they fleece me, and at other times, one must suffer [their] pettiness [*piccolezze*] with the patience of Job.

As for my doing a drawing and sending it, I have made a solemn vow never to send my drawings because people have cheated me. In particular, just today I found myself [in the situation] that, having done a drawing of souls in Purgatory for the Bishop of St. Gata, he, in order to spend less, commissioned another painter to do the painting using my work.[78] If I were a man, I can't imagine it would have turned out this way, because when the concept [*inventione*] has been realized and defined with lights and darks, and established by means of planes, the rest is a trifle.[79] Therefore, it seems to me that this gentleman is very wrong to ask for drawings, when he can see the design and composition of the *Galatea*.

I have nothing else to say, except that I kiss Your Most Illustrious Lordship's hands and pay you most humble reverence, praying for the greatest happiness from Heaven.
From Naples, the 13th of November, 1649.
The most humble servant of Your Most Illustrious Lordship,

Artemisia Gentileschi
    I must caution Your Most Illustrious Lordship that when I ask a price, I don't

---

[78] S. Agata de' Goti, according to Vincenzo Ruffo (1916, 52, n. 2). Artemisia's drawing, and the painting made from it by another artist, are not known.

[79] "*Che fusse homo i non sò come se passerebbe perché quando è fatta l'inventione, et stabilito con li suoi chiari et uscuri, e fundati sul'loro piani tutto il reso ei baia. . . .*" A significant comment on the creative process, as understood in Artemisia's day. Her emphasis on the primacy of invention over execution, and upon the importance of establishing an ab-stract light-and-dark structure before the painting is developed in detail, places her in the tradition of the Florentine academy. Cf. Vasari, in [Giorgio Vasari], *Vasari on Technique, Being the Introduction to the Three Arts of Design, Architecture, Sculpture and Painting, Prefixed to the Lives of the Most Excellent Painters, Sculptors and Architects* [2nd ed., 1568], trans. Louisa S. Maclehose, ed. with intro. and notes by G. Baldwin Brown (New York: Dover Publications, Inc., 1960), 208–209, 212.

follow the custom in Naples, where they ask thirty and then give it for four. I am Roman, and therefore I shall act always in the Roman manner.[80]

## 26

Letter to Don Antonio Ruffo, in Messina.
Written in Naples; not dated.[81]

Most Illustrious Sir and Most Honorable Master,

I wish Your Most Illustrious Lordship a happy celebration of the Most Holy Nativity of Our Lord, and many more in the future. If you wish to have the painting, appeal to God [yourself] and subject it to the four hours [travel] to Messina, because the hand of the Almighty is needed here to appease the ill will the Prior holds toward me. After he induced me to accept a ridiculously low price [*vilissimo prezzo*] because I thought I was getting the money, seeing this situation, he tore me apart [*mi straccia*] and paid me most unwillingly, giving me a lot of nonsense. He put it [the painting] among some old works, and it's been against the wall for three months.[82]

With this I kiss your hands and wish you great happiness.
The most obliged servant of Your Most Illustrious Lordship,

Artemisia Gentileschi

## 27

Letter to Don Antonio Ruffo, in Messina.
Written in Naples, August 13, 1650.[83]

Most Illustrious Sir and Most Respected Master,

I have received Your Most Illustrious Lordship's letters, which I was waiting for, carrying new commissions from you, which show me that you have not totally forgotten me. This gives me hope that you will honor me with your orders in the future

[80] "*Io so' Romana e perciò voglio procedere sempre alla Romana.*"

[81] Original letter lost (see headnote). Published in Russo, 1916, which dates it around December 20, 1649. The *Bath of Diana* as Vincenzo Ruffo notes, was paid for in full by Abbot Ruffo on April 12, 1650, a transaction posted in Don Antonio Ruffo's accounts on April 30, 1650, when the painting must have arrived in Messina.

[82] The painting in question is likely to be the

*Bath of Diana*; see nn. 56 and 81. The recent damage suffered by the *Galatea* in sea travel probably prompted Artemisia to suggest that Ruffo pray for this picture's safe voyage. Artemisia's recommendation that she and Ruffo appeal to God separately for their different problems is more likely an instance of the painter's wry humor than of simple Christian belief.

[83] Original letter lost (see headnote). Published in Ruffo, 1916.

and thus give me the opportunity to prove my devotion to you, of which I hope to show you a sign as soon as possible, by means of this small Madonna.[84] I can assure you that, just as you liked the large things in the past, so will you like these small ones that I hope to show you soon.

Awaiting more frequent orders from Your Most Illustrious Lordship, I kiss your hands with much affection.
Naples, 13 August 1650.
Signore Don Antonio Ruffo
From Your Most Illustrious Lordship's most affectionate servant, in your service,

Artemisia Gentileschi

## 28

Letter to Don Antonio Ruffo, in Messina.
Written in Naples, January 1, 1651.[85]

Most Illustrious Sir and Most Respected Master,

A month has passed since I wrote to Your Most Illustrious Lordship and sent you holiday greetings, rejoicing in your recent good health, but I have not been honored with a reply. This makes me fear that the person [whom I sent], having little regard for me, did not deliver the letters. There were three of them, addressed to various people, and I have received no reply from any of them. I would now like to know from Your Most Illustrious Lordship if in fact you received my letter.[86] I spent this last Christmas in bed, as I was rather ill, and I am now still convalescing. Your little branch [*rametto*] is over half done, and as soon as I am able to paint again, you will be the first one to be served.[87] In my other letter I told Your Most Illustrious Lordship that I have two paintings the same size as the *Galatea* which are half done. One of them represents Andromeda, when she was freed by a certain knight [*un tal Cavaliere*] on the flying horse Pegasus, who killed the monster that wanted to devour that woman. In between, there is a most beautiful landscape and a most splendid seascape; in short, it is a most beautiful painting. In the other one is portrayed the story of Joseph whom Potiphar's wife was trying to seduce, with a very beautiful bed

[84] Vincenzo Ruffo notes (1916, 53 n. 3) that this "*Madonina in piccolo*" was not found among the paintings of Ruffo's *galleria*, nor was it mentioned in the account books.

[85] Original letter lost (see headnote). Published in Ruffo, 1916.

[86] Ruffo observes (1916, 53 n. 4) that the letter must not have been delivered, since otherwise it would have been collected with the others.

[87] According to Vincenzo Ruffo (1916, 53 n. 5), neither the *rametto* nor the other paintings named in this letter, *Perseus and Andromeda* and *Joseph and Potiphar's Wife*, ever came into Don Antonio's possession. None has been identified. It is tempting to connect the implied metaphor of the "little branch" with the "fruit of a sterile tree" mentioned by Artemisia in letter no. 6a.

with draperies and a most beautiful floor perspective. I want to present them to Your Most Illustrious Lordship at a good price. Because of the many illnesses and troubles I have had this past year, and having to finish [the paintings] quickly, I want you to enjoy them with my compliments, because I so greatly esteem Your Most Illustrious Lordship. Therefore, to take care of [*renudar*] a problem of mine,[88] it is necessary that you kindly send me one hundred ducats in advance, and I will charge Your Most Illustrious Lordship only ninety *scudi* for each painting if Your Most Illustrious Lordship will be so kind as to advance the one hundred ducats to me. I will arrange for the paintings to be delivered to you by April or earlier, but, please, I ask you kindly to send me the abovenamed one hundred ducats soon, as I need them to take care of a thousand things.[89]

With this I end, asking you to send me a prompt reply so that I may have [medical] treatment [*accio possa star in cura*] by means of your advance. As always, I am, most devoted and most obliged, at the service of Your Most Illustrious Lordship, and I declare myself most devoted and most obliged, always.

Naples, 1st of January 1651.

The most obliged servant of Your Most Illustrious Lordship,

<div align="right">Artemisia Gentileschi</div>

[88] The word *renudar* does not exist in modern dictionaries. The context here suggests an approximate meaning.

[89] Literally, *migliara*, which may approximate *migliaia* ("a thousand [things]"), or might mean *migliorie* ("ameliorations," "improvements").

# Testimony of the Rape Trial of 1612

EARLY in the year 1612, Orazio Gentileschi brought suit against Agostino Tassi for the rape of his daughter Artemisia. Orazio's undated petition is addressed to Pope Paul V, thus establishing the trial in the context of canon rather than civil law. The reason may have been the alleged participation in the rape by Cosimo Quorli, orderly (*furiere*) of the Pope. The case for the prosecution of Tassi took the form of interrogations of a series of witnesses, beginning with Artemisia herself on March 18, and ending with the testimony of Donna Porzia Stiattesi on May 16, 1612.[1]

Artemisia supported her father's charge that Tassi had raped her, adding that he had promised to marry her. This assurance, she said, led her to continue to have sexual relations with him in the expectation that they would be married; she testified that she had not had sexual relations with anyone other than Tassi. On the order of the court, Artemisia was examined by midwives, who confirmed that she was no longer a virgin. Donna Tuzia, a tenant in the Gentileschi household and friend of the family, was then questioned. Opposing Artemisia's claim that Tuzia had encouraged Tassi and facilitated his access to her, Tuzia testified that against her own advice, Artemisia had freely admitted both Agostino and his friend Cosimo Quorli to her house in her father's absence and had behaved indiscreetly. The next witness, Giovanni Battisti Stiattesi, was a friend of Tassi (whom he had earlier met in Livorno), and a cousin of Cosimo Quorli. Stiattesi affirmed that it was Agostino who had deflowered Artemisia—though in his version the intermediary was not Tuzia but Quorli—adding that while Agostino wanted to marry the girl, Cosimo Quorli was impeding the progress of their courtship out of jealousy. He further alleged that Agostino had interfered with Orazio's efforts to arrange another marriage for Artemisia. In order to support his assertions that Agostino loved and wanted to marry Artemisia and that Cosimo

---

[1] The trial records are deposited in the Archivio di Stato, Rome: Archivio del Tribunale Criminale del Governatore di Roma, processo 7 ("Stupri et Lenocinij—Pro Curia et fisco Conᵉ Augustinum Tassum Pictorem"), busta 104, anno 1612, ms. pp. 1–340. (Bissell, 1968, 153 n. 2, cites the same document, but follows a different pagination, also visible on the manuscript.) The main testimony from the proceedings was published in a brief, synoptic form in Bertolotti, 1876, 183–204; and also by Pas-seri and Orlaan (cited by Wittkower and Witt-kower, 1963, 162–64). The Wittkowers offer a lively interpretative account of the rape trial. A nearly complete Italian transcription of the trial, along with Artemisia's letters, was published in 1981, edited by Eva Menzio, with notes and short essays by Menzio, Anne-Marie Boetti and Roland Barthes (*Artemisia Gentileschi/Agostino Tassi: Atti di un processo per stupro* [Milan: Edizione delle Donne, 1981]).

had acted as his procurer, Stiattesi introduced as evidence two poems and a letter written to him by Tassi, and two letters written by Stiattesi himself, one to Tassi and one to Quorli.

On March 26, Agostino Tassi took the stand for five successive interrogations. He was first questioned closely about his deceased wife, of whose existence Artemisia claimed to have been ignorant, and whom Stiattesi said that Tassi had had murdered in Tuscany. (Tassi claimed to have learned about his wife's death only after his arrival in Rome.) Tassi described Stiattesi as a traitor and, confronted with the letters and poems introduced by Stiattesi, explained that they pertained to Stiattesi's having served him as procurer. He further alleged that Stiattesi had also been sleeping with Artemisia, as had another painter, Geronimo Modenese, and a cleric in a cassock [later identified as a certain Artigenio]. Tassi then accused Artemisia of incest with her father and, denying ever having had intercourse with her himself, claimed that he had tried on Orazio's behalf to negotiate a marriage between Artemisia and Modenese, which did not occur because of her bad reputation. At this stage the judge cautioned Tassi about bearing false witness, stating that the court knew that he had had sexual relations with Artemisia. When Agostino repeatedly denied this, Artemisia was brought into the courtroom to confront him directly.

Recapitulating her previous testimony, Artemisia voluntarily submitted to the torture of the *sibille* for the purpose of proving that she had told the truth. In response to a series of questions Tassi was permitted to ask her, she stated that Stiattesi and his wife knew that Tassi had deflowered her. Stiattesi, who was then brought into confrontation with Tassi in the courtroom, confirmed his deposition of March 24, and his assertion that Tassi had raped Artemisia. Stiattesi then added the new information that he himself had tried to negotiate the marriage between Agostino and Artemisia, as recently as two weeks earlier, by bringing Artemisia to Corte Savella prison to discuss the matter. He claimed to have heard the couple exchange promises to marry, with Artemisia refusing to retract her testimony and blame someone else for deflowering her, as Agostino requested. With the testimony of Stiattesi's wife Porzia, who corroborated her husband's story, adding that Artemisia herself had told her that Tassi deflowered her, the first phase of the trial came to an end.

Witnesses for Tassi's defense were led off by Nicolo Bedino Felice, a painter who had served as apprentice to Orazio, and allegedly to Tassi as well (though he and Tassi denied it). It has recently been discovered that Bedino's testimony of June 8 was preceded by an earlier statement of May 30–June 7, along with testimony by several other witnesses, including the painter Orazio Borgianni.[2] Bedino's testimony was fol-

---

[2] The unpublished material is preserved in the Archivio di Stato, Rome, in a different file from the bulk of the testimony (Miscellanea Artistica, busta 2: Artigiani ed Artisti, fascicolo 108, Tribunale del Governatore, 1612 [May 30–June 7], ms. pp. 78–81.) It was Anna Modigliani who located the new material, while searching at my request for evidence of the trial's outcome. The newly discovered testimony is inserted in the translation below in its proper chronological position.

lowed by six more witnesses produced by him, four of whom supported Bedino's claim that Artemisia had been deflowered by someone other than Agostino Tassi, and that she was a woman of loose morals. Tassi's final witness, Father Pietro Giordano, testified to the contrary, asserting that Agostino had admitted to him that he had deflowered Artemisia, and claiming that Tassi had lined up false witnesses for his defense. Orazio Gentileschi then filed another suit against Bedino and his witnesses for bearing false witness, initiating a separate trial, or subtrial, that lasted at least until October 29, 1612.[3]

Orazio pointed out several contradictions in the preceding testimony, the most telling of them being that Nicolo Bedino had claimed to have carried letters to men that were written by Artemisia herself, while confirming—as had Artemisia (ms. 129)—that she could not write. Cosimo Quorli had made a related tactical error when, according to the testimony of Stiattesi, he forged a note with her signature written to obtain the Judith painting from Tassi (ms. 48; repeated in the narrative, ms. 11). A number of contradictory statements can be found if one examines the trial testimony as a whole. To mention only two examples, Stiattesi (ms. 40) said that Agostino and Artemisia first became acquainted on the day of the carriage ride to St. Peter's and Quorli's house (soon after the day of S. Croce, 1611), while both Artemisia and Tuzia indicated that he had begun to come to the house on Via della Croce sometime earlier than that (mss. 13–14; 27–29). And at one point Tassi flatly contradicted himself, first saying that he had never seen Artemisia and Tuzia in church, then admitting that a year earlier he had followed the two of them to S. Giovanni (mss. 98–101). The judges were openly dubious about some of the testimony they were hearing, particularly that of Tassi, whose statements so drastically diverged from those of Stiattesi and Artemisia that the latter two witnesses were returned to the courtroom to confront their opponent. Yet it is worth noting that only Artemisia and Bedino were subjected to external tests—the *sibille* for both, and for her, the examination by the midwives. For all his discrepancies and in spite of his criminal record, Tassi was merely admonished by the judges to tell the truth.

The records preserved in the Archivio di Stato contain no notice of the trial's resolution. Presumably the court found Tassi guilty, if we may take as indicative of its disposition the narrative account of the proceedings inserted at the head of the testimony, as well as the judges' overt skepticism about the truth of Tassi's testimony. However, Tassi's sentence—which ought to have been deposited in the Vatican Archives separate from the trial testimony, according to the custom of the Tribunal—has not been found.[4] He may have been convicted but not sentenced; by one account

---

[3] Although it is probable that the trial ended with the re-examination by the Curia of Bedino's witnesses, and a final interrogation of Bedino, there is no indication of closure on the final page (ms. 340).

[4] Anna Modigliani, who made a careful search of the Vatican Archives on my behalf, reports finding no record of Tassi's sentence.

Tassi was released after spending less than nine months in prison,[5] which is to say, within a month after the final witness's testimony was recorded. On November 29, 1612, Artemisia was married to Pietro Antonio di Vincenzo Stiattesi, who is very likely to have been a relative of Giovanni Battista Stiattesi, the man whose testimony was critical to her defense.[6]

THIS English translation of the rape trial testimony was made from an Italian transcription of the original manuscript in the Archivo di Stato, Rome. Efrem G. Calingaert transcribed and translated the document; she also contributed valuable information and prepared the synopsis of mss. 172–340. I have edited her translation and synopsis, and provided the footnotes and headnotes. Anna Modigliani of the Archivo di Stato provided Italian translations and transcriptions of some of the Latin passages and generously investigated other problems. We were greatly assisted by the incomplete but basically accurate transcription of the trial published by Eva Menzio in 1981, and have tried to complement that publication by correcting its errors and omissions, and by filling in its ellipses with full Italian texts as far as possible. We include here a complete translation of all known testimony from the first manuscript page through the end of Bedino's testimony of June 8 (ms. 172), followed by a synopsis of the remaining testimony (mss. 172–340). The authoritative numbering of the manuscript established at the end of the trial, superseding other numbers that also appear on manuscript pages, it is given in the margins throughout this translation. (An exception is the inserted new testimony from Miscellanea Artistica, which was never drawn into the final pagination, and whose independent numbering is given here as MA-78, MA-79, etc.)

In the trial testimony, questions are asked in Latin, while answers are given in Italian; that distinction is reflected in the translation that follows by the use of italic and roman type respectively. We have taken certain liberties in the interest of producing a smooth and readable translation. Punctuation, almost non-existent in the manuscript, has been added. In the manuscript, the form of the questions frequently shifts from past to present tense for no particular reason; we have used the past tense consistently. The spelling of proper names has been made consistent: Tassi (occasionally given as Tasso); Stiattesi (sometimes Stiattese); and Artemisia (which is always Artimitia in the testimony). Honorific titles vary considerably, depending upon the speaker and who is addressed; in the interest of preserving useful social information, we have given the Italian for these throughout.

---

[5] Wittkower and Wittkower, 1963, 163. Teresa Pugliatti (1977, 24) says simply that Tassi was detained for about a year in Corte Savella prison. By 1613, Tassi was at work in the Casino Montalto of Villa Lante at Bagnaia (Pugliatti, 1977, 25).

[6] This was proposed by Moir, 1967, 1:99 n. 101.

For

The Curia and the State

Versus

Agostino Tassi Painter

Before

The Illustrious and Excellent Lord Hieronimo Felicio
*Locumtenente*

Lord Decio Cambio Notary *pro charitate*

Ostilio Toccio
Substitute Notary

Romana          1612          Stupri et Lenocinii

270

Pro

Curia et fisco

Con

Augustinum Tassum Pictorem

Coram

Ill.mo admodum et Col.mo d. Hieronimo Felicis Luogotenente

me Decius Cambiis pro Barth.o not.

Castilius decius not. dep.

330. Testimony from Proceedings against Agostino Tassi, Roman Curia, 1612, frontispiece

## *Index of the Witnesses at the Present Trial*[7]

[7] This index was placed at the beginning of the trial testimony. The page numbers listed here correspond to the major numbering sequence established in the final pagination of the manuscript. In the original index, the numbers were those of an earlier pagination.

[ms. 4]   Most Holy Father,[9]

Orazio Gentileschi, painter, most humble servant of Your Holiness, respectfully reports to You how, through Madame Tuzia his tenant, and as a result of her complicity, a daughter of the plaintiff has been deflowered[10] by force and carnally known many, many times by Agostino Tassi, painter and a close friend and associate of the plaintiff; also taking part in this obscene business was Cosimo Quorli, your orderly [*furiere*].[11] By this I mean that besides the rape, the same orderly Cosimo, through his intrigues, took from the hands of the same young woman some paintings of her father's, and in particular a *Judith* large in size.[12] And because, Holy Father, this is such a nasty deed, giving such serious and great injury and damage to the poor plaintiff, especially since it was done under the trust of friendship, it is like a murder, and committed by a person who is used to committing even worse crimes than this one, the perpetrator being the said Cosimo Quorli. Thus, kneeling at your Holy feet, I implore you in the name of Christ to take action against this ugly intemperance by bringing to justice him who deserves it, because, besides granting a very great favor, your action will keep the poor plaintiff from disgracing his other children. And he will always pray to God for your most just reward.

[8] Testimony concludes with final interrogation of Nicolo Bedino, October 29, 1612 (mss. 337–40).

[9] Pope Paul V (Camillo Borghese; 1605–1621).

[10] Because *sverginata* is a more precise term than "rape," indicating as it does that the victim was a virgin, it is here represented by the archaic English "deflowered." Artemisia is frequently described as *zitella*, which can mean either "an unmarried woman" or "a virgin." The word is here translated according to the sense of the passage.

[11] Agostino Tassi, principally a landscape and marine painter, was born about 1580 in Ponzano Romano. He came to Rome around 1590, and settled again in Rome in 1610 after a long sojourn in Florence. At the time of the trial, Tassi was working with Orazio Gentileschi on frescoes in the Sala Regia of the Quirinal Palace. (See above, Chapter 1; also Pugliatti, 1977.) Cosimo Quorli, who died before the trial began (see ms. 140; Menzio, 1981, 155 n. 5), was *furiere* ("adjutant" or "orderly") of the Pope.

[12] The passage, *alcuni quadri di pittura di suo padre*, can mean either that the paintings were by his hand or that they belonged to him. *Di capace grandezza* could also mean "of high quality" (as Bissell pointed out [1981, 155]), but in this context a reference to its size is more probable.

Proceedings of the Case of Agostino Tassi                    [ms. 5]

Narrative of the event which took place between Agostino Tassi, Artemisia Gentileschi, and [ms. 6]
the orderly Cosimo Quorli, with the aid of Tuzia, wife of Stefano Medaglia.¹³

Agostino Tassi, on the day of Santa Croce in May it will have been a year,¹⁴ was let into
the house with the assistance of Tuzia. As soon as he arrived he began with a charming manner
to persuade Artemisia to work on her father to make him throw out of the house Francesco
Scarpellino, who was Signor Orazio's apprentice.¹⁵ Agostino did this because the said Fran-
cesco Scarpellino had refused to act as procurer and bring him into Artemisia's house.

A few days later, Cosimo the orderly drove with his wife and Agostino's sister-in-law¹⁶ in
a carriage to the house of Orazio Gentileschi and took Artemisia for a ride, accompanied by
Orazio her father. And all of them, men and women, went to Cosimo's house where they had
lunch.

Several days after this lunch, Agostino, having found the door of Artemisia's house open,
entered the house as an ungreeted guest and went to Artemisia. He found her painting, and
with her was Tuzia, who held her son on her lap. As he approached Artemisia he ordered [ms. 7]
Tuzia to go upstairs because he wanted to speak with Artemisia in private. Tuzia stood up
immediately and went upstairs. And on that very day Agostino deflowered Artemisia and left.
The same evening he returned to Artemisia's house with Signor Orazio, and Signor Orazio
found Artemisia sick in bed. After this, Cosimo the orderly also went alone one morning to
Artemisia's house and when he was inside he tested Artemisia's honor, and in Tuzia's presence
he forcibly tried to make love to her. But he was unable to do it because Artemisia did not
want it. Tuzia never left the room and saw everything. And Artemisia told Agostino every-
thing as soon as she saw him.

From then on, Agostino continued with Artemisia and enjoyed her as if she were his own
possession, having promised to marry her at the time he deflowered her, despite the fact that
he had a wife. And later on, Agostino reaffirmed this promise twice, in particular when he
received word by letter that his wife had been killed, which news he corroborated by placing
the letters in Artemisia's hands and reading them to her.¹⁷ In addition, he showed her many [ms. 8]

¹³ This "narrative," an unsigned summary of the
case, precedes most of the testimony from which it
is presumably drawn. The final numbering, bolder
than other page numbers on each sheet, was evi-
dently established after the narrative report was in-
serted.

¹⁴ The day of S. Croce, or Holy Cross, one of the
four Ember Days in the Christian calendar, is usu-
ally celebrated on September 14, but in Italy also
on May 3. It is clear from the trial testimony that
the day of S. Croce alluded to was in May.

¹⁵ Scarpellino is here described as Orazio's gar-
zone (which means "shop-boy" as well as "appren-
tice"), and elsewhere (mss. 288, 293) as his model.

He is probably the same person as the model Fran-
cesco (ms. 28) and Francesco the servant (ms. 14).

¹⁶ Costanza, also called "la Frittelletta" (accord-
ing to Menzio, 1981, 155 n. 9), was the sister of
Agostino's wife. In 1611, Agostino was accused by
his own sister Olimpia of adultery and incest with
Costanza, who was married to Filippo Francini of
Florence (mss. 45–46). According to Wittkower
and Wittkower (1963, 162 n. 47), sexual relations
with one's sister-in-law while one's wife was still
alive were considered incestuous.

¹⁷ At this time Artemisia, by her own account,
could read only a little and could not write; see ms.
129.

other letters from the Grand Duke of Florence and some of his courtiers. And thus he continued to be intimate with Artemisia, entering through Tuzia's house whenever it pleased him, taking along with him his apprentice Giovan Luca da Benevento (alias il Napoli), the Indian Salvatore Moro, and others.

Cosimo not only tried to damage Artemisia but several times he tried to have sexual relations with her in Via della Croce, in the house of S. Spirito,[18] and in his own house, having summoned her by sending his wife to fetch her in a carriage many a time. In particular, one day during this year's Carnival,[19] Cosimo and his wife took Artemisia to the rooms downstairs and left her in the hands of Agostino for a good hour, and then Cosimo said to the two of them: "If you have not done your business, it's your loss." Cosimo's children, his wagoner, his servant, Stiattesi's wife and children, Stiattesi, and Orazio Gentileschi's other children, all can testify to this.

[ms. 9]     That Agostino deflowered Artemisia and did what was described above, one can ask Stiattesi for essential details.

That Agostino had his first wife[20] killed is clear since there are letters with this information, and Stiattesi knows all about it, as well as Agostino's apprentice Giovan Luca and his servant Salvatore Moro.

That Agostino was engaged in these activities with the intent of subjecting Artemisia to his desires has been attested by his sister-in-law Costanza. The same Giovan Luca also knows about it and Stiattesi has had proof of it several times. And the old woman who was involved is called Vincenza, and Laura Toscanella, a public prostitute, also knows about it because she was implicated in the affair.

That Agostino is keeping his sister-in-law is of public knowledge, and from the testimony of Costanza's husband Filippo, one can find out the truth about it:[21] that she had children by him, and he deflowered her, and because of this his wife, who had also been forcibly deflowered by Agostino, was at her wit's end and left him. Afterwards, Agostino came to Rome with [ms. 10] his sister-in-law and here in Rome plotted to have his wife killed, as he has done. And bandits from Tuscany came to Rome to get the money for killing his wife. There are letters about it written by Giovanni, a merchant in Livorno, and by another merchant from Lucca.[22]

That Agostino impeded any marriage that was being arranged for Artemisia, this is of notorious public knowledge. Tuzia knows all the details, as does Stiattesi, who knows as a fact about the case of that fellow from Modena.[23]

---

[18] This reads *strada Croce* in the transcript. "S. Spirito" was the house facing S. Spirito in Sassia, where Orazio's family and Tuzia's household lived together at the time of the trial (see n. 28). From the description, the Gentileschi residence would appear to have been within the former Palazzo della Rovere, built in 1478 by Cardinal Domenico della Rovere, whose courtyard directly faces S. Spirito in Sassia.

[19] Carnival (*Carnevale, Carnovale*) is the festival period preceding Lent. In 1612, Easter fell on April 12, hence Lent would have begun on or about March 3. (In 1611, Easter was March 24.)

[20] In this construction, Costanza is perceived as Agostino's second wife.

[21] The testimony of Costanza's husband is not included in the trial records.

[22] As the context makes clear, Mercante is in this case a profession and not a surname.

[23] Stiattesi refers to him as *il Modena* (ms. 47), while Agostino calls him "Geronimo Modenese" (ms. 89), a nickname he obviously acquired because of his city of origin.

That Agostino has had a thousand quarrels with his friends out of jealousy is well known all over Rome.

That Agostino has tried many times to take Artemisia out of Rome can be attested to by Artemisia.

And last of all one can see that Agostino did not want to keep his promise to marry Artemisia. And we shall find that Cosimo Quorli was the reason, first because, recently, at Tuzia's place in the house in S. Spirito, Cosimo wanted to rape Artemisia and he greatly abused her, but he could not have her, having done what you will hear about from Artemisia. [ms. 11] And also because, out of jealousy, he persuaded Agostino secretly and firmly not to marry her, as Stiattesi will testify.

That Cosimo extracted from the hands of Artemisia a painting of a Judith, this can be seen from a note in Cosimo's handwriting in which Agostino is requested to give it to Cosimo. But the note is forged, and is neither written nor signed by Artemisia, but was written instead in Cosimo's house on the small marble table during Carnival. And the painting was sequestered in Agostino's house by Signor Bulgherello.[24] In spite of this, Agostino's brother-in-law Filippo removed it from the house by night to take it to Cosimo's house, carried by Cosimo's servant. When Signor Orazio demanded it back, it was given to the guards of the Borgo, and the painting remained in the hands of the chief Notary of the Borgo.[25]

Cosimo continually went around Rome spreading rumors that Artemisia was his daughter, asking people whether Artemisia resembled him; in particular he asked his servant Dianora, his wagoner Matteo, Stiattesi, Stiattesi's wife, and many others. And then he boasted that he had had her sexually to Stiattesi's wife; and infinite times he bragged to Stiattesi about [ms. 12] her having been his daughter as well as his having had her.

Agostino cannot say that Artemisia has misbehaved with others, since he would be lying through his teeth,[26] because from the day that he deflowered her he constantly put men around Artemisia's house to watch whoever entered and left, both day and night. From their reports he learned that she is a most respectable young woman and that she has not coupled with anyone but himself. He had innumerable discussions with Stiattesi about this, and he openly confessed that he ought to marry Artemisia at any cost, but that he was not going to marry her because Cosimo the orderly had advised him against it quite firmly. And since he was much indebted to Cosimo for having saved him from the gallows,[27] he could not take a decision without Cosimo's consent. This is the truth about everything that follows.

The Eighteenth Day of March 1612 [ms. 13]

*Signora [Domina] Artemisia, daughter of the painter Signor [Dominus] Orazio Gentileschi, was questioned in her Roman house, the place of her usual dwelling, located overlooking the hospital*

[24] Bulgherello (Bulgarello) was the substitute deputy in the trial.

[25] Borgo Rione IV, according to Menzio (1981, 156 n. 16). The identity of this painting has been the subject of some speculation; see above, pp. 28 ff.

[26] Literally, "lying in his throat" (*mentirà per la gola*).

[27] Cosimo's rescue of Agostino from execution is not reported in the principal monograph on Tassi (Pugliatti, 1977).

*of S. Spirito at the foot of the hill,*[28] *by magnificent and excellent Lord Francesco Bulgarello, the substitute deputy [locumtenentem], and by me, etc. Having been ordered to swear to tell the truth, and after she had sworn under oath*[29] *the examinee was asked by the judge whether she knew the reason she was being interrogated.*

*She answered*: I can imagine the reason Your Lordship wants to question me because for the past few days I have watched my father's activities, and he has had imprisoned the tenant who lives in the upstairs apartment, named Tuzia, who has plotted to betray me by taking part in having me disgraced.

*Asked the reason that she asserted what she imagined, and asked to state and relate how she was betrayed by the said Tuzia, and what had been fabricated by [Tuzia] against her reputation,*

*She answered*: Regarding the disgrace and betrayal that, as I mentioned above, was perpetrated by Tuzia against me, I want to say that she acted as procuress to have me deflowered by a certain Agostino Tassi, a painter. In order that you be fully informed about the whole thing, I shall relate in detail the facts as they happened. Last year, when my father lived on Via della Croce, he rented the apartment upstairs to the said Tuzia, who had come to live there about two months before.[30] My father was a close friend of the said Agostino Tassi who, because of this friendship, began to visit our house frequently and to become friends with the said Tuzia. One of the times he came was the day of Santa Croce last May, and the said Tuzia tried to persuade me that Agostino was a well-mannered young man, courteous to women, and that we would get along very well with each other. She pushed so much that she convinced me to speak to the said Agostino, having stated beforehand that a servant who used to be with us was going around spreading scandal about me, and that Agostino would let me know what [the man] was saying. Since I wanted to know what that servant named Francesco had said, I decided on that day of Santa Croce to talk to Agostino, who had been let in the house by Tuzia. In my conversation with Agostino, he told me that Francesco was boasting that I had given him what he wanted. I replied to him that it didn't matter to me what Francesco was saying because I knew what I was, and I was a virgin.[31] He then told me that he was upset by the fact that Francesco was saying these things about me, because of his friendship with my father and because he valued my honor very much, and without going into any further details, he left.

[ms. 14]

[ms. 15]

The following morning when I was in bed and my father had left the house, the said Agostino came again, accompanied by Cosimo, orderly of our Holy Father, and Tuzia let them in. When I heard people walking up the stairs I threw on my dress and went upstairs to her apartment. When I saw that the people who had arrived were Cosimo and Agostino, I greeted

---

[28] The Hospital of S. Spirito in Sassia, and the adjacent church of S. Spirito in Sassia, are located near St. Peter's, in the angle between Borgo S. Spirito and Via della Lungara.

[29] Literally, "after she had done it [sworn] and touched," presumably a bible. "Et cetera" is frequently represented in the manuscript by a symbol; Menzio, on the other hand, uses "etc." to stand for words or phrases she has omitted. We

have eliminated some non-substantive "et ceteras," but, where possible, have supplied words missing in Menzio.

[30] Via della Croce leads into the north end of Piazza di Spagna. Presumably Tuzia had come to live in the neighborhood two months before Orazio rented her an apartment.

[31] *Zitella*. The context makes clear that Artemisia is being described in sexual, not marital, terms.

them, and then turned to Agostino and said: "You even want to bring that man here," meaning Cosimo. Agostino told me to be quiet, and when I had calmed myself down Cosimo came toward me and tried to persuade me to be nice to Agostino because he was a well-mannered young man who deserved the best. When I refused to do that and showed that I was disgusted by the way he was treating me, he added: "You have given it to so many, you can give it to him as well." Enraged, I then told Cosimo that I had little respect for the words of scoundrels like him, asked him to relieve me of his presence, and turned my back on him. He then began to say that he was joking, and finally Cosimo and Agostino left. I was upset by these words for several days, and my father was distressed because I didn't want to tell him the reason I was upset. Tuzia took this opportunity to tell my father that he ought to send me out for walks because it was bad for me to stay home all the time. The following evening Agostino sent me  [ms. 16] a message through one of Tuzia's boys that he wanted to have a few words with me that evening, and along with this message he sent Tuzia a piece of cloth to make a small cape for one of her children. When I heard this message I turned around and said: "Tell him that [it isn't proper to] talk to unmarried women[32] in the evening." The following morning my father told Tuzia that since she had spoken of taking me out, she should take me, and [he asked her] to take me as far as S. Giovanni,[33] believing that she was a respectable person. While we were preparing to go out that morning, Cosimo and Agostino appeared, having probably been informed by Tuzia the evening before that we were planning to go to S. Giovanni. They talked with Tuzia, who [then] wanted to take me to a vineyard.[34] When I heard this, I got angry and said I didn't want to go to a vineyard, and in any case they should get out of my sight. They went about their business, and we went to S. Giovanni, where I saw Cosimo and Agostino close by. As I left the church Cosimo stayed back and Agostino followed me, coming closer and closer. But because I complained about it, he followed me at a distance all the way home. While I was at home, the parish Fathers dropped by to pick up the holy cards for Communion and left the door open. With that, Agostino took the opportunity to come into the house and, on seeing those Fathers, began to boast that he could beat them up, speaking to himself so  [ms. 17] that they couldn't hear him. Then he left, but as soon as the Fathers had gone, he came back and began to complain that I behaved badly towards him and that I didn't care about him, saying that I would regret it. And I answered: "Regret what, regret what? He who wants me must give me this," meaning marry me and put a ring on my finger. I turned my back on him and went to my room and he left. On the same day, after I had eaten lunch, as it was a rainy day, I was painting an image of one of Tuzia's boys for my own pleasure. Agostino stopped by and managed to come in because the masons who were working in the house had left the door open. When he found me painting, he said: "Not so much painting, not so much painting," and he grabbed the palette and brushes from my hands and threw them around, saying to Tuzia: "Get out of here." And when I said to Tuzia not to go and not to leave me, as I had

[32] *Zitelle*—here, young virgin women.

[33] St. John Lateran, the cathedral of Rome, and a major church of the city.

[34] Artemisia lived in an area surrounded by vineyards, and it was common—as it still is—for a man with amorous intentions to take a woman to the fields. Though perhaps not with this association in mind, Agostino Tassi identified with a handwritten note the *vigna* (vineyard) of Villa Montalto on a Roman city-view drawing (Pugliatti, 1977, figs. 197, 198).

previously signalled to her, she said: "I don't want to stay here and argue, I want to go about my own business." Before she left, Agostino put his head on my breast, and as soon as she was gone he took my hand and said: "Let's walk together a while, because I hate sitting down." While we walked two or three times around the room I told him that I was feeling ill and I [ms. 18]      thought I had a fever. He replied; "I have more of a fever than you do." After we had walked around two or three times, each time going by the bedroom door, when we were in front of the bedroom door, he pushed me in and locked the door. He then threw me onto the edge of the bed, pushing me with a hand on my breast, and he put a knee between my thighs to prevent me from closing them. Lifting my clothes, which he had a great deal of trouble doing, he placed a hand with a handkerchief at my throat and on my mouth to keep me from screaming. He let go of my hands, which he had been holding with his other hand, and, having previously put both knees between my legs with his penis [*membro*] pointed at my vagina [*natura*], he began to push it inside. I felt a strong burning and it hurt very much, but because he held my mouth I couldn't cry out. However, I tried to scream as best I could, calling Tuzia. I scratched his face and pulled his hair and before he penetrated me again I grasped his penis so tight [*gli detti una matta stretta al membro*] that I even removed a piece of flesh. All this didn't bother him at all, and he continued to do his business, which kept him on top of me for a while, holding his penis inside my vagina. And after he had done his business he got off me. When I saw myself free, I went to the table drawer and took a knife and moved toward Agostino [ms. 19]      saying: "I'd like to kill you with this knife because you have dishonored me." He opened his coat and said: "Here I am," and I threw the knife at him and he shielded himself; otherwise I would have hurt him and might easily have killed him. However, I wounded him slightly on the chest and some blood came out, only a little since I had barely touched him with the point of the knife. And the said Agostino then fastened his coat. I was crying and suffering over the wrong he had done me, and to pacify me, he said: "Give me your hand, I promise to marry you as soon as I get out of the labyrinth I am in." He added: "I warn you that when I take you [as my wife] I don't want any foolishness," and I answered: "I think you will see if there is any foolishness."[35] And with this good promise I felt calmer, and with this promise he induced me later on to yield lovingly, many times, to his desires, since many times he has also reconfirmed this promise to me. When later I heard that he had a wife I reproached him about this betrayal, and he always denied it, telling me he didn't have a wife, and he always reaffirmed that no one but himself had had me. This is all that happened between Agostino and me.

*She added afterward voluntarily*: And I was even more certain about the promise that the said Agostino was going to marry me, because every time there was any possibility of a mar-[ms. 20]      riage,[36] he prevented it from developing.

*Asked whether, at the time when she had been as violently deflowered as she asserted by the said Agostino, she discovered after the fact that she was bleeding in her pudenda.*

*She answered*: At the time when the said Agostino violated me, as I said, I was having my menstrual period and therefore I cannot tell Your Lordship for certain whether I was bleeding because of what Agostino had done, because I didn't know much about these things. It is quite true that I noticed that the blood was redder than usual.

---

[35] "Foolishness" (*vanità*), presumably meaning unfaithfulness on her own part.

[36] *Parentado* implies an arranged marriage.

*She added afterward voluntarily*: Indeed, after the first time, on many other occasions I bled when the said Agostino had carnal relations with me.[37] And when I asked him what this blood meant, he said it came because I had a weak constitution.

*She added afterward*:[38] Every time Agostino had carnal relations with me, it took place in my home, both here and in the house on Via delle Croce. When it was here, where it took place most of the time, he entered through Tuzia's apartment, when a door that connects the two apartments was open. When the door was locked, he would nonetheless come to Tuzia's place to see what I was doing. He never went anywhere with me except one day this August. When I was about to go to S. Giovanni, the said Agostino came to meet me on the Lungara,[39]   [ms. 21] and with great impertinence, he opened the door of the carriage and jumped inside, along with another fellow named Master Antonio, and made the coachman go toward S. Paolo so that he would not be seen.[40] When we reached S. Paolo, he and I got out of the carriage and went for a walk in the fields there. Then we climbed back in the carriage and returned home; he got off at Ponte Sisto. Tuzia, her aunt Virginia and Tuzia's children were with us.

*She added afterward voluntarily*: I also remember that I had talked [*raggionato*][41] with the said Agostino this Carnival at the house of Cosimo the orderly, where Agostino's sister-in-law took me after she had come to fetch me in a carriage on behalf of Cosimo. Agostino came after I arrived and in that house I talked [*raggionai*] with the said Agostino in the apartment downstairs where Cosimo's wife had taken me. She went back upstairs and Cosimo stayed at the door to keep watch in case my father arrived. After a while he came back inside and said: "It's your loss if you haven't done your business."

*Asked whether the examinee had acted carnally with any other person than the said Agostino,*

*She answered*: No, Sir, I never had any sexual relations with any other person besides the   [ms. 22] said Agostino. It is true that Cosimo made all sorts of efforts to have me, both before and after Agostino had had me, but never did I consent. One time in particular he came to my house after I had been with Agostino and made every effort to force me, but he didn't succeed. And because I did not consent, he said that he was going to boast about it in any case and would tell everyone, which he has done with numerous people, particularly his brother Giovan Battista and his sister-in-law, as well as with Agostino, who because of this indignation, withdrew from wanting to marry me.[42]

[37] "... *M'ha conosciuta carnalmente.* ..."

[38] Given by Menzio as *subdens interrogata*, or "adding, on being questioned." However, according to Anna Modigliani, there is a small hole in the manuscript after *subd.*, and the missing word should probably complete the phrase *subdens postea*, "adding afterward" (as in the preceding question, *subdens postea ex se*). *Subdens interrogata* appears nowhere else in the manuscript.

[39] "La Lungara" (Via della Lungara) was the longest of the broad, straight avenues built by the popes (this one begun by Alexander VI and completed by Julius II). It ran through an area of Trastevere covered with vineyards, and with country houses along the Gianicolo hill. (The preceding information, as well as that regarding the romantic uses of vineyards, was supplied by Efrem G. Calingaert.)

[40] S. Paolo fuori le Mura. As its name indicates, S. Paolo is quite a distance outside the city walls of Rome.

[41] The words *ragionare* or *parlare* are often used in certain regional dialects to mean a broad kind of relationship between a man and a woman that may range from chaperoned courting to sexual intimacy. In this instance it seems to imply sexual intercourse.

[42] Literally, *pigliare*. Giovan Battista Stiattesi was Cosimo's cousin, as Menzio notes (1981, 156 n. 22).

*Asked whether the examinee herself was ever given anything by the said Agostino and if so, what.*

*She answered*: The said Agostino never gave me anything because I didn't want that, since what I was doing with him I did only so that, as he had dishonored me, he would marry me. Except that last Christmas he gave me a pair of earrings as a present and I gave him twelve handkerchiefs.

*She added afterward voluntarily*: I also wish to inform you of something else, that the evening before Agostino was put in jail[43] he and Cosimo came to Tuzia's place and all three of [ms. 23] them got together and agreed on what they should say in case they were arrested. This was told to me by my godfather, the painter Pietro Rinaldi.

*Then the judge, in order to ascertain whether the said examinee has been deflowered as she claims, sent for and had brought in two midwives. They are Diambra, daughter of the late Blasio from Capo di Monte, living on Piazza San Pietro in the Vatican, and Donna [Domina] Caterina, daughter of the late Menico Mordichi, living in Masiano[?][44] Court. The judge instructed the midwives to inspect the said examinee's pudenda, then—in compliance with the instructions—apart from the judge but in the presence of me, the notary, they inspected her. And later Signora [Domina] Diambra, after I told her [to proceed], and after she had taken oath, said and declared the following*:

I have touched and examined the vagina of Donna Artemisia, Orazio Gentileschi's daughter, who is here as Your Lordship had ordered, and I can say that she is not a virgin. I know this because, having placed my finger inside her vagina, I found that the hymen[45] is broken. And I can say this because of the experience that I have in such matters, having been a midwife for ten or eleven years.

*Then, subsequently, the aforenamed Donna Caterina, after I had told her [to proceed], after having touched her, etc., said and declared the following*: I have looked at and examined this young woman by the name of Artemisia as Your Lordship had ordered me. I touched her vagina and [ms. 24] I even put a finger in it, and I found that she has been deflowered since the hymen is broken. And this happened a while ago, not recently, because if it were recent one would recognize it. And this I say and report because of my experience as a midwife for about fifteen years. This is the truth.

[ms. 25]                                                    The second day of March 1612

*Signora Tuzia, wife of Stefano Medaglia of Rome, appeared personally, as a principal [principalis] with regard to herself but indeed as a witness with regard to the others, in Tor di Nona prison in Rome, before the magnificent and excellent Lord Francesco Bulgarello, the substitute deputy [locumtenente], and me, and in the presence of the magnificent and excellent Lord Porzio Camerario.[46] Having been ordered to swear to tell the truth and after she had so sworn under oath, she was*

*asked by the judge how and when she was put in this prison and whether she knew or otherwise imagined the reason for her imprisonment and her present interrogation.*

*She answered*: I was taken last Friday evening from my house at the entrance of S. Spirito at about eleven o'clock, and I don't know nor can I imagine the reason for my imprisonment and for the present interrogation.

*Asked whether on other occasions the witness had been arrested, questioned, and tried for any reason, and before which judge,*

*She answered*: I have never been in jail, nor questioned nor tried.

*Asked how long she has resided at her present address and how much rent she is paying per year,*

*She answered*: On the sixteenth of March it will have been a year that I have lived in the said house, and my husband and I are paying 18 *scudi* per year for two rooms upstairs in the house where we live.                                                                                          [ms. 26]

*Asked whether any other person lives in the said house besides herself and her husband,*

*She answered*: In the downstairs apartments of said house other people are living. The said Orazio Gentileschi lives there.

*She added afterward voluntarily*: I came to live in this house with him, that is, we both came at the same time. I was ill and they brought me in a carriage.

*Asked to state approximately when it was that she became acquainted with the said Signor [Dominum] Orazio, and on what occasion they met,*

*She answered*: I have known Signor Orazio for about a year, since I was living in Via Margutta and he lived across the street from me. The said Signor Orazio had a daughter named Artemisia whom I had never seen and knew nothing about, and because the said Artemisia was alone,[47] she called one of my daughters who asked my permission to visit her. Having been told that the said Artemisia was a respectable young woman [*zitella*], I allowed my daughter to visit her. Later on, my older daughter, who is sixteen, also began to associate with her, and so did I. And we began to enjoy each other's company very much, so much so that when her father Orazio met me in the house, he showed pleasure and delight that his daughter   [ms. 27] had become my friend. And he hugged me warmly, saying he was happy that his daughter and I were friends and she could enjoy herself a little, as she was always alone and didn't have anyone. A few days later he asked me if we would like to take a house jointly and live together. I said that I would have to inform my husband and that I would try to do what would please him, because I also wanted to do it on account of the affection I felt for his daughter. When my husband returned on Holy Saturday, he had a meeting with Signor Orazio and a house was found on Via della Croce. Signor Orazio wanted my husband to pay 25 *scudi*, but my husband was reluctant and refused to pay so much rent. Finally they agreed that we would pay a firm rent of twelve *scudi* and that we would all go together to the said house on Via della

---

*domino Francesco Bulgarello locum tenente substituto meque, etc., assistente magnifico et excellente domino Portio Camerario, etc., subli domina Tutia uxor Stephani Medagliae romana publis quo adserixit vero quo ad alius cui delato iuramento.*" "*Subli*" (or *sub.ˡⁱ*, *subsˡⁱ*) is an abbreviation for *substitutus fiscalis*, here translated as "substitute judge." *Principalis* ("a

principal" in legal terms) usually refers to the person who initiates a suit, but this is not the case here.

[47] Artemisia's mother Prudentia died at age thirty on December 26, 1605 (Libro de' Morti IV, fol. 140; cited by Bissell, 1968, 154 n. 9).

Croce, where we would live together. We lived there for two or three months, that is, from the tenth of April to the 16th of July, and after that we lived in the house at the entrance of S.

[ms. 28]   Spirito, where we are now living.

*Asked whether in the house on Via della Croce, as well as in the one in which she presently lives, it is possible for her and for the said Artemisia to go from one apartment to the other,*

*She answered*: Yes, Sir, while I lived in the same house with the said Artemisia and her father Signor Orazio, I frequently visited her apartment and she used to come to mine when she wished. And in this house where we now live, Signor Orazio had a door and staircase made so that we could go down to their apartment.

*Asked how many family members there were in the house of the said Orazio at the time the witness began to share the house with him and his daughter,*

*She answered*: When I went to live with the said Signor Orazio, there were four in the family, namely, the said Signor Orazio, Signora Artemisia, and her three brothers whose names are Francesco, Giulio, and Marco. And before I moved in, also living there was a fellow named Francesco, who was an ugly type with long black hair whom they said they used as a model for some paintings on occasion. But while I was with them, he was never there.[48]

*Asked whether the witness had ever heard anyone in Orazio's house talk about the said Francesco,*

[ms. 29]   *and if so on what occasion,*

*She answered*: I heard that Artemisia and Signor Orazio considered the said Francesco their enemy, and that they did not want him in the house because he spoke ill of them, but what bad things he was saying I don't know because I didn't ask, as I was occupied with other things for my family.

*Asked whether she knew if Orazio had any friends who used to socialize at his house and who they were,*

*She answered*: The said Signor Orazio had many friends but he associated with two in particular and loved them very much. One of them was called Signor Agostino who, they said, was a painter and together with Signor Orazio was decorating and painting a room in the Palace.[49] And the other was Signor Cosimo the orderly.

*Then she added voluntarily*: The said Signor Agostino and Cosimo always used to come to pick up Signor Orazio and take him out. Sometimes we had to wait until five in the morning before Signor Orazio returned home.

*Asked whether it ever happened, as far as she knew, that either of the two aforementioned[50] men had ever been in the said Signor Orazio's house in his absence,*

*She answered*: Yes, Sir, many a time the aforementioned Cosimo and Agostino both came

[48] Presumably it was Orazio and Artemisia who used him as a model. Francesco, the only brother known to have been a painter, could also have been at work by 1611, when he was fourteen years old. On the other hand, a later witness who modelled for Orazio in 1611 spoke of seeing Orazio's daughter and three sons, the oldest of whom "ground the colors" (ms. 232).

[49] Orazio Gentileschi and Agostino Tassi were working together in 1611 on some now-destroyed frescoes in the Sala del Concistoro of the Palazzo del Quirinale. See above, pp. 18–20.

[50] *Suprannominatis* [sic], sometimes *praedicti*, are here given as "aforenamed," "aforementioned," or "aforesaid."

to Signor Orazio's house while he was out. Sometimes they came together, sometimes one or     [ms. 30]
the other came.

*She added voluntarily*: Whenever Signor Orazio left, he always entrusted his daughter to
me to take care of, and [he expected me] to notify him of the people who came to the house.
Even when I moved into his house, he warned me not to speak to his daughter about hus-
bands, rather, that I should persuade her to become a nun, which I tried to do several times.
However, she always told me that her father did not need to waste his time because every time
he spoke of her becoming a nun he alienated her.

*Asked to state whether, when the two aforementioned men or one of them came to Orazio's house
in his absence, they remained there for some length of time,*

*She answered*: Yes, Sir. At times, when the said Agostino and Cosimo, or one of them,
came to Signor Orazio's house while he was out, they would stay in the house for, let us say,
half an hour or an hour, and they would come up to my room [and say]: "Madam Tuzia, be
happy that we want to help your husband get the job and we want him to stay in Rome."

*Asked whether, when the two aforementioned men or one of them came to the house of the said
Orazio when he was out and they stayed there, the said Artemisia was present and talked to them,*     [ms. 31]

*She answered*: Yes, Sir, many a time when the said Agostino and Cosimo came to the said
Orazio's house and stayed there, Signora Artemisia saw them and talked to them.

*She added afterwards voluntarily*: Agostino came more often than Cosimo, who seldom
came. As a matter of fact, for the past few months, Agostino has been coming up to my place
and has seemed to be suspicous, his words clearly demonstrating that he suspected people were
coming to Artemisia's house. He would knock proudly and boast: "Whoever has come there,
you are doing and saying things and bringing people here to Artemisia's." When Artemisia
was downstairs in her apartment, he would go down to the door that leads into her rooms to
see what she and her father were doing. He showed great affection for Artemisia . . . ,[51] he
loved her very much, and for her and her father he would have given his life.

*And the judge asked her to state the reason that the said Agostino cared so much for the said
Artemisia and pursued her with so much love, and what motive induced him to try to find out whether
anyone else frequented her house, and to spy through the keyhole on what she and her father were
doing, and for what reason the same witness allowed the said Agostino to enter her own house at night
to do such things.*     [ms. 32]

*She answered*: The said Agostino said that he cared so much for Artemisia and that he
loved her very much because he loved her father very much, and was such a good friend of
his. And I opened the door to him whenever he came, so that he would not suspect that
Artemisia was at my place.

*Then the judge, having heard [all this], etc., terminated the interrogation and ordered that
the witness be sent back to her house for the time being.*[52]

---

[51] Hole in the page; three words missing.

[52] "*Ad cius locum pro nunc reponi mandat animo.*"
*Reponi . . . animo* is missing in Menzio. According
to Black's Law Dictionary, *animus* is a legal term
indicating will or intention. In this manuscript, the
word appears formulaically when witnesses are dis-
missed, followed by "etc.," with the intention un-
specified. Since the word *animus* has no particular
force here, we have not given an English equiva-
lent for it in these passages.

The 23rd day of March 1612

*Signora Tuzia, wife of Stefano Medaglia, as referred to above, appeared personally in the aforesaid place, before the aforenamed and me, etc. Having been ordered to swear to tell the truth and after she had so sworn under oath, she was asked by the judge to state whether she had ever accompanied the said Artemisia when Artemisia left the house, and where she had gone with Artemisia outside the house.*

*She answered*: Whenever the said Artemisia went out, while I was living in her house, I always accompanied her. At times I escorted her to Mass in S. Lorenzo in Lucina when we lived on Via della Croce. After we moved here I took her to Mass at S. Spirito. While we were living on Via della Croce, I took her one morning to S. Giovanni because she was not feeling [ms. 33] well and her father asked me to take her out for a walk. I took her to S. Giovanni at dawn because her father was jealously protective of this girl and did not want her to be seen. And when we lived in S. Spirito, I once took her to S. Paolo, and at times I took her to Mass in S. Onofrio.

*Asked whether other people were with them and if so, who, when the witness [and the said Artemisia] went to the churches of San Giovanni and San Paolo either to attend Mass or to revive Artemisia's spirits,*

*She answered*: When I went to S. Giovanni with Artemisia, on the way there we were alone, that is, Artemisia, I, my aunt Virginia, and Orazio's eldest boy Francesco, and while we were in S. Giovanni before the Apostles,[53] Artemisia said to me: "Look, there they are, Agostino and Cosimo, let's go away." And I said, "Let's go." We left without hearing Mass, and the said Artemisia began to walk as fast as she could so that the said Agostino and Cosimo could not catch up with us. The boy stayed behind and the said Cosimo and Agostino fondled him and bought him doughnuts [*ciambelle*]. Then the boy caught up with us, and Agostino followed him and was talking to him, but I couldn't hear what he was saying. And Artemisia [ms. 34] quickened her pace as if she wanted to escape, so much so that the boy and I and my aunt begged her not to walk so fast, because we couldn't keep up with her. Agostino stayed behind and I couldn't see which street he took. And we went straight home.

The time we went to S. Paolo we went in a carriage. We left the house—that is, the said Artemisia, my aforementioned aunt, Artemisia's brothers Francesco, Marco, and Giulio, my young daughter Faustina, Lucretia, and Diego—to go to S. Giovanni and S. Maria Maggiore, and as we were going down the Lungara, Agostino came up, in the company of some others. Stopping our carriage, he told the coachman not to budge because he wanted to get in, and when Artemisia refused to let him in, for fear of her father finding out, Agostino answered: "I want to get in anyway and I don't care if your father finds out; on the contrary, I would like him to find me here." And assuming the right for himself, he got into the carriage, along with another fellow whom I don't know, and ordered the coachman to go, not to S. Giovanni and S. Maria Maggiore as we had planned to do, but to S. Paolo. As we went through the gate and passed the Trinità, the said Artemisia said that she wanted to walk a little and got

[53] This would have been the fresco series of apostles in the transept, carried out from 1597–1601 under the direction of Giacomo della Porta and Cavaliere d'Arpino, which included Orazio Gentileschi's *St. Thaddeus* among apostles by Cesare Nebbia, Giovanni Baglione, Antonio Pomarancio, and others.

out of the carriage; and Agostino got out right after her, as well as some of Artemisia's broth-       [ms. 35]
ers. Agostino and Artemisia walked together and the boys played in the street. When we
reached the arch of S. Paolo, Agostino took the road that leads to the Porta Santa, together
with Artemisia. Those of us in the carriage took the road that leads to the front door,[54] and
then we all joined up again in the church. There we all went to confession, and after doing
that, we left and got into the carriage together and started home. Agostino got out of the
carriage with the other man in a small square near Ponte Sisto.

*She added afterward voluntarily*: In short, Sir, we could not take one step with Artemisia
without Agostino always being nearby, be it when we went to Mass or when we went some-
where else. Agostino was, so to speak, obsessed by Artemisia and he tormented me when he
could not come in and talk to her. He used to knock at my door so [hard], I would at times
refuse to open it, and Agostino would say that I had let someone in to see Artemisia, and he
threatened to do and say [things]. Then I would open the door out of fear, and also to make
it clear that no one had come there.                                                              [ms. 36]

*She added again voluntarily*: Also, Sir, I now remember that when we lived on Via della
Croce, I went with Artemisia one day, as her father had instructed, to Monte Cavallo to see
the hall and the palace.[55] Cosimo the orderly and his wife came to get us in a carriage, together
with a young woman they said was Signor Agostino's sister-in-law.[56] Then Signor Cosimo
took us to Monte Cavallo in the carriage, and there we found Signor Orazio, who showed us
the hall and the palace. Artemisia and Agostino's sister-in-law walked about, always holding
hands. After seeing the palace, we all went back to the carriage, except for the men, and went
to eat at Signor Cosimo's house, where Signor Orazio and Agostino also went. And we stayed
all day. Signora Artemisia played quoits in a small garden with some women of Signor
Cosimo's household, while Signor Orazio, Cosimo, and Agostino watched. Then in the eve-
ning we went home.

*Asked to state whether on the same day in which the witness and the said Artemisia went to the
church of San Giovanni, as she had mentioned above, they had further seen and talked to the said*       [ms. 37]
*Agostino after returning home, and if so, where,*

*She answered*: That day when I went to S. Giovanni with Artemisia, after we returned
home, I don't think we saw the said Agostino again, because when we went back to the house
Signor Orazio was there for dinner, and I don't remember that he [Agostino] came back after
dinner.

*Asked to state whether the said Agostino had been in the said Orazio's house in the latter's
absence while Artemisia was painting,*

*She answered*: Yes, Sir, Agostino sometimes pushed his way into the house while Signor
Orazio was out. One time in particular he came while Artemisia was painting a portrait of my
son,[57] and right after he came, Artemisia stopped painting. I left and went upstairs to my

---

[54] The Porta Santa, or "holy door," of S. Paolo is the righthand portal of the main facade of the basilica. The "front door" used by those in the carriage may have been one of the transept entrances. Cf. ms. 104.

[55] See note 49. Monte Cavallo is the name com-

monly used in the Renaissance for the Quirinal hill.

[56] Costanza.

[57] Although the word *ritratto* is used, no child portrait by Artemisia is known. See above, pp. 22–23.

apartment, leaving the said Agostino with Artemisia, and the boys [her brothers] were also there.

*Asked whether she had ever seen or rather, how she knew that the said Agostino had some scratches or bruises on his face, and if so, on what occasion,*

*She answered*: Yes, Sir, I saw—I don't remember on what occasions—Signor Agostino's face [*mostaccio*] scratched and his eyes sometimes bruised, but I don't remember when that was.

[ms. 38]    *Asked whether she had seen the said Agostino alone with the said Artemisia, how many times and where,*

*She answered*: Many a time have I seen the said Agostino alone in the room with the said Artemisia; she was undressed in bed and he was dressed. When I had occasion to go downstairs, I found them joking together, and sometimes Agostino would throw himself on the bed with his clothes on. And many a time I reproved her, and also in Agostino's presence, and she would say: "What is it you want? Mind your own business and don't meddle in what doesn't concern you."

*Asked if she knew whether carnal copulation had occurred between the said Agostino and Artemisia,*

*She answered*: No, Sir, I don't know whether carnal copulation had occurred between Agostino and Artemisia, because both of them denied it to me.

*Asked whether she had seen any other person alone with the said Artemisia, talking to her in her house or somewhere else when the said Orazio was out,*

*She answered*: I did not see nor am I aware that the said Artemisia has ever been alone anywhere with anyone other than the said Agostino.

[ms. 39]    *Asked whether she had ever seen any other person follow the said Artemisia besides the said Agostino when they went to attend Mass,*

*She answered*: I never saw nor noticed any person follow the said Artemisia when she was out except for the said Agostino.

*She added voluntarily*: Sometimes I told Artemisia that I didn't like this hot pursuit of Agostino's, and the said Artemisia replied that he was doing that because he had promised to marry her.

*Then the judge, having heard [all this], etc., terminated the interrogation and ordered that the witness be sent home for the time being.*

The 24th day of March 1612

*Giovanni Battista Stiattesi, of Florence, witness for the information of the Curia, was questioned in Rome in the office of and by the aforenamed [official] and me, in the presence of the aforementioned. Having been ordered to swear to tell the truth, and after he had sworn under oath, he was asked by the judge how he had come to the present interrogation, whether spontaneously or by summons, or as a result of someone's request, and if so, whose,*

*He answered*: I came to this interrogation because I was notified about Your Lordship's summons by Signor Orazio Gentileschi.

*Asked whether the examinee knew or could imagine what he would be interrogated about,*

*He answered*: I suppose that Your Lordship wants to examine me about whatever is alleged to have occurred between Artemisia Gentileschi and Agostino Tasso, with some participation [ms. 40] by Cosimo the orderly. I am led to believe this because I know that Agostino was put in jail, as was Madonna Tuzia who lives in the same place as the said Artemisia, and because Your Lordship also went to the said young woman's house to examine [her].

*Asked to state what is being said to have occurred between the said Artemisia and the said Agostino with the involvement of Cosimo the orderly, this being the reason for which he believes himself to have been summoned,*

*He answered*: I shall tell truthfully everything I know about what happened between Artemisia and Agostino Tassi, and why I claim that Cosimo the orderly took part in this affair. Having associated often with Agostino Tassi, Cosimo, and Orazio Gentileschi, I have taken part in their discussions both secret and open concerning the matter of Artemisia and Agostino. I have heard them say many, many times that, from the day Agostino arrived in Rome up to now, Cosimo had arranged for . . . Agostino to meet Artemisia in various ways.[58] The first time he arranged for them to meet was a day when the said Cosimo sent his wife to the said Artemisia's house in a carriage to take her out for a ride, and with his wife, his children, and Agostino's sister-in-law, he drove to Artemisia's house on Via della Croce. Cosimo, with his wife and children, got out of the carriage, went in the house and found Artemisia with her brother Giulio and Tuzia and her children. They wanted to take her out in the carriage,[59] but Artemisia didn't want to go without first informing her father, who was at Monte [ms. 41] Cavallo. When he received the message, her father sent someone to tell them to go in the carriage, all of them, and he would join them. And they did so. They went by Monte Cavallo to pick up Signor Orazio, and went all together to Monte Cavallo [*sic*], where I believe they stayed a while for the pleasure of seeing the Palace. Then the women returned to the carriage and Cosimo called Agostino, who was in a room of the Palace. And Cosimo and Agostino, along with Orazio, walked behind the carriage in the direction of St. Peter's, to Cosimo's house. There they dined—or had a light snack, whichever it might have been—the whole party. And there in Cosimo's house they all stayed for a while after the meal. Afterwards, the women got in the carriage and went to see St. Peter's, and then went home.

And the said Agostino, having become acquainted with Artemisia on this occasion through Cosimo's doing, thereafter the said Agostino began to go to the house of the said Artemisia whenever he pleased and whenever he conveniently saw that her father was not at home. By doing this, Agostino came to know the said Artemisia carnally and he deflowered her, as Agostino himself told me many times in confidence. And I also heard from Cosimo many, many times that it is true that Agostino deflowered her, and on this subject Cosimo often let me know that Agostino, having deflowered her, wanted her to marry him. And when [ms. 42] Agostino discussed this matter with me innumerable times, he told me that in any case, he was obliged to marry her, but that Cosimo was preventing this arrangement. He said to me: "Although Signor Cosimo pretends that he wants me to marry her, nevertheless there are very important reasons why I am out of necessity unable to do so." I prodded Agostino many, many

---

[58] Hole in the page; one or two words missing.

[59] ". . . *E volandolo menare fuori in carrozza, Artimitia.* . . ." This phrase is missing in Menzio.

times and urged him to tell me the truth about why he should not or could not marry her. At last, one night when I was sleeping with him in his house on the slope of S. Onofrio, after a long talk in which I practically forced him to tell me the reason, the said Agostino made up his mind, saying: "Stiattesi, I owe you so much that I cannot avoid telling you the whole story, but give me your gentleman's word that you will not mention it to Signor Cosimo." Then we took each other's hands, and I promised absolutely not to mention it to Cosimo. When I had so promised, the said Agostino began to speak and said: "You should know, Stiattesi, that it was Signor Cosimo who was the originator and inventor of the idea to have me meet Artemisia, and it's because of him that I have gotten into this great labyrinth. I am so entangled that I really must resolve to go to Tuscany, because I know that [otherwise] something distinctly unpleasant [*qualche disgusto notabile*] is likely to arise between Signor Cosimo and me.

[ms. 43]    "But because I am so indebted to him, as you know, I want to prevent this from happening. Since he knows how much I love Artemisia, what happened between her and me, and the promise that I made to God and to Artemisia, he had better not dare attempt to have Artemisia sexually, as he has tried to do. Besides trying to force her twice—once in the house on Via della Croce, and the other time in the house on S. Spirito—he has also said whatever he pleased about me. And as if this weren't enough, he tries to go to that house to disgrace me and he has generated a lot of misunderstanding between us.[60] Then, after the many, many times I had to restrain myself with Cosimo so that I could negotiate this matter and indeed go ahead and marry her, conforming to my obligation, Signor Cosimo told me quite firmly that I shouldn't encumber myself with this, because she is a very capricious woman and would cause me trouble as long as I live. In short, because of my debt to Signor Cosimo, to whom I owe my life, as you know, I cannot do anything without his approval. Now you see to what a state I have fallen."

Lamenting thus all night long, the said Agostino told me that he was in love with Artemisia and related what had taken place between them in every minute detail. Then Cosimo and I discussed this matter of Artemisia and Agostino. Cosimo sometimes said good things [ms. 44]   about it, and sometimes bad, but he was rather trying to prove to me that Agostino should not marry her. And since I had the impression that Cosimo was also in love with Artemisia, I prodded him so much that he said abruptly: "Stiattesi, don't concern yourself with this matter any more, because ultimately Agostino is a most virtuous young man who, when he wants to get married, will not lack other possibilities besides this one, because she is a shameless sluggard without any brains, the kind of woman who would bring him bad luck." When I told him that he was speaking out of jealousy, Cosimo answered: "It's not the way it used to be, when one day I wanted to screw [*chiavare*] her and tried with the strength of Hercules, but she never consented to give me even a tiny morsel. Let her just go to hell. And you, if you want to do me a favor, leave that house and let them disentangle themselves."

I had these conversations with both Cosimo and Agostino, innumerable times and in various places—specifically, at the Palace on Monte Cavallo, in Cardinal Borghese's gardens, at Agostino's house, at Cosimo's house, at the Palace of St. Peter's,[61] in church, in taverns,

[60] That is, misunderstanding between Cosimo and Agostino.

[61] On Cardinal (Scipione) Borghese's garden Casino of the Muses, see above, pp. 19–20. The "Palace of St. Peter's" is the Vatican.

everywhere. We haven't talked of anything but this for the past eight or ten months. And this Carnival, Cosimo put on a play [*Comedia*] and several parties at his house, where Artemisia, Agostino, Agostino's sister-in-law, and a sister of Agostino's[62] were always present. On the next-to-last day of Carnival [i.e., the day before Mardi Gras], in order to make Agostino really happy, he [Cosimo] and his wife took Artemisia to the room where the play was performed and, having put them together, left them to their pleasure. After Agostino and Artemisia had been together for a while, Cosimo said to them: "If you have not done your business, it's your loss." This I witnessed with my wife, and his [Cosimo's] children, as well as Orazio's and mine, were all there. And also Matteo the wagoner and Cosimo's servant Enrico the Frenchman were there. [ns. 45]

*Asked whether he knew if Agostino had or has another wife and, if so, where and since when and what was her name,*

*He answered*: I know that Agostino had a wife named Maria. I met both of them in Livorno several years ago when I lived in Livorno. I know that she ran away with a lover and Agostino made a big fuss and commotion to find her. But when he couldn't find her, feeling desperate and disgraced by her flight, as I heard later, he came this way by sea, together with his wife's sister and her husband. They brought along all their goods and utensils, and set up house here in Rome, living together as a family. Because of this cohabitation, last year he [Agostino] was sued by a sister of his for incest with his sister-in-law, as is verified in the records of the Borgo. Later on I learned from the same Agostino that he had had his wife killed, and I saw letters of reply from merchants in Lucca, Pisa, and Livorno, and in these I saw for myself that his wife had been killed. For several months prior to that, he had attempted to have her stabbed I don't know how many times, but he didn't succeed in killing her. All these things he confided in me as his friend, and among other such things I answered some of those letters in his name. [ms. 46]

*Asked when, where, and by whom the said Maria, wife of the said Agostino, was killed, and where he had seen the said letters, and what is their present disposition,*

*He answered*: I don't know who killed the said Maria, but she was killed, according to what Agostino told me, in Mantua or in the state of Mantua about three months ago. He also told me that those who performed the service had come to Rome to collect payment from Agostino himself, and had left right away. The said Agostino told me that he paid them, but he didn't say how much. Agostino showed me the said letters at his home and elsewhere in Rome, and I think he has them with him. I also know that he showed those letters to Artemisia because she told me so. [ms. 47]

*Asked whether he knew what had been negotiated with other people regarding the marriage of the said Artemisia, and with whom and for what reason it had not been concluded,*

*He answered*: Many times I heard Agostino and Cosimo say that Signor Orazio was trying to arrange a marriage for Artemisia, particularly to a young man called "*il Modena.*"[63] This marriage, and any other that was being negotiated, had been prevented by Agostino, who confessed to me many times in confidence and not in jest that it was true that he didn't want anyone to have any claims in that house, because he wanted Artemisia to belong to him and

---

[62] Agostino's sister Olimpia. This phrase, *una sorella di Agostino*, is omitted by Menzio.

[63] See ms. 10.

no one else. The same Cosimo told me many, many times that Agostino had prevented all the [prospective] marriages because he didn't want Artemisia to have any opportunities with anyone but himself.

*He added voluntarily:* On this point, I know that Agostino had many quarrels out of passion and jealousy, and twice in particular with that Modena.

*Asked whether he knew or had heard if the said Cosimo had ever slandered the said Artemisia by asserting that she was his daughter, and if so, in what manner,*

[ms. 48]    *He answered:* With regard to this, I can tell you that many, many times Cosimo asked me confidentially whether Artemisia resembled him even a little. When I asked him why he should ask, he always replied that Artemisia was his daughter for certain, and that other people had told him that she resembled him in certain features of her face, particularly the eyes and eyelashes. I found it strange that he would brag about such a thing and I told him: "Can it be possible that you would brag that she is your daughter and yet you wanted to fuck [*fotter*] her?" And he answered: "Be quiet, you prick, because this is the way one increases one's family." And so I kept quiet because I did not want to continue arguing with him. If you want to know the truth, question Dianora, wife of the mason Francesco Lucano, who was his servant and who lives on Camposanto, and my wife Porzia, and Artemisia herself. From them you will learn the truth.

*The examinee added:* I know that Artemisia had a painting of a Judith, not delivered [*non fornito*],[64] which she had sent to Agostino's house a few days earlier. I also know that Cosimo, with his shenanigans, on the last days of Carnival, while Artemisia was at his house, forged an order to obtain the painting from Agostino as though on her instructions. I was present when this took place. Cosimo wrote the note with his own hand in the name of Artemisia. And

[ms. 49]    regarding this matter I reprimanded Cosimo and told him that he should not take a painting of that sort away from a young woman [*zitella*].

*And to the other question he responded:* Many a time Agostino told me that he wanted to marry Artemisia. He was so jealous that, day and night, he had someone guarding her house to see if anyone went there. In the end he concluded that he found her honorable but he was very suspicious of her cohabitant Tuzia, and because of this suspicion he had asked her to lock a door, I don't know which. That this is true you can see and find out from others. In fact, he wrote several sonnets and letters to me, in which it is clear that he was deeply in love with Artemisia and that Cosimo acted as his procurer, which comes out in a sonnet beginning "Change, change." I am submitting this sonnet and the letters to Your Lordship so that you can verify this fact, with the expectation of getting them back when it is convenient.

*He produced and delivered to me, the notary, a page with a picture and with the following words: "I was the maker of my own misfortune," and also another page beginning with "Change, change,"*

[ms. 50]    *and another sheet beginning with "To the excellent spirit Stiattesi, oh fuck [cazzo]," and then another letter addressed to the witness, which begins "Most magnificent Sir, etc.," and finally another sheet of paper beginning "To the most excellent Signor Tasso, Heaven's cunt [potta]." I the notary received these writings and I kept them with me for reference.*

---

[64] Menzio gives this as *non fornito*; Bissell (1981, 155), as *non finito*. Anna Modigliani has confirmed from the original manuscript that it reads *non for-* *nito*, which could mean either "not commissioned" or "not delivered," most likely the latter. See Fig. 331, seventh line from bottom.

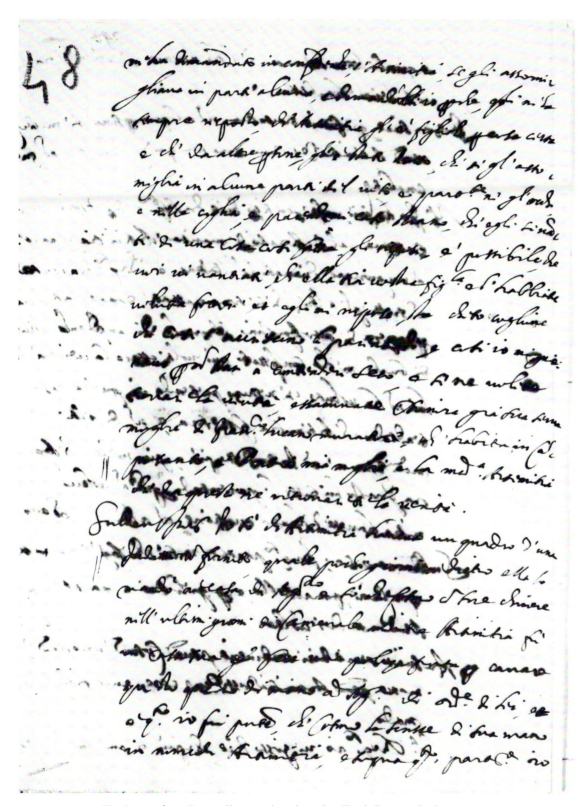

48

331. Testimony from Proceedings against Agostino Tassi, Roman Curia, 1612, ms. 48

*The examinee added:* All these writings which I have produced are by the hand of Agostino except for that page beginning "To the most Excellent Signor Tasso, Heaven's cunt, etc.," which I wrote in reply to the one that begins "Oh, fuck, etc."

*He added voluntarily:* And if you want to confirm that everything I said is the truth, look at this letter which I wrote to Cosimo on the first day of Lent. From this you can understand in detail how this affair transpired.

*Accordingly, he produced the said letter addressed to the said Cosimo: "To the magnificent and honorable. . . ."*

*Then the judge, having heard [all this], terminated the examination and dismissed the same witness after enjoining him to sign: "I, Giovan Battista Stiattesi, testified as to the above in good faith, etc."* [65]

[ms. 51]
Change, Stiattesi, change your mind
and, as my faithful friend, give me a little succor
Do not cross my path, as, indeed,
It really seems to me that you torment me very much.
Do, do like Cosimo the orderly
Who helped me and spared me from suffering.
Be a friend like him.
Keep me in your favor, as well as Napoliello. [66]

Your Lordship's most obliged,

Agostino Tassi

[ms. 52]  Al Signor Giovan Battista Stiattesi

[ms. 53]  [Drawing with the inscription:] I was the maker of my own misfortune
[IO DEL MIO MAL MINISTRO FUI].

[ms. 54]  To the most Excellent Spirit Stiattesi

Oh fuck [*cazzo*], Stiattesi, you are very wrong
to say that I asked you [to do] such a degrading thing.
All the world and Christ can say that
I never sullied myself.

[65] Menzio omits the preceding two sentences, which read as follows: *Prout facto exhibuit dictam epistolam dicto Cosmo directam incipientem al magnifico et honorevole . . . [holes in page]. . . . Tunc Dominus acceperit, etc., examen dimisit, et ipsum constitutum licentiavit iniuncto quod se subscribat. Io Joes Baptista Stiattese supra dicta deposuit pro tesi fate et infide, etc.*

The section of the transcript containing the poems and letters exchanged by Tassi and Stiattesi (mss. 51–63) has been omitted by Menzio.
[66] "Napoliello" was Agostino's apprentice Giovan Luca da Benevento, alias the Napoli (see ms. 8).

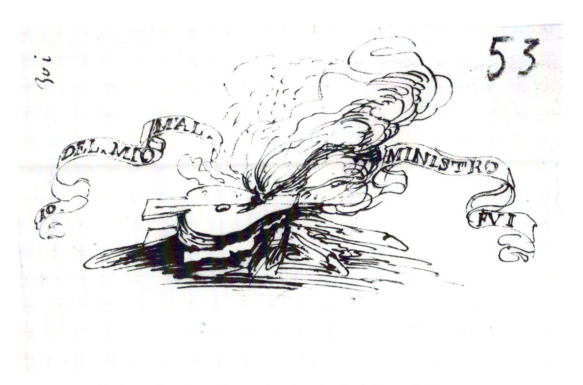

332. Testimony from Proceedings against Agostino Tassi, Roman Curia, 1612, ms. 53,
drawing by Agostino Tassi, "I was the maker of my own misfortune"

But indeed it is true as I always knew
    that I could not hope for compassion and honesty from you
    because you are blinded by those rays
    that have caused me such grief and misery.

But I swear on the body of the anti-Christ,
    that I do not want to see her ever again;
    that this is not the bond I had hoped for
    nor will I grieve for such a reason.

Mind you, you're going astray,
    because Cosimo was never a go-between
    and you were never a great man of honor.
    This is what the whole of Christendom believes.

Oh, what a labyrinth I have got myself into
    by wanting to battle with rhymes.
    I must not duel with you anymore.
    I am not going to live miserably, but am going to enjoy myself,
        for indeed I recognize

[ms. 55]  that it is a burning desire that makes you speak so.
And I shall consort with someone new.
    Do as you wish
as I do not want to lose my mind.
Here I end my duelling verses.
    Along with Napoliello,

I inform you that, whether near or far,
    I shall be at your service, and I kiss your hand.
        To conclude, I tell you and I believe it to be true,

That to change one's mind is often a habit.
    Only in Christ and in Him only I hope.

    I am most obliged to your Lordship
        Agostino Tasso

                    Strict with myself and prodigal with you.

[ms. 56]     To the Very Magnificent Lord and Master, Most Honorable
        Signore Giovanbattista Stiattesi

[ms. 57]  Most Magnificent Sir,
    If Your Lordship was kind enough to take care of those pupils trained by other masters,
you have also tried too hard to bring about change in some difficult matters too quickly. Fur-

thermore, you must not, nor can you, lay down the law to nature. So, I thought I would censure you a little, which I do as a dear friend, intending, however, not to be prejudicial, which is my wont, etc. Whether Your Lordship keeps your school open is of no consequence to me, as all schools are good as long as I make progress in virtue. And I have so determined. But I assure Your Lordship that, leaving aside these trifles and jokes, I assure you that I am your friend as always, and that whenever the occasion arises you will have proof of my good will.

All I have to tell you is that in school I have always acted with the honor characteristic of an obedient pupil. And if Your Lordship or others think otherwise, you are mistaken. For I [ms. 58] have always honored the master and his work, and I shall always do so, because I was never ungrateful towards those from whom I benefitted. And more than that, I could not find praise high enough nor more sublime expressions of respect for those people to whom I had to show appreciation for their infinite courtesies, no matter how small. And as I am in a hurry, I end by praying to Our Lord for all the happiness that you wish for yourself and your family as well.

Your Most Magnificent Lordship's most obliged

<div align="right">Servant Agostino Tassi[67]</div>

<div align="right">[ms. 59]</div>

[back of preceding letter]

> To the Most Magnificent Lord and Most Respected Master Signor
>     Giovan Battista Stiattesi

> To the most Excellent Signor Tasso        [ms. 60]

Heaven's cunt [*potta del cielo*], I am almost too dismayed
    to take this pen, paper, and ink
    to reply to the strong argument which,
    in its entirety, tends in your favor.

But let God act, and heaven as well,
    because it is fundamental to us
    to say that a fool is he who falls in love
    not with a beautiful woman but with a monster.

Your blows are not light
    dear Tasso, my singular friend;
    as you apologize with rhymes,
    wishing to assign your conduct to me.

Not ungrateful was I, but really poor.
    And any honest, just man can

---

[67] Tassi's allusions to school, masters, and pupils are probably intended as a sexual conceit.

always find hospitality in my house.
    If, however, you want to tax me with this:

To foresee is a prophet's thing,
    and it seems to me that you are not a seer,
    though you speak of rays like the priests,
    who make you live in sorrow and misery.

If, then, you are troubled by jealousy because of me,
    I feel that my love for you is breaking my heart.
    I can make you happy at the right time and place,
    but I can just as well make you lose your honor.
        But this is my sorrow

[ms. 61]    . . . was the string with which that woman [*quella*] . . .[68]

Everywhere the mouth of one who loves you
    expresses the ardent fire of the heart
        And this is not a game
To say that I love and adore that woman
    since you did not love the most beautiful one in the world.
        But this is not a tale [*novella*].
She is there for you, and not for other lovers,
    and all of you will go to hell;
        let the saints
Who were present at the high conceits [*alti concetti*][69]
    between the two of you alone be witnesses.
        And with such great delight
You spent your leisure hours many a time
    with the tears and the sights of a faithful lover.
        As many should be
The keys, the chains and the tortures
    which ought to tie you both for eternity.
        Since for you
I am wasting my breath, this paper and this ink;
    heaven help you
    and give you solace.
    And in the end I am all yours,
        Most affectionate and special servant of Your Lordship.[70]

[ms. 62]  I am adding a note for your consideration.
    Beware of what you are saying

[68] The page is torn; two or three words are missing at the beginning of the line, and a line or more is cut off at the bottom of the page.

[69] A sarcastic reference to their relationship.

[70] Page is torn; a final line not legible.

about your very own go-between.
    Listen carefully to everyone else's opinion
And to what the whole of Christendom thinks of him.
    I know and Agostino Tasso knows
    that wherever he turns everything falls apart.
    He should not think that he is talking to a piece of wood or a stone;

Because if I am here it is because of you,
    not because of his favor or charity;
    thus he should not think of himself as a parish-priest,
Nor should he talk behind my back or call me a scoundrel
    because I will not find it difficult to tell him everything
    that is on my mind about this affair [*festa*].
        All I have left to say
Is that Napoli is always in my heart,
    But something else is needed besides my love.
        Because she is in a great rage
The one whom he had so scorned [*sprezzata*]
    despite all her merits and deserts.
        I have no breath left.
The clock has just struck eight, and already, in great torment,
    I feel that I am overcome with sleep.

[back of sheet]                                                         [ms. 62 bis]

To the Most Illustrious Lord and
Most Respected Painter
Signor Agostino Tasso
at Monte Cavallo

[A page containing three rent receipts, whose relationship to the trial is not self-evident.]          [ms. 63]

In summary:

24 August 1611: Tomaso Lucino received from Pavolo Iachini one *scudo* [*scutti*] and thirty *baiochi* for one month's rent to the 23rd of September, for two ground floor rooms . . .

26 September 1611: Tomaso Lucino received from the same . . . for one month's rent to the 24th of October.

26 November 1611: Tomaso Lucino received from the said *mastro* Pavolo Iachini . . . to the 24th of December.

[letter from Giovan Battista Stiattesi to Cosimo Quorli]

[ms. 64]  Magnificent and Honorable Sir,

I don't know to what I owe this latest attack of yours on me, as I cannot imagine the reason you have changed your mind, and why you have not only come to an understanding with Agostino, but have also prevailed on your wife to do what the Devil himself would not do. I am very confused and do not know what steps to take to make you understand that I do not want your friendship.[71] Rather, I abhor it as the Devil does the cross. A while ago I learned that your friendship was not only beneficial to me,[72] but damaged me immensely. God should reward you as you justly deserve for having fed me with hopes in order to consume my life and my shoes. I thought that Carnival and masks were finished, and as a Christian, you also should show God that you remember him who granted you so many benefits. But I know that I am not the only one to be swindled by you, as quite openly you swindle Him who created you and brought you into the world, and you continuously offend Him with more than just vain and hateful words. Remember that in your time you have caused me endless grief and

[ms. 65]  you've gorged yourself on tormenting me, and you boasted about it through words and deeds. I've always had the patience of Job, hoping always that God would make you aware of it and would touch your heart, since I knew your wickedness and the bad way you treat anyone who interferes with you. But it comforts me to believe that what I have thought many times should be true: so I am confident then that, at the right time and place, God cannot fail to punish you for your offenses. For you always mistreat the poor men and all those who sweat for you and give you their labor and their goods. And what is worse, you have never respected your relatives, neither your brothers nor nephews nor cousins, not even your father or mother. As a matter of fact, you know how much trouble you gave everyone. And although you arranged for your nephew to obtain a benefice, you did not give it or donate it to him, but rather you sucked his veins as far as his heart. You know very well how many hundreds of *scudi* it cost his father. Remember that God's wrath is great and cannot be bought off on Saturday. Pay attention to this letter; I am sending it to you by post, so that you will consider it carefully and show it to the whole world. Since you prefer to have me as an enemy rather than a friend, and

[ms. 66]  you do me wrong without cause, at least it helps clear my conscience that as your cousin, I have been and am obliged to tell you what I believe is of help to your soul. And I remind you that during your last illness you did not want me to read anything spiritual to you, saying rather that to be read such things about conscience troubled you too much and I should postpone it until you had recovered. You recovered and went back to acting worse than ever; you have forgotten God completely and the Devil drives you with strange chimeras, causing you to be jealous of you-know-who, because you allowed yourself to believe that I was to act as go-between for your dishonest desires. But when after all that fuss and cajolery you found me a tough and honest man,[73] you involved your wife and Signor Agostino, and in the worst

---

[71] Missing in Menzio is the section from ms. 64, beginning with this sentence, to ms. 67, ending with "the help of God."

[72] He means the opposite: "was not only *not* beneficial. . . ." A negative has been omitted in the manuscript.

[73] This underlined passage on ms. 66, and the two on ms. 68, are underlined by hand in the original manuscript.

manner you took the opportunity to break off our association. Signor Agostino doesn't know you well as yet, but when such a time comes he will resolve as a man of honor to do what all the other people with whom you have associated have done. And by the end of the year you will be the one to suffer the cost, and you know it. In the end he will know me and you, even [ms. 67] though now he is blind with passion and is reluctant to associate with me; instead, to please you, he does everything that you persuade him to do. Have a good time and don't be envious. But remember that by now you should be satisfied with the many torments you have caused me. And to think that I am a man burdened with many children, poor and ruined on your account and because of your bad advice; and you should be satisfied with whatever good and bad you have done to me so far. Don't go too far with this behavior of yours. Let me live my life and don't torture me unjustly any more; give me a chance to see the end of the many torments that you and your wife have caused me. Remember that in Rome there is good justice, and there are also people who will listen to me willingly. They would have heard [from] me by now if I had decided to be indiscreet, but I have always been a respectable man and so I will remain until the end, with the help of God. Your wife was not satisfied with what she said out loud to Signora Artemisia many, many times. And even today, incited by the Devil; it was not enough for her to write one letter, she wrote three, in a tone and form that [ms. 68] you will see in the two of these letters I am sending you. As for the other one, I am keeping it since it is the most vile, to use at the right time and place. I have never said anything against this house, and particularly against this poor girl, that would damage her honor as you have done; and if no one else has disgraced her with deeds and words, you have. Your wife has no brains, so you should have them for her and make up for your faults or you will cause [me more] diabolical beastliness. If you don't want to do me good or be helpful to me, [at least] don't do me ill or damage me; because if I am staying here without rent and [treated] with kindness, you shouldn't bear me a grudge. On the contrary, because of this and because of your friendship with Signor Orazio, you should reward him with other gifts than this abuse. You also ought to be ashamed of taking a painting of that kind from this girl, just as if she were obliged to pay you for [not] having given you a copy of her *naturale*.[74] Yet I cannot see that you are conscience-stricken. Think of the result, do unto others what you would have them do unto you, and nothing less, and believe that God sees and hears every little action of ours.[75] Do not ridicule this, and don't say that I am writing in anger because you are wrong. [ms. 69] Prepare yourself for confession and for the restitution of everything that is on your conscience.

---

[74] ". . . *et anco doveresti vergognarvi di pigliare da questa fanciulla un quadro di quella sorte, come proprio ella sia anco obbligata pagarvi per havervi dato copia del suo naturale. . . .*" In this passage, Stiattesi *appears* to be saying that Artemisia had given Cosimo a (sexual) sample of herself, an assertion that would contradict all other testimony. Efrem G. Calingaert suggests that the speaker has deliberately omitted a negative, just as he had done earlier in the same letter (note 72), in both instances to add a note of sarcasm or irony. We have accordingly restored the "not," so that the passage makes sense. However, it is puzzling that Stiattesi uses *il naturale* ("the male organ") rather than *natura* ("the female organ"). This choice may be influenced by another word play operative in the passage, since *al naturale* ("life-size") and *copia* ("example" or "copy") are terms of art parlance. Thus Stiattesi conjoins Artemisia as artist and as sexual object.

[75] Menzio omits the section from ms. 68, beginning with "Think of the result . . . ," to ms. 69, through the end of the body of the letter.

Today we are alive and tomorrow we could be underground. I give you my best judgment in the name of Christ. If we were in a place of truth you would hear thousands [of words] more beautiful than these, but my stomach is so revolted by your intrigues, I can't bear it anymore.

As a last reminder, I tell you to watch your step and think of your many friends and protectors [*patroni*] who were prosperous but have fallen from their perch. In life and in death you will be judged by your actions, and *what has been acquired dishonestly a third heir will not enjoy*;[76] the river carries things away. One ounce of honor is worth more than one hundred *scudi*. Keep what you have built with the blood of the poor and with ill-gotten gains, and I will stay with my children and will wipe my ass with rags and God will always be with me, now and on the point of death. I leave you to meditate on this letter written with my heart and soul, in order to teach you and to wake you from your sleep.

<div style="text-align: right">Giovan Battista Stiattesi<br>your blood cousin</div>

[ms. 69 bis]    [back of sheet]

To the Magnificent Signor Cosimo Quorli Orderly of our Holy Father.

<div style="text-align: center">At home.</div>

[Interrogation of Agostino Tassi]

[ms. 70]                                         The 26th day of March 1612

*Agostino Tassi of Rome appeared personally, as a principal with regard to himself, as a witness witih regard to the others, in Savella Prison in Rome, before the aforenamed and me, etc., in the presence of the aforenamed. Having been ordered to swear to tell the truth, and after he had so sworn under oath, [he] was asked by the judge when he had been imprisoned, where he was seized, and whether he knew or could imagine the reason for his arrest and the present interrogation.*

*He answered:* I've been in prison since Friday; it's been eight days since I was arrested on Via della Lungara at about ten o'clock in the evening, and I was taken alone. I don't know nor can I guess the reason I was arrested, or why Your Lordship wants to question me.

*Asked whether on other occasions the witness had been arrested, interrogated and tried for any reason, for what cause and before which judge, and whether he had been acquitted or convicted, and if the latter, with what punishment,*

*He answered:* I've been in prison two or three times, once in Borgo, under the pretext that I had had carnal relations with a sister-in-law of mine named Costanza; I stayed in prison two days and then was released by order of Our Lord [i.e., the Pope] and acquitted with no requirement of payment. Violano was my Judge. Another time I was in prison in Tor di Nona for a triviality; Your Lordship was the Judge and I was released immediately. I was also ques-

---

[76] This phrase is given in Latin: *de male acquisitis non gaudebit tertius heres.*

tioned and tried in Livorno for having beaten someone up[77] and I was acquitted. I have not been questioned, tried, or imprisoned any other time.    [ms. 71]

*Asked which was the witness's place of origin and what was his practice and profession,*

*He answered:* I was born in Rome, in Borgo I believe, and I am a painter.

*Asked whether he had always lived in Rome without interruption or whether he had left for some time, and if so, where he went, in which place or places he stayed, and for how long and on what occasion,*

*He answered:* I left Rome as a young man, I was probably about twelve years old when I went to Florence, in Tuscany. There, as I already had introductions and support in my profession as a painter, I got into the service of His Highness of Florence.[78] In this way I was able to perfect my skills to some extent, and I did many paintings while continuing to serve the old Grand Duke until he died. After his death I finished some works that I had begun, and then I came to Rome. Also, as I had gone with the Grand Duke to see the world, I also sailed, by his order, on his galleys.[79] When I returned to Florence I continued to serve him in my capacity as a painter, as I said.

*Asked to state when he returned to Rome, and on what occasion,*

*He answered:* It's been about eighteen months since I returned to Rome, to see my birthplace again, and also to pursue my work as a painter, which I have done through continuous service to Our Lord, painting the apartments at Monte Cavallo.[80]    [ms. 72]

*Asked whether the witness had any blood or other relatives in the city, and if so, who, and would he specify the degree of relationship and consanguinity,*

*He answered:* Here in Rome I have two sisters by the same mother, one called Olimpia, married to a furrier, and another called Clelia, married to a mason. I also have a sister-in-law and a brother-in-law: her name is Costanza and her husband's name is Filippo.

*Questioned about the degree of relationship between himself, the said Costanza, and her husband,*

*He answered:* The said Costanza is my sister-in-law because she was the sister of my wife who died.

*Asked how long ago his wife had died, where, and whether she had died a natural death or otherwise, and how,*

*He answered:* I cannot tell Your Lordship how long it's been since my wife died, because I left her and went away. Since I've been in Rome I had no way of knowing that she died, nor how long ago.

*Asked to state the specific place he had left his said wife when the witness departed Tuscany,*

*He answered:* When I departed Tuscany I left my wife in Lucca.

*Asked to state whether he had lived with his said wife in Lucca, and for how long, before his*    [ms. 73]
*departure for Rome,*

---

[77] See Wittkower and Wittkower, 1963, 162–64, on Tassi's criminal record.

[78] Ferdinando I de' Medici, Grand Duke of Tuscany (1549–1609), who was the father of Artemisia's Florentine patron, Grand Duke Cosimo II.

[79] As Pugliatti observes (1977, 18), Agostino's sea travel on the Grand Duke's galleys provided him a visual repertory for his numerous paintings of ships, sailors, fishermen, and marine scenes.

[80] See note 55.

*He answered:* No, Sir. I wasn't living in Lucca when I left Tuscany to come to Rome, nor was I living with my wife.

*Asked how long the witness had been married to his wife before his departure from Tuscany for Rome,*

*He answered:* I got married about eight years before I left Tuscany.

*Asked how long the witness had not lived with his said wife before his departure from Tuscany,*

*He answered:* Fifteen days before my departure from Tuscany I said goodbye to my wife.

*Asked to name the specific place where he took leave of his said wife when he came to Rome,*

*He answered:* Fifteen days before I left Tuscany, as I said, I was in Lucca with my wife, and unbeknownst to me, she stole seven or eight hundred *scudi* from me, as well as some gold and silver things, and ran away. I let her go to hell and came to Rome. Later I heard that she had died.

[ms. 74]      *Asked how the witness had had news of his said wife's death, and how long before,*

*He answered:* Some friends of mine wrote to congratulate me that she was dead, and thus gave me the news that she had died. But I don't remember how long ago.

*Asked to state and indicate who in fact were his said friends who had informed him of his said wife's death,*

*He answered:* Those from Lucca who informed me of my wife's death were: for one, Signor Bonaventura Mattia, Giovanni Segni, and others whom I don't remember now. They wrote me about it from Lucca.

*Asked whether, in addition to the news that she was dead, the witness had been informed by his aforementioned friends of the way in which his wife had died,*

*He answered:* No, Sir. I was not informed by the aforementioned friends of how my wife had died. They only wrote me that she had died, and I didn't inquire about anything else.[81]

*Questioned and admonished to think carefully and to turn his mind to speaking the truth and avoiding falsehood, on the ground that what was discussed about the matter in great part had been forgotten,[82] it being unlikely that he had not tried to find out how his said wife had died and whether she had left any possessions, if for no other reason than to recover some of the goods left to him,*

[ms. 75]      *He answered:* I didn't pursue it, nor was I concerned to find out how my said wife had died, because I didn't care, and I didn't need to find out whether she had left anything after her death because I had already recovered what she had taken from me, to the last penny, thanks to a letter that His Highness [i.e., the Grand Duke of Tuscany] wrote. If she had left anything of her own, I didn't care to have it because I am not a slave to money, and I have earned more money than what I weigh, even if I haven't got a penny.[83]

*Asked to state where the witness lived here in the city, and whether he lived in a house by himself or had someone to share the house, and if so, who,*

---

[81] Due to a large hole in ms. 74, several words in two lines are lost. This passage is given by Menzio as follows (underlined words not now legible in ms.): "*Signor no che dai predetti amici non son stato avvisato in che modo detta mia moglie sia morta.*"

[82] A hole in the page accounts for one missing word, making this sentence difficult to translate: "*quod ex quo agebatur de re quae . . . (multum ?) interierat ipsius inverosimile est.*"

[83] Menzio (1981, 156 n. 34) notes that Tassi died in extreme poverty (also Pugliatti, 1977, 168).

*He answered*: When I first arrived in Rome I lived near Pandolfino's vineyard on the slope of S. Onofrio. Since the last day of Carnival, I have lived continuously in the house on the Lungara where I am at present.[84] My brother-in-law and his wife Costanza have always lived with me where I now reside. I didn't have them in the other house because it wasn't comfortable with so many people.

*Asked whether he was alone or in someone's company when he came to Rome from Tuscany,*

*He answered*: When I came from Tuscany, I wasn't with anyone; I came alone.

*Asked whether his said brother-in-law and sister-in-law were here in Rome when he came and*          [ms. 76]
*where they lived,*

*He answered*: When I came to Rome my said brother-in-law and sister-in-law were already in Rome, having come there about twenty days before my arrival. They went to my sister's house at the Imagine di Ponte, and stayed there until we took the house on S. Onofrio, where we lived together for a while. Then, when I was in jail, they left the house, but we went back to living together when I was acquitted, because Signor Violano, the trial judge, gave me permission to do so.

*Asked to state whether his said sister-in-law and brother-in-law had come to the city on his behalf and with his participation,*

*He answered*: As I had to leave Tuscany, the said Costanza's husband was sorry to lose my instruction[85] since he hadn't yet finished his study and he valued my advice on the matter. So I said to him that if he wanted to be near me he should come to Rome, and that I would always help him as I had done in the past.

*Asked whether the witness [now] had any close partners or friends in this city or whether he had had such friends in the past with whom he used to keep company, and if so, who they were,*          [ms. 77]

*He answered*: Yes, Sir. Here in Rome I do have friends with whom I usually associate and keep company. In particular, I've kept up and associated with Cosimo Quorli, orderly of the [Vatican] Palace, his friend Francesco Ormandi, and Orazio Gentileschi. I haven't had any other close relationships.

*Then he said*: I was also friendly with Giovan Battista Stiattesi and with Signor Orazio Borgiani,[86] all very close friends of mine, but now I don't know which ones are [my friends], or whether they are friendly to me or not.

*Then he added voluntarily*: Your Lordship should know that I wish to state which ones of these are not my friends now. They are Orazio Gentileschi and Giovan Battista Stiattesi, and I declare these two to be my enemies.

*Asked to state what reason induced him to declare the said Orazio and Giovan Battista his enemies, if previously they had been his closest friends, and when he had crossed them off his list of friends,*

*He answered*: The reason that caused me to declare the said Orazio and Giovan Battista

---

[84] There is a hole in the manuscript, rendering a loss as follows (Menzio's construction; underlined words not legible in manuscript): "*dall'ultimo giorno di Carnevale in qua io son di continuo habitato nella casa.*"

[85] Literally, "to leave my school" (*tralasciare la*

*scola mia*). He probably refers to instruction in art.

[86] Orazio Borgianni (c. 1578–1616), a Sicilian-born painter in the Caravaggesque circle, who worked first in Spain and then, after about 1604, in Rome.

my enemies is that I had lent both of them some money, willingly and without interest. When I tried to get it back they showed themselves to be mortal enemies by saying they would find a way not to pay me back. About fifteen days before I was put in prison, I fought with them to be paid my money back.

[ms. 78]

*Asked to state how long he had associated with the said Giovan Battista and Orazio, and on what occasion they had become friends,*

*He answered*: I know Gentileschi because he is a painter, and I've known him for a while. He also painted with me at Monte Cavallo and thus we became acquainted. I know Giovan Battista because he is Cosimo Quorli's relative, and while I was painting at Monte Cavallo he used to come there to watch. He started to eat and drink with us, and he was always penniless.

*Then he added voluntarily*: On Thursday before Mardi Gras [*giovedì grasso*], the traitor begged me [to help him] for God's sake, because he had to send his children to the steps of St. Peter's [to beg]. And I gave him two *testoni* out of pity, and I also sent a dish with other delicacies to his house.

*Then the judge, having heard all this, etc., terminated the interrogation and ordered that the witness be sent to his place for the time being, etc., enjoining him to sign: Agostino Tasso.*

[ms. 79]

The sixth day of April 1612

*Agostino Tassi, as referred to above, appeared personally and before the aforenamed and me and in the presence of the aforenamed. Having been ordered to swear to tell the truth, and after he had sworn under oath, he was asked by the judge whether he needed to add anything voluntarily to what he had already testified in his other deposition.*

*He answered*: I don't need to add anything else to what I said in my other testimony.

*Asked to state the reason why he had called Giovan Battista Stiattesi a traitor at the end of his last deposition,*

*He answered*: At the end of my last examination I called Giovan Battista Stiattesi a traitor because, having lent him and Orazio Gentileschi some money, I met them both at the entrance to [*portone di*] S. Spirito a few days before I was put in prison, and asked them to return it to me. Instead of giving it back, they said that they intended to persecute me and malign me. Since he wanted to do this to me,[87] I did call him a traitor.

*Asked whether there had ever been an exchange of letters between the witness and the said Giovan Battista Stiattesi, and if so, of what kind and tenor,*

[ms. 80]

*He answered*: It's possible, Sir, that between Giovan Battista Stiattesi and myself there was an exchange of letters, but I don't remember.

*And when the judge told him to answer the preceding [question] accurately and not ambiguously, and furthermore to specify whether, if any letters had been exchanged between the witness and the said Giovan Battista, they were written in verse or in prose,*

*He answered*: Now I remember that once I wrote a sonnet or *ottava rima* to the said Giovan Battista because he had given me his word and promised that he was willing to be my

---

[87] The first clause of this sentence is missing in Menzio. The original reads: *che volendomi lui per il mio far questo.*

procurer and would enable me to enjoy myself at the house of a woman nicknamed Bernascona, who lived in the same building where he lived near Porta Angelica.[88] Day after day he beguiled me with words and thus did me out of some *testoni*, all of which the said Bernascona knew nothing about. Since this happened some time ago, I wouldn't have remembered it now, much less the tenor of the said letters.

*Asked whether, if the said letters were shown to the witness, he would recognize them, and whether he had received a reply from the said Giovan Battista,*

*He answered*: Yes, Sir. If I saw the letters I sent to Giovan Battista on this subject, I would recognize them. And I did have a reply from the said Giovan Battista.

*The witness, having been shown by me, etc., as instructed, some rhymes written on a piece of paper addressed to Signor Giovan Battista Stiattesi, beginning with "To the excellent spirit Stiattesi, oh fuck, Stiattesi," and ending with "Strict with myself and prodigal with you," and also other letters in rhymes addressed to him [the witness] in reply to the above, beginning with "To the most excellent Signor Tasso, Heaven's cunt, etc.," and ending with "Torment," and after having looked at them and inspected them well,[89]*          [ms. 81]

*He answered*: I have looked carefully at these two letters in rhyme which Your Lordship has shown me, and which end and begin as mentioned above, and I say that the letter which begins: "To the Excellent Spirit Stiattesi, oh fuck" is from me, and that that is the address where I sent it to Stiattesi on the aforementioned occasion. But the other one, addressed to me, saying "Heaven's cunt," I never received from the said Stiattesi and I never saw it before now. It's something invented by him.

*Asked to explain in every detail the letters that he had sent to the said Giovan Battista, and to give them a meaning,*

*He answered*: I cannot state clearly, as you want me to do, what was meant to be conveyed by that letter I wrote in verse to Stiattesi unless there turns up[90] another *ottava rima* that I had written previously, in which I had begun discussing the matter.

*Then the judge showed to the same witness a page beginning: "Change, Stiattesi, change" etc., and ending: "As well as Napoliello."*

*After this was shown to the witness and he had looked at it carefully, and it was antedated by the judge,[91] he was asked to give a full explanation of both letters.*          [ms. 82]

*He answered*: I had dealt with the said Giovan Battista in order to be introduced into the said Bernascona's house, and since every day he was doing me out of some money, I was getting more agitated. At last, after he had extorted a lot of money from me, one evening he told me to go [there] and he would introduce me to Bernascona. Since we had an appointment, I went, but the said Stiattesi didn't want to let me in, saying that it couldn't be done that evening, but he would let me in another evening. Thus I sent him those verses beginning

[88] Porta Angelica, unknown today, was according to Menzio (1981, 156 n. 38), formerly called Porta S. Egidio, and also Porta S. Pellegrino, Porta Viridaria, Aurea, Stercoraria, Merdaria, and Porta S. Pietro.

[89] A section is missing from Menzio, from the last three lines of ms. 80 through the first eight lines of ms. 84.

[90] A hole in the page obscures one word; *trova* is likely.

[91] "Antedated" presumably means that the earlier date of the letters was recorded.

with "Change, change" to show him that his mistreatment of me was too much. Later I sent him the others, which begin with "To Stiattesi."

*Asked to specify more explicitly what he had intended to imply in the various parts of the said letters, and to express accurately the meaning intended,*

*He answered*: In the first *ottava rima*, beginning with the first verses, I meant to say that Stiattesi should change his attitude and stop torturing me as he had been doing, showing me one thing for another, and that he should help me enter [that place] as he had promised, and not represent white with black, as he had been doing so far, by making me go there, saying I would be able to go in, which then wasn't true. I exhorted him not to be a false friend, but a true and real one like Cosimo, who served me on all honorable occasions, even though he [Stiattesi] wanted to serve me as a procurer, which he was. And this is what the first *ottava rima* was about. The excellent Napoliello, whom I name at the end, was a servant of mine, mentioned as a joke.

[ms. 83]

As for the other [letter], in the first four verses I referred to the fact that he had made me go there but had not let me in, and then came to Monte Cavallo, giving me as his excuse that he hadn't let me in in order not to upset a friend. Therefore I wrote him that he was very wrong not to give me an introduction into the said woman's house, and that it was base on his part since he was a procurer by profession. As for the second stanza, I impressed upon him that he was only giving me words because he himself was in love with the said Bernascona and this took precedence over me. In the third stanza I meant to say that although I had desired to get pleasure from her, by then I didn't care. In the fourth one I meant to say that, his having touched the person . . . (?),[92] he should be very careful of what he was saying about him, as I didn't want to hear a friend of mine maligned. In the fifth stanza I say that I didn't want to continue arguing with him and wanted to let him go. In the others at the end I say that, since he was in love with Bernascona, I didn't want to lose my mind over him, but wished to concentrate on living without further thoughts about it, as sometimes it is one's habit to change one's mind. And this is the meaning of the sonnets that I wrote to the said Stiattesi.

[ms. 84]

*Asked whether the aforementioned Giovan Battista had ever been in the witness's house and spent the night there during the period when he [Giovan Battista] was a friend,*

*He answered*: Yes, Sir. While the said Giovan Battista was my friend he came to my house many times, and there he also ate and slept.

*Asked whether, when he spent the night in the witness's house, he slept alone or with someone,*

*He answered*: When Giovan Battista came to spend the night in my house he slept with me.

*Asked whether, while the witness and the said Giovan Battista were in bed together, they had any conversation, and if so, about what,*

*He answered*: No, Sir. While the said Giovan Battista slept with me in my house, we never discussed anything but general matters.

*Asked to say and declare specifically what these general subjects were that the witness and the said Giovan Battista discussed in bed,*

*He answered*: Giovan Battista and I talked about his saying that he was going to go beg-

---

[92] A hole in the page, with one or two words missing, makes this phrase illegible.

ging with his children and that he would be desolate. He also told me that he was in love with Gentileschi's daughter, and she with him, and that they were fucking each other. He also told me about other matters of love, and that wherever he had worked, he had deflowered virgins and impregnated women, and that he even impregnated a woman almost 50 years old, and has a son by her. [ms. 85]

*Asked to state on what occasion they got to the particular topic of the said Orazio's daughter, and who had prompted such talk,*

*He answered*: We came to talk about the said Orazio Gentileschi's daughter because he was sighing and wailing that he was in great pain and that he was in love. When I asked him why he was complaining so much, he told me that he was madly in love with said Orazio's daughter named Artemisia. And when I told him that by acting like that he was harming both their friendship and himself, because of the favors that Orazio was doing for him, he said: "I don't know what's wrong with that [*non so che ci fare*], I can fuck and eat in Gentileschi's house."

*Asked to state how long ago and when the aforementioned exchange between the witness and the said Giovan Battista took place,*

*He answered*: Your Lordship may estimate that 25 days after the said Giovan Battista came to Rome, he began to have dealings with the said Artemisia when he started to go to the said Orazio's house together with him [Orazio], then he began to go by himself, and to have to do with the said young woman.

*Asked to explain how he could testify the above so affirmatively, and how it was known to him,*

*He answered*: I said what I had to say affirmatively because Stiattesi himself confessed it in my house. [ms. 86]

*Asked whether the witness used to frequent the said Orazio's house and when he began to visit the said house,*

*He answered*: Yes, Sir, I used to frequent Orazio's house. In fact I have visited it since my arrival in Rome, because he took me to his house to see some paintings.

*Asked whether the witness had ever been to the said Orazio's house in his absence, and if so, how many times,*

*He answered*: Yes, Sir, sometimes I went to the said Orazio's house while he was out, but I don't remember how many times.

*Asked to state for what purpose he had gone to Orazio's house in his absence,*

*He answered*: I went to Orazio's house in his absence because he had sent me there, since he wanted me to teach perspective to his daughter. I went a few times, and then I didn't want to go anymore.

*Asked whether, because of the task for which the witness had been in the said Orazio's house, he had talked with his daughter Artemisia, and whether someone else was present or they were alone,*

*He answered*: Yes, Sir, when I went to Orazio's house while he was out I spoke to his daughter. His boys, Artemisia's brothers, were there, and I never spoke to her alone.

*Then the judge, having heard [all this], terminated the interrogation and ordered that the witness be sent to his place for the time being, enjoining him to sign: Agostino Tassi.*

[ms. 87]                                                                    The 8th day of April 1612

*Agostino Tassi, referred to above, appeared personally in the aforementioned place and before the aforenamed and me, etc., and in the presence of the aforenamed. Having been ordered to swear to tell the truth, and after he had so sworn under oath, he was asked by the judge whether he needed to say anything else voluntarily, in addition to what he had testified in his other depositions, to add to or subtract from it, and if so, what.*

*He answered*: I don't need to say anything more than I have said in my other testimony. Neither do I have anything to add or subtract.

*Asked whether, when the witness spoke to Artemisia, Orazio Gentileschi's daughter, for the said purpose, other persons were present besides Artemisia's brothers, and if so, who,*

*He answered*: This I don't remember, Sir.

*And when the judge told him to answer the preceding question precisely, not with ambiguous words,*

*He answered*: I don't remember, Sir.

*And when the judge went on pressing him many times to give a precise answer, he kept saying*: I don't remember, I have no memory of it, as I have other worries besides these.

*Asked and admonished to state what in fact were these worries that the witness claimed to have*
[ms. 88] *on his mind, because of which he couldn't answer the preceding questions accurately,*

*He answered*: The worries, which are the cause of my inability to answer Your Lordship accurately on the question of whether other people besides Artemisia's brothers were present when I spoke to her in her father's absence, are the study of my profession and the amount of work that I have to do for Our Lord and the Most Illustrious Cardinal Borghese.[93]

*Asked to state whether, according to his knowledge, the said Orazio had any fellow tenants who lived in the same house as he, and if so, who,*

*He answered*: Yes, Sir. In the same house where Orazio lived there also lived with him a certain Madam Tuzia.

*Asked whether the said Tuzia lived together with the said Orazio, or separately in another part of the house, and if so, where,*

*He answered*: Signor Orazio told me that he had rented some rooms upstairs to the said Tuzia.

*Questioned as to the occasion on which the witness was told the aforesaid things by the said Orazio, when, and on what occasion,*

*He answered*: The said Orazio told me that he had brought the said Tuzia to live in the same house where he lived with the firm intention of finding a remedy for the many troubles his daughter was causing him by being wild [*sfrenata*] and leading a bad life. He was very desperate, and therefore had established the said woman in the house to straighten everything
[ms. 89] out. And he told me all this at Monte Cavallo, a little over a year ago if I'm not mistaken, when we were working together at Monte Cavallo in the Sala Regia, and he began to complain about his troubles to me.

---

[93] He speaks of both Pope Paul V (Camillo Borghese), who commissioned the fresco decorations of a number of rooms in the Quirinal Palace, and Cardinal Scipione Borghese, the pope's nephew, who sponsored the decorations of the "Casino of the Muses." Tassi was active in both projects; see Rudolf Wittkower, *Art and Architecture in Italy, 1600 to 1750*, The Pelican History of Art (Baltimore: Penguin, 1958), 11–12.

*Asked to state whether the said Orazio had specified and explained to the witness what he had meant by saying that his daughter was leading a bad life,*

*He answered*: Sir, I will tell you everything as it happened. At the time when Orazio lived on Via dei Greci, one evening he came to call on me and asked me to come with him and help him, as he had seen a fellow called Geronimo Modenese,[94] a painter, enter his house. I went with the said Orazio and with my backing, he dealt the said Geronimo a few blows. The fellow took two or three of them and then ran away.

*He added afterward voluntarily, correcting himself*: I placed myself between the two to protect them both, so that they wouldn't hurt each other. This Geronimo had kept that daughter of Orazio's for two years and had had his pleasure from her until he got the beating. On this occasion, the said Orazio unburdened himself to me about his afflictions and stated to me that by saying that his daughter was leading a bad life he meant that she was a whore, and that he didn't know what to do to remedy this.                                                          [ms. 90]

*Asked to state where the said Orazio had gotten the stick to beat up the aforesaid Geronimo, and if, when Geronimo was beaten up with the said stick, it was during the day or at night, and in which place.*

*He answered*: Orazio took the stick he used to beat Geronimo from his own house, right at the entrance door. It was a broomstick, and he beat him right there in his house. It was about two-thirty in the morning.

*He added afterward voluntarily*: I shall tell you how it happened. That evening Artemisia, Orazio's daughter, believing that Orazio was going to Cosimo Quorli's for dinner and would stay there until four or five [A.M.] before coming home, let this Geronimo in her house. But because Orazio had stopped near the house to talk with I-don't-know-whom, he saw the said Geronimo enter his house. He thus came immediately to look for me in the shop of the man who sells paints on the Corso. I was waiting for him there, and he told me everything. Then he asked me to go with him, and we went together, and I went gladly so that no one would get hurt. But this Geronimo blamed me for everything, and held it against me for six months.          [ms. 91] One morning last summer, as I was hurrying to go to Cardinal Nazaret's vineyard, the said Geronimo together with two other armed men surrounded me, with their swords drawn, to attack me. It was a good thing for me that I could defend myself, because if I hadn't known how to defend myself, they would have killed me.

*Asked to state in which month the aforesaid fight between the witness and the said Geronimo took place, and whether anyone was injured, and if so, who,*

*He answered*: I think that this fight between me and the said Geronimo took place in April. No one was injured nor hurt in any way.

*Asked whether he had had other fights with the said Geronimo, before or after, for other reasons, and if so, how many times and where,*

*He answered*: No, Sir. There was no other fight or argument between the said Geronimo and me, except the one I mentioned above, which occurred when he attacked me.

*Asked whether a reconciliation between the witness and the said Geronimo had followed, and if so, by whose intervention,*

*He answered*: A few days after the fight, Geronimo and I made peace, and it was done

---

[94] See note 23.

through Abbot Bandino in the Cardinal's house, and by his order. Also taking part were those other two fellows who were with Geronimo, who said they were brothers, cousins, or blood relations of his, but I don't know their names.

*Asked whether, from April of the previous year until the present day, the witness had had any fight or dispute with any other persons besides the one with the said Geronimo, with or without arms, and if so, whether anyone was injured in such fight or fights,*

*He answered:* No, Sir. Except for the fight that took place between me and the said Geronimo, I never had any other fight with any person, either with arms or with fists.

*And after he kept silent for a long time, until the aforesaid had been written, having answered the aforesaid, he said:* As far as I remember.

*And as the judge insisted that he now go over in his mind and consider well whether he had had any fight with anyone during the aforenamed period, and that he try to remember well and abstain from such answers,*

*He answered:* I don't remember anything, Sir.

*And when the judge insisted again and again upon a genuinely truthful answer to the preceding questions, he kept saying:* "I don't remember." *Then the judge, in an effort to induce a disclosure, declared that the aforesaid [witness] did not want to answer accurately and reserved the right by law to obtain the aforementioned correct answer at the right place and time. Then, moving on, the witness was questioned by the judge.*

*Before he was questioned, the witness himself burst out:* That wretched scoundrel ought to be killed. Ten times he made me stay with him, to wait for the people to come out of his house, and then he does this to me because he doesn't want to give me back my money and wants to usurp my share of the work in the loggia at Monte Cavallo. But he may not succeed, and undoubtedly he won't succeed, because I am an honest man, and I'm here, where it will be seen.

*Asked the purpose for which he had been taken ten times and more, as he said above, to wait for people who were to come out of the said Orazio's house, and asked to give the said persons' names, and to make clear what happened,*

*He answered:* He took me with him because he wanted to express his anger toward those persons who were coming out of his house. But I never allowed it because I didn't want any scandal to follow. I don't know who the said people are, but I clearly saw them come out every time I went with him for this purpose. Nothing ever happened, and the said Orazio never expressed his anger at any of them.

*Asked whether anyone else had been present when the aforesaid happened at the stated times, or better, as far as the witness knows, whether anyone else knows of it, and if so, who,*

*He answered:* What do you think? That Orazio would call the whole world to see these things? Orazio has no friend, or any other comfort but me in this world. Therefore he didn't discuss these things with anyone else and no one but me was with him, as I said above.

*Asked to state whether the said Tuzia, who lived in the said Orazio's house, used to be friends with the said Artemisia, as far as he knew,*

*He answered:* A few times when I went to the house with Signor Orazio I saw the said Tuzia in the company of the said Artemisia.

*Asked to state whether the said Tuzia is married or single, and whether she has sons or daughters, and if so, which,*

*He answered*: The said Tuzia is married to a certain Messer Stefano and she has some daughters, but I don't know how many.

*Asked whether the witness knew the said Stefano's occupation and profession, and the names of the said Tuzia's daughters,*

*He answered*: I don't know, Sir, the occupation of the said Tuzia's husband, nor the names of her daughters.

*Asked whether the said Tuzia had ever been present when the witness spoke with the said Arte-* [ms. 95]
*misia in her father's absence,*

*He answered*: I think so, [I think] that sometimes Tuzia was present when I spoke to Artemisia in her father's absence.

*And as the judge insisted that he give either an affirmative or negative answer to the above,*

*He answered*: I don't remember, Sir, because, as I said, I have other things on my mind, and I can't rack my brain over these trivia.

*Asked whether, when the witness spoke with the said Artemisia in her father's absence, someone was with the witness, and if so, who,*

*He answered*: No, Sir. No one ever came with me those times I went to Orazio's house and spoke with Artemisia, his daughter, while he was absent, as I said.

*Asked whether the witness had ever been to the rooms upstairs that the said Tuzia occupied in the said Orazio's house,*

*He answered*: Yes, Sir. I have been in the rooms that the said Tuzia occupied in the upstairs apartment in the said Orazio's house.

*Asked on what occasion he went to the aforenamed rooms and how many times, and whether this* [ms. 96]
*happened in the house where they live at the present time or in the other one where they lived before,*

*He answered*: In the house on Via della Croce where they lived before, I never went to the upstairs rooms occupied by Tuzia. But in the house where they live now I went three or four times, and it happened that I saw someone coming out of Orazio Gentileschi's house with whom the girl was flirting. So I went up to her rooms and said to her: "Madam Tuzia, you know very well that Orazio Gentileschi, Artemisia's father, brought you here near him so that you would look after her. Yet you tolerate people going upstairs[95] in his house." And she answered that she didn't know what to do, as she had admonished her several times but Artemisia wanted to do as she pleased.

*Asked to state the reason why he took such interest and pains to try to prevent men from entering the said Orazio's house,*

*He answered*: It seemed to me that, as I was Orazio's friend and he had confided his troubles to me, the terms of our friendship demanded that I should use these measures to safeguard his honor. Therefore I took this action with the said Tuzia, not for other reasons. [ms. 97]

*Asked to state and specify who in fact were these men who came out of the said Orazio's house at the aforesaid times, and, since he didn't know their names, to describe the persons and their clothes,*

*He answered*: The persons that I saw coming out of Orazio's house, which was the reason I went to Tuzia's place, as I said, I saw them come out during the day. I don't know their

[95] *Di sopra*, that is, up to the private quarters. In a typical Italian house of the period, the ground floor was a public space (courtyard, kitchen), while the second and third floors were family living spaces, including bedrooms (cf. other witnesses' descriptions of the Gentileschi houses, mss. 232–35; 239–44; 249–65).

names but I would recognize them if I saw them. One of them was a tall young man with a small red beard, wearing a long silk robe;[96] the others wore secular clothes, but I didn't pay close attention to their features.

*Asked whether he knew for what reason and purpose the aforementioned men went to Orazio's house,*

*He answered*: I believe that they went for Artemisia, to screw her [*chiavarla*], because once while I was passing by, I raised my eyes toward the window and saw Artemisia with her arm on the shoulder of the man in the long robe, and when they saw me, they drew back. She then called to me that evening from her window as I was passing by, and asked me please not to mention this to her father.

[ms. 98]

*Asked to state whether he had ever been to the said Tuzia's house at night and, if so, how many times, when, and for what purpose,*

*He answered*: Yes, Sir, I have been to Tuzia's house at night about five or six times since they've been living in that house on S. Spirito, because Orazio Gentileschi sent me there to find out whether anyone frequented Artemisia's house, with the help [*per mezzo*] of Madam [*madonna*] Tuzia. I was to pretend that I went there for other reasons, that is to say, that I was to discover these intrigues by pretending that I was interested in Artemisia herself, and also sometimes by pretending to go to inquire about Master Stefano, to find out when he would return.

*He added afterward voluntarily*: And I did all this by order of the said Orazio Gentileschi.

*Then the judge, having heard [all this], terminated the interrogation and ordered that the witness be sent to his place for the time being, enjoining him to sign: Agostino Tassi.*

[ms. 99]                                                  The 12th day of April 1612

*Agostino Tassi, as referred to above, appeared personally in the aforesaid place and before the aforesaid and me, and in the presence of the aforenamed. Having been ordered to swear to tell the truth, and after he had so sworn under oath, etc., he was was asked by the judge whether he needed to say anything else voluntarily, in addition to what he had testified in his other depositions, and whether he intended to add or subtract from it, and if so, what.*

*He answered*: I don't need to say anything more than what I've said in my other testimony. Nor do I know of anything to add or subtract.

*Asked whether, when the witness had gone to Tuzia's house at night, he went alone or with someone, and if so, with whom,*

*He answered*: No, Sir, those nights when I went to talk to Tuzia, as I said in my other testimony, I never went with anyone else.

*Asked to state whether, when Artemisia went out either to go to Mass or for some other reason, the said Tuzia usually accompanied her,*

*He answered*: When Artemisia went out, either to go to Mass or somewhere else, wherever she chose to go, sometimes Tuzia went along, other times she didn't.

---

[96] *Vestito di longo con vestiti di seta*, a clerical garment. This man is described below (ms. 168) as having the name Artigenio; later (mss. 127–28) Artigenio is identified as procurator for a Cardinal Tonti.

*Asked to state whether, when the said Tuzia accompanied the said Artemisia for those reasons, it ever happened that the witness saw them, and if so, how many times and in which places,*          [ms. 100]

*He answered*: Twice I met the said Tuzia when she went out with Artemisia. Once I saw them on the Corso, but I don't know where they were going; another time I saw them as they were passing my house, when I lived on the slope of S. Onofrio, as they were going towards the church of S. Onofrio.

*Asked whether the witness had for any reason been in any church at the same time that the said Tuzia and Artemisia were there,*

*He answered*: I don't remember ever having come across the said Tuzia and Artemisia in church.

*And when the judge said that he should answer the above accurately, and that he should think carefully in order to speak the truth,*

*He answered*: I've been in many churches and it may be that they were there at the same time, but I've never seen them.

*Asked if he knew whether the said Artemisia had ever been with Tuzia in the church of San Giovanni, and if so, how many times, when and for what purpose,*

*He answered*: Yes, Sir, I know that Artemisia went to S. Giovanni once, it must be about a year ago, but I don't remember precisely when. And I know this because one morning, when I was at Monte Cavallo quite early, Gentileschi came up, and he told me that Tuzia and his daughter had gone to S. Giovanni, which they had wanted very much to do. However, he suspected something and wanted to go to see what they were up to. But since he had fresh plaster on the wall and I had done mine the [previous] evening,[97] he asked me to do him a big          [ms. 101]
favor and go there. As a favor to him, I went, and I saw her in S. Giovanni together with Tuzia. After she had gone to confession she left, and I followed her as far as S. Maria Maggiore. Then I left her, went back to Monte Cavallo and related everything to her father, and he thanked me.

*Asked whether, at that time, the witness had gone alone or with someone else, and whether he had spoken to the said Artemisia on the street or in any other place, and whether they had any conversation, and on what subject,*

*He answered*: On the said morning, as I was going towards S. Giovanni, I met Cosimo, who joined me and came along to S. Giovanni, as he was going there for his devotions. It seems to me that along the way I approached her, and told her that people who went out so early in the morning were featherbrains, and [told her] that her father had sent me there. Because I saw certain men around her who wanted to take her to a vineyard, moving in front of her and talking to her, I told her that if she didn't go home immediately I would repeat everything to her father.

*Asked to state who in fact the men were who had followed the said Artemisia that morning, as he alleged, and who wanted to take her to a vineyard, and how the witness knew that,*

*He answered*: I don't know them, Sir, and I don't know who they are, these men who          [ms. 102]
followed Artemisia that morning and wanted to take her to a vineyard. But there were two of

---

[97] *Calce fresca*, meaning the *intonaco*, or fresh plaster applied to the wall in the fresco technique, which serves as a wet ground to absorb the pigments. Orazio had to complete his painting while the plaster was fresh, whereas Agostino had done his painting the evening before.

them, one wearing a long robe and the other a short garment. The one in the long garment was the same one I had seen in S. Spirito, in the house where she lived, as I said in my previous testimony. But as for the man in the short garment, I didn't pay much attention to what kind of man he was.

*Asked how the witness knew that the said men wanted to take the aforementioned Artemisia to a vineyard, as he claims,*

*He answered:* I know that the said men wanted to take her to a vineyard because her brother named Francesco told me so.

*Asked if he knew whether on that day anything was given to the said Francesco, the said Artemisia's brother, and if so, what,*

*He answered:* I saw that the said men who were following Artemisia, who as I have said wanted to take her to a vineyard, bought some kind of doughnuts [*ciambelle*] for the said Francesco, her brother, from a doughnut vendor who was passing through the streets.

*Asked to state whether the witness had ever been anywhere for other reasons and had seen the said Tuzia and Artemisia together,*

*He answered:* I remember that I went to S. Paolo once last summer, and there I saw the said Artemisia and Tuzia and Madam Tuzia's daughters. It was a holiday, and they went in a carriage. Her father asked me to go with them and stay with them because he didn't trust the said Tuzia very much, and he had to go somewhere to collect some sort of money that he was [ms. 103] having trouble obtaining. I went, to do him a favor, and Master [*mastro*] Antonio, the mason who was applying plaster on the wall for me, came with me also. We all went to S. Paolo together, and then we returned.

*Asked to state in what place the aforenamed Orazio had asked the witness to accompany the said Artemisia in the carriage to the church of San Paolo, as he claims, and whether someone was present, and if so, who,*

*He answered:* Orazio came to my house specifically to ask me to go and accompany Artemisia to S. Paolo, as I have said, and no one was there to hear him because he was very careful when he encharged me with these matters that no one be present.

*Asked to state where the witness had climbed into the carriage, and how far he had accompanied the said Artemisia on the way back,*

*He answered:* When I accompanied Artemisia, under her father's order, as I said, I got into the carriage near their house; they hadn't yet gone past the gate of S. Spirito. On the way home I accompanied them as far as their house, or, as a matter of fact, I got off on the Lungara, near Porta Settimiana,[98] but I don't remember it that well.

*Asked to state which place in the carriage the witness took when he went with the said Artemisia, and which one Artemisia took,*

*He answered:* In the carriage I sat across from Artemisia, but I don't remember whether [ms. 104] it was in the front or the back of the carriage.

*Asked whether along the way the said Artemisia had for some reason gotten out of the carriage, and if so, where, and for what reason,*

*He answered:* Yes, Sir, on the way Artemisia got out of the carriage near S. Paolo to walk a little.

---

98 Porta Settimiana, at the end of the Lungara, near Ponte Sisto.

*Asked whether anyone else had gotten out of the carriage with her, and if so, who,*

*He answered*: I got out of the carriage with Artemisia, and also her brothers and Master Antonio.

*Asked whether they had walked along a different street, or along the same one on which the carriage was proceeding,*

*He answered*: No, Sir, we didn't go along the same street that the carriage did because, as Your Lordship knows, carriages go one way [*di qua*] and people on foot go towards the Porta Santa.[99]

*Asked whether the witness had had any conversation with the said Artemisia on the way, and if so, what,*

*He answered*: The said Artemisia and I talked as we walked down the street. I told her she should be a good girl, and should not bring shame on her father by falling prey to that manner of behavior that had given her the French disease. And she said: "What do you want me to do? My father led me to this. First, when he was once in prison for twenty days, he left me in need of a loaf of bread; and second, because he wants to use me exactly as if I were his wife." I reproached her and told her that she should not say these things, because I didn't believe her and I considered the said Orazio to be an honest man. We didn't discuss anything but this at that time.    [ms. 105]

*Then he added voluntarily*: I also said to her: "Don't you believe that I don't see these tricks; nothing good comes of such doings." And she confessed to me that she was to have a tryst that day, somewhere or another, but she didn't specify where she was to go or with whom.

*Asked to state who owned the carriage in which they rode to the church of San Paolo on the aforenamed day, and who had provided it,*

*He answered*: I don't know who owned the carriage in which we went to S. Paolo on the said day, nor even who among them provided it, but I believe that her father had found it.

*Asked whether the witness had ever seen and talked to the said Artemisia in any other place outside the said Orazio's house, and if so, in which place or places,*

*He answered*: In addition to the aforementioned places, I saw Artemisia at Cosimo Quorli's house on several occasions, and I also had lunch and dinner there, where I was taken by her father.    [ms. 106]

*Asked whether the witness had ever had, or attempted to have, carnal intercourse with the said Artemisia, and if so, how many times, when, and where,*

*He answered*: Never have I had carnal intercourse, nor tried to have it, with the said Artemisia.

*Asked whether the witness had ever been alone with the said Artemisia in any place, and particularly in the said Orazio's house,*

*He answered*: While I was teaching the said Artemisia, I think that one time I was alone with the said Artemisia.

*Then he said*: Sometimes her little brother was there.

*And when the judge told him that he should answer the questions accurately, either yes or no,*

*He answered*: No, Sir, I've never been alone in Artemisia's house with her.

---

[99] Cf. note 54.

*Asked to state whether he had ever been in the room of the house in which Artemisia used to sleep,*

*He answered*: I have been in all the rooms in the house of Artemisia and Orazio.

*Asked whether the witness had ever been alone with her in the room where the said Artemisia used to spend the night, and particularly when she was in bed,*

[ms. 107]     *He answered*: I have never been alone with her in the room where Artemisia slept, neither while she was in bed, nor otherwise.

*Then the judge, having heard all this, etc., terminated the examination and ordered that the witness be sent to his place for the time being, enjoining him to sign: Agostino Tasso.*

The 14th day of April 1612

*Agostino Tassi, as referred to above, appeared personally in the aforesaid place, and before the aforenamed and me. Having been ordered to swear to tell the truth, and after he had sworn under oath, etc., he was asked by the judge whether the witness needed to say anything else in addition to what he had said and testified in his other depositions, and if so, what.*

*He answered*: I do not need to say anything more than what I have said in my other testimony.

*Asked to state whether he knew if any marriage had been negotiated between the said Artemisia and someone else, and if so, whom,*

*He answered*: Yes, Sir, I know that once a marriage was negotiated for Artemisia.

*Asked to state with whom exactly the said marriage was being negotiated, and who the mediator in this affair was, and who was involved,*

*He answered*: A marriage was being negotiated between the said Artemisia and that Modenese who was keeping her, and I was the mediator, since I dealt with both parties.

[ms. 108]     *Asked who had requested that he become involved in the negotiations for the said marriage, and why it had not been effected,*

*He answered*: I negotiated the said marriage with Modenese because I was asked to do so by Gentileschi, and the reason it didn't come about was that the said young man told me that he had very good information that Artemisia was a whore.

*Then he said*: Strike that "information," because he [Modenese] knew very well that she was a whore, since not only had he himself had relations with her, but he knew that many others as well had had them with her. And thus he didn't want to hear anything more about it.

*Asked in what place the aforenamed Orazio Gentileschi had asked the witness to interpose himself to bring about the said marriage, and whether anyone else had been present, and if so, who,*

*He answered*: I was sought by Gentileschi to interpose myself to bring about the said marriage. No one was present, and it was at my house.

*Asked to state in what place the witness had been informed by the aforenamed Modenese that he no longer intended to go through with the aforementioned marriage and that for the aforesaid reason he did not intend to proceed in the said affair, and whether anyone had been present,*

*He answered*: I will tell you, Sir, everything as it happened. Having heard that Gentileschi wanted to give his daughter to be the wife of the said Modenese, and since I cared for my

[ms. 109]     friend's reputation, and in order to keep this negotiation on the highest possible plane so that it wouldn't seem as if Gentileschi were offering his daughter to just anyone, and since

Modenese was in the service of the Lord Cardinal Bandino,[100] I went to see a friend of mine called Alessandro who worked as a valet in the said Cardinal's house. I told him that Gentileschi had asked me to see to this business with the said Modenese, that he should let things be and should not speak badly of the girl because, if he didn't refrain from doing so, the said Orazio would be forced to make the appropriate remonstrations. If Modenese wanted to negotiate a match honorably, I as a mutual friend would mediate with the said Orazio so that he would resolve to satisfy him [Modenese]. For this purpose the said Alessandro spoke with Modenese, and with this object in view, one night at about two or three in the morning they came to my house together, and Alessandro told me that Modenese had come to discuss the matter of Artemisia with me. And thus the said Modenese and I drew to one side, and I told him that it would be good if he resolved to bring about the said marriage with Artemisia, as he was well aware of the satisfactions he had received from her. And he replied that this was true, and therefore, whenever Artemisia resolved to be a good girl, he would be happy to marry her and to conclude the said marriage arrangements with her. Then I went to relate all this to Genti-          [ms. 110]
leschi. Afterwards I went to see Monsignor Nappi and told him to come to an understanding with Gentileschi regarding the particulars of the dowry. But although the said negotiation seemed concluded, within eight days the said Modenese came to me and told me that he had stationed some friends of his to watch Gentileschi's house, who reported that they had seen various and sundry people go in and out of his house, and also [had seen] the said Artemisia flirt at the window with various sorts of people, so that it looked like a bordello [*pareva che foss'in chiasso*]. Therefore he had no intention of taking her as his wife, and was withdrawing his promise. I tried to get him to change his mind and told him that this could not be so and that he must have been misinformed. He answered: "What I and others have seen with their own eyes cannot be denied and therefore I don't want to go any further with it." And I said to him: "Do whatever God inspires you to do." I then went to see Gentileschi and related all this to him, and he jumped up and down, and wanted me to go with him to the house of the said Cardinal Bandino and speak with Abbot Bandino. The Abbot answered that he didn't want to become involved. This is how the negotiations for the said marriage proceeded, and this is what was involved in it.          [ms. 111]

*Asked whether the witness knew if any other arrangement had been similarly negotiated for another person to marry the said Artemisia, and if so, whom,*

*He answered:* No, Sir, I don't know of any negotiations to marry Artemisia to any other person.

*Then the judge, having heard [all this], etc., terminated the interrogation and ordered that the witness be sent to his place for the time being, etc., enjoining him to sign: Agostino Tassi.*

The 8th day of May 1612

*Antonio Mazzantino, son of Andrea of Florence, witness for [the information of] the Curia, was questioned in Savella prison in Rome by the same aforenamed [official] and me, etc. Having been ordered to swear to tell the truth, and after he had so sworn under oath, he was asked by the judge how long he had been in this prison and whether he knew or could imagine the reason for his imprisonment, and his present interrogation.*

[100] Cf. mss. 91 and 110.

*He answered*: I have been in prison since last night, when I was taken from my house above the Trevi fountain. I don't know why I am in prison or why Your Lordship wants to examine me, unless it is for the same reason that Agostino is in prison. When I came last night Agostino told me that I was being imprisoned for his sake, in order to be examined, and that Gentileschi was responsible for his being kept in prison.

*Asked whether the witness had had any discussion with the said Agostino about the examination*

[ms. 112] *he was to undergo, and if so, what,*

*He answered*: No, Sir, I did not talk at all with the said Agostino, except that this morning, when he saw me as he was being moved, he said that I must be in prison because of him. Although I said above that he saw me when I came into prison, he didn't see me because it was very late.

*Asked whether the said Agostino was his friend, and if so, for how long and under what circumstances,*

*He answered*: Yes, Sir, Agostino is a friend of mine and so is Orazio Gentileschi, the circumstances being that I prepared the wall[101] in the garden of Signor Cardinal Borghese at Monte Cavallo where they were painting. It was about a year ago when the work began.

*Asked whether he had ever been in the houses of the aforementioned Agostino and Orazio, and if so, for what,*

*He answered*: I went to Agostino's house twice to see him when he had a bad foot; I have never been to Orazio's house.

*Asked if he knew whether the said Orazio had any sons or daughters, and if so, how many and which,*

*He answered*: I know that the said Orazio has two sons and one older daughter. One son's name is Francesco, but I don't know the other's name, nor do I know what the daughter's name is.

*Asked how he knew that the said Orazio had the aforementioned sons and daughter,*

*He answered*: I know because I saw the boys, and I heard from Gentileschi that he had a daughter.

[ms. 113] *Asked whether he knew the name of the said Orazio's daughter, and whether he had ever seen her,*

*He answered*: I do not know what the said Orazio's daughter's name is, and I have never seen her.

*Then, since the judge realized that the witness could easily have met with the said Agostino before he was taken to another prison, and since it appears from the above answer, when compared to the said Agostino's testimony, that he bore false witness, he ordered that [the witness] be subjected to torture and placed in isolation so that he would be better prepared to tell the truth.*

*And before he was taken away from the place of interrogation, he said*: Please, Sir, don't give me this punishment, because I want to tell the truth. I saw the said Orazio's daughter one day in a room where there were other women.

*Then the judge, with the aforenamed purpose, ordered that the witness be placed in isolation.*

---

[101] Literally, "I plastered" (*io l'incollavo*).

The 9th day of May 1612

*Antonio Mazzantino, as referred to above, was questioned in the aforesaid place and before the aforenamed [official] and me, etc., and in the presence of the magnificent and excellent Lord Portio Camerario substitute judge, etc. Having been ordered to swear to tell the truth, and after he had sworn under oath, etc., he was asked by the judge whether he needed to say anything else in addition to what he had said in his other testimony, and if so, what.*

*He answered*: I need to say in truth that last summer, I don't remember exactly when, one afternoon as I was coming out of the castle,[102] having collected some money from Signor Americo Capponi, I met Agostino Tassi on the bridge. He said to me: "Come with me, let's go to S. Paolo in a carriage with Gentileschi's family." So he made me turn around and we went towards Gentileschi's house, there among those houses on S. Spirito. We found that the carriage had just started on its way, but Agostino made it stop and got into the carriage on the Lungara just past the S. Spirito gate, and he also made me get in. Inside the carriage were Gentileschi's boys and four women whose names I don't know, except that the one who lived in Gentileschi's house was called Tuzia. There was another old woman and two young ones; one of them was Tuzia's daughter and the other, who was older, was Gentileschi's daughter, who is called Solpizia or Artemisia,[103] from what I heard from them. And so we went to San Paolo to confession and then came back home. We—that is, Agostino and I—got out of the carriage in Trastevere near the Ponte Sisto, and the women went on home in the carriage.   [ms. 114]

*Asked whether the witness had known the said Orazio's daughter before,*

*He answered*: Yes, Sir, I had seen the said Artemisia, Gentileschi's daughter, before I went in the carriage with her and the aforementioned people that time. I saw her at the window once when I went with Orazio as far as his house when we were coming from Monte Cavallo one holiday, but I didn't go inside. I waited for him at the door, and then the said Orazio and I went together to have a drink on the Lungara at Porta Settimiana, and the said Agostino was also with us.   [ms. 115]

*Asked whether, when they went to the church of S. Paolo as he said, anyone had gotten out of the carriage on the way, and if so, who and for what reason,*

*He answered*: Sir, no one ever got out of the carriage until we arrived at San Paolo, where we all got out together.

*And having been told that, since the Curia was informed otherwise, he should direct his attention carefully to speaking the truth and avoiding falsehood,*

*He answered*: Sir, I now remember that Agostino and the said Artemisia got out of the carriage by that tavern just before we reached S. Paolo. And they walked together towards the Porta Santa while the rest of us got out at the other gate at the front of the church where they sell the doughnuts.[104] And we all got together inside the church.

*Asked whether he knew the reason that the aforenamed Agostino and Artemisia got out of the carriage together,*   [ms. 116]

---

[102] Probably Castel Sant'Angelo, as Menzio suggests (1981, 157 n. 46).

[103] Artemisia is not called Solpizia (Solpitia) in any surviving documents.

[104] Menzio omits the following portion of this sentence: "*dove si vendono quelle ciambelle, e dentro la chiesa. . . .*" On the two entrances of S. Paolo, see note 54.

*He answered*: Sir, I can't tell you why Agostino and the said Artemisia got out of the carriage together; maybe they wanted to take a short walk.

*Asked if he knew whether the said Agostino had been in any other place in the company of the aforenamed Artemisia,*

*He answered*: No, Sir, I don't know whether the said Agostino has ever been in any other place with the said Artemisia, and even that time he told me that Gentileschi had sent him.

*Asked whether, while they proceeded together in the carriage, they had had any conversation, and if so, what,*

*He answered*: They were saying in the carriage that at S. Paolo they would see certain paintings done by Gentileschi,[105] and the said Artemisia said that it seemed like a thousand years before they would get there.

*Asked whether the said Agostino had ever had a discussion with the witness himself about the said Artemisia, and especially on the said day after he and the said Agostino had gotten out of the carriage in Trastevere, as he said,*

*He answered*: No, Sir, the said Agostino never discussed the said Artemisia with me, not even there after we got out of the carriage, because he was talking with some of his friends that he met when we got out of the carriage, whom I didn't know, who went with him to his

[ms. 117]  house.

*Asked if he knew whether the said Agostino had ever had carnal relations with the said Artemisia, or had been in love with her, or, at least, [whether] he had heard it said,*

*He answered*: No, Sir, I don't know, I have not heard that the said Agostino is in love with the said Artemisia, nor that he has had carnal relations with her.

*Then the judge, having heard all this, etc., terminated the interrogation and ordered that the witness be sent to his own place for the time being, etc.*

The 11th day of May 1612

*Agostino Tassi, as referred to elsewhere, appeared again before the aforenamed in Tor di Nona prison. Having been ordered to swear to tell the truth under oath, he was asked by the judge whether he needed to say anything else voluntarily in addition to what he had testified in his other depositions, and whether he intended to add or subtract from it, and if so, what.*

*He answered*: I don't need to say anything more than that I have said in my other testimony.

*Asked whether he had thought better [of it] and was ready to tell the truth about the matters on which he had been questioned at other times, and particularly whether the witness had ever had carnal relations with Artemisia, Orazio Gentileschi's daughter,*

*He answered*: I have nothing else to say and I have not had carnal relations with this

[ms. 118]  Artemisia, and there is nothing else I can say.

*Questioned and admonished that the witness should direct his attention to speaking the truth regarding the previous statements, because the Curia was well informed,*

*He answered*: I have spoken the truth and no one will ever be able to prove that I have had relations with the said Artemisia.

---

[105] Probably a reference to Orazio's lost altar painting, *The Conversion of St. Paul*, painted in 1596 and destroyed by fire in 1823 (Bissell, 1981, 134–35).

*And the judge, remarking that the witness dared insist on bearing false witness, in spite of the fact that the Curia knew for certain that the witness had not only had carnal relations with the said Artemisia more than once but also had raped her with violence and had deflowered her, as it clearly appears from the deposition of the same Artemisia, [said] that he should speak the truth, openly before God.*

*He answered*: If the said Artemisia says that I have had relations with her several times and that I have taken away her virginity, she is not speaking the truth and she is telling lies, and would to God that [all the] others had not taken her virginity any more than I have.

*And the judge added that, in addition to the aforenamed deposition by the said Artemisia, in which the witness appears to be guilty of the said crime and of defloration as well as of having had intercourse with the said Artemisia during many and repeated interchanges, one should also add the frequency and familiarity with which the witness had visited the said Orazio's house in his absence,* [ms. 119] *the way in which the witness had followed and associated with the said Artemisia during many and various occasions and in various places, the conversations that he had with her in the house apart from other people, and the spying that he was doing around the house of the said Artemisia both at night and during the day, the confessions that he made many times outside the court about the carnal relationship that he had had with her, and, finally, that he was seen lying in bed alone with her in her own house or in the said Artemisia's bedroom, she being naked [denudata] in the bed: and from these facts as well as from many others that emerged during the trial, he [Agostino] not only remains suspect of the aforesaid rape against the person of the said Artemisia, but has been proved wrong in such a way that he cannot continue being evasive and avoid telling the aforesaid truth. Therefore, he should be willing to speak frankly, and not involve himself further in lies, and not wait to be proven guilty of lying by the witnesses with regard to the above.*

*He answered*: I say this, that none of the things that Artemisia said against me are true, nor what other people said, and even the whole world could not make be what has not been, [ms. 120] because I never had sexual relations with her.

*Then the judge, having heard all this, etc., as he was unable for the time being to obtain an accurate statement of the facts from the witness, terminated the interrogation and ordered that the witness be sent to his place, etc.*

Monday, the 14th day of May 1612

*Agostino Tassi, as referred to elsewhere, appeared again in the presence of the illustrious and excellent Lord Geronimo Felice, deputy [locumtenente], and the illustrious and excellent Lord Francesco Bulgarello, substitute deputy [locumtenente substituto], and me, the notary writing this, and in the presence of the magnificent and excellent Lord Porzio Camerario, substitute judge [subli].*[106] Having been ordered to tell the truth, and to swear under oath, he was asked by the judge whether he needed to say anything else voluntarily in addition to what he had testified in other depositions, and whether he intended to add something to it or subtract from it.

*He answered*: I don't need to say anything other than what I have said in my other testimony, nor do I have anything to add or subtract.

*Asked whether, at last ceasing his obstinacy, he would be willing to tell the truth about whether*

---

[106] See note 46.

*he had raped and had sexual relations with the said Artemisia, Orazio Gentileschi's daughter, about which he had been questioned other times,*

*He answered*: No, Sir, I have spoken the truth and I am telling you that not only have I
[ms. 121] not raped the said Artemisia, but I have never had sexual relations with her.

*Asked what the witness would say if the said Artemisia should be brought in before him, and, after having been told by me everything that had been discussed above, she should confirm it and accuse him of falsehood,*

*He answered*: I will say, every time that Artemisia tells me to my face that I have had relations with her and that I deflowered her, that she is not telling the truth.

*Then the judge, in order to prove to the witness that his previous statement was a lie, and even more, to prepare him to speak the truth, as well as for any other good end and result, ordered that the aforenamed Madam [domina] Artemisia, [daughter] of Orazio Gentileschi, be brought before the witness.*

*After she was brought in and they were both ordered to swear to tell the truth, etc., and having both recognized each other's person and name, she, the one who was summoned, was asked by the judge whether her testimony some days ago about the witness here present was and is true, and whether she intended to confirm and substantiate now, before the witness here present, that what she had testified was true.*

[ms. 122]     *She answered*: Yes, Sir, what I said some days ago in my testimony before Your Lordship about the person Agostino Tasso here present is the truth, and for the sake of truth I am ready to confirm and substantiate it here in front of him.

*Asked now to relate the aforementioned deeds in their essence,*

*She answered*: I have told Your Lordship on other occasions that last year during the month of May, Agostino here present used to frequent my father's house, as he was a friend of my father and in the same profession. He came to the house as a friend and both my father and I trusted him. One day he came to the house under certain pretexts, as I have related at other times in my testimony, and as I have said, I trusted him and would never have believed that he would dare rape me [*usarmi violenza*] and do damage both to me and the friendship he had with my father. And I did not realize it until he grabbed me by the waist, threw me on the bed, closed the door of the room and embraced me [*mi si mise attorno*] to rape me and take
[ms. 123] away my virginity. Even though I struggled for a while, the struggling went on until eleven o'clock, since he had come after dinner as I said in my other testimony, to which I refer. And the bed post was what protected me until that hour, since I was holding tight and turned toward it.

*And as they were writing down these things, the aforenamed witness [Agostino] said voluntarily*: Write down in print everything that she says and note that she maintains that the struggling lasted until eleven o'clock.

*Then the judge ordered that, for their information, I the notary should read [the transcript of] the examination that the aforenamed summoned woman had undergone at another time, as stated above, during the course of the trial on the 28th of March. And after I had read it, and the two of them had listened to it carefully, as they declared, the summoned woman was asked by the judge if what she had just heard read corresponded to what she herself had testified at another time during her examination, and whether all that she had testified was the truth, and whether she was now willing to confirm and substantiate all this before the witness himself.*

*She answered*: I heard the testimony that you had your notary read here, and I recognize that it is the testimony I gave at another time. Everything contained in this I have testified in truth, and in truth I now confirm it here before Agostino. [ms. 124]

*The questioning witness [i.e., Agostino] then said*: I say this, that everything that Signora Artemisia said and put down on paper is a lie and not the truth at all. That I have raped her is not true, nor that I have had relations with her, because in her house there was a stonecutter named Francesco with whom you couldn't trust a female cat; and he had been alone with her both during the day and at night. [And there was] Pasquino from Florence, who boasted publicly that he had had Signora Artemisia. And I visited her house with that honor and respect which one must show in a friend's house. I have not deceived either my friend nor her, and I have always avoided going there because they used to get me involved in continual fights. In conclusion, everything that she has said is untrue.

*The summoned woman [i.e., Artemisia] then replied*: I say this, that everything I have said is the truth, and that if it were not the truth I would not have said it.

*The summoned woman was asked whether she was prepared to confirm her aforesaid testimony and deposition, as well as everything contained in it, even under torture.* [ms. 125]

*She answered*: Yes, Sir. I am ready to confirm my testimony even under torture and whatever is necessary. Indeed, I want to tell you more, that when I went to S. Giovanni that man gave me a twist [*torchina*] that I did not want.[107]

*Then the judge, in order to remove any mark of infamy and any doubt that might arise against the person of the said summoned woman or about the things she had said, from which she could appear to be a partner to the crime, and most of all, to corroborate and strengthen her statement, as well as to all other good ends and results, and, even more, to affect the person of the said summoned woman, decreed and ordered that the summoned woman, in the presence of the witness, be subjected to the torture of the* sibille,[108] *taking into consideration that she is a woman [*mulier*] seventeen years old, as one can tell from her appearance.[109] The prison guard was called in to proceed with the said torture and, before he affixed the cords upon the summoned woman,*

*She was questioned and admonished to beware of unjustly accusing the said Agostino of rape, yet insofar as it is true, she should not change the account as she gave it, because if the truth indeed appears to be as the summoned woman testified in her examination, she should not hesitate to confirm everything, even under the said torture of the* sibille. [ms. 126]

*She answered*: I have told the truth and I always will, because it is true and I am here to confirm it whenever necessary.

[107] She may mean that Agostino pinched her flesh or twisted her arm. A verbal connection is suggested between torture (*tormenti*) and twist (*torchina*), through the Latin *torquere*, which can mean both "to twist" and "to torture." However, a *torchina* could also be a small candle.

[108] Literally, "sibyls." This means of torture was presumably named for the ancient prophetesses because it induced the subject to tell the truth. The method employed, cords wrapped around the fingers and pulled tight, is explained in the narrative that follows.

[109] This passage contains the only statement in the first part of the trial testimony that concerns Artemisia's age. In his later charge of false witness against Agostino and his six witnesses (ms. 227), Orazio claimed that she was fifteen. In fact, in May 1612 she was eighteen, nearly nineteen (born July 10, 1593). The use of *mulier* rather than *puella* or *virgo* suggests that Artemisia was regarded as adult, either because she had been deflowered or because a girl of seventeen was not considered a minor.

*Then the judge ordered that the prison guard put on the* sibille *and, having joined her hands before her breast, that he adjust the cords between each finger, according to custom and practice, in the presence of the witness [Agostino].*[110] *And while the guard tightened the said cords with a running string, the said woman began to say:*

It is true, it is true, it is true, it is true, *repeating the above words over and over, and then saying,*

This is the ring that you give me, and these are your promises.

*Asked whether what she had testified in her examination and had just now confirmed in his presence was and is true, and whether she wished to sanction and confirm it under the said torture,*

*She answered*: It is true, it is true, it is true, everything that I said.

*The said questioning summoned man then said*: It is not true, you are lying through your teeth.

[ms. 127]                *The said summoned woman retorting*: It is true, it is true, it is true.

*Since both of them stood by their statements, the judge ordered that the* sibille *be untied and removed from her hands. She remained there just long enough to say a* Miserere *and then [the judge] dismissed the said summoned woman.*

*And when he was about to dismiss her, the witness said*: Don't let her go, because I want to ask her some questions.

*And when the judge asked him to explain what he wanted to say,*

*He answered*: These are the questions I want to ask. *And he showed a certain page on which were written certain questions, which the judge asked the said summoned woman.*

*She was asked,*[111]

[[1.   Who made you testify against me, where did he approach you, and with what words? And who was present?]]

*And to the first [question] she answered*: It is truth that has induced me to testify against you and no one else.[112]

[[2.   Tell me exactly how and with what opportunity I first had relations with you, as you assert, and where?]]

*To the second one she answered*: I have said so much [about that] this evening that I think it should be enough, both about the place and the time that it happened.

[[3.   Tell me how I frequented your house. Tell me if anyone else frequented it, and who they were.]]

*To the third one she answered*: I have already spoken about how he frequented my house, and many people frequented my father's house, gentlemen and noblemen, but no one came on my account.

[[4.   Tell me the truth: Artigenio [and] unknown others[113] frequented your house, and you are warned that if you deny this, it will be proven [with evidence], etc.]]

---

[110] Despite Menzio's indication of ellipsis here, she accurately represents the manuscript in this passage.

[111] The list of questions put forth by Agostino actually turns up later in the trial proceedings (mss. 159–62). The questions have been inserted here within double brackets, in conjunction with Ar-temisia's answers, since questions and answers must have been directly juxtaposed during the hearing.

[112] The construction suggests that Artemisia is thinking of truth as a personification. (See also Stiattesi's use of the same idiom below, ms. 136.)

[113] In the manuscript, "Artigenio" is written in

*To the fourth question she answered*: The aforementioned Artigenio was a procurator for Cardinal Tonti. He was a friend of Tuzia, and he frequented her house, but he did not frequent mine.

*And while they were writing this down, the witness said*: Ask her whether she has ever done [ms. 128] a portrait for the said Artigenio.

*And the said summoned woman answered*: Yes, Sir, I was asked to paint a portrait of a woman whom he said was his beloved, and I did it. What do you have to say about that? It was Tuzia who sought me out to do this portrait.

〚5. Tell me what opportunity brought the said men to your house.〛

*To the fifth one she answered as above.*

〚6. Tell me, did your father know and did he see the said men and me when we came to your house?〛

*To the sixth one she answered*: When Artigenio frequented Tuzia's apartment my father saw him as he went in and when he came down. My father was painting and Tuzia said: "Come over and see [this], Signor Artigenio," and he went into the said room to watch [my father] passing over the paintings,[114] and they talked. As for Agostino here, he used to come to the house at times, but when he came for me, [my father] did not see him.

〚7. Tell me, did your father provide for your needs?〛

*To the seventh one she answered*: Yes, Sir. My father provided for my needs.

〚8. Did he make you want for anything? Did he ever leave you alone with men in the house?〛

*To the eighth one she said*: My father has never left me alone with any man.

〚9. Were you ever alone in the house with men, and particularly with said men [such as] Francesco Scarpellino?[115]〛

*To the ninth one she said*: I was never alone with Francesco Scarpellino, because my brothers [ms. 129] were also there, and one of them was sixteen years old.[116]

〚10. Did you ever complain that your father made you want for anything?〛

*To the tenth one she answered as above.*

〚11. Did you ever tell anyone that Pasquino [117] had deflowered you?〛

*To the eleventh one she said*: When this Pasquino stayed in my house, I was not more than seven years old, and I never said that he had deflowered me.

〚12. Tell me, is it not true that a man deflowered you?〛

*To the twelfth, she referred to the next one.*

〚13. Did you ever write letters to anyone, and what did the said letters contain?〛

*To the thirteenth, she answered*: I cannot write and I can read very little [*io non so scrivere et poco leggere*].

〚14. To what end, and with what hopes, did you give this testimony?〛

*To the fourteenth, she answered*: I testified with the hope that you would be punished for the wrong that you did.

---

bolder ink, inserted above the letters "*N. et N.*" (an abbreviation for "unknown person"), indicating that Tassi added the name after the question had been written down.

[114] As Menzio suggests (1981, 157 n. 49), Orazio may have been varnishing finished paintings.

[115] Scarpellino's name is inserted above "N . . . ," as in Question 4 (see note 118).

[116] This must have been Francesco (born 1597), aged fourteen in 1611. Artemisia's eldest brother Giovanni Battista was born in 1594, but died in 1601. The other brothers were Giulio (born 1599) and Marco (born about 1604) (Bissell, 1981, 9).

[117] Name inserted, as above (see note 113).

〚15.    Say why you were forced, as you claim.〛
*The fifteenth was omitted as it was not pertinent.*
〚16.    What protest did you make? Did you shout? And why didn't you make any noise?〛
*To the sixteenth, she said the same as in her examination*: Because he gagged my mouth and I could not shout.
〚17.    What are the signs that a virgin shows when she has been deflowered? Say it, and say how you know it.〛
*To the seventeenth, she said*: I said in my testimony that when he raped me the first time, I was having my period, and I noticed that the menstrual blood was redder than usual.
〚18.    How was it when you were deflowered, and what signs appeared in you?〛
*To the eighteenth, she gave the same answer as in her testimony.*
〚19.    Have you told anyone that I deflowered you? Whom did you tell and to whom did you brag of it, and to what end?〛
*To the nineteenth, she said*: I told Stiattesi and his wife that you had deflowered me, and you also told Stiattesi.
〚20.    How long after it happened [did you tell]? Why didn't you tell it immediately, and, if immediately, why didn't you bring suit? Why have you said it now and what induced you to say it?〛
*To the twentieth, she said*: I told Stiattesi that you had deflowered me when he came to live in [ms. 130] our house in December. And you had told him before, but I also told him. We didn't bring suit earlier because something else had been arranged so that this disgrace [*vituperio*] would not become known.
〚21.    Who found out that you had been deflowered? Why, under what circumstances, and when?〛
*To the twenty-first, she said*: You disclosed to Stiattesi that I had been deflowered.
〚22.    Were you hoping to have me as a husband?〛
*To the twenty-second, she said*: I was hoping to have you as a husband, but now I don't, because I know that you have a wife. It's been two or three days since I learned that you have a wife.
〚23.    Did anyone tell you that I would be your husband if you were to say that you were deflowered by me?〛
*To the twenty-third, she said*: No one told me this, but I have said it as the truth.[118]
〚24.    In what manner did it occur when you were deflowered?〛
[No answer to this question is recorded.]

   *And having set aside the said testimony, the judge dismissed the said summoned woman and ordered that the witness be taken to his place, etc.*

                                                    The 15th day of May 1612

   *Agostino Tassi, as referred to elsewhere, appeared again before the illustrious and excellent Lord Francesco Bulgarello, substitute deputy, and me the notary writing this, and in the presence of the magnificent and excellent Lord Porzio Camerario, substitute judge, in Tor di Nona prison. Having been ordered to swear to tell the truth, and having sworn, etc. he was asked by the judge whether he*

---

118 An elliptical sentence; she means "because it is the truth" that she was deflowered by him.

*would finally give up his obstinacy and whether he was willing to tell the truth about the things he had been asked, and particularly about the rape that, it is claimed, the witness committed against Artemisia, and of which at this point he remains guilty [convictus] on account of the deposition by the said Artemisia.*

*He answered*: No, Sir. I spoke the truth and I have in no way deflowered the said Artemisia, nor have I had any relations with her.

*Asked what the witness would say if, in addition to the fact that everything stated above had been confirmed by the said Artemisia to his face, in like manner he were to be accused of those [same] things by the testimony of other witnesses whom he had informed of the said rape he had committed, and to whom he related all of the above,* [ms. 131]

*He answered*: If any of them comes to tell me that I said I had raped Artemisia, they will be my enemies and they won't be speaking the truth, because I didn't do it, and I couldn't have said that.

*Questioned and admonished to give up his obstinacy at last, and to tell the truth about the preceding statements and not expect further to demonstrate falsehood on the part of the witnesses, particularly Giovan Battista Stiattesi, to whom he had spoken of having committed the aforesaid rape, as it appears from his testimony,*

*He answered*: Giovan Battista Stiattesi, and whoever else comes to tell me to my face that I have committed rape on the person of Artemisia, will be telling lies. [ms. 132]

*Then the judge, in order to convince the witness of the falsehood of [his] previous statements, and, even more, to prepare him to speak the truth, as well as for any other good end and result, ordered that Giovan Battista Stiattesi be brought before the witness.*

*After he was brought in and they were both ordered to swear under oath to tell the truth, and having both recognized each other,[119] the summoned man was asked by the judge whether what he had testified about the witness on earlier days was and is true, and whether he now intended to confirm and substantiate before the witness what he had testified as true.*

*He answered*: Yes, Sir. What I said some days ago in my testimony before Your Lordship about the person of Agostino Tassi here present, I said and testified as the truth and in truth I am ready to confirm and substantiate it, and to do whatever is necessary.

*The summoned man was then asked to relate briefly before the witness the most significant and relevant points of his deposition.* [ms. 133]

*He answered*: In short, I said that as it happened that I slept with Agostino here present several times, one night when I was in bed with him, he told me that he had deflowered Artemisia, Orazio Gentileschi's daughter, and he said: "Cosimo was the one who led me into this mistake, leading me to believe that she was not a virgin." And having found that she was a virgin, he had regretted it. This is what I said in my deposition, to which I am referring as a whole.

*Then the judge ordered that I, the notary, read in a loud and distinct voice the deposition by the aforenamed Giovan Battista Stiattesi, referred to above in this trial on the 24th day of March 1612, for the clear understanding of both parties.*

*And after I had read it, and both of them had listened carefully and understood it, as they claimed, the summoned man was asked by the judge if what he had just heard read was and is true and had been testified by him as the truth. And he should now confirm and substantiate it as true*

---

[119] One or two illegible words in the manuscript are omitted, with ellipsis, by Menzio.

[ms. 134]    *in the presence of the witness, and [state] whether it corresponds to what the summoned man affirms
to have testified in the mode and form that now stands.*

*He answered*: I heard very clearly what Your Lordship had read to me, and I recognize it
as being the same as what I said and testified some days ago before Your Lordship as the truth.
And everything was said and testified by me in truth, in the mode and form in which it is
written. And now in truth I confirm and substantiate it before Agostino here present, for it is
all the gospel truth.

*The said questioning Agostino then said*: I say this, that what this man here by the name of
Giovan Battista Stiattesi is saying is not at all the truth, it is all a lie. In response to the many
points that he makes in his testimony, I refer to what I said in my testimony.

*The replying summoned man said*: I say that everything I have said is the truth, and would
to God it were not so for both of them. He confided it to me, and you know that I mediated
for a good solution up until the end, because when you were in prison I tried to intervene to
satisfy you.[120]

[ms. 135]    *This having been concluded, the witness himself said*: Your Lordship, please do not terminate
the examination, because I intend to question him.

*Then the judge gave him permission to question [Stiattesi], as long as he did not question him
on matters irrelevant and not connected with the case. Then the summoned man was [questioned]
by the witness*:

*Asked*: Tell me, Signor Giovan Battista, where do you live at present?

*The summoned man answered*: You know better than I do where I live, but to satisfy you,
I live in the house on S. Spirito on the hill above the caves [*grotte*], in the same house in which
Signor Orazio Gentileschi lives.

*Again the summoned man is asked by the witness*: Tell me something, do you pay rent, to
whom do you pay rent, and have you ever paid it?

*He answered*: I have not made an agreement with anyone, and I have never paid rent to
anyone because it was not asked of me. But when they ask me to pay it, I will pay, and it was
[ms. 136]    you yourself who placed me in that house.

*And again the witness turned to the summoned man and said*: Tell me, now, who sought you
out and induced you to testify, and who ordered you to do it?

*The summoned man answered*: Truth induced me to testify, I was sought out and forced
by justice, and Orazio Gentileschi gave me the message on behalf of His Honor the Judge
[*Signore Giudice*], since I did not want to come into this thing and I came unwillingly.

*Asked*: Tell me, did anyone promise you anything so that you would bring to a conclusion
this business between me and Artemisia?

*He answered*: You promised to help me in case of need through your friendship, if I could
bring off this business of Artemisia, so that this story could be ended and [we] could find a
way to get her married. And if you had consulted with me before about what you discussed
with me in prison these past few days, you would have gone in a different direction.

[ms. 137]    *Asked*: Tell me, have you ever testified against anyone?

*He answered*: I testified, on your request, against Valerio Ursino in a civil suit. *And then
the witness said*: I have nothing else to say for now, but make [*fate*] a declaration that I intend
to repeat the questioning through my solicitor and counsel.

---

[120] Stiattesi shifts in mid-sentence from speaking about Tassi to addressing him directly.

*The summoned man retorted, saying: Sir, this confrontation should not be repeated* (response in Latin). I don't want to go back and forth any more, nor to be bothered with this business of yours that I've had so much of that I'm sick of it. Thus I insist [*mi protesto*] that he should question me right now about anything he wants, because I'm ready to answer him, and there is only one truth.

*And afterward, the summoned man said voluntarily*: I want to say something else, which I thought and his questioning would give me the opportunity to say. But since he didn't bring it up, I will. Your Lordship must know that, in addition to having worked as hard as I could to resolve this matter successfully and to both parties' satisfaction, and having been contacted by Agostino while he was in prison these past days, I made every effort to bring [ms. 138] Orazio Gentileschi to the prison to meet with him, as he had urgently asked me to do. And indeed I took him there one morning, but because Mass was being said in the hall, they couldn't meet. However, the said Orazio talked to a friar named Fra Pietro Giordano, who told us that morning was not the time to negotiate this matter. Therefore Orazio and I left, and I was never able to bring him back again afterwards. For this reason, the said Agostino begged me most insistently, since it was not possible for me to bring the said Orazio, to do him the favor of bringing Artemisia once, so that they could talk to each other, and he could reach a satisfactory solution for them both. As I said, I wanted to bring this matter to a successful conclusion and thus to try any way possible, so I related everything to Artemisia, and asked her to do me this favor of going to meet Agostino. And so that Orazio wouldn't present [ms. 139] any obstacles in this matter by not letting the said Artemisia be taken there, we planned to tell Orazio that we wanted to go to S. Carlo alli Catinari in the evening, and since we would be passing by Corte Savella, we would go into Corte Savella and satisfy Agostino's request. Carrying out what we had planned, one evening—I don't remember the day precisely but I think it may have been the first evening in May—Artemisia, my wife Portia, Artemisia's brother Giulio, and my son Luisio, all left the house about midnight; we went straight down the Lungara and crossed Ponte Sisto. Seeing that it was late, and without going to San Carlo at all, we went to Corte Savella.

When all of us came into the office of the Clerk of the Court, the said Agostino started to talk with Artemisia in front of me and my wife. He said that he was not a man who had [ms. 140] ever broken his word and he didn't want to break it to her, that he was ready to marry her as he had promised, and that he was renewing his pledge. And he held her hand, saying that he had promised to marry her, that he knew his obligation, and was renewing his pledge to marry her, and he wanted her to become his wife before fifteen days went by.[121] And the said Artemisia even said: "Please, Agostino, if you have a wife, tell me, so that we can take care of this in some other way." And the said Agostino answered: "My wife is dead," and added further: "If you want to get me out of this mess, you have to retract [your testimony], and then I will do whatever you want." And then Artemisia said: "I don't want to do that."

*And while the summoned person was saying these things, the witness said*: You are lying

---

[121] This passage and a later one (ms. 148) strongly evoke the longstanding tradition of marriage by *fides*, without witnesses or priest, through a "mutual consent expressed in words and actions," which included a pledge and the joining of hands. Until as late as 1563, such a marriage was legally valid. See Erwin Panofsky, "Jan Van Eyck's 'Arnolfini' Portrait," in W. Eugene Kleinbauer, ed., *Modern Perspectives in Western Art History, An Anthology of Twentieth-Century Writings on the Visual Arts* (New York: Holt, Rinehart and Winston, 1971), 193–203, esp. 197.

[ms. 141] through your teeth, and you are a fucking cuckold [*becco fottuto*]. *As soon as the judge heard that the witness, so irreverently and without respect for the judge himself, dared assault the summoned man with such scandalous words, in order to restrain his effrontery and insolence, ordered the prison guard to handcuff him and [ordered] the substitute judge to inform the governor of all the afore-mentioned so that he would decide without delay on the punishment to be inflicted because of the great irreverence and insult on the part of the witness against the said summoned man before the judge.*[122] *Accordingly, with a view to bringing this about, the said handcuffs were applied and the said substitute judge came up.*

*Continuing, the summoned man said*: And after he heard Artemisia say that she wouldn't retract [her testimony] at all, the said Agostino said to her: "At least blame someone else and say that someone else deflowered you; say that it was Cosimo, who is dead anyhow." Artemisia then answered: "I especially don't want to do that." And then Agostino added: "Say that it was Piero Neri,"[123] and then [she] said: "Piero Neri has been dead for some time, so he couldn't
[ms. 142] be the one either. I will think about it and give you an answer through Giovan Battista." And then we left. This is what I needed to say.

*The questioning witness then said*: First of all, Sir, I ask you not to be offended for the lack of respect which I have shown by uttering those insulting words against Giovan Battista here present. I did not say them to offend or show contempt towards Your Lordship or the court, as I honor all of you and I bow before you. Neither [do I wish] to offend him, since I regard his wife as an honorable woman, and God grant that he be equally honorable as to tell the truth when he speaks. I blurted out those words in anger, forgetting where I was, and as for what he says, he is not telling the truth because he brought Artemisia to Corte Savella of his own accord, not because I asked him to do it, and what he says is simply not true.

[ms. 143] *And then turning around toward the summoned man he said*: You know that you said these things because you hate me, and we are enemies after the words that we have had.

*The summoned man then replied, saying*: I don't know what words you are talking about. I think you imagine that I am a man who answers to you.

*The witness then replied, saying*: You know the words we exchanged, which I said to you at Gentileschi's door. And then you were also beaten up, and you are here to be an informer.

*The summoned man then asked, saying*: Write down, Sir, the words that man is saying, because I want him to be punished in accordance with the law for insulting me, as I have never informed on anyone, nor have I ever been beaten up. To prove that he is not my enemy, I show you these letters which he sent me after he was imprisoned.

*Accordingly, he handed over two letters to me, the notary, one beginning with "Most Magnifi-cent Sir, I hear, etc.," and ending with "Most affectionate servant Agostino Tasso," and the other beginning with "Most Magnificent Sir, I understand," and ending with "Your most
[ms. 144] obliged servant Agostino Tasso."*

[Ed. note: These letters can be found in mss. 152–57, below.]

---

[122] In the manuscript this passage reads as follows (underlined words missing in Menzio): ". . . *apponi manicos ferreos et postea per substitutum fiscalem de premissis omnibus certiorari illustrissimum Dominum Gubernatorem ad effectum deliberandi de poena incon-tinenti inferranda ob tantam irreverentiam et iniuriam* *ab ipso constituto factam coram Domino contra dictum adductum prout ad hunc effectum dicte manice ferrae fuerunt apposite et dictus substitutus fiscalis accessit.*"

[123] "Pierneri," a name not clearly legible in the manuscript (given by Menzio as Piero Nemi), is cited legibly below as Pietro Neri (ms. 149).

*Then the judge terminated the examination, dismissed the summoned man and ordered that the witness be sent to his place, etc.*

*And before the witness was taken away from the examining room, he said*: Sir, write down that he came to Corte Savella and asked me to give him 15 *scudi*, as he wanted to have Artemisia retract [her testimony]. And I told him that I didn't care if she retracted, as I am an honest man, and that what he had said hadn't happened. And I say further that he is fabricator and a liar.

*Then the summoned man spoke, saying*: I say this, that what I said is the truth, and what he is saying now—that I had asked him for money to make Artemisia retract—is not so, and it is not the truth. And he has been lying through his teeth, as the letters written [and exhibited] in this trial [indicate].

*Then the judge, having heard all this, terminated the interrogation, dismissed the summoned man, and ordered that the witness be sent to his place, etc.*

The 16th day of May 1612          [ms. 145]

*Porzia, wife of Giovan Battista Stiattesi, was questioned by me, etc., as instructed, etc., in the house of the witness's usual residence at the gate of S. Spirito, in the presence of the most illustrious and excellent Lord Portio Camerario, substitute judge. Having been ordered to swear to tell the truth under oath, she was questioned by me.*

*Asked whether she knew or otherwise presumed the reason for her present examination,*

*She answered*: No, Sir, I don't know the reason you want to question me. But I guess that it is on account of the time when I and my husband and Signora Artemisia went to Corte Savella to speak to the said Agostino Tassi, since I can't think of any other reason why I should be questioned. And I know that it was for this reason that my husband was examined.

*When I, the notary, told her to tell and relate the aforesaid account which she had given as the reason, how and for what purpose they had gone to speak to the said Agostino in Corte Savella, and who had asked them to do so, and to relate the words which the said Agostino had exchanged with the said Artemisia, or with any other person,*

*She answered*: I shall relate to Your Lordship the facts as they occurred with regard to our visit to Corte Savella.[124] Before the beginning of May, while Agostino Tassi was in prison,          [ms. 147] many times he sent messages to Signora Artemisia asking her please to come to see him and talk to him at Corte Savella. He sent such messages through my son Aloisio,[125] who often visited the said Agostino because he was a friend of my husband. In particular, even more often, he sent them through my husband Giovan Battista, who said to Signora Artemisia: "Perhaps it will be for the best if you go and listen to him," since she didn't want to go. At last, persuaded by my husband, she decided to go. The night of the first of May, at midnight, having first led Signor Orazio, the said Artemisia's father, to believe that we were going to San Carlo alli Catinari, Artemisia, my husband Giovan Battista, my son Aloisio, and Artemisia's brother Giulio, we all left Artemisia's house and went to Corte Savella. We went down

---

[124] Page 146 of the manuscript is a small loose sheet of paper inserted among pages to which it is unrelated. It consists of a series of questions to be put to "Valerio" (probably Valerio Ursini, a witness for the defense of Niccolo Bedino), concerning the relationship between Bedino, Agostino, and Valerio.

[125] Above given as "Luisio" (ms. 139).

[ms. 148] the Lungara, across Ponte Sisto, and arrived at Corte Savella, and it must have been almost one in the morning when we arrived.

When we arrived we found Agostino behind bars [*stava a quella ferrata*] on the left-hand side, just as you enter the first gate. As soon as Agostino saw us, he had someone open the door, and we went in the office of the Clerk of the Court and sat down. The said Agostino came up to us, looking as if he were about to faint and unable to speak. Finally he said these words: "Oh my Signora Artemisia, you know that you must belong to me and to no one else. And you know that I made a promise to you and I want to keep that promise." And he repeated these exact words: "If I don't take you as my wife, then let as many devils take me as the hairs on my head and in my beard, and for the rest of my life." And then he said: "Let's exchange our pledges [to marry]," and he held out his hand as did Artemisia, and they held each other's

[ms. 149] hands, and Artemisia said these or similar words: "As you have given to me, so I accept [your promise], and I believe that you will keep it."[126] The said Artemisia further added: "Agostino, if your wife is alive, tell me." And the said Agostino answered: "Signora Artemisia, my wife is dead; I can tell you she is dead." Then he placed his hand on his heart, saying: "Believe me, it is true." And after these words, the said Agostino tried to convince the said Artemisia to retract [her testimony], saying: "Say that it wasn't I who deflowered you, say that it was someone who is dead." And it seems to me, if I remember correctly, that he said: "Say that it was Pietro Neri." Artemisia replied that she didn't want to do that, saying: "You know very well that it was you, and no one else." I don't remember what other words they said to each other, only that they parted lovingly. Indeed, the said Agostino said: "You have done me a big favor, thank you." And we went back home.

*Asked whether, before Agostino's imprisonment, the witness had known or had heard of the above*
[ms. 150] *complaint by the said Artemisia against Agostino, and if so, how and when,*

*She answered:* Shortly after I came to live in this house where the said Artemisia also lives—I came in November or December—I believe it was about eight or ten days after I came to this house that I was talking to Artemisia, as women do among themselves, and she told me that this Agostino was her boyfriend, and that he had deflowered her. I believe, if I remember correctly, that she said he had deflowered her in May, and that he had raped her [*sforzata*] in her house—at that time she lived in Via della Croce—and that right after he deflowered her, Artemisia had said to him: "You have taken something away from me that you can never replace." And according to what Artemisia told me, the said Agostino replied: "Have no doubt, Signora Artemisia, I want to take you as my wife and marry you." And this is what I can tell you about the subject you asked me about.

*In the interest of knowledge [In causa sciendi].*

[ms. 151]                                                                    The 22nd day of May 1612

*The illustrious and excellent Lord Francesco Bulgarello, substitute deputy, fixed a term of three days for the said Agostino Tassi to prepare his defense, more or less at the discretion of the judge, but without prejudice of the laws of the state [fiscus] and further trial, etc.*[127] *And he ordered that a copy*

---

126 See n. 121 above.

127 The word *preiudicio* ("prejudice") is missing in Menzio.

*of the trial's proceedings be submitted, following the preparation of a statement that the witnesses had been examined according to the correct procedures, etc.*

*Then the aforenamed Agostino, painter,*[128] *appeared before me, etc., of his own accord, etc. After I told him to swear under oath, etc., he declared that he wanted to have some witnesses examined in this case, according to the correct procedures, and with certain exceptions he would examine these persons and their statements, etc., reserving the right to recall them, if and how many [he wished(?)],*[129] *except the absent and the dead.*

*Present in the office of the clerk of the court in Tor di Nona prison were the magnificent and excellent Lord [Domino] Nicolo Claudio di Pergola [Latin:* Pergula*] and Lord [Domino] Francesco Guttieres of Rome as a witness.*
Signed by Callisto Pietro, Notary.

[Letters from Tassi to Stiattesi, cited above, ms. 144:]

Most Magnificent Sir,                                                                              [ms. 152]
I hear that, with much promptness and good will, Your Lordship has pointed out several things that indicate that Gentileschi wants to see me in the depths of misery. I want to let you know that I want Gentileschi to know that I am not just out of school and that neither is he an arbiter of justice, which will be done to me fairly and equitably. I know that he will do whatever he can, neither more nor less. And if I were afraid to be taken to Tor di Nona by order of "*signor Fiscale*,"[130] or anything [*sic*] else, I declare that I am not afraid because I know that "*signor Fiscale*" is a fair gentleman who will act only with justice and honesty.

That Gentileschi doesn't want me to have those fifty *scudi* to which I have a right doesn't concern me, because I will make sure that he doesn't usurp what belongs to me, as he thinks he can. Certainly there are those who will support me and look out after my interests. But to claim injury, as he does! If he had any heart and if he remembered the favors I have done him,       [ms. 153] he wouldn't do to me what he is doing, because I helped him when he was in great need and, for three consecutive months, I gave him his share of the money paid to us by the Cardinal. And he never appeared in that place except on Saturdays. Never has self-interest motivated me the way it has him. How much better it would be for him to earn [money] for the clothes of that poor girl and to give her more happiness than he does: he has ruined his own flesh and his belongings, for which God will punish him. For the merits of Signora Artemisia are so many and such that he is unworthy of being called father by her. But let Gentileschi do what he wants, the time will come when he will need her, and she will look at him with pity. God will allow this because of his [Orazio's] constant lack of compassion toward her.       [ms. 154]

I reply to Your Lordship and declare that you can say to "*signor Fiscale*" and to Bulgarello that even if she [Agostino's wife] had died a thousand times, I still wish that she were alive, nor would I want to do anything like that. And I intend to defend myself in the name of justice. However, Your Lordship can write to Tuscany for verification to no avail, because I know that Your Lordship won't find satisfaction. And you can tell Gentileschi on my behalf that if that

---

[128] The word *pictoris* ("painter") is missing in Menzio.

[129] The "etcs.," represented by Menzio by ellipsis, are in the manuscript. "He wished" is here pro-

posed for an illegible three-letter abbreviation.

[130] A *fiscale* is a public official who defends the interests of the state.

man from Pisa who said that she is dead, if he and Gentileschi both had their heads where they have their feet, they wouldn't abuse or oppose me so unfairly as they are doing. Let him bring [ms. 155] suit, it would be fine with me, because it would show in Rome that I have always behaved honorably in all of my actions.[131] And if this man from Pisa is willing to tell me to my face, when I get out, what he said about me, I will show him how far he is from being right.

I assure you that I am most uplifted by your good heart, and I feel certain that you have done your best for me. But there is not much one can do with something harder than stone. Gentileschi, however, will persevere in acting against me and I will defend myself. I am in a place where, when the innkeeper cooks, everyone is served,[132] and I don't think he is worth a fig, and I will stick it up his ass [*lo inculo*] if he thinks he can corrupt the process of justice, which I hope cannot be done, for everyone has his rights.[133] And with this ending I pray that Our Lord grant you the greatest happiness.
From Corte Savella, the 22nd day of April 1612.
Your Most Magnificent Lordship's most obliged servant,

<div align="right">Agostino Tasso.</div>

[ms. 156]   Most Magnificent Sir,

I understand what you are telling me in your letter and I shall take it into account in order to serve the ends of justice. You can tell Orazio Gentileschi on my behalf that I think he is not worth a dry fig, that truth and reason have such power that I am not afraid of him nor a thousand like him all together. Because as long as I take your advice to keep God on my side, whoever can oppose Him, the One who, I hope, will pull me out of this and greater trouble. However, I thank Your Lordship for your good heart, for which I am most obliged, and when I am beyond these miseries I will show you my gratitude.

If while I am locked up here, he speaks badly of me [or] is a nuisance to me, it won't be prejudicial to me at all, because I'll make sure when I get out of here that I make him tell the truth always, and acknowledge that my actions have been most honorable.

I regret only one thing, which is that it has taken me until now to prepare my defense. [ms. 157]   However, at this point, I am going ahead, but on the conditions that I promised you, for I would rather die than offend a friend [*quello amico*]. You must know that when I make a promise, I keep it. And with this ending I pray to Our Lord that you may have the opportunity to assure yourself of my good will, which, I assure you, you will always find ready to serve you. And with this ending, I kiss your hands.
From Corte Savella, the 27th day of April 1612.
Your Most Magnificent Lordship's
        most obliged servant,

<div align="right">Agostino Tassi.</div>

[ms. 158]   To the Most Magnificent and Honorable Illustrious Cavalier, Signor Giovan Battista Stiattesi.

[131] Although Tassi here speaks in the conditional tense, in fact the trial was well underway when he wrote this letter.

[132] He means that if something new comes up, there will be trouble for all of them.

[133] "*Se lui pensa corompere la giustizia quale spero ne potrasi [or potrari] farno [sic; not fanno as given by Menzio], per tutti il dovere . . .*"

[Here follow questions 1–24, addressed to Artemisia by Agostino. These have been inserted above, mss. 128–130, interwoven with her answers. The list of questions ends with the following rather unclear sentence:]   [mss. 159–62]

These questions should be of use in the judgment of other interrogations to be made by my attorneys, when it is necessary to learn from [or about] Artemisia.

[ED. NOTE: The following testimony, recorded in a file entitled Miscellanea Artistica, was recently discovered in the Archivio di Stato, Rome, apart from the rest of the trial testimony. The file includes interrogations of Nicolo Bedino and Orazio Borgianni (May 30–June 7), which occurred at this point in the proceedings. The new document has its own pagination, pp. 78–82, here labelled MA-78, MA-79, etc., to avoid confusion.]

The Governor's Court          [MA-78–MA-81]
1612 May 30–June 7

Orazio Gentileschi, painter, vs. Agostino Tassi, painter, accused of having seduced Artemisia Gentileschi: interrogations of witnesses, among whom Nicolo Bidino [sic] and Orazio Borgiani.

Eight papers
1612 May 30th

 *The attorney [procurator] gives, does, exhibits, and produces the articles mentioned below and*   [MA-78, recto]
*all that is contained in them, in the name of Signor Agostino Tasso versus the State and the party to*
*the suit [adherentem]. He asks to be admitted to prove them, not to be subject to restrictions except,*
*etc., in the best way possible, etc.*

 *First the attorney produces, repeats, and reproduces all and any proceedings that have been car-*
*ried out in favor of his principal, and then revokes and annuls all and any confessions both judicial*
*and extrajudicial, if there are any, made and to be made against him, and says that from these*
*elements thus accepted and revoked respectively, the good faith and innocence of his principal appear*
*fairly clearly. And to the extent that it is not completely clear, then in that event and on that account*
*he wishes and intends to speak in the vernacular for the easier understanding of the witnesses, speaking*
*however in such manner as to avoid vulgarities, upon which he expressly insists.*

ITEM. That when Orazio Gentileschi dwelled with his family in Via Margutta at Borghetto   [MA-78, recto (separate sheet)]
dei Pidochi, his daughter Artemisia was seen many times to retire to her room in the company
of [different] men, one at a time. As soon as they had entered the room, they closed the door
and stayed for a while, and then they came out all red and flushed in the face [two lines illegible, corner of page completely torn].

ITEM. That at the same time and place the said Artemisia was seen with various persons, touch-   [MA-78, verso]
ing and kissing, and performing other dishonest acts to be specified by the witnesses.

ITEM. That the said Artemisia wrote and sent letters to various persons many times and on various occasions, as it happened [*quod fuit*].

ITEM. That two years ago, Pasquino of Florence had someone take him to the said Artemisia's house several times, during the day and at night, when her father Orazio Gentileschi was not at home. He made the person who had accompanied him wait outside and, after he had stayed for a long time in the house where the said Artemisia was, he was seen to come out red and flushed in the face.

ITEM. That the said Artemisia has confessed to various and sundry people that she had been deflowered by the said Pasquino of Florence.

ITEM. That the said Artemisia was found alone in her chemise [*camicia*, or room, *camera*; a hole in the paper obscures this word] . . . [one or two more words missing] with the said Pasquino, as it appears elsewhere from witnesses, etc.

ITEM. That Artemisia's mother and Artemisia's sisters [hole in the page] were women of ill repute [hole in the page after *ri* . . . ; probably *riputazione*] and fame, and were so deemed by the whole city who knew them . . . [torn right corner of page renders three lines illegible] . . .

[MA-78, *recto*] has been and is a public whore, as it appears elsewhere from witnesses, etc.

ITEM. That for the past two years or longer the said Artemisia has not been regarded and reputed to be a virgin [*zitella*], rather, it is publicly said and held for certain by everybody that she has had sexual relations with several people, and in particular with Gerolamo of Modena, Pasquino of Florence, Francesco Scarpellino, and a certain Archigenio [*sic*]. And this is what the witnesses have heard people say, and they held it and believed it openly.

ITEM. That, as people heard and found out that Agostino Tassi was in prison under the pretense that . . . [*sic*] he had deflowered the said Artemisia, immediately a public voice and rumor arose that this was a real persecution [perpetrated] in the hope of making him take her as his wife and that, truly, the said Artemisia had been deflowered long before, as it appears elsewhere from witnesses, etc.

ITEM. That at the beginning of Lent the said Agostino met Giovan Battista Stiattesi in front of S. Spirito and asked him to return a certain amount of money that he [Agostino] had lent him [Stiattesi]. And the said Stiattesi replied that he didn't have any [money]. And the said Agostino retorted that . . . [hole in page] and that he should find it, that otherwise he would have . . . [hole in page] for this ugly . . . [holes in page].

[MA-79, *verso*] ITEM. That a few days later, when the said Agostino was passing in front of the house of the said Stiattesi, and when he saw that people were laughing about him, he said to him [Stiattesi] that if he were ever to run into him, he would make him regret [all this], adding other insulting words, just as the witnesses [said].

ITEM. That, after the said exchange of insults between the said Agostino and the said Stiattesi, they were reputed [to be] ill-disposed and hateful toward each other publicly, by everyone who had learned of the said words, etc.

ITEM. That the said Stiattesi plotted with Orazio Gentileschi for him [Orazio] to bring suit against Agostino by writing a memorandum in his own hand to give to the Pope, as in fact he did. And to that effect, the said memorandum addressed to the Pope is shown in the original to the witnesses.

ITEM. That the said Stiattesi said in many and varied words that, because of his hostility toward the said A[gostino], he had plotted to have him sued for having deflowered the said Artemisia . . . [hole in page] to make the said Artemisia believe . . . [hole in page] to have her taken as his wife by . . . [hole in page].

ITEM. That the said Stiattesi, in Corte Savella prison, openly said to several people that if the said Agostino were willing to give him fifteen *scudi* he would arrange to have the said Artemisia exculpate him and name the one who had deflowered her, as the said Artemisia had confessed to him that she had been deflowered by a Florentine and others [*et alias*]. [MA-80, *recto*]

ITEM. That several days before the said Agostino his . . . [word unclear] was imprisoned, while he was having a meal in his house, Domina Tuzia [wife] of Stefano came there saying that she wanted to talk to him, and the said Agostino told her to go away, that he didn't want to listen to her. And since she was determined to speak, he took her by the arm and threw her out, kicking her in the rear. And then the said Tuzia said, "I will make you regret this," etc.

ITEM. That this last summer of 1611 the said Agostino tried to arrange by various means to have Gerolamo Modenese take the said Artemisia as his wife, etc.

## List of Witnesses[134]

Orazio Borgianni of Rome, painter, lives in Via della Croce          [MA-80, *verso*, through
Francesco Altediani of Celano [?], lives in Via dei Liutari in the house of          MA-81, *recto*]
    Cavalier Orazio Ricci
Luca Penti of Rome, tailor, lives in Campo Marzio
Rinaldo Coradino of Bologna, a servant of Signor Cardinal Borghese, [lives]
    at Trevi Fountain
Nicolo Bedino of Urbino, who was formerly Orazio Gentileschi's servant, at present stays with
    Master Pasquale, painter, in Via dei Liutari in the house of Cavalier Ricci"
Antonio Maria Acherisio of Romagna at present is in prison at Corte Savella.
Giuliano Formicino of Rome, barber, [lives] in Piazza Mattia [i.e., Mattei].
Salvatore the Indian, a servant of Signor Teodoro Della Porta, [lives] in Borgo Pio.
Madam [*Madona*] Fiore, [wife of] Gian Ruerto(?), weaver, lives in Via della Lungara near the
    . . . [*Cornie*? word unclear].
Luca Finochio [*sic*] has a room in an inn in the Suburra, etc.
Mario

---

[134] The witnesses are essentially the same as those who testified on Tassi's behalf in the main trial testimony to come, though not in the same order.

[hole] . . . witness . . . on the day 14th of June 1612
[hole] must be examined over 2. 9. and 10.

[MA-82, *verso*]                          Before the Governor's Court
For Signor Agostino Tassi versus
the State [*Fiscum*] and
Signor Orazio Gentileschi
On the day 30th of May 1612
Signor Angelo Lact. Notary

[ED. NOTE: The main trial testimony resumes at this point.]

[ms. 163]                                                    Friday the 8th day of June 1612

*On behalf of Agostino Tasso against the State and parties to the suit, [Nicolo Bedino Felice] was
examined in Rome in my office, etc., by me, etc., as instructed, etc., in the presence of the magnificent
and excellent Lord [Domino] Porzio Camerario, substitute judge.*[135] *Nicolo Bedino Felice of Pesaro,
a witness, etc., for the defense of the aforenamed witness, was sworn to tell the truth, and after he had
sworn under oath, he was first questioned and examined with regard to the interrogations on behalf
of Signor [Domini] Orazio Gentileschi as the injured party in the suit. And in response to Item 1
regarding his name, surname, city of origin, as above:* I live at Leutari, I work as a painter.[136]

*With regard to Item 2, he was admonished on that account to answer accurately.*

*To Item 3, he answered*: I went to confession and to Communion at Easter this year. I went
to a confessor in St. Peter's and I took Communion in the same church; there were a lot of
people, among them also my father. I have the baptismal certificate at home.[137]

*To Item 4, he answered negatively.*

*To Item 5, he answered*: I have been summoned to testify at the request of Mr. [*messer*]
Agostino Tassi. He sent for me in Tor di Nona, where my boss Mr. [*messer*] Pasquale was also
present, and he asked me if I knew anything about this matter of Artemisia. I told him what
[ms. 164]   I knew to be true, and he asked me to testify. And thus I was brought here this morning by a
man in a long robe whom I don't know. He found me by chance on the bridge as I was coming
to Rome and said: "Come with me." And thus he brought me here and told me that I would
be examined on behalf of the said Agostino.

*To Item 6, he answered*: I was not given anything nor was I promised anything, nor do I
hope to get anything on account of this from Agostino or from others.

*To Item 7, he answered*: It will be three years on September first that I've been in Rome. I
lived with Signor Orazio Gentileschi on Via Margutta, and also with my uncle Giulio de Felice

---

[135] The original text reads (words missing in
Menzio or corrected are underlined): "*Pro Augus-
tino Tasso contra Fiscum et adherentes examinavit
Romae in offitio mei etc. ac per me etc., de mandato
etc., assistente magnifico et excellenti Domino Portio
Camerario substituto fiscali. . . .*"

[136] *L'essercitio mio e di pittore.* The ellipses in Men-

zio stand for *et cetera* symbols in the manuscript.
The list of questions asked of Bedino is not pre-
served in the trial records.

[137] *Ho il battesimo a casa*, which could also mean
"I was baptized at home." Bedino must have been
asked several questions here, since the final sen-
tence is not obviously related to the preceding two.

in S. Onofrio, and they paid my expenses. I have never worked with anyone else on other terms, that is, as a day worker.

*To Item 8, he answered*: I know both the disputing parties [*le parti che litigano*], that is, Signor Orazio Gentileschi and Signor Agostino Tassi. I've known them since a year ago this coming Lent, as I was an apprentice to Signor Orazio, and I met the said Agostino a little earlier when he lived on the slope of S. Onofrio not far from my uncle's house. [My uncle] used to send me to his house to learn drawing. I don't owe either of them anything, nor do they owe me, and I am a friend of them both, equally.

*To Item 9, he answered*: I know Signor Orazio, as I said, because I lived in his house on [ms. 165] Via Margutta. I went there to begin with during Lent, we stayed in that house two months, and then Signor Orazio took a house in Via della Croce. I don't remember how long we stayed there, but from there we came to S. Spirito, to the house where Signor Orazio lives now. I stayed there until this uproar started about Signor Orazio bringing suit against Agostino, and I left a month later. Living with Signor Orazio on Via Margutta were his daughter Signora Artemisia, and his three sons. In the other houses, in addition to the aforementioned, there also lived a woman called Tuzia, with her daughters and a son.

*To Item 10, he answered*: An upright man is expected not to act badly, to do honorable things, and to be an honest man. On the other hand, one who is a wicked man does dishonorable and wicked things.

*To Item 11, he answered*: Whenever I heard a person spoken ill of, or rather, whenever I heard that people suspected someone of wrongdoing, I didn't believe it, really, because anyone can lie.

*To Item 12, he answered*: I know that reputation means that when one is an honest man or a worthy man, everyone says so. And this comes from one's deeds. And I know that there is a [ms. 166] difference between reputation and that which is said and heard in public, because reputation is when one is spoken well of, but that which is [merely] said in public can be a lie.

*To Item 13, he answered*: While I was staying with Signor Orazio I saw him associate with Signor Agostino Tassi and with Signor Cosimo the orderly of Our Lord [the Pope], as well as with other gentlemen and painters whose names I don't know. I never saw him associate with wicked and disreputable people, as far as I know.

*To Item 14, he answered*: When I saw Signor Orazio associating with the people named above and with others whom I didn't know, I learned for myself that he was considered and deemed to be an honorable man of good position and reputation.

*To Item 15, he answered*: As I said above, I used to converse and associate with Signor Orazio in his house, because I was there as a servant and lived in his company, as I said above, and I've always considered him to be an upright man.

*To Item 16, he answered*: Yes, Sir. I saw important people and persons of repute [*di qualita*] visit Signor Orazio's house, as is customary in other painters' houses. This practice may or may not give rise to a bad name and reputation and to suspicions. [ms. 167]

*Then they came to specific questions [asked] of the said witness. With regard to Item 1, he answered*: No, Sir, I have never been a servant of the said Signor Agostino.

*To Item 2, he answered*: As I said, I worked as an apprentice for Signor Orazio Gentileschi. I arranged this on my own, with no help. It happened that, when I was taking some laundry

to Signor Agostino Tassi at Monte Cavallo, which his sister-in-law had sent, Signor Orazio saw me and asked me if I wanted to become his apprentice. I said yes, and I moved in.[138] He didn't pay me any salary; he only paid for my expenses and clothing. I stayed with him for the periods of time and in the houses that I stated above.

*To Item 3, he said to refer to what had been said above.*

*To Item 4, he answered as above [as in Item 3].*

*To Item 5, he answered as above.*

*To Item 6, he answered:* As I said, I stayed in Signor Orazio's house in Via Margutta because I was with him as an apprentice. That house has a room downstairs on the left side as you enter the door; and there is a courtyard and tubs, and a well. Upstairs there are two rooms;

[ms. 168] in one they painted and in the other they cooked. Above these there are two other rooms where they slept. All the rooms have windows on the street. Signora Artemisia slept in a room at the top, the first one at the head of the stairs.

*To Item 7, he answered in the negative.*

*To Item 8, he answered:* I have seen Signora Artemisia read letters that were printed as well as handwritten, but she cannot write.

*To Item 9, he answered:* I can read and write. I have not seen Artemisia write because she cannot write.

*To Item 10, he answered:* Whenever Artemisia gave me a letter to deliver, she never gave me any message to convey by mouth, just the letters.

*To Item 11, he answered:* I left the said Signor Orazio because the said Artemisia made me deliver letters all over the place. I left on my own and moved in with Mr. [*messer*] Pasquale, a painter.

*Then he was asked by the* fisco *to which person or persons the witness had delivered the aforesaid letters that the said Artemisia had given him, how many times, when, and whether he know their content.*

*He answered:* I delivered letters to Geronimo Modenese, a painter, and to Artigenio, a

[ms. 169] man in a long robe who lives at Monte d'Oro across from the Palazzo Signori.[139] I delivered three or four letters to each of them. Artemisia's brothers Giulio and Francesco also delivered some. I took them when I lived in Via Margutta, and in Via della Croce, and also in S. Spirito. They were sealed, so I don't know what was contained in them.

*Asked whether he knew what was now going on with the said Agostino Tassi, and whether he had ever seen him in the house of the said Signor Orazio, and if so, when and with whom,*

*He answered:* Agostino Tassi is in prison now. I saw him many times in Signor Orazio's house, both in Via della Croce and in S. Spirito; and Signor Orazio was also there with him.

*Asked whether he had ever seen the said Agostino in the aforesaid houses in the absence of the said Signor Orazio, and if so, how many times,*

*He answered:* Yes, Sir. I saw the said Signor Agostino in the said houses of Signor Orazio, and many times he was alone and Signor Orazio was not there.

*Asked whether he knew for what purpose the said Agostino had gone alone to the said Signor Orazio's house,*

---

[138] The preceding five sentences, beginning with "Signor Orazio Gentileschi," are underlined by hand in the manuscript.

[139] See n. 96.

*He answered*: The said Agostino came alone to Signor Orazio's house because he used to teach perspective to the said Signora Artemisia. He taught her both in the house on Via della Croce and the one in S. Spirito. [ms. 170]

*Asked whether, at the said times, anyone was present when the said Agostino was teaching the aforenamed Artemisia perspective, and if so, who,*

*He answered*: In the house there was myself and Artemisia's brothers, and sometimes also Tuzia, when the said Agostino came to teach the said Artemisia.

*Asked in which room of the house the said Agostino taught the said Artemisia, and whether the witness was always in the same room with them,*

*He answered*: Agostino taught perspective to the said Artemisia in the living room [*sala*] of the aforesaid apartment. I wasn't always watching since I was doing my chores around the house.

*Asked whether he knew or had heard anything said about what Artemisia's status and reputation had been and were,*

*He answered*: I didn't consider Artemisia an honest woman because men used to come to the house, that is, Geronimo Modenese and Artigenio. Both of them were always coming to the house in Via Margutta, as well as the one in Via della Croce, and also in S. Spirito. Both of them came to all three houses, and they used to kiss and touch the said Artemisia in my [ms. 171] presence.

*Asked whether anyone else was present when the aforementioned Artigenio and Geronimo Modenese kissed the said Artemisia, and if so, who,*

*He answered*: When the said Artigenio and Geronimo Modenese kissed and touched the said Artemisia, her brothers were sometimes there. And they [Artigenio and Geronimo] used to come separately, sometimes one, sometimes the other.

*Asked how many times he had seen the aforenamed Artigenio and Geronimo in the said houses with the said Artemisia,*

*He answered*: The said Artigenio and Geronimo have been in the house with the said Artemisia many times. Artigenio has probably been about thirty times, and Geronimo about eight times.

*Asked whether he knew or had heard anyone say that the said Artemisia was a virgin or that she had been deflowered, and if so, by whom and when,*

*He answered*: I heard it said by several people, whom I can't recall now, that Artemisia is not a virgin. I began to hear this about a month before I left Signor Orazio. I don't know who deflowered her, nor have I heard anyone say.

*Asked whether he had heard anyone say how long ago, and where, the aforenamed Artemisia had been deflowered,*

*He answered*: I don't know, nor have I heard anyone say, where or when the said Artemisia was deflowered.

*Asked whether he knew or had heard anyone say why the aforenamed Agostino was in prison at* [ms. 172] *the present time,*

*He answered*: The said Agostino is in prison because Signor Orazio brought a suit against him for having deflowered the said Artemisia. I have heard people say this everywhere.

*Then they came to the articles for the defense of the said Signor Agostino, which had been drawn up and set aside subject to his agreement.*

*Regarding number 2, he said*: I saw the said Artigenio and Geronimo kiss Artemisia in Via Margutta. In the same house I also saw her being kissed by Francesco Scarpellino, a painter, who used to come often, and they used to take each other by the hand and go to the room upstairs. But I don't know what they were going to do.

*Regarding number 3, he said to refer to what had been said above.*

*Then, etc., the examination was brought to a conclusion and the witness was asked to leave, having given an oath of silence and having been enjoined to sign*: I, Nicolo Bedino, attest to the above.

## SYNOPSIS OF TESTIMONY

### [Mss. 172–340]

[mss. 172–78]   Giuliano Formicino, of Rome, was questioned in the notary's office on June 9, 1612, as a witness for Tassi's defense. His examination, and the next four in sequence, follow the same format as Bedino's. He testified that, in April during Lent, he overheard Stiattesi promise Agostino that he would have the girl who claimed that he deflowered her retract her accusation and name the guilty man, namely Pasquino Fiorentino. Stiattesi, he said, alleged that [Artemisia] had told him that Pasquino had done this about four years ago.

[mss. 179–89]   Luca, son of Aloisio Penti of Rome, who worked as a tailor, was questioned on June 15, 1612, as a witness for Tassi's defense. He testified that he had seen Artemisia at the window many times in the various houses she had lived in; that he did not know who deflowered her but that a friend of his, Pasquino da Fiorenza, had been visiting her a long time, and that Pasquino told him that he and Artemisia were in love with each other, and they were having a sexual relationship. According to Luca, Cosimo had been boasting the past three or four years of having had intercourse with her, while Stiattesi had said the past winter that she was a whore and had told him that Pasquino had deflowered her. He added that all of them had something bad to say about Artemisia, and that Cosimo had told him a year ago that Agostino was madly in love with Artemisia, but no one had said that he and she had ever had intercourse.

[mss. 190–94]   Donna Fausta, daughter of Domenico Cicerone, a laundress who lived on the Lungara, was questioned on June 18, 1612, as a witness for Tassi's defense. She testified that she had been doing Agostino's laundry for about a year, and at the beginning of Lent, she encountered Tuzia at Agostino's house, being treated very badly by Agostino, whom Tuzia insulted and called a scoundrel.

[mss. 194–99]   Mario, son of Filipo Trotta, a painter from Caserta living in Rome, aged twenty-one, was questioned on June 20, 1612, as a witness for Tassi's defense. He testified that he did not know Artemisia, but had heard people talk about her often when he lived with Antinoro Bertini [*sic*], a man who sold paints and in whose house painters used to gather. They always had good things to say about her, and she was reputed to be a virgin and an honest woman. Only once, Carlo Veneziano said that he had seen her shamelessly at the window. Mario reaffirmed that he had always heard that she was a virgin and that he had never seen anyone kiss her or touch her.

Marco Antonio Coppino of Florence, who had lived in Rome for twenty years, whose job [mss. 199–207] it was to mix ultramarine color, was questioned on June 20, 1612, as a witness for Tassi's defense. He testified that he had been in Tor di Nona with Agostino, and that he had heard that Artemisia had been deflowered long ago, and had gone with many men. He had heard this in many places, in particular in Antinoro Bertucci's shop, where a group of painters had gathered, and talked of her as a public woman. Marco Antonio claimed that, when he refused Agostino's request to testify to this effect in court on the grounds that he was a friend of Orazio as well as Agostino, Agostino had him subpoenaed. He added that he had heard, not only in Antinoro's shop but also in the shop of Angelo the sculptor, that Artemisia was a beautiful woman, that her father did not want her to marry, made her pose in the nude and liked for people to watch her, and that she was not a virgin, having been deflowered about three years ago.

Father [*Baccalaureus*] Pietro Giordano from Benevento, of the Order of the Hermits of St. [mss. 207–214] Augustine, was questioned on June 29, 1612, as a witness for the Curia. He testified that he met Stiattesi in Corte Savella prison, who told him that Agostino had deflowered a young woman, and had forced him [Stiattesi] to go and live in her house to help him out. Not wanting to do this because of Orazio, Stiattesi had quarreled with Agostino and wound up in prison. He asked Father Giordano to intervene, and when Father Giordano accordingly approached Agostino, the latter explained that he had to marry the girl since he had taken her as a virgin, but was concerned that his wife might still be alive. Father Giordano further described a visit to the prison by Artemisia, who showed expressions of love toward Agostino when she left. Agostino told him that she was his dear Artemisia and wife, that they had contracted matrimony and that he had given his pledge to marry her. He added that he was grateful to Stiattesi for what he had done for him.

He then testified that Nicolo Bedino used to come to the prison to bring meals to Agostino, and that he had often seen the two of them eating together. Bedino, he said, and several others had offered their services as witnesses for Tassi to put Orazio Gentileschi to shame.

Agostino Tassi was brought again before the Court on July 5, 1612, and was urged to confess [mss. 214–226] that he had raped Artemisia with the false promise of marrying her. He was informed of Father Giordano's testimony to this effect. Agostino asserted that the testimony of Father Giordano, whom he claimed to have met in prison, was false. Then the Father was brought in and asked to confirm his previous testimony in front of Agostino, which he did, repeating it. Agostino insisted that Father Giordano was lying about everything and that Bedino had never been to Corte Savella, a fact that could have been proven by three or four witnesses. He concluded that the whole thing was a plot designed by Stiattesi and Gentileschi, with the help of Father Giordano. They argued back and forth, the Father reminding Agostino of the false witnesses he had been planning to have testify in his defense. Agostino denied everything, claiming he could prove that Artemisia was a whore.

[ED. NOTE: Orazio Gentileschi here files suit against Agostino Tassi and the six witnesses produced by him for bearing false witness.]

Orazio stated that he had brought action against Agostino a few months earlier because [mss. 227–31] Agostino had deflowered his daughter Artemisia, aged fifteen, against her will. Agostino then

kept her with the promise to marry her, and at the same time threatened her not to tell her father. Because of the friendship between Orazio and Agostino, the latter used to visit Orazio's house, and thus Orazio found out only much later about his despicable behavior. He then brought suit against Agostino, supporting his charge with the following points:

—In the course of his testimony, Agostino produced a series of slanderous charges against Artemisia, claiming not only that she had been deflowered by another man, but that her mother and aunts were whores as well. Since he could not prove that his accusations were true, he produced false witnesses. Of the six witnesses who testified in Agostino's defense, four were blatantly false and had been fed fraudulent information against [Orazio].

—Nicolo Bedino denied that he was Agostino's servant, a fact that is confirmed by Father Pietro's testimony. It is equally false that he had lived in Via Margutta, and the wrong description of the house proves it. He also claimed that he carried letters from Artemisia to some men, and at the same time confirmed that she cannot write.

—Giuliano Formicino's testimony is equally false. Father Pietro's testimony confirms that Agostino and Stiattesi discussed their affair quietly, so as not to be heard. If Stiattesi had wanted to make a deal with Agostino, he would not have announced it in front of other people.

—Luca Sartore's testimony is also false. Stiattesi could not have told Luca about Pasquino because he [Stiattesi] was not in Rome at that time.

—There is a discrepancy between Agostino's claim that two years ago Pasquino had had himself taken to Artemisia's house, and Luca's own statement that at that time he had not gone with Pasquino. Luca accused Pasquino of having had intercourse with Artemisia because he knew Pasquino is dead and cannot speak of it.

—Marcantonio Coppino not only denied that he had been in prison for stealing, but testified that Mario Trotta had said in Antinoro Bertucci's shop that Artemisia was not a virgin but a dishonest woman, whereas Trotta himself declared in his testimony that everyone had said that she was a virtuous young woman, a virgin.

Orazio demanded that Agostino and the other false witnesses be punished for their false testimony.

[mss. 232–35]    Giovan Pietro, son of Angelo Molli of Palermo, age seventy-three, was questioned by the Curia on July 27, 1612. He testified that he worked as a model for Orazio in the previous year during Lent, posing for some heads as well as for a whole figure of St. Jerome, for which he was asked to undress from the waist up.[140] In Orazio's house he saw his daughter and three sons, the oldest of whom used to grind the colors, and a nephew who was learning and helping around. He claimed that Orazio did not have any apprentice, and he did not know who Nicolo Bedino was. Asked to describe Orazio's houses, he gave the following description of the house near the Babuino [i.e., Via Margutta]: there is a fireplace in the entrance hall, and on the left, a room; upstairs are two more rooms on the left side of the staircase, one leading into the other. They used to eat in the first room and work in the other, which had two windows overlooking the street. On the other side of the staircase is an open space with a well and small kitchen; above the two rooms are two more rooms—he never went there—and above the kitchen is a small garden with many trees, belonging to the landlord.

[140] Molli's role as model for Orazio's *St. Jerome in Penitence* is discussed by Bissell, 1981, 151.

Donna Margherita, daughter of Agostino from Milan, washerwoman, was questioned by [mss. 236–39]
the Curia on July . . . [hole in the page; date not legible], 1612. She testified that she had done
the laundry for Orazio for the past eighteen to twenty years, wherever his domicile was, start-
ing in Via di Ripetta, then Piazza della Trinità, Via dei Greci, Via Margutta above the
Babuino, then Via della Croce, and then S. Spirito. She said that since Orazio had lived in
S. Spirito, for about a year, he had had a young man named Nicolo as apprentice and to do
chores around the house. She reiterated that she had never seen him before, in any of the
previous houses.

Bernardino, son of Francesco de Franceschi of Lucina, testified for the Curia on July 31, [mss. 239–45]
1612. He stated that he had been Orazio's barber, and sometimes model, for eighteen to twenty
years, and had gone to his house at the various addresses: Piazza Trinità dei Monti, Via dei
Greci, Via Margutta, and Via della Croce. He had seen the following people at Orazio's house:
Francesco Scarpellino, Giovan Battista (Orazio's nephew), Pasquino Fiorentino, and the
washerwoman Margherita and her husband. He testified that he did not know Nicolo, nor
had he met anyone by that name at Orazio's house. However, when Gentileschi lived in Via
dei Greci, he saw a young man, thirteen or fourteen years old, there a few times. He was
learning to draw, and Bernardino thought that Cavaliere Giuseppe d'Arpino had recom-
mended the boy, whose name he does not remember, to Orazio. He then described the house
in Via Margutta.

Pietro Hernandes, a Spaniard, testified for the Curia on August 4, 1612. He declared that [mss. 245–47]
he had known Orazio only since the past October, as Artemisia was godmother to his son. He
never saw Nicolo there, but heard from a neighbor that Orazio had taken a young man to do
chores around the house. Later he saw the young man there; he was learning to draw, and
Artemisia also taught him to paint. He had heard that Nicolo had been with Agostino, a
painter, who had placed him with Orazio.

Caterina, daughter of Jacopo Zuccarini, testified for the Curia on August 8, 1612. She [mss. 247–49]
declared that she used to help the Gentileschi family with housework in S. Spirito, between
July-August and November of the previous year. At that time, Orazio took in a young man
named Nicolo, who helped him with house chores, and came to learn to draw. She had heard
that before moving in with Orazio, Nicolo used to live with Agostino Tassi. In fact, at times
when Orazio scolded Nicolo, she heard the latter threaten to go back to Agostino's place.

Nicolo Bedino was questioned by the Curia on August 14, 1612. He testified that in Sep- [mss. 249–65]
tember he will have been in Rome three years, and that the first year he lived with his uncle
on S. Onofrio, where he worked in his uncle's vineyard. The following Lent he moved into
Orazio Gentileschi's house, having met Orazio at Monte Cavallo when he took some shirts
and money to Agostino there, as requested by Agostino's sister-in-law. He had met the latter
two through his uncle, four or five days before meeting Orazio. Orazio asked him to move in
with him, and offered to teach him to draw, and [to give him] food and drink as well, in
exchange for work at his house.
When Nicolo moved in with Orazio in Via Margutta, the following people lived in the
house: his daughter Artemisia; his three sons, Francesco, Giulio, and Marco; and a nephew
Giovan Battista (who left four or five days after Nicolo moved in). Orazio used to work at

Monte Cavallo all day long; he did not do any painting at home, nor other work except for the drawings that he used at Monte Cavallo. Nicolo ground the colors and mixed them with oil for Artemisia, who used them to paint her canvases, not for the father.

Two months later, Orazio moved to Via della Croce, a few days after Easter. Nicolo described the house in Via della Croce: there were three doors on the ground floor, the third one leading into a courtyard, and there was a room. And a cellar was below. Upstairs was a room with two windows overlooking the street, and two more rooms over the courtyard. On the top floor they had a tenant, Tuzia.

Nicolo left Orazio during Lent of this year, when the trouble between him and Agostino had begun. He never lived with Agostino, but only went there a few times when sent by Orazio. He claimed to have met Artigenio at Orazio's house in Via Margutta, and to have delivered some letters to him from Artemisia. He stated that Stiattesi bought Nicolo his clothes for the past winter, and that he believed Orazio gave the money for them.

[mss. 265–66]     Carlo Saraceno, a painter from Venice, testified for the Curia on August 17, 1612. He declared that he had known Orazio Gentileschi for about eight to ten years, since he came to Rome. He had heard that Orazio had a daughter called Artemisia, whom he has never met. He heard her mentioned because she was a painter [*l'ho sentita nominare con occasione che lei dipingeva*]. He remembered that Orazio was considered a respectable person, and so was his daughter Artemisia, who was said to be a virgin. However, he had not seen Orazio for the past two years, and in that period, has not heard good or bad things about him.

[mss. 267–69]     Donna Olimpia [Agostino's sister], wife of Salvatore de Baggelli, testified for the Curia on August 24, 1612. She related that about two years earlier, when Agostino was looking for a boy to do household chores, she talked to Vincenza, Giulio Felice's maid, who recommended Giulio's nephew Nicolo. Nicolo moved in, and as he was interested in learning to draw, Agostino agreed to teach him. He stayed with Agostino more or less a year, after which he went to Orazio Gentileschi. Nicolo left Orazio during the preceding Lenten period, and returned to Agostino's place while Agostino was in prison at Corte Savella. She stated that Agostino bought Nicolo some clothes, which she described, and added that Agostino and Cosimo urged Nicolo to go back to Orazio.

[mss. 269–72]     Marta De Rubertis, of Rome, testified for the Curia on the same day. She stated that she was a neighbor of Agostino's at S. Onofrio for about fifteen to eighteen months, having moved about a year ago. She said that Agostino's sister-in-law and her husband lived with him, and that Giulio Bruciavigna's nephew Nicolo came to stay with Agostino. He did house chores, and Agostino taught him to paint. Nicolo then left for about a month, but returned and was still with Agostino on the eve of St. Bartholomew's Day [August 24], when she [Marta] moved. She added that all the neighbors knew that Nicolo had stayed there, and could certainly testify to that effect.

[mss. 272–76]     Nicolo Bedino was again questioned in prison on August 26, 1612. He reiterated that when he left his uncle's house he moved in with Orazio, that he never lived with Agostino before moving in with Gentileschi, and that he only began to frequent Agostino's house five or six days before, during which time he took some shirts and money to him. He stated that

he had met Olimpia, Agostino's sister, but does not remember seeing or meeting Marta de Rubertis. He claimed that the depositions of Olimpia and Marta were false.

Pietro Hernandes was questioned again on September 12, 1612, as a witness for the Curia. [mss. 277–82] He stated that he was asked by Gentileschi to testify, and reiterated that he had met Orazio the preceding October, that he had met Agostino at Orazio's house, but did not know him well, and had also met Nicolo there. He said that he knew Orazio was working at Monte Cavallo, and that Nicolo worked for him and had moved in with him at S. Spirito. He reconfirmed the fact that Artemisia was his son's godmother.

Antinoro Bertucci, who sold paints in Via del Corso, testified for the Curia on the same [mss. 282–84] day. He declared that he had known Orazio Gentileschi for six or seven years, knew that he had a daughter, whom he once saw in their house in Via della Croce when Orazio asked him upstairs to see some paintings. He said that he knew both Mario Trotta and Carlo Veneziano, and that during the time Mario worked in his shop, he never heard anyone talk about Orazio or his daughter. Once, however, Orazio's nephew came in complaining that Orazio had kicked him out of the house because he had reproached the daughter for being at the window. He testified that he had never heard anyone say that Orazio's daughter was a loose or dishonest woman.

Giovan Pietro Molli testified again for the Curia on the same date. He stated that the first [mss. 284–87] time he was asked to testify by Orazio Gentileschi, and the second time by the state [*fisco*]. He restated part of his previous testimony, but, asked to describe Orazio's two houses, said that he could not remember, and referred the questioners to his earlier testimony.

Margherita the washerwoman testified again for the Curia on September 14, 1612. She [mss. 288–93] stated that the first time she was asked to testify by Orazio, and the second time she was subpoenaed. She repeated part of her previous testimony, adding that when Orazio lived in Via Margutta, she saw in the house Bernardino Stuffarolo, Francesco Scarpellino, Pasquino (a Florentine), and [probably] Giovan Pietro Molli [described as "that old man who was testifying a little while ago"]. She knew that he used them as models because he showed her the paintings for which they had posed. She stated that she didn't know Agostino Tassi, and she confirmed having told the truth in her earlier testimony. Margherita also described the house on Via Margutta as having a large entrance door, and a laundry room on the left off the entrance hall; with two rooms upstairs [*sala* and *camera*], a very small kitchen and a *cortile*, and two more rooms above [*camera* and *sala*] with windows overlooking the street.

Giovan Pietro Molli was questioned again on September 26, 1612, and asked to describe [ms. 294] the house in Via Margutta. He repeated that he could not remember, and asked to go to confession and take Communion as he was about to faint.

Donna Olimpia was questioned again on September 17, 1612. She declared that the first [mss. 295–301] time she was asked to testify by Stiattesi, because he knew that she had placed Nicolo with Agostino. She related that she and her brother Agostino were sometimes on bad terms but made up, and that once she brought suit against him for [incest] with his sister-in-law. She gave more details about her relationship with Agostino. She reiterated that Nicolo had moved

in with Agostino in August, staying for about a year, thus making it impossible for him to have been with Orazio during Lent, and repeated her description of Nicolo and the clothing Agostino had bought him.

[mss. 302–312]    Bernardino was questioned again on September 27, 1612. He stated that Orazio had asked him to testify the first time and that the second time he was subpoenaed. He repeated his description of the house in Via Margutta, adding a description of the location of the one in Via dei Greci. He repeated the names of those he often saw at Orazio's house, adding "his daughter Artemisia and sometimes a nurse [*balia*]." He related that every time he went to Orazio's house he found Orazio painting, especially during Lent of 1610 [*sic*], and he remembers seeing him paint the St. Jerome, and some small pictures in alabaster.[141] He reiterated that he had never met Nicolo nor did he know who he was.

[mss. 312–18]    Marta de Rubertis testified again on the same day. She stated that Orazio Gentileschi had asked her to testify the first time and that subsequently she was subpoenaed. She confirmed and ratified her previous testimony, adding that she had heard that Agostino had been brought to court for having a sexual relationship with his sister-in-law.

*[Witnesses for the defense of Nicolo Bedino]*

[mss. 318–24]    Luca, son of Carlo Finicoli, testified on September 30, 1612, as a witness for the defense of Nicolo [Bedino]. He declared that Agostino had asked him to testify because he was acquainted with Giovan Battista, Orazio's nephew, and through this acquaintance he had seen Nicolo at Orazio's house. He stated that he had known Giovan Battista since Carnival of 1611, and that he had gone with him four or five times as far as Gentileschi's house, where Giovan Battista had called Nicolo to the door. And he also saw Nicolo at the fish market with Gentileschi. He added that Agostino, whom he had seen at Corte Savella, where he himself had been imprisoned for a financial matter, had asked him if he had ever seen Gentileschi's daughter and if he knew whether she was involved with anyone, and that he had answered that he had never seen or met her. He also said he had known Agostino for about two years. He further declared that Orazio Gentileschi, whom he had known since Lent—although he never had anything to do with him—had asked him to testify in his favor and to say he had heard Agostino claim that he had deflowered Orazio's daughter and boast he was going to marry her. Luca stated that he had told Orazio that Agostino had never said such a thing, and that when he asked Agostino about it, Agostino had sworn nothing of the sort had ever taken place. He added that he did not know that Nicolo had ever been a servant or apprentice of Agostino, but that he had seen Nicolo in Orazio's house on Via Margutta as he was a friend of Giovan Battista, Orazio's nephew, who had pointed out his uncle's house to him.

[mss. 324–29]    Luca Finicoli was questioned again on October 2, 1612. He repeated some of his earlier testimony, and emphasized that he had never been inside Orazio's house on Via Margutta.

[mss. 329–31]    Luca Finicoli was questioned once again on October 3, 1612. He stated that he would recognize Orazio, but was not sure he could recognize Nicolo, whom he saw occasionally when he went with Giovan Battista as far as the entrance of his uncle's [Orazio's] house.

[141] See n. 140.

Valerio, son of Francesco Ursini, a painter from Florence, testified on October 5, 1612. He [mss. 331–36] declared that he had known Agostino for two years or more, that he had been a close friend for over a year and had lived with him for about eight months, from the time Agostino moved house in the summer of 1610 until after Easter of the following year. While he lived there, Valerio stated, there was also a young man about eighteen years old named Nicolo, who was Brugiavigne's [*sic*] nephew. He had come to Agostino to learn to draw, and did all the house chores in exchange for room and board. Nicolo was still with Agostino when Valerio left the house the preceding summer after disagreements with Agostino. Valerio said that when he saw Nicolo that summer he asked him why he had lied about having lived with Gentileschi on Via Margutta, but that Nicolo had not answered. Valerio further related that he saw Nicolo again a month and a half later with Agostino at Tor di Nona when he went to visit Agostino, and that he had asked Agostino why he had forced the boy to declare that he [Nicolo] had stayed at Via Margutta, since that was not true and there were several witnesses who could testify to that effect. Agostino replied that he had told Nicolo to speak the truth and not tell lies. Valerio said further that, asked by Agostino why he had lied, Nicolo replied that Agostino had forced him to testify that he had stayed with Orazio Gentileschi on Via Margutta, to testify against Orazio Gentileschi, and to state that Gentileschi owed Tassi two hundred *scudi*. Valerio added that Marcantonio Coppini had told him Agostino had asked the same of him.

Nicolo Bedino was again questioned on October 29, 1612. He reiterated that he had stayed [mss. 337–40] in Orazio Gentileschi's house in Via Margutta, and confirmed that there he saw Artemisia perform "those dishonest acts" about which he had testifed previously. When strongly admonished to tell the truth, as his testimony had been contradicted by several witnesses, he insisted that he had always told the truth. Bedino was then subjected to torture—stripped, tied, and pulled up with a rope. Several times he was pressed to speak the truth while the rope was lifting his stripped body. Each time he replied, "I have spoken it."

[ED. NOTE: The trial records end with ms. 340. No notice of the trial's resolution is known to be preserved.]

# NOTES

## INTRODUCTION

1. Throughout this text, Artemisia Gentileschi is called alternately "Gentileschi" or "Artemisia." I have done this, not in the spirit of that deplorable literary habit of calling women artists by their first names (and men by their last), but partly to distinguish Artemisia from her father Orazio, partly for variety, and also because art historians commonly use Italian Renaissance artists' first names, as in Piero (della Francesca) or Michelangelo (Buonarroti).

2. G. Mancini, *Considerazioni sulla pittura* (c. 1617–21); Francesco Scannelli, *Il Microcosmo della Pittura* (1657); G. P. Bellori, *Le vite de' Pittori, Scultori ed Architetti moderni* (1672); G. B. Passeri, *Vite de' pittori, scultori, ed architetti che hanno lavorato in Roma . . .* (1670–80); Lione Pascoli, *Vite de' pittori, scultori ed architetti* (1730–36). For the writers cited who discuss or mention Gentileschi, see Works Cited.

3. Luigi Lanzi, *The History of Painting in Italy, from the period of the revival of the fine arts to the end of the eighteenth century*, trans. Thomas Roscoe (London: W. Simpkin and R. Marshall, 1828); 1:317.

4. Giovanni Gaetano Bottari and Stefano Ticozzi, eds., *Raccolta di lettere sulla pittura, scultura ed architettura scritte da' più celebri personaggi dei secoli XV, XVI, e XVII* (Milan: G. Silvestri, 1822–25); Vincenzo Ruffo, "Galleria Ruffo nel secolo XVII in Messina," *Bollettino d'Arte* 10, nos. 1–12 (1916): 21 ff. The publication of Artemisia's letters was continued by Francesco Imparato ("Documenti relativi ad Artemisia Lomi Gentileschi pittrice," *Archivio Storico dell'Arte* 2 [1889]: 423–25) and Anna Maria Crinò ("Due letter autografe inedite di Orazio e di Artemisia Gentileschi De Lomi," *Rivista d'Arte* 29, ser. 3, vol. 4 [1954]: 203–206; idem, "More Letters from Orazio and Artemisia Gentileschi," *Burlington Magazine* 102 [June 1960]: 264–65; idem [with B. Nicolson], "Further Documents Relating to Orazio Gentileschi," *Burlington Magazine* 103 [April

1961]: 144–45). Eva Menzio, in *Artemisia Gentileschi/Agostino Tassi: Atti di un processo per stupro* (Milan: Edizioni delle Donne, 1981), republished all but one known letter along with a transcription of the rape trial of 1612.

5. Ann Sutherland Harris, in Harris and Linda Nochlin, *Women Artists: 1550–1950*, Los Angeles County Museum of Art (New York: Alfred A. Knopf, 1976), 118–24; Mina Gregori, in numerous articles and catalogue entries, e.g., *70 pitture e sculture del '600 e '700 fiorentino*, exh. cat., Florence, Palazzo Strozzi, October 1965 (Florence: Officine grafiche Vallecchi, 1965); idem, "Su due quadri caravaggeschi a Burghley House," in Antje Kasegarten and Peter Tigler, eds., *Festschrift Ulrich Middeldorf* (Berlin: De Gruyter, 1968), 414–21; idem, "Artemisia Gentileschi," in *Civiltà del Seicento a Napoli*, exh. cat., Museo Capodimonte, October 24, 1984–April 15, 1985; Museo Pignatelli, December 6, 1984–April 14, 1985 (Naples: Electa Napoli, 1984), 1:304–306; Erich Schleier, "Caravaggio e Caravaggeschi nelle Gallerie di Firenze: Zur Ausstellung im Palazzo Pitti, Sommer 1970," *Kunstchronik* 24, no. 4 (April 1971): 85–112; *Artemisia*, texts by Roland Barthes, Eva Menzio, and Lea Lublin (Paris: Yvon Lambert, 1979), a collection of short articles ranging from structuralist to imaginative, of which the most substantive is Menzio's.

6. I have discussed these issues more fully elsewhere; see my re-view of Laura M. Ragg, *The Women Artists of Bologna* (1907), in *Women's Art Journal* 1, no. 2 (Fall 1980/Winter 1981): 58–64; on the question of women lacking artistic genius, see Linda Nochlin, "Why Have There Been No Great Women Artists?" *Art News* 69, no. 9 (January 1971): 22–39, 67–71; the social limitations experienced by women artists are also taken up in Chapter 2, below.

7. A few recent scholars—a good example is the Cavallino catalogue by Ann T. Lurie, and Ann Percy (*Bernardo Cavallino of Naples, 1616–1656* [Cleveland, Ohio: The Cleveland Museum of

Art; Fort Worth, Texas; The Kimbell Art Museum, 1984]—have begun to treat Artemisia as an *interactive* artist among male contemporaries, whose influence is duly noted. Roberto Longhi ("Gentileschi padre e figlia," *L'Arte* 19 [1916]: 308 ff.) had earlier acknowledged her influence, especially on Stanzione and Cavallino.

8. Mary D. Garrard, "Artemisia Gentileschi's *Self-Portrait as the Allegory of Painting*," *Art Bulletin* 62 (March 1980): 97–112; idem, "Artemisia and Susanna," in Norma Broude and Mary D. Garrard, eds., *Feminism and Art History: Questioning the Litany* (New York: Harper & Row, 1982), 146–71.

9. Maude Bodkin, *Archetype Patterns in Poetry* (London and New York: Oxford University Press, 1948), 217, quoted by Carolyn G. Heilbrun, *Toward a Recognition of Androgyny* (New York: Harper & Row, 1973), 96. Relevant too is the comment in Heilbrun's book on Henry James by one of his contemporaries: James, he observed, "seemed to look at women rather as women looked at them. . . . Women look at women as persons; men look at them as women" (p. 96).

The androgyny of Artemisia's characters is also commented upon in Gislind Nabakowski, Helke Sander and Peter Gorsen, *Frauen in der Kunst* (Frankfurt am Main: Suhrkamp, 1980), 149–50.

10. See in particular Martin Kemp, *Leonardo da Vinci, The Marvelous Works of Nature and Man*, (London, Melbourne, Toronto: J. M. Dent & Sons, 1981).

11. John Gash, in *Caravaggio* (London: Jupiter Books, 1980), 10–13, discusses Tridentine moral reactions to the art of Michelangelo and Caravaggio.

12. Leo Steinberg, *Michelangelo's Last Paintings: "The Conversion of St. Paul" and "The Crucifixion of St. Peter" in the Cappella Paolina, Vatican Palace* (London: Phaidon, 1975).

13. A.W.A. Boschloo, *Annibale Carracci in Bologna: Visible Reality in Art after the Council of Trent*, trans. R. R. Symonds, 2 vols. (The Hague: Government Publications Office, 1974); Richard Spear, "The Pseudo-Caravaggisti," *ArtNews* 70, no. 7 (November 1971): 38–41, 93–96. The phrase is Boschloo's.

14. E.g., in the criticism of Agucchi, Mancini, and Malvasia; see Denis Mahon, *Studies in Seicento Art and Theory* [1947], reprint (Westport, Conn.: Greenwood Press, 1971), 33 ff. Their critical outlook was recently perpetuated by Sanford Schwartz, "The Art World: Not Happy to Be Here," *The New Yorker* (September 2, 1985): 75–81.

## CHAPTER 1

1. We owe our knowledge of Artemisia's correct birthdate to R. Ward Bissell's discovery of the relevant entries in the census of S. M. del Popolo in Rome, where the names and ages of the Gentileschi children are recorded between 1601–1607 and 1610–11; and the baptismal books of S. Lorenzo in Lucina, which include the birth of Artemisia (R. Ward Bissell, "Artemisia Gentileschi—A New Documented Chronology," *Art Bulletin* 50 [June 1968]: 153). Her birthdate had previously been placed at 1597, because of Orazio's inaccurate trial testimony that she was 15 (and not 18) in the spring of 1612.

2. Of the three sons who survived to maturity (Giovanni Battista died at age six), only Artemisia's brother Francesco, four years younger than she, was trained as an artist, presumably by Orazio. Francesco's own modest artistic career, little documented, was largely subordinated to his service to his father and sister; see R. Ward Bissell, *Orazio Gentileschi and the Poetic Tradition in Caravaggesque Painting* (University Park and London: Pennsylvania State University Press, 1981), Appendix IV; and Rudolf and Margot Wittkower, *Born Under Saturn, The Character and Conduct of Artists: A Documented History from Antiquity to the French Revolution* (New York and London: W. W. Norton, 1963), 199.

3. In a letter to the Grand Duchess of Tuscany, July 3, 1612, quoted in Leopoldo Tanfani-Centofani, *Notizie di artisti tratte dai documenti pisani* (Pisa: E. Spoerri, 1897), 221–24. Orazio may have meant that she had begun to work independently three years earlier, since sixteen would be rather old to begin artistic training. See also note 11.

4. At the time that Artemisia was born, the family lived on Via Ripetta, which runs from the Ara

Pacis to S. M. del Popolo. According to Bissell (1981, 9), the Gentileschi household was located between 1600 and 1610 in Via Paolina, and on Platea SS. Trinità. Orazio's laundress of twenty years testified in the trial that the sequence of addresses was: Via di Ripetta, Piazza Trinità dei Monti, Via dei Greci, Via Margutta, Via della Croce, and S. Spirito (Appendix B, ms. 236–39). We learn from the testimony of Tuzia that Orazio and his family were living in Via Margutta in the spring of 1611; that they moved to Via della Croce on April 10, 1611; and again to "the entrance of S. Spirito" on July 16, 1611, where they were still living in the spring of 1612 (Appendix B, ms. 27–28). This was S. Spirito in Sassia, where Artemisia was married in November 1612.

5. Bissell, 1968, nn. 8 and 9; 1981, 9. Artemisia identified her godfather Pietro Rinaldi in her rape trial testimony (Appendix B, ms. 22–23).

6. See Bissell, 1981, 19, and 85 n. 38.

7. Baglione's suit has been discussed by many writers; see Bissell, 1981, 12–14. Caravaggio's testimony, denying any recent association with Orazio and excluding him from a short list of "valent'huomini" whose critical judgment agreed with his own, is interpreted by Bissell as a strategy aimed at his own acquittal, to separate himself from the other accused artists. Orazio, on the other hand, spoke highly of his friend Caravaggio, claiming to have seen him as recently as six to eight months ago, and noting that in the past ten days Caravaggio had returned to him a Capuchin's frock that he had borrowed (a studio prop, like the pair of wings also borrowed).

8. Bissell, 1981, 16; see ch. 2 there for a fine account of the relation between Orazio Gentileschi and Caravaggio.

9. Orazio, who left his native Pisa for Rome in 1576 or 1578, when he was 13 or 15, displayed both in his early works and in his proud early signature, FLORENTINUS, his deep acquaintance and affinity with the sixteenth-century Florentine tradition (Bissell, 1981, ch. 1). On the pre-Caravaggesque blend of idealism and realism in late sixteenth-century Florence, see Jack J. Spalding IV, "Santi di Tito and the Reform of Florentine Mannerism," Storia dell'arte 47 (1983): 41–52. The iconography of Orazio's St. Francis and its relation to post-Tridentine imagery is discussed by Pamela Askew, "The Angelic Consolation of St. Francis of Assisi in Post-Tridentine Italian Painting," Journal of the Warburg and Courtauld Institutes 32 (1969): 295.

10. Inv. no. 191; o.c., 170 x 121 cm; signed and dated: "ARTEMITIA GENTILESCHI. F / 1610." The picture has been in the family collection of Dr. Karl Graf von Schönborn, Pommersfelden, Schloss Weissenstein, at least since the early eighteenth century. The first reference in the family archive (1715) ascribes the work to Orazio Gentileschi; it was first given to Artemisia in an entry of 1857. I am grateful to Dr. Schönborn for supplying information on the picture. Literature includes: Hermann Voss, Die Malerei des Barock in Rom (Berlin, 1925), 463; catalogue, "Count von Schönborn Collection," Schloss Weissenstein ob Pommersfelden (1935), 22; Roberto Longhi, "Ultimi studi sul Caravaggio e la sua cerchia," Proporzioni 1 (1943): 47 n. 38; Andrea Emiliani, "Orazio Gentileschi: nuove proposte per il viaggio marchigiano," Paragone 9, no. 103 (1958): 42; Alfred Moir, The Italian Followers of Caravaggio, 2 vols. (Cambridge, Mass.: Harvard University Press, 1967), 1:100; Bissell, 1968, 157; Harris and Nochlin, 1976, 120; Garrard, 1982.

11. Orazio described his daughter as "havendola drizzata nella professione di pittura, in tre anni si è talmente appraticata, che posso ardir de dire che hoggi non ci sia pare a lei, havendo per sin adesso fatte opere, che forse principali mastri di questa professione non arrivano al suo sapere . . ." (Tanfani-Centofani, 1897, 221–24).

It seems safest to assume that Artemisia's apprenticeship with Orazio did not definitively end before the sudden changes precipitated by the rape trial, her marriage and move to Florence. At the same time, she must have painted a number of independent pictures during her early Roman years, as is indicated by Orazio's statement to the Grand Duchess.

Descriptions of activities in the Gentileschi household by several witnesses in the rape trial point to Artemisia's independence and distinctness from her father. Pietro Hernandes (Appendix B, ms. 245–47) states that Orazio was teaching Nicola Bedino to draw, while Artemisia was teaching him how to paint. Bedino himself testified (ms. 249–65) that at home he ground colors, not for Orazio,

but for Artemisia, who used them for oil paintings.

12. From the rape trial proceedings, Appendix B, ms. 129. Artemisia was literate by maturity, as autograph letters show (Fig. 328); however, by her own account she dictated many of her letters (Appendix A, no. 19), which explains the different styles of calligraphy that appear in the preserved correspondence. A context for seventeenth-century female education is afforded in statistics reported by Hilda L. Smith, in *Reason's Disciples: Seventeenth-Century English Feminists* (Urbana-Chicago-London: University of Illinois Press, 1982), 25, which show that in the Diocese of Norwich, 1580–1700, 0 percent of the clergy/professional class, 2 percent of the gentry, and 44 percent of tradesmen and craftsmen (a class to which most artists would have belonged) were illiterate; but among all women, the illiteracy rate was 89 percent.

13. In the later sixteenth and early seventeenth centuries, Michelangelo was generally regarded a poor colorist, despite the fact that his distinctive method of changing colors in shadows had profoundly influenced Mannerist painters. Although the restoration of the Sistine Ceiling now in progress has offered an "original" (and still controversial) color scheme, very different from what we have known, by Artemisia's time—a century after the ceiling was painted—the ceiling's colors had surely already become darker and more muted, as is attested by Lagi's restoration of the frescoes in 1625.

14. The date of the excursion is established by Tuzia's statement in the trial testimony (Appendix B, mss. 32–33) that they lived then in Via della Croce, which places it between April and July of 1611. The group also visited S. Giovanni in Laterano and S. Paolo fuori le Mura.

15. See Howard Hibbard, "Scipione Borghese's Garden Palace on the Quirinal," *Journal of the Society of Architectural Historians* 23, no. 4 (December 1964): 163–92; and Giuliano Briganti, *Il Palazzo del Quirinale* (Rome: Istituto poligrafico dello Stato, Libreria dello Stato, 1962). Other artists, including Reni, Cigoli, and Paul Bril, worked on the decorations of Scipione's garden houses, which were built on the site of the Baths of Constantine. The largest of the casinos (later Rospigliosi) houses Reni's *Au-*

*rora* of 1613–14. On Agostino Tassi as an artist, see Teresa Pugliatti, *Agostino Tassi tra conformismo e libertà* (Rome: De Luca Editore, 1977).

16. See Bissell, 1981, 157.

17. A. Bertolotti, "Agostino Tassi: suoi scolari e compagni pittori in Roma," *Giornale di Erudizione Artistica* 5, fasc. 7 and 8 (July–August 1876): 183–204; and Menzio, 1981.

18. Stiattesi testified that Tassi had been prosecuted for incest with Costanza in 1611 (Appendix B, mss. 45–46). Although Tassi claimed not to know his wife's whereabouts after he left her some eighteen months earlier, and to have heard subsequently of her death, Stiattesi explained to the court that Tassi had had his wife Maria murdered by assassins after she ran away with a lover (the summary says that she left him on account of the sister-in-law episode). Maria's assassination must then have occurred during the Tassi-Gentileschi courtship and before the trial. In 1619, Tassi was again brought to trial over his amorous blunders, this time for alleged misadventures with the wife of his assistant Filippo Franchini (Bissell, 1981, 199), who worked with Tassi at Villa Lante (Luigi Salerno, "Cavaliere d'Arpino, Tassi, Gentileschi and Their Assistants. A Study of Some Frescoes in the Villa Lante, Bagnaia," *Connoisseur* 146, no. 589 [December 1960]: 157–62).

19. No. 298; o.c., 116.5 x 86.5 cm. The picture was catalogued as Artemisia by Amadore Porcella in *La Pittura della Galleria Spada* (Rome: G. Felsina, 1931), 215, following earlier attributions to Bernardo Strozzi and Francesco Cozza. Federico Zeri (*La Galleria Spada in Roma, Catalogo dei dipinti* [Florence: Sansoni, 1954], no. 298) attributed both this painting and the variant in the Pitti Gallery, the so-called *Madonna of the Cherries*, to Guerrieri. Emiliani (1958b, 19–20, 50) gave the Pitti painting to Guerrieri and the Spada painting to a Baglionesque artist, following Longhi; while Moir (1967, 1:55–56) suggested Caroselli for the Spada *Madonna*. Bissell (1968, 155) tentatively accepted the attribution of both pictures to Artemisia.

The Pitti *Madonna of the Cherries* (inv. 2129, 118 x 86 cm; see *Gli Uffizi: catalogo generale*, coordinated by Luciano Berti [Florence: Centro Di, 1979], 285), which came to the Uffizi in

1773 with an attribution to an unknown Tuscan, was reascribed to Artemisia after its cleaning by Evelyn Borea (ed., *Caravaggio e Caravaggeschi nelle gallerie di Firenze*, Florence, Pitti Palace, summer 1970 [Florence: Sansoni, 1970], 75 and cat. 46); this attribution was again supported by Bissell in 1981, 92 n. 4. In my opinion, this variant of the Spada *Madonna* is best excluded from Artemisia's *oeuvre*. The Spada painting exhibits an intensity of vision and coherence of design that are totally absent in the flaccid and conventional imitation. The style of the Pitti painting is not incompatible with that of Guerrieri, who would have had occasion to work from the Spada picture during his first stay in Rome between 1606 and c. 1611.

20. The arrangement of the Child's legs may be connected with Andrea Sansovino's *St. Anne* group, while the long-legged, diagonal position of the child's body recalls Caravaggio's *Madonna of Loreto* (1604–1605), another work in the church of S. Agostino.

21. The ex-Matthiesen Madonna, on panel, 91.5 x 73 cm, was published in *Important Italian Baroque Paintings, 1600–1700*, exh. cat. (London: Matthiesen Fine Art Ltd., 1981), no. 1. (It has recently gone to a private collection in the United States.) Bissell (1981, 144) rightly observed in the picture formal references to Quattrocento Florentine Madonna and Child compositions, suggesting Filippo Lippi's Tarquinia *Madonna*, or a number of Botticelli Madonnas as prototypes for the intimate interaction between mother and child. Although neither Gentileschi had been in Florence in the years 1605–10, any number of relevant Florentine examples may have been on hand in Rome. The Tarquinia *Madonna*, for example, is in the Palazzo Barberini, Rome; also highly pertinent is Donatello's Pazzi *Madonna*, a work whose location in the seventeenth century is unknown. Bissell has connected the Bucharest *Madonna* with a work sent to Vincenzo Gonzaga in Mantua in 1610.

22. See also Bissell, 1981, figs. 61, 82, and 84. The Palazzo Corsini version is also relevant, but its attribution to Orazio has been rejected by Bissell (1981, 204 and fig. 148) and Benedict Nicolson (*The International Caravaggesque Movement, Lists of Pictures by Caravaggio and His Followers throughout Europe from 1590 to 1650* [Oxford: Phaidon, 1979], 54). An early copy of the Matthiesen *Madonna*, of nearly the same dimensions (o.c., 88.8 x 67.3 cm) was formerly in Malta, in the Vincenzo Bonello collection, there as Artemisia Gentileschi (Vincenzo Bonello, *The Madonna in Art*, exh. cat. [La Valetta, Malta: n.p., 1949], 24, no. 65).

23. No. 293, as "St. Cecilia"; o.c., 108 x 78.5 cm. First mentioned in an eighteenth-century inventory as of the school of Titian, the *Lutist* was ascribed to Caravaggio in 1792, an attribution repeated as late as 1910 by L. Venturi. Voss wrested it from the Caravaggio *oeuvre* in 1911, giving it to Artemisia, an opinion challenged by Rouchès in 1920 and Hermanin in 1925, who sustained the Caravaggio attribution, and although in 1927 Longhi tentatively gave the painting to Caroselli, Porcella (in 1931), Lavagnino (in 1933), and Zeri (in 1954) have supported the attribution to Artemisia. For a summary of the literature, see Zeri, 1954, 86.

24. The female figure in the Detroit picture, whose pose echoes the heroine of Orazio's Hartford *Judith* of c. 1611–12 (see Bissell, 1981, cat. 28), appears to have been transformed into a musician at a late stage of execution. Recent x-radiograph analysis has revealed that strips were attached to the canvas on the bottom and both sides, and that the raised arm and violin were added to a figure whose arms were originally in her lap. I am grateful to Barbara Heller, Paintings Conservator, Detroit Institute of Arts, with whom I examined and interpreted the x-radiographs on February 21, 1984, and upon whose reading of the painting I here rely.

25. This line of thinking was suggested by a discussion with H. Diane Russell of Orazio's National Gallery *Woman Playing the Lute*. Independent images of Music apart from Liberal Arts cycles emerged in the sixteenth century, and examples of the Allegory of Music lingered through the seventeenth century; see, e.g., a *Musica* of c. 1648–50, by Lorenzo Lippi, in Gregori, 1965, no. 19. Musica was frequently replaced, however, by St. Cecilia symbolizing sacred music (often accompanied by an angel or multiple musical instruments), or by the Muses representing secular music. See A. F. Mirimonde, "Les Allégories de la Musique—I. La Musique parmi les Artes Libéraux,"

*Gazette des Beaux-Arts* 72 (December 1968): 295–324.

26. Bissell, for example (1981, 155–56), has suggested that the *Judith* mentioned in the trial testimony may be a *Judith* in Oslo that has been ascribed to Orazio. That painting is discussed later in this chapter.

27. Appendix B, ms. 4. The passage implies that all of the paintings taken from Artemisia were works by Orazio.

28. Appendix B, ms. 48. According to our examination of the original document, the correct reading is *non fornito*, and not *non finito* as has been suggested.

29. According to the official narrative of the proceedings (Appendix B, ms. 11), after the trial the stolen painting was given to the chief notary of the Borgo (i.e., the Vatican), in whose hands it remained.

30. Vatican, Pinacoteca, no. 1059, o.c., 127 x 147 cm. The picture was given to the Vatican by Pope Pius XI (1922–39), who received it from Signora Agnese De Angelis, widow of Gammarelli. It was discovered in a storeroom, unattributed, by Redig di Campos, who first published it (Deoclecio Redig di Campos, "Una 'Giuditta' opera sconosciuta del Gentileschi nella Pinacoteca Vaticana," *Rivista d'Arte* 21 [1939]: 311–23), connecting the work with the stolen *Judith* of 1612 (an opinion shared by Andrea Emiliani, *Giovan Francesco Guerrieri da Fossombrone* [Urbino: Istituto statale d'arte, [1958], 42–43). Redig di Campos did not know the Oslo or Hartford pictures; Emiliani knew the Oslo, but not the Hartford painting. The Vatican *Judith*, which measures 127 x 147 cm, would as nearly qualify for the description "*di capace grandezza*" as other works that have been proposed. (The Hartford *Judith* measures 133 x 157 cm; the Oslo painting measures 136 x 160 cm. The figures in the Vatican and Hartford *Judith*s are the same size; the Vatican *Judith*'s smaller dimensions result from a slight reduction of the design at the top and sides.) See Bissell, 1981, cats. 26 and 27, for the six or more *Judith*s associated with the Orazio Gentileschi *oeuvre*.

31. The *Judith* in the collection of Ugo Jandolo, Rome, is discussed by Bissell, 1981, 154–55, who observes that the picture was recognized as a copy even before the original was discovered.

While I cannot agree with D. Stephen Pep-

per's recent redating of Orazio's Hartford *Judith* to later years in his "Baroque Painting at Colnaghi's," *Burlington Magazine* 126 (1984): 315–16, the Orazian chronology remains to be firmly established. See Erich Schleier's discussion of the problems in the exhibition catalogue *The Age of Caravaggio*, Metropolitan Museum of Art (New York: Electa/Rizzoli, 1985), 155–57.

A point in favor of the identity between the stolen *Judith* and the Vatican picture is the latter's location, since the stolen painting remained in the Vatican after the trial.

32. See Bissell, 1981, 46, on the question of Orazio's replicas of his own works. As Bissell notes, Orazio's variants were inevitably better in quality than the "originals."

33. Bissell, 1981, 154. The figure was first identified as depicting Artemisia by Michael Levey ("Notes on the Royal Collection—II: Artemisia Gentileschi's 'Self-Portrait' at Hampton Court," *Burlington Magazine* 104 (February 1962): 79–80), on the basis of its resemblance to the portrait engraving of her by Jérôme David. Conceivably, the head of Judith in the Vatican picture is Tuzia's.

34. For example, Artemisia's hand in the Detroit *Woman with Violin* cannot entirely be ruled out. The picture bore an attribution to Artemisia, not Orazio, when it was sold at auction in 1807 in London (Bissell, 1981, 156). Certain features of the painting, such as the sitter's physiognomy (which Bissell regards as that of Artemisia) and the complex, sinuous drapery of the sleeve, recall Artemisia's Pitti *Judith*. Ultimately, however, the figure's expression seems more Orazian than Artemisian.

35. The Naples version of *Judith Slaying Holofernes* (o.c., 158.8 x 125.5 cm) came to the Capodimonte in 1827 from the Neapolitan collection of Saveria de Simone, bearing an attribution to Caravaggio. See Aldo De Rinaldis, *Neapolitan Painting of the Seicento* [1929], reprint (New York: Hacker Art Books 1976), 111; Bruno Molajoli, *Notizie su Capodimonte; Catalogo delle Gallerie e del Museo* [1955], reprint (Naples: L'Arte Tipografia, 1960), 51; Bissell, 1968, 158. Because of its provenance, the picture has generally been assumed to date from Artemisia's Neapolitan period, though Bissell (1968) suggests that it might be an earlier work brought by the artist to Naples.

In the spring of 1983, while the Naples *Judith*

was in the National Gallery, Washington, D.C., in the exhibition entitled *Painting in Naples: From Caravaggio to Giordano*, the picture was at my request subjected to x-radiograph analysis by museum conservator Sarah Fisher. The absence of dish marks on the left side of the canvas indicated that the painting had definitely been cut down on that side. X-ray photographs make visible the painting's process of development; the numerous pentimenti can be seen, especially in the positioning of Judith's arms, the shape of her hair, and perhaps in details of the two women's physiognomies. The drapery folds at the center left edge were originally arranged differently; no longer visible in the picture is the curtain wedge opening to light at upper left. One also sees a loop of drapery (or perhaps the bag for the head) below Judith's left elbow that does not appear in the painting. Holofernes's right arm, containing no lead white, appears to have been a late decision of placement. Such significant compositional changes, according to Ms. Fisher, clearly indicate that the painting is an original and not a replica of another work.

Similar technical analysis of the Uffizi *Judith* would of course greatly clarify the relation of the two paintings. Dottoressa Caterina Caneva has informed me that such an analysis is unfortunately not possible under the museum's present economic circumstances.

36. Artemisia's compositional use of Rubens's design (which was first pointed out by Frima Fox Hofrichter, "Artemisia Gentileschi's Uffizi *Judith* and a Lost Rubens," *The Rutgers Art Review* 1 [January 1980]: 9–15) serves as a firm document of the Gentileschi's awareness of the Flemish artist, since the "Great Judith" was painted during Rubens's Italian sojourn (1601–1610), when he came under the sway of Caravaggio in Rome and is thought to have had contact with Orazio Gentileschi. (Michael Jaffé, *Rubens and Italy* [Oxford: Phaidon, 1977], 58) suggested that Rubens would have had contact with Orazio, as he worked in the same artistic community.) Much later, Rubens copied a group of figures from Orazio's *Apollo and the Muses* in his own *Triumphal Return of David* of about 1630; see Jaffé, 1977, 58 and fig. 157, and Bissell, 1981, 190.

The connection between Rubens and the Gentileschi is also supported by the quotation of the same antique model by all three painters in works of 1605–1610. The figure of Holofernes in Rubens's "Great Judith" was based upon the slain Aegisthus in the Orestes sarcophagus reflected in Artemisia's Pommersfelden *Susanna and the Elders* and Orazio's Dublin *David and Goliath* (see below, pp. 196 ff.).

37. The records of the Accademia del Disegno show: (1) November 1614, "an itemized account for artists' materials, including several stretchers for paintings" (Bissell, 1968, 154), received by Artemisia and her husband ("Atti e Sentenze," 65, fol. 877 [approx.], Accademia del Disegno, Archivio di Stato, Florence); (2) July 19, 1616, an acknowledgment of her matriculation fee: "*Artemisia donna di Pagolantonio stitesi e figliuola di Oratio Lomi Pittora di contro de havere addi 19 di luglio 1616 quattro recho il Cavaliere vasari per principio di sua matricola aentᵃ A ac 54 ri conobbe per il padre*" ("Debitori e Creditori delle Matricole: 1596–1627," 57, fol. 152).

38. In his letter of March 16, 1615, Cioli asked Piero Guicciardini, the Grand Duke's Ambassador in Rome, about Orazio's reputation as an artist, a reputation Cioli deemed credible on account of Artemisia's success; see Crinò, 1960a, 264–65.

39. The Accademia di S. Luca in Rome, reorganized with a formal academic program in 1593, had as part of its basic curriculum lessons on perspective and anatomy, life drawing classes, as well as lectures and debates on the theory of art. See Nikolaus Pevsner, *Academies of Art, Past and Present* (Cambridge: Cambridge University Press, 1940) 55 ff.; Harris and Nochlin, 1976, 26–27.

40. Renaissance Bologna saw the emergence of an unusual number of women artists, including Lavinia Fontana and Propertia de' Rossi; Sofonisba Anguissola and her sister Lucia were prominent in Cremona; and a number of women worked in Rome, Milan, and Naples, including Fede Galizia and Giovanna Garzoni. Few of these women were associated with academies, however. The domination of art in Florence by official institutions may explain the near-official exclusion of women there.

The matriculation and payment records of the Accademia dei Arte del Disegno, Florence (Archivio di Stato), which begin in 1576, reveal no female names before that of Artemisia.

After her, there were three more women in the seventeenth century (Rosa Maria Setterni [or Setterm?], 1662; Caterina Angiola Pierozzi, *nee* Corsi, 1691; and Colomba Agrani, 1691). I counted nine women members in the eighteenth century (up to 1761): Aretafila Savini, *nee* Ropi, 1715; Agnese Dolci (or Dolcini), *nee* Baci, 1715; Giovanna Fratellini, a miniaturist, 1715; Maria Maddalena di ... Porri, 1731; Suore Terziare della Madonna (possibly not a person but a religious order), 1729–61; and Barbara di Ferd° Paoli, 1706. Thus thirteen females would have been represented among some eight to ten thousand male members of the academy from its beginning to about 1760. It is interesting, and perhaps significant, that while many of these artists are described as *pittrice*, only Artemisia, the first of them, is called *pittora*.

41. Ugo Procacci, in *La Casa Buonarroti a Firenze* (Milan: Electa, 1968), 12, proposed that Buonarroti may have been her godfather, observing (in the documents quoted below, in note 42) his exceptional financial generosity to Artemisia and her husband, and suggesting that Buonarroti could have been present at the time of her birth on one of his many trips to Rome. However, in her trial testimony Artemisia named a Pietro Rinaldi as her godfather (Appendix B, ms. 22–23). Possibly, Buonarroti served as witness at her marriage to Stiattesi, since in the documents of 1615 (below, note 42), both Artemisia and her husband address him as *Compare*, which can mean both "godfather" and "witness at a wedding" (my thanks to Efrem G. Calingaert for this information). Yet there was evidently a strong personal tie, acknowledged in Artemisia's closing words to her patron, "with a daughter's affection" (*"Di V. S. affezionatissima come figliola Artemisia Lomi"*), which could have originated in Orazio's Tuscan family connections.

42. Procacci, 1968, 12, points out that Artemisia received 34 florins for her painting, while the other young artists were given only 10 each, and the older artists were paid about 35 florins for larger pictures. He published the following documents concerning Artemisia at Casa Buonarroti (in the original Italian).

In his ledger, Michelangelo Buonarroti the Younger entered the following: "Artemisia, daughter of Orazio Lomi or Gentileschi, wife of Pierantonio Stiattesi, painter [*pittrice*], on August 24, 1615, must give 10 florins, posted to the account for the painting which she is doing for the ceiling of my gallery, where the figure of *Inclinazione* is to be painted. I sent her the canvas primed as I did for all the painters ... florins 10."

This notice was followed by a note from Artemisia to her patron: "Magnificent Signor *Compare* [see above, note 41], I wish to ask a favor of you, please grant me 21 lire, which I shall return as soon as possible. With a daughter's affection for Your Lordship, Artemisia Lomi." The letter was addressed by Artemisia's husband, who added to his wife's note the following: "Most Illustrious Signor *Compare*, taking courage from the offers that Your Lordship has made me, with this letter I ask you to be so kind as to send me four, or better, five ducats, as Your Lordship knows the many misfortunes I have suffered. Ending thus, I put myself at your disposal and in your hands, and forgive me for troubling you. From my house, the 7th of September, 1615. Your Very Illustrious Lordship's most affectionate servant Pierantonio Stiattesi."

Buonarroti gave them the requested funds, in the amount named by Stiattesi rather than the modest sum asked by Artemisia, and continued to make regular payments to them through August of 1616. The final entry reads: "Artemisia, daughter of Orazio Lomi or Gentileschi on August 20, 1616, must have 34 florins, to be remitted for painting the picture as indicated opposite, where on this date the settlement is recorded. And she will be paid in full. She remains in debt to me in another account in my Debtors and Creditors Book marked B ... florins 34" (Procacci, 1968, 11–12).

43. Pevsner, 1940, ch. 2.

44. The text of Orazio's letter is printed in Tanfani-Centofanti, 1897, 221–24.

45. Wittkower and Wittkower, 1963, 198; and for the text of the letter, see Crinò and Nicolson, 1961, 144–45.

46. Giovanni Battista Passeri, *Vite de' pittori, scultori, ed architetti che [h]anno lavorato in Roma, morti dal 1641 fino al 1673* (Rome: N. Barbiellini, 1772), 105–106 (restated by Wittkower and Wittkower, 1963, 164); this assertion is linked, however, with the belief that Orazio had col-

laborated with Tassi and Lanfranco in the Sala Regia of the Quirinal Palace in the years just after the trial of 1612. Bissell (1981, 222–24) has argued against Orazio's renewed association with Tassi at this time, largely in disbelief that he could so quickly have gotten over his anger.

47. In Florence, Artemisia used Orazio's paternal name of Lomi to sign the *Magdalen*, the Uffizi *Judith*, and the one letter preserved from that period. It has also been suggested (Bissell, 1968, 156) that she wished to be associated with her father's Tuscan family, especially Orazio's brother, the artist Aurelio Lomi, who may have been better known than Orazio in Tuscany.

48. Bissell (1981, 34–35) discusses the matriculation document quoted in note 37 above. Archival records show a number of matriculating artists "recognized" (*riconobbe*) by another artist, and it may have been a formality that young artists were vouched for by an elder.

49. This was on June 26–27, 1618. Florence, AS, Accademia del Disegno, *Atti e Sentenze*, 64, fols. 70rᶜ and 70rᵛ, by count; cited by Bissell, 1981, 115.

50. On Florentine festivals and theatrical events, see A. M. Nagler, *Theatre Festivals of the Medici, 1539–1637* (New Haven and London: Yale University Press, 1964); Arthur Blumenthal, *Theater Art of the Medici*, exh. cat. (Hanover, N.H.: Dartmouth College Museum and Galleries, 1980); and H. Diane Russell, *Jacques Callot, Prints and Related Drawings* (Washington, D.C.: National Gallery of Art, 1975), 59–83.

51. Angelo Solerti, *Musica, Ballo e Drammatica alla Corte Medicea dal 1600 al 1637* (Florence: R. Bemporad & figlio, 1905), 92, and see 135 for names of artist-participants. On the evening that "Signora Artimisia" sang, the music was composed by a woman, Signora Francesca Caccini. On the patronage of Cosimo II, see also Marco Chiarini, ed., *Artisti alla Corte granducale*, exh. cat., Palazzo Pitti, Appartamenti monumentali, May–July 1969 (Florence: Centro Di, 1969), 5–7.

52. On Galileo in Florentine culture, see Stillman Drake, *Galileo at Work: His Scientific Biography* (Chicago and London: University of Chicago Press, 1978); and Eric W. Cochran, *Florence in the Forgotten Centuries, 1527–1800: A History of Florence and the Florentines in the Age of the Grand Dukes* (Chicago and London: University of Chicago Press, 1973), bk. 3.

53. See Miles Chappell, "Cigoli, Galileo, and *Invidia*," *Art Bulletin* 57 (1975): 91–98; and Erwin Panofsky, *Galileo as a Critic of the Arts* (The Hague: M. Nijhoff, 1954).

54. E.g., Christel Thiem, *Florentiner Zeichner des Frühbarock*, Italienische Forschungen, Dritte Folge, Band X, Kunsthistorisches Institut, Florence (Munich: Bruckmann, 1977), 16.

55. The Pitti *Judith and Abra*, inv. 398, o.c., 117 x 93 cm (Bissell, 1968) or 114 x 93.5 cm (Borea, 1970), was described in the 1637 inventory of the Guardaroba and again in 1663 as by the hand of Artemisia. The painting seems always to have been in the Pitti, where it is cited in print from 1826 on (Borea, 1970, 75–76).

Eight replicas and variants of Artemisia's Pitti *Judith* were reported by Bissell (1968, 155 n. 22); these include: (1) a smaller replica, formerly in the Galleria Corsini, Florence (present whereabouts unknown), attributed to Artemisia by Longhi, but not considered autograph by Bissell; (2) a copy (127 x 95 cm), described by Bissell as "crude," in storage in the Galleria di Palazzo Rosso, Genoa; (3) a replica in the Quirós Collection, Madrid; (4) a closely related version (113 x 122 cm) that once belonged to the dealer De Boer in Amsterdam, reputed to have been of "high quality" (Bissell); (5) a *Judith with Maidservant*, private collection, Milan (75 x 92 cm), reportedly signed on the sword "ARTEMYSIA," exhibited by Relarte as Artemisia in 1964 (Bissell, 1968, 159 n. 51); (6) a *Judith with the Servant* in the Puerto Seguro (Aveyro) Collection in Málaga, cited by Pérez Sánchez; (7) a "*Giuditta eretta che impugna la spada*," once belonging to Barone Staffa at Montegiorgio (cited by Ortolani); (8) a replica (?) in the Galerie Charpentier, Paris (cited by E. P. Richardson). Nicolson (1979, 51) noted three more copies (though perhaps overlapping with the preceding), listed by Anthony de Witt, "Ein Werk aus dem Caravaggio-Kries," *Pantheon* 23 (February 1939): 51.

56. Bissell (1981, 155–56) follows Sterling, Borea, and Longhi in ascribing the Oslo painting to Orazio, though he notes some Carosellian features. Bissell reports that Moir questioned the Gentileschi attribution; Nicolson's attribution of the picture to Artemisia (1979, 51) is

untenable. Bissell regarded the Oslo *Judith* as the model for Artemisia's Pitti *Judith*, not for reasons of design, but on the "logical assumption" that the father influenced the daughter; he further speculates that the Oslo picture may be the *Judith* cited in the rape trial documents.

To my eye, the Oslo *Judith* is awkwardly designed, with a fussy confusion of drapery and detail that is like Orazio. There is dramatic disjunction between the figures' movements: Judith reaches as if to stop her companion from advancing, yet Abra herself is motionless. The dramatic impact is also weakened by the conception of Judith as a languid, conventionally attractive female character who does not summon the energy required by the event.

A *Judith* that has recently appeared on the art market (Colnaghi), inscribed with Orazio's name on its back, is compositionally close to Artemisia's Pitti *Judith*. Pepper (1984a, 315–16) has supported this attribution with the argument that Artemisia's Pitti painting is derived from a composition by Orazio (a "fact" for which we have no evidence), and with the possible identification of the Colnaghi painting, whose provenance is traced to the Rondanini family, with a *Judith* by Orazio Gentileschi listed in the inventory of Felice Rondanini. I find it impossible to reconcile the unusual style of the Colnaghi picture with Orazio's known works, particularly of the period around 1612, a date with which the painting is connected by the inscription on its back: "Horazio Gentileschi Aº 1612 Pizzº." It should be noted that the inscription is on eighteenth-century relining canvas, and that the date and abbreviation for "Pisano" are in a different hand from the name. Pepper's argument connecting the Colnaghi painting with the Judith taken in the rape trial, which depends on the authenticity of this inscribed date, remains for me circumstantial.

57. He is believed to have been in Florence to witness Artemisia's matriculation in the Academy; see above, p. 27; and Bissell, 1981, 34–35.

58. Charles McCorquodale, *Bronzino* (New York: Harper & Row, 1981), 90. See also below, Chapter 5, n. 103.

59. O.c., 152 x 61 cm. See Adriaan W. Vliegenthart, *La Galleria Buonarroti: Michelangelo e Michelangelo il Giovane*, trans. Giorgio Faggin (Florence: Istituto Universitario Olandese di Storia dell'Arte VII, 1976), 170–73; also Procacci, 1968, 177–78; Mina Gregori, "Avant-propos sulla pittura fiorentina del Seicento," *Paragone* 13, no. 145 (January 1962): 38; Bissell, 1968, 156.

60. According to Baldinucci (1681, II:10), Lionardo, nephew of Michelangelo Buonarroti the Younger, had the figure draped by Baldassare Volterrano. Baldinucci's description of Artemisia's *Inclination* inexplicably differs from the existing image; he describes the figure as holding a compass, with two small pulleys at her feet, indicating quickness and facility of mind.

61. The full history of the emergence of the female model in art academies and schools remains to be written. Despite occasional mention of female models, as in Malvasia's description of the late sixteenth-century Bolognese academy of the "Incamminati" (Pevsner, 1940, 77), it is clear from numerous illustrations of life drawing classes that in the sixteenth and early seventeenth centuries, nude models were almost invariably male. The earliest visual documentation of a female model may be a drawing of c. 1650 illustrating Rembrandt's studio (see Pevsner, 1940, fig. 8). See also below, Chapter 3, note 37; and Nochlin, 1971, 32 ff.

62. The full program of the Galleria at Casa Buonarroti is given by Procacci, 1968, 10 ff.

63. See Thiem, 1977, 340 and 364; also Gregori, 1962, 38; and Gregori, 1965, 15–16.

64. Allori and Coccopani matriculated in the Accademia del Disegno in 1613, Vignali in 1616 (the same year as Artemisia). Coccapani was ten years older than Artemisia, and would have been fully exposed to *maniera* lyric idealism in Cigoli's shop. Vignali, as a pupil of Matteo Rosselli and Carlo Dolci, would have had a similar late Mannerist background. By contrast, Artemisia's *Inclination* has no roots in her earlier artistic training. The controlling role played by the Accademia del Disegno in the late sixteenth century and its effect upon the uniformity of *maniera* style is discussed by M.A.J. Ward, "The Accademia del Disegno in Sixteenth-Century Florence: A Study of an Artists' Institution" (Ph.D. dissertation, University of Chicago, 1972), esp. 296–97.

A more prosaically realist style, represented by the older artists, prevailed on the walls of the Casa Buonarroti Gallery, establishing a

style distinction that is likely to have resulted from the patron's intention, to set apart the historical events of Michelangelo's life and the allegorical scenes above.

65. Palatine Gallery, inv. no. 142; o.c., 146.5 x 108 cm. Signed, on chair: ARTIMISIA LOMI. On mirror: OPTIMAM PARTEM ELEGIT. Though first recorded in 1826 (in the Pitti), the picture is presumed to have been in Medici collections in the seventeenth century. The number 2985 is inscribed in blue on the back of the canvas. See Bissell, 1968, 156; Borea, 1970, 74–75; Harris and Nochlin, 1976, 121.

66. Solerti, 1905, 157. The play was written by Iacopo Cicognini.

67. Ibid., 158 and 163.

68. Luke 10:42. The Magdalen of Western legend and art is a composite figure drawn from the four canonical gospels; she is fused with Mary, the sister of Martha and Lazarus, by John (11:2). For an illuminating discussion, see Marjorie M. Malvern, *Venus in Sackcloth: The Magdalen's Origins and Metamorphoses* (Carbondale and Edwardsville, Ill.: Southern Illinois University Press, 1975).

69. The iconography of the Magdalen in seventeenth-century Roman painting is discussed by Frederick Cummings ("The Meaning of Caravaggio's 'Conversion of the Magdalen,'" *Burlington Magazine* 116 [October 1974]: 572–78), in relation to the Alzaga Caravaggio at Detroit. (Attribution of the Alzaga *Conversion of the Magdalen* to Caravaggio remains controversial; many scholars see his hand only in the figure of Martha, not Mary; see Howard Hibbard, *Caravaggio* [New York: Harper & Row, 1983], 62). Closely related to the Caravaggio *Magdalen* is the *Conversion of the Magdalen* in Munich that has long borne an attribution to Orazio (though Voss once ascribed it to Artemisia), dated by Bissell (1981, 172–73) to c. 1620. A *Mary Magdalen at the Tomb of Christ* in Leningrad is not a convincing attribution to Artemisia (Svetlana Vsevolozhskaya, with I. Linnik, *Caravaggio and His Followers* [Paintings in Soviet Museums] [Leningrad: Aurora Art, 1975], nos. 68–70).

70. Allori's Pitti *Judith* entered the Guardaroba Medicea in 1621 after the artist's death. Whether this painting can be identified with the work promised to Cardinal Orsini in 1616, when it might have been painted, and how it is related to several variants, have become the subject of extended controversy. See Claudio Pizzorusso, *Ricerche su Cristoforo Allori* (Florence: L. S. Olschki, 1982, 60 ff.; John Shearman, "Cristofano Allori's 'Judith,'" *Burlington Magazine* 121 (January 1979): 3–10; and, most recently, Miles L. Chappell, *Cristofano Allori, 1577–1621*, exh. cat., Florence, Palazzo Pitti, July–October 1984 (Florence: Centro Di, 1984), 78 ff.

71. Pre-restoration photographs of the *Magdalen* suggest that the lower fifth and left fifth (approximately) of the painting may be seamed additions to a canvas that was originally smaller. This was likely done by Artemisia herself, however (despite the awkward foot), since there is no discernible change in style or color in the added portion.

72. Soprintendenza (in whose offices the painting now hangs), inv. no. 8032, o.c., 77 x 62 cm. Cited in the 1890 inventory as by a follower of Artemisia, the *St. Catherine* was ascribed to Artemisia by Luciano Berti at the time of its restoration in 1966; see *Gli Uffizi*, 1979, 285; Borea, 1970, no. 44. Bissell (1968, 167) questioned it on the basis of quality, but the unorthodox interpretation is one that might be expected of Artemisia. A closely related, but more problematic work is a *St. Catherine of Alexandria* attributed to Artemisia, formerly in Berlin, now in El Paso; see Fern Rusk Shapley, *Paintings from the Samuel H. Kress Collection: Italian Schools XVI–XVIII Century* (London: Phaidon, 1973), 2:84, no. K2153. Another *St. Catherine* in the Uffizi, which came from the Museo delle Pietre Dure (*Gli Uffizi*, 1979, no. P688, p. 286), cannot be by Artemisia, despite the attribution assigned by Stricchia in 1952 (see Fiorella Stricchia, "Lorenzo Lippi nello svolgimento della pittura fiorentina della prima metà del '600," in *Proporzioni: Studi di Storia dell'Arte* 4 [1963]: 251) and supported by Borea (1970, no. 45). Its fluid style and fleshy, almost Rubensian, facial features separate the painting from Artemisia's Neapolitan works with which Stricchia connects it, while its questioning gaze and intimate engagement of the viewer relate it more to Vouet than to Artemisia. There is some basis for connecting one of the St. Catherines with an image of the saint that Artemisia promised to send Andrea Cioli in Flor-

ence in a letter of 1635 (Appendix A, no. 10). The plethora of Florentine St. Catherines can perhaps be connected with Caterina de' Medici, the Grand Duke's sister, who lived in ence before her marriage to the Duke of Mantua in 1617.

73. Signed on the shield: "ARTEMISIA GENTILESCHI FACIEBAT." Inv. 1890, n. 8557; o.c., 131 x 103 cm. Bissell (1968, 161) placed it at about 1635; Borea (1970, 79–80) described it as a late work. In relatively poor condition, the painting has not been displayed in a gallery since its acquisition by the Soprintendenza from the Ufficio Esportazione in 1926. (It presently hangs in an office of the Cancelliere della Procura Generale, on Via Cavour.)

74. Caravaggio's *Medusa*, painted as a shield for a tournament (according to Baglione), was sent by Cardinal del Monte as a gift to Cosimo II in 1608, thus Artemisia would have surely known it. The Medusa-headed shield was a traditional attribute of Pallas Athena, but a poem by Marino also connects Caravaggio's *Medusa* with the tradition of metal shields bearing Medusa heads to frighten the enemy. See Hibbard, 1983, 68–69, whose apt quotation of Milton's description of Minerva's shield (*Comus*, 1634) is even more relevant to Gentileschi's image than to Caravaggio's.

75. The *Bath of Diana* entered the Guardaroba on February 28, 1618, with dimensions of five *braccie* (height) by four and one-third *braccie* (A.S.F., Archivio della Guardaroba Medicea, 1618–23, 1618, p. 21). See also Gregori, 1965, 9. Mina Gregori (1968, 420 n. 19) gives this date as 1619, possibly correcting for the Florentine calendar. The *Hercules* must have entered the Guardaroba by 1620, when Artemisia left Florence.

76. Filippo Baldinucci, *Notizie de' Professori del Disegno da Cimabue in Qua . . .* (Florence, 1681–1728); ed. cited, *Opere di Filippo Baldinucci* (Milan: Società tipografica de' Classici italiani, 1808–12), 11:10. The *Aurora* must have been painted by 1625, and a date of around 1617–18 is possible, given its relation to Reni's *Aurora* and its typological similarity to the *Diana*. The *Persephone*'s provenance from a Medici collection implies its acquisition either during Artemisia's Florentine sojourn, 1614–20, or in 1635, when she sent two paintings to Ferdinando II (see Appendix A, no. 9).

77. Inv. 1890, 1567, o.c., 199 x 162.5 cm, signed in lower right: "EGO ARTEMITIA / LOMI FEC." The painting came to the Uffizi from Palazzo Pitti in 1774 (as Caravaggio, despite the signature), and was identified by Borea (1970, 76–78) with a work of its description, but without an artist's name, in 1637 and 1663 Pitti inventories. The attribution to Artemisia was restored at the end of the eighteenth century, and around the same time the painting was engraved in Marco Lastri, *Etruria pittrice ovvero storia della pittura toscana dedotta dai suoi monumenti che si esibiscono in stampa dal secolo X. fino al presente*, vol. 2 (Florence: Niccolò Pagni and Giuseppe Bardi, 1791), Tav. 84 (Fig. 39). Lastri recounts that the painting was relegated to the darkest corner of the Gallery because Grand Duchess Maria Luisa could not stand to see such a horror. The painting is today not on public display in the Uffizi, but hangs in the darkened Corridoio Vasariano.

Replicas and variants of the Naples and Uffizi *Judith*s, noted by Bissell (1968, 156 n. 24) and Nicolson (1979, 50–51), include: (1) a copy (of the Uffizi version), one of two small paintings on touchstone in the Galleria dell'Arcivescovado, Milan, pendant to a copy of Orazio Gentileschi's Spada *David*, both regarded by Longhi as autograph Artemisias (reproduced in Bissell, 1981, figs. 37, 38); (2) a copy of the Naples version in the Pinacoteca, Bologna (161 x 138 cm), cited by Mauceri (not autograph, despite Gregori [*Age of Caravaggio*, 1985, 257]); (3) another copy recorded in a photograph, Gabinetto Fotografico, Rome (E 44973), noted by Borea, 1970, cat. 49; (4) engraving of Uffizi version in Lastri, 1791.

78. The first request for the pigment, a document of January 13, 1620, was written on Artemisia's behalf to the Grand Duke's quartermaster (A.S.F., Archivio della Guardaroba Medicea, 1618–23, 390, inserto 2, foglio 27 (? first digit not clear; foglios out of order). A more extensive entry of February 15, 1620, was written for her by Francesco Maringhi, who states that the Guardaroba has on deposit some *masserizie* belonging to Artemisia as collateral for her debt of 50 *ducati*, plus 15 more for the one and one half ounces of ultramarine blue. Maringhi, who seems to have assumed some personal responsibility for the loan of 65 *ducati*, further

acknowledges that Artemisia is to finish the picture within six months (A.S.F., Guardaroba Medicea, 1618–23, 390, inserto 5, foglio 293).

79. Another indication that the Uffizi *Judith* was the last picture painted for the Grand Duke may be seen in Artemisia's statement to Galileo fifteen years later (Appendix A, no. 9). Reminding the mathematician of "that *Judith*" which she gave to Cosimo II, she states that it would have been forgotten and she would not have been paid if not for Galileo's intervention. His intercession would hardly have been needed if Cosimo himself were alive at the time.

The reconstruction here proposed of the relationship between the Naples and Uffizi *Judiths*—the former painted in Rome in 1612–13, and the latter painted for Grand Duke Cosimo II in 1620—parallels the history of the *Judiths* of Cristofano Allori. Allori painted his earliest version of *Judith with the Head of Holofernes* in 1613 (according to Shearman, 1979, the picture now at Hampton Court, Fig. 263). Another version (Palazzo Pitti) was begun by Allori for Cosimo II in or before 1620, and, not quite finished, it entered the Medici Guardaroba in September of the same year. (On the problems of authenticity and sequence, see Chapter 5, note 71.) The Grand Duke, gravely ill by January 1620, may have attempted to complete patronage projects in the year before his death.

80. Raffaello Soprani, *Vite de' Pittori, Scultori, ed Architetti Genovesi* [1674], with notes by Carlo Giuseppe Ratti (Genoa: Stamperia Casamara, 1768–69), 316–17. See also Bissell, 1981, 42.

81. Both the *Lucretia* and the *Cleopatra* passed from Palazzo Gentile to Palazzo Adorno; the *Lucretia* is still owned by a member of the Cattaneo Adorno family in Genoa. I am grateful to Piero Pagano, whose firm (Rubinacci Galleria d'Arte, Genoa) recently cleaned and restored the *Lucretia*, for informing me that its present measurements, 137 x 130 cm, represent an augmentation of the original canvas by a later hand. The original portion of the painting measures 100 x 77 cm; the column on the right, the drapery on the left, the portion of Lucretia's leg below the calf, and a few inches at the top have all been added to the canvas, perhaps as late as the eighteenth century,

when this practice was common. The *Cleopatra* was for a long time also in the Palazzo Cattaneo-Adorno, but is presently owned by Amedeo Morandotti, Milan (ex-Alessandro Morandotti, Rome).

Ratti's inclusion of the *Lucretia* and *Cleopatra* among the paintings by Orazio in Palazzo Pietro Gentile predisposed later writers to assign to him the pictures in the Palazzo Adorno; see Giovanni Cristoforo Gandolfi, *Descrizione di Genova e del genovesato* (Genoa: Tipografia Ferrando, 1846), 3:294; Federigo Alizeri, *Guida artistica per la città di Genova* (Genoa: G. Grondana Q Giuseppe, 1846), 2:432. It was Antonio Morassi who first ascribed the *Lucretia* and *Cleopatra* to Artemisia (*Mostra della Pittura del Seicento e Settecento in Liguria*, exh. cat., Genoa, Palazzo Reale, June 21–September 30, 1947 [Milan: L. Alfieri, 1947], 101–103), a position supported by Bissell in 1968. In 1981, however, Bissell gave the *Cleopatra* to Orazio (though with somewhat stronger arguments for Artemisia). See Bissell, 1981, 202; and, for the Orazio argument, see Schleier, 1971, 89; and Carlo Volpe, "Annotazioni sulla mostra caravaggesca di Cleveland," *Paragone* 23, no. 263 (1972): 68.

82. The verses were published in Venice in 1627; they are included in Codex Ottoboniano Latino 1100 of the Vatican Library. See Ilaria Toesca, "Versi in lode di Artemisia Gentileschi," *Paragone* 22, no. 251 (January 1971): 89–92; see also below, Chapter 2, pp. 172 ff.).

83. Carlo Giuseppe Ratti, *Instruzione di quanto può vedersi di più bello in Genova in Pittura, Scultura, ed Architettura ecc.*, 2nd ed. (Genoa: I. Gravier, 1780).

84. The *Judith and Maidservant* that Ratti described as by Orazio was identified by Bissell (1981, 153) as probably by Reni.

85. For Gentile, see Marchese Vittorio Spreti, *Enciclopedia storico-nobiliare italiana, Famiglie nobili e titolate viventi, riconosciute dal R.° Governo d'Italia*, 7 vols. (Milan: Ed. Enciclopedia Storico-Nobiliare Italiana, 1928–35), 3:394–96; Soprani, [1674] 1768–69, 2:179, 311; and Carlo Varese, *Storia della Repubblica di Genova, dalla sua Origine sino al 1814*, 8 vols. (Genoa: Ves Gravier, 1836), 3:210. Sauli was wounded while serving as captain of a regiment in 1625, and became general of artillery in Genoa in 1626 (Spreti, 1928–35, 6:157).

86. According to Ratti, the palace of Paolo Spinola held an oval painting of the Virgin with a sleeping child "by Orazio Gentileschi," and the palace of Giacomo Balbi contained a "portrait of a matron with a *piuma* in her hand" (Ratti, 1780, 143 and 196; see Bissell, 1981, 219, L-39 and L-47).

87. See Bissell, 1981, figs. 1 and 46, and pp. 51 and 153–54; also Christopher Brown, *Van Dyck* (Ithaca, N.Y.: Cornell University Press, 1982), 134 ff.

88. C. Brown, 1982, 61–62.

89. Harris and Nochlin, 1976, 106–107; and C. Brown, 1982, 82–84.

90. Soprani ([1674] 1768–69, 1:416), though placing Sofonisba's death date at 1620, stated that she died in Genoa.

91. Keith Andrews, in "*Judith and Holofernes* by Adam Elsheimer," *Apollo* 98, no. 139 (September 1973): 207–209, suggested Elsheimer's picture as an influence on Rembrandt's *Samson* (see below, Chapter 5, Fig. 285). Artemisia's painting is closer to Rembrandt's, however, both in formal motifs and in its vigorous expression.

92. O.c., 208 x 128 cm. Inscribed on back of canvas: ARTEMISIA. GETILSCA. FA-/CIEBAT ROMAE 1622 (preserved after recent relining). The picture was published by F. Malaguzzi-Valeri ("I nuovi acquisti della pinacoteca di Bologna," *Cronache d'arte* 3, fasc. 1 [1926]: 30, 33) soon after its donation to the Pinacoteca, Bologna, by the heirs of Agostino Pepoli.

93. Noted by Guido Zucchini, *Catalogo delle collezioni comunali d'arte di Bologna*, Palazzo del Comune (Bologna: Grafiche Nerozzi, 1938), 22. See also J. H. Lawrence-Archer, *The Orders of Chivalry* (London: W. H. Allen, 1887), 133–37.

94. Zucchini (1938) related that the arms were "said to approximate" those of Marchese Lucrezio Pepoli, governor of papal territories; Bissell's further investigations in a variety of genealogical sources (1968, 157 n. 39) were unsuccessful, as have been my own. The device exposed by the cleaning is somewhat unusual in that the chevrons point down, not up; another peculiar feature is the emblem above the chevrons, an asymmetrical, horizontally placed sword (or cross).

95. See above, p. 56. Pietro Maria di Cesare Gentile may be identical with the Pietro Maria

Gentile who became a senator in 1640 (Spreti, 1928–35, 3:395).

96. In the Louvre portrait the page holds a helmet to which a Maltese cross is attached. A second portrait by Caravaggio, believed also to represent Wignacourt, shows the Maltese cross emblazoned on his chest. See Gregori, in *Age of Caravaggio*, 1985, 328–34.

97. Joachim von Sandrart, *Academie Bau-, Bild- und Mahlerey-Künste* [1675], commentary by A. R. Peltzer (Farnsborough, Hants.: Gregg, 1971) 192; Baldinucci, [1681–1728] 1808–12, II:9; Bernardo De Dominici, *Vite de' pittori, scultori ed architetti napoletani* [1742] (Bologna: Forni Editore, 1971), 3:45; Alessandro da Morrona, *Pisa illustrata nelle arti del disegno* (Livorno: G. Marenigh, 1812), 492; Soprani, [1674] 1768–69, 1:453; Horace Walpole, *Anecdotes of Painting in England*, 4 vols. (London: T. Farmer, 1762–71), 2:114. No other portrait attributions have gained acceptance; see Levey, 1962, 80; and Bissell, 1968, 166–67. The Corsini Gallery *Portrait of a Woman Painter*, wrongly ascribed to Artemisia, is discussed below.

98. Herman Voss, "Artemisia Gentileschi" [1920], entry in Ulrich Thieme and Felix Becker, eds., *Allgemeines Lexikon der bildenden Künstler von der Antike bis zur Gegenwart; unter Mitwirkung von 300 Fachgelehrten des In- und Auslandes*, 37 vols. (Leipzig: Seemann, 1907–50), 13:409.

Perhaps the most credible portrait attribution that has been proposed is a handsome *Portrait of a Noblewoman* now with Trafalgar Galleries, London (reproduced and discussed in *Trafalgar Galleries at the Royal Academy III*, exh. cat. [London: Trafalgar Galleries, 1983], 70–73). Yet, though one must allow for the conservative tastes of patrons, the meticulously detailed clothing, the rather mild face, and the overall flatness of the figure in this painting find no counterpart in Artemisia's *oeuvre*.

99. *Status Animarum*, S. Maria del Popolo, LXV, foll. 11ᵛ, 27ᵛ, 6 (cited by Bissell, 1968, 157 n. 42). The *Status Animarum* of the parish of S. Maria del Popolo listed an "*Artemisia vedova*" on Via del Corso from 1624 through 1631, identified by G. J. Hoogewerff (*Nederlandsche Kunstenaars te Rome [1600–1725]* [1938], Studiën van het Nederlandsch Historisch Instituut te Rome 3 ['s-Gravenhage: Algemeene Lands-

drukkerij, 1942], 6) as the painter herself. This remains a possibility to be considered. Although Bissell assumed that the widow was a different person, there is a good chance that two "Artemisias" living on Via del Corso during the same years were one and the same; moreover, living independently, Artemisia very well might have been described as a widow in the census.

100. "Liber V Baptizatorum: 1620–1639," S. Maria del Popolo, fol. 47, 52ᵛ, cited by Bissell, 1968, 157 n. 42.

101. Bissell (1968, 158 n. 49) reasonably assumed that the second mention of a projected wedding did not mean that Artemisia's only daughter was on the marriage market for thirteen years! Also, Artemisia's reference in the Cioli letter to *una mia figliuola* implies that she had more than one.

Artemisia's choice of the name Prudentia is to be expected, since that was her mother's name. Palmira, which could have been Prudentia's middle name (or vice versa), is a more intriguing selection, as it repeats the association of her own name with a Hellenistic queen, now in the name of the fabled city of Queen Zenobia.

102. Pierre Rosenberg, "'La main d'Artémise,'" *Paragone* 22, no. 261 (November 1971): 69–70. The drawing, which measures 220 x 161 mm, came to the British Museum in 1835.

103. "*Les mains de l'Aurore sont louées pour leur rare beauté. Mais celle cy plus digne le doit estre mille fois plus, pour sçavoir faire des merveilles, qui ravissent les yeux des plus judicieux. S.*" It is possible, but less probable, that Dumonstier alludes to Artemisia's painted *Aurora*.

104. The portrait medal, now in Berlin, has been dated 1625–30 by her apparent age. There is no reverse image (G. F. Hill, *Portrait Medals of Italian Artists of the Renaissance, With an Introductory Essay on the Italian Medal* [London: P. L. Warner, 1912], 81–82 and pl. XXXI).

105. David's engraving of Artemisia, mentioned by Voss in his Thieme-Becker entry on the artist, was published by Levey (1962, 79), who identified it as a replica of a self-portrait. No corresponding portrait is known, but the print is inscribed "*Artem. Pinx.*" The legend beneath the image reads: EN PICTURAE MIRACULUM / INVIDENDUM FACILIUS QUAM IMITANDUM (Behold, a marvel in the art of paint-

ing, more easily envied than imitated). The dedication at the bottom, "*Al Molto Illᵗᵉ et eccᵐᵒ Signʳᵉ Gioseppe Marini*" (To the most illustrious and excellent Signor Giuseppe Marini), could be to the poet Giovanni Battista Marini, despite the differing first name, since both the image and inscriptions are in the spirit of the word portraits of men and women in Marini's *Galeria*, written in 1620.

106. Agucchi's treatise on painting, written c. 1607–1615, was published posthumously in 1646; see Mahon, [1947] 1971, 62 and 111 ff. For a discussion of the Agucchi-Domenichino relationship, see Richard E. Spear, *Domenichino*, 2 vols. (New Haven and London: Yale University Press, 1982), 27 ff.

107. The text of the letter is given in Robert Enggass and Jonathan Brown, *Italy and Spain, 1600–1750*, Sources and Documents in the History of Art Series, ed. H. W. Janson (Englewood Cliffs, N.J.: Prentice-Hall, 1970), 16–20; see also Gash, 1980, 19–20; Walter Friedländer, *Caravaggio Studies* (Princeton: Princeton University Press, 1955), 76–78; and, on the date of Giustiniani's letters, see Francis Haskell, *Patrons and Painters, A Study in the Relations between Italian Art and Society in the age of the Baroque* (New York: Alfred A. Knopf, 1963), 94 n. 3.

108. Luigi Salerno, "The Picture Gallery of Vincenzo Giustiniani, II: The Inventory, Part I," *Burlington Magazine* 102 (1960): 96: "*un quadro con una figura intiegra di* David, *che tiene la testa del Gigante Golia, dipinto in tela, alta palmi 9 lar.6e - circa di mano di Artemisia Gentileschi con cornice.*" A *David with the Head of Goliath* in the *depositi* of the Galleria Corsini, Rome, attributed to Artemisia by Longhi (1916, 290 and fig. 25), does not appear to be by her hand, but is possibly a replica of Giustiniani's painting. Another(?) *David with the Head of Goliath* by Artemisia was shown to Sandrart in 1631 (discussed below).

109. The "Bentvogels" united in mutual support, especially against the Accademia di S. Luca, whose yearly levy on all artists in Rome they successfully resisted in the 1630s; see G. J. Hoogewerff, *De Bentvueghels* ('s Gravenhage: M. Nijhoff, 1952). On Northern artists in Rome, see H. Diane Russell, *Claude Lorrain, 1600–1682* (Washington, D.C.: National Gallery of Art, 1982), ch. 1; Giuliano

Briganti, ed., *I Bamboccianti, pittori della vita popolare nel Seicento*, (Rome: Antiquaria, 1950); *I Caravaggeschi Francesi*, exh. cat., Accademia di Francia, Villa Medici, Rome, November 1973–January 1974 (Rome: De Luca, 1973); and *Valentin et les Caravagesque Français*, exh. cat., ed. Arnauld Brejon de Lavergnée, Grand Palais, Paris, February–April 1974 (Paris: Éditions des musées nationaux, 1974).

110. O.c., 184.1 x 141.6 cm. The picture went from the collection of "Prince Brancaccio" in Rome to that of Leslie H. Green, who gave it to the Detroit Institute in 1952. "Prince Brancaccio" was likely Carlo Brancaccio, Prince of Triggiano among other titles, born in 1870 in Rome (Spreti, 1928–35, 2:174). The painting was first discussed by E. P. Richardson in "A Masterpiece of Baroque Drama," *Bulletin of the Detroit Institute of Arts* 32, no. 4 (1952–53) 81–83; see also Harris and Nochlin, 1976, 122. Bissell's dating of the picture in the mid-twenties (1968, 157–58) has been generally preferred to Moir's proposal of the late teens (1967, 101). Artemisia's later variant of the Detroit picture in the Museo di Capodimonte, Naples, is discussed below.

111. Both Orazio and Artemisia had associations with the Gonzaga court: Orazio had painted a Madonna and Child in 1609 for Duke Vincenzo (Alessandro Luzio, *La galleria dei Gonzaga, Venduta all'Inghilterra nel 1627–28* [Rome: Bardi, 1974], 60–61); Artemisia would have known the current duke's wife, Caterina de' Medici, whose marriage to Ferdinando Gonzaga took place in Florence while Artemisia was there in Medici employ.

112. The Anteveduto was earlier attributed to Artemisia, among others; see Richard E. Spear, *Caravaggio and His Followers*, exh. cat. (Cleveland, Ohio: The Cleveland Museum of Art, 1971), 108 and 127. Rutilio Manetti (1571–1639) worked mostly in Siena, but visited Rome in 1625, which suggests that the *Judith* may have been completed by that year. See *Important Italian Baroque Paintings*, 1981, 20; and Alessandro Bagnoli, *Rutilio Manetti, 1571–1639*, Siena, Palazzo Pubblico, June 15–October 15, 1978 (Florence: Centro Di, 1978). Artemisia's influence on Manetti has been noted (Gregori, 1968, 417, 420; Bagnoli, 1978, 28 and throughout), but she was not a unique influ-

ence upon that talented eclectic, who was also obviously affected by Honthorst, Lanfranco, and Ribera, among others.

113. Honthorst's *Christ before the High Priest*, commissioned by Giustiniani, was probably painted in 1617; see Madlyn M. Kahr, *Dutch Painting in the Seventeenth Century* (New York: Harper & Row, 1978), 38–39; also J. Richard Judson, *Gerrit van Honthorst: A Discussion of His Position in Dutch Art*, 2nd ed. (The Hague: M. Nijhoff, 1959), 44. Honthorst's patrons in Rome were Scipio Borghese and Giustiniani, and in Florence, Cosimo II; the painter returned to Utrecht in 1620.

Saraceni's *Judith with the Head of Holofernes* in Vienna is one of several variants by the artist; there exist as well a number of seventeenth-century copies of these variants by other artists, such as the *Judith* in Dayton, Ohio, which is a replica of the original in the Longhi Collection, Florence. See Richard E. Spear, "Studies in Conservation and Connoisseurship: Problematic Paintings by Manfredi, Saraceni, and Guercino," *Dayton Art Institute Bulletin* 34, no. 1 (October 1975): 5–19.

114. Judson, 1959, 32; and Bissell, 1981, 68–69. Honthorst and Orazio Gentileschi were again in contact in London in 1628. See also Benedict Nicolson, *Hendrick Terbrugghen* (London: H. Humphries, 1958), 11 ff.; and Peter C. Sutton, *Masters of Seventeenth-Century Dutch Genre Painting*, exh. cat. (Philadelphia: Philadelphia Museum of Art, 1984), cats. 47 and 48.

115. Bissell (1968, 158) first observed the connection between these two paintings. See *I Caravaggeschi Francesi*, 1973, 222 ff., on the relation between Vouet and Honthorst.

116. William R. Crelly, *The Painting of Simon Vouet* (New Haven and London: Yale University Press, 1962), 6 ff; Georgette Dargent and Jacques Thuillier, "Simon Vouet en Italie," *Saggi e Memorie di Storia dell'arte*, vol. 4 (Venice: Neri Pozza Editore, 1965), 27–63. Virginia da Vezzo (or Vezzi), whose marriage to Vouet on April 21, 1626, is recorded in the marriage register of S. Lorenzo in Lucina, was described by Felibien as "young, intelligent in the art of painting, which she made her profession by the same efforts that Vouet had made" (Dargent and Thuillier, 1965, 37). A *Judith* by Virginia da Vezzo was engraved by

Claude Mellan; *Valentin et les Caravagesque Français*, 1974, 68.

117. Dargent and Thuillier, 1965, V-9. In turn, the position of Abra in Vouet's *Judith* resembles that of Artemisia's Abra in the Detroit *Judith*. Vouet's *Lady with a Guitar* (Rome, Patrizi Collection; see Dargent and Thullier, 1965, V-3) has been connected stylistically with Artemisia's Florentine *Magdalen* (Crelly, 1962, 22), and it is thematically related to the Gentileschi *Woman with Violin* in Detroit. Attributions have frequently shifted from one of these painters to the other, e.g., the *Two Lovers* in the Galleria Pallavicini, Rome, now acknowledged as a Vouet, but once ascribed to Artemisia (Dargent and Thuillier, 1965, A-4).

118. On Mellan's Women series, see Dargent and Thuillier, 1965, A27–A30. On the artistic relationship between Vouet and Mellan, see Dargent and Thuillier, 1965, 36; and *Valentin et les Caravagesque Français*, 1974, 68 ff.

119. These types are discussed below in Chapter 5. A modern description of Valentin's *Judith* bears out her negative expressive associations: "*tout à la fois cruel et délicat: la toute jeune Judith, délicieusement enfantine mais farouche et déterminée, accomplit tranquillement le geste meurtrier . . .*" (*Valentin et les Caravagesque Français*, 1974, no. 47).

120. Bissell (1968, 163) proposed the later dating. The painting, o.c., measuring 207 x 274 cm, was given to the Metropolitan Museum in 1969 by Elinor Dorrance Ingersoll. The picture was purchased in Naples by a member of the Harrach family; it remained in the Harrach'sche Gemäldegalerie in Vienna until the twentieth century, passing through the Morandotti Collection, Rome, and Aquavella Galleries, New York, before its acquisition by Mrs. Stuart H. Ingersoll. The *Esther* was first attributed to Artemisia by Voss (1925, 463). See also *Il seicento europeo: Realismo, Classicismo, Barocco*, exh. cat., Council of Europe, Palazzo della Esposizione, December 1956–January 1957, 2nd ed. (Rome: De Luca, 1967), 131, no. 114; and Thomas DaCosta Kaufmann, "Esther before Ahasuerus: A New Painting by Artemisia Gentileschi in the Museum's Collection," *The Metropolitan Museum of Art Bulletin* 29 (December 1970): 165–69.

121. I wish to thank Metropolitan curator Keith Christiansen for having the x-ray photographs made at my request, and for arranging a useful discussion with museum conservators before the painting. The *Esther* is unfortunately badly abraded in places, especially to the right of center. Although signs of dishing are visible at the top, the picture appears to have been cut down on all sides, especially at the top (which therefore may have been reduced before early restretching). The awkwardly rendered loops of curtain at upper right, despite the loading of pigment, are nevertheless original, according to the conservator who recently worked on the painting. The changes in pigment that have rendered pentimenti visible are discussed briefly by Kaufmann (1970, 169), who notes the compositional advantage of removing the figure between the protagonists.

Although the Louvre *Esther* has borne a traditional ascription to Veronese, Terisio Pignatti (*Veronese*, 2 vols. [Venice: Alfieri Edizioni d'Arte, 1976], cat. A237) regards it as a Veronese workshop production.

122. Unlike the book of Judith, the book of Esther early became one of the canonical texts; see Morton S. Enslin and Solomon Zeitlin, eds., *The Book of Judith* (Leiden: E. H. Brill, 1972), 21 ff., who attribute this to the greater popularity of the Esther story among Jews.

123. See Madlyn Millner Kahr, "The Meaning of Veronese's Paintings in the Church of San Sebastiano in Venice," *Journal of the Warburg and Courtauld Institutes* 33 (1970): 235–43. As Kahr points out (240), Esther, as bride of Ahasuerus, represented Ecclesia, the bride of Christ; in the *Bible Moralisée*, Esther crowned as queen represented the Church triumphant over the Synagogue, represented by Vashti, the preceding queen.

The image of a swooning figure supported by two others is also reminiscent of the theme of the Angelic Consolation of St. Francis of Assisi, which in turn, as Pamela Askew has shown (1969), often alluded to Christ's Passion in its frequent depictions during the later sixteenth and seventeenth centuries.

124. See Anthony Blunt, *The Paintings of Nicolas Poussin, A Critical Catalogue* (London: Phaidon, 1966), 29. In his *Nicolas Poussin* (the A. W. Mellon Lectures in the Fine Arts, Washington, D.C., National Gallery of Art, Bollingen Series 35, 2 vols. [New York: Bollingen Foundation, 1967], 1:179 ff.), Blunt dis-

cusses Poussin's *Esther* as an Old Testament theme representing a category of salvation, in accordance with Early Christian models studied (as antique) by Cassiano dal Pozzo. The golden scepter held by the king, in accord with the biblical account, was to be extended by Ahasuerus as a sign of his favor. That in the Leningrad painting the scepter is still in repose indicates that Poussin, like Artemisia, compressed several stages of the story into one scene.

A feminist reinterpretation of the story of Esther was offered by Elizabeth Cady Stanton, who in 1895 described the heroine as a rather disappointing model of wifely obedience and self-abnegation; Elizabeth Cady Stanton, *The Original Feminist Attack on the Bible (The Woman's Bible)* [1895] (New York: Arno Press, 1974), 84 ff. Stanton much preferred Esther's disobedient predecessor: "I have always regretted that the historian allowed Vashti to drop out of sight so suddenly. Perhaps she was doomed to some menial service, or to entire sequestration in her own apartments" (p. 90).

125. The foreshortened head, which appears elsewhere in the Sistine Ceiling (the figure of Jonah, the created Adam) is discussed by Carmen C. Bambach ("A Note on Michelangelo's Cartoon for the Sistine Ceiling: Haman," *Art Bulletin* 65 [December 1983]: 661–65) as a staple image in Michelangelo's repertory, to such an extent that it was caricatured by an assistant.

126. In fact, the x-ray reveals several stages of compositional development, since the image of the dog is overlapped by the foot of Ahasuerus, and itself overlaps (or is overlapped by) the bottom step. The dog was either painted before the king and his podium were put in, or was meant to be placed in front of the steps, in the foreground. However, in the latter position the dog would have obscured the pictorially important foot of Ahasuerus, hence the logical inference is that the dog was painted in, and removed, before the present position of Ahasuerus was established.

127. O.c., 231.8 x 194.9 cm. The painting was given to the Fogg Museum in 1962 by the Samuel H. Kress Foundation, which acquired it in 1950 from Robert Brothers, New York. It was published by Shapley (1973, 84–85) as by Arte-

misia, following Fahy's attribution of 1968. Earlier, according to the Museum's records, the painting had been ascribed to Roman School, Flemish School, Vouet, Biliverti, seventeenth-century Italian School, and Lami (Giulia Lama?). The Gentileschi attribution was supported by Mina Gregori, Erich Schleier, Frederick Cummings, and Ward Bissell (who dated it in the 1640s). Fahy's reattribution of the picture to Finoglia in 1976, published by S. J. Freedberg ("Lorenzo Lotto to Nicolas Poussin," *Apollo* 107, no. 195 [May 1978]: 395) is explained in Fahy's catalogue entries for the Fogg's Italian paintings, presently in manuscript. Nicolson (1979, 110) listed the painting as by an unidentified follower of Vouet.

128. Cigoli's *Chastity of Joseph*, and the variants and copies produced by his pupil Biliverti, are discussed by Thiem (1977, 294) in connection with Cigoli's preparatory drawing now in Budapest. As G. J. Hoogewerff observed ("Appunti sulle opere di Giovanni Biliverti," *Commentari* 11, fasc. 2 [April–June 1960]: 142), the Barberini version of Biliverti's *Joseph* here reproduced is a near-replica of the artist's first version, now in the Uffizi, which was painted for Cardinal Gian Carlo de' Medici around 1611 (or, according to Baldinucci, about 1624). See also Giuseppe Cantelli, *Repertorio della Pittura Fiorentina del Seicento* (Florence: Opus Libri, 1983), figs. 31, 32. Artemisia could have known the Cigoli version in Rome, and the Bilivertis in Florence.

Alternatively, a version of the theme painted in Rome by Cesari d'Arpino (private collection, London), perhaps as early as 1602–1603, could have been the prototype for the entire group. See Herwarth Röttgen (ed., *Il Cavaliere d'Arpino*, Soprintendenza d'arte medioevali e moderne del Lazio, Ministero della pubblica istruzione, direzione generale delle antichità e belle arti, Rome, Palazzo Venezia, June–July 1973 [Rome: De Luca, 1973], 112–13 and fig. 35), who notes the composition's origin in the Raphaelesque version of the same subject in the Vatican Loggie.

129. Gregori (1965, 9) noted the popularity of the theme of the chastity of Joseph in Florence around 1620. Andor Pigler (*Barockthemen, eine Auswahl von Verzeichnissen zur Ikonographie des 17. und 18. Jahrhunderts* [1956], 2 vols. [Buda-

pest: Akadémiai Kiadó, 1974], 1:80–83) lists numerous central Italian versions of this theme in the seventeenth century, but few if any Neapolitan ones. No Neapolitan examples of the theme are included in Clovis Whitfield and Jane Martineau, eds., *Painting in Naples 1606–1705, From Caravaggio to Giordano* (Washington, D.C.: National Gallery of Art; London: Royal Academy of the Arts, 1982); nor in De Rinaldis ([1929] 1976). A major Joseph painting of the 1620s, the *Joseph Interpreting the Pharaoh's Dreams* in the Borghese Gallery, once ascribed to Artemisia by Roberto Longhi (1916, 92), was attributed to Claude Mellan by Thuillier in 1958 (*Valentin et les Caravagesque Français*, 1974, 70). For Bronzino's tapestry of the 1540s, see McCorquodale, 1981, fig. 67; Properzia de' Rossi's relief is discussed by Elsa Honig Fine (*Women and Art, A History of Women Painters and Sculptors from the Renaissance to the Twentieth Century* [Montclair, N.J., and London: Allenheld & Schram/Prior, 1978], 8–9), who recounts Vasari's ridiculous interpretation of the relief as the artist's metaphor for her romantic rejection by a young man.

130. Orazio Gentileschi's *Joseph and Potiphar's Wife* at Hampton Court is dated about 1632 by Bissell (1981, 191) for reasons of style; also, an accounting bill in the English Royal Collections indicates that the frame for this painting was varnished and gilded in 1633 or 1634. Although Orazio's *Joseph* follows a fairly well-established type, it may have been inspired by Artemisia's earlier version in such features as the bedclothes and Joseph's prominent garment.

In the last years of her life, 1650–51, Artemisia painted a *Joseph and Potiphar's Wife* for her Sicilian patron, Don Antonio Ruffo, that may have been unfinished at her death (discussed below; see also Appendix A, no. 28).

131. Genesis 39: 1–23. See also Moses Hadas, *Hellenistic Culture, Fusion and Diffusion* (Morningside Heights, N.Y.: Columbia University Press, 1959), 155 ff., in which Joseph is compared with other mythic heroes, such as Hippolytus, who reject temptresses out of loyalty to religious principles. Hadas notes that Joseph's rejection exclusively concerns the question of breach of trust.

132. E.g., organizing a "medieval joust" in the Piazza Navona in 1634, which he commissioned artists to record, in order to entwine Rome's chivalric and ancient past with Barberini family history (Haskell, 1963, 55–56).

133. Marilyn A. Lavin, *Seventeenth-Century Barberini Documents and Inventories of Art* (New York: New York University Press, 1975) (Inventory of Cardinal Antonio Barberini, 1644, 4, inv. 44), 165. This is not to be identified with a *Venus and Cupid* in a private collection in Switzerland wrongly ascribed to Artemisia by Voss (Hermann Voss, "*Venere e Amore* di Artemisia Gentileschi," *Acropoli* 1, pt. 1 [1960–61]: 79–82). It could be related to the "*Amoretto in Parangone*" by Artemisia praised in the Venetian verses of 1627 (see below, Chapter 2, pp. 172 ff.); conversely, it may be identical with the *Sleeping Venus* at Princeton recently attributed to Artemisia (discussed below).

134. Baldinucci ([1681–1728] 1808–12, II:11–13). Romanelli's portrait of Artemisia is not known. The account itself is tainted by stereotyped amorous overtones: Romanelli, who asked to paint Artemisia, kept the picture for himself and, to tease his wife, extolled Artemisia's beauty at such length that the jealous woman went to Artemisia's house to see for herself. On recognizing that her husband had not exaggerated, the wife forgave all, and became fast friends with Artemisia.

Still-life paintings by other women artists, such as Giovanna Garzoni and Fede Galizia, are presently being rediscovered. See John T. Spike, *Italian Still-Life Paintings from Three Centuries*, Centro Di, National Academy of Design, and Old Masters Exhibition Society of New York (Florence: Centro Di, 1983), 30 ff. and 65 ff., which documents the extensive new attributions included in a major recent exhibition of Italian still-life paintings (none of which are ascribed to Artemisia).

135. The primary sources for Cassiano dal Pozzo are: Giacomo Lumbroso, "Notizie sulla vita di Cassiano dal Pozzo: Protettore delle Belle Arti Fautore della scienza dell'antichità nel secolo decimosettimo," *Miscellanea di storia italiana* 15 (1876): 129–211; Francis Haskell and Sheila S. Rinehart, "The Dal Pozzo Collection: Some New Evidence, Part I," *Burlington Magazine* 102 (July 1960): 318–26; Sheila S. Rinehart, "Cassiano dal Pozzo (1588–1657): Some Unknown Letters," *Italian Studies*,

Cambridge, England, vol. 16 (1961): 35–59; and Haskell, 1963, 98–119.

136. Over sixty letters written to Cassiano from artists in his service are published in Bottari and Ticozzi, 1822–25; for Artemisia's letters, see vol. 1, 348 ff. For Cassiano's own letters (none to Artemisia), see Rinehart, 1961.

137. The promised paintings, the *Samaritan Woman* and *St. John Baptist in the Desert*, are not recorded in the Barberini inventories. There are other indications that no self-portrait by Artemisia ever joined Cassiano's collection of portraits of famous exponents of art, science, and letters. No portrait of or by Artemisia was named either in de Cotte's description of the dal Pozzo collection (c. 1689), or in Ghezzi's inventory of the collection (1715) (Haskell and Rinehart, 1960, 318 ff.). In the set of epigrams composed by Gabriel Naudé in 1641 to accompany forty-two of the portraits (Gabriel Naudé, *Epigrammatum libri duo* [Paris: Sebastianum et Gabrielam Cramoisy, 1650]), Artemisia is not among those commemorated.

138. O.c., 96.5 x 73.7 cm; signed on the table with initials "A.G.F." This painting is first mentioned in an inventory of 1649, where it is described as "Arthemesia gentelisco, done by her selfe" (Oliver Millar, ed., "The Inventories and Valuations of the King's Goods 1649–1651," *The Walpole Society* 43 [1970–72], 186). It does not appear in van der Doort's inventory of 1639, though other paintings by Artemisia are there mentioned (see below, pp. 111–12 and note 191). The *Pittura* was sold in 1651, but recovered for the Crown at the Restoration; it is mentioned again in an inventory of 1687–88 ("The Note Books of George Vertue Relating to Artists and Collections in England," *Walpole Society* 24 [1935–36]: 90). Formerly at Hampton Court, the picture has been at Kensington Palace since 1974. The *Pittura* was first identified as an Allegory of Painting by Michael Levey (1962, 79–80). See also Michael Levey, *The Later Italian Pictures in the Collection of Her Majesty the Queen* (Greenwich, Conn.: New York Graphic Society, 1964), 82; Spear, 1971a, 98; Garrard, 1980, 97–112; and Whitfield and Martineau, 1982, 167–68.

Other paintings that have been interpreted as self-portraits by Artemisia include: (1) the Palazzo Corsini painting here discussed; (2)

an allegorical female portrait, *Woman with a Dove*, in the Prado, Madrid, whose attribution to Cecco da Caravaggio has been generally accepted (Moir, 1967, 1:100; Bissell, 1968, 166–67; and Nicolson, 1979, 51)—Levey (1962, 80) rejected the identification of the figure depicted as Artemisia; (3) a *Portrait of a Woman Painter* in Earl Spencer's collection, neither of nor by Artemisia, as observed by Levey (1962, 80); and (4) a *Portrait of a Woman Painter* in Krakow, Wawel Castle, earlier exhibited as by Artemisia, but questioned as such by Jan Bialostocki (Jan Bialostocki and Michal Walicki, *Europäische Malerei in polnischen Sammlungen, 1300–1800* [Warsaw: P(aństwowy) I(nstytut) W(ydawniczy), 1957], no. 225), and now ascribed to Guercino. (I am especially grateful to Mary B. Kelly, and also to John Delido and Nina Michatek for information on the latter.)

In addition to the self-image promised to Cassiano dal Pozzo, Artemisia later promised a self-portrait to Don Antonio Ruffo (Appendix A, nos. 16 and 17). This picture was never delivered.

139. The extensive differences of style between the Palazzo Corsini and Kensington Palace paintings are discussed in Garrard, 1980, 111–12. Although the woman in the Corsini painting does not have the attributes of *Pittura* (her laurel wreath suggests *Poesia*), the Allegory of Painting was sometimes shown without Ripan attributes (Garrard, 1980, 112 n. 68).

140. The Corsini painting could have been in the Barberini Collection. Bissell (1968, 162) noted that in the year it was acquired for the Galleria Nazionale (1935), pictures from the Barberini Collection were sold by the Galleria l'Antonina in Rome. Other pictures in the Galleria Nazionale came from the collection of Cardinal Francesco Barberini, and Bissell suggested that this picture may have been one of them. However, Bissell's proposal (1968, 162) that the Corsini picture was painted by Artemisia in 1630, and the London *Self-Portrait* in 1637, for a putative second commission from Cassiano, is not convincing, for reasons given in Garrard, 1980, 110–12.

The Palazzo Corsini picture measures 93 x 74.5 cm; Artemisia's *Pittura*, 96.5 x 73.7 cm. Artemisia's mention of "*misura*" and "*conforme*" regarding her self-portrait for Cassiano (Appendix A, nos. 2 and 13) suggests that the

patron may have stipulated dimensions for pictures destined for his portrait gallery.

141. Lumbroso, 1876, 129–388, 164. On Cassiano's collection of portraits, see also Haskell and Rinehart, 1960, 318 ff., esp. 320.

142. For mention of the Colonna, d'Aubignan, and d'Ampus portraits, see Bottari and Ticozzi, 1822–25, 1:342–48 and 361–69. The portrait of Christina of Sweden is included among Naudé's epigrams (Naudé, 1650).

143. Contributors to a recent exhibition catalog of Neapolitan art (Whitfield and Martineau, 1982) range widely in setting this date, from 1626–30 (Schleier) to after 1630 (de Castris).

144. For example, Artemisia was still ordering gloves and slippers from Rome, and she asked Cassiano's assistance in getting a license for an assistant to carry arms. These are matters one imagines might be carried out in the new city after more than a year in residence.

145. De Dominici, [1742] 1971, 45.

146. In Appendix A, no. 9 and 17, she instructs her correspondents to write her in care of two different male names, Signori Maringhi and Guaragna respectively. These may simply have been her landlords; they at any rate were not husbands.

147. *St. Bruno Receiving the Rule of the Carthusian Order*, for the Certosa di S. Martino; and *The Circumcision* (patron unknown, but sent to Naples). See Whitfield and Martineau, 1982, 264–66.

148. François de La Chesnaye-Desbois et Badier, *Dictionnaire de la Noblesse*, 3rd ed., 19 vols. (Paris: Schlesinger frères, 1863–77), 12:414–15; and Varese, 1836, 3:207 ff. The Duke of Guise, who had earlier served as governor of Provence, moved with his family to Florence in 1622. In 1624, he was in charge of the French command at Genoa, where he and the artist may have met. The Duke died in 1640.

149. From 1629 to 1658, Francesco I d'Este extensively enriched the family collections with works by sixteenth- and seventeenth-century masters of the stature of Correggio, Veronese, Guercino, and Reni. Velázquez's portrait was painted when Francesco was in Madrid in 1638; Bernini's bust of the Duke dates from 1651 (Adolfo Venturi, *La R. Galleria Estense in Modena* [Modena: Paolo Toschi & C. Editore, 1882], esp. 199–222). In January 1635 Francesco d'Este was in Rome, where Artemisia sent

paintings to him along with works for Antonio Barberini (Appendix A, no. 6). By her own account, Artemisia had earlier served Cardinal Alessandro d'Este (no. 7), though no Modenese works by her have been identified; the Cardinal's collections are discussed by Venturi, 1882, 157–69.

150. Marie de' Medici was the niece of Ferdinando I and a cousin of Artemisia's patron Cosimo I. Artemisia could have had independent associations with the young Louis XIII through her Barberini patrons in Rome, through whom the new king sent the Rubens tapestries to Urban VIII in 1625.

According to Bissell (1968, 166), a *Portrait of St. Louis* at S. Luigi dei Francesi, Rome, assigned by Longhi to Artemisia in the 1620s, is instead Charles VIII of France, and by another artist.

151. Pietro Giannoni, *The Civil History of the Kingdom of Naples* [1723], trans. Captain James Ogilvie, 2 vols. (London: W. Innys, 1729–31), 2:731 ff. The paintings for the Empress, not specified, were to be done by September 1630. Later in the same year, Artemisia had been away from Naples to paint a portrait of a duchess (Appendix A, no. 4), completed shortly before her *Self-Portrait* for Cassiano.

152. Madrid, Prado; see Madlyn Millner Kahr, *Velázquez: The Art of Painting* (New York: Harper & Row, 1976), 70–71 and fig. 28; and Carl Justi, *Diego Velazquez and His Times* (London: H. Grevel & Co., 1889), 175 ff.

153. According to Carl Justi, *Diego Velasquez und sein jahrhundert* (Bonn: Cohen & sohn, 1888), 1:101, it is reported in Francisco Pacheco's *Dialogo de la Pintura* of 1633 that the Duke bought a painting in Rome by Artemisia Gentileschi. Longhi (1916, 313) adds that this work went to the Palace of Henriquez de Ribera, Duke of Alcalá, in Seville. However, in F. J. Sánchez Cantón's edition of Pacheco's *El Arte de la pintura* (Madrid: Instituto di Valencia de Don Juan, 1956), 1:148, the Duke's purchases are said to include "some paintings."

154. Jonathan Brown and Richard L. Kagan, "The Duke of Alcalá: His Collection and Its Evolution," *Art Bulletin* 69 (June 1987): 231–55. The Duke's inventory was compiled soon after his return to Seville from Naples in 1631; listed in it are works of art acquired by Alcalá before his death in 1637. The authors suggest (p. 243)

that Alcalá himself may have brought Artemisia to Naples in 1629–30.

155. Brown and Kagan, 1987, 239–40, who also cite E. Valdivieso, *Catálogo de las pinturas de la Catedral de Sevilla* (Seville, 1978), 131. I have only seen this work in reproduction, but its Artemisian characteristics include the facial type and the sharply bent wrist, which resembles the London *Cleopatra* (Fig. 98).

　　In addition to these pictures, the inventory lists a copy after a presently unknown (and quite uncharacteristic) work by Artemisia: a "Savior [blessing?] some young boys with his right hand," an image connected by Brown and Kagan with the central episode depicted in Rembrandt's "Hundred Guilder Print" (Matthew 19:13–14). Artemisia's original is said in the inventory to have been given to the Cartuja de Sta. María de las Cuevas (Brown and Kagan, 1987, 240). The listing of the *Magdalen*, the *David*, and the *Christ Blessing* copy without a crate number suggested to Brown and Kagan that these works were purchased in Rome; if so, both date from before 1629. Presumably, the *St. John* and the two portraits could have been painted later in Naples.

156. O.c., 257 x 179 cm. Signed and dated, lower right: "AERTEMISIAE GENTILSECHA / F: 1630." The painting was acquired in 1815 from Francesco Saverio di Rovette of Naples (Bissell, 1968, 158–59 n. 50). Bissell (who noted the painting's compositional relation to Orazio's *Annunciation*) reasonably connects the Capodimonte *Annunciation* with a painting of unspecified subject by Artemisia that was removed in 1811 from S. Giorgio de' Genovese in Naples. (The *Annunciation* entered the Capodimonte Museum in 1815, the same year that many pictures removed from churches during the French occupation were reassembled in the royal gallery.) Bissell offered the welcome suggestion that the cherub heads are probably later additions to the painting.

157. O.c., 127 x 97.4 cm; New York, private collection. Originally painted on canvas, the picture was transferred to panel while in an English collection, and has recently been restored to its canvas support. Trimming is indicated on the left and top (Harris and Nochlin, 1976, 122). Collections: Oswald T. Falk, Oxford; C. R. Churchill, Colemore, Alton, Hampshire; London and New York art markets from 1943; Arcade Gallery, London (1955); Sotheby; Wil-

denstein (1958). Despite its English provenance, Artemisia's painting of Clio cannot be identified with the *Poesia with Trumpet* that belonged to Charles I (see note 191 below), since as L. Fröhlich-Bume observed in "A Rediscovered Picture by Artemisia Gentileschi," *Burlington Magazine* 77 (1940): 169, it differs in size and appearance from the *Poesia*, which is described in Van der Doort's inventory as "Done by Artemesio Gentellesco *baht bij juw* M. Item a woemans picture *pijntit opan de lijeht* in some bluish draperie = with a trumpett in her hand Signifying ffame with her other hand having a penn to write being upon a Straining frame painted upon Cloath. Hight 3f3—Breadth 2f5" (Oliver Millar, ed., "Abraham van der Doort's Catalogue of the Collections of Charles I," *The Walpole Society* 37 [1960]: 46). See also Harris and Nochlin, 1976, 122.

The text of inscription has been read variously as follows: Fröhlich-Bume: 1632 Artemisia faciebat a Illstrmo Signre. T Rosiers (TR in monogram). Undecipherable description on right. Bissell: (I)632 / (A)RTEMISIA / (F)ACIEBAT / ALL(?) ILLSTR^{mo} SIG(NRE?) TR (in monogram) OSSIER(S?). (Right page illegible preceding restoration, except for letters "TIGA"[?].) Harris and Nochlin: (I)632 / (A)RTEMISIA / (fa)CIEBAT ALL IIIS.^{te} M. / SENE. (?) TROSIERS (TR in monogram) / SELM . . . DEL / TIQ (?)

158. Bissell, 1968, 159; Harris and Nochlin, 1976, 122.

159. La Chesnaye-Desbois, 1863–77, 18:702 ff.

160. For instance, see Mary D. Garrard, "The Liberal Arts and Michelangelo's First Project for the Tomb of Julius II (With a Coda on Raphael's 'School of Athens')," *Viator* 15 (1984): esp. 361, for this iconography in Michelangelo's first project for the tomb of Julius II; and David Rosand, in D. Rosand and Robert W. Hanning, eds., *Castiglione: The Ideal and the Real in Renaissance Culture* (New Haven: Yale University Press, 1983), 91–129, who discusses related concepts in Renaissance portraiture.

161. Cesare Ripa's influential handbook of allegorical iconography, published in Italy in the late sixteenth century, was first published in Dutch translation in 1644; see Leonard J. Slatkes, *Vermeer and His Contemporaries* (New York: Abbeville Press, 1981), 78. Pigler (1954) gives no independent examples of the muse

Clio, whereas about twenty seventeenth-century Italian Allegories of Fame are listed. The Decimal Index to the Art of the Low Countries (D.I.A.L.) includes only one image of Clio (by Goltzius), and not a single seventeenth-century example. To my knowledge, no study of Vermeer's painting has looked to influences beyond Ripa.

162. Prado, no. 149; o.c., 184 x 258 cm (dimensions almost identical to two of Stanzione's canvases for the Buen Retiro). Signed: "ARTEMITIA GINTILESCHI." The picture was described in the Buen Retiro Palace in 1656 (by Lázaro Díaz del Valle), as Artemisia's contribution to Stanzione's Baptist series (Bissell, 1968, 161). See Roberto Longhi, *Scritti giovanili: 1912–1922* (Florence: Sansoni, 1961), vol. 1, tomo 1:281; F. J. Sánchez Cantón, *Fuentes literarias para la historia del arte español*, 5 vols. (Madrid: Imprenta clásica española, 1923–41) 2:361; A. Pérez Sánchez, *Pintura italiana del siglo XVII en España* (Madrid: Universidad de Madrid, Fundación Valdecilla, 1965), 452–53; 499; Moir, 1967, 167; and Bissell, 1968, 161. Besides Artemisia's painting and his own *Decollation*, Stanzione's cycle also included *The Annunciation to Zacharias*, *The Baptist Taking Leave of His Parents*, and *The Baptist Preaching in the Wilderness*.

163. The St. John the Baptist cycle was commissioned by the Count of Monterrey, who gathered a number of paintings in Naples for his own collection and for the Retiro while he was viceroy in Naples from 1631–37. Monterrey's Neapolitan pictures came to Spain in two shipments, in 1633 and 1638, and as the Stanzione had been copied by 1637, the Baptist cycle must have come on the first shipment. See Jonathan Brown and J. H. Elliott, *A Palace for a King: The Buen Retiro and the Court of Philip IV* (New Haven and London: Yale University Press, 1980), esp. 68–72, 116–25; and Whitfield and Martineau, 1982, 258. Pérez Sánchez (1965, 452–53 and 499) called attention to Francesco Guarino's copy of Stanzione's *Annunciation of the Birth of St. John* in S. Michele at Solofra, dated 1637. Artemisia's mention in a letter of 1635 (Appendix A, no. 9) that she had done work for the King of Spain provides further indication that the Buen Retiro picture had been painted by that date.

164. Other works by Artemisia were sent to Madrid. Pérez Sánchez (1965, 501) names as lost or unidentified two pictures described in early inventories: a *Hercules and Omphale* (of the same size as a Rubens now in the Prado, *Achilles Discovered among the Daughters of Lycomedes*, 266 x 267 cm), cited in a 1636 inventory of the Alcázar Real, depicting "the story of Hercules spinning among some women, with a cupid who points out what he is doing. By the hand of the Roman painter Gentilezca." (On Rubens's *Achilles* modello for a tapestry series of c. 1630–35, see Egbert Haverkamp-Begemann, *The Achilles Series*, Corpus Rubenianum Ludwig Burchard 10 [Brussels: Arcade Press; London: Phaidon, 1975].) Lurie (in Lurie and Percy, 1984, cat. 68, n. 5) has suggested that Artemisia's lost *Hercules* may be reflected in Cavallino's *Hercules and Omphale* (ibid., cat. 22), which seems likely given its similarity to this description and Cavallino's other dependences on Gentileschi (see below, pp. 122 ff.). The second painting, by "Artemisa," depicted a *St. Catalina* with an angel with a black standard who held a sword of fire (Monterrey Collection, 1653; perhaps the same as a work in the Alba Collection). The descriptions suggest that Artemisia carried on her unconventional iconography. A fiery-sword-bearing angel does not conform to any known St. Catherine attributes (and there is no St. Catalina). The theme of Hercules Spinning, though not uncommon in the seventeenth century, might well have appealed to her. A *Madonna and Child* preserved in a remote location in the Escorial is said by Pérez Sánchez to be signed by Artemisia, but it remains to be studied. None of the pictures ascribed to her in eighteenth-century inventories are likely attributions: two pendant portraits, a *Young Woman with a Dove* and a *Man with a Rabbit*, and a *St. Martha (or Margaret) with the Dragon* (Pérez Sánchez, 1965, 499–500) have been reattributed to Cecco da Caravaggio (Moir, 1967, 1:100 n. 104; Bissell, 1968, 166–67). A copy of Artemisia's Pitti *Judith* was in Málaga (Pérez Sánchez, 1965, 500); another (or same?) is in the Quirós Collection, Madrid (Frick Art Reference Library, no. 54780).

Despite these notices, Artemisia's identity in Spain was none too secure. Palomino at one point called her "Sofonisba Gentilesca" (as Pérez Sánchez said, a "*fantamagórica personalidad*"); and in a Buen Retiro inventory of

1701, she is described as Stanzione's daughter (Pérez Sánchez, 1965, 498–99).

165. De Dominici, [1742] 1971, 3:45–46. For writers who follow De Dominici in this assessment see Whitfield and Martineau, 1982, 258–59. An exception is De Rinaldis ([1929] 1976, 22–23), who notes Stanzione's maturity and seniority. De Rinaldis, however, exceeds De Dominici in considering Gentileschi *hors de combat*; though he mentions Artemisia frequently in his text, he excludes her entirely from his eighty illustrations of "Neapolitan painting."

166. The documents published by Angelo D'Ambrosio (*Il Duomo di Pozzuoli, storia e documenti inediti* [Pozzuoli, 1973], 29–30) have clarified the dating of the church's decoration. All eleven paintings produced for the choir, by "Lanfranco and other famous and expert painters," were carried out before 1640. After 1640, some changes were made in the arrangement of the paintings, with two paintings by Lanfranco and his workshop, later in date than the rest, placed in the choir. Lanfranco also contributed the frescoes in the choir vault (before 1640) and the dome of the sacrament chapel (1640–46). See also Whitfield and Martineau, 1982, 188.

167. Lucy Menzies, *The Saints in Italy: A Book of Reference to the Saints in Italian Art* (London: The Medici Society Ltd., 1924), 231–32. Bissell (1968, 160 n. 56) had conjectured that the renovation and decoration of the Pozzuoli Duomo was prompted by the salvation of Naples from the eruption of Vesuvius in 1631; recently published documents neither confirm nor disprove this suggestion (D'Ambrosio, 1973, esp. 27 ff.) The cult of St. Januarius (S. Gennaro), martyred c. 305, is centered in Naples, where he is buried in the cathedral of S. Gennaro. The Cappella del Tesoro di S. Gennaro, which houses two old crystal goblets in which the saint's blood is said to liquify on feast days, was the focus of extensive pictorial decorations in the 1630s by Domenichino, Lanfranco, and others. See Spear, 1982, 1:286 ff.

168. O.c., 300 x 200 cm. Signed, lower right: "Artemi . . . Gentilesc . . F" The *SS. Proculus and Nicea* (300 x 180 cm) is signed, lower right: "AG F," and bears the inscription "S. PROCVLVS LEVITA ET NICEA EIVS MATER MARTIRES ET CIVES PV . . ." The *Adoration of the Magi* (308 x 205 cm) bore a signature "AR-

TIMITIA G<sup>sca</sup> F.," which was removed as a later addition (Bissell, 1968, 160). Following a fire in the Duomo at Pozzuoli in 1964, the paintings were taken to the Laboratorio di Conservazione di Capodimonte. See also *La mostra della pittura napoletana dei secoli XVII, XVIII e XIX*, exh. cat., ed. Sergio Ortolani (Naples: Castel Nuovo, 1938), 317; and, with further bibliography, *La Madonna nella pittura del '600 a Napoli*, exh. cat., Castel Nuovo, Naples, May 15–September 15, 1954, ed. Raffaello Causa (Naples, 1954), 20.

169. Stefano Bottari (*Storia dell'arte italiana*, 2 vols. [Milan-Messina: G. Principato, 1943], 2:347) and Ferdinando Bologna (*Francesco Solimena* [Naples: L'Arte tipografica, 1958], 127 n. 19) connect the architectural background in the *St. Januarius* with Codazzi. Bernardo De Dominici (*Vite dei pittori, scultori ed architetti napoletani*, reprint, vol. 3 [Naples: Tipografia Trani, 1844], 414) reports that Codazzi painted the architectural background of Artemisia's *Bathsheba* now in Columbus. On the collaboration of Codazzi and Spadaro, see *In the Light of Caravaggio*, exh. cat. (London: Trafalgar Galleries, 1976), 35; and on Codazzi, see Whitfield and Martineau, 1982, 148. Estella Brunetti ("Situazione di Viviano Codazzi," *Paragone* 7, no. 79 [July 1956]: 65) saw the hand of Domenico Gargiulo (Spadaro) in the *St. Januarius*. Longhi (1961, vol. 1, tomo 1, 265) and Moir (1967, 1:100 n. 105) also saw workshop involvement in the *Adoration*.

170. I am grateful to Dottoressa Maria Nappi of the Capodimonte Museum for a very helpful discussion in front of the painting, and for her clarifying thoughts about Codazzi's participation.

171. Richard Spear (1971b, 38 ff.) pointed out the relation of mood between the Velázquez *Adoration* and Venetian paintings by the Bassani.

172. Longhi (1961, vol. 1, tomo 1, 265) even attributed the Virgin's head in the Pozzuoli *Adoration* to Stanzione. On the other hand, it was surely Artemisia's female characters who inspired the central figure (though not the expression) of Stanzione's *Lot and His Daughters* in the Palazzo Reale (De Rinaldis, [1929], 1976, fig. 13).

173. O.c., 108 x 94 cm. The painting, previously unattributed, was restored in c. 1952 and included in an exhibition of 1952–53 as by an "unknown Neapolitan in the circle of Stan-

zione" (*III Mostra di restauri*, exh. cat., ed. Raffaello Causa [Naples: Museo di San Martino, 1953] 11,11). It hangs today in the Palazzo Reale under the name of Stanzione. Longhi (1916, 299–300) recognized Artemisia in the *Lucretia* in the handling of fabrics and in the perspective pavement, and ascribed to her as well a *Susanna* in the Capodimonte, then attributed to Guarino. This *Susanna*, now given to Vaccaro, is in any case not by Artemisia.

174. On Van Dyck's English followers, see C. Brown, 1982, ch. 5.

175. O.c., 117 x 175.5 cm. Mina Gregori, who wrote the entry on the painting in *Civiltà del Seicento a Napoli* (exh. cat., Museo di Capodimonte, October 24, 1984–April 14, 1985; Museo Pignatelli, December 6, 1984–April 14, 1985, 2 vols. [Naples: Electa Napoli, 1984]), 1:306), reports that the painting, previously ascribed to Stanzione, was recognized as an Artemisia by Patrick Matthiesen, Erich Schleier, Ferdinando Bologna, and Nicola Spinosa. The picture was previously unpublished. See also *Baroque III, 1620–1700*, exh. cat. (London: Matthiesen Fine Art Ltd., 1986), 48–52.

176. Gregori, in *Civiltà*, 1984, 1:306. Bissell (1981, 173–74, 181–82) discusses the Sauli *Magdalen* (now in the Grange collection, New York) in relation to Mellan's engraving, and catalogues Orazio's variants of this image (Lucca, c. 1619; New York, Feigen, c. 1625; Vienna, c. 1625–28).

177. Gregori, in *Civiltà*, 1984, 1:306. The relationship between Mellan's print and Orazio's *Magdalen* paintings was pointed out by Barbara Brejon de Lavergnée, who dated the print c. 1629–30 (its inscription places it in Mellan's Roman period, 1624–36). Barbara Brejon de Lavergnée, "[Abbeville. Musée Boucher-de-Perthes.] *La Sainte Madeleine pénitente* de Claude Mellan," *La Revue du Louvre et des Musées de France* 29, nos. 5–6 (1979): 407–410.

178. Józef Grabski, "On Seicento Painting in Naples: Some Observations on Bernardo Cavallino, Artemisia Gentileschi and Others," *Artibus et historiae* 6, no. 11 (1985): 56–63.

179. Friedländer (1955, 212) noted that Caravaggio's *Cupid* must have come early to Florence, since it was used as a compositional model in a now-destroyed fresco of 1620 by Giovanni da San Giovanni.

180. See above, pp. 83 ff., and Appendix A, no. 5.

Other paintings destined for the Barberini in this period are described by name (*The Samaritan Woman* and *St. John Baptist in the Desert*; nos. 13 and 14).

181. Sandrart, [1675] 1971, 31 and 290. Sandrart, who had come to Italy with his teacher Honthorst in 1628, eventually settled in Rome, where he remained untl 1635. He took a trip to Naples in 1631, the probable date of his visit to Artemisia Gentileschi. See Jane Costello, "The Twelve Pictures 'Ordered by Velasquez' and the Trial of Valguarnera," *Journal of the Warburg and Courtauld Institutes* 13 (1950): 237–84; and Christian Klemm, "Sandrart a Rome," *Gazette des Beaux-Arts* 93 (April 1979): 153–66. Sandrart had no doubt heard of Artemisia from Orazio, whom he met in England in 1628 and described as his good friend. Although the portrait engraving of Orazio in Sandrart's *Teutsche Academie* ([1675] 1971, plate opposite p. 298) is based upon Van Dyck's drawing, the portrait of Artemisia does not resemble other portraits of her, and may be a conventional image.

182. See F.W.H. Hollstein, *Dutch and Flemish Etchings, Engravings and Woodcuts ca. 1450–1700* (Amsterdam: M. Hertzberger, 1949–[c. 1978]), 9: 210, 212. The *Child Sleeping* was labeled by the engraver "GENTILESCA (ARTEMISIA GENTILESCHI) *pinxit Napoli*." I have not found extant impressions of these prints.

183. Ascanio Filomarino, who befriended Reni, Poussin, and Pietro da Cortona, brought with him to Naples a large collection of paintings by Roman artists, and he set the stamp of his classicizing tastes on Naples as early as the late 1630s, when he built the Chapel of the SS. Annunziata in SS. Apostoli, with an altar by Borromini. On being named Archbishop, Filomarino commissioned Lanfranco to decorate the Archbishop's Palace. (See Whitfield and Martineau, 1982, 23, 33, 62–63; and Carlo de Lellis, *Famiglie nobili del Regno di Napoli* [1654–71], 3 vols. [Bologna: Forni, 1968], 3:188.)

184. Bissell suggested (1968, 166) that the *St. John* might be identified with a *St. John the Baptist Sleeping* in the Galleria Filomarino de' Duchi della Torre, Naples, a work that da Morrona (1812, 485) had attributed to Artemisia.

185. Artemisia arrived in London sometime after November 24, 1637, and she was still in England on December 16, 1639 (Appendix A, nos.

14, 15). No documents survive to establish her subsequent whereabouts until her first letter to Ruffo (January 30, 1649), but she is likely to have returned to Naples soon after her father's death in 1639, probably in the early 1640s.

186. Orazio Gentileschi's death date, long a matter of debate, was established by Anna Maria Crinò, "Rintracciata la data di morte di Orazio Gentileschi," *Mitteilungen des kunsthistorischen Instituts in Florenz* 9 (1960): 258; see also Moir, 1967, 1:100; and Bissell, 1981, x.

187. This *Tarquin and Lucretia* was cited in the royal collection in 1633 or 1634 among works by Orazio; Bissell plausibly identifies it, however, with the *Tarquin and Lucretia* by Artemisia that was at Greenwich by 1639 (Bissell, 1968, 161 n. 65).

188. Artemisia's brother, in England with Orazio, had made a buying trip in Italy for Charles I in 1627–28. In 1633, Francesco was sent to the court of Philip IV to deliver Orazio's *Finding of Moses*. (On Francesco's activities, see Bissell, 1981, Appendix IV.) By January 1635, he was in Naples, working as Artemisia's business manager and, by her account, was at that time sent to Rome to deliver a painting to Antonio Barberini (Appendix A, no. 5), and then to Modena (no. 6a) with paintings for the Duke.

189. The best account remains that of Francis Haskell (1963, 177 ff.).

190. Hugh R. Trevor-Roper, *The Plunder of the Arts in the Seventeenth Century* (London: Thames and Hudson, 1970, 27–36. For the Gonzaga holdings, see Luzio, 1974; and Pamela Askew, "Ferdinando Gonzaga's Patronage of the Pictorial Arts: The Villa Favorita," *Art Bulletin* 60 (June 1978): 274–96.

Anglo-Italian relations were especially friendly during Charles's reign, thanks to strong diplomatic ties between the Stuarts and the Barberini papacy and to the popularity of Catholicism at the English court (Henrietta Maria, Charles's queen, was herself a French Catholic, the sister of King Louis XIII).

191. Van der Doort inventory, in Millar, 1960, 177, 194, 203. This *Fame*, a woman holding a trumpet in her left hand and a pen in her right, is a different work from the Wildenstein *Clio*, though it could also have represented Clio. The *Poesia with Trumpet* of the 1649 inventory (note 157) is presumably the same work as the

*Fame* cited by Van der Doort. As a picture acquired by Charles in the 1630s, this could have been a variant of the Rosières painting of 1632 (which also wound up in England), perhaps acquired or commissioned through Charles's French connections.

192. Millar, 1970–72, 65, 186, 191, 312, 315, 316. (The *Tarquin and Lucretia* was at Greenwich.) The "*Pintura,*" or *Allegory of Painting*, is clearly a different picture from the *Self-Portrait*, listed separately and with a different valuation in the same inventory. A "naked womans picture" (p. 266), to which "Gentileschi" was added in copies, may have been by Artemisia and not Orazio, as could another *Susanna and the Elders*, this one from Whitehall (p. 306), identified simply as by "gentilesco," although that usually meant Orazio. The Whitehall *Susanna* cannot be the same as the Burghley House *Susanna* discussed in Chapter 3 if, as the Burghley house curator attested (Bissell, 1968, 167), the latter was purchased in Florence in the eighteenth century. "A woman's head: by gentilesco" at Hampton Court (p. 191, no. 95) was identified by Levey as Orazio's *Sibyl* and by Bissell as the Benn Collection portrait (Bissell, 1981, 194); conceivably, however, this was one of Artemisia's royal portraits. "A Peece of Joseph" at Greenwich (p. 137, no. 9) by "Gentilesco" could be the second of Orazio's versions of *Joseph and Potiphar's Wife* (now Paul Drey Gallery, New York); alternatively, it might have been Artemisia's picture now in the Fogg Museum. The two *Susannas*, the *Pittura*, the *Tarquin and Lucretia*, and the *Saint* cannot be connected with existing pictures. The *Bathsheba* does not correspond to known versions.

193. "Note Books of George Vertue," 1935–36, 90. Horace Walpole (*Anecdotes of Painting in England* . . . , additions by Rev. James Dallaway, 5 vols. [London: J Major, 1826–28], 2:269) claimed that Artemisia had painted a *David and Goliath* for Charles I.

194. Judson, 1959, 110 ff. See also Oliver Millar, "Charles I, Honthorst, and Van Dyck," *Burlington Magazine* 96 (February 1954): 36–42.

195. See D. J. Gordon, "Rubens and the Whitehall Ceiling," in *The Renaissance Imagination: Essays and Lectures*, collected and ed. by Stephen Orgel (Berkeley and Los Angeles: University of California Press, 1975), 24–50.

196. Orazio expressed his desire to return to Italy

in a letter of 1633 to the Grand Duke of Tuscany. For this, and on the verbal and physical abuse of Orazio and his sons by Balthasar Gerbier, former Keeper of York House, see Bissell, 1981, 58–59.

197. The commission was given exclusively to Orazio; no records of payment to Artemisia are included in the documents concerning the ceiling project published by George H. Chettle (*The Queen's House, Greenwich* [Greenwich: Trustees of the National Maritime Museum, 1937]) and Jacob Hess ("Die Gemälde des Orazio Gentileschi für das 'Haus der Königen' in Greenwich," *English Miscellany* 3 [1952]:159–87). In eighteenth-century descriptions of the project, her name is not mentioned.

198. Bissell, 1981, 61 and fig. 229, following Hess.

199. Bissell, 1981, 195–98; and John Charlton, *The Queen's House, Greenwich* (London: H. M. Stationery Office, 1976).

200. The transfer was accompanied by careless repainting, damage, and alteration of format. In the perfectly square ceiling (12.2 m) at Greenwich, the framed canvases included a square in the center (approximately 6 m), four squares at the corners (2 m), and four rectangles of 6 x 2 m. At Marlborough House, whose available space was a smaller oblong, the rectangles were randomly shortened on their long or short sides, or in the middle (Chettle, 1937, 89–91). Four of the canvases have been changed in orientation since Chettle published his study in 1937; for a detailed discussion of the alterations, see Bissell, 1981, 195–98.

201. This interpretation of the program of the ceiling is Bissell's, which takes Hess and Chettle into account.

202. Judson, 1956, 110 ff.; Millar, 1954, 36–42.

203. Bissell, 1981, 56. Rubens's *Apotheosis of James I*, installed on the Banqueting House ceiling in 1635, was an allegory of wise and peaceful kingship that celebrated Charles's reign, in imagery derived from the rule of James I, the self-styled King of Peace. For this and other paintings by Rubens in England devoted to this theme, see Gordon, 1975, 24–50.

204. See John Harris, Stephen Orgel, and Roy Strong, *The King's Arcadia: Inigo Jones and the Stuart Court*, exh. cat., Banqueting House, Whitehall, July 12–September 2, 1973 (London: Arts Council of Great Britain, 1973).

205. The compositional structure of the Greenwich ceiling also closely resembles French types that Orazio would have seen during his tenure at the court of Marie de' Medici. See especially the ceiling designed for the Cabinet Doré in the Luxembourg Palace during the 1620s; Anthony Blunt, "A Series of Paintings Illustrating the History of the Medici Family Executed for Marie de Médicis—II," *Burlington Magazine* 109 [October 1967]: 566, fig. 24.

206. The Italian situation is reviewed in Garrard, 1980; and Garrard, 1984b, 335–76. On Spain, see George Kubler, "Vicente Carducho's Allegories of Painting," *Art Bulletin* 47 (December 1965): 439–45; and Mary Crawford Volk, "On Velázquez and the Liberal Arts," *Art Bulletin* 60 (March 1978): 69–86. In England, the Painter-Stainer's Company had difficulty getting artists to comply with their requirements, and among those the guild wanted to prosecute was Orazio Gentileschi (Bissell, 1981, 59, who also notes Orazio's social sensitivity and his probable jealousy of Van Dyck's knighthood).

207. Hess had stressed the scientific and intellectual theme of the ceiling, while Bissell focuses exclusively upon the peace theme, but neither considers the implication of including allegories of the arts in the scheme. On Charles I's political, peace-oriented ideals, see also Graham Parry, *The Golden Age Restor'd: Culture of the Stuart Court, 1603–42* (New York: St. Martin's Press, 1981), especially ch. 9.

One exception was an Inigo Jones masque of 1631, *Chloridia*, in which—responding to an ongoing debate with Ben Jonson—Jones makes Architecture a Liberal Art (see Harris, Orgel, and Strong, 1973, 171.)

208. Hess, 1952, 159–87; Bissell, 1968, 161.

209. Restoration has obscured the original character of some of the figures and most of the draperies, however. No repainting is documented other than the restoration of the early 1960s, but Bissell agrees with Hess that overpaintings occurred, perhaps beginning in the early eighteenth century with Louis Laguerre, who then worked at Marlborough House. See Bissell, 1968, 161.

210. The daughter who married a knight of St. James in 1649 may have come with her mother to England (see above, p. 63). Francesco was in London at the time the Greenwich panels were painted, as is attested in Artemisia's letter of December 16, 1639, to Fran-

cesco d'Este (Appendix A, no. 15a), in which she speaks of her brother "who is going to Italy."

211. As Bissell pointed out (1968, 163), Baldinucci's statement that she was in Naples in 1642 probably followed Baglione, who said in his *Vite* that she was "now" working in Naples. Giovanni Baglione, *Le vite de' pittori, scultori ed architetti. Dal pontificato di Gregorio XIII del 1572 in fino a' tempi di papa Urbano Ottauo nel 1642* [1642] (Rome: E. Calzoni, 1935).

212. De Dominici, 1844, 3:414. The *Bathsheba* (265.4 x 209.5 cm) was purchased by Carlo Sestieri, Rome (c. 1960), by Colnaghi (1962), and by the Columbus Gallery in 1967. The pendant *Susanna* has not been traced.

213. The collaboration between Codazzi and Gargiuolo reportedly began around 1638, not an impossible date for the *Bathsheba*, especially if, as is probable, Artemisia's share of the painting came first. On Codazzi, who did such architectural backgrounds for many artists, including Lanfranco and Cesari d'Arpino, see Whitfield and Martineau, 1982, 148–49. Domenico Gargiuolo, a latter-day follower of the sixteenth-century Roman and Flemish landscape traditions, decorated the Coro dei Conversi in S. Martino, Naples, with extensive landscape frescoes (see De Rinaldis, [1929] 1976, 37 and pls. 66, 67).

214. Lurie and Percy, 1984, cat. 29, pp. 107–109. The entry, by Nicola Spinosa, supports the attribution of the *Lot* to Cavallino, while acknowledging the doubts of Causa (who suggested Guarino) and Prohaska, and the rejection of the attribution of the *Lot* to Cavallino by Lurie and Percy. Spinosa reports the anonymous suggestion that "the painting may be a work from Artemisia Gentileschi's second Neapolitan period."

215. De Dominici, 1844, 3:414–15. De Dominici does not date Romeo's Gentileschi pictures (despite reports in the literature to the contrary).

Józef Grabski (1985, 23–40) has recently rejected the ascription of this work to Artemisia in favor of a tentative attribution to Agostino Bettiano, for reasons that remain unclear, since he emphasizes its Artemisian qualities.

216. The technical note following the *Lot* entry in the Cavallino catalogue indicates that the picture's technique, with varying densities of pigment ranging from very solid to delicate and thin layers, is characteristic of Cavallino. One can only observe that this technique is found in Gentileschi as well—for example, the Columbus *Bathsheba*.

217. The version here reproduced, from a private Swiss collection, is pendant to a *Noah*, and has been dated c. 1650 by Lurie (Lurie and Percy, 1984, cat. 74). See also the Louvre version (Lurie and Percy, 1984, cat. 38), which is somewhat more restrained, yet also differs in expression from the Toledo *Lot*. Orazio Gentileschi's several versions of this theme offer a precedent for dignified, non-seductive daughters, though Artemisia's composition is her own invention.

218. De Dominici, 1844, 3:178, 414. Longhi (1916, 302; 308–10) was the first modern scholar to point out the importance of Artemisia for Cavallino; Raffaello Causa, in *La Pittura del Seicento a Napoli dal naturalismo ad barocca*, vol. 5, pt. 2 of *Storia di Napoli* (Naples: Società Editrice Storia di Napoli, 1972), 941–44, emphasized her influence among several others; see also Lurie and Percy, 1984, esp. 5–6; and cat. 55, 66. Artemisia's influence has been discovered almost everywhere, much mentioned and seldom defined, especially in relation to Stanzione and Cavallino (but also Lanfranco; see Schleier in Whitfield and Martineau, 1982, 46–47), just as earlier she was similarly linked with Vouet, and before that with several Florentine artists. With the exception of Cavallino, these assertions tend to oversimplify the nature of exchange between artist contemporaries. Cf. Elizabeth Cropper's review of the *Painting in Naples* exhibition (Cropper, "Naples at the Royal Academy," *Burlington Magazine* 125 [February 1983]: 104–106), which offers an appropriately skeptical view of influence-mongering art history.

219. Nicola Spinosa, in Whitfield and Martineau, 1982, 144–45; see also the review of the Naples exhibition by Carl Goldstein ("Painting in Seventeenth-Century Naples," *Art Journal* 43, no. 3 [Fall, 1983]: 270). It was Lurie (Lurie and Percy, 1984, cat. 68) who pointed out that Cavallino's painting represents Galatea and not Amphitrite, whose Triumph should be attended by her husband, Neptune, as in Poussin's version in Philadelphia. The *Triumph of Galatea*, recently in the hands of Richard L.

Feigen & Co., is now in a private collection in New York.

220. Ruffo's Galatea was described in the 1703 inventory of his collection (V. Ruffo, 1916, p. 315, no. 80) as a "Galatea seated on a shell [*grancio*] pulled by two dolphins and accompanied by five tritons," measuring 8 x 10 *palmi* (212 x 264 cm; see Appendix A, no. 16 ff.). Lurie, in Lurie and Percy, 1984, cat. 68, suggests that Gentileschi may have been directly inspired by Raphael's *Galatea* in the Farnesina, Rome. Although it is surprising to find Artemisia drawing upon Raphael when he had not figured in her art earlier, it is noteworthy that she lived quite near the Farnesina, on Via S. Spirito, in 1611–12. The image of a female figure riding a zoologically exotic float might well have originated long before in Artemisia's Florentine experience, when she could have seen such marvels as Cantagallina's "Argonautica," with its giant lobster float (designed for the wedding festivities of Cosimo I and Maria Maddalena of 1608; see Blumenthal, 1980, esp. 73 ff.).

221. Grabski, 1985, 41–55. The ex-Feigen *Galatea* measures 145 x 203 cm, compared with the *Galatea*'s 212 x 264 cm. Grabski reports that the painting is folded around the stretcher on all sides, a trace of the frequent practice in the seventeenth and eighteenth centuries of fitting existing pictures to a smaller format. Artemisia's *Galatea* was damaged at sea while in transit to Ruffo (see Appendix A, no. 17), a fact that could have led to its eventual reduction.

222. Grabski, 1985, offers an expanded pictorial context for Artemisia's *Galatea*, including Vasari's *Marine Venus* in the Palazzo Vecchio, Florence, Annibale Carracci's *Galatea* in the Palazzo Farnese, Rome, and analogous subjects by Fetti, Poussin, and others.

223. De Dominici, 1844, 3:162. This description of Cavallino's impecunious condition has been confirmed by the recently discovered archival evidence that in 1646 Cavallino closed a small bank account of three *ducati* and three *tari* in the Banco Sacro dei Poveri, Naples (Grabski, 1985, 45).

224. Grabski (1985, 59) pointed out the similarities among these tassels.

225. Conservators at the Cleveland Museum, according to Ann T. Lurie, have said that the oil paint bleeds out at the edges of the canvas, indicating that it has not been cut down. Grabski, on the other hand (1985, 49), claims that the painting was folded around the edges of the stretcher. At present, I have not been given permission to examine the picture outside its frame independently.

226. The principal sources for Ruffo's collections are Vincenzo Ruffo, 1916 ("Galleria Ruffo nel secolo XVII in Messina"), 21–64, 95–128, 165–192, 369–388; and idem, "La Galleria Ruffo (Appendice)," *Bollettino d'Arte* 13, nos. 1–4 (1919): 43–56, which include records of payment and artists' letters published by a descendant of the Sicilian prince. The second article corrects certain errors in the first.

227. Jakob Rosenberg, *Rembrandt, Life and Work* [1948] (London and New York: Phaidon, 1968), 277 ff.; and Julius S. Held, *Rembrandt's "Aristotle" and Other Rembrandt Studies* (Princeton: Princeton University Press, 1969), esp. 5–14.

228. Ruffo, 1916, 315, no. 81 (directly following the *Galatea*, no. 80, in the inventory). Both measured 8 x 10 *palmi*. However, Grabski (1985, 41) errs in stating that they are here described as pendants. In c. 1618, Artemisia painted another *Bath of Diana* for her Medici patrons (see above, Chapter 1, p. 51).

229. The Ruffo collection remained essentially intact until 1689, though parts of the collection began to be dispersed among numerous heirs in the early eighteenth century. As late as 1750, one hundred of the pictures remained in the Ruffo palace at Regio Campo; however, many were sold in the early nineteenth century, while others were destroyed by fire in 1848. None of Artemisia's paintings has been traced. See Ruffo, 1916, 369–88; and Olga Moschella, *Il Collezionismo a Messina nel Secolo XVII* (Messina: EDAS, 1977), 71 ff.

230. O.c., size unknown, in a private collection, Leipzig, on loan to the Museum der bildenden Künste, Leipzig, in 1968, according to Ann Sutherland Harris, who first published the work as by Artemisia (Harris and Nochlin, 1976, 123).

231. The ex-Bari *Bathsheba* (280 x 220 cm) was published by Federico Hermanin as in the Ramunni Collection in Castello di Conversano, Bari ("Gli ultimi avanzi d'un'antica galleria romana," *Roma* 22 [1944]: 46–47 and pl. VII).

518 NOTES TO PP. 130–36

Ward Bissell has informed me that the painting is now in a private collection in Rome. Related to the ex-Bari version is a painting in a private collection, Vienna; see Harris and Nochlin, 1976, 123 n. 28.

232. This figure is seen in Orazio's Hampton Court *Joseph and Potiphar's Wife* (c. 1632), in the *Diana the Huntress* of the mid-1630s, and in the lost *Apollo and Nine Muses* (see Bissell, 1981, figs. 132, 134, 129).

233. The tapestry (358 x 233 cm), now in the Uffizi, was woven by a Flemish artist, P. Fevere, who was head of the Medici tapestry works. On all these works, see Bissell, 1968, 163–64; and Borea, 1970, 78–79.

234. The Brünn *Susanna* (168 x 205 cm) is signed "ARTEMISIA / GENTILESCHI / MDC . . ." (final cipher not legible). This could be the same picture as that described by da Morrona (1812, 2:487–88), who reports it as signed with an inscription on the basement, "ARTEMISIA GENTILESCHI F. 1652" (like the first *Susanna*). The Brünn painting, "severely damaged and overpainted" (Bissell, 1968, 164), was published by H. Böhomová-Hájková ("Die Restaurierung des Bildes 'Susanna und die beiden Alten,'" *Casopis Moravského Musea* 41 [1956]: 309–310, pls. 1–3). I have been unable to obtain a reproduction of the Brünn *Susanna*.

Apart from the works named in the Ruffo correspondence, Artemisia's *oeuvre* of the 1640s included an *Archangel Michael Expelling Lucifer from Paradise* and a *Lot and His Daughters* (here identified with the Toledo painting). Both are mentioned by De Dominici, who describes them as having life-size figures (1844, 3:414–15). As noted by Bissell (1968, 165), another later source ("Notizie ed Osservazioni" [unsigned], *Napoli nobilissima, rivista di topografia e d'arte napoletana* 6, fasc. 7 [July 1897]: 110) mentions a poem of 1694 by Giovanni Canale that addresses an *Apollo with the Lyre* by Artemisia, in the Girolamo Fontanella Collection, Naples. A *St. Sebastian* by Artemisia (4 x 3 *palmi*) was cited as in the Quadreria of the Prince of Scilla (Castello di Scilla, Ruffo di Calabria collection) ("La Quadreria del Principe di Scilla" [unsigned], *Napoli nobilissima, rivista di topografia e d'arte napoletana* 7, fasc. 5 [May 1898]: 73).

Perhaps also dating from the 1640s was a now-lost *Samson and Delilah* by Artemisia,

whose design is known from a copy in Naples (Capodimonte, Banco di Napoli Collection). Bissell (1981, 221) connects Artemisia's *Samson* with a lost Orazio painting of the same theme.

235. The *Judith* measures 272 x 221 cm; *Tarquin and Lucretia*, approximately the same; *Bathsheba*, 258 x 218 cm. The three *quadroni*, which hung together in the so-called Emperor's Chamber of the Palazzo del Giardino (or della Fontana), were described as by Artemisia by Giacomo Barri, *The Painter's Voyage of Italy*, trans. W. Lodge (London: T. Flesher, 1679), 130–31. The *Judith*, and perhaps the other two pictures, came to Naples from Parma in 1734 (Bissell, 1968, 163–64, who confirmed Voss's suggestion that the Potsdam paintings were the same as those described in Parma). Marchese Giuseppe Campori (*Raccolta di cataloghi ed inventarii inediti di quadre, statue, disegni . . . dal seccolo* [sic] *xv al secolo xix* [Modena: C. Vincenzi, 1870], 244–46) reported that the Farnese owned copies by Francesco Maria Retti of the *Lucretia* and the *Judith*.

236. Some comparative prices are given in the Ruffo correspondence. Ruffo paid Artemisia 230 *ducati* for the *Bath of Diana* and 160 *ducati* for the *Galatea*. Stanzione received 50 *ducati* for a *Lucretia*, 50 for a *Madonna and Child*, and 300 for a *Judgement of Paris*. Ribera was paid 270 *ducati* for a *Pietà* (Ruffo, 1919).

237. See David Summers, *Michelangelo and the Language of Art* (Princeton: Princeton University Press, 1981), 186 ff.; and Denis Mahon, *Studies in Seicento Art and Theory* [1947] (reprint, Westport, Conn.: Greenwood Press, 1971), pt. 2.

238. An apparently unusual arrangement, which may have been typically South Italian. Richard Spear has pointed out to me an analogy in Reni's and Domenichino's commissions for the Cappella del Tesoro, Naples, which provided for each artist a certain sum per life-size figure. Malvasia reported that Lanfranco and Ribera accused Domenichino of packing his pictures with figures to earn more money (Spear, 1982, 1:286–89).

239. For Sofonisba Anguissola, see above, pp. 57–58. Lavinia Fontana spent the last years of her productive, celebrated career in Rome, where she resided between 1603 and 1614. At least one major commission, for a large altarpiece in St. Peter's, came to Fontana in Rome (see

*Age of Caravaggio*, 1985, 19); and it was in Rome in 1611 that the portrait medal was struck in her honor (see Eleanor Tufts, *Our Hidden Heritage: Five Centuries of Women Artists* [New York, London, and Toronto: Paddington Press, 1974], 34, figs. 14a and 14b). Giovanna Garzoni's career must have intersected with that of Artemisia at several points. Born in the Marches in 1600, she was early patronized by the Medici in Florence, a city she at least visited. She was in Venice in 1625, probably in Rome in the late 1620s, and she moved to Naples in 1630, about the same time that Artemisia did. Like Artemisia, Garzoni was both a correspondent and protégée of Cassiano dal Pozzo, and was similarly patronized by the Barberini family and the Duke of Alcalà. (See Harris and Nochlin, 1976, 135; and especially, Spike, 1983, 65–70.) A number of women artists active in Naples in this period are mentioned by De Dominici, including Suor Luisa Capomazza and Anna di Rosa (Annella di Massimo) ([1742] 1971, 3:90 ff., 96 ff., 382, 576, 621, 622). Though active primarily in Milan, Fede Galizia (1578–1630) was in contact with Jesuit intellectuals, and may have spent some time in Rome; one major autograph picture, a *Judith* of 1601, is in the Borghese Gallery.

240. Epitaphs 39 and 40 in *Cimiterio, Epitafij Giocosi di Giovan Francesco Loredano e Pietro Michiele* (Venice, 1653) (published in Eugenio Battisti, "La Data di Morte di Artemisia Gentileschi," *Mitteilungen des Kunsthistorischen Institutes in Florenz* 10, no. 4 [February 1963]: 297). Since the date 1652 was inscribed on her last known painting, a *Susanna* (da Morrona, 1812, 2:488), Artemisia must have died in 1652 or 1653.

The translation given here (from *Artemisia, mot pour mot/word for word 2*; texts by Roland Barthes, Eva Menzio, and Lea Lublin [Paris: Yvon Lambert, 1979], 41) effectively conveys the intended puns on Artemisia's surname. Gentileschi means "of gentlefolk," *esca* means "bait" or "lure."

Co'l dipinger la faccia a questo, e a quello
Nel mondo m'acquistai merto infinito;
Ne l'intagliar le corna a mio marito
Lasciai il pennello, e presi lo scalpello.

Gentil'esca de cori a chi vedermi
Poteva sempre fui nel cieco Mondo;
Hor, che tra questi marmi mi nascondo,
Sono fatta Gentil'esca de vermi.

Misogynist satire as a genre is discussed by Felicity Nussbaum, *The Brink of All We Hate: English Satires on Women, 1660–1750* (Lexington, Ky.: University Press of Kentucky, 1984).

241. On Raphael's epitaph, which was composed by Pietro Bembo, see Oskar Fischel, *Raphael* (London: Spring Books, 1964), 296–97. This translation of Caravaggio's epitaph is given in Enggass and Brown, 1970, 86.

242. Da Morrona (1812, 2:93) reported the inscription, which was already lost by his day, from information given by Averardo de' Medici, who owned the *Susanna*. Artemisia was allegedly buried in S. Giovanni dei Fiorentini, Naples, a church that Bissell has identified with the church of S. Vincenzo (transferred to the Florentines in 1577), which was completely restored in the eighteenth century and destroyed by urban renewal after World War II (Bissell, 1968, 165).

The cause of Artemisia's relatively early death at fifty-nine or sixty is not known. In her last letter to Don Antonio Ruffo, dated January 1, 1651, she speaks of "many illnesses and troubles" during the preceding year (Appendix A, no. 28).

243. Battisti (1963) noted that the frequent reprintings of the verses contributed to the "erotic legend" of the artist. Artemisia's reputation as a sexual libertine flourished in the eighteenth century, when she was described by an English commentator as "famous all over Europe for her amours as for her painting" (from an anonymous note added to the English edition of Roger de Piles's *The Art of Painting*, 3rd ed. [London: T. Payne, 1754], 376). Artemisia's love life has continued to be emphasized in the twentieth century: e.g., the fictional romance about her, *Artemisia*, by Lucia Longhi Lopresti (pseud. Anna Banti) (Florence: G. Sansoni, 1947); and the comment of John Canaday (*The Lives of the Painters* [London: Thames & Hudson, 1969], 2:366) that "she demonstrated until her death . . . an enduring enthusiasm for the art of love that paralleled her very great talent as a painter."

CHAPTER 2

1. Joan Kelly, "Early Feminist Theory and the *Querelle des Femmes*, 1400–1789," *Signs* 8, no. 1 (Autumn 1982): 5.

2. Quoted by Bonnie G. Smith, "The Contribution of Women to Modern Historiography in Great Britain, France, and the United States, 1750–1940," *American Historical Review* 89, no. 3 (June 1984): 721; and also by Sandra M. Gilbert and Susan Gubar, *The Madwoman in the Attic: The Woman Writer and the Nineteenth-Century Literary Imagination* (New Haven and London: Yale University Press, 1979), 132–36. I am grateful to Claire R. Sherman for showing me Smith's useful article.

3. See Henry Kraus, "Eve and Mary: Conflicting Images of Medieval Women," in *The Living Theatre of Medieval Art* (Bloomington, Ind.: Indiana University Press, 1967), ch. 3; reprinted in Norma Broude and Mary D. Garrard, *Feminism and Art History: Questioning the Litany* (New York: Harper & Row, 1982), 79–99; JoAnn McNamara and Suzanne F. Wemple, "Sanctity and Power: The Dual Pursuit of Medieval Women," and Joan Kelly-Gadol, "Did Women Have a Renaissance?" in Renate Bridenthal and Claudia Koonz, eds., *Becoming Visible: Women in European History* (Boston: Houghton Mifflin, 1977), chs. 4 and 6.

4. Leon Battista Alberti, *I Libri della Famiglia* [1430s], trans. Renee Neu Watkins, *The Family in Renaissance Florence* (Columbia: University of South Carolina Press, 1969), 208.

5. The engraving, by Gaspar Isaac, is reproduced in Jean Adhemar, "La médecine dans l'estampe satirique et burlesque," *Aesculape* (March 1950) (as indicated in Warburg Institute files; I am unable to locate the article).

6. See Susan L. Smith, " 'To Women's Wiles I Fell' ": The Power of Women *Topos* and the Development of Medieval Secular Art," Ph.D. dissertation, University of Pennsylvania, 1978.

7. Giovanni Boccaccio, *Concerning Famous Women* [1473], trans. and intro. by Guido Guarino (New Brunswick, N.J.: Rutgers University Press, 1963). See also Kelly, 1982, 8; and Constance Jordan, "Feminism and the Humanists: The Case of Sir Thomas Elyot's *Defence of Good Women*," *Renaissance Quarterly* 36, no. 2 (Summer 1983): 181–201, esp. 181–85.

8. Lionardo Bruni, *De Studiis et Literis* [1409], trans. W. H. Woodward, in *Vittorino de Feltre and Other Humanist Educators* (Cambridge: Cambridge University Press, 1897) (see Jordan, 1983, 182). Boccaccio's *De claris mulieribus* was the model for Chaucer's *Legend of Good Women* (1385–86), which, though not specifically a humanist defense of women, was the immediate precursor of the complex, multifaceted examination of women found in the *Canterbury Tales*. See Walter W. Skeat, ed., *The Complete Works of Geoffrey Chaucer* (Oxford: Clarendon Press, 1894), xvi ff.; and V. A. Kolve, "From Cleopatra to Alceste: An Iconographic Study of *The Legend of Good Women*," in John P. Hermann and John J. Burke, Jr., eds., *Signs and Symbols in Chaucer's Poetry* (University, Ala.: University of Alabama Press, 1981).

9. Baldesar Castiglione, *The Book of the Courtier (Il libro del cortegiano)* [1528], trans. Charles Singleton (Garden City, N.Y.: Doubleday, 1959). Two useful studies for the context of the *Courtier* are J. R. Woodhouse, *Baldesar Castiglione: A Reassessment of "The Courtier"* (Edinburgh: Edinburgh University Press, 1978), ch. 1; and Rosand and Hanning, 1983. See also Dain A. Trafton, "Politics and the Praise of Women: Political Doctrine in the *Courtier*'s Third Book," in Rosand and Hanning, 1983, 29–44.

10. Juan Luis Vives, *Instruction of a Christian Woman* [1523], in Foster Watson, ed., *Vives and the Renascence Education of Women* (New York: Longmans, Green & Co., 1912). Hilda Smith (1982, 41 ff.) discusses the influence of Vives's tract on women's education in sixteenth-century England.

11. Henry Cornelius Agrippa, *A Treatise of the Nobilitie and Excellencye of Woman Kynde* [1529]. See H. Smith, 1982, 7, 116; and Ian Maclean, *Woman Triumphant: Feminism in French Literature, 1610–1652* (Oxford: Clarendon Press, 1977), 25–26.

12. Giovanni Boccaccio, *Von den erlychten Frouen* (Augsburg: Anton Sorg, 1479). The woodcut images in this text were based on those in a Latin edition by Johannes Zainer of 1473. See Adam von Bartsch, *The Illustrated Bartsch*, general editor, Walter I. Strauss (New York:

Abaris Books, 1978– ), vol. 80 (supplement), 8279, and (for Zainer), 8073.

13. A major example is the pair of tapestries now at the Cloisters, Heroes and Heroines cycles created for Jean, Duke of Berry, in the late fourteenth century. See James J. Rorimer and Margaret B. Freeman, "The Nine Heroes Tapestries at the Cloisters," *Metropolitan Museum of Art Bulletin* 7 (May 1949): 243–60.

14. From *Les trois bons hommes et femmes des Chrétiens, des Juifs, et des Païens* (one of which bears the date 1519), B. VII.64–69. The masculine *exempli* in Burghmair's cycle were Hector, Alexander the Great, Julius Caesar (pagans); Joshua, David, Judas Maccabee (Jews); and Charlemagne, Godefroi de Bourgogne, King Arthur (Christians). A useful catalogue of images of the Nine Worthies in art (primarily graphic) is found in Horst Schroeder, *Der Topos der Nine Worthies in Literatur und bildender Kunst* (Göttingen: Vandenhoeck & Ruprecht, 1971). On the relationship between cycles of famous women and early Italian examples of *uomini famosi*, see Christiane L. Joost-Gaugier, "Giotto's Hero Cycle in Naples: A Prototype of Donne Illustri and a Possible Literary Connection," *Zeitschrift für Kunstgeschichte* 43, no. 3 (1980): 311–18.

15. The cycle reproduced includes eight etchings designed and executed by Heemskerck (Hollstein, VIII, 230); another *Judith* cycle by Heemskerck of 1564, a *Susanna* cycle of 1551, and an undated *Esther* cycle were produced in several editions by I. H. Cock, Th. Galle, Joan Galle and others (Hollstein, vol. 8, nos. 76–81; 248–55; 272–79).

16. Castiglione, [1528] 1959, 214, 217.

17. Caspar Hofmann, in a commentary on Galen, cited by Maclean, 1977, 9. See also Carolyn Merchant, *The Death of Nature: Women, Ecology and the Scientific Revolution* (San Francisco and New York: Harper & Row, 1980), chs. 1 and 6. The second of these ideas was sustained by Rabelais, who described it thus: "For Nature has placed inside [women's] bodies in a secret intestinal place an *animal*, a member, which is not in man, in which sometimes are engendered certain saline, nitrous, boracic, acrid, biting, shooting, bitterly tickling humors, through whose prickling and grievous wriggling (for this member is very nervous and sensitive) the entire body is shaken, all the

senses ravished, all inclinations unleashed, all thoughts confounded" (quoted by Carolyn C. Lougee, *Le paradis des femmes: Women, Salons and Social Stratification in Seventeenth-Century France* [Princeton: Princeton University Press, 1976], 13–14). On the "wandering womb," see also Natalie Zemon Davis, *Society and Culture in Early Modern France* (Stanford, Calif.: Stanford University Press, 1975), 124–25.

18. See Maclean, 1977, ch. 1.

19. The *Economics* was thought in the Renaissance to have been written by Aristotle; see Maclean, 1977, 18–19.

20. Jordan, 1983.

21. See Costello, 1950, 245; and Maclean (1977, ch. 8), who discusses types of female virtue.

22. Jordan, 1983, 194–96.

23. Thomas Heywood (*Gynaikeion, or Nine Bookes of Various History Concerning Women; Inscribed by the names of the Nine Muses* [London: n.p., 1624]) places Semiramis among incestuous women, recounting her amorous passion for soldiers as well as her own son, and her unnatural affection for a horse (p. 167). See also Marilyn L. Johnson, *Images of Women in the Works of Thomas Heywood* (Salzburg: Institut für Englische Sprache und Literatur, Universitat Salzburg, 1974), 31 ff. Boccaccio ([1473] 1963, 4–7) adds to the legend of Semiramis's incest that she was killed by her shamed and angry son.

24. Jacobus Bergomensis, *De Claris Mulieribus* [1493], in Jacopo Filippo Foresti, *De memorabilibus* (Paris, 1521). This work, produced by a Carmelite scholar in Bergamo, was very probably encouraged or inspired by Eleonora of Aragon, the publicly active and learned Duchess of Ferrara, mother of Isabella d'Este. See Werner L. Gundersheimer, "Women, Learning and Power: Eleonora of Aragon and the Court of Ferrara," in Patricia H. Labalme, ed., *Beyond Their Sex: Learned Women of the European Past* (New York: New York University Press, 1980), 43–65, esp. 54.

25. Francesco Pona, *La galleria delle donne celebri* (Bologna: Cavalieri, 1633).

26. See James V. Mirollo, *The Poet of the Marvelous: Giambattista Marino* (New York: Columbia University Press, 1963), 48–49.

27. Boccaccio's female characters, both in *De claris mulieribus* and in the *Decameron*, may be grouped in categories of virtue and vice (Boc-

caccio, [1473] 1963, xvi–xvii). On the other hand, Chaucer and John Lydgate attempted to reinstate the moral virtue of Cleopatra and Dido (Katharine M. Rogers, *The Troublesome Helpmate: A History of Misogyny in Literature* [Seattle and London: University of Washington Press, 1966], 57–58). An important source for Renaissance typologies of women is Francis Lee Utley, *The Crooked Rib, An Analytical Index to the Argument about Women in English and Scots Literature to the End of the Year 1568* (Columbus: The Ohio State University, 1944).

28. Boccaccio, [1473] 1963, 127.

29. Queen Elizabeth I was proudly and positively described as a "virago," as Winfried Schleiner has shown ("*Divina virago*: Queen Elizabeth as an Amazon," *Studies in Philology* 75, no. 1 [January 1978]: 163–80). This, however, was by Englishmen, whose troops she led in victory against the Spanish Armada. Evidently, a virago is perceived as dangerous only by her enemies.

30. Jordan, 1983, 194–96.

31. Torquato Tasso, *Discorso della Virtù Feminile, e Donnesca* (Venice: Bernardo Giunti e fratelli, 1582). Maclean, 1977, 18 ff., discusses the treatise at length, noting that Tasso's Aristotelian (but also Thomist) position of complementary but not identical virtues for men and women was based on the *Economics*, misattributed to Aristotle by Renaissance writers.

32. Maclean, 1977, 16.

33. Christine de Pizan, *L'Epistre au Dieu d'Amours* [1399] and *Le Dit de la Rose* [1402]. See Christine de Pizan, *The Book of the City of Ladies* [1405], trans. and intro. by Earl Jeffrey Richards (New York: Persea Books, 1982), xxii ff.; and Susan Groag Bell, "Christine de Pizan (1364–1430): Humanism and the Problem of a Studious Woman," *Feminist Studies* 3 (Spring-Summer 1976): 173–84. Important recent contributions to Christine de Pizan scholarship include Sandra L. Hindman, "With Ink and Mortar: Christine de Pizan's *Cité des Dames* (An Art Essay)," *Feminist Studies* 10, no. 3 (Fall 1984): 457–77; and Charity Cannon Willard, *Christine de Pizan: Her Life and Works* (New York: Persea Books, 1984).

34. E.g., "I am amazed by the opinion of some men who claim that they do not want their daughters, wives, or kinswomen to be edu-cated because their mores would be ruined as a result" (Pizan, [1405] 1982, 153).

35. E.g., H. Smith, 1982, 40 ff.

36. On More and Erasmus, see H. Smith, 1982, 5, 41 ff., 77; and Jordan, 1983, 195–96.

37. Pizan, [1405] 1982, 65.

38. Marie de Gournay, "Egalité des hommes et des femmes," in Mario Schiff, ed., *La Fille d'alliance de Montaigne: Marie de Gournay* (Paris: H. Champion, 1910), cited by Kelly, 1982, 22.

39. Lucrezia Marinelli, *La nobiltà et l'eccellenza delle donne, co' diffetti et mancamenti de gli Huomini* (Venice, 1601). Agrippa's arguments had been restated in Italy by Domenichi and Bronzini; see Ginevra Conti Odorisio, *Donna e Società nel Seicento: Lucrezia Marinelli e Arcangela Tarabotti* (Rome: Bulzoni, 1979), 53. Two generations earlier, Laura Terracina had faulted Ariosto's depiction of women in *Orlando Furioso* (Laura Terracina, *Discorso sopra tutti li primi canti d'Orlando Furioso* [Venice: Ferrari, 1550]; see Kelly, 1982, 17, and Ruth Kelso, *Doctrine for the Lady of the Renaissance* [Urbana: University of Illinois Press, 1956], 5–37).

40. Marinelli, 1601, 124, quoted by Conti Odorisio, 1979, 56. Marinelli suggested that an experiment in coeducation would demonstrate that a girl would learn more quickly than a boy (1601, 33; Conti Odorisio, 1979, 55).

41. Moderata Fonte, *Il merito delle donne scritto da Moderata Fonte in due giornate, ove chiaramente si scuopre quanto siano elle degne e più perfette degli uomini* (Venice: Presso Domenico Imberti, 1600) (published posthumously).

42. Fonte, 1600, 14, quoted by Conti Odorisio, 1979, 62. A French counterpart to these writings was Marie de Romieu's *Brief discours que l'excellence de la femme surpasse celle de l'homme* [1581] (Maclean, 1977, 33 n. 32).

43. Lucretia Marinelli objected to Tasso's exclusion of only exceptional women from the general category of women as imperfect males, and she complained about the implied condemnation of all women in apologies aimed at the vices of some women. See Kelly, 1982, 18; and Kelso, 1956, 7.

44. Pizan, [1405] 1982, 160 ff.

45. In Domenichi's treatise (Lodovico Domenichi, *La nobiltà delle donne* [1548] [Venice: G. Giolito di Ferrarii e fratelli, 1551], bk. 4, 152 ff.), Signora Violante Bentivoglia complains

that "we women have not read history or po-
etry," and asks Signor Mutio Giustinopolitano
to tell the history of noble women, which he
obliges with stories of the worthies, similar to
those recounted by Castiglione's Magnifico
Giuliano for the benefit of the ladies at Urbino
(Castiglione, [1528] 1959, bk. 3, secs. 21–49, pp.
222–54).

46. Arcangela Tarabotti [pseud. Galerana Bara-
totti], *La semplicità ingannata, o Tirannia pa-
terna* (Leiden: G. Sambix, 1654), quoted in
Conti Odorisio, 1979, 124–25 (Tarabotti is dis-
cussed by Conti Odorisio in ch. 3).

47. Tarabotti, 1654, quoted in Conti Odorisio,
1979, 128–29.

48. E.g., Maclean, 1977, 40.

49. F. Agostino Della Chiesa, *Teatro delle donne
letterate, con un breve discorso della preminenza,
e perfettione del sesso donnesco* (Mondovi:
G. Gislandi, 1620). Della Chiesa's ideas are
discussed by Conti Odorisio, 1979, 74 ff., who
considers him to have been much influenced
by Marinelli.

50. Pizan, [1405] 1982, 7–8. Joan Kelly (1982, 14)
cites this passage to define with moving clarity
Christine's escape from "the self-disdain of
the colonized."

51. H. Smith, 1982, 64.

52. Of the many scholars who cite Knox's *Blast*, see
especially Johnson, 1974, 11 ff., who discusses
the work in the context of feminist and anti-
feminist tracts published in England in the
sixteenth and seventeenth centuries.

53. The names are obviously pseudonyms, yet the
writers' passion suggests their probable fe-
male identity. See Johnson, 1974, 17 ff.

54. A full analysis of the position of women, and
attitudes toward women, in Italy under the
Council of Trent remains to be written, but
Conti Odorisio's discussion (1979, esp. 35 ff.)
is very useful; she has analyzed the limitations
of Italian social historians such as Belloni (An-
tonio Belloni, *Il seicento* [Milan: F. Vallardi,
1929]). A good discussion of early patristic
misogyny is found in Rosemary R. Ruether,
"Misogynism and Virginal Feminism in the
Fathers of the Church," in R. R. Ruether, ed.,
*Religion and Sexism: Images of Woman in the
Jewish and Christian Traditions* (New York: Si-
mon and Schuster, 1974), 150–83. According to
Natali (Giulio Natali, *Idee, costumi, uomini del
settecento; studii e saggi letteraii* [Turin: Sten,

1926], 180), the Italian adoption of Spanish
*mores* in the later sixteenth and seventeenth
centuries also served to strengthen the strict
separation of the sexes and the confinement of
women to the home, and helped legitimize the
servile and degraded position of women.

55. According to Hugh R. Trevor-Roper (*The Eu-
ropean Witchcraze of the Sixteenth and Seven-
teenth Centuries and Other Essays* [Harmonds-
worth: Penguin, 1969], 91), "the years 1550–
1600 were worse than the years 1500–1550, and
the years 1600–1650 were worse still." See also
Jeffrey B. Russell, *A History of Witchcraft: Sor-
cerers, Heretics and Pagans* (London: Thames
and Hudson, 1980), 83 ff. A feminist assess-
ment of the extensive literature on the witch-
hunts is given by Mary Daly, in *Gyn/Ecology:
The Metaethics of Radical Feminism* (Boston:
Beacon Press, 1978), ch. 6. The witch craze in
Italy is discussed in the context of misogyny
by Conti Odorisio, 1979, ch. 2. A close, prob-
ing analysis of witchcraft in Italy, and the re-
lated but opposing cult of the *benandanti*, is
provided by Carlo Ginzburg, *The Night Bat-
tles: Witchcraft and Agrarian Cults in the Six-
teenth and Seventeenth Centuries* [1966], trans.
J. and A. Tedeschi (Baltimore: Johns Hopkins
University Press, 1983).

56. That virulent misogyny continued in Italy
throughout the seventeenth century is dem-
onstrated by the equally fanatical treatise of
the abbot B. Tondi, *La femina origine d'ogni
male, overo Frine rimproverata* (Venice, 1687),
in which a torrent of invective is unleashed
against the dangerous and corrupt nature of
women (see Conti Odorisio, 1979, 37 ff.).

57. Kelso, 1956, 346. Cardinal G. B. De Luca (*Il
cavaliere e la dama* [Rome, 1675]) took a more
moderate tone, offering instead of direct mis-
ogyny a manual on masculine control of
women, conceding the theoretical cultivation
and virtue of woman, but cautioning against
the dangers of allowing women any worldly
independence, especially participation in gov-
ernance (Conti Odorisio, 1979, 42 ff.).

58. On Trousset's *Alphabet*, see Maclean, 1977,
30 ff. Trousset's own source of inspiration was
Ferville's *Cacogynie, ou méchanceté des femmes*
[1617]; Jean Besly's *Plaidoyer . . . sur les mon-
danités des femmes et pucelles* was also issued in
1617. Leonora Galigai, Marie de' Medici's child-
hood friend who was burned as a witch in July

1617, was the subject of numerous anti-feminist pamphlets (Maclean, 1977, 31; and Jacques Thuillier, text, *Rubens' Life of Marie de' Medici*, with a catalogue and a documentary history by Jacques Foucart, trans. Robert E. Wolf [New York: H. N. Abrams, 1967], 12, 17).

59. St. Antoninus's *Tertia pars totius summe* (Venice, 1503) was a negative version of the Old Testament Alphabet of the Good Woman (Proverbs 31: 10–29). See Maclean, 1977, 31–32; his chapter 2 and Kelly (1982) are essential sources for the feminist and anti-feminist writings of the fifteenth to seventeenth centuries.

60. Elaine Rubin, "The Heroic Image: Women and Power in Early Seventeenth-Century France," Ph.D. dissertation, George Washington University, 1977, 93–95.

61. Quoted by Rubin, 1977, 105–06.

62. Rubin, 1977, 53–55.

63. Ovid's description of the four ages (*Metamorphoses* 1.149–50) initiated the long and important tradition of Virgo-Astraea in Western literature. Virgil's reference in the Fourth Eclogue to the virgin who would herald the golden age (*Iam redit et virgo, redeunt Saturnia regna*) was interpreted by Christian writers as a reference to the Virgin Mary and to the Christian era brought by her divine Son. The political application of this figure to the rule of Elizabeth the Virgin Queen, and to Marie de' Medici as well, is discussed by Frances A. Yates, *Astraea, The Imperial Theme in the Sixteenth Century* (London and Boston: Routledge & Kegan Paul, 1975), esp. 29 ff. and 208 ff.

64. Yates, 1975, 118.

65. Rubin, 1977, 65, and 71 ff.

66. Thuillier, 1967; and Deborah Marrow, *The Art Patronage of Maria de' Medici*, Studies in Baroque Art History, no. 4 (Ann Arbor: UMI Research Press, 1982). Thuillier credits Marie de' Medici with control of the commission, and although he stops short of political characterization, he notes Marie's likely input in the choice of themes. Marrow examines the iconography of the cycle from the perspective of Marie's feminist and political interests. Susan Saward's equally valuable study of the Medici cycle, *The Golden Age of Marie de' Medici*, Studies in Baroque Art History, no. 2, (Ann Arbor: UMI Research Press, 1982), fo-

cusses upon the cycle's continuation of Medicean dynastic imagery and its use of the classical tradition of the Panegyric.

67. Thuillier, 1967, 27 ff. See also Maclean, 1977, 209 ff.

68. The Amazon allusion is not mentioned by Saward (nor Marrow, who suggests that the bared breast is a Charity allusion). However, an important precedent for the conception of Marie de' Medici as Amazon would have been Elizabeth I, who was compared to Amazons by writers and sometimes depicted with a single bare breast (see Schleiner, 1978, 163–80, esp. 164 ff. and plate 1. (I am grateful to Jeanne Roberts for the preceding reference.)

69. On Marie as Bellona, see Marrow, 1982, 68–69, and Thuillier, 1967, 73; on the Felicity of the Regency, Marrow, 1982, 69–70, and Thuillier, 88. (The latter subject is identified by Saward [1982, 142 ff.] as Marie de' Medici as Patroness of the Fine Arts.)

70. Crelly, 1962, 110 n. 97. These were: Olympias, mother of Alexander; Berenice, mother of Philadelphos; Livia, wife of Augustus; Mammaea, mother of Alexander Severus; St. Helena, mother of Constantine; St. Clothilde, wife of St. Slodwig; Berta, mother of Charlemagne; and Blanche, mother of St. Louis. The cycle was ordered in c. 1622 by Marie, who asked for famous women and left the individual choices up to her advisors. The outcome of the cycle is discussed by Marrow, 1982, 22. One wonders whether the bust-length paintings of eight women that presently flank the central ceiling painting in the Salle de Livre d'Or (now in the Cabinet Doré), described by Blunt as unrelated to Pierre Monier's central scene, an *Allegory in Honor of Marie de' Medici*, might not be remainders of another such aborted project. See Blunt, 1967b, pt. 2, fig. 25.

71. Marrow, 1982, 68; Maclean, 1977, 211 n. 9. According to Maclean, the cycle at Richelieu included Thomyris, Judith, Dido, Artemisia, Cleopatra, Sophonisba, Esther, Semiramis, Bathsheba, and the wife of Astrobel (cf. Marrow, 1982, 95 n. 74).

72. Discussed by Crelly, 1962, 108 ff., who gives a full list of heroic women, 110 n. 97. Maréchale de la Meilleraye was a relative of Richelieu.

73. Maclean, 1977, 211; Marrow, 1982, 68. Numerous print galleries of famous women appeared under Anne of Austria, e.g., François de

Grenaille, *Galerie des dames illustres* [1643]; and two "galleries" published by Puget de la Serre in 1645 and 1648, in honor of Anne of Austria (see Maclean, 1977, 211). On the gallery of famous women commissioned for Vienna in the early seventeenth century by the Medici-Austrian Archduke Leopold Wilhelm, apparently carried out by Florentine artists, see Günther Heinz, "Gedanken zu Bildern der 'donne famose' in der Galerie des Erzherzogs Leopold Wilhelm," *Jahrbuch der Kunsthistorischen Sammlungen in Wien* 77 (1981): 105–118.

74. Marrow, 1982, 68.

75. See Bissell, 1981, 47–48 and cat. 54. The *Public Felicity*, formerly ascribed to Jean Monier, was reattributed to Orazio Gentileschi by Charles Sterling ("Gentileschi in France," *Burlington Magazine* 100 [April 1958]: 110; 112–21). Bissell would also place in Orazio's Paris years the *St. Mary Magdalen in Penitence* and the *Rest on the Flight* (both in Vienna), and "probably" the *Penitent Magdalen* in New York.

76. E. Müntz, *Les Archives de Arts* (Paris, 1890), 183, cited by Marrow, 1982, 18. Cassiano is said to have described history paintings, portraits, gilded woodwork, and other furnishings.

77. Marrow, 1982, 73.

78. Ibid., 57; Rubin, 1977, 86–87. The Dubois painting and its identification as Minerva are discussed in *L'École de Fontainebleau*, exh. cat., Paris, Grand Palais, October 17, 1972–January 15, 1973 (Paris: Editions des musées nationaux, 1972), 85–87, and S. Béguin, B. Jestaz, and J. Thirion, *L'École de Fontainebleau (Guide)* (Paris: Éditions des musées nationaux, 1972), no. 86. The medal is illustrated in Thuillier, 1967, fig. 4.

79. See Francis H. Dowley, "French Portraits of Ladies as Minerva," *Gazette des Beaux-Arts* 45, ser. 6 (1955): 261–86.

80. In *Un tournai de trois pucelles en l'honneur de Jeanne d'Arc* (Paris, 1878), cited by Maclean, 1977, 214–15.

81. Efforts have been made to connect this portrait with an entry in an inventory at Versailles that describes an image of Anne as Minerva: *"la reine mère assise tenant une pique d'une main et appuyant l'autre sur un casque posé sur un piédestal"* (Dowley, 1955, 264). According to Dowley (p. 268), a lost double portrait by Vouet of Anne of Austria as Minerva, goddess of the arts, and Louis XIII as Mars, god of

war, is preserved in a tapestry after Vouet's cartoon (designed before 1643, the date of the tapestry). The tradition of allegorical Minerva portraits that continued through the seventeenth century is traced by Dowley; two examples are at Versailles: one by Antoine Mathieu of c. 1663 shows Henriette of England (daughter of Charles I and Henrietta Maria); another by Pierre Bourguignon of c. 1671 depicts Anne Marie Louise d'Orléans.

82. For discussion of other portraits of Anne of Austria, see Jerzy T. Petrus, "Portrety infantek hiszpańskich, córek Filipa III, z klasztoru SS. Wizytek w Warszawie," *Biuletyn historii sztuki* 39, vol. 1 (1977): 31–46.

83. The *Minerva* was first mentioned in the 1890 Uffizi inventory; its earlier whereabouts are unknown (see Chapter 1, n. 73). Presumably, the picture was never delivered to Marie de' Medici, for reasons that are impossible to guess. Artemisia claimed that she had served the king of France in a letter to Galileo (Appendix A, no. 9); see also Chapter 1, p. 90.

84. Certain details of the Gentileschi *Minerva* support the regal identification, e.g., the pike held by the figure, which, without its blade visible, suggests a royal scepter. The olive branch held by the figure establishes her as the type of "Minerva Pacifica," who, as Wittkower has shown, was often associated in the Renaissance with monarchs and the evocation of Augustan peace, as in Laurana's medals depicting this theme executed in 1461–63 for René of Anjou, king of Sicily and count of Provence; Rudolf Wittkower, "Transformations of Minerva in Renaissance Imagery," *Journal of the Warburg and Courtauld Institutes* 2 (1939): 194–205.

85. See Blunt, 1967b. On continuing Florentine references in Marie's created imagery, see Marrow, 1982, 59 ff.

86. For the fifteenth-century Minerva tradition, in which the theme of Minerva Pacifica was especially prevalent, see Wittkower, 1939. The history of the *Andrea Doria* and its dating are briefly discussed by McCorquodale, 1981, 46 and 61.

87. Thus far, I have been unable to find replicas or prints of the *Minerva* in French collections.

88. Marie de Gournay, a supporter of Marie de' Medici, took the position in her *Egalité des hommes et des femmes* [1622] that the sexes were

89. Maclean, 1977, 220.

90. See ibid., 220 ff. Maclean suggests that Thomas Heywood's *The exemplary lives and memorable acts of nine of the most worthy women of the world: 3 Jewes, 3 Gentiles, 3 Christians* (London, 1640) and its accompanying illustrations may have influenced Le Moyne's conception. The pictorial sources for Le Moyne's gallery are discussed by Patrick Ramade, "Une source d'inspiration du XVIIᵉ siècle: *La galerie des femmes fortes*, de Claude Vignon," *Bulletin des Amis du Musée de Rennes* 4 (1980): 19–26. In addition to Du Bosc's and Le Moyne's galleries of famous women, pro-feminist writings included such works as Grenaille's *Honneste fille, Honneste mariage, Bibliothèque des dames*, Machon's *Discours ou sermon apologetique en faveur des femmes*, and (Madeleine) de Scudéry's *Femmes illustres*, to cite only a few names from the exhaustive list compiled by Maclean (1977, 76–77), at least eight of which were dedicated to Anne of Austria herself.

91. Maclean (1977, 21–22 and fig. 15) observed the connection between the prints, noting it as a reflection of the popularity of the gallery theme. An edition of Le Moyne's *Galerie* in the Library of Congress, published in Leiden in 1660, includes as the frontispiece an engraving showing a single female bust (Anne of Austria?) in a hall, surrounded by other female busts.

92. Maclean, 1977, 69.

93. Ibid., 65 ff.

94. Pierre Le Moyne, *The Gallery of Heroick Women*, trans. by the Marquesse of Winchester (London: Henry Seile, 1652), 35.



equal in virtue and capability, and thus avoided the sexual chauvinism that had been stimulated, and was represented, by the *Alphabet* and its critics (see H. Smith, 1982, xiii ff.). De Gournay's treatise and that of Lucrezia Marinelli are considered typical of the next stage of the debate achieved in the seventeenth century, when feminist writers focussed upon the abilities of all women, rather than upon the exceptional worthies (Maclean, 1977, 65 ff.). Madeleine de Scudéry (*Artamenes; or, The Grand Cyrus* [1649–53], 5 vols. in 2 [London: H. Moseley, 1653–55]) was the foremost champion of women's education and strongly advocated women's use of their learning to play an important intellectual role in the salons. See Lougee, 1976, esp. ch. 1.

95. "*Mulierem fortem quis inveniet?*" (Proverbs 31:10).

96. The fusion of feminine virtue and masculine strength in the *femme forte* was buttressed by emblematic literature as well, for the image of *virtus* in Ripa—"*donna bella, armata e d'aspetto virile*"—was almost identical with his description of *fortitudo*. These were combined in the type of *Pallas armata*. Alciati's emblem called "*custodiendas virgines*" is shown as Phidias's statue of Minerva (see Maclean, 1977, 213 and fig. 3); the same figure was used by Alciati as a representative of chastity, and as "*la vertu*" by A. Bosse in an engraving of 1637. See Maclean, 1977, 81–82.

97. See Maclean, 1977, 74 n. 36; and also Emerson Brown, Jr., "Biblical Women in the Merchant's Tale: Feminism, Antifeminism, and Beyond," *Viator* 5 (1974): 402 ff. A number of texts make the association between Mary and the biblical *mulier forte* explicit, such as Guerry's *Traicté de l'excellence du sexe foeminin et des prerogatives de la mere de Dieu* [1635] and Laurens Le Peletier's *De la chasteté* [1635] (cited by Maclean, 72 ff.).

98. Maclean, 1977, 73. The central virtue of the Virgin Mary, her chastity, supported a renewed preoccupation with sexual purity found among the "new feminist" writers. Le Moyne refuted Tasso's exclusion of heroic women from the need to be chaste, insisting that they should be and have been chaste, and specifically exonerating Joan of Arc (Maclean, 1977, 83–84). To the extent that Le Moyne attempted to reassert through this argument traditional patriarchal control of women's sexuality, his position must be interpreted as anti-feminist, as Lougee (1976, 110) has pointed out. Yet for Du Bosc and other writers, chastity is presented as an aggressive trait, a source of independence in women (Maclean, 1977, 84 ff.), a combination that perhaps has origins in the recent memory of Elizabeth, the Virgin Queen, and in the older memory of the strong, independent virginal Greek goddesses Athena and Diana.

99. E.g., by Maclean (1977, 223, 230), as was (he says) the series *La femme genereuse* of 1643.

100. Cited by Marvin Lunenfeld, "The Royal Image: Symbol and Paradigm in Portraits of Early Modern Female Sovereigns and Regents," *Gazette des Beaux-Arts* 97 (April 1981): 158. See also Schleiner, 1978.

101. Maclean, 1977, 229 ff., and ch. 8. Natalie Ze-
mon Davis gives a political analysis of
switches in role and position between male
and female, to express or to rebel against tra-
ditional political structures (in Davis, 1975).

102. Pierre Le Moyne, *La Galerie des femmes fortes*
(Paris: Antoine de Sommaville, 1647), 251,
cited by Lougee, 1976, 63. See also Maclean,
1977, 78.

103. Cf. Maclean, 1977, 85–87 and 110 ff., who con-
cedes that the *femme forte* is "feminist" only in
masculine terms; and Lougee, 1976, 63, who
points out that pro-feminist views only subtly
differ from anti-feminist views.

104. See Maclean, 1977, 178 ff., for a discussion of
these characters in the seventeenth century.

105. See Lougee, 1976, especially ch. 2; and
Maclean, 1980, 24 ff.

106. See Barbara Matulka, "The Feminist Theme
in the Drama of the Siglo de Oro," *The
Romanic Review* 26, no. 3 (July–September
1935): 191–231.

107. Ibid., 208 ff. As Matulka notes, pro-feminist
literary arguments had earlier been produced
in Spain, notably Juan de Flores's fifteenth-
century novella, *Grisel y Mirabella*, and Rod-
ríguez del Padrón's exhortation to women in
the *Triunfo de las donas*.

108. See Pigler, [1956] 1974, 2:107–133. Artemisia
Gentileschi also treated this theme in a lost or
unidentified painting in Madrid (see above,
Chapter 1, n. 164). The iconography of Venus
and Mars is discussed in a relevant context by
E. H. Gombrich, *Symbolic Images*, Studies in
the Art of the Renaissance, 2 (Oxford: Phai-
don, 1978), 66–69. The pornographic appeal
of much Renaissance and Baroque art is dis-
cussed by Edward Lucie-Smith, *Eroticism in
Western Art* (New York: Praeger, 1972), ch. 11;
and Margaret Walters, *The Nude Male: A New
Perspective* (Harmondsworth and New York:
Penguin, 1978), 166–67.

109. Cf. Harris and Nochlin, 1976, 119.

110. Giovanni Battista Marino, *La Galeria* [1619]
(Venice: Ciotti, 1635). See also Mirollo, 1963.

111. The verses, printed in Venice in 1627 (c. 100–
101, cod. Ottoboniano Latino 1100, Biblioteca
Vaticana, "Manuscritti e stampe di materie di-
verse"), were published in Toesca, 1971: 89–
92. The English translations given here and
below were done by Efrem G. Calingaert.

112. Dumonstier's eulogizing of the part to stand
for the whole should be seen as a continuation
of a Petrarchan tradition in which woman was
depicted as a composite of details, a "poetics
of fragmentation" (John Freccero, "The Fig
Tree and the Laurel: Petrarch's Poetry," *Dia-
critics* 5 [Spring 1975]: 34–40) that results, as
Nancy Vickers has recently observed, in the
dismemberment and distortion of the original
whole woman. Nancy J. Vickers, "Diana
Described: Scattered Woman and Scattered
Rhyme," *Critical Inquiry* 8 (1981): 265–79.
See also Elizabeth Cropper, "On Beautiful
Women, Parmigianino, *Petrarchismo*, and the
Vernacular Style," *Art Bulletin* 58 (September
1976): 374–94.

113. Letter of December 1558, recorded by Baldi-
nucci ([1681–1728] 1808–12, 215); quoted by
Harris and Nochlin, 1976, 107.

114. The Quattrocento concept of *ingegno* is dis-
cussed by Martin Kemp, "From 'Mimesis' to
'Fantasia': The Quattrocento Vocabulary of
Creation, Inspiration and Genius in the Vis-
ual Arts," *Viator* 8 (1977): 347–98. Cinque-
cento theories on the relationship of reason
and artistic inspiration are conveniently sum-
marized by Erwin Panofsky, *Idea, A Concept
in Art Theory* [1924], trans. Joseph J. S. Peake
(Columbia, S.C.: University of South Caro-
lina Press, 1968). The general cultural belief
that women artists lack the "golden nugget"
of artistic genius was broadly examined by
Linda Nochlin ("Why Have There Been No
Great Women Artists?" 1971). The Renais-
sance concept of artistic inspiration is also dis-
cussed in Chapter 6 below.

115. See Ian Maclean, *The Renaissance Notion of
Woman: A Study in the Fortunes of Scholasticism
and Medical Science in European Intellectual
Life* (Cambridge and New York: Cambridge
University Press, 1980), esp. 13–14 and 52; and
Charles Trinkaus, *In Our Image and Likeness:
Humanity and Divinity in Italian Humanist
Thought*, 2 vols. (Chicago: University of Chi-
cago Press, 1970), vol. 2, esp. ch. 15.

116. See above, Chapter 1, note 11, for text.

117. Sandrart, [1675] 1971, 290: *"vielen andern Werken
von ihrer Hand sehr vernünftig gemacht
ware."* Baldinucci, [1681–1728] 1808–12, 2:11:
*". . . fa conoscere fino a qual segno giungesse
l'ingegno, e la mano d' una tal Donna."*

118. See H. Smith, 1982, esp. 4, 11, 20 ff.; and 43.

119. Anna Maria van Schurman, *De Ingenii Mulie-
bris* [1641], English edition: *The Learned maid,
or, Whether a maid may be a scholar?* (London:

printed by John Redmayne, 1659); Mary Astell, *A Serious Proposal to the Ladies for the Advancement of Their True and Greatest Interest by a Lover of Her Sex* (London: printed for R. Wilkin at the King's Head in St. Paul's Churchyard, 1694) and *Some Reflections upon Marriage, occasion'd by the Duke & Duchess of Mazarine's case; which is also considered* (London: J. Nutt, 1700); Daniel Defoe, "An Academy for Women," in *An Essay upon Projects* (London, 1697).

120. Bathsua Makin, *An Essay to Revive the Antient* [sic] *Education of Gentlewomen, in Religion, Manners, Arts & Tongues* (London, 1673); republished, with intro. by Paula L. Barbour, The Augustan Reprint Society, no. 202 (Los Angeles: William Andrews Clark Memorial Library, University of California, 1980). On Makin, see J. R. Brink, "Bathsua Makin: Educator and Linguist (1608?–1675?)," in J. R. Brink, ed., *Female Scholars: A Tradition of Learned Women before 1800* (Montreal: Eden Press Women's Publications, 1980), 86–100; and also H. Smith, 1982, 102–105.

121. From a contemporary description, cited in Carola Oman, *Henrietta Maria* [1936] (London: White Lion Publishers, 1976), 109.

122. Oman, [1936] 1976, 149. Felicity A. Nussbaum (1984, 14) claims (without elaboration) that Henrietta Maria brought feminist philosophy from her native France to England.

123. Only one non-female subject by Artemisia—a male saint laying his hand on fruit—is recorded in Charles's inventories.

124. Elizabeth Hamilton, *Henrietta Maria* (New York: Coward, McCann & Geoghegan, 1976), 128.

125. Makin, [1673] 1980, 21.

126. Evidence that the personification of abstract qualities was a common mode of thought in Artemisia's day is found in the rape trial; see Appendix B, ms. 127 (answer to question 1). Artemisia herself employs the procreation metaphor in Appendix A, no. 6a.

127. E.g., Chester F. Chapin (quoting Addison), *Personification in Eighteenth-Century English Poetry* (New York: King's Crown Press, 1955), 52. (I am grateful to Judith Stein for this reference.) Gombrich, among others, has acknowledged the roots of personification in languages that give nouns gender (E. H. Gombrich, "Personification," in R. R. Bolgar, ed., *Classical Influences in European Culture, A.D. 500–1500* [Cambridge: Cambridge University Press, 1971], 247–57). Various theories on this subject are discussed in István Fodor, "The Origin of Grammatical Gender," *Lingua* 8, no. 1 (January 1959): 1–41, and 8, no. 2 (May 1959): 186–214.

128. For example, the list of paintings by Elisabetta Sirani given by Malvasia, which indicates a preponderance of female themes (Carlo Cesare Malvasia, *Felsina Pittrice: Vite de' pittori bolognesi* [1678], ed. Giampietro Zanotti, 2 vols. [Bologna: Tip. Guidi all'Ancara, 1841], vol. 2, pt. 4, pp. 393–400). A similar impression is given by many other brief accounts of women artists, such as Veronica Franchi, a pupil of Sirani, who is described by Luigi Crespi (*Vite De' pittori Bolognesi non descritte Nella Felsina Pittrice* [Rome: Stamperia di M. Pagliarini, 1769], 76) as having painted many pictures; those named were "a Lucretia, an Artemisia, a Lot with his Daughters, a Galatea with Tritons, a St. Andrew, a Cleopatra, and a large Rape of Helen."

## CHAPTER 3

1. Pizan, [1405] 1982, 160–61.

2. This chapter is a revised version of my article written in the year following the *Women Artists* exhibition, "Artemisia and Susanna," published in Broude and Garrard, 1982, 146–71.

3. See Harris and Nochlin, 1976, 120. The painting's history in the Schönborn collection, first ascribed to Orazio and later to Artemisia, is given above, in Chapter 1, note 10.

4. Longhi, 1943, 47 n. 38. See also Emiliani, 1958, 42.

5. Bissell, 1968, 153 ff., esp. 157; Voss, 1925, 463.

6. Harris and Nochlin, 1976, 120.

7. When the *Women Artists* exhibition moved from Los Angeles to the Brooklyn Museum in October 1977, I took the opportunity to consult the museum's chief conservator, Susanne P. Sack, who, with the generous cooperation of the owner, Dr. Karl G. Schönborn, subjected to laboratory analysis the inscribed portion of the painting. Ultraviolet photography revealed no overpainting of a previous date or

signature, and in Mrs. Sack's opinion, the character of the pigment, the structure of the lettering and its conformity with the internal lighting of the painting, and the craquelure of the surface all strongly indicate that the signature and date originated with the painting. As the conservator pointed out, the white highlights visible on the left portion of the signature fade as the inscription passes into the shadow cast by Susanna's right leg, a carefully thought-out detail that appears to have been part of the initial conception. (Some damages in this passage have been repaired by restorers, but these are easily distinguished from the original pigment.) Mrs. Sack confirmed that surface cracks run through the lettering, which can be seen indistinctly in Fig. 152. The picture is in unusually good condition, with much of the freshness of the original color still preserved.

8. In a letter of 1612 (Tanfani-Centofanti, 1897, 221–24), Orazio declared that Artemisia had been painting for three years. By this, as is discussed above (pp. 5–6), he probably meant that she had been painting independently for three years, since her apprenticeship would undoubtedly have begun before the age of sixteen.

9. Moir, 1967, 1:100; Longhi, 1943, 47, no. 38. Harris (Harris and Nochlin, 1976, 120) also thought that Orazio might have helped Artemisia with the design. Bissell (R. Ward Bissell, "The Baroque Painter Orazio Gentileschi, His Career in Italy," Ph.D. dissertation, The University of Michigan, 1966, 2:262) aptly questioned why Orazio would have wanted the name of his young daughter on one of his own paintings.

10. Daniel, chapter 13 in Roman Catholic editions. The full text is given, with a brief critical commentary, in *The Book of Daniel*, intro. and commentary by Louis F. Hartman; trans. and commentary by Alexander A. Di Lella (Garden City, N.Y.: Doubleday, 1978), 19 ff. and 315 ff.

11. The story of Susanna and the Elders is believed by some scholars to have been based upon a legend that symbolized a struggle between the Pharisees and Saducees over laws concerning false accusation and false testimony, the Pharisees having reformed more lax Saducee practices by instituting the thorough exami-

nation of witnesses and the severe punishment of false witnesses. See W.O.E. Oesterley, *An Introduction to the Books of the Apocrypha, Their Origin, Teaching and Contents*, (New York: Macmillan, 1935) 391 ff. An alternative view is represented by scholars who argued that the Susanna story derives from a combination of folklore and myth. See Paul F. Casey, *The Susanna Theme in German Literature, Variations of the Biblical Drama* (Bonn: Bouvier, 1976), 21 ff. (Further bibliography is given in the *New Catholic Encyclopedia*, 13:825–26; see especially M. Delcor, *Le livre de Daniel* [Paris: J. Gabalda et Cⁱᵉ, 1971].) There is general agreement that the story, which first circulated independently, was written in Hebrew during the reign of Alexander Jannaeus (102–75 B.C.). The story was later appended to the Book of Daniel, although the two Daniels are historically unrelated, and acquired its present position as chapter 13 in that book in 1547, as decreed by the Council of Trent.

12. See Marie-Louise Thérel, *Les Symboles de l' "Ecclesia" dans la création iconographique de l'art chrétien du IIIᵉ au VIᵉ siècle* (Rome: Edizioni di storia e letteratura, 1973), 43, on this striking symbolic image of Susanna coveted rathered than delivered. For other Early Christian examples of the theme, see Engelbert Kirschbaum, *Lexicon der christlichen Ikonographie*, 8 vols. (Rome: Herder, 1968–76), 4:228–31.

13. See André Grabar, *Christian Iconography, A Study of Its Origins*, trans. Terry Grabar, The A. W. Mellon Lectures in the Fine Arts, National Gallery of Art, Washington, D.C., 1961, Bollingen Series 35/10 (Princeton: Princeton University Press, 1968), 137–38. Symbolic interpretations of the Susanna theme are also discussed by Louis Reau, *Iconographie de l'art chrétien* (Paris: Presses Universitaires de France, 1955–59), vol. 2, pt. 1, 393 ff.

14. See Ernst Kitzinger, *Early Medieval Art, with Illustrations from the British Museum and British Library Collections*, rev. ed. (Bloomington, Ind.: Indiana University Press, 1983), 118–19. For other medieval examples of the Susanna theme, which despite the theme's theological popularity were relatively infrequent, see Karl Künstle, *Ikonographie der christlichen Kunst*, 2 vols. (Freiburg-im-Breisgau: Herder, 1928), 1:302–303. Extended narrative Susanna cycles

continued in the Renaissance and later, although by this time they were unusual; examples include Pinturicchio's frescoes in the Borgia Apartments, Vatican, of 1494; and Baldassare Croce's early seventeenth-century fresco cycle in S. Susanna, Rome.

15. W. R. Rearick ("Jacopo Bassano and Changing Religious Imagery in the Mid-Cinquecento," in Sergio Bertelli and Gloria Ramakus, eds., *Essays Presented to Myron P. Gilmore* [Florence: La Nova Italia Editrice, 1978], 2:331–43) discusses Susanna-Mary iconography in paintings by Jacopo Bassano, Tintoretto, and others, noting that the revived interest in moralized Susannas observable in the 1560s was likely a response to the directives of the Council of Trent, in which voluptuous imagery was synthesized with religious iconography in "a puritan paradox of pleasure-pain, sin-retribution, and temptation-anxiety." In early Cinquecento Venice, Rearick points out, Susanna was a rare theme, usually seen in allegories of justice painted for civic buildings.

16. Tintoretto's Vienna *Susanna* (c. 1555–56), one of half a dozen versions of the theme that he painted, appears to be the one described by Ridolfi in the house of Niccolò Renieri; see Rodolfo Pallucchini and Paola Rossi, *Tintoretto: Le opere sacre e profane* (Milan: Electa, 1982), 1:173–74. I am indebted to Pamela Askew for enlarging my understanding of Tintoretto's painting.

17. Giuseppe Cesari (Cavaliere) d'Arpino, to whom Caravaggio was early apprenticed, may have been the godfather of Artemisia's brother Giovanni Battista (see above, p. 14). On d'Arpino's Siena *Susanna*, and its relation to a variant recently discovered in England, see Nicholas Turner, "A Newly Discovered Painting by the Cavaliere d'Arpino," *Burlington Magazine* 119 (October 1977): 710–13. Röttgen has traced Cesari's figure of Susanna to a Bathsheba in the Vatican Loggia ascribed to Perino del Vaga, whose own model was a lunette figure in the Sistine Chapel; Röttgen, 1973, 117.

18. The *Susanna* in the Doria-Pamphilj Gallery, now definitively ascribed to Domenichino (Spear, 1982, 1:130–31), is identified by Spear as a copy of Annibale's lost work, and as the painting described by Bellori as made when Domenichino lived in Agucchi's house. The picture is dated at lower left, 1603. A second, independent *Susanna* (now Munich) painted by Domenichino in 1606–1608 is structurally closer to the Pommersfelden painting, and may well have formed part of Artemisia's typological reserve (Spear, 1982, 1:149–51, fig. 49). For literature on Annibale's print of c. 1590, see Diane DeGrazia Bohlin, *Prints and Related Drawings by the Carracci Family*, (Washington, D.C.: National Gallery of Art; Bloomington and London: Indiana University Press, 1979), 444.

19. Harris and Nochlin, 1976, 120. Harris connects Artemisia's shushing Elder with a similar figure in another print by Agostino Carracci; see Maurizio Calvesi and Vittorio Casale, *Le incisioni dei Carracci, catalogo critico* (Rome: Communità europea dell'arte e della cultura, 1965), no. 178.

20. By far the largest number of versions of the Susanna theme date from the sixteenth through the eighteenth century, with only occasional examples from after the eighteenth century. See Reau, 1955–59, 2:393 ff.; and Pigler, [1956] 1974, 1:218 ff.

21. Speaking of Rubens's several depictions of Susanna and the Elders, Rooses remarks: "*Il est permis de croire que, pour lui, le charme du sujet n'était pas tant la chasteté de l'héroïne biblique que l'occasion de montrer une belle femme nue, deux audacieux qui tentent une enterprise galante et les émotions fort diverses qui en résultent pour chacun de personnages*" (Max Rooses, *L'Oeuvre de P. P. Rubens: Histoire et description de ses tableaux et dessins*, 5 vols. [Antwerp: J. Maes, 1886–92], 1:171).

22. Susan Brownmiller (*Against Our Will: Men, Women and Rape* [New York: Simon and Schuster, 1975] 31 ff.) offers a graphic parallel from military history. Examining rape as an acceptable corollary of wartime conquest, she observes that in a situation in which killing is viewed as "heroic behavior sanctioned by one's government or cause," other forms of violence acquire part of that heroic luster.

23. Sarah Booth Pomeroy, in *Goddesses, Whores, Wives and Slaves: Women in Classical Antiquity* (New York: Schocken Books, 1975), 12, comments upon the "passivity of the woman [who] never enticed or seduced the god but was instead the victim of his spontaneous lust" in the "endless catalogue of rape in

Greek myth." That myths often preserve stories older than the shapings they received from the Achaean and Dorian Greeks has been extensively demonstrated by Robert Graves (*The Greek Myths*, 2 vols. [Harmondsworth and New York: Penguin Books, 1960]).

24. Hippolytus of Rome, *Commentary on the Book of Daniel*, quoted and discussed in Thérel, 1973, 43–44. As Leach has demonstrated (see note 25, below), similar analogies between Susanna and Eve were also drawn by St. John Chrysostom and by the fourth-century bishop St. Asterius of Amasus.

25. Mark C. Leach, "Rubens' *Susanna and the Elders* in Munich and Some Early Copies," *Print Review* 5 (1976): 120–27, esp. 125. (Further bibliography on the Susanna theme is given in ibid., 121 n. 8.) According to St. Ambrose, Susanna "did well to pour forth her soul, so that the fires of the body and the fears of death and the desires of life could not evaporate into it" (see Michael P. McHugh, trans., *Seven Exegetical Works*, vol. 65, *The Fathers of the Church, A New Translation* [Washington, D.C.: Catholic University Press, in association with Consortium Press, 1972], 320–21).

26. See Phyllis Bird, "Images of Women in the Old Testament," in Ruether, 1974, 41–88, esp. 48 ff.

27. Reau (1955–59, 2:396–98) lists as many Susannas at the Bath as Stonings or Judgments combined; Pigler ([1956] 1974, 218 ff.) gives nearly eight times as many Susannas at the Bath as Judgments, and lists no Stonings.

28. Honthorst, of course, who was in Rome in the decade of the teens and in demonstrable contact with the Gentileschi, could have known Artemisia's *Susanna*, a work that is at least as relevant to his conception (though there are no resemblances of design) as Domenichino's Munich *Susanna*, which has been proposed as Honthorst's model. I am grateful to Madlyn Kahr for prompting my consideration of Honthorst's painting in this context.

29. A study in the Louvre connects Rembrandt's Berlin *Susanna* with a painting of 1614 by Pieter Lastman (also in the Dahlem Museum; see Horst Gerson, *Rembrandt Paintings*, trans. Heinz Norden, ed. Gary Schwartz [New York: Reynal, 1968], illus. on p. 94, and fig. a, p. 327), but Rembrandt deviates from Lastman in repeating the *Medici Venus* pose for

Susanna that he had used in his 1637 *Susanna* in The Hague.

30. The connection between Rubens's Susanna figure and the famous antique model has been observed by a number of writers (see Leach, 1976, 123 n. 14). Leach himself attempts to distinguish the expressive character of Rubens's Susanna in the Munich painting from that seen in several copies of the picture by other artists, suggesting that the copyists mistakenly converted a "carefully selected gesture of modesty" into a "coy and inviting gesture." In my view, Leach attaches too much importance to an inconspicuous detail added by the copyists—Susanna's grasping of a lock of her hair—and too little importance to the overtly seductive facial expression in Rubens's original *Susanna*, an expression that surpasses the copies in coyness (not fear) and countermands whatever modesty the "closed-composition" pose may convey.

31. See Carl Robert, *Die Antike Sarcophagreliefs im Auftrage des Kaiserlich Deutschen Archaeologischen Instituts*, 5 vols. (Berlin: G. Grote'sche Verlagsbuchhandlung, 1890–1919), 2:155, 157, 171. Raphael drew a number of the figures seen in the Loggia frescoes from this sarcophagus, as Robert notes. Titian also used poses taken from the Orestes sarcophagus, e.g., the figure of Bacchus in the London *Bacchus and Ariadne* (based on Orestes), and the figure of Goliath in the S. M. della Salute *David and Goliath*, which is based upon the fallen Aegisthus. (See Otto Brendel, "Borrowings from Ancient Art in Titian," *Art Bulletin* 37 [1955]: 118, 121.) The defensive gesture of the nurse also appears in Sebastiano del Piombo's *Raising of Lazarus* (National Gallery, London); in the Raphael/ Giulio *Repulse of Attila* in the Vatican Sala di Costantino; and in the eighteenth century, in Fuseli's *Oedipus Curses His Son Polynices* (Paul Mellon Collection).

32. See Charles de Tolnay, *Michelangelo*, 5 vols. (Princeton: Princeton University Press, 1943–60), 2:134 and fig. 304, which illustrates the Orestes sarcophagus in reverse. Tolnay credits Walther Horn for first observing the connection between Adam's gesture and the Orestes sarcophagus.

33. It is unlikely that the specific subject of the Orestes sarcophagus was known in either Michelangelo's or Artemisia's time, inasmuch as

two learned early writers betrayed their own ignorance of its theme in their descriptions of the sarcophagi. In his Naples diary, Cassiano dal Pozzo identified a sarcophagus in the house of the Duke of Bracciano as having the same theme as the Vatican and Giustiniani sarcophagi with the note that a certain painter, Micheli, who worked for the duke had some information about what its subject might be (Theodor Schreiber, ed., *Unedirte römische Fundberichte aus italiënischen Archiven und Bibliotheken veröffentlicht* [Leipzig: n.p., 1885], 37, no. 54). And when the Giustiniani sarcophagus was published in Pietro Santi Bartoli's *Admiranda Romanorum antiquitatum* of 1693 (Rome: I. I. de Rubeis), Bellori, who wrote the notes that accompanied the engravings, resorted to a literal description of the action without identifying the characters, although nearly every other monument in the album is named by subject. Montfaucon, in the eighteenth century, supposed that the relief commemorated one of the grandest deeds of antiquity, but admitted he did not know which one. It was apparently Winckelmann who first identified the subject of these celebrated sarcophagi as the story of Orestes avenging his father's death by slaying his mother Clytemnestra and her lover Aegisthus (J. J. Winckelmann, *Monuments inédits de l'antiquité, statues, peintures antiques, pierres gravés, bas-reliefs de marbre et de terre cuite gravés par David . . . et par Mlle Sibire son élève,* trans. from Italian to French by A. F. Désodoards, 3 vols. [Paris: L. Paravicin, 1809], 3:26 ff.; see also Robert, 1890–1919, 2:130).

But if the early writers could not pinpoint the relief's theme, some at least understood the action generally to involve punishment. In a description of 1550, Fabricius names it as "this image in which some figures are punished . . ." (*"servilium suppliciorum (simulachra) in quibus alii capite plectuntur, aliis brachium saxo impositum alio saxo frangitur . . . ."* Georgius Fabricius, *Roma* (1550), in Justus Lipsius, *Roma illustrata, sive Antiquitatum romanarum breviarium* (Amsterdam: J. Wolters, 1689), 177.

34. It may suffice to recall the intricate interplay of moral forces in Aeschylus's *Oresteia* through one critic's observation that while the Odyssey's Orestes kills his father's assassins "without a qualm of conscience" and is "completely

successful and completely in the right," Aeschylus's Orestes is "right and wrong, his father's avenger and a guilty matricide and more, the vortex where the Furies and the gods converge with fresh intensity and effect" (W. B. Stanford, introduction to *Aeschylus: The Oresteia*, trans. Robert Fagles [London: Wildwood House, 1976], 42).

35. For the dating of this *David* in the period 1605–1610, see Bissell, 1981, 146.

36. The pose assumed by Orazio's contemplative Davids is a familiar one in antique art, seen in depictions of the contest between Poseidon and Athena (e.g., the cameo in Naples upon which one of the fifteenth-century relief tondos in the Medici Palace cortile is based; see Nicole Dacos, ed., *Il tesoro di Lorenzo il Magnifico*, exh. cat., Palazzo Medici-Riccardi, 2 vols. [Florence: Sansoni, 1973–74], vol. 1, pl. ix, fig. 81, and cat. 6). See also the *Odysseus before Telemachus* in the Villa Albani (Winckelmann, 1809, vol. 3, no. 157).

37. In a paper delivered in a symposium, *The Carracci and Italian Art around 1600*, National Gallery of Art, Washington, D.C., April 7, 1979, Carl Goldstein demonstrated that the use of a female studio model was rare before the nineteenth century, as a result of the prevalent attitude that women had uglier bodies than men. The occasional specific mention of female models in contemporary descriptions of seventeenth-century Roman art academies indicates that these were unusual practices; see Pevsner, 1940, 73, 77.

38. This dating was suggested by Andrea Emiliani, who connected the painting with Cantarini's Roman journey (entry in Cesare Gnudi, *Nuove acquisizioni per i Musei dello Stato, 1966–71*, exh. cat., Palazzo dell'Archiginnasio, Bologna, September 28–October 24, 1971, 62–63). Emiliani considers Cantarini's *Susanna* to be a development of an idea first stated by the artist in a drawing of Ariadne (Brera, inv. 509). I have not seen the drawing, but if Emiliani is correct in suggesting that it was influenced by Annibale Carracci's *Susanna* print of 1592, Cantarini's Ariadne would not appear to be particularly similar to his Susanna.

39. Other paintings of the Susanna theme that may have been partly influenced by Artemisia's picture, but which sustain the masculine perspective, include Ottavio Leoni's *Su-

*sanna* of c. 1615–20 (Detroit Institute of Art; see R. Ward Bissell and Alan P. Darr, "A Rare Painting by Ottavio Leoni," *Detroit Institute Bulletin* 58, no. 1 [1980]: 46–53 and fig. 1); and Giuseppe Chiari's *Susanna* of c. 1712 in the Walters Art Gallery, Baltimore (see John Maxon and Joseph J. Rishel, eds., *Painting in Italy in the Eighteenth Century: Rococo to Romanticism*, exh. cat. [Chicago: Art Institute of Chicago, Minneapolis Institute of Arts, and Toledo Museum of Art, 1970], no. 79, with illustration). I thank Judith Stein for calling my attention to the latter picture.

The gap between masculine and feminine perceptions of the Susanna theme continues in the twentieth century. It is instructive to compare Wallace Stevens's poem "Peter Quince at the Clavier," which uses Susanna ("and her shame") as a vehicle for a meditation on beauty and mortality, with Marina Warner's modernized account of the story from Susanna's point of view, in "After Titian's 'Susanna and the Elders,'" *Ms.*, 12 (January 1984): 75–79.

40. The Burghley House *Susanna* was published as a work of Artemisia by Mina Gregori (1968, 414–21). See also Bissell, 1968, 167. The painting, which measures 151.8 x 103.5 cm, was according to the memory of the modern curator purchased in Florence in the eighteenth century by the Fifth Earl of Exeter. As Bissell noted, this provenance, if correct, would prohibit the painting's identification with the *Susanna and the Elders* by Artemisia inventoried in the collection of Charles I in 1639.

41. Harris (Harris and Nochlin, 1976, 121) sees the influence of Guercino in the background and the color scheme.

42. On account of this feature, the Burghley House picture cannot be identified with Artemisia's *Susanna* commemorated in the Venetian poem published in 1627 (see above, pp. 172–73), whose heroine is described as wishing to lift her eyes to heaven but daring not. That description more nearly fits the appearance (though not the expression) of the Pommersfelden *Susanna*.

43. The Burghley House painting is not considered in Bissell, 1981.

44. See above, p. 34; and Bissell, 1968, 154, on Artemisia's marriage to Pietro Antonio di Vincenzo Stiattesi, who may have been related to the G. B. Stiattesi who testified on Tassi's behalf at the trial, as Moir suggested (1967, 1:99, 101.).

45. See above, p. 22, and Appendix B, headnote and narrative.

46. See above, pp. 20–21, and Appendix B, mss. 13–14. Artemisia testified that the rape occurred in May, which would agree with Tuzia's testimony that it was the same day that the group went together to S. Giovanni, a visit that she fixed as during the period she lived with the Gentileschi family in the house on Via della Croce (elsewhere described by Tuzia as lasting from April 10 to July 16 of 1611).

47. See, for example, Bissell, 1968, 153, and also Pugliatti, 1977, 24 and 167.

48. Appendix B, mss. 18–19.

49. Appendix B, ms. 126. Quoted also in Passeri's biography of Tassi; see Bertolotti, 1876, 183–204, 195.

50. I am grateful to Malcolm Campbell for calling to my attention the modern vestiges of older practices concerning rape. See also Germaine Greer, *The Obstacle Race: The Fortunes of Women Painters and Their Work* (New York: Farrar, Straus and Giroux, 1979), 192. On the traditions under which rape was seen as an offense against property, see in particular Bird, 1974, 51–52; and Lorenne M. G. Clark and Debra J. Lewis, *Rape: The Price of Coercive Sexuality* (Toronto: Women's Press, 1977), 115 ff. See also Guido Ruggiero, *The Boundaries of Eros: Sex Crime and Sexuality in Renaissance Venice* (New York and Oxford: Oxford University Press, 1985), ch. 5, which reports that in the fourteenth and fifteenth centuries, claims of rape were often used to force reluctant men into marriage.

51. Appendix B, mss. 42–44. See also Moir, 1967, 1:99 n. 101.

52. Appendix B, mss. 85, 89 ff. See also Wittkower and Wittkower, 1963, 163.

53. Appendix B, ms. 4.

54. Bissell, 1968, 153; Spear, 1971a, 96.

55. Canaday, 1969, 2:364, 366.

56. From an anonymous note on Artemisia added to the English edition of Roger de Piles's *The Art of Painting* (London, 1754), 376.

57. Cf. Moir (1967, 1:100), who adds two scarcely damning bits of information (of unknown origin): that she may have had some relationship with one of her roomers, and that she had a

reputation for writing good love letters. Such reports as these were undoubtedly generated, or at least given credence—like the sexually focussed satirical Venetian epigrams published within a year of Artemisia's death (see above, pp. 137 ff.)—by the reputation for licentiousness that began with the rape trial, which the artist has never escaped. The artist's love life has continued to be emphasized by twentieth-century writers who might have done better, e.g., Lucia Longhi Lopresti, who wrote a fictional romance about her (*Artemisia*, 1947). For a feminist critique of Germaine Greer's treatment of Artemisia as flawed by sexual typecasting, see the review of *The Obstacle Race* by Ti-Grace Atkinson, in *Drawing* 2, no. 1 (May-June 1980): 12–16.

58. Wittkower and Wittkower, 1963, 164. There is no definite evidence of their reconciliation, however; see above, p. 36.

59. Orazio's desire to publicize his daughter's precociousness is expressed in his letter of 1612 to the Grand Duchess of Tuscany (see above, p. 13; and Bissell, 1968, 154).

60. Pugliatti, 1977, 19. Compare Appendix B, ms. 86.

61. These include (1) a painting in the collection of Charles I, mentioned in Van der Doort's inventory as being in Henrietta Maria's chamber at Whitehall (Millar, 1960, 177); (2) a *Susanna* of the 1640s in the house of Dott. Luigi Romeo, Baron of S. Luigi, Naples, said to have been a pendant to the *Bathsheba* in Columbus, Ohio; (3) a signed *Susanna* in Brünn, Czechoslovakia, a heavily damaged and overpainted work, whose design is said to resemble that of the Schönborn *Susanna* (Bissell, 1968, 164); and (4) a *Susanna* signed and dated 1652, known only from the citations of Da Morrona and Lanzi to have been in the collection of Averardo de' Medici (Bissell, 1968, 164). (Nos. 3 and 4 may be identical; see above, p. 131.) In addition to these, Roberto Longhi (1916, 299) attributed to Artemisia a *Susanna* in the Pinacoteca, Naples, that was previously ascribed to Stanzioni; more recently, the work has been given to Francesco Guarino, and now to Andrea Vaccaro.

62. Item (4) in note 61 above; see Bissell, 1968, 164.

63. Cf. Germaine Greer: "The fear of sexual assault is a special fear; its intensity in women can best be likened to the male fear of castration" ("Seduction Is a Four-Letter Word," in LeRoy G. Schultz, ed., *Rape Victimology* [Springfield, Ill.: Thomas, 1975], 376).

## CHAPTER 4

1. Vergil, *Aeneid* 4.630 ff. Guercino's *Death of Dido*, painted in 1631, was commissioned by Philip IV, along with Guido Reni's *Abduction of Helen* and other major works, but was never sent to Spain, and was acquired instead by Cardinal Bernardino Spada. See Costello, 1950, 237–84; and Zeri, 1954, 30–36.

2. The iconography of Sappho and the numerous Romantic images of her suicide are treated in a doctoral dissertation by Judith E. Stein, "The Iconography of Sappho: 1775–1875," University of Pennsylvania, 1979.

3. The antique *Dying Seneca*, formerly in the Villa Borghese and now in the Louvre, served as inspiration for paintings by Rubens and Sandrart. See Francis Haskell and Nicholas Penny, *Taste and the Antique, The Lure of Classical Sculpture, 1500–1900* (New Haven and London: Yale University Press, 1981), no. 76 and figs. 160–61. The theme of the Hanging of Judas, which first appeared in Early Christian ivories, was also popular in the late Middle Ages (Reau, 1955–59, 2:442–43). There are surprisingly few depictions of the death of Socrates. Pigler ([1956] 1974) lists only thirty-one from the seventeenth through nineteenth centuries (by contrast, in an adjacent entry, he lists fifty-five images of the death of Sofonisba, a relatively minor figure). Sardanapalus, of course, did not go alone; Delacroix's picture is as much about the sadistic murder of his female entourage as about his own suicide.

4. Charles Neuringer and Dan J. Lettieri, *Suicidal Women, Their Thinking and Feeling Patterns* (New York: Gardiner Press, 1982), 1 ff.

5. Ibid., 6.

6. Ibid., 5, 8. On Shakespeare's suicides, see M. D. Faber, "Shakespeare's Suicides: Some Historic, Dramatic and Psychological Reflections," in Edwin S. Schneidman, ed., *Essays in Self-Destruction* (New York: Science House Inc., 1967), 30–58.

7. Neuringer and Lettieri, 1982, 86.

8. Plutarch, *The Parallel Lives*, 6.13.2–6 (Loeb Classical Library, 1961).

9. Kolve, 1981, 130–78. The manuscript depiction of the *Deaths of Antony and Cleopatra* here reproduced, illustrating Boccaccio's *De claris mulieribus*, is dated 1410; the illustration of the *Death of Lucretia* is dated c. 1470–83. Kolve reproduces other manuscript examples of these themes, connecting them with *transi* tombs of the period.

10. Ibid., 151.

11. The primary sources are: Livy (begun 27–25 B.C.), *Ab Urbe Condita* 1.57.6–1.60.4; Ovid (after 7 B.C.), *Fasti* 2.721–852; and Dio Cassius (3rd century A.D.), *Roman History* 2.13–20. Other classical accounts of the story are cited in Ian Donaldson, *The Rapes of Lucretia, A Myth and Its Transformations* (Oxford: Clarendon Press, 1982), 5–6. Arthur M. Young, *Echoes of Two Cultures* (Pittsburgh: University of Pittsburgh Press, 1964), though largely superseded by Donaldson's study, contains a useful synopsis of the various versions of and writings on the Lucretia theme, from Roman to seventeenth-century sources. A good comparative analysis of the different accounts is found in R. Thomas Simone, *Shakespeare and 'Lucrece': A Study of the Poem and Its Relation to the Plays* (Salzburg: Institut für Englische Sprache und Literatur, Universitat Salzburg, 1974).

12. Livy 1.58.10–11.

13. Donaldson, 1982, 7.

14. See Robert L. Herbert, *David, Voltaire, "Brutus" and the French Revolution: An Essay in Art and Politics* (New York: Viking Press; London: Allen Lane, 1972); and Robert Rosenblum, *Transformations in Late Eighteenth-Century Art* (Princeton: Princeton University Press, 1967), 69 and fig. 70.

15. The phrase is that of R. M. Ogilvie, explaining Livy's moralized interpretation of the history of the Tarquins (*A Commentary on Livy, Books 1–5* [Oxford: Clarendon Press, 1965], 196).

16. See Jacobus Bergomensis, [1493] 1521, 42ᵛ; and see Don Cameron Allen, *Image and Meaning, Metaphoric Traditions in Renaissance Poetry* (Baltimore: Johns Hopkins University Press), ch. 4, p. 58.

17. A. Alvarez, *The Savage God, A Study of Suicide* (London: Weidenfeld and Nicolson, 1971), 62 ff.

18. The only known representations of the Lucretia theme in classical art have been found on a small group of Etruscan urns. These images, which show not only the suicide of Lucretia but Venus's interference with the revenge upon Tarquinius Sextus, have been interpreted as telling the story from the Etruscan, pro-Tarquin point of view. See Jocelyn Penny Small, "The Death of Lucretia," *American Journal of Archaeology* 80, no. 4 (Fall 1976): 349–60.

19. Donaldson, 1982, 25–26. On the cult of the virgin martyr in the Early Christian church, see Marina Warner, *Alone Of All Her Sex: The Myth and Cult of the Virgin Mary* (New York: Knopf, 1976), ch. 5.

20. Augustine, *The City of God*, Book 1, ch. 19, trans. Rev. Marcus Dods, 2 vols. (Edinburgh: T. & T. Clark, 1871–72), 28–29. See also Donaldson, 1982, ch. 2.

21. A recent discussion of this phenomenon is found in Marilyn French, *Beyond Power: On Women, Men, and Morals* (New York: Summit Books, 1985), 150 ff.

22. Dante, *Inferno* 4.118 ff.; Chaucer, *The Legend of Good Women*, ll.1871–72. See Donaldson, 1982, 26–27, and 175 nn. 17, 18. A useful general survey of the Lucretia theme in literature and drama is found in Hans Galinsky, *Der Lucretia-Stoff in der Weltliteratur* (Breslau: Priebatsch, 1932).

23. The sources cited in this paragraph were adduced by Donaldson, 1982, 31 ff.: Jeremy Taylor, *Ductor Dubitantium or the Rule of Conscience* (London, 1660), vol. 2, bk. 3, ch. 2, 71–79; John Sym, *Lifes Preservative against Self-killing* (London, 1637), 178; William Vaughan, *The Golden-groue*, 2nd ed., enlarged (London, 1608), bk. 1, chs. 24, 28.

24. William Tyndale, "The Obedience of a Christian Man," in H. Walter, ed., *Doctrinal Treatises*, Parker Society (Cambridge, 1848), 183–84 (cited by Donaldson, 1982, 177 n. 35).

25. John Prince, *Self-Murder Asserted to Be a Very Heinous Crime* (London, 1709), 26–27 (quoted by Donaldson, 1982, 35).

26. Coluccio Salutati, *Declamatio* (see Donaldson, 1982, 36; and Hans Baron, *The Crisis of the Early Renaissance* [Princeton: Princeton University Press, 1966], 115). Matteo Bandello, *Le Novelle*, ed. Gioachino Brognoligo, 3 vols. (Bari: G. Laterza & figli, 1931), vol. 3, pt. 2,

Novella XXI, 69–70. Donaldson (1982, 36–37) cites two other examples of writers who doubt Lucretia's chastity, finding the suicide a "tacit confession of her moral corruption": George Rivers, *The Heroinae: Or The Lives of Arria, Paulina, Lucrecia, Dido, Theutilla, Cypriana, Aretaphila* (London, 1639), 67; and Jacques Du Bosc, *The Compleat Woman* (London, 1639), 52 (the latter is an English translation of *L'Honneste Femme* [Paris, 1633–36]).

27. Pietro Aretino, letter to Malatesta, December 20, 1537 (Thomas C. Chubb, *The Letters of Pietro Aretino* [Hamden, Conn.: Archon Books, 1967], 129), also cited by Donaldson, 1982, 89–90.

28. Niccolò Machiavelli, *La Mandragola* [1520], trans. Bruce Penman, in *Five Italian Renaissance Comedies* (Harmondsworth: Penguin, 1978). On Machiavelli's use of parody in this connection, see Donaldson, 1982, 90–94. An interesting analysis of the play is to be found in Hanna Fenichel Pitkin, *Fortune Is a Woman: Gender and Politics in the Thought of Niccolò Machiavelli* (Berkeley-Los Angeles-London: University of California Press, 1984), who points out that Machiavelli regarded the ancient Lucretia as a model of "the danger that women constitute for the rulers of a state" (p. 112). For discussion of the contemporary political overtones in Machiavelli's play, see Ronald L. Martinez, "The Pharmacy of Machiavelli: Roman Lucretia in *Mandragola*," *Renaissance Drama* n.s. 14: *Relations and Influences*, ed. Leonard Barkan (Evanston, Ill.: Northwestern University Press, 1983), 1–43.

29. These and other writers are discussed in Donaldson, 1982, ch. 5.

30. Ibid., 89.

31. Pizan, [1405] 1982, 160–62, 207.

32. Marinelli (1601), in Conti Odorisio, 1979, 114–57. (Marinelli is discussed above, pp. 151 ff.)

33. "You want with foolish presumption, / to find in the girl you seek, / at wooing time, Thais, / and in marriage, Lucrece. . . ." Gerard Flynn, "Sor Juana Ines de la Cruz: Mexico's Tenth Muse (1651–1695)," in J. R. Brink, ed., *Female Scholars: A Tradition of Learned Women before 1800* (Montreal: Eden's Press Women's Publications, 1980), 134–35. Sor Juana, recognized for her learning and literary achievement, fought with the clerical establishment over the right of women to education.

34. Simone de Beauvoir, *The Second Sex*, trans. and ed. by H. M. Parshley (New York: Knopf, 1953), 131.

35. Courtauld negative B69/1316; there described as in the collection of Mr. Serge Philipson.

36. See Costello, 1950, 245; and Ellen Callman, "The Growing Threat to Marital Bliss as Seen in Fifteenth-Century Florentine Paintings," *Studies in Iconography* 5 (1979): 73–92.

37. According to Callman, 1979, the didactic exhortation to civic duty replaced an earlier, courtly celebration of love and marriage; it seems evident, however, that the imagery of the *cassoni* continued to support family values even as it took on public associations. See also Paul Schubring, *Cassoni, Truhen und Truhenbilden der italienischen Frührenaissance*, 2 vols. (Leipzig: Karl W. Hiersemann, 1923), for numerous early Renaissance *cassone* panels that treat the theme of Lucretia. Wolfgang Stechow (" '*Lucretiae Statua*,' " in *Beiträge für Georg Swarzenski zum 11. Januar 1951* [Berlin and Chicago: Verlag Gebr. Mann, with Henry Regnery Co., 1951], 114–24) provides an overview of Renaissance versions of the Lucretia theme. Lucretia was sometimes combined with Camilla as a symbol of chastity (Schubring, 1923, pl. CXI), or with the antique martyr Virginia in late medieval book illustrations (Stechow, 1951, 115 n. 5).

38. Stechow (1951, 118–19) gives the older literature on Marcantonio's engraving after Raphael, of c. 1510–11 (B. 14.VI.192). He connects the statuesque character of this and related early sixteenth-century Lucretias (by Lucas van Leyden, Dürer, Scorel, and others) with a report of a Roman excavation in the first decade of the sixteenth century of an ancient statue believed (probably erroneously) to represent Lucretia, and with a related poem in Latin composed by Pope Leo X, "*in Lucretiae statuam*." Related to these as well is a *Lucretia* at Hampton Court, which was described in the inventory of Charles I as "a Mantua piece by Titian." (See "The Pictures in Hampton Court," editorial in *Burlington Magazine* 81 [August 1942]: 185–86 and illustration.)

39. Stechow, 1951, 116 ff.

40. Michael Jaffé, "Pesaro Family Portraits: Pordenone, Lotto, and Titian," *Burlington Magazine* 113 (1971): 696–702. See also Donaldson, 1982, 16. A *St. Lucretia* by Dosso Dossi in the

National Gallery, Washington, D.C., may have had a similar origin as an intentional echo of a patron's name, in this case, Lucrezia Borgia, wife of Alfonso I d'Este; see Fern Rusk Shapley, *Catalogue of the Italian Paintings*, 2 vols. (Washington, D.C.: National Gallery of Art, 1979), 1:162–63 and vol. 2, pl. 117. The legendary devotion of Andrea del Sarto to his wife Lucrezia resulted in more than one portrait of her, both as herself and allegorized, but apparently not as Lucretia Romana; see Sydney J. Freedberg, "Andrea and Lucrezia: Two New Documents in Paint for Their Biography," in John Maxon, Harold Joachim, and Frederick A. Sweet, eds., *Museum Studies 1* (Chicago: Art Institute, 1966), 15–27.

41. Sodoma's *Lucretia*s, at least four in number, are discussed by Marianne Haraszti-Takacs, "Encore une fois sur les Lucrèce du Sodoma," *Bulletin du Musée Hongrois des Beaux-Arts* 51 (1978): 71–86 and 203–209. The Hannover *Lucretia*, which has been dated c. 1510, was pendant to a *Judith*. The Turin version is a variant of a similarly erotically focussed *Lucretia* of c. 1513–16, now in Budapest. Stechow (1951, 120 ff.) connects Sodoma's *Lucretia*s of c. 1515–16 with Leo X's "*statua*."

42. Lucie-Smith, 1972, 240. For an inventory of Cranach's *Lucretia*s, see Max J. Friedländer and Jakob Rosenberg, *The Paintings of Lucas Cranach* (Ithaca, N.Y.: Cornell University Press, 1978), 78, 80, 94, 102, 116–17, 140, 151.

43. This *Lucretia*, a Lansdowne picture (no. 302 in the 1897 catalogue), was sold on May 16, 1952. The attribution to Reni is not sustained in recent literature (Edi Baccheschi, with Cesare Garboli, *L'opera completa di Guido Reni* [Milan: Rizzoli, 1971]; and D. Stephen Pepper, *Guido Reni, A Complete Catalogue of His Works with an Introductory Text* [New York: New York University Press, 1984], cat. 89, p. 247, who describes it as a studio variant of a Reni *Lucretia* in a New York private collection [pl. 113]).

Less common in the seventeenth century are scenes showing the dead Lucretia attended by a group of men; two examples, however, may be noted: one by Vouet (Dargent and Thuillier, 1965, fig. 31), and one by Francesco Rustici (Borea, 1970, cat. 35).

44. Donaldson, 1982, 13. Titian's two versions of *Tarquin and Lucretia* are discussed by Erwin Panofsky, *Problems in Titian, Mostly Iconographic* (New York: New York University Press, 1969), 139n.; see also Harold Wethey, *The Paintings of Titian*, vol. 3, *The Mythological and Historical Paintings* (London: Phaidon, 1975), cat. 34 and X-34. (The attribution of the Vienna version to Titian is rejected by Wethey). The Fitzwilliam picture, signed by Titian (though executed with some assistance) and engraved by Cornelis Cort, is regarded by Panofsky as reflecting a Raphaelesque design, transmitted through an engraving by Enea Vico (B. XV.287–88).

45. This *Lucretia*, in the Accademia di S. Luca, Rome, has yet to receive a definitive attribution. Formerly given to Cagnacci, it has been reascribed to Biliverti (*L'Accademia Nazionale di S. Luca*, with contributions by Carlo Pietrangeli, Paolo Marconi, Luigi Salerno et al. [Rome: De Luca, 1974], pl. VI, p. 107). A nearly identical version on deposit in the Florentine galleries is ascribed by Giuseppe Cantelli (1983, no. 330) to Ficherelli (il Riposo). Other copies and variants of the Accademia di S. Luca painting are in the Wallace Collection, Dresden, Cassel, Madrid, and elsewhere (Pierre Bautier, "Le opere d'arte italiana nella Francia invasa," *Rassegna d'arte* 19, nos. 9–10 [September–October 1919]: 162).

46. Vouet's lost *Lucretia*, of c. 1625–26, is known through the engraving by Claude Mellan (Dargent and Thuillier, 1965, 46–47; Crelly, 1962, cat. 227). Reni's Potsdam painting of the *Suicide of Lucretia* is generally considered to be the superior version of its type, also datable c. 1625–26; a close replica in the Spada Gallery, Rome, has been regarded by some as autograph (Baccheschi, 1971, 121), but by Pepper (1984, cat. 198, p. 254) as a copy. For other types of Lucretias by Reni, see Baccheschi, 1971, nos. 123, 124, 198, 209; and Pepper, 1984, cats. 89, 103, 108, 176–77, 208, 209.

47. The painting was extended on all sides by a later restorer; see Chapter 1, note 81. The original portion of the canvas, which may itself have been reduced, is visible in Fig. 196.

48. Correggio's *Madonna del Latte*, now in Budapest, was in the Aldobrandini Collection in Rome in the early seventeenth century; following its sale at mid-century, it was described by Pietro da Cortona and G. D. Ottonelli as

the "*famosissima Madonna del Correggio*." It was copied or adapted by a number of artists, including Van Dyck and Pier Francesco Mola. See Cecil Gould, *The Paintings of Correggio* (Ithaca, N.Y.: Cornell University Press, 1976), 196–98; and the exhibition catalog *Important Italian Baroque Paintings, 1600–1700, 1981*, 82.

The Virgin is also seen exposing one breast, especially in late medieval manuscript illustrations, in her role as dual intercessor with Christ, who shows his wounds to God the Father. The image of Mary exhibiting "her heart and breast" to her Son is related to the Madonna *lactans* theme in recalling Mary's power to nourish as well as her compassion. See Barbara G. Lane, "The Symbolic Crucifixion in the Hours of Catherine of Cleves," *Oud-Holland* 87, no. 1 (1973): 1–26.

49. Marino's poetic epigram entitled *Lucrezia Romana* reads as follows: "Lucretia, if you submit to the adulterous Roman without a struggle, you unjustly ask of just Death the fame of a chaste name. If you submit under force, what folly to suffer in dying the penalty of another's sin! In vain then, in vain do you aspire to immortal honors through death, for you die either wicked or mad" (Marino, 1619, 266; this translation from Mirollo, 1963, 48).

50. Donaldson, 1982, 23, a cultural attitude that anthropologists call "transferred pollution." Mary Douglas, *Purity and Danger: An Analysis of Concepts of Pollution and Taboo* (London: Routledge & Kegan Paul, 1966).

51. E.g., Hugh Downman's tragedy, *Lucius Junius Brutus* [1779], cited by Donaldson, 1982, 23–24.

52. *Boswell's Life of Johnson*, ed. R. W. Chapman, new ed., J. D. Fleeman (London, Oxford, and New York, 1970), 393, cited by Donaldson, 1982, 24.

53. This is seen in versions by artists such as Orazio Gentileschi, Caravaggio (lost), El Greco, Rembrandt, Guercino, etc. However, the facial type of Artemisia's anguished heroine, with her knotted brow, may have been drawn from Orazio's *St. Mary Magdalen in Penitence* of c. 1605, at Fabriano.

54. Matthew 26: 36–46; Luke 22: 39–46.

55. Tertullian described Christ's death as a form of suicide, since, the Godhead being omnipotent, the giving of his life must be regarded as voluntary. He was followed in this thinking by Origen, and later by John Donne in *Biathanatos*. See Michael Rudick and M. Pabst Battin, intro. and commentary, *John Donne, Biathanatos*, Garland English Texts, no. 1 (New York and London: Garland, 1982); and Alvarez, 1971, 51.

56. Donaldson (1982, 27 and pl. 15) cites as well Francesco Trevisani's image of Lucretia as a dying Christian martyr.

57. James H. Marrow and Alan Shestack, eds. *Hans Baldung Grien, Prints and Drawings, With Three Essays on Baldung and His Art*, exh. cat. (Washington, D.C.: National Gallery of Art; New Haven: Yale University Art Gallery, 1981), 156.

58. Pierre Le Moyne, *La Galerie des femmes fortes*, 2 vols. (Lyons: Les Libraires de la Compagnie, 1667), 191, 195; see also Donaldson, 1982, 27.

59. The Capodimonte *Lucretia* bears an attribution to Stanzione. The artist, if not Stanzione, was probably Neapolitan, even though the Lucretia theme was not very popular in seventeenth-century Naples.

60. The Potsdam *Lucretia* is discussed above, pp. 131–35, where doubts about its authenticity as an Artemisia are raised. A *Tarquin and Lucretia* probably by Artemisia (rather than Orazio) was inventoried in the collection of Charles I in England in 1633–34 (see above, Chapter 1, p. 111).

61. Rudick and Battin, 1982, xlii; also Alvarez, 1971, 50–51. Earlier, less abstract terms such as "self-killer" and "self-slaughter" reflected the association with murder.

62. Rudick and Battin, 1982, xxiii.

63. Montaigne, "On a Custom of the Isle of Cea," *Essais* 2.3; and Pierre Charron, *De la sagesse* 2.11; both cited by Rudick and Battin, 1982.

64. Burton's *Anatomy of Melancholy* is discussed by Alvarez, 1971, 160 ff.

65. Ioannes Azorius [Juan Azor], *Institutionium moralium*, 3 vols. (Lugduni: H. Cardon, 1600?–1612) (a text in casuistic divinity for the instruction of his order); and Ludovico Carbo, *Summae summarum casuum conscientiae sive totius theologiae practicae, in tribus tomis distributa*, 3 vols. in 1 (Venice: Meiettus, 1606).

66. The tally is by Henry Romilly Fedden, in *Suicide, A Social and Historical Study* (London: P. Davies, Ltd., 1938), 176.

67. *Hamlet*, act 1, sc. 2, lines 129–32; act 3, sc. 1, lines 56 ff.; *Macbeth*, act 1, sc. 7, lines 4–6.

68. Donaldson, 1982, 49.

69. See Simone, 1974, 63–64 and 189–90.

70. On Rembrandt's *Lucretias*, see J. Rosenberg, [1948] 1968, 286–87; and Abraham Bredius, *The Complete Edition of the Paintings by Rembrandt*, rev. by H. Gerson, (London: Phaidon, 1969), nos. 484 and 485. Both pictures are signed and dated. Bredius unconvincingly interprets the Minneapolis picture as representing Lucretia the moment after she has inflicted the wound.

71. Edna St. Vincent Millay, "Dirge without Music," in *Collected Poems* (New York: Harper, 1949), 240–41.

72. Michael Hirst, "Rembrandt and Italy," letter in *Burlington Magazine* 110 (April 1968): 221.

73. Kenneth Clark, *Rembrandt and the Italian Renaissance* (New York: W. W. Norton, 1966).

74. Cf. ibid., esp. 10 ff.

75. There is, of course, a visual tradition for un-idealized, physically ugly women in sixteenth-century Germany art, but such images as Dürer's *Nemesis*, or the witches of both Dürer and Baldung Grien, are intended as negative figures, not as goddesses or ordinary benign humans.

76. Otto Benesch, *The Drawings of Rembrandt*, 6 vols. (London: Phaidon, 1954–57), 1:38. The red chalk drawing, now in the J. Paul Getty Museum, measures 245 x 140 mm.

77. Clark, however, questions this traditional interpretation (1966, 108–10).

78. Two versions of Orazio's *Danae* exist, the one in Cleveland and a recently discovered picture in the hands of Richard L. Feigen, New York. While there remains some controversy over which of the two extant versions by Orazio might be the Sauli version, the differences between them are slight, and both versions are generally accepted as authentic works by the artist, close in date. See Bissell, 1981, cats. 49 and 50.

79. Panofsky connected Rembrandt's *Danae* with the now-destroyed Bridgewater House *Danae* attributed to Annibale Carracci (Erwin Panofsky, "Der gefesselte Eros [Zur Genealogie von Rembrandts Danae]," *Oud-Holland* 50, no. 5 [1933]: 193–217). This mannered, marmoreal goddess from the Carracci studio (but sometimes ascribed to Domenichino) may have been Orazio's own prototype, which, as Bissell suggested (1981, 49), could have helped launch him into the production of commercially successful female nudes. Yet Orazio's *Danae* seems a more probable compositional intermediary for Rembrandt. Ann T. Lurie has suggested that Rembrandt knew both the Carracci and Gentileschi examples (Ann T. Lurie, "Pictorial Ties between Rembrandt's *Danaë* in the Hermitage and Orazio Gentileschi's *Danaë* in the Cleveland Museum of Art," *Acta Historiae Artium* 21, nos. 1–2 [1975]: 75–81). A *Reclining Venus* by Spadarino of c. 1618–20 is related to these works; see *In the Light of Caravaggio*, 1976, no. 4.

80. Madlyn Millner Kahr ("Danaë: Virtuous, Voluptuous, Venal Woman," *Art Bulletin* 60 [March 1978]: 43–55) has discussed the Rembrandt *Danae* and its pictorial models, exploring the iconographic implications of his changes, which resulted in a new, positive image of the heroine.

81. See Clark, 1966, 41 ff. and 193 ff.

82. Bissell, 1981, 51; and see above, pp. 56 ff. See also C. Brown, 1982, 61, 134–35.

83. C. Brown, 1982, 128–30.

84. Clark, 1966, 30–32.

85. The late Alessandro Morandotti informed me in 1979 that the drapery had at some point been added to the figure, and was removed by a later restorer. The resolution of this problem must await careful technical examination of the painting.

The question of the Milan *Cleopatra*'s original appearance in this respect is complicated by a work that recently appeared on the art market, a small-scale replica on copper of the *Cleopatra* (transformed into a *Danae*). The new painting, acquired in 1986 by the Saint Louis Art Museum, was published as by Artemisia in *Baroque III*, 1986, 52 and fig. 1, but is considered by Bissell, S. J. Freedberg, and others to be by Orazio. In my opinion, this work cannot be by Artemisia's hand, and although the bland refinement of the figure somewhat recalls Orazio's style, it is more likely to have been painted by a later artist. The *Danae* appears to have been modelled upon the *Cleopatra* in its restored state, when an 18–20 cm strip augmented the area above the figure (see above, Chapter 1, n. 81). If I am right in thinking that the repainted pubic area of the *Cleopatra* covers drapery original to the picture, then the *Danae* would postdate that

86. John Berger, *Ways of Seeing* (London: British Broadcasting Corporation; Harmondsworth: Penguin, 1972), 59.

87. Plutarch, *Lives*, 9.85–86; and Dio Cassius, *Roman History*, 11.13–15.

88. The School of Fontainebleau engraving (B. XVI.392.41) may follow an ancient tradition that Cleopatra's death was caused by not one but two snakes, a view reflected in the accounts of Propertius and Virgil (see Michael Grant, *Cleopatra* [New York: Simon and Schuster; London: Weidenfeld and Nicholson, 1972], 227). Sebastiano Mazzoni (1611–78), a pupil of the Florentine Cristofano Allori who later moved to Venice, painted several such theatrical and erotic Cleopatras; another example is illustrated in *Le Caravage et la peinture italienne du XVIIe siècle*, exh. cat., Paris, Musée du Louvre, February–April 1965 (Paris: Ministère d'Etat, Affaires culturelles, 1965), 181–83. The *Cleopatra* by Domenico Maria Muratori (c. 1661–1744) is discussed by Zeri, 1954, 101.

89. On the relation of Bandinelli's design (as executed by Agostino Veneziano, B. 14.VI.193) to the Marcantonio engraving of *Lucretia* discussed above (Fig. 184), and the connection of both with a damaged Lucretia marble relief in the Walters Art Gallery, Baltimore, see Wolfgang Stechow, "The Authorship of the Walters 'Lucretia,'" *Journal of the Walters Art Gallery* 23 (1960): 73–85. Bandinelli's design is also discussed in Karla Langedijk, "Baccio Bandinelli's *Orpheus*: A Political Message," *Mitteilungen des Kunsthistorischen Institutes in Florenz* 20, no. 1 (1976): 33–52. On this Guercino *Cleopatra* (formerly with Thomas Agnew & Sons, London, and now at the Norton Simon Museum, Pasadena, California), see Denis Mahon, *Il Guercino (Giovanni Francesco Barbieri, 1591–1666)*, exh. cat., Palazzo dell'Archiginnasio, September 1–November 18, 1968 (Bologna: Alfa, 1968), no. 48, who dates the painting to the end of 1621. See also Charles McCorquodale, "Italian Painting of the Seventeenth and Eighteenth Centuries," *Connoisseur* 193 (November 1976): 205–206.

90. Guido Cagnacci, or Canlassi (1601–1681), a follower of Reni who worked in Vienna at the court of Emperor Leopold, has like his master been assigned the authorship of several Lucretia and Cleopatra pictures. See Bautier, 1919, no. 9–10, 162.

According to L. Masson ("L'aspic de Cleopatre—la mordit-il au sein?" *Aesculape* 20 [1930]: 118 ff.), the only early writer to say that Cleopatra was bitten on her breast was Paul of Aegina (whose account, written some 700 years after Cleopatra's death, is loosely based on Galen). G. Watson, in a set of letters written to the Warburg Institute in 1963, noted that from the late sixteenth century, dramatists (including Shakespeare) began to describe Cleopatra as applying the asp to her breast. The error was noted by Sir Thomas Browne (*Pseudodoxia Epidemica* [1646], bk. 5, ch. 12), who also cites the Florentine Petrus Victorius (or Pettori; 1499–1585) as blaming artists for this deviation from the accounts of ancient writers.

91. Catherine and Robert Enggass, trans. and intro., *Carlo Cesare Malvasia, The Life of Guido Reni* (University Park, Pa., and London: Penn State University Press, 1980), 85. The poet "Bruni" is not further identified by Malvasia.

92. Another Cagnacci *Cleopatra*, seated in a chair alone, is of this type (Spiridon Collection, Rome, illustrated in Milton Gendel, "The Italians from the Dying Renaissance to the Futurist Explosion," *Art News* 58 [October 1959]: 27). See also Bautier, 1919, 9–10, 162–63.

93. Malvasia ([1678] 1841, 2:375–76) lists in his inventory of Guercino's paintings, marginally annotated with the year of execution, "*una Cleopatra in letto moribonda à Monsig. Carlo Durazzi Genovese*" (1648), and "*una Cleopatra moribonda al sig. Girolamo Pauese da Genova*" (1649). Aside from this reference, which establishes the connection between the painting now in the Palazzo Rosso and one of the two citations (probably the earlier one), the Guercino literature is silent about the *Cleopatra*. (See, however, Orlando Grosso, *Genova* [Italia Artistica] [Bergamo: Istituto italiano d'arti grafiche, 1926], 112, who reproduces and locates the painting.) Even more closely related to Guercino's *Cleopatra* than Artemisia's Genoa *Cleopatra* is her recently attributed second version (Color Plate 17), and this work may have been his direct source.

An unusual number of Cleopatras seem to

have been produced for Genoese patrons. In addition to Artemisia's and the two by Guercino, Reni produced two of his four Cleopatras named by Malvasia for the Genoese patrons Cesare Gentile and Agostino Franzone (see Enggass and Enggass, 1980, 147–50). Artemisia's picture, also painted for a member of the Gentile family, may have set off a Cleopatra competition, such as the one Malvasia describes Reni to have been invited to join in Venice (Enggass and Enggass, 1980, 129).

94. The statue was moved to the Stanza della Cleopatra in the 1550s from a fountain installation in the Belvedere; see Hans Henrik Brummer, *The Statue Court in the Vatican Belvedere* (Stockholm: Almquist & Wiksell, 1970), 155. An important discussion of the Vatican *Ariadne* is found in Elisabeth B. MacDougall, "The Sleeping Nymph: Origins of a Humanist Fountain Type," *Art Bulletin* 57 (1975): 357–65. A replica of the Vatican statue now in the Museo Archeologico, Florence, but in the seventeenth century displayed in the Villa Medici, may also have been known to Artemisia; see Clelia Laviosa, "L'Arianna Addormentata del Museo Archeologico di Firenze," *Archeologia Classica* 10 (1958): 164–71.

95. MacDougall, 1975, 359. The pose may be multivalent; in the ancient *Laocoon* it is often said to denote pain, while in Michelangelo's Louvre *Dying Slave*, the same arm position suggests both sleep and death.

96. Brummer, 1970, 154; see also Otto Kurz, "*Huius Nympha Loci*: A Pseudo-Classical Inscription and a Drawing by Dürer," *Journal of the Warburg and Courtauld Institutes* 16 (1953): 171–77. Winckelmann reinterpreted the statue as not Cleopatra, but a sleeping nymph; already in the sixteenth century there were those who expressed uncertainty about the Cleopatra identification (Kurz, 1953, 174–75).

97. A. Veneziano (B. XIV.161.198, "after Raphael"). Brummer (1970, 183) interprets Cupid as reference to Cleopatra's series of sexual conquests, the end of which is now lamented on her death. Another example of a dying Cleopatra based upon the *Sleeping Ariadne* is by Marcantonio; see also two examples by the Master of Year 1515 (Brummer, 1970, figs. 156, 157, 160). The association between Cleopatra and Venus, already suggested in antiquity

when Caesar placed a statue of the queen in the Temple of Venus Genetrix (Dio Cassius, *Roman History* 51.22; see also Brummer, 1970, 182 n. 61), was sustained in Renaissance imagery (e.g., Jacopo Francia's *Cleopatra* print [B. XV.459.6], in which a nude Cleopatra stands in a Venusian contrapposto accompanied by a cupid with a bow; see also Jan van Scorel's *Cleopatra*, discussed below).

98. Millard Meiss, "Sleep in Venice: Ancient Myths and Renaissance Proclivities," in idem, *The Painter's Choice: Problems in the Interpretation of Renaissance Art* (New York: Harper & Row, 1976), 216.

99. Bissell (1981, 202) also connected Artemisia's *Cleopatra* with Venetian art, and with her visit to Venice in the early 1620s.

100. It was Saxl who first related Giorgione's *Venus* to the woodcut illustration (*A Heritage of Images, A Selection of Lectures by Fritz Saxl* [1957], ed. Hugh Honour and John Fleming [Harmondsworth: Penguin, 1970], 73; see also Meiss, 1976, 14.) Vestiges of a cupid formerly at the feet of Venus in Giorgione's Dresden picture have been revealed by x-ray; the question whether the cupid was added by Titian or painted in later has not been resolved. See Meiss, 1976, 14; George M. Richter, *Giorgio da Castelfranco, Called Giorgione* (Chicago: University of Chicago Press, 1937), 215–16; and Terisio Pignatti, *Giorgione*, trans. Clovis Whitfield (London: Phaidon, 1971), 108.

Jaynie Anderson ("Giorgione, Titian and the Sleeping Venus," in *Tiziano e Venezia, Convegno internazionale di studi* [Venice: Neri Pozza Editore, 1980], 337–42) has traced the literary origins of Giorgione's *Venus* to the epithalamium of late Latin literature, a prenuptial song that glorified love, as personified by Venus and Cupid. In poems by Claudian, Ennodius, and others, Venus's slumber in a sacred landscape precedes her journey to the wedding over which she presides.

101. The approach of Priapus to Lotis is known to us through the example of Bellini's *Feast of the Gods*. The discovery of Ariadne sleeping on the island of Naxos by Bacchus (Dionysos) was depicted in a number of ancient frescoes; see Salomon Reinach, *Répertoire de les peintures grecques et romaines* (Paris: Editions Ernest Leroux, 1922), 111–13; a later example by Giovanni di Paolo is illustrated by Meiss,

1976, fig. 223. The unveiling of Ariadne by a satyr is seen on a sarcophagus illustrated by MacDougall, 1975, fig. 6.

102. MacDougall, 1975, 357; Brummer, 1970, 154 ff.

103. Translation by Alexander Pope, from a letter to Edward Blount, June 2, 1725 (*Correspondence*, ed. J. W. Crocker [London, 1871], 1:384), cited by Saxl, among others (Saxl, 1970, 77). The pseudo-antique epigram appeared in a manuscript dated between 1477 and 1484; widespread imitations of the image described, both pictorial and poetic, are discussed by MacDougall, 1975, 357 ff. Cranach's painting of the Sleeping Nymph is illustrated in Kurz, 1953, fig. 24a; a figure of the same type appears in Claude Lorrain's *Narcissus* (National Gallery, London; see Kurz, 1953, fig. 24b).

104. Numerous examples are illustrated by Meiss, 1976; and by Kurz, 1953, esp. 23 and 24. The Diana relief described by Meiss (1976, 219) forms the front of a late-Quattrocento sarcophagus in the Palazzo Odescalchi, Rome.

105. Scorel's *Cleopatra* was painted some years after he had visited Venice in c. 1520–21, and after he had spent time in Rome, where he worked with the antique collection in the Vatican Belvedere during the pontificate of Adrian VI (1522–24). See G. J. Hoogewerff, *Jan van Scorel, Peintre de la Renaissance Hollandaise* (The Hague: M. Nijhoff, 1923), 28–29.

106. This fountain was in the Casa Salviati, Rome; see Kurz, 1953, 173.

107. The question that prompted Elisabeth MacDougall to her investigation was posed by Marilyn Aronberg Lavin (MacDougall, 1975, 357).

108. Meiss, 1976, 223.

109. MacDougall, 1975, 359–61; she observes, however, that the ancient Ariadne figure type may not have been known in the Renaissance, and suggests that literary sources (passages in Propertius and Pliny) may account instead for the representation of a fountain nymph as a reclining sleeping figure.

110. Kurz, 1953, 174.

111. These examples of sleeping women and many more are assembled in Kurz, 1953; MacDougall, 1975; and Meiss, 1976. Jefferson's intention to create a grotto containing a sleeping nymph, accompanied by Pope's translation of the epigram, is mentioned by MacDougall, 1975, 365.

112. This engraving by Marcantonio of an unidentified subject (B. XIV.274.359; despite the name, it is doubtful that it reproduces a Raphael design) may derive from the same lost Giorgione painting as Campagnola's engraving (Fig. 229). See Meiss, 1976, 217; and Richter, 1937, pl. LXII and p. 259.

113. See Erwin Panofsky, *Studies in Iconology: Humanistic Themes in the Art of the Renaissance* [1939] (New York and Evanston, Ill.: Harper Torchbooks, 1962), ch. 5.

114. On the subject of the traditional association between women and nature, see esp. Sherry B. Ortner, "Is Female to Male as Nature Is to Culture?" in Michelle Z. Rosaldo and Louise Lamphere, eds. *Woman, Culture, and Society* (Stanford, Calif.: Stanford University Press, 1974), 67–87; Susan Griffin, *Woman and Nature: The Roaring Inside Her* (New York: Harper & Row, 1978); and Merchant, 1980.

115. My interpretation of Egypt and Cleopatra as archetypally female is indebted to Marilyn French, *Shakespeare's Division of Experience* (New York: Summit Books, 1981), especially 254–65; and Linda Bamber, *Comic Women, Tragic Men: A Study of Gender and Genre in Shakespeare* (Stanford, Calif.: Stanford University Press, 1982), ch. 2. French, 1985, and Gerda Lerner, *The Creation of Patriarchy* (New York and Oxford: Oxford University Press, 1986) are important recent syntheses of the scattered literature on women, nature, and the birth of patriarchy in Western history.

116. *Antony and Cleopatra*, 2.2.196–209.

117. This myth has been traced to a short passage in the *Liber de viris illustribus* (86,2) (of Diodorus Siculus?): "*Haec tantae libidinis fuit, ut saepe prostiterit, tantae pulchritudinis ut multi noctem illius morte emerint*" (cited in Mario Praz, *The Romantic Agony* [1933], trans. Angus Davidson [Oxford and New York: Oxford University Press, 1951] 204).

118. Swinburne and Gautier are discussed and quoted at length in Praz, [1933] 1951, 203–281, esp. 242. Anna Jameson shared her era's disapproval of Cleopatra, yet was clearly fascinated by, and deeply sympathetic to, the character as depicted by Shakespeare (Mrs. Anna Brownell Jameson, *Characteristics of Women: Moral, Poetical, and Historical* [London: Saunders and Otley, 1833], 95–141).

119. Casa Buonarroti, cat. no. 133 *recto*; black chalk, 23.2 x 18.2 cm. See Ludwig Goldschneider,

*Michelangelo Drawings* (Greenwich, Conn.: Phaidon, 1951), no. 96, on the authenticity of this drawing, which some writers have considered a copy.

120. Swinburne, "Notes on Designs of the Old Masters in Florence" [1864], in *Essays and Studies* (London: Chatto and Windus, 1875), quoted by Praz, 1951, 239–41. The rest of the description sustains the theme of analogy between hair and snakes: "Here also the electric hair, which looks as though it would hiss and glitter with sparks if once touched, is wound up to a tuft with serpentine plaits and involutions; all that remains of it unbound falls in one curl, shaping itself into a snake's likeness as it unwinds, right against a living snake held to the breast and throat."

121. Cf. also Piero di Cosimo's so-called portrait of Simonetta da Vespucci as Cleopatra, Musée Condé, Chantilly. Eve Borsook has suggested that the serpent draped around the woman's neck and biting its tail may be an emblem of Lorenzo di Pierfrancesco de' Medici (see Frederick Hartt, *History of Italian Renaissance Art*, 2nd ed. [Englewood Cliffs, N.J.: Prentice-Hall; New York: Harry N. Abrams, 1979], 486), an interpretation that does not fully explain the relation of the Cleopatra theme to this curious female image.

122. Estienne Jodelle, *Cléopâtre Captive* [1552], crit. ed. by Lowell B. Ellis, "Estienne Jodelle, Cléopâtre Captive," Ph.D. dissertation, University of Pennsylvania, 1946. (See also Oliver C. de Champfleur Ellis, *Cleopatra in the Tide of Time* [London: Williams and Norgate, 1947], 91 ff.) Jodelle's Cleopatra, like the heroine of other sixteenth-century Cleopatra dramas, including Shakespeare's, is a character drawn from Plutarch, whose seductive feminine charm is balanced by a queenly pride and a basic loyal devotion to Antony. Thomas May (1639) reversed this traditional approach, presenting the heroine not as a loyal and loving consort, but as a schemer seeking to forward her own interests. See Denzell S. Smith, " 'The Tragoedy of Cleopatra Queene of Egypt' by Thomas May, A Critical Edition," Ph.D. dissertation, University of Minnesota, 1965 (Garland Series, *Renaissance Drama, A Collection of Critical Editions*, ed. Stephen Orgel [New York: Garland, 1979]), lxxiv ff.

123. Jean Guillaume, "Cleopatra Nova Pandora," *Gazette des Beaux-Arts* 80 (October 1972): 185–

94. The association between Pandora and Eve is treated in Dora and Erwin Panofsky, *Pandora's Box, The Changing Aspects of a Mythical Symbol* [1956], Bollingen Series 52 (New York: Pantheon Books, 1962).

124. Guillaume (1972, 191–92) suggests that Diane de Poitiers may have been compared by her enemies to *femmes fatales* of antiquity.

125. Castiglione's poem on the *Cleopatra* (Pier Antonio Serassi, *Delle lettere del Conte Baldessar Castiglione*, vol. 2 [Padua: G. Camino, 1769–71], 293) is quoted by Brummer, 1970, 220–21. The other poem, attributed to Evangelista Maddaleni Fausto di Capodiferro (quoted by Brummer, 1970, 221–22) compares, as does Castiglione, the Belvedere installation of the statue with the ancient triumphal effigy of the dead queen (see note 127, below).

126. See Christoph L. Frommel, " 'Capella Iulia': Die Grabkapelle Papst Julius' II in Neu-St. Peter," *Zeitschrift für Kunstgeschichte* 40, Heft 1 (1977): 26 ff.; and Garrard, 1984b, 342, 357–58.

127. Plutarch, *Lives*, 9.86.3. See also Brummer, 1970, 220. A painting identified as the effigy of Cleopatra allegedly carried in Octavian's triumphal procession, discovered near Rome in the early nineteenth century, has been dismissed as a forgery. See Reinach, 1922, 221, no. 5; and John Sartain, *Peinture Grecque sur ardoise a l'encaustique représentant la Reine Cléopâtre se donnant la mort, au moyen du serpent africain le "naja"* (Nice: Berna & Barra, 1889); and (for the rejection) Otto Kurz, *Fakes, A Handbook for Collectors and Students* (London: Faber and Faber, 1948), 78–79.

  Antique portraits of Cleopatra (unrelated to Caesar's effigy) are discussed in Klaus Vierneisel, "Die Berliner Kleopatra," *Jahrbuch der Berliner Museen* 22 (1980): 5–33.

128. Erik Iversen, *The Myth of Egypt and Its Hieroglyphs in European Tradition* (Copenhagen: Gad, 1961). The association between Cleopatra and obelisks, reflected in the several examples called "Cleopatra's Needle," began with sixteenth- and seventeenth-century travellers to Alexandria, who connected the obelisks lying near the "palace of Alexander" with the queen they thought must have built the palace (see Erik Iversen, *Obelisks in Exile*, vol. 2, *The Obelisks of Istanbul and England* [Copenhagen: Gad, 1968–72], 94–95).

129. Dante, *Inferno*, canto V, line 63; Boccaccio, *De Claris Mulieribus*, ch. 86 (Boccaccio, [1473]

1963, 192–93). See also D. Smith, 1965, lxxiv ff., which discusses attitudes toward Cleopatra of these writers, as well as Chaucer, Daniel, Jodelle, etc.

130. Dio Cassius, *Roman History*, 51.15.4; and Propertius, 3.11, 30, who describes her as "*incesti meretrix regina Canopi,*" the royal whore of lewd Canopius, a suburb of Alexandria known for its immorality (Hans Volkmann, *Cleopatra, A Study in Politics and Propaganda*, trans. T. J. Cadoux [New York: Sagamore Press, 1958], 214). Sarah Booth Pomeroy (*Women in Hellenistic Egypt, From Alexander to Cleopatra* [New York: Schocken Books, 1984], 26–27) explains this as a result of the anomalous classification of a non-wife who consorted with Roman male leaders, for whom the relevant category was courtesan (*meretrix*). See also Grant, 1972, 178; and Ilse Becher, *Das Bild der Kleopatra in der Griechischen und Lateinischen Literatur*, Deutsche Akademie der Wissenschaft zu Berlin, Schriften der sektion für Altertumswissenschaft (Berlin: Akademie-Verlag, 1966).

131. *Aeneid*, Book 8. See Jack Lindsay, *Cleopatra* (London: Constable, 1971), 360 ff.; Volkmann, 1958, 216; and Ellis, 1947, 52 ff. Lindsay interprets the *Aeneid* itself (begun in 30 B.C., shortly after Cleopatra's death) and the characters Aeneas and Dido as having been strongly shaped by the recent memory of Antony and Cleopatra.

132. Horace, *Odes* 1.37; see Lindsay, 1971, 438.

133. Volkmann, 1958, 220 ff.; and Grant, 1972, 239 ff. As Grant has noted, a particularly unfortunate loss is the *History* of Gaius Asinius Pollio, who was a supporter of Antony and wrote about events down to 42 B.C., and perhaps as far as 36–35 B.C.

134. See Ernle Bradford, *Cleopatra* (New York: Harcourt Brace Jovanovich, 1972), 13 ff.; and Grant, 1972, ch. 1, who stresses her Macedonian Greek (not Egyptian) ancestry. An unsentimental assessment of Cleopatra's character and intellectual and political skills is also put forth by Grace H. Macurdy, *Hellenistic Queens, A Study of Woman-Power in Macedonia, Seleucid Syria, and Ptolemaic Egypt* (Baltimore: The Johns Hopkins University Press, 1930), 184 ff. See also the brief discussion of the historical Cleopatra in Pomeroy, 1984, 24–28.

135. Dio Cassius, *Roman History*, 50.5.5.

136. See Bradford, 1972, 53 ff., especially 70; and Volkmann, 1958, 122 ff. and 215, who explains the political situation. Cleopatra gave Caesar and Antony the access to Egypt that they gave her to Rome; in 37 B.C., Antony gave Cleopatra large gifts of territory, a donation that angered Rome.

137. Grant, 1972, ch. 15, especially 235–36. The Sibylline oracular prophecies, produced in the last two centuries B.C., foretold the righteous defeat of Rome by "Asia," in the person of "the Queen," and the subsequent rule of Homonoia. Different forms of these verses were differently interpreted, and the avenger figure from the East was variously identified with Cleopatra, the Jews, and Christ. See Grant, 1972, 172–78; and Lindsay, 1971, 355–80, who also discusses the recurrent appearance in late Roman literature of the idea of Rome's downfall and replacement by a golden age of equalized East and West.

138. Grant, 1972, 7.

139. Plutarch, *Lives*, 9.54.6. See also Pomeroy, 1975, 224–25.

140. Lindsay, 1971, 245; Grant, 1972, 26–27 and 117–20.

141. Grant, 1972, 111–12.

142. Grant, 1972, 25–26. "*Neos Dionysos*" was expressed in the hieroglyphic texts as "the young Osiris" (Volkmann, 1958, 48; see also 28 ff.).

143. Grant, 1972, 116.

144. Plutarch, in the passage that inspired Shakespeare's famous description of Cleopatra's barge on its journey to Tarsus (*Lives* 9.25.4ff), says that Cleopatra was dressed in the character of Aphrodite; Caesar put a statue of Cleopatra in the Temple of Venus Genetrix in Rome, which was still standing in the third century A.D. (Grant, 1972, 115–17; 233).

145. See Nancy Luomala, "Matrilineal Reinterpretations of Some Egyptian Sacred Cows," in Broude and Garrard, 1982, 19–31; Evelyn Reed, *Woman's Evolution, From Matriarchal Clan to Patriarchal Family* (New York: Pathfinder Press, 1975), 437 ff.; E. O. James, *The Cult of the Mother Goddess: An Archaeological and Documentary Study* (London: Thames and Hudson, 1959), 55; and Robert Briffault, *The Mothers: A Study of the Origin of Sentiments and Institutions*, 3 vols. (New York: Macmillan, 1927), 3:37 ff.

146. For example, Arsinoe II, the sister-wife of Ptolemy II Philadelphus, and Cleopatra II, sister-wife of Ptolemy VI Philometor (see Grant, 1972, 47–48). Patriarchal custom was evidently well enough established by this time, however, for female co-rulers to take second place to the kings.

147. Barbara G. Walker, *The Woman's Encyclopedia of Myths and Secrets* (New York: Harper & Row, 1983), 454–55.

148. Luomala, 1982, 25–27.

149. Lindsay, 1971, 433–34; and Grant, 1972, 226–27 nn. 44, 45. The Roman goddess Hygeia is also depicted holding snakes; for the connection between this goddess and Isis-Salutaris, see Ennio Quirino Visconti, *Oeuvres de Ennius Quirinus Visconti, Musée Pie-Clémentin*, 7 vols. (Milan: T. P. Giegler, 1818–22), 7:22–26 and pl. V.

150. Lindsay, 1971, 433 ff. See also Reginald Eldred Witt, *Isis in the Graeco-Roman World* (Ithaca, N.Y.: Cornell University Press, 1971), 34. Pomeroy (1984, 28) observes that "it was surely by design that Cleopatra chose to be killed by cobra's poison, for this animal was an ancient symbol of Pharaonic power." Pomeroy also notes (p. 28) that Charmion used the masculine form of the Greek word for "descendant" in describing Cleopatra's death.

151. It has also been speculated that the legend of Cleopatra's death by poisonous asp arose from the sight of an Isis or an Isis/Cleopatra image (and not a newly created portrait) being carried in the triumphal procession (see Grant, 1972, 227).

152. The relief dates from the second century A.D. Reliefs on the temple of Hathor at Dendera show Cleopatra, wearing the headdress of Isis, offering incense, walking behind her son Caesarion, who is depicted as a pharaoh (Bradford, 1972, 10–11; see also Lindsay, 1971, 124; and Kurt Lange and Max Hirmer, *Egypt: Architecture, Sculpture, Painting in Three Thousand Years*, 2nd ed. [London: Phaidon, 1957], 528–29).

153. This statue was not yet in the Vatican in Artemisia's day; Amelung states that it was acquired by Pius VI in the eighteenth century from the collection of a "Consigliere Bianconi" (Walther Amelung, *Die Sculpturen des Vaticanischen Museums, im auftrage und unter mitwirkung des kaiserlich deutschen archäologischen instituts (römische abteilung)*, 4 vols. [Berlin: G. Reimer, 1908], 2:179–80). However, this work—or one like it—may well have been known to artists in a private Roman setting. The sleeping figure was catalogued in the early nineteenth century in the Museo Pio-Clementino as a "Bacchic nymph" that may have adorned a woman's sarcophagus; Visconti, 1818–22, vol. 3, pl. XLIII and pp. 205 ff.

154. Titian's *Bacchus and Ariadne* in the National Gallery, London, which remains the best known Renaissance example of their encounter, does not depend formally on antique prototypes of the same theme. Those found at Pompeii, for example, show a reclining Ariadne; see Fig. 223, and Reinach, 1922, III–13.

155. Some Pompeiian wall-paintings show Ariadne wearing a snake on one arm (*Real Museo Borbonico*, 16 vols. [Naples: Stamperia reale, 1827–57], vol. 3, pl. 19, and pp. 255–59). For the myth of Ariadne and its relation to the Neolithic goddess, and for the snake cult on Crete, see Graves, 1960, 2:98.5, 98.9. Sir Arthur Evans (*The Palace of Minos, A Comparative Account of the Successive Stages of the Early Cretan Civilization as Illustrated by the Discoveries at Knossos* [1921], 6 vols. in 4 [New York: Biblo and Tannan, 1964]) provides extensive discussion of the Snake Goddess as an aspect of the Minoan Goddess and of the Cypriote Ariadne as a form of the Goddess, as well as of the relationship between Minoan and Egyptian Goddess imagery, the latter represented by Hathor-Isis (see especially 1:495–523; 3:74; and 4:158–77).

156. Cesare Ripa, "Logica" (second entry), *Iconologia* [Rome, 1603], ed. Erna Mandowsky [Hildesheim and New York: Georg Olms Verlag, 1970], 299. Ripa's similar entry for Prudence, who also holds a serpent, ends with the scriptural homily, "*Estote prudentes sicut Serpentes*" (Ripa, [1603] 1970, 417).

157. Giulio Bonasoni, *Dialectic*, in Achille Bocchi, *Symbolicarum quaestionum de universo genere quas serio ludebat libri quinque* (Bologna: Apud Societatem Typographiae Bononiensis, 1555), LXII. This influential emblem book is briefly discussed by Irving Lavin, "Divine Inspiration in Caravaggio's Two 'St. Matthews,'" *Art Bulletin* 56 (March 1974): 73.
A painting by Rubens in the Detroit Institute depicting either Cleopatra or Hygeia, a variant of the version in Prague that has been

dated c. 1615, shows a standing figure with a snake entwined around her forearm, which she feeds from a cup. This image is to be connected with Roman Hygeia statues (and not the "sleeping nymph" tradition), which are in turn, however, closely related to images of Isis Salutare (cf. Visconti, 1820, vol. 7, pl. V). See Jaromír Síp, "Obrazy Petra Paula Rubense v Prazské Národní Galerii," *Umení* 26, no. 3 (1978): 193–210; and *Masterpieces of Painting and Sculpture from The Detroit Institute of Arts* (Detroit: Detroit Institute of Arts, 1949), 101, where the figure is described as Hygeia.

158. Bernard Berenson, *Piero della Francesca, or, The Ineloquent in Art* (London: Chapman & Hall, 1954).

159. Plutarch, *Lives*, 9.54 (Loeb ed., p. 263), relates that Cleopatra "assumed a robe sacred to Isis, and was addressed as the New Isis"; see also 9.74, and Jodelle, 1552, 2:771–76 (Ellis, 1947, 95).

160. Apuleius, *The Golden Ass* (Loeb Classical Library, 1965), bk. 11. See also Michael Lloyd, "Cleopatra as Isis," *Shakespeare Survey* 12 (1959): 88–94; and James Tatum, *Apuleius and the Golden Ass* (Ithaca, N.Y.: Cornell University Press, 1979). In a recent study, Barbara Bono has also interpreted Shakespeare's Cleopatra as a figure of creative regeneration in the light of Neoplatonic views of Venus and Isis, and points to Shakespeare's own source in Lucretius, *De rerum natura* (Barbara J. Bono, "What Venus Did with Mars in Shakespeare's *Antony and Cleopatra*," in Barbara J. Bono, *Literary Transvaluation: From Vergilian Epic to Shakespearean Tragicomedy* [Berkeley: University of California Press, 1984]). I thank Peggy Simonds for calling my attention to these two articles.

161. "For the Phrygians that are the first of all men call me the Mother of the gods at Pessinus; the Athenians, which are sprung from their own soil, Cecropian Minerva; the Cyprians, which are girt about by the sea, Paphian Venus; the Cretans which bear arrows, Dictynnian Diana; the Sicilians, which speak three tongues, infernal Proserpine; the Eleusians their ancient goddess Ceres; some Juno, other Bellona, other Hecate, other Rhamnusia, and principally both sort of the Ethiopians which dwell in the Orient and are enlightened by the morning rays of the sun, and the Egyptians,

which are excellent in all kind of ancient doctrine, and by their proper ceremonies accustom to worship me, do call me by my true name, Queen Isis" (Apuleius, *The Golden Ass*, 11.5 [Loeb ed., pp. 545–46]).

162. Vincenzo Cartari, *Le vere e nove imagini de gli dei delli antichi* [1615] (first published, Venice, 1556) (New York: Garland Press, 1976); the Isis images appear in the chapter describing the various forms of the goddess Diana. The *Mythologiae* of Natale Comes, first published in 1551, appeared in a Paduan edition of 1616, with illustrations taken largely from Cartari's *Imagini*; on Isis, see Natale Comes, *Mythologiae* [1616], trans. Jean Baudouin, 2 vols. (New York: Garland, 1976), 470–71. A good general account of the importance of the myth of Egypt and the Isis cult for Italian Renaissance art is provided by Patrizia Castelli, *I Geroglifici e il Mito dell'Egitto nel Rinascimento* (Florence: Edam, 1979).

163. See Iversen, 1961, 60 ff.

164. Ibid., 89 ff.

165. Athanasius Kircher, *Oedipus Aegyptiacus*, 3 vols. in 2 (Rome: V. Mascardi, 1652–54). Kircher, whose interest in Egyptian studies dated from his youth in Germany, came to Rome in 1633 as Chair of Mathematics at the Collegium Romanum. His research, aimed at explaining the underlying universal principles in Egyptian, classical, and Christian thought, was focussed from 1650 upon interpreting the meaning of the Pamphilian obelisk. See Iversen, 1961, 92 ff.; Frances A. Yates, "The Hermetic Tradition in Renaissance Science," in Charles S. Singleton, ed., *Art, Science, and History in the Renaissance* (Baltimore: The Johns Hopkins University Press, 1967), 255–74; and René Taylor, "Hermetism and Mystical Architecture," in Rudolf Wittkower and Irma B. Jaffe, eds., *Baroque Art: The Jesuit Contribution* (New York: Fordham University Press, 1972), 63–97.

166. Cf. Charles Scribner III, "*In Alia Effigie*: Caravaggio's London *Supper at Emmaus*," *Art Bulletin* 59 (September 1977): 375–82. Caravaggio's second rendering of this image (Milan, Brera) is considerably different in expression (see *The Age of Caravaggio*, 1985, 306–310).

167. See above, pp. 105–108. The painting was first published in 1984 by Mina Gregori, who cred-

ited the attribution to Artemisia to Patrick Matthiesen, Erich Schleier, Ferdinando Bologna, and Nicola Spinosa. Neither the Milan nor the London *Cleopatra* is documented; no other Cleopatras by Gentileschi are known.

168. Plutarch, *Lives* 9.85.3: "When [the guards] opened the doors they found Cleopatra lying dead upon a golden couch, arrayed in royal state."

169. Alessandro Spinelli's *Cleopatra* (Venice: Pietro de Nicolini da Sabbio, 1550) and Cesare de' Cesari's *Cleopatra Tragedia* (Venice: Appresso Giovan. Griffio, 1552) both draw a sharp contrast between Cleopatra as representative of Nature, and Augustus as exponent of civilized culture.

170. The statue of the reclining *Diana* in the Palazzo Barberini, though of a distinctly Berninian style, was not mentioned by Baldinucci and has not been included in Bernini's *oeuvre* by modern scholars. It is discussed briefly by Stanislao Fraschetti, *Il Bernini, la sua vita, la sua opera, il suo tempo* (Milan: Ulrico Hoepli, 1900), 138–39.

## CHAPTER 5

1. Bissell (1968, 155–56) suggested that Artemisia identified with Judith, and perhaps cast Tassi as Holofernes, while Shearman (1979, 8) stated flatly that Artemisia had painted herself as Judith. The *locus classicus* for the connection between decapitation and castration is Sigmund Freud, "Medusa's Head" [1922], trans. James Strachey, in *The Standard Edition of the Complete Psychological Works of Sigmund Freud*, ed. James Strachey, in collaboration with Anna Freud, assisted by Alix Strachey and Alan Tyson, vol. 18 (London: Hogarth Press, 1955), 273–74. The notion that Artemisia's decapitation scene is a symbolic castration was advanced by, among others, Hans J. Kleinschmidt, "Discussion of Laurie Schneider's Paper," *American Imago* 33, no. 1 (Spring 1976): 92–97, following Laurie Schneider, "Donatello and Caravaggio: The Iconography of Decapitation," on pp. 76–91 of the same issue.

2. The identification between Giorgione and his painted David goes back to Vasari, who included in the 1568 edition of the *Lives* a woodcut of a lost Giorgione painting of David, described by the author as a self-portrait. The full composition of the *David* in question is known through the engraving by Wenzel Hollar, and through a reduced version preserved in the Herzogliches Museum, Braunschweig. (See Ludwig Baldass, *Giorgione*, trans. J. Maxwell Brownjohn [New York: Abrams, 1965], 156–57.) Titian's self-image in the figure of St. Jerome in his late Frari *Pietà* is discussed by, among others, David Rosand, "Titian in the Frari," *Art Bulletin* 53 (June 1971): 196–213. On Michelangelo's self-images in the works cited, see Steinberg, 1975, ch. 5.

3. The various suggestions that Caravaggio's Borghese *Bacchino Malato* and Uffizi *Bacchus* are self-images have been outlined by Mina Gregori in the exhibition catalogue, *Age of Caravaggio*, 1985, 241 ff. The Goliath head in the Borghese *David* has been recognized as Caravaggio's self-portrait since the seventeenth century; differing psychological interpretations have been given by Christoph L. Frommel, "Caravaggio und seine Modelle," *Castrum Peregrini*, 96 (1971): 52 ff., who saw the image as one of homosexual punishment; and by Herwarth Röttgen, *Il Caravaggio: richerche e interpretazioni* (Rome: Bulzoni Editore, 1974), 203 ff., who interpreted the work as expressing self-punishment for the artist's murder of Ranuccio Tommasoni. See also Gregori, in *Age of Caravaggio*, 1985, 338.

4. Gilbert and Gubar, 1979, 50.

5. I wish to acknowledge an important exploratory study of Artemisia's *Judith*s, which only came to my attention after this chapter was written. Peter Gorsen ("Venus oder Judith? Zur Heroisierung des Weiblichkeitsbildes bei Lucas Cranach und Artemisia Gentileschi," *Artibus et historiae* 1 [1980]: 69–81) has in a comparative discussion of Cranach's and Gentileschi's Judith images taken an approach somewhat analogous to my own, and I hope to have addressed here some of the questions he raised. See also Hans Mayer, *Aussenseiter* (Frankfurt am Main: Suhrkamp, 1975), who examines Judith and Joan of Arc as "outsider" heroines in patriarchal culture.

6. The most useful critical editions are: Enslin and Zeitlin, 1972; Edgar J. Goodspeed, *The Apocrypha, An American Translation*, intro. by

Moses Hadas (New York: rev. ed. Modern Library, 1959); and W.O.E. Oesterley, *An Introduction to the Books of the Apocrypha: Their Origin, Teaching, and Contents* (New York: Macmillan, 1935). An analysis of texts is found in André M. Dubarle, *Judith: Formes et Sens des Diverses Traditions*, 2 vols. (Rome: Institut biblique pontifical, 1966).

7. Reau, 1955–59, vol. 2, pt. 1, 329. An alternative view places it in the first century A.D., but most scholars agree that the story originated in the midst of the Maccabean revolt. See also Jean Steinmann, *Lecture de Judith* (Paris: J. Gabalda, 1953), ch. 2; and Luis Alonso-Schökel, S. J., "Narrative Structures in the Book of Judith," in W. Wuellner, ed., *Protocol of the Eleventh Colloquy, The Center for Hermeneutical Studies in Hellenistic and Modern Culture*, The Graduate Theological Union and the University of California, Berkeley, California, January 27, 1974 (Berkeley, Calif.: The Center for Hermeneutical Studies in Hellenistic and Modern Culture, 1975), esp. 17–19, where it is suggested that Judith may be a counterpart of Judas Maccabeus. On the formation of the Hebrew canon, see H. Wheeler Robinson, *The Old Testament, Its Making and Meaning* (Nashville, Tenn.: Cokesbury Press, 1937), ch. 8; and on the exclusion of Judith from the Hebrew canon, see Enslin and Zeitlin, 1972, who explain that the story was controversial because it described Achior as having converted to Judaism without being baptized, which conflicted with Jewish teaching after A.D. 65.

8. Enslin and Zeitlin, 1972, 49. Luther's introduction to the book of Judith can be found in Martin Sommerfeld, *Judith-Dramen des 16./17. Jahrhunderts, Nebst Luthers vorrede zum buch Judith* (Berlin: Junker und Dünnhaupt, 1933), 1–2. See also Emil G. Kraeling, *The Old Testament Since the Reformation* (New York: Harper, 1955), ch. 1.

9. Reau, 1955–59, vol. 2, pt. 1, 329. It was Luther who observed that Judith's name simply meant "Judea." Some scholars have followed Luther in interpreting the name "Bethulia" as *betula*, "virgin," but as Alonso-Schökel has observed, the author of the book of Judith may have chosen the name for its multiple resonances (Alonso-Schökel, 1975, 19).

10. E.g., "Come down and sit in the dust, O virgin daughter of Babylon, sit on the ground without

a throne, O daughter of the Chaldeans . . ." (Isaiah 47:1); and "How lonely sits the city that was full of people, how like a widow has she become, she that was great among the nations" (Lamentations 1:1). See Alonso-Schökel, 1975, 15. A case for a historical Judith, on the other hand, was made by Artur Weiser, *The Old Testament: Its Formation and Development*, trans. Dorothea M. Barton (New York: Association Press, 1961), 399–401.

11. Hadas, 1959, 165–69. The relevant section of Herodotus's Chronicle of Lindos is quoted by Hadas. See also Goodspeed, 1959, 131; and J. C. Dancy, *The Shorter Books of the Apocrypha: Tobit, Judith, Rest of Esther, Baruch, Letter of Jeremiah, Additions to Daniel, and Prayer of Manasseh* (Cambridge: Cambridge University Press, 1972), 127.

12. Cf. Jessie L. Weston, *From Ritual to Romance* [1920] (Garden City, N.Y.: Doubleday, 1957), esp. ch. 2.

13. In *The Hero with a Thousand Faces* [1949] (New York: Meridian Books, 1956), Joseph Campbell has analyzed the archetypal journey of the hero. Campbell's and other theories of the heroic myth, such as those of Jung and Dorothy Norman, are applied to female characters by Carol Pearson and Katherine Pope, *The Female Hero in American and British Literature* (New York and London: R. R. Bowker, 1981), ch. 1.

14. The Apocryphal book called Ecclesiasticus was written about 180 B.C. Although the Book of Esther was eventually accepted as canonical, it was long a disputed and controversial text, along with Canticles and Ecclesiastes. See Robinson, 1937, 198–99 and 205. Misogyny was not the direct basis for exclusion, since the test for an authoritative or canonical scripture was that it have been divinely inspired. Yet as Ecclesiasticus's exclusion of all female forebears shows, the identity between famous men and prophetic capability was self-reinforcing.

15. See Bernard P. Prusak, "Woman: Seductive Siren and Source of Sin? Pseudepigraphal Myth and Christian Origins," in Reuther, 1974, 89–116.

16. See Pearson and Pope, 1981.

17. See Frances G. Godwin, "The Judith Illustration of the *Hortus Deliciarum*," *Gazette des Beaux-Arts* 36, ser. 6 (July–September 1949): 25–46, for a discussion of this and other medi-

eval Judith manuscripts. On the St. Paul Bible of Charles the Bald, see Florentine Mütherich and Joachim E. Gaehde, *Carolingian Painting* (New York: Braziller, 1976), no. 19.

18. In the St. Paul Bible, the return is shown in the same scene as the exit, perhaps for the sake of pictorial economy. Many other manuscripts emphasize the triumphant return more forcefully, including the *Hortus Deliciarum* (3rd quarter, 12th century) and the Roda Bible (Spanish, 11th century). See Godwin, 1949.

19. Edna Purdie, *The Story of Judith in German and English Literature* (Paris: H. Champion, 1927), 25–28.

20. The Judith story is narrated in an archivolt cycle at Chartres; see Adolf Katzenellenbogen, *The Sculptural Programs of Chartres Cathedral* (Baltimore: The Johns Hopkins University Press, 1959), 70–73; and Kraus, 1967, ch. 3 (reprinted in Broude and Garrard, 1982, 87–88).

21. One is the six-episode cycle in the Ashmolean Museum, Oxford, attributed to Veronese, which ends with the killing of Holofernes. See Pignatti, 1976, cat. A-229, figs. 912–17. Another example is a set of eight Flemish tapestries woven in Brussels in the second half of the seventeenth century, which was in the Barberini collection in Rome until the nineteenth century; see Charles M. Ffoulke, *Monograph by Charles M. Ffoulke on the Judith and Holofernes Series, consisting of eight Flemish tapestries with original borders* (Washington, D.C.: n.p., 1907). For other versions of the Judith theme in Renaissance and post-Renaissance art, see Reau, 1955–59, vol. 2, pt. 1, 329 ff.; Kirschbaum, 1968–76, 2:454–58; Pigler, [1956] 1974, 1:191–98. Giuseppe di Lentaglio, "La 'Giuditta' biblica nell'arte," *Emporium* 74 (September 1931): 131–42, is of limited value.

22. The two small panels unanimously attributed to Botticelli, were described in the inventory of the house of Antonio de' Medici (1588) as "a small picture, divided in half, making two smaller pictures." After his death in 1632, the paintings went to the Uffizi collections (Roberto Salvini, *All the Paintings of Botticelli*, trans. John Grillenzoni, 4 vols. [New York: Hawthorn Books, 1965], pt. 1, 45–46).

23. Richard Krautheimer, in collaboration with Trudi Krautheimer-Hess, *Lorenzo Ghiberti* (Princeton: Princeton University Press, 1956), 172–73 and pl. 130a. The scriptural gloss of St.

Augustine was influential (*Enarrationes in Psalmos*, XXXIII.4 [Migne, PL 37.302]: "*Et quod David prostavit Goliam, Christus est qui occidit diabolum. Quid est autem Christus qui diabolum occidit? Humilitas occidit superbiam.*" ["As David overcame Goliath, so did Christ slay the Devil. Who is this Christ who slays the Devil? Humility slays Pride"]).

24. Reau, 1955–59, 2, 1:330–31; and E. Brown, Jr., 1974, 395 n. 55.

25. Judith and Mary are represented on adjacent pages (folios 67ᵛ and 68ʳ) in the Leipzig manuscript, which presents the *Speculum historicum* of Vincentius Bellovacensis. (I thank Dr. D. Debes, of the University Library of Karl-Marx-Universität, for this information.) The two women are directly paired in the *Speculum humanae salvationis* (see Volker Herzner, "Die 'Judith' der Medici," *Zeitschrift für Kunstgeschichte* 43, no. 2 [1980]: fig. 2). See also Reau, 1955–59, 2, 1:330–31; and Kirschbaum, 1968–76, 2:454–58.

26. Augustine (*Sermo* 37, on Proverbs 31.10–13 [PL 38.221–35]) and Bede ("De muliere forti" [PL 91.1039–1052]) connect the *mulier fortis with the Virgin*. Bernard (*Super missus est homilia* 2.4–5 [PL 183.63]), Bonaventura (*De nativitate b. virginis Mariae, sermo 5.3* [*Opera omnia* 9.718], and other writings), and Albertus Magnus (*Questiones super evangelium missus est*, 43.2 [*Opera omnia* 37.86]) apply the type of the Virgin triumphing over the Devil to such triumphant biblical women as Judith and Esther. These sources are cited by E. Brown, 1974, 402–403.

27. Prudentius, *Psychomachia* 40–71 (Loeb Classical Library, *Prudentius*, vol. 1, 1949). Prudentius refers to Judith and Holofernes in a passage describing the battle of Chastity and Lust, as a metaphor for that battle. He stresses Judith's bravery ("no trembling hand"), while making clear, as later medieval writers were also to do, that it was a "boldness heaven-inspired." For manuscript illustrations of Judith killing Holofernes paired with the allegorical figure of Chastity, see Rosemond Tuve, "Notes on the Virtues and Vices—Part II," *Journal of the Warburg and Courtauld Institutes* 27 (1964): 50 and figs. 7d and 7e; and Herzner, 1980, 139–80.

28. According to recent investigations, Donatello's *Judith* was commissioned for the Medici Palace by Piero de' Medici, as a political

expression of *Libertas Medicea*, and, following the replacement of the Medici oligarchy by a republican government in 1495, confiscated along with Verrocchio's *David* and brought to the Piazza Signoria. Now exhibited publicly, its inscriptions both old and new proclaiming republican virtue and warning of the fall of tyrants were newly adapted to anti-Medicean expression (Herzner, 1980, 139–180). For earlier political and iconographic interpretations, see H. W. Janson, *The Sculpture of Donatello* (Princeton: Princeton University Press, 1969), 203 ff.; and Edgar Wind, "Donatello's *Judith*: A Symbol of 'Sanctimonia,'" *Journal of the Warburg and Courtauld Institutes* 1 (1937–38): 62–63. Hans M. von Erffa, "JUDITH-VIRTUS VIRTUTUM-MARIA," *Mitteilungen des Kunsthistorisches Institutes in Florenz* 14 (1969–70): 460–65, stresses the Marian associations for Donatello's *Judith*. A useful discussion and summary of the literature on this statue is found in Michael Greenhalgh, *Donatello and His Sources* (London: Duckworth Press, 1982), 181–92.

29. For general discussion of the French provenance and the modern attribution to Giorgione of the *Judith* now in the Hermitage, see Baldass, 1965, 131–32. Inspiration for Giorgione's image of Judith was seen by Morassi in Dürer's engraved *Hercules* (or *Jealousy*); Baldass proposed instead a probable source in Mantegna.

30. Hendrick Goltzius, after Bartholomaeus Spranger (B. III.83.272).

31. Alessandro Cecchi, "Borghini, Vasari, Naldini e la 'Giuditta' del 1564," *Paragone* 28, no. 323 (January 1977): 100–107.

32. Evelyn Borea, *Domenichino*, Collana d'arte 12 (Florence: G. Barbèra, 1965), fig. 92a and cat. 1016; and Spear, 1982, cat. 101ii and fig. 329. Solimena's painting dates from the early eighteenth century; see Bologna, 1958, 89–90. Solimena's work (though not the *Judith*) is discussed in *The Golden Age of Naples: Art and Civilization under the Bourbons 1734–1805*, exh. cat., ed. Susan L. Caroselli, J. Patrice Marandel, Susan F. Rossen, and Robert Sharp, 2 vols. (Detroit: The Detroit Institute of Arts; with The Art Institute of Chicago, 1981), which also reproduces a similarly conceived image of Judith displaying the head by Luca Giordano (cat. 26a).

33. Purdie, 1927, 43 ff. The later sixteenth-century

struggle between the Venetians and the Turks found metaphoric echo in another Judith drama, Giovanni Lottini's *Giudetta* of 1605; see Frank Capozzi, "The Evolution and Transformation of the Judith and Holofernes Theme in Italian Drama and Art before 1627," Ph.D. dissertation, The University of Wisconsin-Madison, 1975, 154–55.

34. Werner Schade, "Das unbekannte Selbstbildnis Cranachs," *Dezennium* 2 (1972): 368–75. For Cranach's two *Judith* panels in the Schlossmuseum, Gotha, see Friedländer and Rosenberg, 1978, cat. 214 and 215.

35. See Carlo Ginzburg, *Il Nicodemismo, Simulazione e dissimulazione religiosa nell'Europa del '500* (Torino: Einaudi, 1970), 78 ff., cited and discussed by Adriano Sofri, "La vedova, il generale e la metà del regno," *Lotta continua* 10, December 16–17, 1979; on the *Nicodesmi*, see also Delio Cantimori, "Italy and the Papacy," in *New Cambridge Modern History*, 14 vols., vol. 2, *The Reformation 1520–1559*, ed. G. R. Elton (Cambridge: Cambridge University Press, 1958), ch. 8. An earlier instance of the use of Judith's cunning and deceit to justify political intrigue is found in the writings of Petrarch's friend, Cola di Rienzo (see Capozzi, 1975, 21 ff.).

36. See Capozzi, 1975, 74 ff.

37. Elena Ciletti presented these findings at the College Art Association meeting in Toronto, February 1984, in an excellent paper ("'*Ma questa è la donna terribile!*': Artemisia Gentileschi and Judith") that, it is to be hoped, will soon be published. My divergence from Ciletti's interpretation of Gentileschi's *Judith*s as consonant with Marian theological emphasis will be apparent later in this chapter.

38. Purdie, 1927, 10. See also Bissell, 1981, 22.

39. See Purdie, 1927, 56 ff.

40. Caravaggio's *Judith*, acquired by the Galleria Nazionale d'Arte Antica in 1971 from the Roman collection of Dr. Vincenzo Coppi, is assumed by scholars to be the painting that, according to Baglione (1642), Caravaggio executed for "*li signori Costi*" whose principal has been identified as Ottavio Costa, Roman banker and early patron of the artist. North Italian prototypes for violent action such as is seen here (though not specifically limited to Judiths) are discussed by Mina Gregori, in *Age of Caravaggio*, 1985, 256–62.

41. Observed by Gregori, in *Age of Caravaggio*,

1985, 257. A fuller discussion of the revival of interest at the end of the sixteenth century in the Aristotelian dramatic unities is found in Capozzi, 1975, 120 ff.

42. See Hibbard, 1983, 67; David Summers, "Contrapposto: Style and Meaning in Renaissance Art," *Art Bulletin* 59 (September 1977): 336–61; and Gregori, in *Age of Caravaggio*, 1985, 257, who notes that the particular juxtaposition of a beautiful young woman and an old hag was recommended by Gregorio Comanini in a treatise, *Il Figino*, of 1591.

Maurizio Marini (*Io Michelangelo da Caravaggio* [Rome: Studio B, Bestetti e Bozzi, 1974], 26–27) suggests that Judith's pure and righteous image intentionally evokes the Church Triumphant in its battle against heresy.

43. Purdie, 1927, 38 ff. (the quoted phrase is Purdie's).

44. For example, Hugh of St. Cher, Nicholas of Lyra, and Robert Holkot; see E. Brown, 1974, 394 n. 21.

45. Engraving after Hendrik Goltzius, B. III.126.1 (the inscription, which appears on an impression seen in a Warburg Institute photograph, is not recorded by Bartsch).

46. See Sommerfeld, 1933, in which we may observe that, of the six plays that are discussed, three bear Holofernes's name, two are called "Judith," and one is named for the siege of Bethulia. Capozzi, 1975, points out the dramatic emphasis upon Holofernes's human qualities in Sacchetti's Judith play of 1564 (p. 99), and his emergence as the tragic hero, contrasted with a morally lethargic Judith, in Alberti's drama of the 1590s (p. 150).

47. For modern psychological analyses of masculine fear of women, see especially Karen Horney, "The Dread of Woman, Observations on a Specific Difference in the Dread Felt by Men and by Women Respectively for the Opposite Sex," *International Journal of Psychoanalysis* 13, no. 3 (July 1932): 348–60; and Dorothy Dinnerstein, *The Mermaid and the Minotaur: Sexual Arrangements and Human Malaise* (New York: Harper & Row, 1976), 124–54.

48. Reported by Smith, 1978, 216–17. Examples of the *Weibermacht* theme in prints by Lucas van Leyden are discussed by Ebria Feinblatt, "Two Prints by Lucas van Leyden," *Los Angeles County Museum of Art Bulletin* 17, no. 2 (1965): 9–15.

49. Judith's dialogue with Holofernes is full of *double-entendres*; for example, she tells him that she has been commissioned by God to accomplish an outstanding deed, which he understands as support for his own cause. See Enslin and Zeitlin, 1972, 11.

50. The overlapping attributes of Judith and Salome are discussed by Panofsky, [1939] 1962, 12–14. See also Mechtilde Hatz, "*Frauengestalten des Alten Testaments in der bildenden Kunst von 1850 bis 1918: Eva, Dalila, Judith, Salome*," dissertation, Heidelberg, 1972.

51. Delilah's iconography is discussed by Madlyn Kahr, "Delilah," *Art Bulletin* 54 (September 1972): 282–99; reprinted in Broude and Garrard, 1982, 121–45.

52. Francis Marion Crawford, *Soprano* (1905); quoted in Herbert Pentin, *Judith (The Apocrypha in English Literature)* (London: Samuel Bagster and Sons, 1908), 68. The story of Jael and Sisera parallels that of Judith and Holofernes in Jael's sexual temptation of the Canaanite captain Sisera, and her killing of him (with a nail driven through the temple) (Judges 4: 18–24).

53. E. Brown, 1974, 391.

54. Ibid., 410.

55. John Ruskin, *Mornings in Florence, being simple studies of Christian art, for English travelers* (New York: J. Wiley & Sons, 1876), 54.

56. Gilbert and Gubar, 1979, 23.

57. The *Judith* attributed to Elisabetta Sirani in the Walters Art Gallery, Baltimore, is discussed by Federico Zeri (*Italian Paintings in the Walters Art Gallery*, ed. Ursula McCracken, condition notes by Elisabeth C. G. Packard [Baltimore: Walters Art Gallery, 1976], 2:478–79), who tentatively retains the attribution to her, noting that the painting (not to be identified with a *Judith* by her mentioned by Malvasia) is identical in composition with an engraving that has been attributed to Sirani's father, Giovanni Andrea Sirani (B. XVIII.314.1). Zeri suggests that Elisabetta may have borrowed the composition from her father. D. Stephen Pepper, however, gives the Walters *Judith* to G. A. Sirani, as a copy of a Reni (1984b, 301).

58. The phrase "angel in the house," which was used in a spirit of feminist critique by Virginia Woolf ("Professions for Women," in *The Death of the Moth and Other Essays* [New York: Harcourt, Brace, 1942], 236–38), originated in the title of a popular collection of poems by

Coventry Patmore (*The Angel in the House*, 6th ed. [London: G. Bell, 1885]), which praised the selfless virtues of an ideal Victorian lady. See Gilbert and Gubar, 1979, 22.

59. Robert Klein and Henri Zerner, eds., *Italian Art, 1500–1600*, Sources and Documents in the History of Art Series (Englewood Cliffs, N.J.: Prentice-Hall, 1966), 41. As Saul Levine has observed, the herald's comment must also be understood in the context of the original—and by 1504 unfortunate—association of Donatello's *Judith* with the Medici family (Saul Levine, "The Location of Michelangelo's 'David': The Meeting of January 25, 1504," *Art Bulletin* 56 [March 1974]: 31–49). Levine notes "a tradition of hostility against the biblical Judith" (p. 38 n. 29), but connects this—too narrowly, in my view, since he neglects the larger misogynist framework—with the possible influence of Sebastian Brant's *Ship of Fools*, which contains the lines: "Had Judith not dressed up and spruced / Holofernes had not been seduced."

60. Honoré de Balzac, *La cousine Bette*, ed. André Lorant (Paris: Garnier-Flammarion, 1977) 411–12. See also Hatz, 1972, 149.

61. Anna Jameson, *Visits and Sketches at Home and Abroad*, 4 vols. (London: Saunders and Otley, 1834), 2:119; 3:252–53 (as quoted by Greer, 1979, 189). In this book, Jameson reveals a distinct bias against Artemisia that goes beyond (while perhaps being founded upon) her *Judith*s. In a general discussion of women artists—Rosalba Carriera, Angelica Kauffman, Lavinia Fontana, Sofonisba Anguissola, etc.—she concludes that "Gentileschi has the most power: she was a gifted, but a profligate woman . . . all, except Gentileschi, were *feminine* [her italics] painters" (2:129–33 [1839 ed.]).

62. W. R. Valentiner, "Judith with the Head of Holofernes," *Detroit Institute Bulletin* 14, no. 8 (May 1935): 101–104.

63. *Gardner's Art through the Ages*, revised by Horst de la Croix and Richard G. Tansey, 8th ed. (New York: Harcourt Brace Jovanovich, 1986), 729.

64. Deviations from the biblical story pointed out by S. Smith (1978, 21–22) include the assertion of an early fourteenth-century *Meistersinger* that Judith "loved [Holofernes] a long time and freed Bethulia. . . . Wherever that hap-

pens, she comes with her bright appearance, and she plays him a lover's trick." An image on the cover of an early fifteenth-century *Minne-kästchen* presents Judith slaying Holofernes juxtaposed with "a lady plucking phalluses from a tree while her lover looks on," implying, as Smith observes, that Judith is "the classic type of seductress who follows sexual conquest by murder."

65. Charles W. Talbot, in Marrow and Shestack, 1981, 28–31.

66. Marrow and Shestack, 1981, 28–31 and 121.

67. Rooses, 1886, 1:157, unaccountably interprets Judith's expression as one of disgust for her atrocious deed.

68. Correggio's miniature *Judith* is briefly discussed by Cecil Gould (1976, 33), who interprets Abra as a mulatto, a "macabre" feature indebted to Mantegna's *Judith* in Dublin.

69. Kahr, 1972, 292. Eugene Carroll has suggested, with respect to a *Judith with the Head of Holofernes* drawing by Rosso Fiorentino, that a *memento mori* may be intended in the juxtaposition of the young heroine and the aged hag (Eugene A. Carroll, "A Drawing by Rosso Fiorentino of Judith and Holofernes," *Los Angeles County Museum of Art Bulletin* 24 [1978]: 24–49).

70. Filippo Baldinucci, *Notizie dei Professori del Disegno da Cimabue in qua per le quali si dimostro come* [1681–1728] (Florence: Eurografica, 1974), iii, 732–33, cited in Shearman, 1979, 3–10. On the tradition of representing Holofernes with the features of the artist, which developed in the sixteenth century and is exemplified in works by Giorgione, Catena, and Titian, see Jaynie Anderson, "The Giorgionesque Portrait: From Likeness to Allegory," in *Giorgione. Atti del Convegno internazionale di studio per il 5° Centenario della nascita* (Venice: Comitato per le celebrazioni Giorgionesche, Commune di Castelfranco Veneto, 1979), 153–58. Agostino Carracci's posthumous portrait of the Bolognese Olimpia Luna, commissioned by her husband Melchiorre Zoppio, who was depicted as Holofernes, is a work in the same vein (see *Around 1610: The Onset of the Baroque*, exh. cat. [London: Matthiesen Fine Art Ltd., 1985], 18–25).

71. Shearman, 1979, 3–10. The problem is complicated by the existence of numerous variants of the Pitti and Hampton Court paintings.

While scholars generally agree that the Hampton Court version reflects an Allori composition earlier than the Pitti version, some writers—Chiarini, Del Bravo, Pizzorusso—have regarded it as a copy rather than the original. For a summary, with relevant bibliography and illustrations, see Chappell, 1984, 78–81. See also above, Chapter 1, note 79.

72. For literature on Caravaggio's self-image as Goliath in the Borghese picture, see note 3 above; the analogy between Caravaggio's and Michelangelo's expressive projection of their own faces onto their created characters is discussed generally by Hibbard, 1983, 264–67.

73. "*Di Betulia la bella / Vedovetta feroce / Non ha lingua, né voce, e pur favella. / E par seco si glorij, e voglia dire, / Vedi s'io so ferire, / E di strale, e di spada. / Di due morti, Fellon, vò che tu cada, / Da me pria col bel viso, / Poi con la forte man due volte ucciso.*" G. B. Marino, "Giudit con la testa d'Oloferne di Christoforo Bronzino," in Marino, 1619 (*La Galeria*). Marino's poem is quoted, along with two other early seventeenth-century poems on the Judith-Holofernes theme, by Claudio Pizzorusso (1982, 70ff.), who emphasizes their Counter-Reformation context.

74. Pizzorusso, 1982, 72.

75. Purdie, 1927, 94–105; and Philippe Comte, "Judith et Holopherne, ou la naissance d'une tragédie," *Revue du Louvre* 27, no. 3 (1977): 137–39.

76. See Helen Grace Zagona, *The Legend of Salome and the Principle of Art for Art's Sake* (Geneva: Droz, 1960); and Hatz, 1972, who discusses Eve, Delilah, Judith, and Salome. Herodias, oddly enough, was (Zagona points out) originally a benign figure, and began to be treated as immoral only from the fourth century on.

77. Alessandra Comini, *Gustav Klimt* (New York: G. Braziller, 1975), 22–23. See also Fritz Novotny and Johannes Dobai, *Gustav Klimt, with a Catalogue Raisonné of His Paintings* [1968] (Boston: N.Y. Graphic Society, 1975), cat. 113.

78. Scholars have recently begun to recognize that Caravaggio's *David* contains not one, but two spiritual self-images. See, for example, Röttgen, 1974, 207–213, who interprets David as the instrument of the ego's self-punishment by the superego; and Hibbard, 1983, 265–67, who also finds in the dual image the expres-

sion of self-punishment by Caravaggio (who, as a murderer, identified with both figures), though in keeping with the traditional theological glosses of David as Christ killing the Devil, Humility slaying Pride.

79. Reni's competition with Caravaggio, who accused the Bolognese painter of "stealing his style and color," is recognized as being generally reflected in his Louvre *David* (1605–1606), in his reformulation of Caravaggesque features in a more classical style (see D. S. Pepper, in *Age of Caravaggio*, 1985, 175–76). It seems to me that Reni may be alluding quite specifically in his *David* to Caravaggio's Borghese *David* (which has long been dated 1605–1606), and that Caravaggio's own features in the head of his Goliath are deliberately evoked in the Goliath head in Reni's painting. Thus Reni's "defeat" of Caravaggio would be neatly summed up in a pictorial image. Recent proposals to redate Caravaggio's Borghese *David* to 1609–1610 remain inconclusive, and to me, unconvincing (see *Age of Caravaggio*, 338–41).

80. See Julius Held's discussion of "the melancholy sage" (1969, 29 ff.); and Rudolf and Margot Wittkower (1963, ch. 5, esp. 106–107), who point out that the melancholic temperament, in its eccentric manifestations, was already ridiculed by seventeenth-century writers on melancholy such as Robert Burton (*Anatomy of Melancholy*, 1621). Artists, however, continued to draw prestige from association with melancholy in its meditative and thoughtful aspects, as can be seen in self-portraits by Carlo Dolci (Uffizi; Wittkower and Wittkower, 1963, fig. 72) and Annibale Carracci (see Fig. 321 below), and in numerous works by Jusepe Ribera and Salvator Rosa.

81. Anteveduto Grammatica's *Judith*, once attributed to Artemisia as well as Caravaggio and Fetti, was correctly ascribed to the Roman painter by Longhi, who dated it in the 1620s (see Spear, 1971a, cat. 34). Anteveduto's *Judith* appears to have been partly based upon a print of Salome of 1528 by H. Aldegrever (B. VIII.371.34). Her statuesque bearing may also reflect the influence of Artemisia's figure types.

82. See Chapter 1 for an overview of the chronology of the *Judith*s, in the context of Artemisia's stylistic development.

83. The relationship between Caravaggio's and Artemisia's *Judith*s has been discussed provocatively by contemporary Italian journalists. See Sofri, 1979, which is a rebuttal of Laura Viotti's review of Germaine Greer's *The Obstacle Race* (1979), in the December 12, 1979, issue of *Lotta continua*.

84. Hofrichter, 1980, 9–12.

85. According to Sarah Fisher, the National Gallery of Art conservator who produced the x-rays and examined them with me, Holofernes's left arm was set in place early in the development of the composition, but the right arm—painted not in lead white, but in something like calcium carbonate, and thus not showing up clearly in the x-ray—was a very late decision (though unquestionably part of the original creative process, and not another artist's alteration). The vague and indefinite contours visible in the x-ray indicate a series of adjustments, even after the arm positions were established, as we see in Judith's arms as well. See above, Chapter 1, note 35, for further explanation of the recent x-ray and technical analysis of the Naples *Judith*.

86. Keith Andrews, *Adam Elsheimer: Paintings, Drawings, Prints* (Oxford: Phaidon, 1977), 144 (cat. 12). For Rubens's eloquent praise of Elsheimer on hearing of his death, see Jaffé 1977, 53–54.

87. Spear (1971a, cat. 19) and Gregori (*Age of Caravaggio*, 1985, cat. 77) discuss the checkered history of this painting's attribution. Longhi, Mahon, and others have supported Venturi's original attribution of the picture to Caravaggio, while Friedländer, Battisti, and others have doubted it; some (Ainaud de Lasarte, Berenson) have considered it a copy of a lost Caravaggio. The originality of the composition, noted by Spear and Gregori, points to the probability that the picture is at least a close replica of a Caravaggio painting, if not the original itself. Bissell (1981, 203, cat. X-9) has suggested that Orazio Gentileschi may have painted the Madrid *David* (as an original work, not a copy of Caravaggio), as well as the *Narcissus* (Rome, Palazzo Barberini), whose close relation to the *David* has been noted by many scholars.

     Pamela Askew pointed out to me an equally relevant source for Abra's pose in the figure of David in Orazio Borgianni's *David and Goliath* in Madrid (dated 1607; see *Age of Caravaggio*, 1985, 102–103).

88. Artemisia's (and Caravaggio's) decapitation scenes appear to the modern eye to be horrifyingly explicit, cold-blooded images, yet, as Edgerton has reminded us ("*Maniera* and the *Mannaia*: Decorum and Decapitation in the Sixteenth Century," in Franklin W. Robinson and Stephen G. Nichols, Jr., eds., *The Meaning of Mannerism* [Hanover, N.H.: University Press of New England, 1972], 67–103), public executions in that period were social rituals experienced aesthetically as "visually attractive *psychomachia*." Artemisia herself grew up in a world in which decapitations were commonplace, and she could have witnessed, as a child, the notoriously gruesome beheading of Beatrice Cenci and her mother (by the *mannaia*, a kind of guillotine) in Piazza Sant'Angelo, Rome, on September 11, 1599.

89. The painting has undergone more than one bout of restoration. Although its present appearance, after cleaning, probably reflects the painting's original surfaces more accurately than did earlier restorations (cf. the photograph previously published in Bissell, 1968, fig. 10), there remains a significant amount of overpainting by later restorers.

90. E. P. Richardson, "A Masterpiece of Baroque Drama," *The Art Quarterly* 16, no. 2 (Summer 1953): 90–92.

91. Cf. Gilbert and Gubar (1979, esp. 77 ff.), who have detected as characteristic of female writers the projection of the self into two sharply contrasted characters. Thus we have Mary Wollstonecraft Shelley's rational scientist, Dr. Frankenstein, and his violent monster; Emily Brontë's angelic Catherine and wild, satanic Heathcliff; and similarly divided and opposed characters found in Jane Austen, George Eliot, Emily Dickinson, Virginia Woolf, Doris Lessing, Sylvia Plath, and others.

92. The Sarasota version of Fede Galizia's *Judith* is signed and dated 1596; a very similar version in the Borghese Gallery was painted in 1601. See Denise Minault, *Woman as Heroine*, exh. cat., September-October 1972 (Worcester, Mass.: Worcester Art Museum, 1972), 28; and Harris and Nochlin, 1976, 115. Despite the pic-

ture's somewhat *retardataire* style, Galizia presents in her Judith a rather heroic and refreshingly unsex-stereotyped image.

93. For reasons discussed above, pp. 39–40, I do not believe that the *Judith with Her Maidservant* in Oslo, a work carrying a debated attribution to Orazio Gentileschi, could have predated Artemisia's Pitti version. I am even more skeptical of the early position in this sequence that has been proposed for a recently published *Judith* ascribed to Orazio (Pepper, 1984, 315–16); see above, Chapter 1, note 56.

94. Stage design in the Italian theater of this period is discussed in Oscar G. Brockett, *History of the Theatre* (Boston: Allyn and Bacon, 1968); Allardyce Nicoll, *The Development of the Theatre: A Study of Theatrical Art from the Beginnings to the Present Day* [1927] (New York: Harcourt, Brace & World, 1967), esp. 79 ff.; Margarete Baur-Heinhold, *The Baroque Theatre, A Cultural History of the Seventeenth and Eighteenth Centuries* (New York: McGraw-Hill, 1967), ch. 5; and Per Bjurström, "Baroque Theater and the Jesuits," in Rudolf Wittkower and Irma B. Jaffe, eds., *Baroque Art: The Jesuit Contribution* (New York: Fordham University Press, 1972), 99–110. See also an anonymous editorial entitled "The Natural Man," *Apollo* 79 (April 1964): 258–63, in which general but provocative analogies are drawn between the stage spaces of Italian Baroque paintings (including works by Caravaggio, Orazio, and Artemisia) and the design of Shakespearean theaters.

The relationship between art and theater in the Baroque period was complex and distinguished by mutual influence. For example, while much Baroque art displays a theatrical staging of images evidently influenced by real theatrical performances (e.g., Bernini's Cornaro Chapel at S. M. della Vittoria), theater sets were not only frequently designed by artists, but sometimes inspired by developments in the visual arts. Such was the case with the proscenium arch, which, many scholars have argued, was influenced by the frame concept of Renaissance perspective. A good discussion of the effect of theater and stage designs, especially those of Serlio and Palladio, on sixteenth-century Venetian painting is found in David Rosand, *Painting in Cinquecento*

*Venice: Titian, Veronese, Tintoretto* (New Haven and London: Yale University Press, 1982), ch. 4.

95. See Bjurström, 1972, esp. 106. He contrasts the Roman stage (as exemplified in the *theatrum sacrum* decorations at the church of the Gesù), whose depth was less than its breadth, with the typical Florentine-Venetian set, which was much deeper and narrower.

96. For example, the anonymous *Rappresentatione di Judith hebrea* (1518) (Capozzi, 1975, 32 ff., esp. 51), or the *Juditha* by the Jesuit Stefano Tuccio (1564) (Capozzi, 1975, 76 ff., esp. 82–83). In the latter, the beheading is followed by Judith's conventional prayer to God. In Lottini's *Giudetta* (1605), Judith and Abra do not appear at all before the last scenes of the fifth act, after their return to Bethulia (Capozzi, 1975, 154 ff.)

97. Federico Della Valle's *Iudit*, now acclaimed as one of the great dramatic works of Italian literature, sets forth a heroine who has been praised as a complex, strong-willed, and fully human character with manly vigor (Capozzi, 1975, 174 ff.). Della Valle (1560?-1628), who was at the court of Charles Emanuel of Savoy, also wrote a tragedy based on Mary Queen of Scots, and another on Esther. See Luciana Amelotti, *Il teatro di Federigo della Valle* (Genoa: n.p., 1951); and especially Benedetto Croce, "Le tragedie di Federigo Della Valle di Asti," in *Nuovi saggi sulla letteratura italiana del Seicento* [1931], 3rd. ed. (Bari: Laterza, 1968). It was Croce who rediscovered and reevaluated Della Valle; see also Franco Croce, *Federico Della Valle* (Florence: La Nuova Italia Editrice, 1965).

98. Federico della Valle, *Iudit*, scene 7, lines 789 ff. (Federico della Valle, *Iudit*, ed. Andrea Gareffi [Rome: Bulzone editore, 1978], 125–26).

99. In the Corsini Gallery replica of the Pitti *Judith*, there is space surrounding the figures, at the top as well as the sides, a fact that suggests the possibility that the Pitti painting may have been cut down a few inches on three sides. It is doubtful that Artemisia would have cut off the top of Judith's head, or the full curve of her right arm and sleeve.

100. Orazio's *Justice* is a frescoed figure on the wall of the Chapel of St. Ursula in Farfa, executed 1597–99. See Bissell, 1981, 135–36. The tradi-

tional description of David as *manu fortis* goes back to St. Jerome, according to Tolnay (1943–60, 1:153–54).

101. Prudentius, *Psychomachia* 66–67. The Judith–Justice relationship is well exemplified in Titian's figure on the Fondaco dei Tedeschi, Venice, now lost but known through Zanetti's engraving. The latter image was recently identified as a Judith-Justice following a fifteenth-century tradition that merged the heroine with the allegory, here also joined with the personification of Venezia (Serena Romano, "Giuditta e il Fondaco dei Tedeschi," in *Giorgione e la cultura veneta tra '400 e '500, Mito, Allegoria, Analisi iconologica* [Rome: De Luca Editore, 1981], 113–25). See also Charles Hope, *Titian* (New York: Harper & Row, 1980), 12–14. The connection between Donatello's *Judith* and Justice is discussed by Herzner, 1980, 169–70. An example of the separate, though visually similar, tradition that connects Judith with Fortezza is noted by John Shearman, "The Florentine *Entrata* of Leo X, 1515," *Journal of the Warburg and Courtauld Institutes* 38 (1975): 145 n. 29.

102. Bink's *Judith* is pendant to a *Salome* by Aldegrever (B. VIII.371.34), also after Beham.

103. Donatello's *St. George* was of course prominently displayed at Or San Michele; see also Pollaiuolo's *David*, now Berlin (L. D. Ettlinger, *Antonio and Piero Pollaiuolo: Complete Edition with a Critical Catalogue* [Oxford: Phaidon; New York: Dutton, 1978], pl. 12 and p. 138), whose spread-legged stance is characteristic of other fifteenth-century Florentine Davids. Orazio's interest in very different aspects of Quattrocento Florentine art is discussed by Bissell, 1981, ch. 4.

Sixteenth-century Florentine precedents for the loading of jewelry with iconographic meaning are discussed above, p. 31. A particularly relevant example, again in a Medicean context, is Pontormo's so-called *Halberdier* (New York, Stillman Collection), which has been identified as the young Cosimo I wearing a Hercules and Antaeus medal on his hat (Kurt W. Forster, "Metaphors of Rule—Political Ideology and History in the Portraits of Cosimo I de' Medici," *Mitteilungen des kunsthistorischen Instituts in Florenz* 15 [1971, Heft 1]: 65–104; see also Janet Cox-Rearick, *Dynasty*

*and Destiny in Medici Art: Pontormo, Leo X, and the Two Cosimos* [Princeton: Princeton University Press, 1984], 254 n. 10).

104. The rich literature on the Medusa legend is usefully summarized by Schneider, 1976, 76–77. See especially A. A. Barb, "Diva Matrix," *Journal of the Warburg and Courtauld Institutes* 16, nos. 3–4 (1953): 205–206; idem, "Antaura: The Mermaid and the Devil's Grandmother," *Journal of the Warburg and Courtauld Institutes* 29 (1966): 1–23, and Thalia Phillies Howe, "The Origin and Function of the Gorgon-Head," *American Journal of Archeology*, 58, no. 3 (July 1954): 209–221. While Cellini's *Perseus* displays Medusa's head as trophy of his conquest, the Perseus legend goes on to describe his use of the head to turn his own enemies into stone. A similiar "apotropaic" function for Caravaggio's *Medusa*, which was painted on a tournament shield, was proposed by Kleinschmidt, 1976, 95–97, who objected to Schneider's reading of the painting in terms of Caravaggio's homosexual identification with Medusa. Hibbard (1983, 67–68) echoes Kleinschmidt's view, citing Marino's poem on the painting. Schneider (1976, 86) cites a sixteenth-century cameo gem of the positive Medusa type.

105. Gilbert and Gubar, 1979, 476–77. May Sarton's poem, "The Muse as Medusa," reads in part:

I turn your face around! It is my face.
That frozen rage is what I must explore—
Oh secret, self-enclosed, and ravaged place!
This is the gift I thank Medusa for.

(In *Collected Poems [1930–1973]* [New York: W. W. Norton, 1974].)

106. Cf. Pearson and Pope, 1981, 102–103.

107. See above, Chapter 1, note 77.

108. The story is told in the Talmud that when Alexander the Great had the citadel of the Amazons under attack, the Amazon queen successfully repelled him with the argument that "if you slay us, people will say that he killed women, and if we slay you, they will call you the king who was killed by women." B. Talmud, Tamid 32a.

The inscription on Galle's engraving of the lost Rubens *Judith*, a work discussed more fully below, reads: "Surrender Roman leader,

surrender Greeks: A woman has stopped your glories / Your great victory was brought forth by manly strength, / And a good part of the praise fell on the soldiers, / The foreign commander fell to a single right hand / The destruction of the country driven away by the hand of a woman" (translation from Hofrichter, 1980, 9–15).

109. Hofrichter (1980, 9) reports that in Pigler's *Barockthemen*, out of 187 works treating the Judith and Holofernes theme, only 28 examples actually show the decapitation.

110. As is discussed above (pp. 51–53), the Uffizi *Judith* is likely to be identical with one of the last paintings ordered from Artemisia by the Grand Duke before his death in 1621. Unable to obtain payment from his heirs for a certain *Judith*, presumably this picture, the painter turned to Galileo for assistance.

The only direct comment on the picture that predates the eighteenth-century Grand Duchess's banishment of the painting from view (as "a horror") is that of Baldinucci, who described Artemisia's *Judith* as inducing "no little terror," though he admired the painting's well-conceived design and lifelike expression, and thought it her best work (Baldinucci, [1681–1728] 1808–12, II:11).

111. Greer, 1979, 189.

112. See Desmond Macrae, "Observations on the Sword in Caravaggio," *Burlington Magazine* 106 (September 1964): 412–16, for a useful description of sword parts and discussion of the various sword types that appear in Caravaggio's paintings. According to Macrae, Latin apocryphal texts describe the sword used by Judith as a *pugio* ("dagger"), while Italian texts use the word *scimitarra*. Caravaggio's scimitar-like sword in the Coppi *Judith* is called a "falchion."

113. Quoted by Purdie, 1927, 38.

114. See Hibbard, 1983, 66, who points out that Judith is "still invoked on the feast day of Mary's Immaculate Conception as the savior of her people, as Mary was of hers."

115. For example, Warner, 1976; see also Maclean, 1980, 23–24.

116. While there is a long tradition paralleling Judith with David and David with Hercules, certain features of the Judith legend connect her directly with Hercules. This connection is expressed in Artemisia's Uffizi *Judith* in the vigorous way that the heroine grasps the hair of her enemy (a motif found in numerous seventeenth-century *Judith*s, e.g., those of Caravaggio, Caroselli, Manfredi). The image recalls many a Cinquecento sculptural *Hercules* (e.g., those of Bandinelli and Giambologna in the Piazza Signoria). Hair, as the Samson-Delilah legend clearly illustrates, has a traditional association with strength and virility, and in images that stress the victor's dominating grasp of the hair of the vanquished, it is suggested that the physical strength of the latter is not only transferred to the former, but also transformed into spiritual strength. In Artemisia's Uffizi *Judith*, the motif is unusually prominent, and effectively suggests the complex exchange: she simultaneously decapitates (castrates) her male enemy while drawing masculine energy from his hair, symbolic source of his power.

117. Artemisia herself painted at least two *Diana*s (both lost). Her earlier *Bath of Diana*, painted in Florence just two or three years before the Uffizi *Judith*, may have been formally related to the nearly contemporary Borghese *Diana* of Domenichino (see above p. 51). The upper image on the bracelet could reflect the figure of Diana in Artemisia's own painting. Classical prototypes for Diana as huntress abound. Giustiniani—Artemisia's patron at least once—owned no less than five antique versions of Diana with a stag and, usually, a bow; these are reproduced in Sandrart's engravings in the *Galleria Giustiniani del Marchese Vincenzo Giustiniani*, 2 vols. (Rome: n.p., 1640), esp. pl. LXII.

118. For the provenance of the painting and relevant literature, see above, pp. 67 ff. and n. 110. There are no known replicas or copies of the Detroit *Judith*, except for the variant in the Capodimonte Museum, Naples, that is ascribed to Artemisia (Fig. 125).

119. The unusual, monumental figure of Judith standing full-length has an important antecedent in a *Judith* of 1602–1603 by Cesari d'Arpino in the Villa Aldobrandini, Frascati (see Luigi Spezzaferro, "Il recupero del Rinascimento," in *Storia dell'arte italiana*, part 2; vol. 2, I, *Cinquecento e Seicento* [Turin: Giulio Einaudi editore, 1981], 220, fig. 180). D'Ar-

pino's image also offers an early interpretation of the theme as a dramatic narrative focussed upon the two women. I am grateful to Pamela Askew for bringing this example to my attention.

120. This was suggested to me by Suzanne P. Sack, chief conservator of the Brooklyn Museum, as we examined the painting together in 1977.

121. "Ab. Zarah, 25b," quoted by Enslin and Zeitlin, 1972, 14.

122. An exceptional image of a heroine with long dress and closed shoe is Francesco Curradi's *Artemisia* (several versions) of c. 1623–25 (see Cantelli, 1983, 199–200), but this statuesque figure may well have been inspired by Artemisia's *Judith*.

123. "*Donna con faccia, & mani leprose, vestita di pelle di pecora bianca, con una Canna verde in mano, la quale habbia le sue foglie, & pennacchio: I piedi medesimamente saranno leprosi, & nudi, con un lupo che esca di sotto alla veste di essa, & con un Cigno vicino.*" Ripa, [1603] 1970, 195.

124. Kahr, 1972, 295, gives the instance of Rubens's *Samson and Delilah* (then in Hamburg; now National Gallery, London), in which the crossed hands of the man who cuts Samson's hair, and the crossed legs of Delilah, signal the betrayal of Samson—an association preserved (as Kahr notes) in the slang expression "double-cross."

125. Panofsky, [1939] 1962, 89–90. See also Michael Levey, "Sacred and Profane Significance in Two Paintings by Bronzino," *Studies in Renaissance and Baroque Art Presented to Anthony Blunt* (London and New York: Phaidon, 1967), 30–33; and Charles Hope, "Bronzino's *Allegory* in the National Gallery," *Journal of the Warburg and Courtauld Institutes* 45 (1982): 239–43, who finds Panofsky's description of the deceptive attachment of left hand to right arm, and vice versa, to be "mistaken." The at-

tachment of hands to arms is structurally implausible in this image whichever way we read it, but as the figure clearly has a left hand on her right side, and vice versa, the simplest and iconographically most plausible explanation is that the arms are crossed.

126. Cf., for example, Carol Gilligan, *In a Different Voice: Psychological Theory and Women's Development* (Cambridge, Mass.: Harvard University Press, 1982), esp. 71, which points out that the "conventions of femininity" require a "moral equation of goodness with self-sacrifice." Gilligan notes that the traditionally "good woman" self-deceptively ignores her own needs, while the "bad woman," struggling to assert the needs of self, may be closer to a healthy moral solution.

127. Ironic parallels between Judith and Holofernes are discussed in Alonso-Schökel, 1975.

128. Samuel Edgerton, Jr., "Galileo, Florentine 'Disegno,' and the 'Strange Spottednesse' of the Moon," *Art Journal* 44 (Fall 1984): 225–32. The drawings, presumably executed around 1610, appear on two sides of a single sheet, in a special collection of the Biblioteca Nazionale, Florence. It is relevant that Galileo named the moons of Jupiter "Medicean Stars" in honor of his and Artemisia's mutual Florentine patron, Cosimo II de' Medici. See also Chappell, 1975, 91–98, which discusses the influence of Galileo's discoveries upon his friend Cigoli. In the Pauline Chapel at S. M. Maggiore, Rome, in 1610–12, Cigoli depicted the Virgin as Queen of Heaven standing upon, not the traditional lunar crescent, but an image of the pock-marked lunar landscape as revealed by Galileo. Artemisia would have seen this image at the time it was painted (see above, pp. 18–19), but since her own relationship with Galileo came later, the combined impact may understandably have been delayed until her return to Rome in c. 1622.

## CHAPTER 6

1. This chapter is an expanded version of an article published in 1980: Mary D. Garrard, "Artemisia Gentileschi's *Self-Portrait as the Allegory of Painting*," *Art Bulletin* 62 (March 1980): 97–112. Documentation and history of Artemisia's *Self-Portrait* are given above, pp. 68 ff.

In 1962 Michael Levey confirmed the identity

of the artist through comparison with other seventeenth-century images of Artemisia and connected the picture with Ripa's description of Pittura (Cesare Ripa, *Iconologia* [1593] [Padua: P. P. Tozzi, 1611], 429–30). See Levey, 1962, 79–80; and also Levey, 1964.

2. Garrard, 1980, 110 n. 54. In a recent note affirm-

ing the identity of the seated artist on the reverse of the Casoni medal as the Allegory of Painting, and not Lavinia Fontana herself, Jean Owens Schaefer observes that the Fontana medal is likely to have been the first pictorial rendering of Ripa's Pittura. Jean Owens Schaefer, "A Note on the Iconography of a Medal of Lavinia Fontana," *Journal of the Warburg and Courtauld Institutes* 47 (1984): 232–34.

3. Garrard, 1984b, 337–76.

4. Walter Bombe, "Giorgio Vasaris Häuser in Florence und Arezzo," *Belvedere* 12–13 (1928): 55 ff.; Paola Barocchi, *Vasari pittore* (Milan: Il Club di Libro, 1964), 23, 127; 50–51 and 138. On the Florentine house, see Fredrika H. Jacobs, "Vasari's Vision of the History of Painting: Frescoes in the Casa Vasari, Florence," *Art Bulletin* 66 (September 1984): 399–416; for the Arezzo house, see Liana De Girolami Cheney, *The Paintings of the Casa Vasari (Arezzo)* (Ph.D. dissertation, Boston University, 1978), 2 vols. (New York: Garland Press, 1985). The decorations of Vasari's houses are also discussed by Matthias Winner, "Die Quellen der Pictura-Allegorien in gemalten Bildergalerien des 17. Jahrhunderts zu Antwerpen," dissertation, Cologne, 1957.

Vasari's images of Pittura designed for the frames surrounding the artists' portraits appeared as woodcut illustrations in the second (1568) edition of the *Lives of the Artists*. These images were also included in Vasari's *Libro de' disegni*; proofs of the woodcut illustrations were pasted in as headings of the decorative borders framing the drawings in his collection. Giorgio Vasari, *Le Vite de' più eccellenti pittori, scvltori e architettori, scritte di nuovo ampliate, da M. Giorgio Vasari pittore et architetto Aretino*, 2nd ed., 3 vols. (Florence: I. Giunti, 1568). See also Otto Kurz, "Giorgio Vasari's Libro de' Disegni," *Old Master Drawings* 11 (June 1937): 1–15; and 12 (December 1937): 32–44.

5. Passerotti's *Pittura* (Adam von Bartsch, *Le Peintre graveur* [1803–21] [Leipzig: J. A. Barth, 1854–76], 13:6) is discussed briefly by Mary Pittaluga, *L'Incisione italiana nel Cinquecento* (Milan: U. Hoepli, 1930), 313. The print is not dated, but it undoubtedly postdates Vasari's *Pittura* of 1542.

6. On the complex history of the Liberal Arts in the Middle Ages, see especially Paolo d'Ancona, "Le rappresentazioni allegoriche delle arti liberali nel medio evo e nel rinascimento," *L'Arte* 5 (1902): 137–55; 211–28, 269–89; and 370–85; L. D. Ettlinger, "Pollaiuolo's Tomb of Pope Sixtus IV," *Journal of the Warburg and Courtauld Institutes* 16 (1953): 239–74, esp. 250 ff.; Jean Seznec, *The Survival of the Pagan Gods, The Mythological Tradition and Its Place in Renaissance Humanism and Art* [1940], trans. Barbara F. Sessions, Bollingen Series 38 (Princeton: Princeton University Press, 1972), ch. 4; Adolf Katzenellenbogen, "The Representation of the Seven Liberal Arts," in Marshall Clagett, ed., *Twelfth-Century Europe and the Foundations of Modern Society* (Madison, Wis.: University of Wisconsin Press, 1961); and Philippe Verdier, "L'iconographie des arts libéraux dans l'art du moyen âge jusqu'à la fin du quinzième siècle," in *Arts libéraux et philosophie au moyen âge*, Actes du Quatrième congrès international de philosophie médiévale, Université de Montréal, 1967 (Paris: Librairie philosophique J. Vrin, 1969), 305–355. Other literature is also cited in Garrard, 1984b; and in Garrard, 1980, note 8.

Contrary to a belief widely held in the Renaissance, the art of painting appears to have had no firm standing among the Liberal Arts in antiquity (though individual artists were held in high esteem). In part, this is because the Liberal Arts did not become an organized set of entities until the Middle Ages, but Nikolaus Pevsner (1940, 34) observes that art was not the profession of educated men in ancient Greece, and Rudolf and Margot Wittkower (1963, 7–8 and 16) assert that the visual arts were never considered to be liberal arts in ancient Rome. Panofsky, on the other hand ([1924] 1968, 13), sustains the contrary position of Pliny the Elder, that painting was a liberal art in antiquity (*Natural History* 35.77), and points to the acceptance of this view in the Renaissance and to its reiteration by theorists. See also Ernst Kris and Otto Kurz, *Legend, Myth, and Magic in the Image of the Artist, A Historical Experiment* (New Haven and London: Yale University Press, 1979), 4 ff.

7. Figures representing Painting are found on the central portal of Sens Cathedral (end of the twelfth century), at Laon Cathedral (1210–30),

and on the north porch of Chartres (c. 1250); at Chartres, the male personification appears among male Liberal Arts figures. (See Eugène Emmanuel Viollet-le-Duc, *Dictionnaire raisonné de l'architecture française du XIᵉ au XVIᵉ siècle*, 10 vols. [Paris: A. Morel & Cⁱᵉ, 1868–74], 2:1–10.) On the Florentine Campanile, reliefs from the Andrea Pisano workshop (1337–40) show male figures representing Painting and Sculpture among female personifications of the traditional Liberal Arts. A century later, Luca della Robbia added Liberal Arts figures to the north side of the Campanile, using male exponents, e.g., Orpheus for Music, Euclid for Geometry, Pythagoras for Arithmetic. See Walter and Elisabeth Paatz, *Die Kirchen von Florenz*, 6 vols. (Frankfurt am Main: Klostermann, 1952–55), 3:389 and 549 ff.; and d'Ancona, 1902, 223 ff.

8. The seven *artes mechanicae*, first codified by Hugh of St. Victor in the twelfth century, were eventually joined in pictorial representations by a variety of other non-liberal crafts, occupations, and skills. See Michael Evans, "Allegorical Women and Practical Men: The Iconography of the *Artes* Reconsidered," in Derek Baker, ed., *Medieval Women*, Studies in Church History, Subsidia I (Oxford: Basil Blackwell, for The Ecclesiastical History Society, 1978), 325–26.

9. M. Evans (1978, 325–26) has shown that male figures represented the Liberal Arts in some medieval manuscripts, either as famous exponents in combination with female personifications or, more rarely, as the *artes* themselves. In the case of the canonical seven Liberal Arts, it is not easy to determine whether the male figure is an unidentified historical exponent or an anonymous practitioner. Figures who represent the non-liberal arts, however, especially in the later Middle Ages, are almost invariably male and, necessarily, practitioners rather than the famous exponents.

10. Ettlinger (1953, 258–59) convincingly rejects the interpretation of some historians that Perspective on the Tomb of Sixtus IV represents the fine arts in general and Painting in particular, on the grounds that *Prospettiva*, following medieval usage, is synonymous with optics, not with pictorial perspective construction. Ettlinger's position is confirmed by the inscription and by the attribute of *Prospettiva*, which is an astrolabe.

11. L. B. Alberti, *Della Pittura*, 2:28 (*On Painting and On Sculpture, The Latin Texts of De Pictura and De Statua* [1430s], ed. and trans. by Cecil Grayson [London: Phaidon, 1972]) echoes Pliny in asserting that painting was among the liberal arts in ancient Rome; Ghiberti had planned to add to the third book of his *Commentaries* a discussion of the *artes liberales*, which were in his view a necessary humanistic foundation for the education of the sculptor. See Krautheimer, 1956, 311.

12. A good brief overview of the *Tarocchi* engravings is given in Jay Levenson, Konrad Oberhuber, and Lynn Sheehan, *Early Italian Engravings from the National Gallery of Art* (Washington, D.C.: National Gallery of Art, 1973), 81 ff. See also Seznec, 1972, 137 ff.

13. On Apollo and the Muses as symbols of the arts, and the deliberate anagrammatic parallel with Apelles, see Winner, 1957, 13 ff.; and Seznec, 1972, 140 ff.

14. For the passage in which Leonardo argues for the separation of the art of painting from craftsmanship, see Jean Paul Richter, ed., *The Literary Works of Leonardo da Vinci*, 2nd ed., enlarged and revised by J. P. Richter and Irma A. Richter, 2 vols. (London: Oxford University Press, 1939), 1:654 ff. See also Pevsner, 1940, 30 ff.; Anthony Blunt, *Artistic Theory in Italy, 1450–1600*, 2nd ed. (Oxford: Oxford University Press, 1962), 49 ff.; Kemp, 1977; and Garrard, 1984b, esp. 345–49.

15. See above, p. 177.

16. Charles de Tolnay, "Velázquez' *Las Hilanderas* and *Las Meninas* (An Interpretation)," *Gazette des Beaux-Arts* 35 (January 1949): 32.

17. Blunt, 1962, ch. 4.

18. Pevsner, 1940, ch. 2. See also Carl Goldstein, "Vasari and the Florentine Accademia del Disegno," *Zeitschrift für Kunstgeschichte* 38, no. 2 (1975): 145–52.

19. Vasari's house in Florence is located at Borgo S. Croce, No. 8; see note 4 above for literature. For Bocchi's description of the episodes in the life of Apelles, see Barocchi, 1964b, 138.

20. Zuccaro's painting, executed a few years after the establishment of the Accademia di S. Luca, also follows shortly after the publication of Romano Alberti's *Trattato della nobiltà della pittura . . .* (Rome: F. Zannetti, 1585), a trea-

tise devoted to the proof that painting is a Liberal and not Mechanical Art. See Mahon, [1947] 1971, 163 n. 3; and Friedländer, 1955, 65 ff.

21. For a fuller discussion of the role of Athena (Minerva) as emblem of the arts, see Tolnay, 1949, 21–38; and Winner, 1957, esp. 88 ff. The picture by Hans von Aachen is a *modello* for a painting presently in a private collection, London. This *Pittura* predates by a number of years the foundation of art academies in Germany, the first of which appeared about 1650 (Pevsner, 1940, 115 ff.). Numerous examples of paintings and prints representing the theme of the admission of Painting to the Liberal Arts have been gathered in the photographic archive of the Warburg Institute, London.

22. Horace, *Ars Poetica* 361; Rensselaer W. Lee, *Ut Pictura Poesis: The Humanistic Theory of Painting* (New York: W. W. Norton, 1967). For literature on the relation of Poetry and Painting in the Middle Ages and Renaissance, see Garrard, 1984b, esp. 343 ff.

23. E.g., Lodovico Dolce, *Dialogo della pittura, intitolato l'Aretino* (Venice: Gabriel Giolito de' Ferrari, 1557); and Giovanni Paolo Lomazzo, *Trattato dell'arte della pittvra, scoltvra, et archi-tettvra* (Milan: Per P. G. Pontio, 1584). These and other Renaissance theorists are discussed by Lee, 1967.

24. Furini's *Pittura and Poesia* (Florence, Uffizi) is here represented by the engraving of it that appeared in *L'Etruria Pittrice* (Lastri, 1791, pl. LXXXXII, there ascribed to Cesare Dandini). Christel Thiem (1977, 378 and fig. 297) confirms Furini's authorship. Boschini's engraving of the Allegory of Painting, frontispiece to the *Ricche Minere*, is based upon an illustration in G. Cesare Gigli's *Pittura Trionfante*, designed by Palma Giovane and engraved by D. Fialetti; see Marco Boschini, *La Carta del Navegar Pitoresco, edizione critica con la "Breve Instruzione" premessa alle "Ricche Minere della Pittura Veneziana,"* ed. Anna Pallucchini (Venice: Istituto per la collaborazione culturale, 1966), fig. 30.

25. The date 1558 is inscribed on Moro's easel. The Greek verses on the canvas were published by Baldinucci, and were translated into Italian by order of Cosimo III, who acquired the painting. For the text, see *Reale galleria di Firenze illustrata*, ser. 3, *Ritratti di pittori* (Florence: Luigi di G. Molini, 1817), 1:167–69.

26. The golden chain given to Titian by Charles V symbolized the rank of Count Palatine and the Order of the Golden Spur, both conferred in 1533. See Panofsky, 1969, 7–8; and on the more general relation between rulers and painters, see Kris and Kurz, 1979, 40 ff.

27. In Bourdon's engraving, the inscription relates the story of Alexander's gift of Campaspe to the painter, who had fallen in love with her, and provides the appropriate reference to Pliny, the source of the legend (*Natural History* 35.86–87; see K. Jex-Blake, trans., *The Elder Pliny's Chapters on the History of Art* [Chicago: Argonaut Publishers, 1968], 125). Other notable Italian versions of the Alexander and Apelles theme include the painting by Primaticcio at Fontainebleau, and Tiepolo's picture (Montreal, Museum of Fine Arts), in which the image of Apelles is said to be combined with a self-portrait of the artist (Winner, 1957, 30).

In the Netherlands, the Alexander-Apelles-Campaspe theme was often introduced into gallery pictures, as a prominent painting in a room full of pictures, in order to glorify the collector as well as the artist. Madlyn Kahr and Jonathan Brown have independently examined this tradition: Madlyn Kahr, "Velázquez and *Las Meninas*," *Art Bulletin* 57 (June 1975): 225–46; Kahr, 1976; Jonathan Brown, *Images and Ideas in Seventeenth-Century Spanish Painting* (Princeton: Princeton University Press, 1978), ch. 4 (based on material presented in public lectures in 1973–74).

28. For example, Velázquez's portrait of the Infante Don Carlos of c. 1626 (Madrid, Prado). Don Carlos wears a chain of a type that, according to Cassiano dal Pozzo, was currently popular in Spain. See Enriqueta Harris, "Cassiano dal Pozzo on Diego Velázquez," *Burlington Magazine* 112 (June 1970): 371.

29. See Georg Eckhardt, *Selbstbildnisse niederländischer Maler des 17. Jahrhunderts* (Berlin, 1971), 177–78. Carlo Dolce's *Self-Portrait* of 1674 (Florence, Uffizi) very literally illustrates this dilemma, showing the "gentleman" self holding a drawing that depicts the "craftsman" self in the act of drawing. The picture was described by Wittkower as a "revealing pictorial document of the dichotomy in the life of the gentleman-artist," who sees himself simultaneously as a "stylish melancholicus"

and "a drably dressed, unshaven, anaemic little craftsman" (Wittkower and Wittkower, 1963, 240 and fig. 72).

30. Self-portraits that included emblems of the arts in the background were rare before the eighteenth century. An exception is Livio Mehus's *The Genius of Sculpture*; see Gerhard Ewald, "Livio Mehus's 'Genius of Sculpture,'" *Burlington Magazine* 116 (July 1974): 392. By the eighteenth century, when the battle for the elevated status of painting was largely won, attributes such as statuettes or brushes were often included in a relaxed, off-hand way in the background of a self-portrait (e.g., that of Largillière, Musée des Beaux-Arts, Tours).

31. The earlier engraving bears the inscription "ACADEMIA DI BACCHIO BRANDIN IN ROMA IN LUOGO DETTO BELVEDERE MDXXXI." The second engraving is inscribed "*Baccius Bandinellus inven. Enea Vigo Parmegiano Sculpsit.*" Pevsner (1940, 39 ff.) contrasted the two prints to show the changing meaning of "academy" in the sixteenth century and the evolving character of Florentine art education.

32. On the "Academia d' Pitori" of P. F. Alberti (1584–1638), see Bartsch, [1803–21] 1854–76, 17:313–14. On the likelihood that the *School of Athens* itself contains among its philosophers exponents of the Liberal Arts, see Gombrich, 1972, 92 ff.; Konrad Oberhuber and Lamberto Vitali, *Raffaello: Il cartone per la scuola di Atene* (Milan: Silvana, 1972), 28 ff.; and Garrard, 1984b, 366 ff. G. P. Lomazzo's *Allegory, Art and Glory* (*Beschreibender Katalog der handzeichnungen in der graphischen sammlung Albertina herausgegeben von Alfred Stix*, 6 vols. [Vienna: A. Schroll & Co., 1926–41], 6:443) represents a variant of this tradition, combining allegorical figures with artists' workshops.

33. See Elizabeth Cropper, "Bound Theory and Blind Practice: Pietro Testa's Notes on Painting and the Liceo della Pittura," *Journal of the Warburg and Courtauld Institutes* 34 (1971): 285–86; and idem, *The Ideal of Painting, Pietro Testa's Düsseldorf Notebook* (Princeton: Princeton University Press, 1984), 88.

34. J. Bruyn and J. A. Emmens, "The Sunflower Again," *Burlington Magazine* 99 (March 1957): 97. Van Dyck was given the golden chain by Charles I in 1633; this picture (London, Coll.

Duke of Westminster) dates from 1633–35. See R. R. Wark, "Notes on Van Dyck's *Self-Portrait with a Sunflower*," *Burlington Magazine* 98 (February 1956): 53–54.

35. On this painting, see Gnudi, 1971, pl. 22.

36. See Donald Posner, "The Picture of Painting in Poussin's *Self-Portrait*," in Douglas Fraser, Howard Hibbard, and Milton Lewine, eds., *Essays in the History of Art Presented to Rudolf Wittkower* (London: Phaidon, 1967), 200–203. Posner proposes that the female figure wearing the crown with one eye depicted on the canvas in the left background of Poussin's *Self-Portrait* symbolizes Perspective, employed here "to denote the intellectual and creative vision which is the supreme characteristic of Painting." This interpretation concurs with Bellori's statement that the woman symbolizes Painting (see Blunt, 1966, 8).

37. "The hair will be shaggy and dishevelled on top, and with curls in various places, [an effect] that appears to be produced by negligence, because these exterior effects of the head are born, just as inside thoughts are born, and phantasms, which are the means as much to speculations as to material works." ("*Saranno i capelli hirsuti, & sparsi in alto, & in diuerse parti con anellature, cha appariscano prodotte dalla negligenza, perch nascono questi esteriormente dalla testa, come interiormente ne nascono i pensieri, & i fantasmi, che sono mezzi come alle speculatione, cosi ancora all'opere materiali*"). "Pittura," in Ripa, [1603] 1970, 367–68.

38. Cf. Roger P. Hinks, *Myth and Allegory in Ancient Art* (London: The Warburg Institute, 1939), 12–13, who explains that allegory, for ancient authors, was a means by which "an abstract intellectual concept could be made accessible to the concrete imagination," a process, like myth, to be distinguished from *ekphrasis*, a late antique literary exercise designed to display erudition rather than to make a complex abstraction graphically clear.

39. Levey (1962, 80) accounts for Artemisia's "slightly learned depiction of herself" through his suggestion that Cassiano was the patron of the picture. Spear (1971a, 98) states that "Cassiano himself may well have dictated the Ripa-based allegory." Bissell (1968, 158) more generally connects Artemisia's interest in allegorical subject-matter in the 1630s with "an in-

fluence of the Roman cultural climate, particularly that of the circle of Cassiano dal Pozzo."

40. On Ripa's approach to his subject, see Erna Mandowsky, "Ricerche intorno all' *Iconologia di Cesare Ripa*," *La Bibliofilia* 41 (1939): particularly 13 ff. and 279 ff.; and also Cropper, 1971, 270.

41. One of the earliest images of Pittura, if not the earliest, appears in a French edition of 1644 (Cesare Ripa, *Iconologie*, trans. Jean Baudouin [New York and London: Garland, 1976]).

42. "*Ora questo è il maggior diletto e piacere che con colori si possa porgere ai risguardanti; e chiamasi via del fare i cangianti, cioè un panno di seta solo, che nei lumi abbia un colore di una specie, e nell'ombra uno di un'altra....*" Lomazzo, 1584, bk. 3, ch. 10, 198–201.

43. Luigi Salerno, in *Age of Caravaggio*, 1985, 17–21. Rosand (1982, 15–26) discusses the *disegno-colore* controversy of the sixteenth century, conspicuously expressed in (but not limited to) Vasari's *Lives*. On the continuation of the *disegno-colore* controversy in the seventeenth century, and on the relatively low status of color in academic theory, see Donald Posner, *Annibale Carracci: A Study in the Reform of Italian Painting around 1590*, 2 vols. (London: Phaidon, 1971), text, 136–38; and Mahon, [1947] 1971, 65 ff., 138, and 178 ff.

44. As Salerno observed (*Age of Caravaggio*, 1985, 19), Zuccaro's initial reaction to Caravaggio's paintings in the Contarelli Chapel, "I see nothing here beyond the idea of Giorgione," alluded to the *disegno-colore* controversy. Later academic appraisals of Caravaggio by Roger de Piles and Anton Raphael Mengs are quoted by Richard Spear, in *Age of Caravaggio*, 1985, 23. Bernardo De Dominici (1844, 3:161) relates that both Stanzione and Cavallino tried to imitate the delicacy of Artemisia's coloring.

45. Cropper, 1976, 374–94.

46. Despite his recommendation, faithful to tradition, that Pittura be depicted with her mouth bound, Ripa appears not to have understood its literary allusion. He explains: "The covered mouth is a sign that nothing is more helpful than silence and solitude." Both Lomazzo and Dolce indicate in their treatises an informed understanding of the simile ascribed by Plutarch to Simonides, though without specifically mentioning the covered mouth given the Allegory of Painting: "Some

men of parts have called the painter a 'mute poet,' and the poet a 'speaking painter.'" Mark W. Roskill, *Dolce's "Aretino" and Venetian Art Theory of the Cinquecento* (New York: New York University Press, for the College Art Association of America, 1968), 97; the same remark is made by Lomazzo (1584, 2:67).

47. This woodcut was executed by the Bolognese artist G. M. Mitelli (1634–1718) as part of a series of satirical prints that illustrated popular sayings. The maxim itself appears to be of sixteenth-century origin. See Paolo Toschi, *Populäre Druckgraphik Europas: Italien vom 15. bis zum 20. Jahrhunderts* (Munich: G.D.W. Callwey, 1967), 23 ff., and pl. 114. The verse at the bottom reads in translation:

Woman, you who want to show yourself off,
Don't affect in your ornaments any
  ostentation,
Little wisdom is sometimes concealed under
  a large cape.

48. Quoted in Merlyn Stone, *When God Was a Woman* (New York: Dial Press, 1976), 70.

49. Roberto Longhi, "Gentileschi padre e figlia," *L'Arte* 19 (1916): 292.

50. Giovanni Paolo Lomazzo, *Idea del tempio della pittura* [1590], trans. and commentary by Robert Klein, 2 vols. (Florence: Istituto nazionale di studi sul Rinascimento, 1974), 1:23 ff; and Federico Zuccaro, *L'Idea de' pittori, scultori ed architetti* (Torino: Agostino Disserolio, 1607), bk. 1, ch. 3, 38 ff. See also Blunt, 1962, 140 ff.; and Panofsky, [1924] 1968, 85 ff. and n. 30.

51. Cropper, 1971, 270 ff., 284–85. Alternate pairs of terms for the same basic distinction include *Ars* and *Usus* (see Matthias Winner, "Gemalte Kunsttheorie: Zu Gustave Courbets 'Allegorie reelle' und der Tradition," *Jahrbuch Berliner Museen* 4 [1962]: 151–85); and also *Paideia* and *Techne* (see Panofsky, [1924] 1968, 183 n. 6).

52. The figures of Theory and Practice with their respective upward and downward orientations appeared in the title page of Vincenzo Scamozzi's *L'Idea della Architettura Universale*, 2 vols. (Venice: Expensis auctoris, 1615), presumably taken from Ripa, and were thence adapted by Inigo Jones in his scenery designs for a masque, *Albion's Triumph*, of 1632. See D. J. Gordon, "Poet and Architect: The Intellectual Setting of the Quarrel between Ben

Jonson and Inigo Jones," *Journal of the Warburg and Courtauld Institutes* 12 (1949): 152–78, pl. 30 a, b, and c.

53. Testa's intention, however, was to express the complementarity of Theory and Practice; see Cropper, 1984, 84–89.

54. "The hair of the head is made black and thick, because the good painter is in continuous thought on the imitation of nature, and on art, with regard to perspective, and it is the object of the eye, and for this one needs almost continuously to have for his imagination all the visible effects of nature; he comes for this reason to have much anxiety and melancholy, which then generates dryness, as the doctors say, which is naturally produced in men . . ." ("*I capelli della testa si fanno neri, & grossi, perche stando il buon Pittore in pensieri continui dell'imitatione della natura, & dell'arte, in quanto da prospettiua, & è oggetto dell'occhio, et per questo bisognandoli quasi continua menta hauer per la fantasia tutti gli effeti visibili della natura, viene per tal cagione à prendere molta cura, & malinconia, che genera poi adustione, come dicono i Medici, dalla quale naturalmente ne gli huomini . . . si produce*"). "Pittura," in Ripa, [1603] 1970.

55. Wittkower and Wittkower, 1963, especially ch. 5. While Aristotle had drawn a connection between the melancholic humor and intellectual and artistic talent, it was Marsilio Ficino, in the late fifteenth century, who defined the artistic temperament as Saturnine (and melancholic) rather than Mercurial, conjoining Aristotle's view with Plato's idea of divine creative *mania* (Wittkower and Wittkower, 1963, 102–104).

56. Annibale's painting (Leningrad, Hermitage) is described by Posner (1971, text, p. 22) as "a statement about art as well as self." The qualities of disconnection, isolation, and silence are conveyed, as Posner notes, not only in the silent and sullen image of the artist, but also in the armless and faceless herm at upper left, and the withdrawn cat and mutely suspicious dog at the foot of the easel. It is likely, as Posner observes, that the character of expression here may have arisen from Annibale's personal feelings in an alien social world, yet one wonders if the strangely undefined mouth of the artist's self-image might not be an oblique allusion to the tradition of painting as mute poetry.

57. If two mirrors are arranged at an appropriate distance from one another, at an angle of slightly less than 90 degrees, one can see one's own left profile by looking into the mirror on the right. The fact that Artemisia would have had to lean forward and away from the intervening canvas in order to see herself in the mirror may account in part for her unusual position, turned slightly away from her canvas.

58. Diogenes Laertius, *Lives of the Philosophers*, 2.33, as paraphrased by Heinrich Schwarz, "The Mirror in Art," *Art Quarterly* 15, no. 2 (Summer 1952): 110. See Andreas Pigler, "Sokrates in der Kunst der Neuzeit," *Die Antike* 14, no. 4 (1938): 281–94, for a discussion of images of Socrates with the mirror, including the painting now ascribed to Mola. The generally accepted attribution of this painting to Mola is discussed in *Art Venitien en Suisse et en Lichtenstein*, Geneva, Musée d'art et d'histoire, September 13–November 5, 1978 (Milan: Electa Editrice, 1978), cat. no. 1.

59. Ripa, [1593] 1611, 441: "*Lo specchiarsi significa la cognitione di se medesimo, non potendo alcuno regolare le sue attioni, se i propri difetti non conosce.*"

60. See Lee, 1967, ch. 1; and Panofsky, [1924] 1968 (a book devoted to the exploration of this concept).

61. Panofsky, [1924] 1968, 109.

62. Ripa, [1603] 1970, 367–68: "*Lo specchio dove si vedono l'immagini che non son reali ci può esser similitudine dell'intelletto nostro, ove facciamo a piacer nostro aiutati dalla dispositione naturale nascere molte idee di cose che non si vedono: ma si possono porre in opera mediante l'arte operatrice di cose sensibili per mezzo di istromenti materiali.*"

63. The emblematic and pictorial traditions of Veritas with a mirror as her attribute are discussed briefly by Schwarz, 1952.

64. Panofsky, [1924] 1968, 88.

65. Vasari's painting is discussed by Paola Barocchi in connection with its preparatory drawing, in Barocchi's edited volume, *Mostra di Disegni del Vasari e della sua Cerchia*, Gabinetto dei Disegni e Galleria delle Stampe degli Uffizi, no. 17 (Florence: Leo S. Olschki, 1964), no. 27. George Kubler (1965, 439–45) mentions Vasari's example, as well as those of Ripa, Carducho, and others. In his discussion of Invenzione, Ripa describes Diana of Ephesus as the emblem of Nature. Carducho, in the

fourth dialogue of his *Diálogos de la pintura* (Madrid: Fr.co Martinez, 1633), depicts Nature, "the object of imitation by poetry and painting" (Kubler, 1965, 442), as the many-breasted Diana of Ephesus. Jacobs (1984, 408) adduces sixteenth-century depictions of Diana of Ephesus as an allegory of nature: a fountain figure by Tribolo, and a drawing by Cellini.

66. Marini, 1974, 388 (reflecting an oral proposal of M. Beltrame), connects Caravaggio's Narcissus with a passage in the *Corpus Hermeticum*, as elaborated by Marsilio Ficino: ". . . e mostrò alla Natura sottostante la bella forma divina. Quando vide in lui l'inesauribile bellezza, e tutta l'energia dei Governatori unita alla forma divina, la Natura sorrise di amore, poiché aveva visto i tratti della stupenda forma dell'Uomo, vista nella Natura una forma simile alla sua—riflessa nell'acqua—l'amò, e volle vivere con essa. Nel momento stesso in cui concepì questo desiderio, lo realizzò, e assunse la forma irrazionale. Allora la Natura, avendo accolto in sé il suo amato lo abbracciò, e furono uniti, perché bruciavano d'amore."* The ancient text, a disquisition on the position of Man in relation to Nature and God, may be consulted in English translation in Walter Scott, ed. and trans., *Hermetica: The Ancient Greek and Latin Writings Which Contain Religious or Philosophic Teachings Ascribed to Hermes Trismegistus*, 4 vols. (London: Dawsons of Pall Mall, 1968), 1:115–33. The attribution of the Corsini Gallery *Narcissus* to Caravaggio, long disputed, has recently gained broader acceptance; see *Age of Caravaggio*, 1985, cat. 76.

67. I take Caravaggio's painting to offer an alternative understanding of the Narcissus legend to that advanced by Plotinus, who saw Narcissus's fascination with his own reflection as a vain concern for fleeting sensory images and physical beauty that obstructed his contemplation of the superior world of timeless ideas (see Panofsky, [1924] 1968, 31). Other Neoplatonic interpretations of the myth are given by Louise Vinge, *The Narcissus Theme in Western European Literature up to the Early Nineteenth Century*, trans. Robert Dewsnap and Lisbeth Grönlund (Lund: Gleerups, 1967), 36–41. As Vinge points out, an early connection was made between Narcissus and Dionysus, who, according to the Orphic myth, created the world after viewing his image in a mirror. The associated idea found in some Neoplatonic

doctrines that the Narcissus myth is "an image of the soul's first descent into the body" (p. 40) would appear to be more relevant to Caravaggio's image.

68. See Panofsky, [1924] 1968, 104 n. 10 for Bernini's judgment; and 240 nn. 6, 12, for Caravaggio's defenders. According to Belloni, Caravaggio came upon his models by chance and "was fully satisfied with this invention of nature and made no effort to exercise his brain further." See Friedländer, 1955, 246.

69. L. B. Alberti, *Della Pittura* 2:26 ([1430s] 1972, 61–63). Marino's poems on the Narcissus theme, which emphasize the artful illusion of beauty and its power to deceive the viewer, are discussed by Vinge, 1967, 210–11. For commentaries that connect Ovid's Narcissus with pictures, see Vinge, 1967, esp. 13–14. An extensive discussion of Caravaggio's *Narcissus*, with thoughtful attention to the implications of Alberti's connection of the myth with painting, is given by Hubert Damisch, "D'un Narcisse l'autre," *Nouvelle Revue de Psychoanalyse*, 16 (1976): 109–146.

70. Corvi's *Allegory* of 1764 (Walters Art Gallery, Baltimore) is discussed by Nadia Tscherny, "Domenico Corvi's Allegory of Painting: An Image of Love," *Marsyas* 19 (1977–78): 23–27. See also Maxon and Rishel, 1970, no. 80.

71. Artistic associations between mirrors and Vanitas (in the sense both of transitoriness and conceit), and also between mirrors and Pride and Lust, are discussed briefly by Schwarz, 1952. The connection between women and earthly vanity is prevalently illustrated in Magdalen and Vanitas images. Yet an alternative tradition might be traced connecting mirror self-portraiture especially with women artists, beginning with Pliny's account of Lala, noted for a famous mirror self-image, and Boccaccio's description of another Roman artist, Marcia, who painted her portrait with the aid of a mirror (the latter is illustrated in a manuscript of the *De claris mulieribus* of 1402; see Schwarz, 1952, 110 and fig. 9).

According to Vinge (1967, 36), the now commonplace association between Narcissus and Vanitas appeared first in the Christian context.

72. The appearance in this chapter of a single example of a depicted canvas with a blank surface (that of Moro, Fig. 306), among a large number of paintings in which the canvas bears

73. *"Non ha l'ottimo artista alcun concetto / c'un marmo solo in sé non circonscriva / col suo superchio, e solo a quello arriva / la man che ubbidisce all'intelletto. . . ."* This translation of the first quatrain of Michelangelo's sonnet is by David Summers (Summers, 1981, 206). The Neoplatonic (but also Aristotelian) context of the sonnet is discussed by Panofsky ([1924] 1968, 117 ff.) and Summers (1981, ch. 14), who also discusses Varchi's commentary on the sonnet, and the extended thoughts of Francesco de Hollanda.

74. The English translation given here was provided in a short comment on Carducho by John F. Moffitt, in a review of Madlyn Millner Kahr, *Velázquez: The Art of Painting*, in *Art Journal* 38, no. 3 (Spring 1979): 213–16.

    The concept of the *tabula rasa* can be traced to antiquity; the O.E.D. cites Plato (Benjamin Jowett, *The Dialogues of Plato*, 3:73): "The artist will do nothing until he has made a *tabula rasa*."

75. See Kubler, 1965; and also Mary Crawford Volk (*Vicencio Carducho and Seventeenth-Century Castilian Painting* [New York and London: Garland, 1977]), who has stressed Carducho's theoretical grounding in Italian ideas of the late sixteenth century. (I have been unable to locate, however, any specific discussion of the *tabula rasa* in treatises by writers such as Dolce, Lomazzo, Romano Alberti, and Zuccaro.) Florentine by birth, Carducho was attached to the Spanish court from c. 1585; though he maintained contact with Florence and Rome, he was in Madrid between 1626 and 1632, engaged upon a major painting commission. See Volk, 1977, esp. 46 ff.

76. See also J. Brown, 1978, 38–40, on the Duke of Alcalá's patronage and collecting; he was a major patron of Jusepe de Ribera in Naples. The purchase of Gentileschi paintings by the Duke of Alcalá is mentioned in Pacheco's dialogues; see Pacheco, 1956, 1:148.

77. On the admission of the art of painting to the Liberal Arts in Spain, see Volk, 1978, 69–86. The important role played by Carducho and his *Diálogos* in the efforts of Spanish artists to found an official art academy is also discussed by Volk, 1977, ch. 4. Volk (1977, 107 ff.) has proposed that Velázquez may have been the unnamed *discípulo* of the master Carducho, in the latter's dialogues on the art of painting. On Pacheco's treatise, which was composed at irregular intervals from c. 1604 to 1638, see J. Brown, 1978, esp. 81–83.

78. Moffitt (1976, 214) suggested that Velázquez's *Portrait of the Sculptor Juan Martínez Montañes* (1635), which shows the sculptor with one hand on a barely roughed-out bust of the king, demonstrated the painter's early knowledge of the end-piece of Carducho's *Diálogos*. The portrait indeed projects something of the idea that the unworked material, like the blank canvas, contains more *in potentia* than development of the image may bring (cf. José López-Rey's interpretation of this painting, in his *Velasquez* [London: Studio Vista, 1980], 114–18). It is equally likely, however, that Artemisia's *Pittura* was a source of inspiration for this picture.

79. The importance of the keys, which indicate the painter's position as *aposentador*, is discussed at length by Jonathan Brown (1978, ch. 4). Brown has recently challenged the accuracy of Palomino's statement that the Cross of Santiago was added on the king's order after Velázquez's death in 1660, on technical grounds, observing that "the brushwork of the cross is uniform with the rest of the surface" (Jonathan Brown, *Velázquez, Painter and Courtier* [New Haven and London: Yale University Press, 1986], 257). Presumably, after being knighted in 1658, Velázquez himself added to the painting the sign of that highest professional rank he had struggled for years to obtain, thus reiterating the external symbolism of the artist's social worth. Especially relevant to the focus of this discussion are the studies of *Las Meninas* by Tolnay (1949, 21–38) and Kahr (1975, 225–46).

80. Artemisia's innovative achievement does not appear to have been highly influential upon successive women artists. Few of the numerous portraits and self-portraits of women artists that exist directly join the image of the artist with the Allegory of Painting. Frima Fox Hofrichter has recently proposed that Judith Leyster's *Self-Portrait* in Washington displays an association with the doctrine of painting and poetry; this does not include, however, the idea of the female allegory; Frima Fox Hofrichter, "Judith Leyster's 'Self-

Portrait': 'Ut Pictura Poesis,' " *Essays in Northern European Art Presented to Egbert Haverkamp-Begemann on His Sixtieth Birthday* (The Netherlands: Davaco Doornspijk, 1983), 106–109. A portrait of the Dutch artist Anna Maria von Schurman as the Muse of Painting, from the studio of Frans van Mieris the Elder (sold at auction, July 1981), presents that painter, sculptor, and feminist activist (1607–1678) who was patronized by Christina of Sweden as holding the attributes of painting and sculpture; though described as a muse, she may have been conceived as the Allegory, since she wears the mask of imitation on a chain. (I am grateful to H. Diane Russell for bringing this example to my attention.) In her *Angelica Hesitating between the Arts of Music and Painting*, Angelica Kauffman employed the male artist's mode and kept the separate identities intact. For other examples of unallegorical self-portraits and impersonal allegories of painting, see Tufts, 1974, figs. 14a and b, 60, 63, 69, etc.

Ann T. Lurie has proposed that Bernardo Cavallino's *La Pittura: An Allegory of Painting* may have been inspired by Artemisia's London *Self-Portrait* (and also by Vaccaro's portrait of Ana Massimo di Rosa, another woman painter), in Lurie and Percy, 1984, cat. 66. In both of these works by men, the artist has necessarily been eliminated in the process of translation.

# WORKS CITED

*L'Accademia Nazionale di San Luca.* 1974. With contributions by Carlo Pietrangeli, Paolo Marconi, Luigi Salerno et al. Rome: De Luca.

Aeschylus. 1976. *Aeschylus: The Oresteia.* Translated by Robert Fagles. Introduction, notes, and glossary by W. B. Stanford. London: Wildwood House.

*The Age of Caravaggio.* 1985. Exh. cat., New York, Metropolitan Museum of Art. New York: Electa/Rizzoli.

Agrippa, Henry Cornelius. 1529. *A Treatise of the Nobilitie and Excellencye of Woman Kynde.* Translated by David Clapham. N.p., 1542. (Subsequent editions under different titles: *The Glory of Women* [London, 1652]; and *Female Pre-eminence; or, The Dignity and excellency of that Sex, above the male* [London, 1670]).

Alberti, Leon Battista. [1430s] 1969. *I Libri della Famiglia.* Translated by Renee Neu Watkins, *The Family in Renaissance Florence.* Columbia, S.C: University of South Carolina Press.

———. [1430s] 1972. *On Painting and On Sculpture, The Latin Texts of De Pictura and De Statua.* Edited and translated by Cecil Grayson. London: Phaidon.

Alberti, Romano. 1585. *Trattato della nobiltà della pittura. . . .* Rome: F. Zannetti.

Alizeri, Federigo. 1846. *Guida artistica per la città di Genova.* 2 vols. in 3. Genoa: G. Grondana Q Giuseppe.

Allen, Don Cameron. 1968. *Image and Meaning, Metaphoric Traditions in Renaissance Poetry.* Baltimore: Johns Hopkins University Press.

Alonso-Schökel, Luis, S.J. 1975. "Narrative Structures in the Book of Judith." In W. Wuellner, ed., *Protocol of the Eleventh Colloquy, The Center for Hermeneutical Studies in Hellenistic and Modern Culture,* The Graduate Theological Union and the University of California, Berkeley, California, January 27, 1974. Berkeley: The Center for Hermeneutical Studies in Hellenistic and Modern Culture.

Alvarez, A. 1971. *The Savage God, A Study of Suicide.* London: Weidenfeld and Nicolson.

Amelotti, Luciana. 1951. *Il teatro di Federigo della Valle,* Genoa: n.p.

Amelung, Walther. 1908. *Die Sculpturen des Vaticanischen Museums, im auftrage und unter mitwirkung des kaiserlich deutschen archäologischen instituts (römische abteilung).* 4 vols. Berlin: G. Reimer.

Anderson, Jaynie. 1979. "The Giorgionesque Portrait: From Likeness to Allegory." In *Giorgione. Atti del Convegno internazionale di studio per il 5° Centenario della nascita,* pp. 153–58. Venice: Comitato per le celebrazione Giorgionesche, Commune di Castelfranco Veneto.

———. 1980. "Giorgione, Titian and the Sleeping Venus." In *Tiziano e Venezia, Convegno internationale di studi,* 337–42. Venice: Neri Pozza Editore.

Andrews, Keith. 1973. "*Judith and Holofernes* by Adam Elsheimer." *Apollo* 98, no. 139 (September): 206–209.

———. 1977. *Adam Elsheimer: Paintings, Drawings, Prints,* Oxford: Phaidon.

Apuleius. 1965. *The Golden Ass.* Loeb Classical Library.

*Around 1610: The Onset of the Baroque.* 1985. Exh. cat. London: Matthiesen Fine Art Ltd.

*Art Venitien en Suisse et en Liechtenstein.* 1978. Geneva, Musée d'art et d'histoire, September 13–November 5, 1978. Milan: Electa Editrice.

*Artemisia.* 1979. Texts by Roland Barthes, Eva Menzio, Lea Lublin. *Mot pour mot/word for word* 2. Paris: Yvon Lambert.

Askew, Pamela. 1969. "The Angelic Consolation of St. Francis of Assisi in Post-Tridentine Italian Painting." *Journal of the Warburg and Courtauld Institutes*: 280–306.

———. 1978. "Ferdinando Gonzaga's Patronage of the Pictorial Arts: The Villa Favorita." *Art Bulletin* 60 (June): 274–96.

Astell, Mary. 1694. *A Serious Proposal to the Ladies for the Advancement of Their True and Greatest Interest by a Lover of Her Sex.* London, printed for R. Wilkin at the King's Head in St. Paul's Churchyard.

———. 1700. *Some Reflections upon Marriage, occasion'd by the Duke & Duchess of Mazarine's case; which is also considered.* London: J. Nutt.

Atkinson, Ti-Grace. 1980. Review of *The Obstacle*

*Race.* In *Drawing* 2, no. 1 (May–June): 12–16.

Augustine. *The City of God.* 1871–72. Translated by Rev. Marcus Dods. 2 vols. Edinburgh: T. & T. Clark.

Azorius, Ioannes [Juan Azor]. 1600?–1612. *Institutionum moralium.* 3 vols. Vols. 2 and 3, ed. A. Chacon. Lugduni: H. Cardon.

Baccheschi, Edi, with Cesare Garboli. 1971. *L'opera completa di Guido Reni.* Milan: Rizzoli.

Baglione, Giovanni. [1642] 1935. *Le vite de' pittori, scultori ed architetti. Dal pontificato di Gregorio XIII del 1572 in fino a' tempi di papa Urbano Ottauo nel 1642.* Rome: E. Calzoni.

Bagnoli, Alessandro. 1978. *Rutilio Manetti, 1571–1639.* Siena, Palazzo Pubblico, June 15–October 15, 1978. Florence: Centro Di.

Baldass, Ludwig. 1965. *Giorgione.* Translated by J. Maxwell Brownjohn. New York: Abrams.

Baldinucci, Filippo. [1681–1728] 1808–12. *Notizie de' professori del disegno da Cimabue in qua.* Florence. Edition cited: *Opere di Filippo Baldinucci.* 14 vols. Milan: Società tipografica de' Classici italiani, 1808–12.

———. [1681–1728] 1974. *Notizie dei Professori del Disegno da Cimabue in qua per le quali si dimostro come.* Florence: Eurografica.

Balzac, Honoré de. 1977. *La cousine Bette.* Edited by André Lorant. Paris: Garnier-Flammarion.

Bambach, Carmen C. 1983. "A Note on Michelangelo's Cartoon for the Sistine Ceiling: Haman." *Art Bulletin* 65 (December): 661–65.

Bamber, Linda. 1982. *Comic Women, Tragic Men: A Study of Gender and Genre in Shakespeare.* Stanford, Calif.: Stanford University Press.

Bandello, Matteo. 1931. *Le Novelle.* Edited by Gioachino Brognoligo. 3 vols. Bari: G. Laterza & figli.

Barb, A. A. 1953. "Diva Matrix." *Journal of the Warburg and Courtauld Institutes* 16, nos. 3–4: 193–238.

———. 1966. "Antaura: The Mermaid and the Devil's Grandmother." *Journal of the Warburg and Courtauld Institutes* 29: 1–23.

Barocchi, Paola. 1964a. *Mostra di Disegni del Vasari e della sua Cerchia.* Gabinetto dei Disegni e Galleria delle Stampe degli Uffizi, no. 17. Florence: Leo S. Olschki.

———. 1964b. *Vasari pittore.* Milan: Il Club di Libro.

*Baroque III, 1620–1700.* 1986. Exh. cat. London: Matthiesen Fine Art Ltd.

Barri, Giacomo. 1679. *The Painter's Voyage of Italy.* Translated by W. Lodge. London: T. Flesher.

Bartoli, Pietro Santi. 1693. *Admiranda Romanorum antiquitatum.* Rome: I. I. de Rubeis.

Bartsch, Adam von. [1803–21] 1854–76. *Le Peintre graveur.* 21 vols. Leipzig: J. A. Barth.

———. [1802–21] 1978– . *The Illustrated Bartsch.* Walter L. Strauss, general editor. New York: Abaris Books.

Battisti, Eugenio. 1963. "La Data di Morte di Artemisia Gentileschi." *Mitteilungen des Kunsthistorischen Institutes in Florenz* 10, no. 4 (February): 297.

Baur-Heinhold, Margarete. 1967. *The Baroque Theatre, A Cultural History of the Seventeenth and Eighteenth Centuries.* New York: McGraw-Hill.

Bautier, Pierre. 1919. "Le opere d'arte italiana nella Francia invasa." *Rassegna d'arte* 19, nos. 9–10 (September–October): 157–67.

Becher, Ilse. 1966. *Das Bild der Kleopatra in der Griechischen und Lateinischen Literatur.* Deutsche Akademie der Wissenschaft zu Berlin, schriften der sektion für Altertumswissenschaft, 51. Berlin: Akademie-Verlag.

Béguin, S., B. Jestaz, and J. Thirion. 1972. *L'École de Fontainebleau (Guide).* Paris: Éditions des musées nationaux.

Bell, Susan Groag. 1976. "Christine de Pizan (1364–1430): Humanism and the Problem of a Studious Woman." *Feminist Studies* 3 (Spring–Summer): 173–84.

Belloni, Antonio. 1929. *Il seicento.* Milan: F. Vallardi.

Benesch, Otto. 1954–57. *The Drawings of Rembrandt.* 6 vols. London: Phaidon.

Berenson, Bernard. 1954. *Piero della Francesca, or, The Ineloquent in Art.* London: Chapman & Hall.

Berger, John. 1972. *Ways of Seeing.* London: British Broadcasting Corporation; Harmondsworth: Penguin.

Bergomensis, Jacobus. [1493] 1521. *De Claris Mulieribus.* In Jacopo Filippo Foresti, *De memorabilibus.* Paris.

Bertolotti, A. 1876. "Agostino Tassi: suoi scolari e compagni pittori in Roma." *Giornale di Erudizione Artistica* 5, fasc. 7 and 8 (July–August): 183–204.

*Beschreibender Katalog der handzeichnungen in der graphischen sammlung Albertina herausgegeben von Alfred Stix.* 1926–41. 6 vols. Vienna: A. Schroll & Co.

Bialostocki, Jan, and Michal Walicki. 1957. *Europäische Malerei in polnischen Sammlungen, 1300–*

*1800*. Warsaw: P[aństwowy] I[nstytut] W[ydawniczy].

Bird, Phyllis. 1974. "Images of Women in the Old Testament." In *Religion and Sexism: Images of Woman in the Jewish and Christian Traditions*, edited by Rosemary R. Ruether. New York: Simon and Schuster.

Bissell, R. Ward. 1966. "The Baroque Painter Orazio Gentileschi, His Career in Italy." 2 vols. Ph.D. dissertation, The University of Michigan.

———. 1968. "Artemisia Gentileschi—A New Documented Chronology." *Art Bulletin* 50 (June): 153–68.

———. 1981. *Orazio Gentileschi and the Poetic Tradition in Caravaggesque Painting*. University Park and London: Pennsylvania State University Press.

Bissell, R. Ward, and Alan P. Darr. 1980. "A Rare Painting by Ottavio Leoni." *Detroit Institute Bulletin* 58, no. 1: 46–53.

Bjurström, Per. 1972. "Baroque Theater and the Jesuits." In Rudolf Wittkower and Irma B. Jaffe, eds., *Baroque Art: The Jesuit Contribution*, pp. 99–110. New York: Fordham University Press.

Blumenthal, Arthur. 1980. *Theater Art of the Medici*. Exh. cat. Hanover, N.H.: Dartmouth College Museum and Galleries.

Blunt, Anthony. 1962. *Artistic Theory in Italy, 1450–1600*. 2nd ed. Oxford: Oxford University Press.

———. 1966. *The Paintings of Nicolas Poussin, A Critical Catalogue*. London: Phaidon.

———. 1967a. *Nicolas Poussin*. The A. W. Mellon Lectures in the Fine Arts, Washington, D.C., National Gallery of Art. Bollingen Series 35. 2 vols. New York: Bollingen Foundation.

———. 1967b. "A Series of Paintings Illustrating the History of the Medici Family Executed for Marie de Médicis—I and II." *Burlington Magazine* 109 (September and October): 492–98, and 562–66.

Boccaccio, Giovanni. 1479. *Von den erlychten Frouen*. Augsburg: Anton Sorg.

———. [1473] 1963. *Concerning Famous Women*. Translated and introduction by Guido Guarino. New Brunswick, N.J.: Rutgers University Press.

Bocchi, Achille. 1555. *Symbolicarum quaestionum de universo genere quas serio ludebat libri quinque*. Bologna: Apud Societatem Typographiae Bononiensis.

Bodkin, Maude. 1948. *Archetypal Patterns in Poetry*.

London and New York: Oxford University Press.

Bohlin, Diane DeGrazia. 1979. *Prints and Related Drawings by the Carracci Family*. Washington, D.C.: National Gallery of Art; Bloomington and London: Indiana University Press.

Böhomová-Hájková, H. 1956. "Die Restaurierung des Bildes 'Susanna und die beiden Alten.'" *Casopis Moravského Musea* 41: 309–10.

Bologna, Ferdinando. 1958. *Francesco Solimena*. Naples: L'Arte tipografica.

Bombe, Walter. 1928. "Giorgio Vasaris Häuser in Florence und Arezzo." *Belvedere* 12–13: 55 ff.

Bonello, Vincenzo. 1949. *The Madonna in Art*. Exh. cat. La Valletta, Malta: n.p.

Bonnefoy, Yves. 1970. *Rome 1630: l'horizon du premier baroque*. Paris: Flammarion.

Bono, Barbara J. 1984. "What Venus Did with Mars in Shakespeare's *Antony and Cleopatra*." In Barbara J. Bono, *Literary Transvaluation: From Vergilian Epic to Shakespearean Tragicomedy*. Berkeley: University of California Press.

Borea, Evelyn. 1965. *Domenichino*. Collana d'arte 12. Florence: G. Barbèra.

———, ed. 1970. *Caravaggio e Caravaggeschi nelle gallerie di Firenze*. Exh. cat., Florence, Pitti Palace, summer 1970. Florence: Sansoni.

Boschini, Marco. 1966. *La Carta del Navegar Pitoresco, edizione critica con la "Breve Instruzione" premessa alle "Ricche Minere della Pittura Veneziana."* Edited by Anna Pallucchini. Venice: Istituto per la collaborazione culturale.

Boschloo, A.W.A. 1974. *Annibale Carracci in Bologna: Visible Reality in Art after the Council of Trent*. Kunsthistorische studien van het Nederlands Instituut te Rome. Translated by R. R. Symonds. 2 vols. The Hague: Government Publications Office.

Bottari, Giovanni Gaetano, and Stefano Ticozzi, eds. 1822–25. *Raccolta di lettere sulla pittura, scultura ed architettura scritte da' più celebri personaggi dei secoli XV, XVI, e XVII*. 8 vols. Milan: G. Silvestri.

Bottari, Stefano. 1943. *Storia dell'arte italiana*. 2 vols. Milan-Messina: G. Principato.

Bradford, Ernle. 1972. *Cleopatra*. New York: Harcourt Brace Jovanovich.

Bredius, Abraham. 1969. *The Complete Edition of the Paintings by Rembrandt*. Revised by H. Gerson. London: Phaidon.

Brendel, Otto. 1955. "Borrowings from Ancient Art in Titian." *Art Bulletin* 37: 113–25.

Bridenthal, Renate, and Claudia Koonz. 1977. *Be-*

*coming Visible: Women in European History.* Boston: Houghton Mifflin.

Briffault, Robert. 1927. *The Mothers: A Study of the Origin of Sentiments and Institutions.* 3 vols. New York: Macmillan.

Briganti, Giuliano, ed. 1950. *I Bamboccianti, pittori della vita popolare nel Seicento.* Rome: Antiquaria.

————. 1962. *Il Palazzo del Quirinale.* Rome: Istituto poligrafico dello Stato, Libreria dello Stato.

Brink, J. R. 1980. "Bathsua Makin: Educator and Linguist (1608?–1675?)." In J. R. Brink, ed., *Female Scholars: A Tradition of Learned Women before 1800,* 86–100. Montreal: Eden Press Women's Publications.

Brockett, Oscar G. 1968. *History of the Theatre.* Boston: Allyn and Bacon.

Broude, Norma, and Mary D. Garrard, eds. 1982. *Feminism and Art History: Questioning the Litany.* New York: Harper & Row.

Brown, Christopher. 1982. *Van Dyck.* Ithaca, N.Y.: Cornell University Press.

Brown, Emerson, Jr. 1974. "Biblical Women in the Merchant's Tale: Feminism, Antifeminism, and Beyond." *Viator* 5: 387–412.

Brown, Jonathan. 1978. *Images and Ideas in Seventeenth-Century Spanish Painting.* Princeton: Princeton University Press.

————. 1986. *Velázquez, Painter and Courtier.* New Haven and London: Yale University Press.

Brown, Jonathan, and J. H. Elliott. 1980. *A Palace for a King: The Buen Retiro and the Court of Philip IV.* New Haven and London: Yale University Press.

Brown, Jonathan, and Richard L. Kagan. 1987. "The Duke of Alcalá: His Collection and Its Evolution." *Art Bulletin* 69 (June): 231–55.

Brownmiller, Susan. 1975. *Against Our Will: Men, Women and Rape.* New York: Simon and Schuster.

Brummer, Hans Henrik. 1970. *The Statue Court in the Vatican Belvedere.* Stockholm: Almquist & Wiksell.

Brunetti, Estella. 1956. "Situazione di Viviano Codazzi." *Paragone* 7, no. 79 (July): 48–69.

Bruni, Lionardo. [1409] 1897. *De Studiis et Literis.* In W. H. Woodward, *Vittorino de Feltre and Other Humanist Educators.* Cambridge: Cambridge University Press.

Bruyn, J., and J. A. Emmens. 1957. "The Sunflower Again." *Burlington Magazine* 99 (March): 96–97.

Callmann, Ellen. 1979. "The Growing Threat to Marital Bliss as Seen in Fifteenth-Century Florentine Paintings." *Studies in Iconography* 5: 73–92.

Calvesi, Maurizio, and Vittorio Casale. 1965. *Le incisioni dei Carracci, catalogo critico.* Rome: Communità europea dell'arte e della cultura.

Campbell, Joseph. [1949] 1956. *The Hero with a Thousand Faces.* New York: Meridian Books.

Campori, Marchese Giuseppe. 1870. *Raccolta di cataloghi ed inventarii inediti di quadre, statue, disegni . . . dal seccolo* [sic] *xv al secolo xix.* Modena: C. Vincenzi.

Canaday, John. 1969. *The Lives of the Painters.* 4 vols. London: Thames & Hudson.

Cantelli, Giuseppe. 1983. *Repertorio della Pittura Fiorentina del Seicento.* Florence: Opus Libri.

Cantimori, Delio. 1958. "Italy and the Papacy." In *New Cambridge Modern History,* 14 vols., vol. 2, *The Reformation 1520–1559,* ed. G. R. Elton, ch. 8. Cambridge: Cambridge University Press.

Capozzi, Frank. 1975. "The Evolution and Transformation of the Judith and Holofernes Theme in Italian Drama and Art before 1627." Ph.D. dissertation, The University of Wisconsin-Madison.

*Le Caravage et la peinture italienne du XVIIᵉ siècle.* 1965. Exh. cat., Paris, Musée du Louvre, February–April 1965. Paris: Ministère d'Etat, Affaires culturelles.

*I Caravaggeschi Francesi.* 1973. Exh. cat., Accademia di Francia, Villa Medici, Rome, November 1973–January 1974. Rome: De Luca.

Carbo, Ludovico. 1606. *Summae summarum casuum conscientiae sive totius theologiae practicae, in tribus tomis distributa.* 3 vols. in 1. Venice: Meiettus.

Carducho [Carducci], Vincenzo. 1633. *Diálogos de la pintura.* Madrid: Fr.ᶜᵒ Martinez.

Carroll, Eugene A. 1978. "A Drawing by Rosso Fiorentino of Judith and Holofernes." *Los Angeles County Museum of Art Bulletin* 24: 24–49.

Cartari, Vincenzo. [1615] 1976. *Le vere e nove imagini de gli dei delli antichi.* New York: Garland Press.

Casey, Paul F. 1976. *The Susanna Theme in German Literature, Variations of the Biblical Drama.* Bonn: Bouvier.

Castelli, Patrizia. 1979. *I Geroglifici e il Mito dell'Egitto nel Rinascimento*. Florence: Edam.

Castiglione, Baldesar. [1528] 1959. *The Book of the Courtier (Il libro del cortegiano)*. Translated by Charles Singleton. Garden City, N.Y.: Doubleday.

Causa, Raffaello. 1972. *La Pittura del Seicento a Napoli dal naturalismo al barocco*. In *Storia di Napoli*, vol. 5, pt. 2. Naples: Società Editrice Storia di Napoli.

Cecchi, Alessandro. 1977. "Borghini, Vasari, Naldini e la 'Giuditta' del 1564." *Paragone* 28, no. 323 (January): 100–107.

Cesari, Cesare de'. 1552. *Cleopatra Tragedia*. Venice: Appresso Giouan. Griffio.

Chapin, Chester F. 1955. *Personification in Eighteenth-Century English Poetry*. New York: King's Crown Press.

Chappell, Miles. 1975. "Cigoli, Galileo, and *Invidia*." *Art Bulletin* 57: 91–98.

———. 1984. *Cristofano Allori, 1577–1621*. Exh. cat., Florence, Palazzo Pitti, July–October 1984. Florence: Centro Di.

Charlton, John. 1976. *The Queen's House, Greenwich*. London: H. M. Stationery Office.

Cheney, Liana De Girolami. 1985. *The Paintings of the Casa Vasari* (Arezzo). (Ph.D. dissertation, Boston University, 1978.) 2 vols. New York: Garland Publications.

Chettle, George H. 1937. *The Queen's House, Greenwich*. Greenwich: Trustees of the National Maritime Museum.

Chiarini, Marco, ed. 1969. *Artisti alla Corte granducale*. Exh. cat., Palazzo Pitti, Appartamenti monumentali, May–July 1969. Florence: Centro Di.

Chubb, Thomas C. 1967. *The Letters of Pietro Aretino*. Hamden, Conn.: Archon Books.

*Civiltà del Seicento a Napoli*. 1984. Exh. cat., essays by Nicola Spinosa et al., Museo Capodimonte, October 24, 1984–April 14, 1985; Museo Pignatelli, December 6, 1984–April 14, 1985. 2 vols. Naples: Electa Napoli.

Clark, Kenneth. 1966. *Rembrandt and the Italian Renaissance*. New York: W. W. Norton.

Clark, Lorenne M. G., and Debra J. Lewis. 1977. *Rape: The Price of Coercive Sexuality*. Toronto: Women's Press.

Cochran, Eric W. 1973. *Florence in the Forgotten Centuries, 1527–1800: A History of Florence and the Florentines in the Age of the Grand Dukes*. Chicago and London: University of Chicago Press.

Comes, Natale. [1616] 1976. *Mythologiae*. Translated by Jean Baudouin. 2 vols. New York: Garland.

Comini, Alessandra. 1975. *Gustav Klimt*. New York: G. Braziller.

Comte, Philippe. 1977. "Judith et Holopherne, ou la naissance d'une tragédie." *Revue du Louvre* 27, no. 3: 137–39.

Conti Odorisio, Ginevra. 1979. *Donna e Società nel Seicento: Lucrezia Marinelli e Arcangela Tarabotti*. Rome: Bulzoni.

Costello, Jane. 1950. "The Twelve Pictures 'Ordered by Velasquez' and the Trial of Valguarnera." *Journal of the Warburg and Courtauld Institutes* 13: 237–84.

"Count von Schönborn Collection." 1935. Catalogue. Schloss Weissenstein ob Pommersfelden.

Cox-Rearick, Janet. 1984. *Dynasty and Destiny in Medici Art: Pontormo, Leo X, and the Two Cosimos*. Princeton: Princeton University Press.

Crelly, William R. 1962. *The Painting of Simon Vouet*. New Haven and London: Yale University Press.

Crinò, Anna Maria. 1954. "Due lettere autografe inedite di Orazio e di Artemisia Gentileschi De Lomi." *Rivista d'Arte* 29, ser. 3, vol. 4: 203–206.

———. 1960a. "More Letters from Orazio and Artemisia Gentileschi." *Burlington Magazine* 102 (June): 264–65.

———. 1960b. "Rintracciata la data di morte di Orazio Gentileschi." *Mitteilungen des kunsthistorischen Instituts in Florenz* 9: 258.

Crinò, A. M., and B. Nicolson. 1961. "Further Documents Relating to Orazio Gentileschi." *Burlington Magazine* 103 (April): 144–45.

Croce, Benedetto. [1931] 1968. "Le tragedie di Federigo Della Valle di Asti." In [Benedetto Croce], *Nuovi saggi sulla letteratura italiana del Seicento*. 3rd ed. Bari: Laterza.

Croce, Franco. 1965. *Federico Della Valle*. Florence: La Nuova Italia Editrice.

Cropper, Elizabeth. 1971. "Bound Theory and Blind Practice: Pietro Testa's Notes on Painting and the Liceo della Pittura." *Journal of the Warburg and Courtauld Institutes* 34: 262–96.

———. 1976. "On Beautiful Women, Parmigianino, *Petrarchismo*, and the Vernacular Style." *Art Bulletin* 58 (September): 374–94.

Cropper, Elizabeth. 1983. "Naples at the Royal Academy." *Burlington Magazine* 125 (February): 104–106.

———. 1984. *The Ideal of Painting: Pietro Testa's Düsseldorf Notebook*. Princeton: Princeton University Press.

Cummings, Frederick. 1974. "The Meaning of Caravaggio's 'Conversion of the Magdalen.' " *Burlington Magazine* 116 (October): 572–78.

Dacos, Nicole. 1973–74. *Il tesoro di Lorenzo il Magnifico*. Exh. cat., Palazzo Medici-Riccardi. 2 vols. Florence: Sansoni.

Daly, Mary. 1978. *Gyn/Ecology: The Metaethics of Radical Feminism*. Boston: Beacon Press.

D'Ambrosio, Angelo. 1973. *Il Duomo di Pozzuoli, storia e documenti inediti*. Pozzuoli, n.p.

Damisch, Hubert. 1976. "D'un Narcisse l'autre." *Nouvelle Revue de Psychanalyse* 16: 109–146.

da Morrona, Alessandro. 1812. *Pisa illustrata nelle arti del disegno*. 3 vols. Livorno: G. Marenigh.

d'Ancona, Paolo. 1902. "Le rappresentazioni allegoriche delle arti liberali nel medio evo e nel rinascimento." *L'Arte* 5: 137–55, 211–28, 269–89, and 370–85.

Dancy, J. C. 1972. *The Shorter Books of the Apocrypha: Tobit, Judith, Rest of Esther, Baruch, Letter of Jeremiah, Additions to Daniel, and Prayer of Manasseh*. Cambridge: Cambridge University Press.

*The Book of Daniel*. 1978. Intro. and commentary on chs. 1–9 by Louis F. Hartman; trans. and commentary on chs. 10–12 by Alexander A. Di Lella. Garden City, N.Y.: Doubleday.

Dargent, Georgette, and Jacques Thuillier. 1965. "Simon Vouet en Italie." In *Saggi e Memorie di Storia dell'arte*, vol. 4, pp. 27–63. Venice: Neri Pozza Editore.

Davis, Natalie Zemon. 1975. *Society and Culture in Early Modern France*. Stanford, Calif.: Stanford University Press.

de Beauvoir, Simone. 1953. *The Second Sex*. Translated and edited by H. M. Parshley. 1st American ed. New York: Knopf.

De Dominici, Bernardo. 1844. *Vite dei pittori, scultori ed architetti napoletani*. Reprint. Vol. 3. Naples: Tipografia Trani.

———. [1742] 1971. *Vite de' pittori, scultori ed architetti napoletani*. Vol. 3. Bologna: Forni Editore.

Defoe, Daniel. 1697. "An Academy for Women." In *An Essay upon Projects*. London. Facsimile reprint, Menston: Scholar P., 1969.

de Lavergnée, Barbara Brejon. 1979. "[Abbeville.

Musée Boucher-de-Perthes.] *La sainte Madeleine pénitente* de Claude Mellan." *La Revue du Louvre et des Musées de France*, 29, nos. 5–6: 407–410.

Delcor, M. 1971. *Le livre de Daniel*. Paris: J. Gabalda et Cⁱᵉ.

de Lellis, Carlo. [1654–71] 1968. *Famiglie nobili del Regno di Napoli*. 3 vols. Bologna: Forni.

Della Chiesa, Francesco Agostino. 1620. *Teatro delle donne letterate, con un breve discorso della preminenza, e perfettione del sesso donnesco*. Mondovi: G. Gislandi.

Della Valle, Federico. 1978. *Iudit*. Edited by Andrea Gareffi. Rome: Bulzone.

De Rinaldis, Aldo. [1929] 1976. *Neapolitan Painting of the Seicento*. New York: Hacker Art Books.

De Scudéry, Madeleine [Monsieur de Scudery, pseud.]. 1653–55. *Artamenes; or, The Grand Cyrus*. 5 vols. in 2. London: H. Moseley.

De Witt, Anthony. 1939. "Ein Werk aus dem Caravaggio-Kreis." *Pantheon* 23 (February): 51–53.

Dinnerstein, Dorothy. 1976. *The Mermaid and the Minotaur: Sexual Arrangements and Human Malaise*. New York: Harper & Row.

Dolce, Lodovico. 1557. *Dialogo della pittura, intitolato l'Aretino*. Venice: Gabriel Giolito de' Ferrari.

Domenichi, Lodovico. [1548] 1551. *La nobiltà delle donne*. Venice: G. Giolito di Ferrarii e fratelli.

Donaldson, Ian. 1982. *The Rapes of Lucretia, A Myth and Its Transformations*. Oxford: Clarendon Press.

Douglas, Mary. 1966. *Purity and Danger: An Analysis of Concepts of Pollution and Taboo*. London: Routledge & Kegan Paul.

Dowley, Francis H. 1955. "French Portraits of Ladies as Minerva." *Gazette des Beaux-Arts* 45, ser. 6: 261–86.

Drake, Stillman. 1978. *Galileo at Work: His Scientific Biography*. Chicago and London: University of Chicago Press.

Dubarle, André M. 1966. *Judith: Formes et Sens des Diverses Traditions*. 2 vols. Rome: Institut biblique pontifical.

Eckhardt, Georg. 1976. *Selbstbildnisse niederländischer Maler des 17. Jahrhunderts*. Berlin.

*L'Ecole de Fontainebleau*. 1972. Exh. cat., Paris, Grand Palais, October 17, 1972–January 15, 1973. Paris: Editions des musées nationaux.

Edgerton, Samuel, Jr. 1972. "*Maniera* and the *Mannaia*: Decorum and Decapitation in the Six-

teenth Century." In Franklin W. Robinson and Stephen G. Nichols, Jr., eds., *The Meaning of Mannerism*, 67–103. Hanover, N.H.: University Press of New England.

———. 1984. "Galileo, Florentine 'Disegno,' and the 'Strange Spottednesse' of the Moon." *Art Journal* 44 (Fall): 225–32.

Ellis, Oliver C. de Champfleur. 1947. *Cleopatra in the Tide of Time*. London: Williams and Norgate.

Emiliani, Andrea. 1958a. *Giovan Francesco Guerrieri da Fossombrone*. Urbino: Istituto statale d'arte.

———. 1958b. "Orazio Gentileschi: nuove proposte per il viaggio marchigiano." *Paragone* 9, no. 103: 38–57.

Enggass, Catherine, and Robert Enggass, trans. and intro. 1980. *Carlo Cesare Malvasia, The Life of Guido Reni*. University Park, Pa., and London: Penn State University Press.

Enggass, Robert, and Jonathan Brown. 1970. *Italy and Spain, 1600–1750*. Sources and Documents in the History of Art Series, edited by H. W. Janson. Englewood Cliffs, N.J.: Prentice-Hall.

Enslin, Morton S., and Solomon Zeitlin, ed., trans., commentary, and notes. 1972. *The Book of Judith*. Leiden: E. H. Brill.

Ettlinger, L. D. 1953. "Pollaiuolo's Tomb of Pope Sixtus IV." *Journal of the Warburg and Courtauld Institutes* 16: 239–74.

———. 1978. *Antonio and Piero Pollaiuolo: Complete Edition with a Critical Catalogue*. Oxford: Phaidon; New York: Dutton.

Evans, Sir Arthur. [1921] 1964. *The Palace of Minos, A Comparative Account of the Successive Stages of the Early Cretan Civilization as Illustrated by the Discoveries at Knossos*. 6 vols. in 4. New York: Biblo and Tannen.

Evans, Michael. 1978. "Allegorical Women and Practical Men: The Iconography of the *Artes* Reconsidered." In Derek Baker, ed., *Medieval Women*, Studies in Church History, Subsidia I, 305–29. Oxford: Basil Blackwell, for The Ecclesiastical History Society.

Ewald, Gerhard. 1974. "Livio Mehus's 'Genius of Sculpture.'" *Burlington Magazine* 16 (July): 392.

Faber, M. D. 1967. "Shakespeare's Suicides: Some Historic, Dramatic and Psychological Reflections." In Edwin S. Schneidman, ed., *Essays in Self-Destruction*, 30–58. New York: Science House, Inc.

Fabricius, Georgius. 1550. *Roma*. In Justus Lipsius,

*Roma illustrata, sive Antiquitatum romanarum breviarium*, 1770. Amsterdam: J. Wolters, 1689.

Fedden, Henry Romilly. 1938. *Suicide, A Social and Historical Study*. London: P. Davies, Ltd.

Feinblatt, Ebria. 1965. "Two Prints by Lucas van Leyden." *Los Angeles County Museum of Art Bulletin* 17, no. 2; 9–15.

Ffoulke, Charles M. 1907. *Monograph by Charles M. Ffoulke on the Judith and Holofernes Series, consisting of eight Flemish tapestries with original borders*. Washington, D.C.: n.p.

Fine, Elsa Honig. 1978. *Women and Art, A History of Women Painters and Sculptors from the Renaissance to the Twentieth Century*. Montclair, N.J., and London: Allenheld & Schram/Prior.

Fischel, Oskar. 1964. *Raphael*. London: Spring Books.

Flynn, Gerard. 1980. "Sor Juana Ines de la Cruz: Mexico's Tenth Muse (1651–1695)." In J. R. Brink, ed., *Female Scholars: A Tradition of Learned Women before 1800*, 119–37. Montreal: Eden Press Women's Publications.

Fodor, István. 1959. "The Origin of Grammatical Gender." *Lingua* 8, no. 1 (January): 1–41, and 8, no. 2 (May): 186–214.

Fonte, Moderata. 1600. *Il merito delle donne scritto da Moderata Fonte in due giornate, ove chiaramente si scuopre quanto siano elle degne e più perfette de gli huomini*. Venice: Presso Domenico Imberti.

Forster, Kurt W. 1981. "Metaphors of Rule—Political Ideology and History in the Portraits of Cosimo I de' Medici." *Mitteilungen des kunsthistorischen Instituts in Florenz* 15 (Heft 1): 65–104.

Fraschetti, Stanislao. 1900. *Il Bernini, la sua vita, la sua opera, il suo tempo*. With preface by Adolfo Venturi. Milan: Ulrico Hoepli.

Freccero, John. 1975. "The Fig Tree and the Laurel: Petrarch's Poetry." *Diacritics* 5 (Spring): 34–40.

Freedberg, Sydney J. 1966. "Andrea and Lucrezia: Two New Documents in Paint for Their Biography." In John Maxon, Harold Joachim and Frederick A. Sweet, eds., *Museum Studies 1*, pp. 15–27. Chicago: Art Institute.

———. 1978. "Lorenzo Lotto to Nicolas Poussin." *Apollo* 107, no. 195 (May): 389–97.

French, Marilyn. 1981. *Shakespeare's Division of Experience*. New York: Summit Books.

———. 1985. *Beyond Power: On Women, Men, and Morals*. New York: Summit Books.

Freud, Sigmund. [1922] 1955. "Medusa's Head." Translated by James Strachey. In *The Standard Edition of the Complete Psychological Works of Sigmund Freud*, edited by James Strachey, in collaboration with Anna Freud, assisted by Alix Strachey and Alan Tyson, vol. 18, pp. 273–74. London: Hogarth Press.

Friedländer, Walter. 1955. *Caravaggio Studies*. Princeton: Princeton University Press.

Friedländer, Max J., and Jakob Rosenberg. 1978. *The Paintings of Lucas Cranach*. Ithaca, N.Y.: Cornell University Press.

Fröhlich-Bume, L. 1940. "A Rediscovered Picture by Artemisia Gentileschi." *Burlington Magazine* 77 (November): 169.

Frommel, Christoph L. 1971. "Caravaggio und seine Modelle." *Castrum Peregrini* 96: 21–64.

———. 1977. " 'Capella Iulia': Die Grabkapelle Papst Julius' II in Neu-St. Peter," *Zeitschrift für Kunstgeschichte* 40, Heft 1: 26–62.

Galasso, Giuseppe. 1982. "Society in Naples in the Seicento." In Clovis Whitfield and Jane Martineau, eds., *Painting in Naples 1606–1705, From Caravaggio to Giordano*, pp. 24–30. Washington, D.C.: National Gallery of Art; London: Royal Academy of the Arts, in association with Weidenfeld and Nicolson.

———. 1985. "Napoli città e capitale moderna." In *Civiltà del Seicento a Napoli*, exh. cat., Museo Capodimonte, October 24, 1984–April 14, 1985; Museo Pignatelli, December 6, 1984–April 14, 1985, 2 vols., 1: 23–28. Naples: Electa Napoli.

Galilei, Galileo. 1929–39. *Le Opere di Galileo Galilei*. 20 vols. in 21. Florence: G. Barbèra.

Galinsky, Hans. 1932. *Der Lucretia-Stoff in der Weltliteratur*. Breslau: Priebatsch.

*Galleria Giustiniani del Marchese Vincenzo Giustiniani*. 1640. With engravings by Theodor Matham, Claude Mellan, Pierre de Balliu, Anne Marie Vajani et al., under the supervision of Joachim von Sandrart. 2 vols. Rome, n.p.

Gandolfi, Giovanni Cristoforo. 1846. *Descrizione di Genova e del genovesato*. 4 parts in 3 vols. Vol. 3. Genoa: Tipografia Ferrando.

*Gardner's Art through the Ages*. 1986. Revised by Horst de la Croix and Richard G. Tansey. 8th ed. New York: Harcourt Brace Jovanovich.

Garrard, Mary D. 1980. "Artemisia Gentileschi's *Self-Portrait as the Allegory of Painting*." *Art Bulletin* 62 (March): 97–112.

———. 1980–81. Re-view of Laura M. Ragg, *The Women Artists of Bologna* (1907). In *Woman's Art Journal* 1, no. 2 (Fall/Winter): 58–64.

———. 1982. "Artemisia and Susanna." In Norma Broude and Mary D. Garrard, eds., *Feminism and Art History: Questioning the Litany*, pp. 146–71. New York: Harper & Row.

———. 1984a. "Artemisia Gentileschi: The Artist's Autograph in Letters and Paintings." In Domna C. Stanton, guest ed., *The Female Autograph*, New York Literary Forum, no. 12–13, pp. 91–105. New York: New York Literary Forum.

———. 1984b. "The Liberal Arts and Michelangelo's First Project for the Tomb of Julius II (With a Coda on Raphael's 'School of Athens')." *Viator* 15: 335–76.

Gash, John. 1980. *Caravaggio*. London: Jupiter Books Publishers.

Gendel, Milton. 1959. "The Italians from the Dying Renaissance to the Futurist Explosion." *Art News* 58, no. 6 (October): 26–28, 53–55.

Gerson, Horst. 1968. *Rembrandt Paintings*. Translated by Heinz Norden, edited by Gary Schwartz. New York: Reynal.

Giannoni, Pietro. [1723] 1729–31. *The Civil History of the Kingdom of Naples*. Translated by Captain James Ogilvie. 2 vols. London: W. Innys.

Gilbert, Sandra M., and Susan Gubar. 1979. *The Madwoman in the Attic: The Woman Writer and the Nineteenth-Century Literary Imagination*. New Haven and London: Yale University Press.

Gilligan, Carol. 1982. *In a Different Voice: Psychological Theory and Women's Development*. Cambridge, Mass.: Harvard University Press.

Ginzburg, Carlo. 1970. *Il Nicodemismo, Simulazione e dissimulazione religiosa nell'Europa del '500*. Torino: Einaudi.

———. [1966] 1983. *The Night Battles: Witchcraft and Agrarian Cults in the Sixteenth and Seventeenth Centuries*. Translated by J. and A. Tedeschi. Baltimore: Johns Hopkins University Press.

Gnudi, Cesare. 1971. *Nuove acquisizioni per i Musei dello Stato, 1966–71*. Exh. cat., Palazzo dell'Archiginnasio, Bologna, September 28–October 24, 1971.

Godwin, Frances G. 1949. "The Judith Illustration of the *Hortus Deliciarum*." *Gazette des Beaux-Arts* 36, ser. 6, (July–September): 25–46.

*The Golden Age of Naples: Art and Civilization under the Bourbons 1734–1805*. 1981. Exh. cat., edited by Susan L. Caroselli, J. Patrice Maran-

del, Susan F. Rossen, and Robert Sharp. 2 vols. Detroit: The Detroit Institute of Arts, with The Art Institute of Chicago.

Goldschneider, Ludwig. 1951. *Michelangelo Drawings*. Greenwich, Conn.: Phaidon.

Goldstein, Carl. 1975. "Vasari and the Florentine Accademia del Disegno." *Zeitschrift für Kunstgeschichte* 38, no. 2: 145–52.

———. 1983. "Painting in Seventeenth-Century Naples." *Art Journal* 43, no. 3 (Fall): 267–70.

Gombrich, E. H. 1971. "Personification." In R. R. Bolgar, ed., *Classical Influences on European Culture*, A.D. *500–1500*, pp. 247–57. Cambridge: Cambridge University Press.

———. 1972. *Symbolic Images*. Studies in the Art of the Renaissance 2. Oxford: Phaidon.

Goodspeed, Edgar J. 1959. *The Apocrypha, An American Translation*. Introduction by Moses Hadas. New York: Modern Library.

Gordon, D. J. 1949. "Poet and Architect: the Intellectual Setting of the Quarrel between Ben Jonson and Inigo Jones." *Journal of the Warburg and Courtauld Institutes* 12: 152–78.

———. 1975. "Rubens and the Whitehall Ceiling." In *The Renaissance Imagination: Essays and Lectures*, collected and edited by Stephen Orgel, pp. 24–50. Berkeley and Los Angeles: University of California Press.

Gorsen, Peter. 1980. "Venus oder Judith? Zur Heroisierung des Weiblichkeitsbildes bei Lucas Cranach und Artemisia Gentileschi." *Artibus et historiae* 1: 69–81.

Gould, Cecil. 1976. *The Paintings of Correggio*. Ithaca, N.Y.: Cornell University Press.

De Gournay, Marie. 1910. "Egalité des hommes et des femmes." In *La Fille d'alliance de Montaigne: Marie de Gournay*, ed. Mario Schiff. Paris: H. Champion.

Grabar, André. 1968. *Christian Iconography, A Study of Its Origins*. Translated by Terry Grabar. The A. W. Mellon Lectures in the Fine Arts, National Gallery of Art, Washington, D.C., 1961. Bollingen Series 35/10. Princeton: Princeton University Press.

Grabski, Józef. 1985. "On Seicento Painting in Naples: Some Observations on Bernardo Cavallino, Artemisia Gentileschi and Others." *Artibus et historiae* 6, no. 11: 23–63.

Grant, Michael. 1972. *Cleopatra*. New York: Simon and Schuster; London: Weidenfeld and Nicolson.

Graves, Robert. 1960. *The Greek Myths*. 2 vols. Harmondsworth and New York: Penguin Books.

Greenhalgh, Michael. 1982. *Donatello and His Sources*. London: Duckworth Press.

Greer, Germaine. 1975. "Seduction Is a Four-Letter Word." In LeRoy G. Schultz, ed., *Rape Victimology*, pp. 374–95. Springfield, Ill.: Thomas.

———. 1979. *The Obstacle Race: The Fortunes of Women Painters and Their Work*. New York: Farrar, Straus and Giroux.

Gregori, Mina. 1962. "Avant-propos sulla pittura fiorentina del Seicento." *Paragone* 13, no. 145 (January): 21–40.

———. 1965. *70 pitture e sculture del '600 e '700 fiorentino*. Exh. cat., Florence, Palazzo Strozzi, October 1965. Florence: Officine grafiche Vallecchi.

———. 1968. "Su due quadri caravaggeschi a Burghley House." In Antje Kosegarten and Peter Tigler, eds., *Festschrift Ulrich Middeldorf*, pp. 414–21. Berlin: De Gruyter.

Griffin, Susan. 1978. *Woman and Nature: The Roaring Inside Her*. New York: Harper & Row.

Grosso, Orlando. 1926. *Genova* (Italia Artistica). Bergamo: Istituto italiano d'arti grafiche.

Guillaume, Jean. 1972. "Cleopatra Nova Pandora." *Gazette des Beaux-Arts* 80 (October): 185–94.

Gundersheimer, Werner L. 1980. "Women, Learning and Power: Eleonora of Aragon and the Court of Ferrara." In Patricia H. Labalme, ed., *Beyond Their Sex: Learned Women of the European Past*, pp. 43–65. New York: New York University Press.

Hadas, Moses. 1959. *Hellenistic Culture, Fusion and Diffusion*. Morningside Heights, N.Y.: Columbia University Press.

Hamilton, Elizabeth. 1976. *Henrietta Maria*. New York: Coward, McCann & Geoghegan.

Haraszti-Takacs, Marianne. 1978. "Encore une fois sur les Lucrèce du Sodoma." *Bulletin du Musée Hongrois des Beaux-Arts* 51: 71–86 and 203–209.

Harris, Enriqueta. 1970. "Cassiano dal Pozzo on Diego Velázquez." *Burlington Magazine* 112 (June): 364–73.

Harris, Ann Sutherland, and Linda Nochlin. 1976. *Women Artists: 1550–1950*. Los Angeles County Museum of Art. New York: Alfred A. Knopf.

Harris, John, Stephen Orgel, and Roy Strong. 1973. *The King's Arcadia: Inigo Jones and the Stuart Court*. Exh. cat., Banqueting House, Whitehall, July 12–September 2, 1973. London: Arts Council of Great Britain.

Hartt, Frederick. 1979. *History of Italian Renais-*

*sance Art*. 2nd ed. Englewood Cliffs, N.J.: Prentice-Hall; New York: Harry N. Abrams.

Haskell, Francis. 1963. *Patrons and Painters, A Study in the Relations between Italian Art and Society in the Age of the Baroque*. New York: Alfred A. Knopf.

Haskell, Francis, and Nicholas Penny. 1981. *Taste and the Antique, The Lure of Classical Sculpture, 1500–1900*. New Haven and London: Yale University Press.

Haskell, Francis, and Sheila S. Rinehart. 1960. "The Dal Pozzo Collection: Some New Evidence, Part I." *Burlington Magazine* 102 (July): 318–26.

Hatz, Mechthilde. 1972. "Frauengestalten des Alten Testaments in der bildenden Kunst von 1850 bis 1918: Eva, Dalila, Judith, Salome." Dissertation, Heidelberg.

Haverkamp-Begemann, Egbert. 1975. *The Achilles Series*. Corpus Rubenianum Ludwig Burchard, 10. Brussels: Arcade Press; London: Phaidon.

Heilbrun, Carolyn G. 1973. *Toward a Recognition of Androgyny*. New York: Harper & Row.

Heinz, Günther. 1981. "Gedanken zu Bildern der 'donne famose' in der Galerie des Erzherzogs Leopold Wilhelm." *Jahrbuch der Kunsthistorischen Sammlungen in Wien* 77: 105–118.

Held, Julius S. 1969. *Rembrandt's "Aristotle" and Other Rembrandt Studies*. Princeton: Princeton University Press.

Herbert, Robert L. 1972. *David, Voltaire, "Brutus" and the French Revolution: An Essay in Art and Politics*. New York: Viking Press; London: Allen Lane.

Hermanin, Federico. 1944. "Gli ultimi avanzi d'un'antica galleria romana." *Roma* 22: 46–47.

Herzner, Volker. 1980. "Die 'Judith' der Medici." *Zeitschrift für Kunstgeschichte* 43, no. 2: 139–80.

Hess, Jacob. 1952. "Die Gemälde des Orazio Gentileschi für das 'Haus der Königin' in Greenwich." *English Miscellany* 3: 159–87. Reprinted in *Kunstgeschichtliche Studien zur Renaissance und Barock*, Rome: Edizione di Storia e Letteratura (1967), 1: 241–57; 1: 421–22; vol. 2, pls. 171–83.

Heywood, Thomas. 1624. *Gynaikeion, or Nine Bookes of Various History Concerning Women; Inscribed by the names of the Nine Muses*. London, n.p.

Hibbard, Howard. 1964. "Scipione Borghese's Garden Palace on the Quirinal." *Journal of the Society of Architectural Historians* 23, no. 4 (December): 163–92.

———. 1983. *Caravaggio*. New York: Harper & Row.

Hill, G. F. 1912. *Portrait Medals of Italian Artists of the Renaissance, With an Introductory Essay on the Italian Medal*. London: P. L. Warner.

Hindman, Sandra L. 1984. "With Ink and Mortar: Christine de Pizan's *Cité des Dames* (An Art Essay)." *Feminist Studies* 10, no. 3 (Fall): 457–77.

Hinks, Roger P. 1939. *Myth and Allegory in Ancient Art*. London: The Warburg Institute.

Hirst, Michael. 1968. "Rembrandt and Italy." Letter in *Burlington Magazine* 110 (April): 221.

Hofrichter, Frima Fox. 1980. "Artemisia Gentileschi's Uffizi *Judith* and a Lost Rubens." *The Rutgers Art Review* 1 (January): 9–15.

———. 1983. "Judith Leyster's 'Self-Portrait': 'Ut Pictura Poesis.'" *Essays in Northern European Art Presented to Egbert Haverkamp-Begemann on His Sixtieth Birthday*, pp. 106–109. The Netherlands: Davaco Doornspijk.

Hollstein, F.W.H. 1949–[c. 1978]. *Dutch and Flemish Etchings, Engravings and Woodcuts ca. 1450–1700*. 20 vols. Amsterdam: M. Hertzberger.

Hoogewerff, G. J. 1923. *Jan van Scorel, Peintre de la Renaissance Hollandaise*. The Hague: M. Nijhoff.

———. [1938] 1942. *Nederlandsche Kunstenaars te Rome (1600–1725). Uittreksels uit de Parochiale Archieven*. Studiën van het Nederlandsch Historisch Instituut te Rome 3. 's-Gravenhage: Algemeene Landsdrukkerij.

———. 1952. *De Bentvueghels*. 's-Gravenhage: M. Nijhoff.

———. 1960. "Appunti sulle opere di Giovanni Biliverti." *Commentari* 11, fasc. 2 (April–June): 139–54.

Hope, Charles. 1980. *Titian*. New York: Harper & Row.

———. 1982. "Bronzino's *Allegory* in the National Gallery." *Journal of the Warburg and Courtauld Institutes* 45: 239–43.

Horney, Karen. 1932. "The Dread of Woman, Observations on a Specific Difference in the Dread Felt by Men and by Women Respectively for the Opposite Sex." *International Journal of Psychoanalysis* 13, no. 3 (July): 348–60.

Howe, Thalia Phillies. 1954. "The Origin and Function of the Gorgon-Head." *American Journal of Archeology* 58, no. 3 (July): 209–221.

Imparato, Francesco. 1889. "Documenti relativi ad

Artemisia Lomi Gentileschi pittrice." *Archivio Storico dell'Arte* 2: 423–25.

*Important Italian Baroque Paintings, 1600–1700*. 1981. Exh. cat. London: Matthiesen Fine Art Ltd.

*In the Light of Caravaggio*. 1976. Exh. cat. London: Trafalgar Galleries.

Iversen, Erik. 1961. *The Myth of Egypt and Its Hieroglyphs in European Tradition*. Copenhagen: Gad.

———. 1968–72. *Obelisks in Exile*. Vol. 1: *The Obelisks of Rome*; vol. 2: *The Obelisks of Istanbul and England*. Copenhagen: Gad.

Jacobs, Fredrika H. 1984. "Vasari's Vision of the History of Painting: Frescoes in the Casa Vasari, Florence." *Art Bulletin* 66 (September): 399–416.

Jaffé, Michael. 1971. "Pesaro Family Portraits: Pordenone, Lotto, and Titian." *Burlington Magazine* 113: 696–702.

———. 1977. *Rubens and Italy*. Oxford: Phaidon.

James, E. O. 1959. *The Cult of the Mother-Goddess: An Archaeological and Documentary Study*. London: Thames and Hudson.

Jameson, Anna Brownell. 1833. *Characteristics of Women, Moral, Poetical and Historical*. London: Saunders and Otley.

———. 1834. *Visits and Sketches at Home and Abroad*. 4 vols. London: Saunders and Otley.

Janson, H. W. 1969. *The Sculpture of Donatello*. Princeton: Princeton University Press.

Jex-Blake, K., trans. 1968. *The Elder Pliny's Chapters on the History of Art*. Chicago: Argonaut Publishers.

Jodelle, Estienne. 1552. *Cléopâtre Captive*. Crit. ed. by Lowell B. Ellis, "Estienne Jodelle, Cléopâtre Captive." Ph.D. dissertation, University of Pennsylvania, 1946.

Johnson, Marilyn L. 1974. *Images of Women in the Works of Thomas Heywood*. Salzburg, Austria: Institut für Englische Sprache und Literatur, Universität Salzburg.

Joost-Gaugier, Christiane L. 1980. "Giotto's Hero Cycle in Naples: A Prototype of *Donne Illustri* and a Possible Literary Connection." *Zeitschrift für Kunstgeschichte* 43, no. 3: 311–18.

Jordan, Constance. 1983. "Feminism and the Humanists: The Case of Sir Thomas Elyot's *Defence of Good Women*." *Renaissance Quarterly* 36 no. 2 (Summer): 181–201.

Judson, J. Richard. 1959. *Gerrit van Honthorst: A Discussion of His Position in Dutch Art*. 2nd ed. The Hague: M. Nijhoff.

Justi, Carl. 1888. *Diego Velasquez und sein jahrhundert*. 2 vols. Bonn: Cohen & sohn.

———. 1889. *Diego Velazquez and His Times*. London: H. Grevel & Co.

Kahr, Madlyn Millner. 1970. "The Meaning of Veronese's Paintings in the Church of San Sebastiano in Venice." *Journal of the Warburg and Courtauld Institutes* 33: 235–47.

———. 1972. "Delilah." *Art Bulletin* 54 (September): 282–99; Reprinted in Norma Broude and Mary D. Garrard, eds., *Feminism and Art History: Questioning the Litany*, pp. 121–45. New York: Harper & Row, 1982.

———. 1975. "Velázquez and *Las Meninas*." *Art Bulletin* 57 (June): 225–46.

———. 1976. *Velázquez: The Art of Painting*. New York: Harper & Row.

———. 1978a. "Danaë: Virtuous, Voluptuous, Venal Woman." *Art Bulletin* 60 (March): 43–55.

———. 1978b. *Dutch Painting in the Seventeenth Century*. New York: Harper & Row.

Katzenellenbogen, Adolf. 1959. *The Sculptural Programs of Chartres Cathedral*. Baltimore: The Johns Hopkins University Press.

———. 1961. "The Representation of the Seven Liberal Arts." In Marshall Clagett, ed., *Twelfth-Century Europe and the Foundations of Modern Society*. Madison, Wis.: University of Wisconsin Press.

Kaufmann, Thomas DaCosta. 1970. "Esther before Ahasuerus: A New Painting by Artemisia Gentileschi in the Museum's Collection." *The Metropolitan Museum of Art Bulletin* 29 (December): 165–69.

Kelly, Joan. 1982. "Early Feminist Theory and the *Querelle des Femmes*, 1400–1789." *Signs* 8, no. 1 (Autumn): 4–28.

Kelly-Gadol, Joan. [Joan Kelly.] 1977. "Did Women Have a Renaissance?" In Renate Bridenthal and Claudia Koonz, eds., *Becoming Visible: Women in European History*, pp. 137–64. Boston: Houghton Mifflin.

Kelso, Ruth. 1956. *Doctrine for the Lady of the Renaissance*. Urbana, Ill.: University of Illinois Press.

Kemp, Martin. 1977. "From 'Mimesis' to 'Fantasia': The Quattrocento Vocabulary of Crea-

tion, Inspiration and Genius in the Visual Arts." *Viator* 8: 347–98.

———. 1981. *Leonardo da Vinci, The Marvelous Works of Nature and Man.* London, Melbourne, Toronto: J. M. Dent & Sons.

Kircher, Athanasius. 1652–54. *Oedipus Aegyptiacus.* 3 vols. in 2. Rome: V. Mascardi.

Kirschbaum, Engelbert, S.J. 1968–76. *Lexikon der christlichen Ikonographie.* 8 vols. Rome: Herder.

Kitzinger, Ernst. 1983. *Early Medieval Art, with Illustrations from the British Museum and British Library Collections.* Rev. ed. Bloomington, Ind.: Indiana University Press.

Klapisch-Zuber, Christiane. 1985. *Women, Family, and Ritual in Renaissance Italy.* Translated by Lydia Cochrane. Chicago and London: The University of Chicago Press.

Klein, Robert, and Henri Zerner, eds. 1966. *Italian Art, 1500–1600.* Sources and Documents in the History of Art Series. Englewood Cliffs, N.J.: Prentice-Hall.

Kleinschmidt, Hans J. 1976. "Discussion of Laurie Schneider's Paper." *American Imago* 33, no. 1 (Spring): 92–97. Following Laurie Schneider, "Donatello and Caravaggio: The Iconography of Decapitation," pp. 76–91.

Klemm, Christian. 1979. "Sandrart a Rome." *Gazette des Beaux-Arts* 93 (April): 153–66.

Kolve, V. A. 1981. "From Cleopatra to Alceste: An Iconographic Study of *The Legend of Good Women.*" In John P. Hermann and John J. Burke, Jr., eds., *Signs and Symbols in Chaucer's Poetry,* pp. 130–78. University, Ala.: University of Alabama Press.

Kraeling, Emil G. 1955. *The Old Testament Since the Reformation.* New York: Harper.

Kraus, Henry. 1967. "Eve and Mary: Conflicting Images of Medieval Woman." In *The Living Theatre of Medieval Art,* ch. 3. Bloomington, Ind.: Indiana University Press. Reprinted in Norma Broude and Mary D. Garrard, *Feminism and Art History: Questioning the Litany,* pp. 79–99. New York: Harper & Row, 1982.

Krautheimer, Richard, in collaboration with Trudi Krautheimer-Hess. 1956. *Lorenzo Ghiberti.* Princeton: Princeton University Press.

Kris, Ernst, and Otto Kurz. 1979. *Legend, Myth, and Magic in the Image of the Artist, A Historical Experiment.* New Haven and London: Yale University Press.

Kubler, George. 1965. "Vicente Carducho's Alle-

gories of Painting." *Art Bulletin* 47 (December): 439–45.

Künstle, Karl. 1928. *Ikonographie der christlichen Kunst.* 2 vols. Freiburg-im-Breisgau: Herder.

Kurz, Otto. 1937. "Giorgio Vasari's Libro de' Disegni." *Old Master Drawings* 11 (June): 1–15; and 12 (December): 32–44.

———. 1948. *Fakes, A Handbook for Collectors and Students.* London: Faber and Faber.

———. 1953. "*Huius Nympha Loci*: A Pseudo-Classical Inscription and a Drawing by Dürer." *Journal of the Warburg and Courtauld Institutes* 16: 171–77.

Labalme, Patricia H., ed. 1980. *Beyond Their Sex: Learned Women of the European Past.* New York: New York University Press.

La Chesnaye-Desbois et Badier, François de. 1863–77. *Dictionnaire de la Noblesse.* 3rd ed. 19 vols. Paris: Schlesinger frères.

Lane, Barbara G. 1973. "The Symbolic Crucifixion in the Hours of Catherine of Cleves." *Oud-Holland* 87, no. 1: 1–26.

Lange, Kurt, and Max Hirmer. 1957. *Egypt: Architecture, Sculpture, Painting in Three Thousand Years.* 2nd ed. London: Phaidon.

Langedijk, Karla. 1976. "Baccio Bandinelli's *Orpheus*: A Political Message." *Mitteilungen des Kunsthistorischen Institutes in Florenz* 20, no. 1: 33–52.

Lanzi, Luigi. 1828. *The History of Painting in Italy, from the period of the revival of the fine arts to the end of the eighteenth century.* Translated by Thomas Roscoe. 6 vols. London: W. Simpkin and R. Marshall.

Lastri, Marco. 1791. *L'Etruria pittrice, ovvero storia della pittura toscana dedotta dai suoi monumenti che si esibiscono in stampa dal secolo X. fino al presente.* Vol. 2. Florence: Niccolò Pagni and Giuseppe Bardi.

Lavin, Irving. 1974. "Divine Inspiration in Caravaggio's Two 'St. Matthews.'" *Art Bulletin* 56 (March): 59–81.

Lavin, Marilyn A. 1975. *Seventeenth-Century Barberini Documents and Inventories of Art.* New York: New York University Press.

Laviosa, Clelia. 1958. "L'Arianna Addormentata del Museo Archeologico di Firenze." *Archeologia Classica* 10: 164–71.

Lawrence-Archer, J. H. 1887. *The Orders of Chivalry.* London: W. H. Allen Co.

Leach, Mark C. 1976. "Rubens' *Susanna and the*

*Elders* in Munich and Some Early Copies." *Print Review* 5: 120–27.

Lee, Rensselaer W. 1967. *Ut Pictura Poesis: The Humanistic Theory of Painting.* New York: W. W. Norton.

Le Moyne, Pierre. 1647. *La Galerie des femmes fortes.* Paris: Antoine de Sommaville.

———. 1652. *The Gallery of Heroick Women.* Translated by the Marquesse of Winchester. London: Henry Seile.

———. 1660. *La Galerie des femmes fortes.* Leiden: J. Elsevier.

———. 1667. *La Galerie des femmes fortes.* 2 vols. Lyons: Les Libraires de la Compagnie.

Lentaglio, Giuseppe di. 1931. "La 'Giuditta' biblica nell'arte." *Emporium* 74 (September): 131–42.

Lerna, Gerda. 1986. *The Creation of Patriarchy.* New York and Oxford: Oxford University Press.

Levenson, Jay, Konrad Oberhuber, and Lynn Sheehan. 1973. *Early Italian Engravings from the National Gallery of Art.* Washington, D.C.: National Gallery of Art.

Levey, Michael. 1962. "Notes on the Royal Collection—II: Artemisia Gentileschi's 'Self-Portrait' at Hampton Court." *Burlington Magazine* 104 (February): 79–80.

———. 1964. *The Later Italian Pictures in the Collection of Her Majesty the Queen.* Greenwich, Conn.: New York Graphic Society.

———. 1967. "Sacred and Profane Significance in Two Paintings by Bronzino." *Studies in Renaissance and Baroque Art Presented to Anthony Blunt,* pp. 30–33. London and New York: Phaidon.

Levine, Saul. 1974. "The Location of Michelangelo's 'David': The Meeting of January 25, 1504." *Art Bulletin* 56 (March): 31–49.

Lindsay, Jack. 1971. *Cleopatra.* London: Constable.

Lloyd, Michael. 1959. "Cleopatra as Isis." *Shakespeare Survey* 12: 88–94.

Lomazzo, Giovanni Paolo. 1584. *Trattato dell'arte della pittvra, scoltvra, et architettvra.* 7 vols. in 1. Milan: Per P. G. Pontio. (Hildesheim, 1968 facsimile.)

———. [1590] 1974. *Idea del tempio della pittura.* Translated and commentary by Robert Klein. 2 vols. Florence: Istituto nazionale di studi sul Rinascimento.

Longhi, Roberto. 1916. "Gentileschi padre e figlia." *L'Arte* 19: 245–314.

———. 1943. "Ultimi studi sul Caravaggio e la sua cerchia." *Proporzioni* 1: 5–63.

———. 1961. *Scritti giovanili, 1912–1922.* 2 vols. Florence: Sansoni.

Longhi Lopresti, Lucia [Anna Banti, pseud.]. 1947. *Artemisia.* Florence: G. Sansoni.

López-Rey, José. 1980. *Velasquez.* London: Studio Vista.

Lougee, Carolyn C. 1976. *Le paradis des femmes: Women, Salons and Social Stratification in Seventeenth-Century France.* Princeton: Princeton University Press.

Lucie-Smith, Edward. 1972. *Eroticism in Western Art.* New York: Praeger.

Lumbroso, Giacomo. 1876. "Notizie sulla vita di Cassiano dal Pozzo: Protettore delle Belle Arti Fautore della scienza dell'antichità nel secolo decimosettimo." *Miscellanea di storia italiana* 15: 129–211.

Lunenfeld, Marvin. 1981. "The Royal Image: Symbol and Paradigm in Portraits of Early Modern Female Sovereigns and Regents." *Gazette des Beaux-Arts* 97 (April): 157–62.

Luomala, Nancy. 1982. "Matrilineal Reinterpretations of Some Egyptian Sacred Cows." In Norma Broude and Mary D. Garrard, eds., *Feminism and Art History: Questioning the Litany,* pp. 19–31. New York: Harper & Row.

Lurie, Ann T. 1975. "Pictorial Ties between Rembrandt's Danaë in the Hermitage and Orazio Gentileschi's Danaë in the Cleveland Museum of Art." *Acta Historiae Artium* 21, nos. 1–2: 75–81.

Lurie, Ann T., and Ann Percy. 1984. *Bernardo Cavallino of Naples, 1616–1656.* Catalogue, with introduction by Ann Percy and essays by Nicola Spinosa and Giuseppe Galasso. Cleveland, Ohio: The Cleveland Museum of Art; Fort Worth, Texas: The Kimbell Art Museum.

Luzio, Alessandro. 1974. *La galleria dei Gonzaga, Venduta all'Inghilterra nel 1627–28.* Rome: Bardi.

McCorquodale, Charles. 1976. "Italian Painting of the Seventeenth and Eighteenth Centuries." *Connoisseur* 193 (November): 205–216.

———. 1981. *Bronzino.* New York: Harper & Row.

MacDougall, Elisabeth B. 1975. "The Sleeping Nymph: Origins of a Humanist Fountain Type." *Art Bulletin* 57: 357–65.

Machiavelli, Niccolò. [1520] 1978. *La Mandragola.* Translation by Bruce Penman. In *Five Italian*

*Renaissance Comedies*. Harmondsworth: Penguin.

McHugh, Michael P., trans. 1972. *Seven Exegetical Works*. Vol. 65, *The Fathers of the Church, A New Translation*. Washington, D.C.: Catholic University of America Press, in association with Consortium Press.

Maclean, Ian. 1977. *Woman Triumphant: Feminism in French Literature, 1610–1652*. Oxford: Clarendon Press.

———. 1980. *The Renaissance Notion of Woman: A Study in the Fortunes of Scholasticism and Medical Science in European Intellectual Life*. Cambridge and New York: Cambridge University Press.

McNamara, JoAnn, and Suzanne F. Wemple. 1977. "Sanctity and Power: The Dual Pursuit of Medieval Women." In Renate Bridenthal and Claudia Koonz, eds., *Becoming Visible: Women in European History*, pp. 90–118. Boston: Houghton Mifflin.

Macrae, Desmond. 1964. "Observations on the Sword in Caravaggio." *Burlington Magazine* 106 (September): 412–16.

Macurdy, Grace. H. 1930. *Hellenistic Queens, A Study of Woman-Power in Macedonia, Seleucid Syria, and Ptolemaic Egypt*. Baltimore: The Johns Hopkins University Press.

*La Madonna nella pittura del '600 a Napoli*. 1954. Exh. cat., edited by Raffaello Causa, Castel Nuovo, Naples, May 15–September 15, 1954. Naples.

Mahon, Denis. [1947] 1971. *Studies in Seicento Art and Theory*. Reprint. Westport, Conn.: Greenwood Press.

———. 1968. *Il Guercino (Giovanni Francesco Barbieri), 1591–1666*. Exh. cat., Palazzo dell'Archiginnasio, September 1–November 18, 1968. Bologna: Alfa.

Makin, Bathsua. [1673] 1980. *An Essay to Revive the Antient* [sic] *Education of Gentlewomen, in Religion, Manners, Arts & Tongues*. Republished, with introduction by Paula L. Barbour, The Augustan Reprint Society, no. 202. Los Angeles: William Andrews Clark Memorial Library, University of California.

Malaguzzi-Valeri, F. 1926. "I nuovi acquisti della pinacoteca di Bologna." *Cronache d'arte* 3, fasc. 1:30 ff.

Malvasia, Carlo Cesare. [1678] 1841. *Felsina Pittrice: Vite de' pittori bolognesi*. Edited by Giampietro Zanotti. 2 vols. Bologna: Tip. Guidi all'Ancara.

Malvern, Marjorie M. 1975. *Venus in Sackcloth: The Magdalen's Origins and Metamorphoses*. Carbondale and Edwardsville, Ill.: Southern Illinois University Press.

Mandowsky, Erna. 1939. "Ricerche intorno all' *Iconologia* di Cesare Ripa." *La Bibliofilia* 41:7–27 (dispensa 1–2); 111–24 (d. 3); 204–235 (d. 5–6); 279–331 (d. 7–8).

Marinelli, Lucrezia. 1601. *La nobiltà et l'eccellenza delle donne, co' diffetti et mancamenti de gli Huomini*. Venice. Reproduced in Ginevra Conti Odorisio, *Donna e Società nel Seicento: Lucrezia Marinelli e Arcangela Tarabotti*, pp. 114–57. Rome: Bulzoni, 1979.

Marini, Maurizio. 1974. *Io Michelangelo da Caravaggio*. Rome: Studio B, Bestetti e Bozzi.

Marino, Giovanni Battista. 1619. *La Galeria*. Venice: Ciotti.

Marrow, Deborah. 1982. *The Art Patronage of Maria de' Medici*. Studies in Baroque Art History, no. 4. Ann Arbor: UMI Research Press.

Marrow, James H., and Alan Shestack, eds. 1981. *Hans Baldung Grien, Prints and Drawings, With Three Essays on Baldung and His Art*. Exh. cat. Essays by Alan Shestack, Charles W. Talbot and Linda C. Hults. Washington, D.C.: National Gallery of Art; New Haven, Conn.: Yale University Art Gallery.

Martinez, Ronald L. 1983. "The Pharmacy of Machiavelli: Roman Lucretia in *Mandragola*." *Renaissance Drama*, n.s. 14: *Relations and Influences*, edited by Leonard Barkan. Evanston, Ill.: Northwestern University Press.

Masson, L. 1930. "L'aspic de Cleopatre—la mordit-il au sein?" *Aesculape* 20: 118 ff.

*Masterpieces of Painting and Sculpture from The Detroit Institute of Arts*. 1949. Detroit: Detroit Institute of Arts.

Matulka, Barbara. 1935. "The Feminist Theme in the Drama of the Siglo de Oro." *The Romanic Review*, 26, no. 3 (July–September): 191–231.

Maxon, John, and Joseph J. Rishel, eds. 1970. *Painting in Italy in the Eighteenth Century: Rococo to Romanticism*. Exh. cat. Chicago: Art Institute of Chicago, Minneapolis Institute of Arts, and Toledo Museum of Art.

Mayer, Hans. 1975. *Aussenseiter*. Frankfurt am Main: Suhrkamp.

Meiss, Millard. 1976. "Sleep in Venice: Ancient Myths and Renaissance Proclivities." In idem, *The Painter's Choice: Problems in the Interpretation of Renaissance Art*, pp. 212–39. New York: Harper & Row.

Menzies, Lucy. 1924. *The Saints in Italy: A Book of Reference to the Saints in Italian Art*. London: The Medici Society Ltd.

Menzio, Eva, ed. 1981. *Artemisia Gentileschi/Agostino Tassi: Atti di un processo per stupro*. Milan: Edizioni delle Donne.

Merchant, Carolyn. 1980. *The Death of Nature: Women, Ecology and the Scientific Revolution*. San Francisco and New York: Harper & Row.

Millar, Oliver. 1954. "Charles I, Honthorst, and Van Dyck." *Burlington Magazine* 96 (February): 36–42.

———, ed. 1960. "Abraham van der Doort's Catalogue of the Collections of Charles I." *The Walpole Society*. 37: xi–xxiv, 1–235.

———, ed. 1970–72. "The Inventories and Valuations of the King's Goods 1649–1651." *The Walpole Society* 43.

Millay, Edna St. Vincent. 1949. "Dirge without Music." In *Collected Poems*, pp. 240–41. New York: Harper.

Minault, Denise. 1972. *Woman as Heroine*. Exh. cat. September–October 1972. Worcester, Mass.: Worcester Art Museum.

Mirimonde, A. P. de. 1968. "Les Allégories de la Musique—1. La Musique parmi les Arts Libéraux." *Gazette des Beaux-Arts* 72 (December): 295–324.

Mirollo, James V. 1963. *The Poet of the Marvelous: Giambattista Marino*. New York: Columbia University Press.

Moffitt, John F. 1979. Review of Madlyn Millner Kahr, *Velázquez: The Art of Painting* (New York: Harper & Row, 1976). *Art Journal* 38, no. 3 (Spring): 213–16.

Moir, Alfred. 1967. *The Italian Followers of Caravaggio*. 2 vols. Cambridge, Mass.: Harvard University Press.

Molajoli, Bruno. [1955] 1960. *Notizie su Capodimonte; Catalogo delle Gallerie e del Museo*. Naples: L'Arte Tipografica.

Morassi, Antonio. 1947. *Mostra della Pittura del Seicento e Settecento in Liguria*. Exh. cat. Genoa, Palazzo Reale, June 21–September 30, 1947. Milan: L. Alfieri.

Moschella, Olga. 1977. *Il Collezionismo a Messina nel Secolo XVII*. Messina: EDAS.

*La mostra della pittura napoletana dei secoli XVII, XVIII e XIX*. 1938. Exh. cat., edited by Sergio Ortolani. Naples: Castel Nuovo.

*III Mostra di restauri*. 1953. Exh. cat., edited by Raffaello Causa. Naples: Museo di San Martino.

Nabakowski, Gislind, Helke Sander, and Peter Gorsen. 1980. *Frauen in der Kunst*. Frankfurt am Main: Suhrkamp.

Nagler, A. M. 1964. *Theatre Festivals of the Medici, 1539–1637*. New Haven and London: Yale University Press.

Mütherich, Florentine, and Joachim E. Gaehde. 1976. *Carolingian Painting*. New York: Braziller.

Natali, Giulio. 1926. *Idee, costumi, uomini del settecento; studii e saggi letteraii*. Turin: Sten.

"The Natural Man." 1964. Editorial. *Apollo* 79 (April): 258–63.

Naudé, Gabriel. 1650. *Epigrammatum libri duo*. Paris: Sebastianum et Gabrielam Cramoisy.

Neuringer, Charles, and Dan J. Lettieri. 1982. *Suicidal Women, Their Thinking and Feeling Patterns*. New York: Gardiner Press.

Nicoll, Allardyce. [1927] 1967. *The Development of the Theatre: A Study of Theatrical Art from the Beginnings to the Present Day*. New York: Harcourt, Brace & World.

Nicolson, Benedict. 1958. *Hendrick Terbruggen*. London: H. Humphries.

———. 1974. "Caravaggio and the Caravaggesques: Some Recent Research." *Burlington Magazine* 116 (October): 603–616.

———. 1979. *The International Caravaggesque Movement, Lists of Pictures by Caravaggio and His Followers throughout Europe from 1590 to 1650*. Oxford: Phaidon.

Nochlin, Linda. 1971. "Why Have There Been No Great Women Artists?" *Art News* 69, no. 9 (January): 22–39, 67–71.

"The Note Books of George Vertue Relating to Artists and Collections in England." 1935–36. *Walpole Society* 24.

"Notizie ed Osservazioni." 1897. *Napoli Nobilissima, rivista di topografia e d'arte napoletana* 6, fasc. 7 (July): 108–112.

Novotny, Fritz, and Johannes Dobai. [1968] 1975. *Gustav Klimt, with a Catalogue Raisonné of His Paintings*. Boston: N.Y. Graphic Society.

Nussbaum, Felicity A. 1984. *The Brink of All We Hate: English Satires on Women, 1660–1750*. Lexington, Ky.: University Press of Kentucky.

Oberhuber, Konrad, and Lamberto Vitali. 1972. *Raffaello: Il cartone per la scuola di Atene*. Milan: Silvana.

Oesterley, W.O.E. 1935. *An Introduction to the Books of the Apocrypha, Their Origin, Teaching and Contents* [1915]. New York: Macmillan.

Ogilvie, R. M. 1965. *A Commentary on Livy, Books 1–5*. Oxford: Clarendon Press.

Oman, Carola. [1936] 1976. *Henrietta Maria*. London: White Lion Publishers.

Ortner, Sherry B. 1974. "Is Female to Male as Nature Is to Culture?" In Michelle Z. Rosaldo and Louise Lamphere, eds. *Woman, Culture, and Society*, pp. 67–87. Stanford, Calif.: Stanford University Press.

Paatz, Walter, and Elisabeth Paatz. 1952–55. *Die Kirchen von Florenz*. 6 vols. Frankfurt am Main: Klostermann.

Pacheco, Francisco. 1956. *El arte de la pintura*. Edited by Francisco J. Sánchez Cantón. 2 vols. in 1. Madrid: Instituto di Valencia de Don Juan.

Pallucchini, Rodolfo. 1945. *I Dipinti della Galleria Estense di Modena*. Rome: Cosmopolita, Casa Editrice.

Pallucchini, Rodolfo, and Paola Rossi. 1982. *Tintoretto: Le opere sacre e profane*. 2 vols. Milan: Electa.

Panofsky, Dora, and Erwin Panofsky. [1956] 1962. *Pandora's Box, The Changing Aspects of a Mythical Symbol*. Bollingen Series 52. New York: Pantheon Books.

Panofsky, Erwin. 1933. "Der gefesselte Eros (Zur Genealogie von Rembrandts Danae)." *Oud-Holland* 50, no. 5: 193–217.

———. 1954. *Galileo as a Critic of the Arts*. The Hague: M. Nijhoff.

———. [1939] 1962. *Studies in Iconology: Humanistic Themes in the Art of the Renaissance*. New York and Evanston, Ill.: Harper Torchbooks.

———. [1924] 1968. *Idea: A Concept in Art Theory*. Translated by Joseph J. S. Peake. Columbia, S.C.: University of South Carolina Press.

———. 1969. *Problems in Titian, Mostly Iconographic*. New York: New York University Press.

———. 1971. "Jan Van Eyck's 'Arnolfini' Portrait." In W. Eugene Kleinbauer, ed., *Modern Perspectives in Western Art History, An Anthology of Twentieth-Century Writings on the Visual Arts*. New York: Holt, Rinehart and Winston.

Parry, Graham. 1981. *The Golden Age Restor'd: Culture of the Stuart Court, 1603–42*. New York: St. Martin's Press.

Passeri, Giovanni Battista. 1772. *Vite de' pittori, scultori, ed architetti che [h]anno lavorato in Roma, morti dal 1641 fino al 1673*. Rome: N. Barbiellini.

Patmore, Coventry. 1885. *The Angel in the House*. 6th ed. London: G. Bell.

Pearson, Carol, and Katherine Pope. 1981. *The Female Hero in American and British Literature*. New York and London: R. R. Bowker.

Pentin, Herbert. 1908. *Judith (The Apocrypha in English Literature)*. London: Samuel Bagster and Sons.

Pepper, D. Stephen. 1984a. "Baroque Painting at Colnaghi's." *Burlington Magazine* 126: 315–16.

Pepper, D. Stephen. 1984b. *Guido Reni, A Complete Catalogue of His Works with an Introductory Text*. New York: New York University Press.

Pérez Sánchez, A. 1965. *Pintura italiana del siglo XVII en España*. Madrid: Universidad de Madrid, Fundación Valdecilla.

Petrus, Jerzy T. 1977. "Portrety infantek hiszpańskich, córek Filipa III, z klasztoru SS. Wizytek w Warszawie." *Biuletyn historii sztuki* 39, vol. 1: 31–46.

Pevsner, Nikolaus. 1940. *Academies of Art, Past and Present*. Cambridge: Cambridge University Press.

"The Pictures at Hampton Court." 1942. Editorial. *Burlington Magazine* 81 (August): 185–86.

Pigler, Andreas [Andor]. 1938. "Sokrates in der Kunst der Neuzeit." *Die Antike* 14, no. 4: 281–94.

———. [1956] 1974. *Barockthemen, eine Auswahl von Verzeichnissen zur Ikonographie des 17. und 18. Jahrhunderts*. 2 vols. Budapest: Akadémiai Kiadó.

Pignatti, Terisio. 1971. *Giorgione*. Translated by Clovis Whitfield. London: Phaidon.

———. 1976. *Veronese*. 2 vols. Venice: Alfieri Edizioni d'Arte.

Piles, Roger de. 1754. *The Art of Painting*. 3rd ed. London: T. Payne.

Pitkin, Hanna Fenichel. 1984. *Fortune Is a Woman: Gender and Politics in the Thought of Niccolò Machiavelli*. Berkeley-Los Angeles-London: University of California Press.

Pittaluga, Mary. 1930. *L'Incisione italiana nel Cinquecento*. Milan: U. Hoepli.

Pizan, Christine de. [1405] 1982. *The Book of the City of Ladies*. Translated by Earl Jeffrey Richards, foreword by Marina Warner. New York: Persea Books.

Pizzorusso, Claudio. 1982. *Ricerche su Cristoforo Allori*. Florence: L. S. Olschki.

Plutarch. 1961. *The Parallel Lives*. Loeb Classical Library.

Pomeroy, Sarah Booth. 1975. *Goddesses, Whores, Wives and Slaves: Women in Classical Antiquity.* New York: Schocken Books.

———. 1984. *Women in Hellenistic Egypt, From Alexander to Cleopatra.* New York: Schocken Books.

Pona, Francesco. 1633. *La galleria delle donne celebri.* Bologna: Cavalieri.

Porcella, Amadore. 1931. *Le Pitture della Galleria Spada.* Rome: G. Felsina.

Posner, Donald. 1967. "The Picture of Painting in Poussin's *Self-Portrait.*" In Douglas Fraser, Howard Hibbard, and Milton J. Lewine, eds., *Essays in the History of Art Presented to Rudolf Wittkower,* pp. 200–203. London: Phaidon.

———. 1971. *Annibale Carracci: A Study in the Reform of Italian Painting around 1590.* 2 vols. London: Phaidon.

Praz, Mario. [1933] 1951. *The Romantic Agony.* Translated by Angus Davidson. London and New York: Oxford University Press.

Procacci, Ugo. 1968. *La Casa Buonarroti a Firenze.* Milan: Electa.

Prusak, Bernard P. 1974. "Woman: Seductive Siren and Source of Sin? Pseudepigraphal Myth and Christian Origins." In Rosemary Radford Reuther, ed., *Religion and Sexism, Images of Woman in the Jewish and Christian Traditions,* pp. 89–116. New York: Simon and Schuster.

Pugliatti, Teresa. 1977. *Agostino Tassi tra conformismo e libertà.* Rome: De Luca Editore.

Purdie, Edna. 1927. *The Story of Judith in German and English Literature.* Paris: H. Champion.

"La Quadreria del Principe di Scilla." 1898. *Napoli Nobilissima, rivista di topografia e d'arte napoletana* 7, fasc. 5 (May): 72–75.

Ramade, Patrick. 1980. "Une source d'inspiration du XVIIᵉ siècle: *La galerie des femmes fortes,* de Claude Vignon." *Bulletin des Amis du Musée de Rennes* 4: 19–26.

Ratti, Carlo Giuseppe. 1780. *Instruzione di quanto può vedersi di più bello in Genova in Pittura, Scultura, ed Architettura ecc.* 2nd ed. Genoa: I. Gravier.

*Real Museo Borbonico.* 1827–57. 16 vols. Naples: Stamperia reale.

*Reale galleria di Firenze illustrata.* 1817. Ser. 3, *Ritratti di pittori.* Vol. 1. Florence: Luigi di G. Molini.

Rearick, W. R. 1978. "Jacopo Bassano and Changing Religious Imagery in the Mid-Cinquecento." In Sergio Bertelli and Gloria Ramakus, eds., *Essays Presented to Myron P. Gilmore,* vol. 2, pp. 331–43. Florence: La Nova Italia Editrice.

Reau, Louis. 1955–59. *Iconographie de l'art chrétien.* 3 vols. in 6. Paris: Presses universitaires de France.

Redig de Campos, Deoclecio. 1939. "Una 'Giuditta' opera sconosciuta del Gentileschi nella Pinacoteca Vaticana." *Rivista d'Arte* 21: 311–23.

Reed, Evelyn. 1975. *Woman's Evolution, From Matriarchal Clan to Patriarchal Family.* New York: Pathfinder Press.

Reinach, Salomon. 1922. *Répertoire de les peintures grecques et romaines.* Paris: Editions Ernest Leroux.

Richardson, E. P. 1952–53. "A Masterpiece of Baroque Drama." *Bulletin of the Detroit Institute of Arts* 32, no. 4: 81–83.

———. 1953. "A Masterpiece of Baroque Drama." *The Art Quarterly* 16, no. 2 (Summer): 91–92.

Richter, George M. 1937. *Giorgio da Castelfranco, Called Giorgione.* Chicago: University of Chicago Press.

Richter, Jean Paul, ed. 1939. *The Literary Works of Leonardo da Vinci.* 2nd ed. Enlarged and revised by J. P. Richter and Irma A. Richter. 2 vols. London: Oxford University Press.

Rinehart, Sheila S. 1961. "Cassiano dal Pozzo (1588–1657): Some Unknown Letters." *Italian Studies,* Cambridge, England, vol. 16: 35–59.

Ripa, Cesare. [1593] 1611. *Iconologia, overo Descrittione d'imagini delle virtv' vitij, affeti, passioni humane, corpi celesti, mondo e sue parti.* Padua: P. P. Tozzi.

———. [1603] 1970. *Iconologia.* Rome ed. Edited by Erna Mandowsky. Hildesheim and New York: Georg Olms Verlag.

———. [1644] 1976. *Iconologie.* Paris ed. Translated by Jean Baudouin. New York and London: Garland.

Robert, Carl. 1890–1919. *Die Antiken Sarcophagreliefs im Auftrage des Kaiserlich Deutschen Archaeologischen Instituts.* 5 vols. Berlin: G. Grote'sche Verlagsbuchhandlung.

Robinson, H. Wheeler. 1937. *The Old Testament, Its Making and Meaning.* Nashville, Tenn.: Cokesbury Press.

Rogers, Katharine M. 1966. *The Troublesome Helpmate: A History of Misogyny in Literature.* Seattle and London: University of Washington Press.

Romano, Serena. 1981. "Giuditta e il Fondaco dei Tedeschi." In *Giorgione e la cultura veneta tra*

'400 e '500, Mito, Allegoria, Analisi iconologica, pp. 113–25. Rome: De Luca Editore.

Rooses, Max. 1886–92. L'Oeuvre de P. P. Rubens: Histoire et description de ses tableaux et dessins. 5 vols. Antwerp: J. Maes.

Rorimer, James J., and Margaret B. Freeman. 1949. "The Nine Heroes Tapestries at the Cloisters." Metropolitan Museum of Art Bulletin 7 (May): 243–60.

Rosand, David. 1971. "Titian in the Frari." Art Bulletin 53 (June): 196–213.

———. 1982. Painting in Cinquecento Venice: Titian, Veronese, Tintoretto. New Haven and London: Yale University Press.

Rosand, David, and Robert W. Hanning, eds. 1983. Castiglione: The Ideal and the Real in Renaissance Culture. New Haven: Yale University Press.

Rosenberg, Jakob. [1948] 1968. Rembrandt, Life and Work. 3rd ed. London and New York: Phaidon.

Rosenberg, Pierre. 1971. " 'La main d'Artémise.' " Paragone 22, no. 261 (November): 69–70.

Rosenblum, Robert. 1967. Transformations in Late Eighteenth-Century Art. Princeton: Princeton University Press.

Roskill, Mark W. 1968. Dolce's "Aretino" and Venetian Art Theory of the Cinquecento. New York: New York University Press, for The College Art Association of America.

Röttgen, Herwarth, ed. 1973. Il Cavaliere d'Arpino. Soprintendenza d'arte medioevali e moderne del Lazio, Ministero della pubblica istruzione. Direzione generale delle antichità e belle arti, Rome, Palazzo Venezia, June–July 1973. Rome: De Luca.

———. 1974. Il Caravaggio: richerche e interpretazioni. Rome: Bulzoni.

Rubin, Elaine. 1977. "The Heroic Image: Women and Power in Early Seventeenth-Century France." Ph.D. dissertation, George Washington University.

Rudick, Michael, and M. Pabst Battin, intro. and commentary. 1982. John Donne, Biathanatos. Garland English Texts, no. 1. New York and London: Garland.

Ruether, Rosemary Radford, ed. 1974. Religion and Sexism: Images of Woman in the Jewish and Christian Traditions. New York: Simon and Schuster.

Ruffo, Vincenzo. 1916. "Galleria Ruffo nel secolo XVII in Messina." Bollettino d'Arte 10, nos. 1–12: 21–64, 95–128, 165–92, 237–56, 284–320, 369–88.

———. 1919. "La Galleria Ruffo (Appendice)." Bollettino d'Arte 13, nos. 1–4: 43–56.

Ruggiero, Guido. 1985. The Boundaries of Eros: Sex Crime and Sexuality in Renaissance Venice. New York and Oxford: Oxford University Press.

Ruskin, John. 1876. Mornings in Florence, being simple studies of Christian art, for English travelers. New York: J. Wiley & Sons.

Russell, H. Diane. 1975. Jacques Callot, Prints and Related Drawings. Washington, D.C.: National Gallery of Art.

———. 1982. Claude Lorrain, 1600–1682. Washington, D.C.: National Gallery of Art.

Russell, Jeffrey B. 1980. A History of Witchcraft: Sorcerers, Heretics and Pagans. London: Thames and Hudson.

Salerno, Luigi. 1960a. "Cavaliere d'Arpino, Tassi, Gentileschi and Their Assistants. A Study of Some Frescoes in the Villa Lante, Bagnaia." Connoisseur 146, no. 589 (December): 157–62.

———. 1960b. "The Picture Gallery of Vincenzo Giustiniani, II: The Inventory, Part I." Burlington Magazine 102 (1960): 93–104.

Salvini, Roberto. 1965. All the Paintings of Botticelli. Translated by John Grillenzoni. 4 vols. New York: Hawthorn Books.

Sánchez Cantón, F. J. 1923–41. Fuentes literarias para la historia del arte español. 5 vols. Madrid: Imprenta clásica española.

Sandrart, Joachim von. [1675] 1971. Academie Bau-, Bild- und Mahlerey-Künste. Commentary by A. R. Peltzer. Farnborough, Hants.: Gregg.

Sartain, John. 1889. Peinture Grecque sur ardoise a l'encaustique représentant la Reine Cléopatre se donnant la mort, au moyen du serpent africain le "naja." Nice: Berna & Barra.

Sarton, May. 1974. "The Muse as Medusa." In Collected Poems (1930–1973). New York: W. W. Norton.

Saward, Susan. 1982. The Golden Age of Marie de' Medici. Studies in Baroque Art History, no. 2. Ann Arbor: UMI Research Press.

Saxl, Fritz. [1957] 1970. A Heritage of Images, A Selection of Lectures by Fritz Saxl. Edited by Hugh Honour and John Fleming, with an introduction by E. H. Gombrich. Harmondsworth: Penguin.

Scamozzi, Vincenzo. 1615. L'Idea della Architettura

*Universale.* 2 vols. Venice: Expensis auctoris.

Schade, Werner. 1972. "Das unbekannte Selbstbildnis Cranachs." *Dezennium* 2:368–75.

Schaefer, Jean Owens. 1984. "A Note on the Iconography of a Medal of Lavinia Fontana." *Journal of the Warburg and Courtauld Institutes* 47: 232–34.

Schleier, Erich. 1971. "Caravaggio e Caravaggeschi nelle Gallerie di Firenze: Zur Ausstellung im Palazzo Pitti, Sommer 1970." *Kunstchronik* 24, no. 4 (April): 85–112.

Schleiner, Winfried. 1978. "*Divina virago*: Queen Elizabeth as an Amazon." *Studies in Philology* 75, no. 1 (January): 163–80.

Schneider, Laurie. 1976. "Donatello and Caravaggio: The Iconography of Decapitation." *American Imago* 33, no. 1 (Spring): 76–91.

Schreiber, Theodor, ed. 1885. *Unedirte römische Fundberichte aus italiënischen Archiven und Bibliotheken veröffentlicht.* Leipzig: n.p.

Schroeder, Horst. 1971. *Der Topos der Nine Worthies in Literatur und bildender Kunst.* Göttingen: Vandenhoeck & Ruprecht.

Schubring, Paul. 1923. *Cassoni, Truhen und Truhenbilder der italienischen Frührenaissance.* 2 vols. Leipzig: Karl W. Hiersemann.

Schurman, Anna Maria van. [1641] 1659. *De Ingenii Muliebris.* English edition: *The Learned maid, or, Whether a maid may be a scholar?* London: printed by John Redmayne.

Schwartz, Sanford. 1985. "The Art World: Not Happy to Be Here." *The New Yorker* (September 2): 75–81.

Schwarz, Heinrich. 1952. "The Mirror in Art." *Art Quarterly* 15, no. 2 (Summer): 97–118.

Scott, Walter, ed. and trans. 1968. *Hermetica: The Ancient Greek and Latin Writings Which Contain Religious or Philosophic Teachings Ascribed to Hermes Trismegistus.* 4 vols. London: Dawsons of Pall Mall.

Scribner, Charles, III. 1977. "*In Alia Effigie*: Caravaggio's London *Supper at Emmaus.*" *Art Bulletin* 59 (September): 375–82.

*Il seicento europeo: Realismo, Classicismo, Barocco.* 1967. Exh. cat., Council of Europe, Palazzo della Esposizione, December 1956–January 1957. 2nd ed. Rome: De Luca.

Serassi, Pier Antonio. 1769–71. *Delle lettere del Conte Baldessar Castiglione.* 2 vols. in 1. Padua: G. Camino.

Seznec, Jean. [1940] 1972. *The Survival of the Pagan Gods, The Mythological Tradition and Its Place in Renaissance Humanism and Art.* Translated by Barbara F. Sessions. Bollingen Series 38. Princeton: Princeton University Press.

Shapley, Fern Rusk. 1973. *Paintings from the Samuel H. Kress Collection: Italian Schools XVI–XVIII Century.* 3 vols. London: Phaidon, for the Samuel H. Kress Foundation.

———. 1979. *Catalogue of the Italian Paintings.* 2 vols. Washington, D.C.: National Gallery of Art.

Shearman, John. 1975. "The Florentine *Entrata* of Leo X, 1515." *Journal of the Warburg and Courtauld Institutes* 38: 136–54.

———. 1979. "Cristofano Allori's 'Judith.'" *Burlington Magazine* 121 (January): 3–10.

Simone, R. Thomas. 1974. *Shakespeare and 'Lucrece': A Study of the Poem and Its Relation to the Plays.* Salzburg: Institut für Englische Sprache und Literatur, Universitat Salzburg.

Síp, Jaromír. 1978. "Obrazy Petra Paula Rubense v Prazské Národní Galerii." *Umení* 26, no. 3: 193–210.

Skeat, Walter W., ed. 1894. *The Complete Works of Geoffrey Chaucer.* Oxford: Clarendon Press.

Slatkes, Leonard J. 1981. *Vermeer and His Contemporaries.* New York: Abbeville Press.

Small, Jocelyn Penny. 1976. "The Death of Lucretia." *American Journal of Archaeology* 80, no. 4 (Fall): 349–60.

Smith, Bonnie G. 1984. "The Contribution of Women to Modern Historiography in Great Britain, France, and the United States, 1750–1940." *American Historical Review* 89, no. 3 (June): 709–732.

Smith, Denzell S. 1965. "'The Tragoedy of Cleopatra Queene of Aegypt' by Thomas May, A Critical Edition." Ph.D. dissertation, University of Minnesota. (Garland Series, *Renaissance Drama, A Collection of Critical Editions*, edited by Stephen Orgel. New York: Garland, 1979).

Smith, Hilda L. 1982. *Reason's Disciples: Seventeenth-Century English Feminists.* Urbana-Chicago-London: University of Illinois Press.

Smith, Susan L. 1978. "'To Women's Wiles I Fell': The Power of Women *Topos* and the Development of Medieval Secular Art." Ph.D. dissertation, University of Pennsylvania.

Sofri, Adriano. 1979. "La vedova, il generale e la metà del regno." *Lotta continua* 10, December 16–17.

Solerti, Angelo. 1905. *Musica, Ballo e Drammatica alla Corte Medicea dal 1600 al 1637*. Florence: R. Bemporad & figlio.

Sommerfeld, Martin. 1933. *Judith-Dramen des 16./17. Jahrhunderts, Nebst Luthers vorrede zum buch Judith*. Berlin: Junker und Dünnhaupt.

Soprani, Raffaello. [1674] 1768–69. *Vite de' Pittori, Scultori, ed Architetti Genovesi*. 2nd ed., revised and with notes by Carlo Giuseppe Ratti. Genoa: Stamperia Casamara.

Spalding, Jack J., IV. 1983. "Santi di Tito and the Reform of Florentine Mannerism." *Storia dell'arte* 47: 41–52.

Spear, Richard E. 1971a. *Caravaggio and His Followers*. Exh. cat. Cleveland, Ohio: The Cleveland Museum of Art.

———. 1971b. "The Pseudo-Caravaggisti." *Art News* 70, no. 7 (November): 38–41, 93–96.

———. 1975. "Studies in Conservation and Connoisseurship: Problematic Paintings by Manfredi, Saraceni, and Guercino." *Dayton Art Institute Bulletin* 34, no. 1 (October): 5–19.

———. 1982. *Domenichino*. 2 vols. New Haven and London: Yale University Press.

Spezzaferro, Luigi. 1981. "Il recupero del Rinascimento." In *Storia dell'arte italiana*, part 2, vol. 2, I, *Cinquecento e Seicento*, pp. 185–279. Torino: Giulio Einaudi Editore.

Spike, John T. 1980. *Italian Baroque Paintings from New York Private Collections*. Princeton, N.J.: Art Museum, Princeton University Press.

———. 1983. *Italian Still-Life Paintings from Three Centuries*. Centro Di, National Academy of Design, and Old Masters Exhibition Society of New York. Florence: Centro Di.

Spinelli, Alessandro. 1550. *Cleopatra*. Venice: Pietro de Nicolini da Sabbio.

Spreti, Marchese Vittorio. 1928–35. *Enciclopedia storico-nobiliare italiana, Famiglie nobili e titolate viventi, riconosciute dal R.° Governo d'Italia*. 7 vols. Milan: Ed. Enciclopedia Storico-Nobiliare Italiana.

Stanton, Elizabeth Cady. [1895] 1974. *The Original Feminist Attack on the Bible (The Woman's Bible)*. Introduction by Barbara Welter. New York: Arno Press.

Stechow, Wolfgang. 1951. " '*Lucretiae Statua*.' " In *Beiträge für Georg Swarzenski zum 11. Januar 1951*, foreword by Oswald Goetz, pp. 114–24. Berlin and Chicago: Verlag Gebr. Mann, with Henry Regnery Co.

———. 1960. "The Authorship of the Walters 'Lucretia,' " *Journal of the Walters Art Gallery* 23: 73–85.

Stein, Judith E. 1979. "The Iconography of Sappho: 1775–1875." Ph.D. dissertation, University of Pennsylvania.

Steinberg, Leo. 1975. *Michelangelo's Last Paintings: "The Conversion of St. Paul" and "The Crucifixion of St. Peter" in the Cappella Paolina, Vatican Palace*. London: Phaidon.

Steinmann, Jean. 1953. *Lecture de Judith*. Paris: J. Gabalda.

Sterling, Charles. 1958. "Gentileschi in France." *Burlington Magazine* 100 (April): 110, 112–21.

Stone, Merlyn. 1976. *When God Was a Woman*. New York: Dial Press.

Stricchia, Fiorella. 1963. "Lorenzo Lippi nello svolgimento della pittura fiorentina della prima metà del '600." In *Proporzioni: Studi di Storia dell'Arte* 4: 242–70.

Summers, David. 1977. "Contrapposto: Style and Meaning in Renaissance Art." *Art Bulletin* 59 (September): 336–61.

———. 1981. *Michelangelo and the Language of Art*. Princeton: Princeton University Press.

Sutton, Peter C. 1984. *Masters of Seventeenth-Century Dutch Genre Painting*. Exh. cat. Philadelphia: Philadelphia Museum of Art.

Swinburne, Algernon Charles. [1864] 1875. "Notes on Designs of the Old Masters in Florence." In *Essays and Studies*. London: Chatto and Windus.

Tanfani-Centofani, Leopoldo. 1897. *Notizie di artisti tratte dai documenti pisani*. Pisa: E. Spoerri.

Tarabotti, Arcangela [Galerana Baratotti, pseud.]. 1654. *La semplicità ingannata, o Tirannia paterna*, Leiden: G. Sambix.

Tasso, Torquato. 1582. *Discorso della Virtù Feminile, e Donnesca*. Venice: Bernardo Giunti e fratelli.

Tatum, James. 1979. *Apuleius and the Golden Ass*. Ithaca, N.Y.: Cornell University Press.

Taylor, René. 1972. "Hermetism and Mystical Architecture." In Rudolf Wittkower and Irma B. Jaffe, eds., *Baroque Art: The Jesuit Contribution*, pp. 63–97. New York: Fordham University Press.

Terracina, Laura. 1550. *Discorso sopra tutti li primi canti d'Orlando Furioso*. Venice: Ferrari.

Thérel, Marie-Louise. 1973. *Les Symboles de l' "Ecclesia" dans la création iconographique de l'art chrétien du IIIe au VIe siècle*. Rome: Edizioni di storia e letteratura.

Thiem, Christel. 1977. *Florentiner Zeichner des*

*Frühbarock*. Italienische Forschungen, Dritte Folge, Band X, Kunsthistorisches Institut, Florence. Munich: Bruckmann.

Thuillier, Jacques, text. 1967. *Rubens' Life of Marie de' Medici*. With a catalogue and a documentary history by Jacques Foucart. Translated by Robert E. Wolf. New York: H. N. Abrams.

Toesca, Ilaria. 1971. "Versi in lode di Artemisia Gentileschi." *Paragone* 22, no. 251 (January): 89–92.

De Tolnay, Charles. 1943–60. *Michelangelo*. 5 vols. Vol. 1: The Youth of Michelangelo (1943). Vol. 2: The Sistine Ceiling (1945). Princeton: Princeton University Press.

———. 1949. "Velázquez' *Las Hilanderas* and *Las Meninas* (An Interpretation)." *Gazette des Beaux-Arts* 35 (January): 21–38.

Tondi, B. 1687. *La femina origine d'ogni male, overo Frine rimproverata*. Venice.

Toschi, Paolo. 1967. *Populäre Druckgraphik Europas: Italien vom 15. bis zum 20. Jahrhunderts*. Munich: G.D.W. Callwey.

*Trafalgar Galleries at the Royal Academy III*. 1983. Exh. cat. London: Trafalgar Galleries.

Trafton, Dain A. 1983. "Politics and the Praise of Women: Political Doctrine in the *Courtier*'s Second Book." In David Rosand and Robert W. Hanning, eds., *Castiglione: The Ideal and the Real in Renaissance Culture*, 24–99. New Haven: Yale University Press.

Trevor-Roper, Hugh R. 1969. *The European Witch-craze of the Sixteenth and Seventeenth Centuries and Other Essays*. Harmondsworth: Penguin.

———. 1970. *The Plunder of the Arts in the Seventeenth Century*. London: Thames and Hudson.

Trinkaus, Charles. 1970. *In Our Image and Likeness: Humanity and Divinity in Italian Humanist Thought*. 2 vols. Chicago: University of Chicago Press.

Tscherny, Nadia. 1977–78. "Domenico Corvi's Allegory of Painting: An Image of Love." *Marsyas* 19: 23–27.

Tufts, Eleanor. 1974. *Our Hidden Heritage: Five Centuries of Women Artists*. New York, London and Toronto: Paddington Press.

Turner, Nicholas. 1977. "A Newly Discovered Painting by the Cavaliere d'Arpino." *Burlington Magazine* 119 (October): 710–13.

Tuve, Rosemond. 1964. "Notes on the Virtues and Vices—Part II." *Journal of the Warburg and Courtauld Institutes* 27: 42–72.

*Gli Uffizi: catalogo generale*. 1979. Coordinated by Luciano Berti. Florence: Centro Di.

Utley, Francis Lee. 1944. *The Crooked Rib, An Analytical Index to the Argument about Women in English and Scots Literature to the End of the Year 1568*. Columbus: The Ohio State University.

*Valentin et les Caravagesque Français*. 1974. Exh. cat., edited by Arnauld Brejon de Lavergnée, Grand Palais, Paris, February–April 1974. Paris: Éditions des musées nationaux.

Valentiner, W. R. 1935. "Judith with the Head of Holofernes." *Detroit Institute Bulletin* 14, no. 8 (May): 101–104.

Varese, Carlo. 1835–36. *Storia della Repubblica di Genova, dalla sua Origine sino al 1814*. 8 vols. Genoa: Yves Gravier.

Vasari, Giorgio. 1568. *Le Vite de' più eccellenti pittori, scvltori e architettori, scritte di nuovo ampliate, da M. Giorgio Vasari pittore et architetto Aretino*. 2nd ed. 3 vols. Florence: I. Giunti.

[Vasari, Giorgio.] [2nd ed., 1568] 1960. *Vasari on Technique, Being the Introduction to the Three Arts of Design, Architecture, Sculpture and Painting, Prefixed to the Lives of the Most Excellent Painters, Sculptors and Architects*. Translated by Louisa S. Maclehose, edited with introduction & notes by G. Baldwin Brown, 1907. New York: Dover Publications, Inc.

Venturi, Adolfo. 1882. *La R. Galleria Estense in Modena*. Modena: Paolo Toschi & C. Editore.

Verdier, Philippe. 1969. "L'iconographie des arts libéraux dans l'art du moyen âge jusqu'à la fin du quinzième siècle." In *Arts libéraux et philosophie au moyen âge*, Actes du Quatrième congrès international de philosophie médiévale, Université de Montréal, 1967, pp. 305–55. Paris: Librairie philosophique J. Vrin.

Vickers, Nancy J. 1981. "Diana Described: Scattered Woman and Scattered Rhyme." *Critical Inquiry* 8: 265–79.

Vierneisel, Klaus. 1980. "Die Berliner Kleopatra." *Jahrbuch der Berliner Museen* 22: 5–33.

Vinge, Louise. 1967. *The Narcissus Theme in Western European Literature up to the Early Nineteenth Century*. Translated by Robert Dewsnap and Lisbeth Grönlund. Lund: Gleerups.

Viollet-le-Duc, Eugène Emmanuel. 1868–74. *Dictionnaire raisonné de l'architecture française du XI$^e$ au XVI$^e$ siècle*. 10 vols. Paris: A. Morel & C$^{ie}$.

Visconti, Ennio Quirino. 1818–22. *Oeuvres de Ennius*

*Quirinus Visconti, Musée Pie-Clémentin.* 7 vols. Milan: T. P. Giegler.

Vives, Juan Luis. [1523] 1912. *Instruction of a Christian Woman.* In Foster Watson, ed., *Vives and the Renascence Education of Women.* New York: Longmans, Green & Co.

Vliegenthart, Adriaan W. 1976. *La Galleria Buonarroti: Michelangelo e Michelangelo il Giovane.* Translated by Giorgio Faggin. Florence: Istituto Universitario Olandese di Storia dell' Arte VII.

Volk, Mary Crawford. 1977. *Vicencio Carducho and Seventeenth-Century Castilian Painting.* New York and London: Garland.

———. 1978. "On Velázquez and the Liberal Arts." *Art Bulletin* 60 (March): 69–86.

Volkmann, Hans. 1958. *Cleopatra, A Study in Politics and Propaganda.* Translated by T. J. Cadoux. New York: Sagamore Press.

Volpe, Carlo. 1972. "Annotazioni sulla mostra caravaggesca di Cleveland." *Paragone* 23, no. 263: 50–76.

von Erffa, Hans M. 1969–70. "JUDITH-VIRTUS VIRTUTUM-MARIA." *Mitteilungen des Kunsthistorisches Institutes in Florenz* 14: 460–65.

Voss, Hermann. 1920. "Artemisia Gentileschi." Entry in Ulrich Thieme and Felix Becker, eds., *Allgemeines Lexikon der bildenden Künstler von der Antike bis zur Gegenwart; unter Mitwirkung von 300 Fachgelehrten des In- und Auslandes.* 37 vols. Vol. 13. Leipzig: Seemann, 1907–50.

———. 1925. *Die Malerei des Barock in Rom.* Berlin.

———. 1960–61. "*Venere e Amore* di Artemisia Gentileschi." *Acropoli* 1, pt. 1: 79–82.

Vsevolozhskaya, Svetlana, with I. Linnik. 1975. *Caravaggio and His Followers (Paintings in Soviet Museums).* Leningrad: Aurora Art.

Walker, Barbara G. 1983. *The Woman's Encyclopedia of Myths and Secrets.* New York: Harper & Row.

Walpole, Horace. 1762. *Anecdotes of Painting in England; with some account of the principal artists; and incidental notes on other arts; collected by the late Mr. George Vertue and now digested and published from his Original Mss. by Mr. Horace Walpole.* 4 vols. London: T. Farmer.

———. 1826–28. *Anecdotes of Painting in England. . . . Additions by Rev. James Dallaway.* 5 vols. London: J. Major.

Walters, Margaret. 1978. *The Nude Male: A New Perspective.* Harmondsworth and New York: Penguin.

Ward, M.A.J. 1972. "The Accademia del Disegno in Sixteenth-Century Florence: A Study of an Artists' Institution." Ph.D. dissertation, University of Chicago.

Wark, R. R. 1956. "Notes on Van Dyck's *Self-Portrait with a Sunflower.*" *Burlington Magazine* 98 (February): 53–54.

Warner, Marina. 1976. *Alone of All Her Sex: The Myth and Cult of the Virgin Mary.* New York: Knopf.

———. 1984. "After Titian's 'Susanna and the Elders.' " *Ms.* 12 (January): 75–79.

Weiser, Artur. 1961. *The Old Testament: Its Formation and Development.* Translated by Dorothea M. Barton. New York: Association Press.

Weston, Jessie L. [1920] 1957. *From Ritual to Romance.* Garden City, N.Y.: Doubleday.

Wethey, Harold. 1975. *The Paintings of Titian.* Vol. 3. *The Mythological and Historical Paintings.* London: Phaidon.

Whitfield, Clovis, and Jane Martineau, eds. 1982. *Painting in Naples 1606–1705, From Caravaggio to Giordano.* Washington, D.C.: National Gallery of Art; London: Royal Academy of the Arts, in association with Weidenfeld and Nicolson.

Willard, Charity Cannon. 1984. *Christine de Pizan: Her Life and Works.* New York: Persea Books.

Winckelmann, J. J. 1809. *Monuments inédits de l'antiquité, statues, peintures antiques, pierres gravés, bas-reliefs de marbre et de terre cuite gravés par David . . . et par Mlle Sibire son élève.* Translated from Italian to French by A. F. Désodoards. 3 vols. Paris: L. Paravicin.

Wind, Edgar. 1937–38. "Donatello's *Judith*: A Symbol of 'Sanctimonia.' " *Journal of the Warburg and Courtauld Institutes* 1: 62–63.

Winner, Matthias. 1957. "Die Quellen der Pictura-Allegorien in gemalten Bildergalerien des 17. Jahrhunderts zu Antwerpen." Dissertation, Cologne.

———. 1962. "Gemalte Kunsttheorie: Zu Gustave Courbets 'Allégorie réelle' und der Tradition." *Jahrbuch Berliner Museen* 4: 151–85.

Witt, Reginald Eldred. 1971. *Isis in the Graeco-Roman World.* Ithaca, N.Y.: Cornell University Press.

Wittkower, Rudolf. 1939. "Transformations of Minerva in Renaissance Imagery." *Journal of the Warburg and Courtauld Institutes* 2: 194–205.

———. 1958. *Art and Architecture in Italy, 1600 to 1750.* The Pelican History of Art. Baltimore: Penguin Books.

Wittkower, Rudolf, and Margot Wittkower. 1963.

*Born under Saturn, The Character and Conduct of Artists: A Documented History from Antiquity to the French Revolution*. New York and London: W. W. Norton.

Woodhouse, J. R. 1978. *Baldesar Castiglione: A Reassessment of "The Courtier."* Edinburgh: Edinburgh University Press.

Woolf, Virginia. 1942. "Professions for Women." In *The Death of the Moth and Other Essays*. New York: Harcourt, Brace.

Yates, Frances A. 1967. "The Hermetic Tradition in Renaissance Science." In Charles S. Singleton, ed., *Art, Science, and History in the Renaissance*, pp. 255–74. Baltimore: The Johns Hopkins University Press.

———. 1975. *Astraea, The Imperial Theme in the Sixteenth Century*. London and Boston: Routledge & Kegan Paul.

Young, Arthur M. 1964. *Echoes of Two Cultures*. Pittsburgh: University of Pittsburgh Press.

Zagona, Helen Grace. 1960. *The Legend of Salome and the Principle of Art for Art's Sake*. Geneva: Droz.

Zeri, Federico. 1954. *La Galleria Spada in Roma, Catalogo dei dipinti*. Florence: Sansoni.

———. 1976. *Italian Paintings in the Walters Art Gallery*. Edited by Ursula E. McCracken, with condition notes by Elisabeth C. G. Packard. 2 vols. Baltimore: Walters Art Gallery.

Zuccari (Zuccaro), Federico. 1607. *L'Idea de' pittori, scultori ed architetti*. Torino: Agostino Disserolio.

Zucchini, Guido. 1938. *Catalogo delle collezioni comunali d'arte di Bologna*. Palazzo del Comune. Bologna: Grafiche Nerozzi.

# INDEX